THE NEW ART—THE NEW LIFE

The Collected Writings of

PIET MONDRIAN

THE DOCUMENTS OF TWENTIETH CENTURY ART

General editors, Robert Motherwell & Jack Flam

Other titles in the series by G. K. Hall & Co.

THE NEW ART—THE NEW LIFE

The Collected Writings of
PIET MONDRIAN

Edited and translated by
Harry Holtzman and Martin S. James

G. K. Hall & Co. • Boston

G. K. Hall & Co.
70 Lincoln Street
Boston, Massachusetts 02111

86 87 88 89 / 4 3 2 1

Mondrian, Piet, 1872–1944.
 The new art, the new life.

 (The documents of twentieth century art)
 Bibliography.
 1. Mondrian, Piet, 1872–1944—Correspondence.
2. Artists—Netherlands—Correspondence.
3. Neoplasticism. I. Holtzman, Harry. II. James, Martin S. III. Title.
IV. Series: Documents of twentieth century art (G. K. Hall & Company)
N6953.M64A3 1986 700 86-9873
ISBN 0-8057-9957-5

Designed and produced by Carole Rollins.
Copyedited under the supervision of Michael Sims.
Set in 10.5/13 Sabon by r/tsi typographic co., inc.

Aux hommes futurs

[This was Mondrian's dedication to
his essay *Le Néo-Plasticisme* of 1920]

Contents

Illustrations

"In 1925 the contemporary art collector Ida Bienert asked El Lissitzky to put her in touch with Mondrian, who at that very moment in his Bauhaus book *Neue*

Gestaltung had expressed himself forcefully on the subject of architecture and the environment. Mondrian . . . did not himself come to Dresden."—Fritz Löffler, quoted in Nancy J. Troy, *The De Stijl Environment*, (Cambridge: MIT Press, 1983), 144.

"The design was completed in Spring 1926, but "the monetary compensation was too low for me to go there and execute it myself. I do not think it can be executed by anyone else."—Mondrian to J. J. P. Oud, 22 May 1926.

177 Piet Mondrian. *Set design for Michel Seuphor's play "L'Ephémère est l'èternel,"* unexecuted maquette, 1926. (Reconstruction by Ad Dekkers, 1964.) Cardboard and wood, 21 × 30⅛ × 10½ in. (53.3 × 76.5 × 26.5 cm). Van Abbemuseum, Eindhoven, The Netherlands.

178 Mondrian's studio, rue du Départ, Paris, late 1920s. North wall. Photo: Collection Harry Holtzman, Lyme, Connecticut.

"I do not make the sharp distinction that Léger does between the concentrated inwardness of the easel painting and the outward decorativeness of the wall. Just as my painting is an abstract surrogate for the whole, so the abstract plastic of the wall is integral with the essential content of the room as a whole. Rather than being superficially decorative, the entire wall expresses an objective and universal outlook. . . ."—Mondrian as reported in a 1922 interview, "Bij Piet Mondrian," *Nieuwe Rotterdamse Courant*, 22 March 1922, 9.

179 Mondrian with Michel Seuphor and Enrico Prampolini in his rue du Départ studio, ca. 1928. Unidentified photographer.

180 *Composition with Red, Yellow, and Blue*, 1928. Oil on canvas, 17¾ × 17¾ in. (45 × 45 cm). Wilhelm-Hack-Museum, Ludwigshafen am Rhein, West Germany.

181 *Composition with Red, Yellow, Blue, and Black*, 1928. Oil on canvas, 20½ × 19⅝ in. (52.1 × 49.8 cm). Morton Neumann Family Collection, Chicago.

182 *Composition*, 1929. Oil on canvas, 20⅝ × 20⅝ in. (52.5 × 52.5 cm). Öffentliche Kunstsammlung, Kunstmuseum Basel.

183 *Fox Trot B*, 1929. Oil on canvas, 17⅜ × 17⅜ in. (44 × 44 cm). Yale University Art Gallery, New Haven, Connecticut. Gift of the Societé Anonyme.

184 Mondrian's studio, rue du Départ, Paris, ca. 1929: north wall with contemporary paintings and maquette of stage design for Seuphor's play. Photo: Collection Harry Holtzman.

185 *Composition in Black and White*, 1930. Oil on canvas, 16¼ × 13 in. (41 × 13.2 cm). Collection Mrs. James H. Clark, Dallas.

186 *Composition no. II with Black Lines*, 1930. Oil on canvas, 19¾ × 20⅛ in. (50 × 51.1 cm). Van Abbemuseum, Eindhoven, The Netherlands.

187 *Composition with Red, Black, and White*, 1931. Oil on canvas, 31⅞ × 21¼ in. (80 × 54 cm). Unlocated.

188 *Composition I*, 1931. Oil on canvas, 20 × 19½ in. (51 × 49.5 cm). Sidney Janis Gallery, New York.

189 *Fox Trot A*, 1930. Oil on canvas, diagonal: 43¼ in. (110 cm). Yale University Art Gallery, New Haven, Connecticut. Gift of the artist to the Collection Societé Anonyme.

190 *Composition with Two Lines*, 1931. Oil on canvas, diagonal: 44⅞ in. (114 cm). Stedelijk Museum, Amsterdam.

191 *Composition with Yellow Lines*, 1933. Oil on canvas, diagonal: 46⅛ in. (117 cm). Haags Gemeentemuseum, The Hague. Gift of admirers of the artist.

192 *Composition A*, 1932. Oil on canvas, 21¹¹⁄₁₆ × 21¹¹⁄₁₆ in. (55 × 55 cm). Kunstverein Winterthur, Switzerland.

193 *Composition B with Gray and Yellow*, 1932. Oil on canvas, 19¾ × 19¾ in. (50 × 50 cm). Collection Müller-Widman, Basel.

194 *Composition with Blue and Yellow*, 1933. Oil on canvas, 16⅛ × 13³⁄₁₆ in. (41 × 33.5 cm). Collection Pezzold-Müller, Basel.

195 *Composition in Red and Blue*, 1933. Oil on canvas, 15¾ × 13 in. (40 × 33). Sidney Janis Gallery, New York.

196 *Composition with Yellow and Blue*, 1933. Oil on canvas, 16⅛ × 13 in. (41 × 33 cm). Collection Gerard Bonnier, Stockholm.

197 *Composition with Gray and Red*, ca. 1933. Oil on canvas, 55 × 57 in. (119.7 × 144.8 cm). Unlocated.

198 *Composition Gray-Red*, 1935. Oil on canvas, 21⅝ × 22⅜ in. (54.9 × 56.8 cm). The Art Institute of Chicago, Gift of Mrs. Charles B. Goodspeed.

199 *Composition with Yellow and Blue*, 1935. Oil on canvas, 28¾ × 27½ in. (73 × 69.8 cm). The Hirshhorn Museum and Sculpture Garden, Smithsonian Institution, Washington, D.C.

200 Mondrian in his studio with the British painter Gwen Lux, early 1930s. Photo: Collection Harry Holtzman, Lyme, Connecticut.

201 *Composition B with Red*, 1935. Oil on canvas, 36 × 28¼ in. (91.5 × 61.5 cm). Private collection, England.

202 *Composition with Red and Black*, 1936. Oil on canvas, 23¼ × 22¼ in. (59 × 56.5 cm). Private collection, Brazil.

203 *Composition, Black, White, Yellow*, 1936. Oil on canvas, 28⅜ × 26⅜ in. (72 × 66.7 cm). Philadelphia Museum of Art. The Louise and Walter Arensberg Collection.

204 *Composition with Red and Blue*, 1936. Oil on canvas, 35⅝ × 31⅝ in. (98 × 80.3 cm). Staatsgalerie Stuttgart.

205 *Composition with Yellow*, 1935. Oil on canvas, 23 × 20⅝ in. (58.3 × 52.2 cm). Galerie Beyeler, Basel.

206 *Composition with Blue, Yellow, and White*, 1936. Oil on

Preface

Between 1914 and his death in 1944, Piet Mondrian devoted a considerable part of his time to writing. Almost every one of his essays was published soon after completion, in a wide range of cultural journals or exhibition catalogs. They are here assembled for the first time, in English, together with all drafts and notes not already incorporated by Mondrian into his finished essays.

The writings that form the heart of this book are preceded by a chronology surveying Mondrian's career and by two introductory contributions by the editors. The essays are presented in order of their completion, and each is preceded by a headnote tracing the circumstances of its composition and publication. At the end of the volume are a list of Mondrian's publications during his lifetime, a selected bibliography on aspects of his life and work, and an index of proper names mentioned in the text.

The first essay in the collection ("The New Plastic in Painting") dates from 1915–17, with additions made in 1918. Mondrian's earlier thought is known chiefly from his letters of 1909 on and from notations in his sketchbooks of ca. 1912–14. These sources are quoted at length in the second introductory essay. The entire text of the sketchbooks is transcribed and translated in an earlier publication: R. P. Welsh and J. M. Joosten, *Two Mondrian Sketchbooks 1912–1914* (Amsterdam: Meulenhoff, 1969).

Mondrian's letters and sketchbook notations were written in his native Dutch, as were his essays published in *De Stijl* from 1917 to 1924. Living in France from 1919 to 1938, Mondrian at first made his own translations into French, but by the late twenties he appears to have been writing directly in that language. His publications from 1938 on were almost exclusively in English, and, after moving to the United States in 1940, he began to formulate his ideas in English.

Where variations occur between different versions or translations of a text, the editors have looked for guidance to the original manuscripts, to Mondrian's corrected tearsheets, or to the version that seemed to embody his final intention. Dates following essay titles indicate the year of completion. Titles in square brackets have been supplied by the editors.

The illustrations are intended to give a continuous picture of Mondrian's entire artistic development. They are augmented by photographs of the artist in different periods of his life.

Unless otherwise stated, quotations from Mondrian's letters to Theo van Doesburg are based on documents formerly in the *De Stijl* archive in Meudon-Val-Fleury and now in the Van Doesburg Archive, Dienst Verspreide Rijkskollekties, The Hague. Similarly, quotations from Mondrian's letters to J. J. P. Oud are from correspondence preserved in the Fondation Custodia, Institut Néerlandais, Paris.

The editors wish to thank the eminent Mondrian scholars Carel Blotkamp and Joop M. Joosten for their great generosity in sharing data, helping with translation problems, and reviewing portions of the text. Also invaluable was the assistance of Carla Koen-de Josselin de Jong in performing documentary research and translation, and of Annette Klein in facilitating contacts with Dutch informants. Herbert Henkels made available the resources of the Mondrian Archive of the Gemeentemuseum, The Hague; his chronology in the catalog of the 1981 Stuttgart exhibition and his research into Mondrian's early life have been drawn on in establishing the chronology of the present volume.

Individuals who were in direct contact with Mondrian and shared their recollections or documents include Peter Alma, Paul Citroen, Cornelis van Eesteren, Bart van der Leck, Mr. and Mrs. Carel Mondriaan, Arthur Lehning, J. J. P. Oud, Gerrit Rietveld, and Friedrich Vordemberge-Gildewart in Holland; Nelly van Doesburg and Michel Seuphor in France; Carola Giedion-Welcker and Alfred Roth in Switzerland; Sir Leslie Martin in the United Kingdom; and Sidney Janis and Carl Holty in the United States.

Documentation, advice, or assistance were also provided by Joost Baljeu, Hans L. C. Jaffé, Charles Karsen, Jan Leering, Harry G. M. Prick, and H. J. Pos in the Netherlands; Mme C. Courcier, Marie Françoise Cristout, and Carlos van Hassoldt in France; Alan Bowness, Nicolette Gray, and Andrew Nicholson in England; Alessandro Prampolini in Italy; Volke Heybroek in Sweden; Arthur A. Cohen, Bernard Karpel, Russel Maylone,

Angelica Rudinstine, and Professor J. W. Smit in the United States; and Gilles Gheerbrant and Guido Molinari in Canada. The editors also acknowledge their debt to the scholarly work of Yve-Alain Bois, Nancy J. Troy, and Robert P. Welsh.

Translations from the Dutch were reviewed by Alan Doig, and assistance in translation was given at various times by Gerda Braunschweig, Charles Duits, Hans Locher, and Otie Storm.

Gratitude is expressed to the following institutions: Gemeentemuseum, The Hague; Nederlands Documentatiecentrum voor de Bouwkunst, Amsterdam; Fondation Custodia, Institute Néerlandais, Paris; and the Archives of American Art, New York.

Also acknowledged with deep gratitude is the skillful editorial care of Barbara Burn and Phyllis Freeman, and of the editors of the Documents of Twentieth Century Art series: Jack Flam (series editor), Caroline Birdsall and Anita D. McClellan (executive editors), Michael Sims (development editor), and Carole Rollins (designer). Editorial assistance was also rendered by Diana Brownell, Jan Henry James, Warren Robbins, Dorothy Strike, and Christopher Sweet (photographs). Finally, the editors would like to thank all those who lent the photographs included in this volume.

Chronology

1869

Pieter Cornelis Mondriaan (1839–1921)—Piet Mondrian's father—marries Johanna Christina de Kok (1839–1909) in The Hague. In the same year he is appointed principal of a Protestant primary school in Amersfoort. His family was long established in The Hague and he had trained at a Protestant teachers college there.

Besides primary school subjects, P. C. Mondriaan, Sr., was qualified to teach French and free-hand drawing. From 1872 on, he designed lithographs of a religious and patriotic nature. His activity on behalf of Dutch Reformed Church ideals brought him into contact with statesman Groen van Prinsterer, leader of the Réveil (Christian Awakening); his career was also advanced by Dr. Abraham Kuyper (1837–1920), parliamentary leader of the dominant wing of the Dutch Reformed party.

1872

Birth on 7 March of the Mondriaans' first son, also named Pieter Cornelis, known as Piet Mondriaan and, after his move to France, Piet Mondrian. He had an older sister, Johanna (1870–1939), and three younger brothers: Willem (1874–1944), Louis (1877–1942), and Carel (1880–1957).

1880

P. C. Mondriaan, Sr., is appointed headmaster of a Protestant primary school in Winterswijk, in the eastern region of the Netherlands. Piet attends the school. At an early age he begins to assist his father in executing the ideological prints.

1886

Piet completes primary school at age fourteen. Studies for license to teach drawing on the primary level. In nearby Doetinchem, frequently visits Jan Braet von Uberfeldt, a retired drawing teacher who has an extensive collection of paintings and reproductions.

1889

Licensed to teach drawing on the primary level. Piet's uncle Frits Mondriaan (1853–1932), later a professional landscape painter, is a regular visitor to Winterswijk; Piet often accompanies him on painting trips.

1892

Licensed to teach drawing on the secondary level. Moves to Amsterdam and begins two years of full-time study at Rijksacademie.

> 1892–93 Painting Class. Application and ability: quite good.
> 1893–94 Painting Class. Application: very good. Ability: good.

1894–97

Continues at the Academy, in evening classes.

> 1894–95 Drawing class. Application and ability: quite good.
> 1896–97 Drawing class. Application: good. Ability: fair.

From about 1893, supports himself by making copies in the Rijksmuseum, by painting still lifes, portraits, and landscapes (eventually landscape almost exclusively), and by giving private art lessons.

Exhibits regularly with local art associations (Utrecht from 1892; Amsterdam: Arti et Amicitiae from 1897, St. Lucas from 1897).

Executes allegorical decoration *Thy Word Is Truth* (1894) for his father's school.

1898

Unsuccessful in Prix de Rome competition, which centered on academic figure painting.

Visits to Winterswijk, where does work in proto-symbolist manner. Paints the ceiling of an Amsterdam house with cherubs (1899).

ca. 1900

Visits Cornwall.

Around this time, becomes interested in theosophy, together with his friend Albert van den Briel (1881–1971).

1901

Again unsuccessful in Prix de Rome competition.

Concentrates on landscapes, often working along the River Gein on the outskirts of Amsterdam.

Brief trip to Spain with the painter Simon Maris (probably in this year).

1901–3

Paints chiefly in environs of Amsterdam.

1903

Visits Brabant in August.

1904

Seeking isolation, paints for a year (January 1904–January 1905) in rural Uden, Dutch Brabant, where Van den Briel is employed as a forester. Is impressed by the simple piety of the people.

1905

Returns to Amsterdam.

Van Gogh retrospective at Stedelijk Museum, Amsterdam.

1906

Mondrian is one of four winners of the Willinck van Collen prize.

Paints at farm of friends in Oele, province of Overijssel, eastern Netherlands.

Period of the Evening Landscapes, 1906–1907: dusk or early night scenes, with expressive rendering of light, space, and color. Details are subsumed within broad masses—a trend already discernible in Mondrian's work since about 1900.

1907

Summer in Oele.

Amsterdam: Modernist work by Van Dongen, Sluyters, and Otto van Rees at Vierjaarlijke exhibition, national salon (fall).

1908

The Modernist phases (1908–11): Luminist (i.e., late Divisionist) paintings by Sluyters and Jan Toorop at Sint Lucas exhibition, Amsterdam, mark the rise of Modernism in Holland.

Continues to paint at Oele.

Mondrian's first visit to Zeeland seaside resort of Domburg (September).

1909

Joint exhibition with Sluyters and the more conservative Cornelis Spoor at Stedelijk Museum, Amsterdam (January); Mondrian's Modernist or Luminist work of 1908 places him among the most controversial Dutch artists.

Joins the Dutch Theosophical Society (May).

Summer: second visit to Domburg, where he also spends time in fall and winter. Letter to the writer Israël Querido clarifying the intention behind work shown in January.

1910

Works in Domburg (August–October).

Fourteen works in Sint Lucas exhibition (spring).

His Salon d'Automne entry rejected (fall).

Moderne Kunstkring (Modern Art Circle) founded with Conrad Kikkert, Sluyters, and Mondrian as steering committee, Jan Toorop chairman (December).

1911

Adopts a mode employing angular planes.

Shows a Fauvist painting at Salon des Indépendants, Paris (spring).

First Moderne Kunstkring exhibition (October), with early Cubist works by Picasso and

Braque. Mondrian shows late 1910–11 work in his new manner. In his tripytch *Evolution*, uses overt theosophical symbolism for the last time.

Officially gives up residence in Amsterdam (20 December).

1912

Several works at the Indépendants (March); also shows in Domburg and at the Cologne Sonderbund.

Registers as resident of Paris (11 May), living first at 33 avenue du Maine, then at 26 rue du Départ, adjoining the Gare Montparnasse. In France, begins to spell his name with one *a*.

In Paris is friendly with the Dutch painters Lodewijk Schelfhout and Otto van Rees, and with the pianist-composer Jacob van Domselaer; becomes acquainted with Fernand Léger.

Returns to Domburg (summer).

Second Moderne Kunstkring exhibition.

The Cubist Phase (1912–14): figuration progressively dissolved. "Compositions" in ochres, browns, and grays are based chiefly on trees (1912–13), party walls, and church facades (1913–14).

Drawings of these subjects appear in two sketchbooks of ca. 1912–14, interspersed with notes on his conception of life and art.

1913

Exhibits at Salon des Indépendants.

Exhibits with Moderne Kunstkring, and at first Deutscher Herbstsalon, Berlin (fall).

His article on art and theosophy, written for a Dutch periodical (winter 1913), is rejected.

1914

Exhibits at Salon des Indépendants. Mondrian has his first solo exhibition, at Walrecht Gallery, The Hague.

The world war breaks out while Mondrian is in Domburg (August); he remains in Holland until June 1919.

The Late Cubist Phase (1914–16): Through intensified abstraction, Mondrian increasingly em-phasises the straight and the horizontal-vertical. The curved and the oblique are gradually eliminated. The so-called "plus-minus" compositions originate in studies of church facades, breakwaters ("pier and ocean"), sea, and starry sky.

Informative letters written by Mondrian to Lodewijk Schelfhout and to the collectors H. P. Bremmer and the Reverend H. van Assendelft between 1914 and 1917 are preserved.

By 1913–14, according to his letters, Mondrian thought of his work as the consequence of all previous art, an "art for the future."

1915

Lives in Laren, a village near Amsterdam favored by artists and writers. Meets Salomon Slijper who becomes his friend and foremost collector of his representational and Cubist oeuvre.

Shares house with the Van Domselaers. Discussions with Van Domselaer, as well as with another neighbor, the esoteric philosopher Dr. M. H. J. Schoenmaekers, who in this year publishes *The New World Image*. Becomes familiar with the writings of the Dutch Hegelian Professor G. J. P. J. Bolland.

Letter to critic A. de Meester-Obreen justifying his nondescriptive art (spring). Early in year sets about writing a book; in September, he thinks it nearly complete.

Work exhibited in Amsterdam (October) is praised by critic-artist Theo van Doesburg. Van Doesburg proposes the founding of a periodical devoted to the new art and ideas.

1916

The painter Bart van der Leck, working in a highly stylized manner with flat planes of primary color, settles in Laren (spring). A close relationship with Mondrian ensues.

Composition 1916 is the first canvas to be mounted "on, instead of behind, the frame." Mondrian completes few new paintings in 1915–16 owing to the demands of his writing and his need to earn a living. Over the next few years, at the suggestion of H. P. Bremmer, art advisor to Mrs. H.

Kröller-Müller, he receives a regular stipend in return for a stated number of works.

1917

Over 200 pages of "The New Plastic in Painting" are completed by May; only an introduction is lacking.

The first number of *De Stijl*, edited by Theo van Doesburg, appears in October. It contains the first installment of "The New Plastic in Painting" and articles by Van der Leck and the architect J. J. P. Oud.

The Neo-Plastic Phase: Composition in Line, begun in 1916 in the "plus-minus" manner and completed in early 1917 in the new manner, can be regarded as the first work of the New Plastic (Nieuwe Beelding). Its hard-edged planes against a white ground show the influence of Bart van der Leck. Larger planes appear by the end of the year. Mondrian also called his work Abstract-Real Art at this time (from 1920 on, *Néo-Plastique, Néo-Plasticisme*).

1918

Compositions with light color planes and gray divisions; compositions based on a regular grid. First composition in diamond format.

1919

Returns to Paris in June, living first at 26 rue du Départ and moving in November to 5 rue de Coulmiers.

Continues compositions employing grid, in diamond as well as in rectangular formats.

Writes "Dialogue on the New Plastic" (dated February 1919) and "Natural Reality and Abstract Reality: A Trialogue" (1919–20).

1920

Organizes rue de Coulmiers studio as described in "Trialogue," scene 7 (published March–August).

Stimulated by Futurism and Dada writing, interests shared by Theo van Doesburg, who visits Mondrian in Paris in spring. He encourages Mondrian's literary experiments: "Les Grands Boule-

vards" (published in *De Telegraaf* in March–April) and "Little Restaurant" (unpublished).

"De Stijl Manifesto on Literature" is written by Van Doesburg after consultation with Mondrian; signed by Van Doesburg, Mondrian and Antony Kok (*De Stijl*, April).

In course of year Mondrian writes his pamphlet *Le Néo-Plasticisme (Neo-Plasticism: The General Principle of Plastic Equivalence)*, published by Léonce Rosenburg in early 1921.

In April meets the sculptor-painter Georges Vantongerloo.

In August is visited by the architect J. J. P. Oud, with whom he had corresponded since the beginning of the year.

First characteristic Neo-Plastic canvases: red, yellow, blue, and gray (later white) planes, divided by gray (later black).

1921

Attends Futurist concert employing *bruiteurs* (mechanical noise-makers, *intonarumori*) (late June).

In October, returns to 26 rue du Départ building, where he establishes his renowned studio along Neo-Plastic lines.

Is included in exhibition "Les Maîtres du Cubisme," organized by Léonce Rosenberg at his Galerie de l'Effort Moderne, Paris. Rosenberg is unable to sell Mondrian's work.

Writes "The Manifestation of Neo-Plasticism in Music and the Italian Futurist's *Bruiteurs*" (dated July).

1922

A retrospective exhibition in honor of Mondrian's fiftieth birthday is held at the Stedelijk Museum, Amsterdam, organized by J. J. P. Oud, Salomon Slijper, and the painter Peter Alma (March).

Controversy with J. J. P. Oud as to the applicability of Neo-Plasticism in architecture (February–May).

Mondrian is included in Léonce Rosenberg's exhibition "Du Cubisme à une renaissance plastique."

Occasional sales in Holland through Dutch friends; supplements his small income by painting watercolors of flowers.

Writes "Neo-Plasticism: Its Realization in Music" (dated 1922) and "The Realization of Neo-Plasticism in the Distant Future and in Architecture Today" (dated March 1922).

1923

The Belgian writer Michel Seuphor becomes Mondrian's friend, and (1956) his first biographer.

At Léonce Rosenberg's Gallerie de l'Effort Moderne, exhibition of De Stijl architecture, organized by Van Doesburg, assisted by Cornelis van Eesteren; models by Gerrit Rietveld.

After 1922 Mondrian uses only primary red, yellow, and blue against white and black. Gray becomes rare.

Writes "Neo-Plasticism," "Is Painting Inferior to Architecture?," "No Axiom but the Plastic Principle," and "Blown by the Wind."

1924

Mondrian's work attracts attention in the exhibition "De Stijl Architecture and Related Arts," Ecole Spéciale d'Architecture, Paris (spring).

In 1923–24 Van Doesburg announces his modification of Neo-Plastic principles, Elementarism: by introducing the oblique, he seeks to express a dynamic opposition to nature (Counter-construction).

Mondrian's last contributions appear in De Stijl, early 1924.

1925

"Le Néo-Plasticisme" and four of Mondrian's essays from De Stijl are published in German translation as Neue Gestaltung, Bauhaus Book no. 5.

Mondrian's third solo exhibition, at Kühl and Kühn Gallery, Dresden, arranged by Sophie Küpper. In group exhibitions in Rotterdam, Paris, and The Hague.

From 1925–26 on, Mondrian's work is bought by collectors in Germany, Switzerland, and the United States.

Writes "The Neo-Plastic Architecture of the Future."

1926

Meets Arthur Müller-Lehning, editor of a new progressive Dutch journal, i 10.

Mondrian's studio attracts many visitors in the second half of the twenties.

In 1926 makes designs (unexecuted) for Salon de Mme. B . . . à Dresden; also maquette of set with figures for Michel Seuphor's play L'Ephémère est l'éternel (not executed).

Is represented in Societé Anonyme exhibition at Brooklyn Museum, New York.

Writes "Purely Abstract Art," "The New Plastic Expression in Painting," and "Home—Street—City."

1927

Van Doesburg's aggressive critique of Neo-Plasticism in De Stijl precipitates break on Mondrian's part.

Two paintings of Mondrian's are placed on permanent view by El Lissitzky in the Abstract Cabinet of Landesmuseum, Hanover.

Writes "Jazz and Neo-Plasticism" and "Painting and Photography."

1929

Five works in exhibition "Abstract and Surrealist Painting" at Kunsthaus, Zurich.

Toward the end of the 1920s, Mondrian's canvases tend to include fewer elements, notably in the diamond compositions of 1926–33.

Writes "Pure Abstract Art."

Is writing a "book about the old culture and the new," that is, "The New Art—The New Life: The Culture of Pure Relationships."

1930

Exhibits with the Cercle et Carré group founded by Michel Seuphor and Joaquín Torres-García and contributes to its journal. Exhibits in Stockholm.

Writes "A Note on Fashion," "Realist and Superrealist Art," and "Cubism and Neo-Plastic."

1931

First of his three contributions to the yearbooks of Abstraction-Création group, founded by Georges Vantongerloo and Auguste Herbin. Exhibits in Brussels.

Van Doesburg dies in Switzerland at age of forty-seven, soon after founding a new group, Art Concret.

Completes manuscript of "The New Art—The New Life: The Culture of Pure Relationships."

New developments in his painting over the next few years cause Mondrian to devote less time to writing.

Writes introduction to "The New Art—The New Life."

1934

Mondrian is visited in Paris by the British artist Ben Nicholson and the American artist Harry Holtzman.

In the 1930s, American collectors show increasing interest in Mondrian. His leading position in the modern movement is recognized by James Johnson Sweeney (*Plastic Redirections in Twentieth Century Painting*, 1934) and by Alfred Barr (*Cubism and Abstract Art*, 1936).

Exhibits in Holland and Wadsworth Atheneum, Hartford, Conn. (went on to Arts Club, Chicago.)

Writes "The True Value of Oppositions in Life and Art."

1935

Takes part in exhibition in Lucerne.
Writes "Reply to an Enquiry."

1936

Urban renewal compels Mondrian to vacate his rue du Départ studio; in March he moves to 278 boulevard Raspail, where he resides for two and a half years until his departure for London.

1937

"Plastic Art and Pure Plastic Art," Mondrian's first essay published in English, appears in the anthology *Circle* (London), edited by Nicholson, Gabo, and Martin.

1938

The signing of the Munich Pact brings pressure from Holtzman and from English friends for Mondrian to leave Paris. In September he moves to London, bringing all his work (some paintings begun in Paris are later completed in London and New York).

Lives at 60 Parkhill Road, Hampstead, near Nicholson, Gabo, and other artists. The collector Peggy Guggenheim acquires his work.

After Munich, begins "Notes toward a New Art Teaching" and "The Necessity of New Art Teaching in Architecture and Industry" (1938–40), with a view to finding a position with Laszló Moholy-Nagy at the New Bauhaus in Chicago.

Writes "Art without Subject" and "Neo-Plastic."

1940

Nazi bombing raids persuade Mondrian to move to New York. He arrives 3 October 1940, sponsored by Harry Holtzman. Has first studio at 353 East 56th Street.

Becomes member of American Abstract Artists.

Works on completion of "Liberation from Oppression in Art and Life," the last of his longer essays (begun in 1940 as "Art Shows the Evil of Nazi and Soviet Oppression").

1941

In New York, he at first works on canvases brought with him from Europe, augmenting and intensifying them with small planes of primary color unbounded by black. Bands of color that cross the entire format appear in his first painting initiated in America: *New York, 1941–42*.

Writes "Abstract Art" and "Toward the True Vision of Reality."

1942

Mondrian's first one-man show at the Valentine Dudensing Gallery (January–February); his autobiographical *Toward the True Vision of Reality*, drafted the previous spring, is issued on this occasion. The show includes *New York City I*, 1941–42. Of a series developed in colored paper tape (without black bands), it is the only version ever completed in paint.

Writes "A New Realism" and "Pure Plastic Art."

1943

His second exhibition at Valentine Gallery (March–April) includes *Broadway Boogie-Woogie*, 1942–43, which is acquired by the Museum of Modern Art.

Begins *Victory Boogie-Woogie*, unfinished at his death.

On 1 October, moves into his last studio, at 15 East 59th Street. Applies himself intensely to the design of this environment, positioning planes of colored card on the walls and constructing his own furniture.

Is extensively interviewed by James Johnson Sweeney in connection with planned retrospective at the Museum of Modern Art.

1944

Largely completes *Victory Boogie-Woogie*.

Dies of pneumonia on 1 February, aged seventy-two. Is interred at Cypress Hills Cemetery.

Holtzman, named testamentary legatee and executor in Mondrian's will, opens the studio to public view for six weeks and, assisted by Fritz Glarner, documents it with photos, motion pictures, and tracings of *Wall-Works*.

1945

Posthumous retrospective at Museum of Modern Art, New York (March–April).

Mondrian's essays in English, 1937–43, edited by Harry Holtzman, are published under the title *Plastic Art and Pure Plastic Art* in the Documents of Modern Art series.

Piet Mondrian
The Man and
His Work

Piet Mondrian (Pieter Cornelis Mondriaan) (1872–1944), one of the seminal minds of the twentieth century, is universally known for his "Neo-Plasticism," the new plastic in art. It is impossible to imagine twentieth-century painting, sculpture, and architecture without Mondrian's oeuvre.

Mondrian's present worldwide recognition came many years after his death. In 1945, Robert Motherwell observed this lag in his preface to Mondrian's essays in English, *Plastic Art and Pure Plastic Art*: "Among the twentieth century's strongest plastic expressions, e.g., those of Henri Matisse and Picasso, must be put that of the late Piet Mondrian. . . . Neo-Plasticism has encountered stronger and sometimes bitter resistance over a longer period of time than any of the others, and it is some measure of its force and vitality that despite this, it has come to exert an international influence. . . ."

The quintessence of Mondrian's contribution is his art: his paintings, and also his studios. Both show his impassioned assimilation of the vital contemporary spirit, its new levels of consciousness, the new realities of art's continuous transformation, and its evolving social significance. But no one is free of language, and Mondrian's unprecedented perception obliged him to complement his art with the essays that show the evolution of his way of speaking about art and life. His writings and his theories, Mondrian repeatedly cautioned, "always came later," after his paintings, as their consequence. The paintings are the result of "pure intuition," of direct experience through the means of expression—for which there can be no substitute; the writings were his efforts to fulfill the constant demand for verbal rationalization.

Because of my close relationship with Mondrian during the last ten years of his life, I am often asked to characterize his person and his contribution. A quick sketch of our first meeting in early December 1934 is revealing. I am a native New Yorker (born in 1912), involved with art since childhood and with abstract art since 1930. In 1933, without knowing Mondrian's work, my painting evolved in a parallel direction, all rectilinear forms. My friend Burgoyne Diller, on seeing these studies in my studio, told me of the two paintings by Mondrian recently hung for public view in A. E. Gallatin's Collection, the Museum of Living Art, in the study room of New York University on Washington Square. When I saw the two paintings I immediately felt that Mondrian had probably already been where I was going. Except for Diller, whose work then also turned in the same direction, the structural, philosophical, and historical implications that I was deducing were alienating to the few artists I knew in New York who represented the advancing extremes of art. I determined to go to Paris to meet Mondrian, to check my assumptions, and to discuss their implications.

With the help of friends I managed to scrape together the money for the passage. I arrived in Paris on the night of 7 December 1934, knowing no one in Europe. The social and political atmosphere was as dismal as the weather: the Great Depression, the misery of Hitler's Nazism, Mussolini's fascism, Stalin's communism, Franco's Falange. But I had come to Paris with great enthusiasm, intent only on meeting Mondrian.

Four days later, having found Mondrian's address, I concluded that my extremely elementary French could not produce a persuasive letter. With some trepidation I decided simply to knock on Mondrian's door at 26 rue du Départ, boldly, unannounced, waiting only until the afternoon darkness fell completely.

Mondrian opened the door. I had carefully rehearsed in French my apology for the intrusion, explaining that as an artist, although I knew only two of his paintings, I had come to Paris especially to meet with him; that my French was too limited to write confidently. . . . "I know some English . . . ," he said, "This is very unusual. . . . Please come in." We talked for three hours, half English, half French, without interruption, excitedly. Despite our age difference—Mondrian was sixty-two, I was twenty-two—we immediately became good friends. We met frequently during the four months I stayed in Paris, and it was through Mondrian that I first met Léger, Gabo, Pevsner, Hélion, Le Corbusier, Duchamp, and others.

I had intended to stay in Europe indefinitely. Mondrian and Hélion together exerted their influence to help my meager finances. William Hayter offered to help me get an exhibition. It became possible for me to remain in Paris. But after four months it was apparent that Hitler's increasing persecutions were leading inevitably to a greater crisis. I felt certain that war was in the making: the general pessimism was overwhelming. "Piet," I said, "I am sure that the United States is now the only country where modern art can flourish freely. . . . I'm going home to New York. . . ." When we said goodbye, Mondrian's last words were, "Nous sommes confrères. If I were younger, I would go with you."

In 1938, after the Munich Pact, I wrote to Mondrian, urging him to leave Paris for New York, telling him that my own recently improved economic situation made it possible for me to finance his move and that I could well afford to sponsor his immigration. However, Ben Nicholson, Barbara Hepworth, Naum Gabo, and others of the English Circle group persuaded him that London was "closer." . . . A small studio in Hampstead. . . . Then the "blitz" bombs. . . . When a time-bomb shattered his studio windows, Mondrian wrote to me that he was ready to come to New York. He arrived there in October 1940 . . . to his great delight. . . . and my complete joy.

During the years I knew him, Mondrian's way of living was consonant with his work—one could say that his life was his work. He had little contact with his two surviving brothers, one in Holland and the other in South Africa. All of his social relationships centered around his painting and writing. The increasing complexity of each painting demanded great concentration of time and energy, but he never ceased making notes for further essays. *Broadway Boogie-Woogie* required a year to complete, *Victory Boogie-Woogie*, unfinished at his death, much longer. His only excesses were on his paintings, sometimes to the neglect of his health.

He was always ready to welcome a friend and to attend a colleague's vernissage. A sympathetic visitor would find himself being asked for his reaction to the painting on the easel, "What do you think?" he might begin, "Do you think this part is quite right?" Few artists are so open.

The Mondrian I knew was gentle, courteous, quiet in manner, rarely abrupt or hostile. I found a direct, spontaneous, responsive man, unpretentious, vital, completely free of "kitsch"; an eternal optimist with undiminished interest in the dynamics of change.

Mondrian was average in height and thinly built. In the years I knew him he had a balding head, a large nose, and wore glasses that emphasized his dark eyes; he had, on the surface, a serious introspective face. His clothing was always simple, conventional, undistinguished. Only his eyes and his long elegant hands gave hint of the artist. His speech often seemed slow, restrained by the change of language and his scrupulous search for the appropriate words.

Although I have no personal knowledge of Mondrian's younger days, early photos and self-portraits show him as somewhat romantic in appearance, then dapper, energetic, proud, and lively. Mondrian was among the first in Europe to write about the importance to modern culture of black American jazz and its dances, which he thoroughly enjoyed until the end of his life. In Paris, he had had a large collection of jazz discs. On the night Mondrian arrived in New York, I introduced him to the boogie-woogie piano music of Ammons, Johnson, and Lewis. His response was immediate, he clasped his hands together with obvious pleasure, "Enormous! Enormous!" he repeated. He often went with me and others to enjoy what he called a "dancing party." Nobody has ever written more brilliantly about the symbolic ambience of the night-club ("Jazz and Neo-Plastic," 1927). In 1926, learning that the Charleston might be legally banned in Holland because of its "sensuality," Mondrian wrote from Paris, "If the ban on the Charleston is enforced, it will be a reason for me never to return [to Holland]" (*De Telegraaf*, 12 September, 1926). Ten years later Mondrian wrote to me of his great admiration for what he called "the ripe mentality of America" that he felt was so strongly manifested in the dances of Fred Astaire in his films with Ginger Rogers.

The period of Mondrian's lifetime probably witnessed more rapid and revolutionary changes in the physical and social character of Western culture than in all the preceding two thousand years. Mondrian was born into the era of oil lamps and gaslight, the horse and carriage, and the bicycle. Only the steam engine—for industry, ships, and the railroads—reflected the promise of the swiftly emerging technology, the promise of new ways of living. His lifetime was witness to the electric generator and its magic light and power, central heating, the automobile, the airplane, the cinema, electronic communication—telephone, radio, the beginnings of television; the new physics, the social sciences, the new medicine, and on and on. It was a time marked by

social change, two world wars, revolution—an epoch of radical upheaval and ferment in life and in art.

Mondrian was of the same generation as Einstein, Freud, Bergson, Russell, Whitehead, Picasso, Léger, Matisse, Kandinsky, Klee, Marinetti, Frank Lloyd Wright, Maillart, Le Corbusier . . . Stein, Joyce and Kafka . . . progeny of the Enlightenment, the instruments of cultural transformation. It should not be difficult to appreciate their genius, their strength and courage in their days of isolation.

Piet Mondrian was born on 7 March 1872 in Amersfoort, in the center of Holland. His father, Pieter Cornelis Mondriaan (1839–1921), often described as "a strict Calvinist," was the headmaster of a school. Amersfoort, with its medieval walls and church tower, remains today a tranquil middle-class town, comfortable, quiet, and pretty. Mondriaan senior, "an ardent prosyletizer of Christian ideals in education," was also a competent amateur artist who was qualified to teach drawing. Little is known of Mondrian's mother, Johanna Cristina de Kok (1839–1909), except that she had five children, four boys and a girl. Piet was the oldest and the only one to become an artist. In 1880 his father accepted a new post as headmaster of a school in Winterswijk, a small town near the German border, where Piet grew up. His uncle, Frits Mondriaan, a professional artist of the Dutch Impressionist tendency, was a frequent visitor. It was in Winterswijk, when he was about fourteen, that Mondrian's career began seriously. He first attended his father's school, where he obtained the diplomas that qualified him to teach drawing in primary and secondary schools. In 1892, at age twenty, he moved to Amsterdam, where he enrolled as a student in the Rijksakademie and began his independent life.

In Amsterdam, Mondrian quickly made contact with the larger world of art and artists. In his first year he exhibited still-life paintings in group shows—the Kunstliefde in Utrecht and the Society of St. Lucas and the Arti et Amicitiae in Amsterdam, among others. His associations with the artists Jan Toorop, Kees van Dongen, and Jan Sluyters provided great stimulation; later he was close with Bart van der Leck and Theo van Doesburg. Mondrian's contacts with other artists and movements were important to him throughout his life. His association with Van Doesburg, who founded *De Stijl*, was of particular importance. In the 1930s in Paris he gave his support to Cercle et Carré, and to Abstraction-Création, an international group; in England

land to the Circle group (1937); in New York to the American Abstract Artists.

Holland in the late nineteenth century, though geographically small, was one of the most international, global, worldly, enlightened, parliamentary monarchies in Europe; a seagoing colonial power extending around the world, from the Far East to the Caribbean. With the exception of France and Switzerland all of the European countries were monarchies, some still extremely feudal in organization and culture. Until World War I the aristocracy of Victorian Europe was riveted to the values and ways of life that sustained ancient social traditions. It was the past brought forward, socially impenetrable except by a small elite. But under the surging impetus of industrialization, a new international middle-class was rising, which was literally engaged in creating the new technology and the actual social and physical structure of life. Holland, perhaps also because of its small size, was culturally vitalized by its colonial ethnic variety, especially through its Far Eastern empire. It is not surprising that the influence of Oriental philosophy penetrated this cosmopolitan milieu.

One of the most widespread universalist groups influenced by Oriental thought was the Theosophical movement, led by Madame Blavatsky, Annie Besant, and Rudolf Steiner. The Indian philosopher, Krishnamurti, was sponsored by the Theosophical Society; Mondrian became a member in 1909.

Robert Welsh has contributed[1] the most comprehensive study of the influence of Theosophy upon Mondrian's early thought (1909–11). He has shown how "Mondrian's repeated emphasis on the polarities spirit-matter, universal-individual, abstract-real . . . its cardinal Doctrine of Evolution . . ." convey theosophically derived influences upon the artist's vocabulary of ideas. When I asked Mondrian about his interest in Theosophy, he told me how sympathetic he found this group: "They were always very, very nice people," he said, suggesting that many were open to the new as well as to the old. Theosophy was important to him for its philosophical exegesis, and for its vocabulary of abstract thought. It reinforced the universalism essential to the broadening scope of his perception. The chief published reference that Mondrian made to Theosophy is in his 1922 essay, "The Realization of Neo-Plasticism in the Distant Future and in Architecture Today": "Although they [Theosophy and Anthroposophy] already knew the *basic symbol of equivalence* . . . [they] could never

achieve the experience of equivalent relationship, real, fully human harmony." Only a few of his paintings directly expressed theosophically influenced symbolism. By the end of 1911, its influence was thoroughly absorbed and his art completely transformed.

In 1912, when Mondrian was forty years old, he moved to Paris—not as a romantic gesture, but because of his insistent and growing need for the most completely urban, the most cosmopolitan environment. Paris, "the city of light," the international center of the world of art, bursting with intellectual energy and modernity, was the inevitable choice. Here, with his immediate response to Cubism, began the ideological and aesthetic odyssey fundamental to Mondrian's *Neo-Plasticism.*

In 1914, during Mondrian's annual visit to Holland, World War I began, and he stayed in his neutral homeland until the end of the war. In 1915, his friendship with the energetic young artist-architect-poet, Theo van Doesburg, resulted in the collaboration of the international nucleus of artists, sculptors, architects, musicians, and poets, who were published in *De Stijl* (Style), a journal begun in 1917, founded and edited by Van Doesburg. It was Mondrian, as artist and theorist, however, who was credited by Van Doesburg as "the father of De Stijl." The Swiss historian, Sigfried Giedion, pointed out that De Stijl was not a formal group but consisted rather of avant-garde individualists, mutually sympathetic in spirit and action through their aspiration for the "new."[2] Among the contributors were the painters and sculptors Bart van der Leck, Georges Vantongerloo, Archipenko, Vilmos Huszár, El Lissitzky, Kurt Schwitters, Vordemberge-Gildewart, Césare Domela, Gino Severini, Hans Richter, and Hans (Jean) Arp; the composers George Antheil, and Jacob van Domselaer; and the architects Gerrit Rietveld, J. J. P. Oud, Robert van 't Hoff, and Cornelis van Eesteren. *De Stijl* was internationally forceful and extremely influential in the postwar years, giving Mondrian widespread recognition.

In 1919, as soon as possible after the war, Mondrian returned to Paris. It was during this time in Paris that Mondrian first synthesized the form that distinguishes his mature style; at the same time he established his famous studio at 26 rue du Départ. Shortly after he arrived in Paris, Mondrian immediately began to write his famous pamphlet *Le Néo-plasticisme: Principe général de l'équivalence plastique (Neo-Plasticism: The General Principle of Plastic Equivalence)*, dedicated in capital letters, AUX HOMMES FUTURS ("to the men of

the future"). This was Mondrian's first publication in French of the essential ideas he first formulated in "De Nieuwe Beelding in de schilderkunst" ("The New Plastic in Painting," 1917), recapitulated and brought forward. This essay marked the first appearance of the term "Neo-Plasticism." It was published in 1920 under the imprint of l'Effort Moderne, directed by Léonce Rosenberg.

Mondrian resided in Paris until 1938. Although he received little attention or acclaim in France—only once did he have a small one-man show in Paris, and the French did not acquire his paintings—he was nevertheless gaining international recognition. The important early period of the Bauhaus was much influenced by his work. The Bauhaus Book no. 5, published in 1925, included five of Mondrian's essays. His paintings were collected in Holland, Germany, Switzerland, and the United States. His writings appeared in the liveliest avant-garde journals of his time, in Holland, France, Germany, and England.

Mondrian's studios are justly famous and historic, especially the two at 26 rue du Départ in Paris and at 15 East 59th Street in New York, his last. Like his paintings, the studios clearly mirrored Mondrian's concern with the mores, creeds, and sociocultural habits of our time, and with the actual forms of the environment. Both studios were vital influences on the generations of artists and architects who visited or studied them. Alexander Calder spoke of the effect the Paris studio had on him as a source of inspiration for his mobiles. Willem de Kooning, who saw only the last studio in New York, said to me that it was "like walking around inside one of Mondrian's paintings." Mondrian occupied the Paris studio from 1921 to 1936; the New York studio from 1 October 1943 until his death on 1 February 1944. (Both buildings have been destroyed by "urban renewal.") The studios were Mondrian's only opportunity to partially concretize his radical ideas toward the total environment.

Mondrian arrived in New York in early October 1940. His first studio, at 353 East 56th Street, was too small, too filled with his paintings for him to do more than indicate the inevitable transformation of the space with rectangles of red, yellow, and blue.

Much revitalized by his first three years here, the happiest of his life he always said, Mondrian moved into the large three-room studio on 59th Street on 1

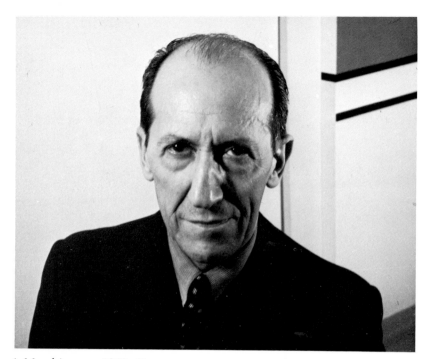

1 Mondrian, ca. 1940–41.

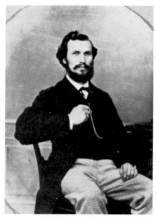

2 Pieter Cornelis Mondriaan, Sr., Mondrian's father, 1839–1915.

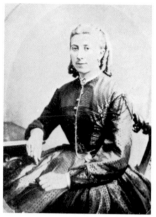

3 Johanna Christina Mondriaan, née De Kok, Mondrian's mother, 1839–1905.

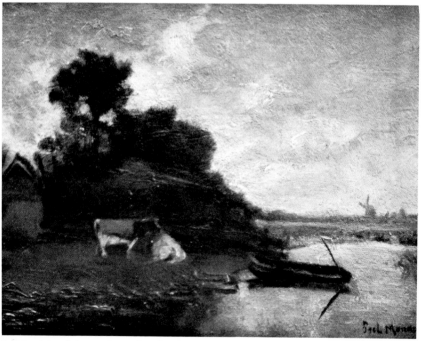

5 Frits Mondriaan. *Cows by the Water*, ca. 1900.

4 Frits Mondriaan, Mondrian's uncle and early teacher, 1853–1932.

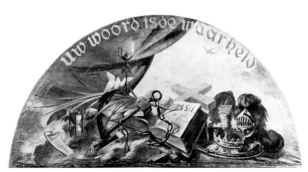

6 *Thy Word Is Truth*, painting executed by Piet
Mondrian after his father's design, ca. 1890.

7 P. C. Mondriaan, Sr. *Revolution or Gospel*, 1874.

8 Mondrian, aged about 20, ca. 1892.

9 Matthijs Maris. *Young Bride*, 1888–90.

10 Jan Toorop. *Fatalisme*, 1893.

12 Greta Heybroek (right) with her mother (left) and relatives, Amsterdam, ca. 1905.

11 Antoon Derkinderen. *Health*, cartoon for mural, 1897–99.

13 Mondrian, ca. 1907.

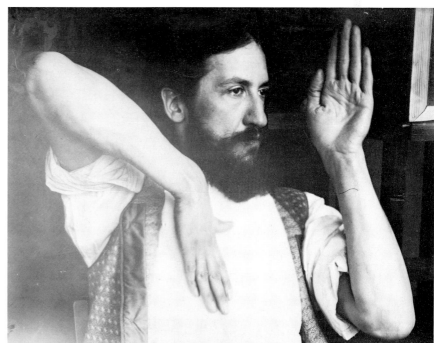

15 Mondrian demonstrating a meditational gesture, 1909.

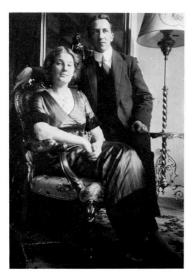

14 Mondrian with his fiancée Greta Heybroek (right), Amsterdam, ca. 1905.

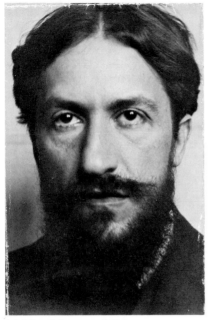

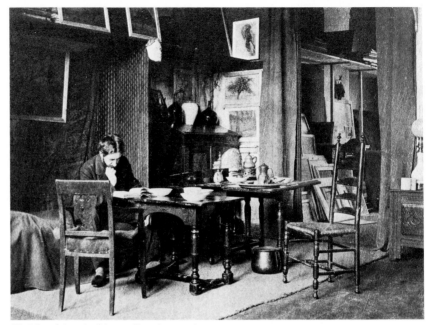

16 Mondrian, ca. 1909.

17 Mondrian in his studio, Amsterdam, ca. 1908–9.

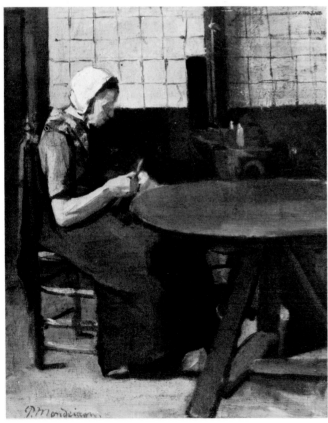

18 Mondrian in the studio of Lodewijk Schelfhout, Paris, ca. 1912.

19 *Interior*, ca. 1895.

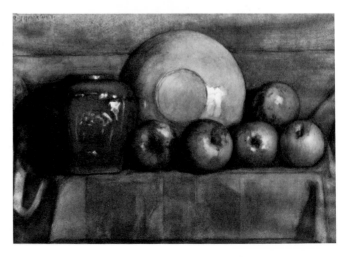

20 *Still Life with Apples and Plate*, 1901.

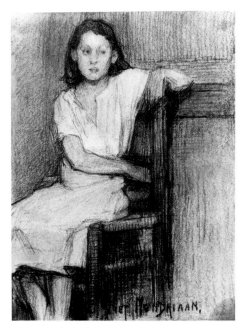

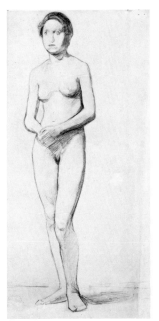

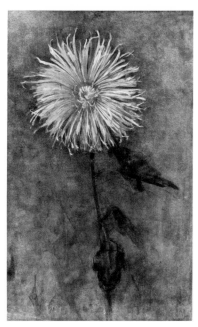

21 *Seated Girl*, ca. 1904.

22 *Nude*, ca. 1904.

23 *Chrysanthemum*, 1900.

25 *Empty Barges and Sheds*, ca. 1898–99.

24 *Young Girl*, ca. 1900–1901.

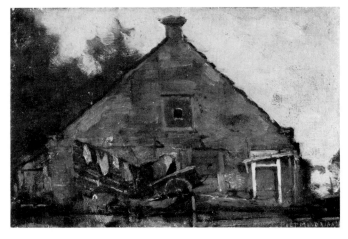

26 *House on the Gein*, ca. 1900.

27 *Woods*, ca. 1898–1900.

28 *Ditch near "The Kalfje,"* ca. 1900–1902.

29 *The River Gein*, 1903.

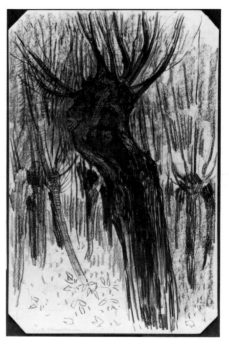

30 *Willows*,
 ca. 1902–4.

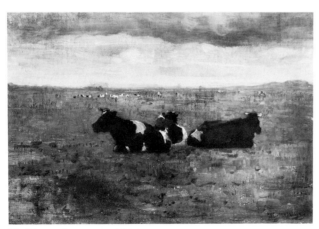

31 *Three Cows*, ca. 1904.

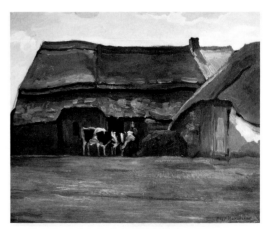

32 *Farm with Cattle*, 1905.

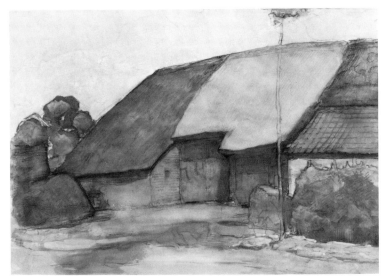

33 *Farm at Nistlerode*, 1904.

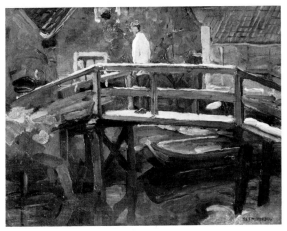

34 *The Wooden Bridge*, 1903.

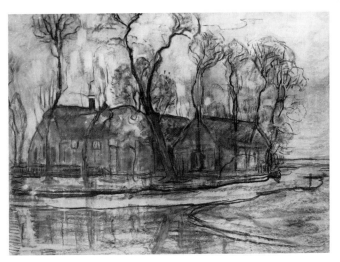

35 *Farm near Duivendrecht*, ca. 1905–6.

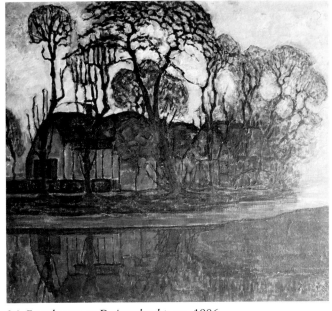

36 *Farmhouse at Duivendrecht*, ca. 1906.

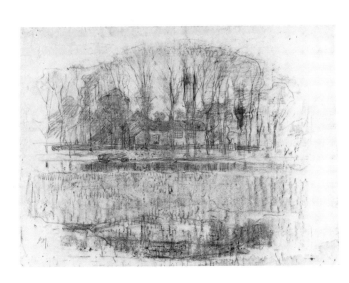

37 *Farmhouse behind Trees and Water*, 1906.

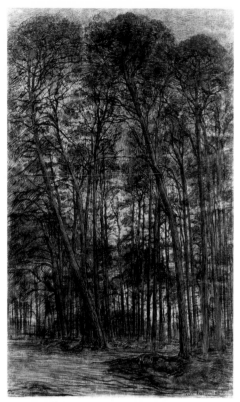

38 *Woods near Oele*, 1906.

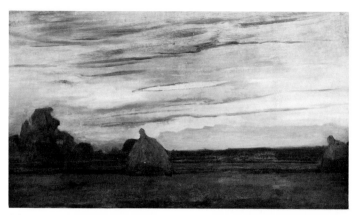

39 *Two Haystacks*, ca. 1907.

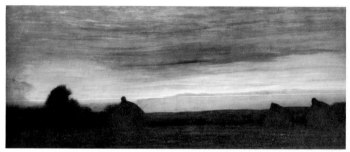

40 *Three Haystacks*, ca. 1907.

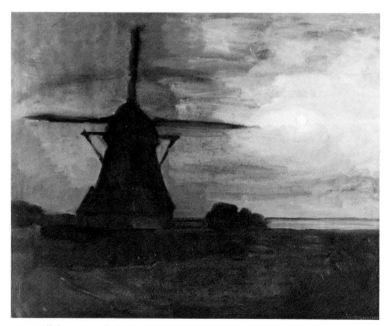

41 *Mill by Moonlight*, ca. 1907.

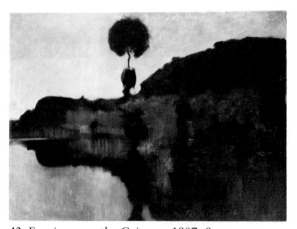

42 *Evening over the Gein*, ca. 1907–8.

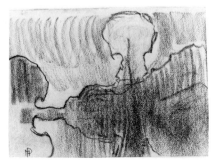

43 *Solitary Tree*, 1907.

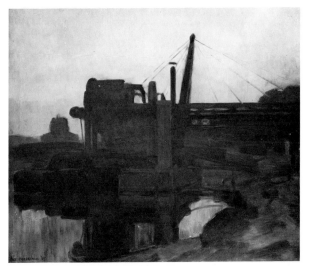

44 *The Amstel at Twilight*, 1907.

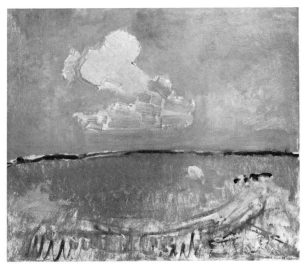

45 *The Red Cloud*, ca. 1907–8.

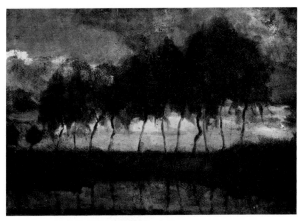

46 *The Gein: Trees near the Water*, ca. 1906–7.

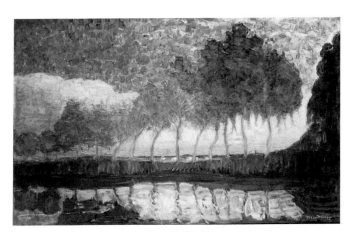

48 *Trees along the Gein*, ca. 1907–8.

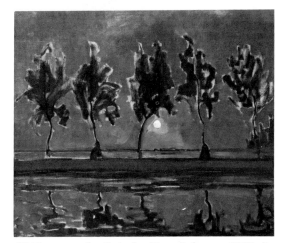

47 *Trees on the Gein by Moonlight*, ca. 1907–8.

49 *Woods near Oele*, 1908.

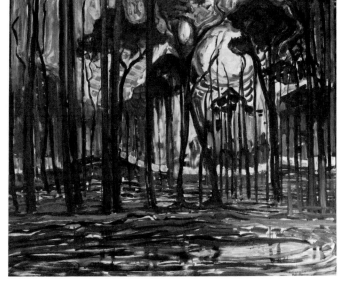

50 *Chrysanthemum*, ca. 1906.

51 *Chrysanthemum*, ca. 1908–9.

52 *Dying Sunflower*, 1908.

54 *Rhododendrons*, 1909/10.

53 *Dying Chrysanthemum*, 1908.

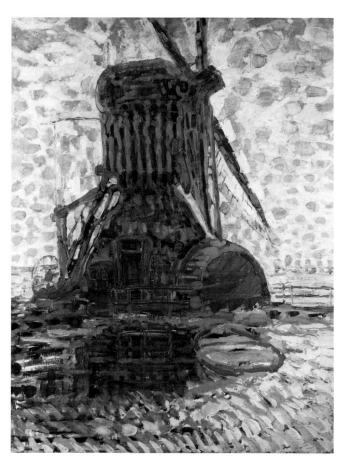

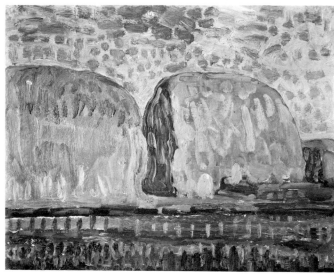

56 *Haystacks*, 1908.

55 *Windmill by Sunlight*, 1908.

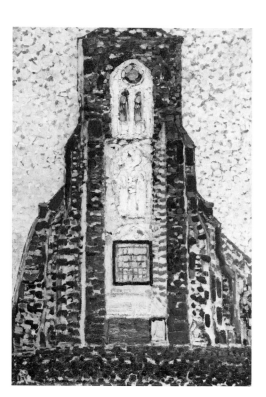

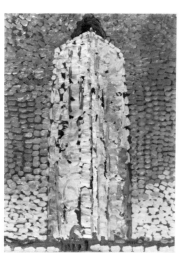

58 *Lighthouse near Westkapelle*, 1909/10.

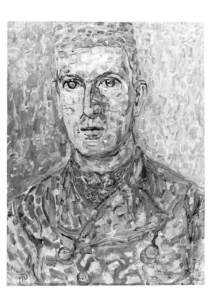

59 *Zeeland Farmer*, 1909/10.

57 *Church at Zoutelande*, ca. 1909/10.

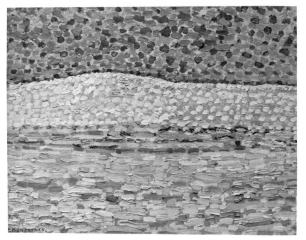

60 *Dune III (Variation)*, 1909.

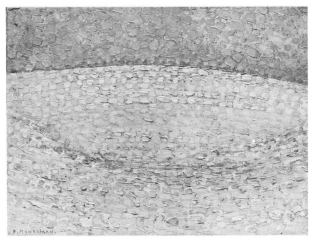

61 *Dune*, 1909.

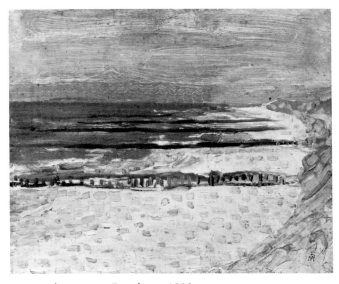

62 *Breakwaters at Domburg*, 1909.

64 *Sea at Sunset*, 1909.

63 *Sea-View I*, 1909.

65 *Dune V*, 1909/10.

66 *Dune Landscape*, ca. 1911.

67 *Church at Domburg*, 1910/11.

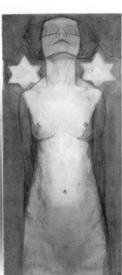

69 *Evolution*, 1910/11.

68 *The Red Mill*, 1910/11.

70 *Dunes and Sea*, ca. 1911 (dated 1909).

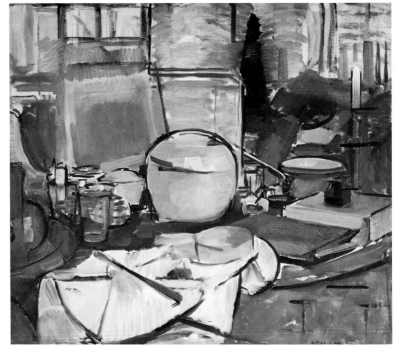

71 *Still Life with Ginger Pot*, 1911/12.

72 *Dunes and Sea*, ca. 1911 (dated 1909).

73 *Dunes and Sea*, ca. 1911 (dated 1909).

74 *Dunes and Sea*, ca. 1911 (dated 1909).

75 *Dunes and Sea*, ca. 1911 (dated 1909).

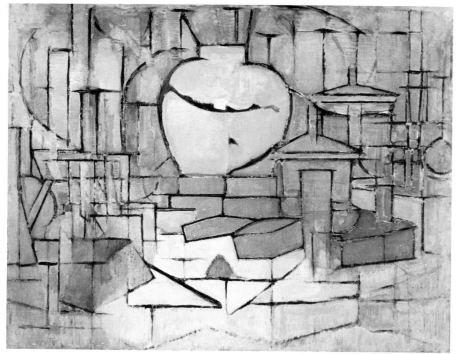

76 *Still Life with Ginger Pot II*, 1911/12.

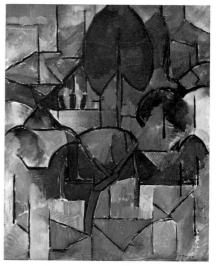

77 *Landscape with Trees*, 1911/12.

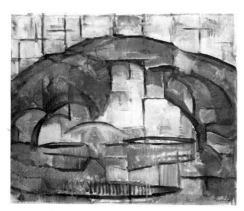

78 *Landscape*, 1911/12.

80 *Self-Portrait*, 1912/13.

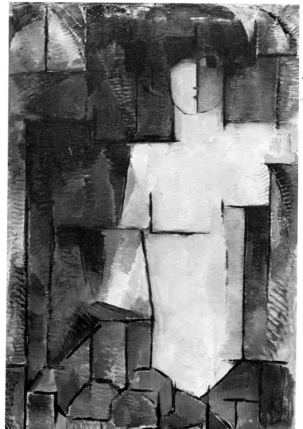

79 *Nude*, 1911/12.

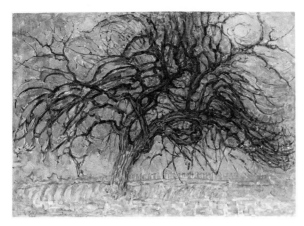

81 *Red Tree*, ca. 1908.

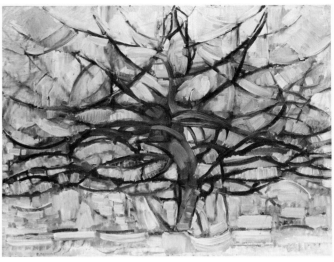

83 *The Gray Tree*, 1912.

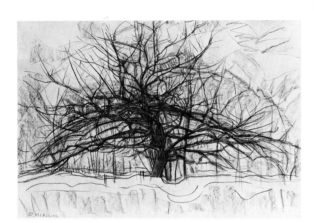

82 *Tree II*, 1912.

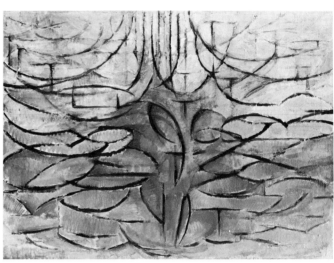

84 *Apple Tree in Blossom*, 1912.

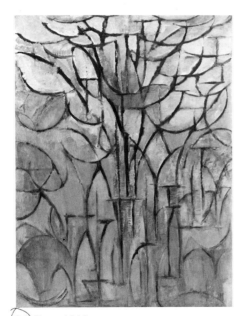

86 *Tree*, 1912.

85 *Tree in Bloom*, 1912.

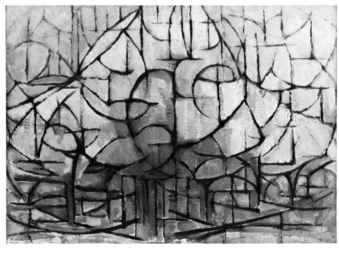

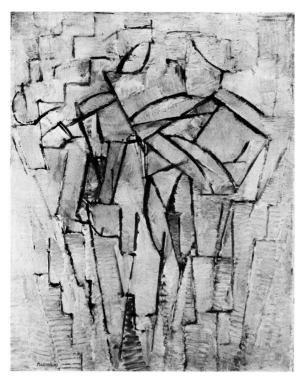

87 *Eucalyptus Tree in Gray and Tan*, 1912.

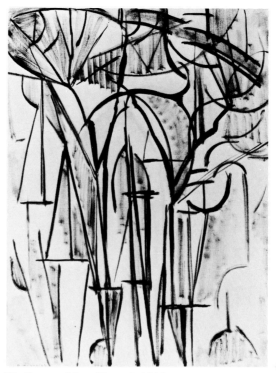

88 *Composition: Trees I*, 1912.

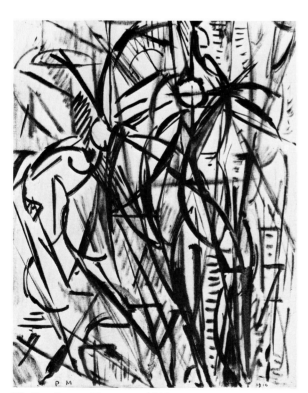

89 *Eucalyptus Trees*, ca. 1912.

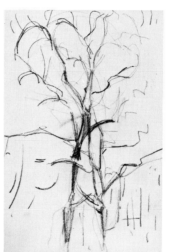

90 *Trees* (sketchbook drawing), 1913/14.

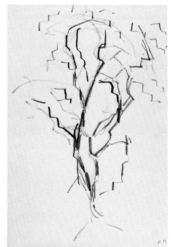

91 *Tree* (sketchbook drawing), 1913–14.

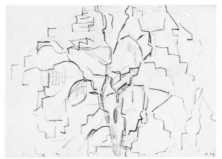

92 *Tree*, ca. 1912.

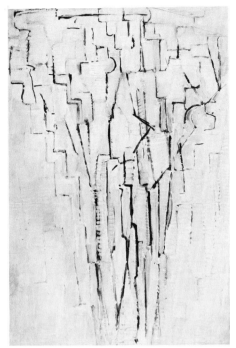

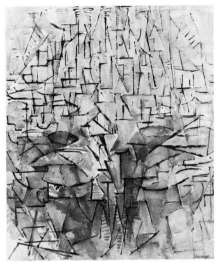

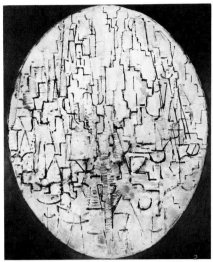

93 *Tree*, 1912.

94 *Composition no. 3 (Tree)*, 1913.

95 *Painting no. 3 (Oval Composition with Trees)*, 1913.

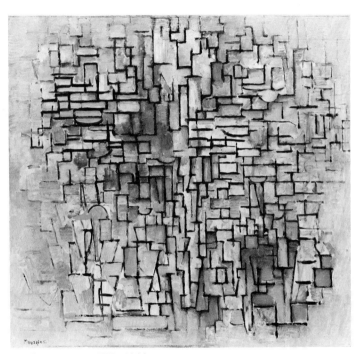

96 *Composition VII*, 1913.

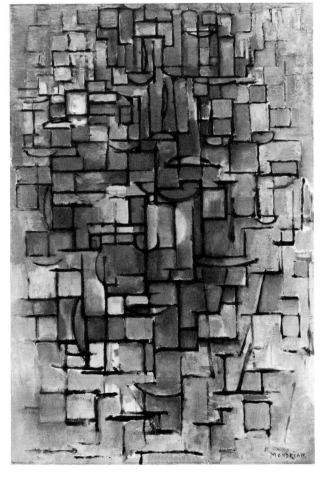

97 *Composition in Line and Color*, 1913.

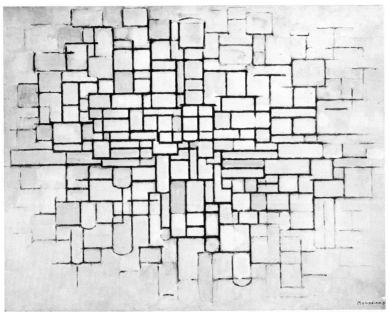

98 *Composition in Line and Color (Windmill)*, 1913.

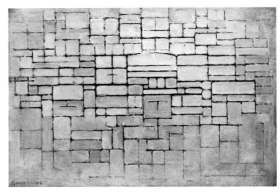

99 *Composition V*, 1913/14.

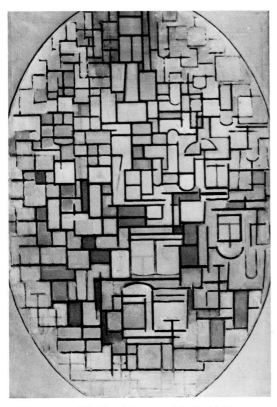

100 *Painting III (Oval Composition)*, 1914.

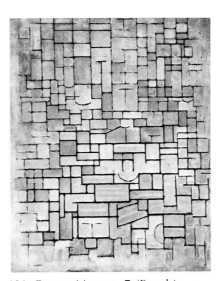

101 *Composition no. 7 (Facade)*, 1913/14.

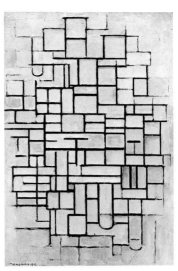

102 *Composition no. 6*, 1914.

103 *Scaffolding*, ca. 1912.

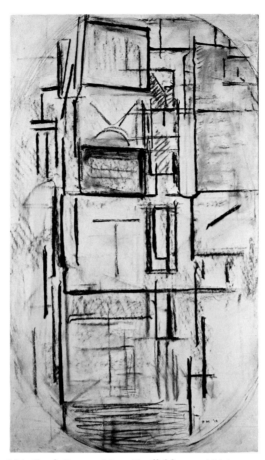

104 *Oval Composition (Scaffold)*, ca. 1914 (dated 1912).

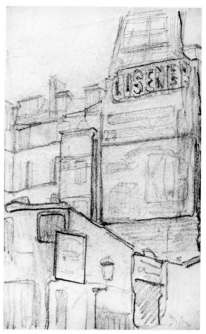

105 *Paris Buildings*, 1912/13.

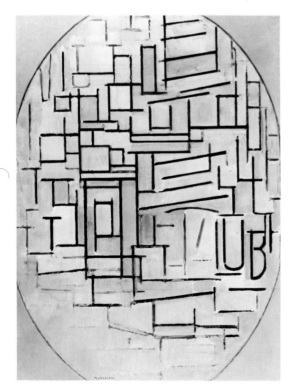

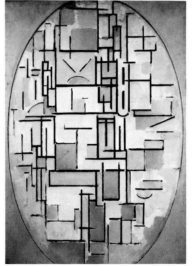

107 *Color Planes in Oval*, 1913/14.

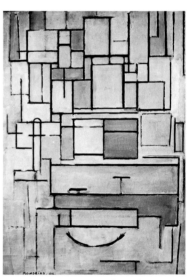

108 *Composition with Color Planes*, 1914.

106 *Composition in an Oval: KUB*, 1914.

109 *Church Facade*, ca. 1912.

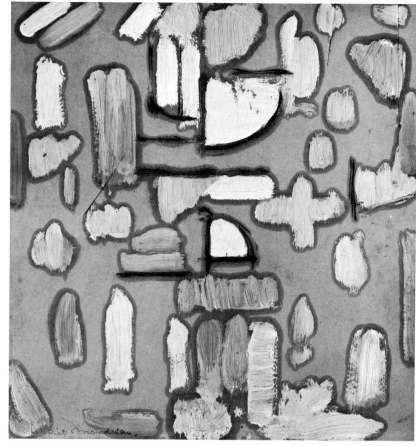

110 *Composition with Pink, Blue, Yellow, and White (Church Facade)*, 1913/14.

111 *Church Facade*, 1914.

112 *Church Facade*, ca. 1914 (dated 1912).

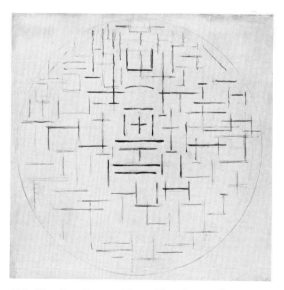

113 *Circular Composition: Church Facade*, 1914.

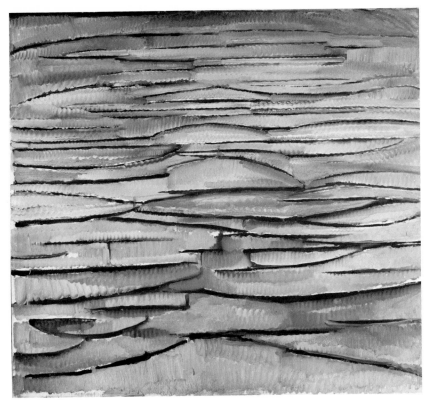

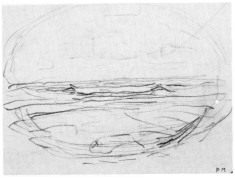

115 *The Sea* (from Sketchbook no. I), ca. 1914.

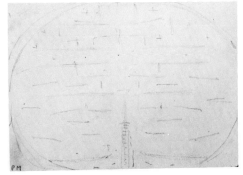

117 *Pier and Ocean* (from Sketchbook no. I), ca. 1914.

114 *The Sea*, 1912.

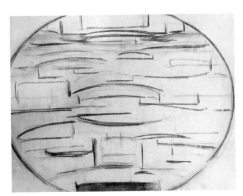

116 *Seascape*, ca. 1914.

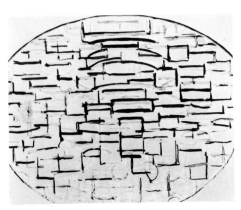

118 *Pier and Ocean*, 1914.

119 *The Sea*, 1913/14.

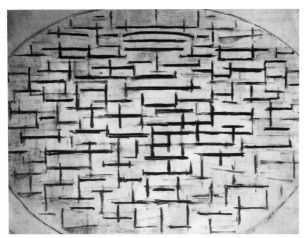

120 *The Sea*, 1914.

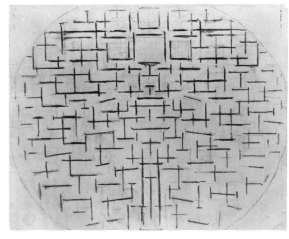

121 *Pier and Ocean*, 1914.

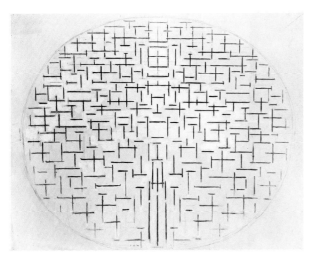

122 *Pier and Ocean*, 1914.

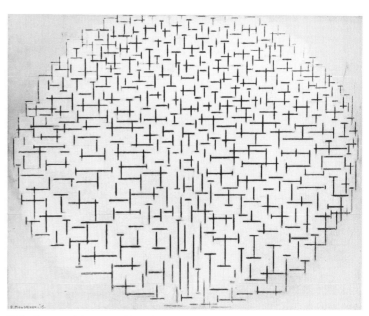

124 *Composition*,
 1916.

123 *Composition no. 10*, 1915.

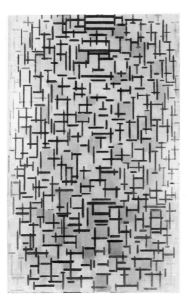

125 *Composition in Line
 (Black and White)*,
 1916–early 1917.

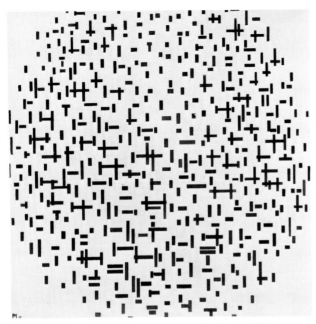

126 *Composition in Line (Black and White)*, 1916– early 1917.

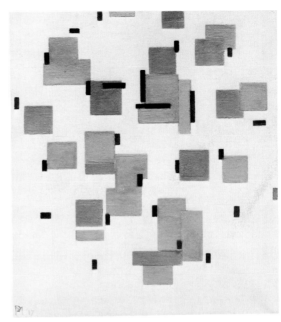

127 *Composition in Color B*, 1917.

128 Bart van der Leck. *The Tempest*, 1916.

130 Vilmos Huszár. *Colophon for "De Stijl" 1, no. 1 (October 1917).*

129 Bart van der Leck. *Horseman*, 1918.

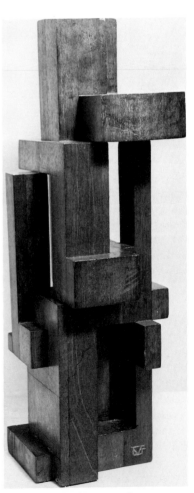

131 Georges Vantongerloo. *Construction of Volume Relations*, 1921.

September 1943. He found it the most agreeable and stimulating space he had ever occupied. Although he lived there only five months before he succumbed to pneumonia, he worked with incredible concentration, energy, and speed on its spacial organization, on the wall compositions, and on the construction of the desk and stool, worktable, shelf-cases, and tabouret. The *Wall Works 1943–44*[3] are the only compositions he did on an environmental scale, and the desk and stool and worktable are his only three-dimensional constructions. The studio, the evolution of which I witnessed during my frequent visits, was Mondrian's last work.

The sole painting displayed in the studio was the *Victory Boogie-Woogie*, on his easel at right angles to the largest wall work, the long east wall. He had been working on the *Victory Boogie-Woogie* for almost a year before moving into the new studio, and he considered the canvas completed except for the task of replacing the remaining pieces of colored tape with paint.

The *Wall Works 1943–44* were composed with rectangular cards of red, yellow, blue, gray, and white, tacked to the off-white (*not white*) walls with small nails. The desk for his bedroom-study was constructed from segments of painting crates, the stool from an apple box. The tabouret, and the shelves for his paints, books, and papers, were made from two-tiered orange crates tied together with horizontal strips. The worktable for his kitchen, a room that he did not live long enough to develop plastically, was constructed from canvas stretchers, the foot-support part of a sling deck-chair, and part of a packing case. These *objets trouvés*, these "ready-made" elements, conformed usefully to his plastic conception.

Before dismantling the studio, I opened it to the public for more than six weeks. With Fritz Glarner's help, I photo-documented the studio, and I also made a 16mm color film. We then carefully traced the wall compositions, including the one on the hallway wall directly visible through the open studio door. The original colored cards were carefully preserved, and in 1982 I remounted the compositions on eight plywood panels under lucite. They were shown at the Museum of Modern Art in New York in the summer of 1983.

Mondrian did not practice what I call *iconomania*, the habit of collecting mementos of past experiences. He considered letters as private affairs to be destroyed after answering. The envelopes were sometimes saved—for making notes. For Mondrian, the conventional approach to "furniture" and "comfort," among other things, belonged to ways of living that failed to stimulate and satisfy his essential needs. He once commented to me sardonically that a woman friend who had just left his studio had complained that he had no "comfortable" chairs. There was a folding canvas deck-chair, a metal stool with round red top and white legs, and another stool, the top of which folded back so that the rungs became a small ladder. He joked about the complaint: "If it is too comfortable, people will stay too long! When I want to rest, I lie down on my bed." His only other conventional objects were a studio-couch in the bedroom-study, a standard tilt-top drafting table that could be lowered or raised to work horizontally on a canvas, and a sturdy folding easel whose tripod legs supported a single vertical post on which the painting appeared as if suspended in space, only the lower support being visible.

Mondrian's 59th Street studio previously belonged to an artist friend of mine who admired Mondrian and offered it to him through me. During the war telephone service was extremely difficult to arrange and my friend thoughtfully suggested that the phone could be kept in his name. Mondrian had never had a telephone. (In Paris, the rue du Départ studio had only gas light.) In response to my suggestion that he keep the phone, he said, "Perhaps I should have one. Then I wouldn't have to write so many letters. . . . But on the other hand, if I have it, it will always be ringing like in your house, always interrupting the work! No! I will keep my old way, I'm better used to that."

Legends and stereotypes arise about Mondrian's personality. The grains of truth are often distorted through hostility provoked by reactions to the implications of his art. Mondrian has often been characterized as utopian; as rigid, ascetic, a kind of recluse, a hermit. The absurdity of such prejudice should become obvious: the scores of artists, architects, collectors, curators, historians, journalists, the friends and acquaintances who marched through his studios in the four countries he lived in, belie and contradict this. And at seventy he still enjoyed dancing.

In New York, unless I was away from the city, we saw each other almost every day to discuss our

work and ideas. It was also my privilege to help Mondrian put his writing into "correct" English. This allowed me to discuss every idea and to become thoroughly familiar with his ideological vocabulary. Other friends were also ready to assist him whenever he needed them. In point of fact, Mondrian had very little opportunity to become a recluse, even if he had wanted to—which he didn't.

A few weeks after Mondrian had settled in to his new life in New York, we were once walking across 57th Street from a gallery visit. "Tell me, Harry, why don't I see prostitutes on the streets here?" In mock surprise I chided, "Why Piet!" "Don't misunderstand me," he laughed, "it has been some time since I've had such a need, but why is it?" In Paris prostitution was legal, and each neighborhood had its regularly assigned entrepreneurs. I explained that prostitution was illegal here, and then told him what I knew of the way it operated. After some discussion of culture differences, I took the opportunity to ask Piet why he had never married. "Well," he said, "to tell you the truth, I never could afford it." He chuckled and went on, "Once I did live with a woman for a time, but when we differed and decided to separate, she took all the furniture!" When he died, the Dutch press reported stories of three women who proudly claimed to have been his very intimate friends.

One night in New York we were returning home from a party in a taxi, with Peggy Guggenheim sitting between us. An old friend and admirer of Mondrian, Peggy was an uninhibited woman to say the least. Peggy leaned her head on Piet's shoulder, snuggling close to him. Piet put his arms around her, and after a moment he bent his head and kissed her mouth arduously and long. "Why Mondrian!" she exclaimed in seeming astonishment, "I thought you were so *pure*!" After we dropped her off at her house, Mondrian was delighted: "They"—meaning the Surrealists: Peggy was then married to Max Ernst—"*they* always call me *pure*!"

A year after Mondrian arrived in New York, an article by Sidney Janis, entitled "School of Paris Comes to U.S.," appeared in the December 1941 issue of *Decision*. The article described Léger, Mondrian, Ernst, and Matta, and provided full-page photos of each artist and his work. The caption under Mondrian's photo read "The disciplinarian disciplined." He showed it to me with some consternation, "But I am against discipline!" he exclaimed, "I am for necessity!" He meant that the passionate refinement of his expression was not the result of an idea of superficially imposed perfection or formula but was based upon direct perception, the need for unequivocal clarity, unequivocal structural, plastic perception, unity, wholeness, internal consistency.

Mondrian's painting method, which he called "pure intuition," was the direct approach, by trial and error, to the given space of the canvas. There were no a priori measures of any kind, there was no "golden section." He also called it "pure sensuality."

Today it is often held that only heavy brushwork, accidental effects, impasto surfaces, and mannerisms are the manifestations of spontaneity. This is both naive and misleading.

When Mondrian encountered misrepresentations of his work and ideas, he would sometimes shake his head wearily and say, "Writers are the greatest criminals." He observed that in our time the power of the printed word could pervert, could be disastrous toward understanding. But then he would add philosophically that "Life is full of obstacles . . . but life is always right!" For Mondrian, the negative factors, the obstacles encountered in life, are realities that reveal the disequilibrium in life that has to be opposed—but constructively opposed, without becoming similarly negative.

Two incidents are further revealing. Mondrian's paintings and studio props were to follow by several weeks his arrival in New York. During the interim, we spent several hours together daily, working on his great essay, "Liberation from Oppression in Art and Life." Before the war, in 1939, the art editor of a major American intellectual quarterly had visited Mondrian in London and had requested an essay. During the time of his preparation to come to New York, packing, making shipping arrangements, endless trips to the consulate for his visa, etc., and during the month-long voyage by convoy, he had the piece essentially sketched out. All that remained was to put in into "correct" English. Mondrian worked for almost three months on the writing, and—as in his paintings—expressed himself with great economy and circumspection. When it was completed, he sent it to the editor who then asked for a meeting. We met in my apartment. The editor politely expressed his admiration, following it with a somewhat arrogant

"But it's too long. I can shorten it for you." Mondrian sat quietly for a few moments, eyes cast downward, reflecting. When he lifted his head, he spoke very quietly, "In that case you can't have it."

Following the success of Mondrian's first New York exhibition at the Valentine Gallery in 1942, one of the leading writers for New York's largest, most sophisticated weekly magazines had arranged an interview with Mondrian in his studio. Early that afternoon my bell rang. Mondrian appeared at the foot of the stairs and climbed the long flight of steps with most unusual speed—talking as he came—flustered, animated, indignant—such as I had never seen him before. He had unceremoniously evicted the writer. "I told him to go away! I made him leave! I never thought it would be like that!" "What happened Piet?" I asked, wondering what could have been so cataclysmic, so distressing. "I thought he came to see my work and talk about my ideas. . . . But he only asked questions about my personal life. . . . I told him to go!" It was impossible for me to suppress my laughter at the image of the famous writer, probably accustomed to eager response to this kind of personal attention, finding the reverse reaction, suddenly, explosively. After a few moments, Mondrian joined in my laughter. Then we discussed the implicit meanings in such a situation. Of course, he readily acknowledged, there exists the tradition of seeking and finding recognition through emphasis on the personal, but for him this was contradictory to the values he strove to achieve through his art and writing.

It was not a matter of modesty or shyness on Mondrian's part, although many people were led to think so by his usually gentle, circumspect manner. It certainly was not withdrawal: he had exhibited his paintings internationally for half a century; he had written and published some forty essays. It was simply that in his view one cannot express a set of values by its contradiction. His way of life, his morality, should not be confused with "the puritanism of the past," to use his phrase.

Among artists, Mondrian had a straight-faced way of introducing the issues that he found useful for discussion. Many misinterpreted his irony as seriousness. Nelly van Doesburg, who knew Mondrian many years before I met him, also remarked on his deadpan humor: "he could jest, with ironic intent, about the dangers of staining his clothing green from the reflec-

tions of the grass. [But] in fact, his appreciation of nature remained quite keen. . . . Moreover, he was appreciative of naturalism in the paintings of others . . . some his friends. He enjoyed attending Dada soirées and Futurist manifestations."[4]

At a lunch in Arp's studio in Meudon, Mondrian asked to sit with his back to the window so that he would not have to look at the green landscape. Gallatin told me of Mondrian's visit to his midtown Park Avenue apartment. Mondrian looked out the window at the carefully manicured, flowering green centerstrip and asked Gallatin how he could "tolerate living in such a suburban environment."

After his first winter in New York, during which he was slowly recovering his health after the debilitating stress of the London blitz and the tense monthlong ocean voyage by convoy, I urged Mondrian to spend at least a week in the early June sun and fresh air at my summer place in the Berkshires. I overcame his reluctance only when I guessed that his past image of country life probably meant the absence of minimally comfortable urban amenities. When I reassured him that my modest house and studio were even more comfortable than my modern apartment in New York, he finally but skeptically agreed: "All right then, I'll go, for my health." When we arrived, he stepped out of the car, looked around, obviously impressed by the neatly kept close-cropped lawns and lush, flowering gardens, and exclaimed, "Just like Hollywood!"

At a lunch at Peggy Guggenheim's house, Max Ernst, André Breton, Marcel Duchamp, and Mondrian were present. At one point, Peggy told me, Breton asked Mondrian what he thought of the paintings—fantasy landscapes—of the Surrealist Yves Tanguy. Mondrian's reply was quickly to his point: "It is too abstract, too abstract for me!"

Mondrian was not "against nature," not against the natural. The failure to distinguish between the natural and the naturalistic-in-art, the failures to distinguish between phenomenal reality and expressive reality leads to the confusion of the two.

In the first chapter of "The New Plastic in Painting" (1917), his first published essay, Mondrian wrote: "From the viewpoint of the particular, naturalistic representation always remains inferior to actual appearance; from the viewpoint of the universal, naturalistic representation is always individual. No

art has ever been able to express the power and grandeur of nature by imitation: all true art has made the universal more dominant than it appears to the eye in nature. . . . In the old art, tension of form (line), the intensity and purity of color, and natural harmony were accentuated—sometimes even exaggerated. In the new art, this exaggeration increased to the point where *form and color themselves became the means of expression*. . . . Thus the culture of the *whole* man was necessary to lead him to a plastic expression in which natural reality was interiorized as abstract reality . . . equilibrium between man's outwardness and his inwardness, between the natural and the spiritual within him. . . ."

In 1917 Mondrian wrote again in "The New Plastic in Painting," "The truly modern artist sees the metropolis as abstract life given form: it is closer to him than nature and it will more easily stir aesthetic emotion in him. For in the metropolis nature is already tensed, ordered by the human spirit. The relationships and rhythm of plane and line in its architecture will move man more directly than the capriciousness of nature."

In 1926, in "Home—Street—City," he says, "Neo-Plasticism is more at home in the Métro than in Notre Dame, prefers the Eiffel Tower to Mont Blanc." And in 1931, in "The New Art—The New Life: The Culture of Pure Relationships," he wrote that "The Place de l'Opéra in Paris gives a better image of the new life than many theories."

To study any subject is to study its history. Human symbol-forming as we know it is a very recent development. Although it is estimated that the human brain has had its present neurological capacity for well over a million years, the oldest known examples of human symbol-forming, in the caves of Altimira and Lescaux, are only about 25,000 to 40,000 years old. Writing has existed for a mere fraction of that time. Symbolic behavior, codified into mythology, theology, mathematics, the physical and social sciences, and art, are relatively recent events. "Aesthetics," in its modern sense, is an eighteenth-century German invention (by Baumgarten). How and what we know—and how and what we express—appears as an irreversible, ongoing, social-evolutionary process.

From the Middle Ages until Cézanne, Cubism, and Mondrian's Neo-Plasticism, the descriptively symbolic image dominated the structure of Western art. In Post-Impressionism, the surface of the painting itself comes to the fore: the brush strokes, the intensified color of the Symbolists and Synthetists complement the literary and philosophical movements toward individual expression and subjective freedom. It is not until Cézanne that the almost complete annihilation of the dominance of subject matter begins to consciously reveal the plastic structure, the elements of the painting itself—the interaction of the planes and color, their movement, harmony, and rhythm.

Mondrian saw Cubism as the new awareness of the intrinsic means of plastic expression, as the destruction of the naturalistic and the mimetic, as the conscious construction of the picture-plane, as the dynamic rhythm of its composition of forms in space. Mondrian observed: "One can never appreciate enough the splendid effort of Cubism, which broke with the natural appearance of things and partially with limited form. Cubism's determination of space by the exact construction of volumes is prodigious. Thus the foundation was laid upon which there could arise a plastic of *pure relationships*, of *free rhythm*, previously imprisoned by limited form. If there had been sufficient consciousness of the extent to which limited form is hostile to true plastic and of the extent to which it is individual and tragic, there would have been less risk of falling back into romanticism or classicism as generally happens to modern movements. Cubist plastic pushed to its limit . . ." ("Cubism and Neo-Plastic," 1930).

In Mondrian's Neo-Plasticism, the determination of the space of the painting itself, finally opens awareness to the intrinsic spacial experience as environment, rather than as the projection of mimetic or arbitrary forms in space; the structure of dynamic movement, rhythm, equilibrium—plastic structure itself—becomes iconic: as Mondrian said, not space expression but space determination. Mondrian explored the limits of painting: pure plastic art, pure structure; the inseparability, the simultaneous unity of content and form; sensory reality here and now, free of imposed external associations. He saw art as a function of the total environment. He anticipated the displacement of painting, sculpture, and architecture as separate, disparate elements of the total visual environment. The forms of painting, sculpture, and architecture create the environment and have inherent social meaning, fundamental survival value. What we

call the quality of life cannot be measured only by material amenities. All the arts embody the values and transformations of cultures. They articulate the knowledge, the values, the aspirations and ideological strivings that underlie the process of civilization. They create the environment physically and symbolically.

Although Mondrian's only opportunities to explore his conception in environmental scale were the interior spaces of his studios, he nonetheless had enormous influence on modern architecture and design.

Four years after Mondrian's death, Le Corbusier wrote:

In the dilemma between representational and nonrepresentational art, we must see an architectural instinct. The spirits of architects are unemployed, diffused, in suspense in time, and they cannot take on flesh. Architecture is still too mean, too stupid, too devoid of its proper essence: outstanding distinction and radiating light. Piet Mondrian, a heroic pilgrim, one of the "homeless," incarnated that tragic destiny. Coming after him are young people who find themselves plunged into the same dilemma. They are no longer painters—they are already architects. They will emerge as architects when the time shall have come.[5]

Seven years later, Sir Herbert Read, Mondrian's contemporary, described him as a

modest and saintlike pioneer who wished to show the direction in which artists of the future might lead humanity. He was trembling at the limits of a new dimension of consciousness . . . towards a total reconstruction of our environment. He knew . . . that the old era of painted canvases and mantelpiece ornaments was at an end. He realized that the traditional concept of the artist—a tradition of twenty-five centuries, it is true, but that is only a tenth part of the history of art—was no longer valid for an age of nuclear fission. The future scale of the artist is not domestic, nor even monumental, but environmental: the artist of the future . . . a new molder of plastic forms who will be painter and sculptor and architect in one—not an adulterous mixture of all these talents, but a new kind of talent that subsumes and supersedes them all . . . Mondrian realized that he had opened a way which led, as he said,

. . . towards the end of *art as a thing separated from our surrounding environment, which is the actual plastic reality.* But this end is at the same time a new beginning. . . . By the unification of architecture, sculpture and painting, a new plastic reality will be created. Painting and sculpture will not manifest themselves as separate objects, not as "mural art" which destroys architecture itself, nor as "applied art," but *being purely constructive* will aid the creation of a surrounding not merely utilitarian or rational but also pure and complete in its beauty.[6]

Piet Mondrian was the sanest human being I have ever known. If his life was often economically restrained and difficult, he nevertheless lived a most luxurious life. He enjoyed the luxury of continuous productive development, the consistent unity of his philosophical values with the way that he actually lived, worked, and related to others and to the world. His inner and outer life was extraordinarily full and free of the superfluous—like his paintings. Impeccably honest and responsible, he was too understanding of differences to waste himself negatively on polemics, on anger, on bitterness or competitive anxiety. Certainly he had his share of tragedy in life, but he was too philosophically optimistic, too detached from the machinations of the marketplace to deviate from the surety of his art and thought. He was forthrightly convinced of humanity's inevitable progress toward the humanization of society, despite all apparent obstacles. Moreover, he saw his art and himself as instruments toward this unending end. He saw himself as a realist: "from the very beginning," he wrote, "I was always a realist."[7] And in his last essay, "A New Realism" (1943), he wrote: "Culture produces relative consciousness of the changeable expression of reality. When this consciousness is attained, a revolt takes place: the beginning of the deliverance from the expression of reality. Destruction of its limitation follows. The culture of intuitive faculties has conquered. A new realism appears."

In a religious culture, life is preparation for Paradise, outside the life of this world, outside the life we know. In a secular culture, where the order of life is scrutinized and pressed toward the goals of equivalent mutual freedom and justice for all humanity, here and now, we call it utopian.

Mondrian was regarded as utopian, as "ivory tower."

The word "utopian" is often used pejoratively, observes Karl Mannheim, to describe a state of mind "incongruous with the state of reality within which it occurs." But, Mannheim continues, "it is possible to perceive utopian as an orientation which transcends reality and breaks the bonds of the existing order."[8]

Baudelaire said it too, when he observed: "One must be willing to dream—but one must know how!"

Mondrian knew how.

HARRY HOLTZMAN

Piet Mondrian
Art and Theory
to 1917

In October of 1917—the year in which Mondrian created his first compositions in rectangular planes—his fundamental treatise and first published essay, "The New Plastic in Painting," began its serial appearance in the newly founded journal *De Stijl*. These linked achievements, art and theory, were the outcome of his ten-year enquiry into the nature and purpose of art in relation to life and to the choices open to painting.

Around 1900, Mondrian painted rural scenes in the Dutch Impressionist, or Hague School, manner then dominant in Holland. Between 1905 and 1906, in his "Evening Landscape" series, he imparted a more expressive character to this picturesque naturalism. Then in his mid-thirties, he began a rapid exploration of Modernist possibilities (1908–11): a manner related to Fauvism, a pointillistlike technique, a monumental style of angular planes.

In 1912, impelled by the work of the Cubists and their "grandiose accomplishment in breaking with natural appearances,"[1] Mondrian moved from Amsterdam to Paris. During the two and a half years of his first stay there, he gradually developed his personal variants of Cubism to the threshold of pure abstraction.

The outbreak of World War I during Mondrian's summer 1914 visit to Holland delayed his return to Paris until mid-1919. Within this time he took the historic step toward a purely plastic art that transcends the naturalistic image. The New Plastic—or Abstract-Real Art—involved no break with the external world, which Mondrian repeatedly characterizes as the constant stimulus to creation. "The New Plastic in Painting," written during this period, served to rationalize the assumptions of the new art—*after* its creation, he always insisted. In 1916 began his collaboration with the writer and painter, Theo van Doesburg (1883–1931), who founded and edited *De Stijl*.

The Naturalistic Period
(ca. 1887–1907)

Mondrian's preferred subject was landscape, in which he gained considerable skill as a youngster working with his uncle, Frits Mondriaan (1853–1932), a successful painter in The Hague manner. Piet's early scenes with cows, meadows, and water (cf. *Toward the True Vision of Reality*) strongly resemble those of this uncle.[2]

The painters of The Hague school, although contemporaries of the French Impressionists, remained closer to the Barbizon artists in their picturesque subject matter and composition. Like earlier Dutch painters they skillfully rendered light and atmosphere; their subtle tonalism converged with the late nineteenth-century evocation of "mood." Thus Mondrian received early training in accurate and sensitive observation.

Mondrian's studies between the ages of seventeen and twenty qualified him to teach drawing on primary and secondary levels, the secure vocation urged upon him by his father. The diplomas enabled him to enroll—against his father's wishes—at the Amsterdam Rijksakademie in 1892. At the academy, skill in rendering the human figure was stressed. Courses in art history and aesthetics were also given; Mondrian received high marks in both subjects in the Prix de Rome competition of 1898.[3]

Mondrian grew up in a family with close ties to the conservative wing of the Dutch Reformed Church. His father, Pieter Cornelis Mondriaan, Sr. (1839–1921), aligned himself with the leaders of the Reformed party, who assisted his career as a headmaster of Protestant schools. A capable draftsman, he created commemorative prints promoting their religious and political position. While still a boy, Piet helped execute these; later (1894), he painted an allegorical decoration for the school at his father's direction.[4] After leaving home, Mondrian freed himself from the sectarian views of his father, who roundly condemned his son's Modernist work.[5] Mondrian's background nevertheless endowed him with important qualities: outstanding resoluteness and probity; belief in the sanctity of principles; faith in the illuminating power of truth; and conviction of the duty to actively spread truth through word and image.

Mondrian's generation, maturing in the 1890s, witnessed the reaction against materialism and positivism that brought idealist values to the fore. Focus on the mundane and external in art gave way to exalted themes

and antinaturalistic styles. In the eighties and nineties, Matthew Maris (1839–1917) created an atmosphere of dream and mystery much admired by the Symbolists. Around 1900, Mondrian briefly essayed this diffuse and evocative manner.[6]

Dutch Symbolist painting is best represented by Jan Toorop (1858–1928) and Johan Thorn-Prikker (1862–1932). Early in their careers, at the outset of the 1890s, they left Impressionist modes for art with religious or social content, employing allegory, mystical signs, and highly stylized figures amid decorative patterns and rhythms. Themes of spiritual or of public import were also characteristic of the "Stylizers," the muralist Antoon Derkinderen (1859–1925) and Willem van Konijnenburg (1869–1943). Derkinderen's ideal of "monumental" public art was a formative influence on Bart van der Leck, and thus indirectly on Mondrian and the De Stijl group.[7]

Symbolist painters often contributed to the flowering of architecture and applied art in the Netherlands between the 1890s and the 1920s, particularly during the first decade of the century. Like the English Arts and Crafts movement associated with John Ruskin and William Morris, the Dutch movement wanted to restore to artists and craftsmen their traditional roles in building and embellishing the surroundings, from private home to the community itself. Art was seen as the instrument, and the artist as the prophet, of social salvation. The renowned architect H. P. Berlage (1856–1935), for instance, believed in aesthetic socialism that was more visionary than political. Berlage at some point commissioned a mural from almost every Symbolist painter of note.[8]

Values of the Symbolist era—its idealist cast of thought, its aspiration to bring about unity between, art, artist, environment, and society—helped shape the vision of Mondrian and De Stijl even if they rejected other traits of the period: its nostalgia for the past; its reliance on representation, no matter how stylized; its notion of decorative art, that is, art "applied" to, rather than integral with, its context; its emphasis on the individual, whether expressed in handicrafts or in the cultivation of subjective feeling.

By 1900, Mondrian had become preoccupied with the universalistic outlook of the French Symbolist and Theosophist Edouard Schuré's *The Great Initiates* (first French edition, 1889).[9] Throughout the ages, according to Schuré, there existed constant and fundamental laws: truths that remained concealed from the masses, but

were from time to time revealed—in veiled form—by the Initiates, sages, philosophers, founders of the great world religions. Theosophy, in general, taught that over the vast eras of cosmic time, humanity evolved from the physical toward spiritual levels of being. In the stage of evolution now dawning, the great truths would become luminously apparent, at first to an advanced few, but soon to the generality of mankind. Theosophy or "spiritual science" far surpassed the observations of materialistic science in the clarity and exactness of its vision.

Mondrian's theosophical interest was clearly marked in a few works of 1907–8. This change seems presaged by the contemplative mood of the "Evening Landscape" series (1906–7), crepuscular scenes in which dark bosky masses stand silhouetted against light-streaked skies and glinting waters. Mondrian later described in his "Trialogue" how, as individual details fade into darkness, we become more conscious of the universal.[10]

The Modernist Phases (1908–11)

"Modernism" in Holland has been described as "the artistic idiom of the avant-garde Dutch painters of the first decade of the century . . . , a synthesis of Van Gogh's expressive color and of Georges Seurat's systematic brushwork.[11] Painting with heightened color or divided brushwork was referred to in Belgium and Holland as "Luminism."[12] In Paris, the center of innovation, the mainstream mode around 1900 was Impressionism. Emerging tendencies looked to the Post-Impressionist approaches of Seurat, Cézanne, Gauguin, and Van Gogh, with their assertion of color, surface and structure. In the early 1900s, Seurat's follower Paul Signac advocated a Neo-Impressionist technique that employed large regular strokes of chromatic color, while in the circle of Matisse, a tendency toward Fauvism was evolving from Post-Impressionist sources that included Bonnard and Vuillard.

These influences were rapidly assimilated by the rising Modernist generation in Holland, artists somewhat younger than Mondrian (b. 1872): Jan Sluyters (1881), with whom Mondrian was to become closely associated in 1906–7, Kees van Dongen (1873), and Otto van Rees (1884). Even before the turn of the century, Toorop returned to Impressionist and Neo-Impressionist techniques, becoming a leader of Dutch Luminism. All these artists had gained firsthand experience of developments

in Paris or Brussels. Most of them, like Mondrian himself at the time he turned to Modernism, responded to the art of Van Gogh, who was occasionally shown in Holland prior to his major retrospective in Amsterdam (1905). By the end of 1907, Van Dongen,[13] Sluyters and Van Rees had startled the Dutch art world with their Luminist color. The "triumph of Luminism" began in 1908, when Toorop was given an important place at the annual Saint Luke exhibition. Luminism now appeared as a movement, comparable to Fauvism under Matisse a few years earlier.

In 1908, Mondrian also moved from the romanticism of his evening landscapes to the Modernism of the *Haystacks*, painted in a large-stroke Luminist manner; the *Mill by Sunlight*, whose red and yellow intensity recalled Van Gogh, and the impressive *Woods at Oele*, with its sinuous bands of color reminiscent of Edvard Munch or the Fauves. All these canvases of 1908 were shown in the January 1909 Mondrian retrospective at the Stedelijk Museum, Amsterdam, jointly held with Jan Sluyters and the more conservative Cornelis Spoor. Thus Mondrian, at thirty-seven, became identified with Toorop and Sluyters as one of the "Luminist Triumvirate." In 1910–11, they founded their own organization, the Moderne Kunstkring (Modern Art Circle).

In the late summer of 1908, Mondrian made his first visit to the little seaside resort of Domburg in Zeeland, where he often returned to work until 1914. In contrast to the inland scene, most often conducive to picturesque treatment, the flat Zeeland coast gave prominence to single features—the strong verticals of church, beacon tower, or windmill rising above the low horizon: the sea, dunes, and shoreline, where the horizontal strongly dominates.

Mondrian's Luminist phase was of short duration. At the first Moderne Kunstkring exhibition (fall 1911), he showed Zeeland subjects painted in a new manner, one that with its broad planes, linear stylization, and "exaggerated" color (cf. the "Trialogue," scene 6), expressed permanence, grandeur, monumentality. The symbolism implicit or explicit in the hieratic *Red Mill* or the large triptych *Evolution* (both late 1910–11) shows a will to transcend appearance in favor of the constant, the spiritual.

Mondrian's first known statement of his goals appears in his letter of 1909 to Israel Querido, one of the rare critics to have written in praise of such works as *Woods at Oele*. While Mondrian appreciated Querido's perceptiveness, he felt obliged to amend the description, in a second article planned by Querido, of the 1908 painting *Devotion*, which depicted a young girl with gaze upturned toward an ethereal flower. Querido had interpreted this theosophically significant subject in too literal a way, as a "praying girl."[14] He printed Mondrian's letter of explanation in place of his own sequel. "I seem to have expressed myself incorrectly if I led you to believe that I wanted with that girl to represent an act of prayer," Mondrian wrote:

I intended only a girl considered in a devotional aspect, or viewed devotedly, or with great devotion. By making the hair that particular red, I intended to tone down the material side of things, suppressing associations with "hair," "costume," etc., and bringing the spiritual side to the fore. I believe that color and line can do much toward that end; moreover, I do not wish to do without line. . . . It is precisely the essential lines that I find fundamentally important, and also the color. I did indeed tell you that for me "actions" were always such transient things. They can become one great world action, something of great universal significance, and thus very beautiful, but I meant to say that this was not my task.

You have sensed and explained why human movement is a hindrance to me; but I did not mean to say that I could not find it beautiful in the work of others and in older, earlier periods. I find the work of the great masters of the past most beautiful and grand; but you will agree with me that nowadays in our time everything must be expressed quite differently, even through the adoption of a different technique. I believe it definitely necessary in our period that paint be applied as far as possible in pure colors set next to each other in a pointillist or diffuse manner. This is stated strongly, yet it relates to the thought which, as I see it, is the basis of outward expression.

It seems to me that clarity of thought should be accompanied by clarity of technique. . . . There are great intrinsic values or truths that remain the same throughout the ages, but form and expression change. . . .

. . . You write: "Mondrian wishes to represent a praying girl without action." I had rather intended, as I said, to convey the very deepest sources of the act of "prayer"; that, among other things, to pray could be to express thankfulness, etc. And finally you write that what I have achieved is through my talent as a painter, etc., and you regard my work as similar to that of others, who are engaged in the same thing.

I am sure, however, that—despite great similarity—there is a great difference. I think you too recognize the important relationship between philosophy and art, and it is just this relationship that most painters deny. The great masters do grasp it, unconsciously; but I believe that a painter's conscious spiritual knowledge will have a much greater influence upon his art, and that it would be due only to a weakness in him, or lack of genius, should this spiritual knowledge be harmful to his art. Should a painter progress so far that he attains definite firsthand knowledge of finer regions through the development of his finer senses—then his art would perhaps become incomprehensible to mankind, which as yet has not come to know these finer regions. . . .

I do not know how I shall develop, but for the present I am continuing to work within ordinary, generally known terrain, different only because of a deeper substratum, which leads receptive viewers to sense the finer regions. Thus my work remains entirely outside the occult realm, although I try to attain occult knowledge for myself in order to gain a better understanding of things.

Accordingly, I observe my work attaining greater consciousness and losing all that is vague. . . .

For the present at least I shall restrict my work to the ordinary world of the senses, since that is the one in which we still live. Still, art can already provide a transition to the finer regions, which I call the spiritual realm, perhaps erroneously; for I have read whatever has form is not yet spiritual. It is nonetheless the path of ascension: away from the material.[15]

At the time of Mondrian's first visit to Domburg (September 1908), this summer colony was frequented by an enlightened middle class mingling with artists and writers like Toorop and Querido. It was a milieu hospitable to burgeoning social and ethical movements such as Theosophy and Anthroposophy. In May 1909, Mondrian joined the Dutch Theosophical Society.

Within two years, however, perceiving the limited applicability in art of a "doctrine of symbols,"[16] Mondrian abandoned for good the mode of expression exemplified by *Devotion* and *Evolution*. From 1912 on, any reference to the broader scheme of things is inherent in the structure of the work itself, in the plastic means. "Plastic," he later noted, also signifies "that which creates an image."[17]

Paris and Cubism (1912–14)

Cubism, Mondrian repeatedly stressed, opened the way for the New Plastic. Shortly after seeing examples of early Cubist work by Picasso and Braque at the Moderne Kunstkring in late 1911, he settled in Paris. His analytical Cubist "compositions" of 1912–13 in grays and browns were based on a favorite motif, the tree, where particular forms disappear almost completely in the whole. In his review of the spring 1913 Indépendants, Guillaume Apollinaire pointed to "the very abstract Cubism of Piet Mondrian."[18]

In Paris, in 1913–14, Mondrian found his themes in urban architecture: walls bared by demolition, courtyards, roofscapes—subjects distinguished by their planarity and rectangularity. Planes of light color (grayed blues, pink) articulated and accentuated by dark linear contrasts are characteristic of this second Cubist phase.

How clearly and confidently Mondrian now saw his goals is apparent from his January 1914 letter to the critic and editor H. P. Bremmer:

People generally think my work rather vague: at best it reminds them somewhat of music. I have no objection to this so long as they do not conclude that it therefore lies beyond the sphere of art. I construct complexes of lines and colors on a flat plane so as to plastically express *universal beauty*—as consciously as possible. Nature (or the visible) inspires me, arousing in me the emotion that stimulates creation, no less than with any other painter, but I want to approach truth as closely as possible; I therefore abstract everything until I attain the essential of things (though still their outward essential!). I am convinced that, precisely by *not trying to express anything determinate*, one expresses what is most determinate: truth (the all-embracing).

The architecture of the ancients seems to me the greatest art. . . . With the use of horizontal and vertical lines constructed *consciously* but without calculation, under the guidance of higher intuition, and brought to harmony and rhythm with these elements of beauty—supplemented where necessary by lines in other directions or by curved lines—I think one can create a work of art as strong as it is true.

There is nothing vague in this for anyone who can see deeply: it is vague only when one sees nature superficially. *Accident* is to be avoided no less than *calculation*. I also think it necessary that a horizontal

or vertical line be constantly interrupted: for unopposed, these directions would again express something "particular," therefore human.

When one does not describe or depict anything human—then, through complete negation of the self, a work of art emerges that is a monument of Beauty: far above anything human, yet most human in its depth and universality! This, I feel certain, is an art for the future.

Mondrian also recognized what set his work apart from other tendencies to abstraction:

Futurism, although a step beyond naturalism, is excessively concerned with human sensations. Cubism, which still relies for its subject matter on earlier forms of beauty (and is therefore less of our time than Futurism), took the great step toward abstraction; it thus belongs both to our time and to the future: modern not in its content but in its effect. I think of myself as belonging to neither tendency, while recognizing in myself the contemporary spirit of both.

[Formerly] I strove for the monumental, as I still do, attempting abstraction by transforming natural color into a few intensified colors. But I later became convinced that such work remained still too outward and that, even if perhaps good in its own way, it was not sufficiently "constructed."

Finally I should say that I was influenced by seeing Picasso's work, which I *very* much admire. I am not ashamed to mention this influence, for I think it better to hold oneself open to improvement than to remain satisfied with one's imperfections—thus thinking oneself more original, as so many painters do.[19]

At the time of his letter to Bremmer, Mondrian composed his first essay, on art and theosophy, at the request of the Dutch journal *Theosophia*. It cost him "a great deal of effort" in the winter of 1913. "It will appear at the end of the month, if they do not find it too anarchistic," he wrote Bremmer in April 1914.[20] The essay was rejected, the idea of abstract art apparently being too audacious even in these relatively liberal circles. "That may speak well for it," Mondrian wrote a friend.[21] While he remained supportive of theosophical ideals, he had many reservations about the movement "as it commonly appears."[22] The 1914 article is lost,

but its rudiments probably survive in Mondrian's sketchbook notations of the time.

Holland 1914–16: The "Plus-Minus" Phase and the Sketchbooks

Obliged by the outbreak of World War I to prolong a summer 1914 visit to Holland, Mondrian found a studio in the village of Laren, near Amsterdam. Now he developed his late Cubist manner, taking the forms of the sea and the church tower at Domburg as motifs for his compositions. In this so-called "Plus-Minus" phase, curves and obliques are almost eliminated, and the composition reduced to complexes of horizontal and vertical linear segments.[23]

Mondrian's postnaturalistic work posed difficulties for at least one critic, who remembered with a sense of loss his earlier paintings of flowers (ca. 1907–8), full of "tender emotion." His recent work struck her as cold and without feeling—a common reaction of those who require particular subject matter. Once again, Mondrian explained himself in a letter to the critic, Augusta de Meester-Obreen, who printed the artist's response (February 1915) as Querido had done:

Emotion is more outward than spirit. Spirit constructs, composes; emotion expresses mood and the like. Spirit constructs most purely, with the simplest line and the most basic color. The more basic the color, the more inward: the more pure. I do not neglect color, but wish precisely to make it as intense as possible. I do not neglect line, but rather want its strongest expression. The flowing line of things in nature entails a slackening of form. You say that to those who do not understand me I appear not to represent the visible, the divine source of beauty, but only what I have personally abstracted from it. So it may appear, but it *is not so*. When we show things in their outwardness (as they *ordinarily* appear), *then* indeed we allow the human, the individual to manifest itself. But when we plastically express the inward (through the abstract form of the outward), then we come closer to manifesting the spiritual, therefore the divine, the universal.

We individuals perceive this universal as more cold and unfeeling than the particular, which pre-

dominates in us humans. For example, concerning what it is you say we see in a flower: you are surprised that I dissect its tender beauty and transform it into vertical and horizontal lines. . . . *But to express this tender beauty is not my aim.* Whatever we experience in the flower as beauty that does not come from the deepest part of its being; its form and its color is beauty, to be sure, but not *the deepest* beauty.

I too find the flower beautiful in its outward appearance: but a deeper beauty lies concealed within. I did not know how to express this when I painted the withered chrysanthemums with the long stems. I expressed it through emotion—human, perhaps even an already universal human emotion. I later found *too much* human emotion in this work and painted a blue flower *differently.* The latter remained stiffly staring; it already suggested more of the immutable. But the colors, although now pure, still expressed too much individual feeling. I then entered into a period of sober colors, gray and yellow, and tried to make my line more definite. *Gradually* I came to use vertical and horizontal lines almost exclusively.[24]

Two small sketchbooks of ca. 1913–14[25] contain pencil drawings of the Cubist to Plus-Minus phases, interspersed with notes that provide valuable evidence for the development of Mondrian's thought. During the early war years in Laren, he shared a house with the pianist-composer Jacob van Domselaer. Mrs. Domselaer recalled Mondrian's use of such notes or drafts:

[Mondrian] had already begun to write down his thoughts concerning his work. . . . Sometimes on his way to the studio in the morning he would greet us through the door, often continuing the evening's conversation about his work. . . . [He] spoke hesitantly, searching for words. Abruptly, he might lean his notebook on the piano and jot down a promising idea. He always had the book with him, and when he had roughly organized his remarks he would read them to us in the evening. Writing was not easy for him: he often had to rework what he had written, later reading us the revised version.[26]

Sketchbook I contains series of aphoristic observations:[27]

There is a cause for everything, but we do not always know it! . . . To know constitutes happiness. (1:2)

Custom is the obstacle to understanding. (1:13)

The surface of things causes pleasure, their inner character brings life. (1:35)

After having loved surface (appearances) for a long time, one searches for something greater. And yet this is equally present in the surface. (1:50)

For in nature the surface of things is beautiful but its imitation is lifeless. The objects give us everything, but their depiction gives us nothing. (1:49)

According to sketchbook II, which contains the longer passages perhaps linked to the *Theosophia* article, Life is governed and animated by the duality of Spirit and Matter. To this basic opposition there correspond other oppositions: abstract/real (i.e., concrete); active/receptive; creating/conserving; male/female. The advanced artist, who attains a clear vision of reality, discerns these oppositions within nature. His mission is to make them visible and to reconcile them in unity:

The conflict between Matter and Force exists in everything; between the male and female principle. This also in social life. Balance between the two means happiness. This is difficult to achieve, partly because the one is abstract and the other real. Through conflict comes life; change is necessary. (1:19)

The positive and negative states of being bring about *action* . . . the loss of balance and of happiness . . . the eternal revolutions—the *changes that follow one upon the other.* They explain why happiness cannot be achieved in time. (1:67)

Opposites are complementary and are necessary in the achievement of equilibrium. Equilibrated duality leads to happiness in life, to unity and repose in art; beauty can thus be created, as an expression of the life force.

The female and male principles . . . achieve Unity in *rest.* If one considers the spirit alone, then neither life nor art comes into being; if matter alone, likewise nothing. The unity of these two results in Creation. (2:29–30)

Spirit (Force) and matter: a unity. From this Unity comes the Creative Urge. (2:37)

Only by seeing things in their wholeness and mutual relationships can we understand their significance in the broad scheme of Evolution:

Man's one-sided way of thinking is grossly errone-ous; a storm is seen only as a storm . . . and not as a general Good. . . . A personal and noble emotion, strongly expressed in one direction, may become a weakness in relation to the generality (in relation to others). Similarly in art; a certain very beautiful, one-sided emotion is not universal (many-sided) enough to crystallize into universal, eternal beauty. (1:22)

Do not regard a human being merely as a *person* by himself; but also as he *is* with regard to another person (that is, *how beneficial* he is to another). (1:53)

Every human being, every object, everything in this world has a reason to exist. Everything is beauti-ful, everything is good. Everything is necessary—all things and all men in their relative value of existence. Likewise all art is good. Everything finds itself in a certain stage of life at a certain time. . . . (1:51)

In the general progress along the path of knowl-edge, some are ahead of others in the degree of con-sciousness they have attained:

The artist intuitively sees things much more spiritu-ally than does the ordinary man; thus he sees more beauty in reality and that again makes his art bene-ficial to the ordinary man. (2:8–9)

The artistically minded person . . . needs an art-ist who sees more subtly than himself. . . . (2:8)

Even without knowing it, the artist is forced by the spirit of the times toward abstraction—exactly along the course of evolution (Picasso). (2:24)

That [matter is rendered differently] from its vis-ual appearance is something the artist is responsible for and that is justified when [it] results from an inner feeling of necessity. . . .
If this expression is on the one hand individual, on the other hand it is not, because the artist's spirit is part of the general spirit of the times. (1:59)

This unity of positive and negative is pro-nounced in the artist, in whom both male and female elements are found. (1:65)

The emerging art will be abstract, for it no longer seeks to imitate material things:

the elimination of matter also eliminates the imita-

tion of matter. We arrive at the representation of other things such as laws which hold matter together. These are the great general truths which do not change. (2:35–36)

These laws were veiled by the surfaces of objects. Now they emerge in all their purity. (2:34)

these laws are becoming the principal concern of art. (2:38)

In order to approach the spiritual in art, one employs reality as little as possible. . . . This explains logically why primary forms are employed. Since these forms are abstract, an abstract art comes into being.
Art must transcend reality—Art must transcend humanity. Otherwise it would be of no value to man.
This transcendent character appears *vague* and dreamy to the materialist, but for the spiritual person it is precisely positive and clear. (2:5)

In depicting something perceptible to the senses, one makes a human statement because one knows the world through one's self. If one does not represent things, a place remains for the divine. (2:33)

The focus of consciousness is being transferred from without to within. . . . As consciousness turns away from the surface the latter is also less imitated in the art of painting. Only the link with life and matter must remain. This can be accomplished by very little and depends on the intuition of the artist. By turning from the surface one comes closer to the inner laws of matter, which are also the laws of the spirit. Hence the two finally converge. (2:40)

The principle of this art is not the negation of matter, but love of matter, viewed in the most intense man-ner and expressed in form in the artistic creation. (1:58)

Earlier culture sought to express these laws, which were manifested in diverse forms that changed with the time:

All religions have the same ultimate content; they differ only in form. The *form* is the external manifes-tation of this content, and is thus an indispensable vehicle for the expression of the primal principles. . . . Form will be appropriate to a specific period of human development. Consequently, form is depen-dent upon the *period* and upon the measure of man's development. This implies that the *form* can never

continuously remain the same. This also holds for *form* in art (think of the varying forms of temples). (2:18)

In order to visibly express the basic laws, the artist must intensify line and color and accentuate the opposition of horizontal and vertical:

There is a necessity for strengthening and simplifying the form and color of visible objects. (1:13)

In order to express in form the power that emanates from nature, lines generally must be made much blacker in the plastic arts than one ordinarily sees them in nature. (2:14)

Since the male principle is the vertical line, a man shall recognize this element in the ascending trees of a forest; he sees his complement in the horizontal line of the sea. The woman, with the horizontal line as characteristic element, recognizes herself in the recumbent lines of the sea and sees herself complemented in the vertical lines of the forest. (1:15)

Finally, the sketchbooks touch on the role that art plays in making us conscious of the spiritual—even though the purely spiritual remains unattainable in concrete expression:

In speaking of the impulse in the spirit of the age toward spiritual art, one must carefully consider that the word "spiritual" has a broad meaning. The spiritual (i.e., the supersensory) has many degrees. . . . If we concern ourselves with the purely spiritual alone, we are led astray because this needs to be [concretely] expressed. (1:46)

If art transcends the human sphere, it cultivates the transcendent element in mankind, and art, like religion, is a means for the evolution of mankind. (1:7)

Those who have risen above the material not only in their thinking but also in their *lives*, they no longer need abstract art either; they are truly spiritual persons. (1:14–15)

This last thought points toward Mondrian's later speculation that, in the end, even Neo-Plastic art will become unnecessary, being only a temporary substitute, or surrogate, for the perfecting of life itself.

The New Plastic and "The New Plastic in Painting" (1915–17)

During the period in which he wrote "The New Plastic in Painting," ("De Nieuwe Beelding in de schilderkunst"), Mondrian's work developed from the "Plus-Minus" manner to that of *Composition in Lines* (1916–early 1917) and *Compositions in Color*, A and B (1917). *Composition in Lines* marks a turning point: from a first, more painterly state, it evolved to its final state with small rectangular planes, "influenced by Van der Leck's exact technique."[28]

Theo van Doesburg's response in late 1915 to *Composition 10* of that year led him to propose to Mondrian the founding of a journal that would manifest the new spirit. *De Stijl*, which appeared two years later (October 1917), derived its style largely from Mondrian's painting, and its theoretical position in considerable measure from Mondrian's views as stated in "The New Plastic in Painting," as well as from his exchanges with Van Doesburg.

"The New Plastic in Painting" represents the integration of the sketchbook ideas into a systematic whole consonant with Mondrian's advances in painting of 1916–17. The essay probably constitutes the most thorough and consistent statement of position by a leader of the modern movement. As the title implies, the "New Plastic in painting" manifests a spirit shared with the other arts and expressions of life. Mondrian developed this tenet of De Stijl in his "Trialogue" (1919–20) and "Neo-Plasticism: The General Principle of Plastic Equivalence" (1920).

The aesthetic theories of Georg Wilhelm Friedrich Hegel (1770–1831), in which art appears as a manifestation of Spirit, strongly appealed to idealist art circles in Holland. It was from this sphere of thought that Mondrian assimilated the concepts of neutralizing opposition, of abstract and concrete, universal and individual, spirit and nature, determinate and indeterminate—all terms used interconnectedly in "The New Plastic in Painting."

Writing to Bremmer in January 1914, Mondrian spoke of his work as an art "for the future." Despite clear references to the "spirit of the age," the sketchbook texts touch but indirectly on the contemporary, the "modern" in the sense attached to that term after 1910. "The New Plastic in Painting," published in in-

stallments in *De Stijl* through December 1918, shows a more explicit concern with "the new": the New Plastic, the new style, the new consciousness, the new way of seeing modern man, and finally the modern city as the home of the new.

Mondrian became a passionate admirer of "the new" in all its forms. In this he joined the evolving outlook of De Stijl, especially Van Doesburg and the architect J. J. P. Oud, reflecting the climate generated by Cubism and Futurism, followed by Purism, Constructivism, and Dada. Mondrian's conception of the modern embraced everything progressive and liberating, in opposition to the limiting and oppressive forms of the past, the disequilibrium that he called "the tragic."

While many stimuli could be cited as contributing to Mondrian's mature Neo-Plastic art and theory, an overemphasis on influences and sources would divert attention from the unique synthesis he was able to achieve. Mondrian's great independence of mind is apparent in his letter (ca. 1910) to the writer Arnold Saalborn,[29] who had questioned the wisdom of his being "too much alone":

Many thanks for your letter. When I have a little time I will be happy to show you more of my work. But since I do not earn much with "my kind of work," I also have to devote a great deal of time to work for the mass, that is, a more conventional manner of painting—so I have to work twice as much. This means that I really have to concentrate my effort if I am to achieve anything.

. . . There are so many factors that make people of the same feeling and disposition seem temporarily different from one another—such as their experiences and situations in life, and also the kind of work they do. These are seemingly small matters, yet they affect the manifestations of outward life among people in general and artists, do they not? There will for instance be a difference (not in essence, but in way of life) between an artist who has to live by the work he produces, and another who does not entirely depend on this. I mention this only to emphasize that circumstances overturn all the rules and laws (of which you cited one, namely, if I understood you well, that it is not good to be too much alone).

On this same question of being "alone," I would like also to offer this thought: I think the ordinary person seeks beauty in concrete life, but this is what an artist must *not do*. He must stand alone and all alone. He must create solely from the urge to create, just like all of nature: but he must create in a sphere that is not concrete for us—that of thought. And if he obeys only this urge to create and, as far as possible, keeps himself free in order to do this—then he will have done enough. For he will consequently have great significance for mankind.

I have just reread what you wrote me: "To be alone is very harmful, especially for the great and noble among men." I must tell you frankly that I hold just the opposite to be true. To be alone is (for the *great*) the opportunity to penetrate and know the self, the true man, the god-man and, in the highest case, god. In this way one becomes greater, one becomes conscious, one becomes, finally, God.[30] How can that be harmful?

MARTIN S. JAMES

PART I

The De Stijl Years
1917–24

From 1912 until 1938, when the Munich crisis prompted him to leave for London, Mondrian lived in Paris, the center of international culture. During his first years there, 1912–14, his art evolved through Cubism to an expression that was almost purely abstract. The outbreak of World War I in 1914, while Mondrian was on a visit to Holland, compelled him to remain there, painting and writing, until June 1919. It was during these war years that he developed his conception of the New Plastic (*Nieuwe Beelding*).

When the writer and artist Theo van Doesburg (1883–1931) encountered Mondrian's post-Cubist work in Amsterdam in late 1915, his enthusiastic response led to their meeting and friendship, and even before that, to Van Doesburg's proposal for a journal to propagate the new art and the new spirit.

The journal *De Stijl* appeared as a monthly in October of 1917. Its contributors included, besides Mondrian, the painters Bart van der Leck and Vilmos Huszár as well as the architects Jan Wils, and Robert van 't Hoff and—closely associated with Van Doesburg at this time—J. J. P. Oud. Van der Leck soon withdrew because of the journal's tendency, as he saw it, to subordinate the work of the painter to that of the architect. *De Stijl* went on, however, to include the prismatic sculpture and theoretical writings of the Belgian Georges Vantongerloo in late 1918, and in the following year, the furniture of Gerrit Rietveld, constructed of discrete vertical and horizontal elements.

Van Doesburg continued to edit the journal in Leiden until early 1921, and in Paris from 1922 to 1928. Almost all the writings completed by Mondrian from 1917 to 1923–24 were immediately published in *De Stijl* in the original Dutch—with the major exception of his first publication in French, the pamphlet *Le Néo-Plasticisme* (1920).

The ideology that inspired *De Stijl* must be viewed in the context of the turn of the century Dutch architecture and decorative art movement and its collaborative ideal, as well as the tendencies to Cubism and abstraction found in Holland as elsewhere after 1910. Furthermore, the group's optimistic convictions were a hopeful response to the social malaise already discernible before 1914 and accentuated by the catastrophe of the war.

A new era was thought to be dawning, in which the truly modern, universal outlook would eventually prevail. Accordingly, art was no longer to be a primarily individualistic expression, or conceived in terms of the isolated object, but rather in relationship to the larger social, philosophical, and environmental whole. In a common spirit of renewal, workers in diverse fields would join in transforming the incoherent surroundings of the day into a setting unified by a pure and universal style.

The early spirit of *De Stijl* appears in its manifesto printed in four languages in the November 1918 issue:

1. There is an old and there is a new consciousness.
 The old centers on the individual.
 The new centers on the universal.
 The struggle between individual and universal is manifested in the world war, as well as in contemporary art.

2. The war is destroying the old world and its content: domination by the individual in every area.

3. The new art has asserted the content of the new consciousness: individual-universal equilibrium.

4. The new consciousness is ready to be realized in every area, including material life.

5. This realization is obstructed by tradition, dogma, and domination by the individual (the natural).

6. Therefore the founders of the new art call on all who believe in the renewal of art and culture to annihilate these obstacles— just as in the new art, by abolishing naturalistic form, they annihilated whatever obstructs pure aesthetic expression, the ultimate consequence of all art.

7. Driven by the same consciousness, contemporary artists throughout the world have united in a world war against the dominance of the individual and of the arbitrary. They are therefore in accord with all who are working, spiritually or materially, to create international unity in Life, Art, and Culture.

8. To this end they founded the journal *De Stijl*, which seeks to assist in promulgating the new outlook.[1]

During the period of his association with *De Stijl* (1917–23) Mondrian's painting evolved from his first composition with rectangular planes (1916–17), through works with subdued color planes over an underlying grid (1918–19), to the compositions with strong primary color, black, and white that assumed their now familiar form about 1920–22.

Mondrian's initial contribution to *De Stijl*, "The New Plastic in Painting" (published October 1917 through 1918) was his first major writing and the cornerstone of Neo-Plastic theory. His next two essays, the "Dialogue" (1919) and the trialogue "Natural and Abstract Reality," present the case for Abstract-Real painting in conversational form.

Mondrian addressed the implications of Neo-Plasticism for literature, music, and other arts in his pamphlet *Le Néo-Plasticisme* (*Neo-Plasticism: The General Principle of Plastic Equilibrium*), written in the course of 1920; and in the same year, he himself essayed the possibilities of literary art with his sketches of urban life "Les Grands Boulevards" and "Little Restaurant—Palm Sunday." New Music was the theme of two major essays, "The Manifestation of Neo-Plasticism in Music and the Italian Futurists' *Bruiteurs*" (1921) and "Neo-Plasticism and Its Realization in Music," both printed in Dutch in *De Stijl* before they appeared in French and German publications.

After 1920, Van Doesburg broadened the contributorship of *De Stijl* from a chiefly Dutch to a more international one. Dada was represented by Kurt Schwitters and Raoul Hausmann, and especially by Van Does-

burg himself under the pseudonyms of I. K. Bonset and Aldo Camini. Kinetic art, Futurism, and Constructivist tendencies were represented by Hans Richter, Enrico Prampolini, and El Lissitzky, respectively. From 1923 on, the magazine reflected Van Doesburg's own involvement with architectural design.

Mondrian's *De Stijl* essays of the early twenties discreetly voice his and Van Doesburg's disagreement with J. J. P. Oud as to the feasibility of realizing in practice an "architectural chromo-plastic" consistent with purely Neo-Plastic principles. In "The Realization of Neo-Plasticism in the Distant Future and in Architecture Today" (1922) and "Is Painting Inferior to Architecture?" (1923) Mondrian presents Neo-Plasticism as the principle that must govern the architecture of the future.

Important in the spread of Neo-Plastic conceptions was the Bauhaus at Weimar and (1925) Dessau, Germany. The Bauhaus Book series, edited by Walter Gropius and László Moholy-Nagy between 1925 and 1930, published writings by members of the Bauhaus faculty, such as Gropius, Kandinsky, Klee, and Oskar Schlemmer, and others, including Mondrian, Malevich, Oud and Van Doesburg. Mondrian was the first of the outside authors. Bauhausbuch no. 5 (1925), *Neue Gestaltung*, presented in German translation Mondrian's "Le Néo-Plasticisme" (1920) and his four major articles on music and architecture.

Mondrian's last contributions to *De Stijl* appeared in early 1924, after Van Doesburg advanced his conception of Elementarist painting, wherein the perpendicular relationship was turned to a 45° angle with the vertical-horizontal, in order to express time and dynamic opposition to the natural. The consequent instability was clearly at odds with the original assumptions of Neo-Plasticism. In his final short articles in *De Stijl*, "No Axiom but the Plastic Principle" and "Blown by the Wind" (both 1923), Mondrian deplores the general lack of belief in firm principles and the tendency among prewar pioneers of the abstract movement to revert to figurative modes and compositional formulas.

This first section closes with the brief tribute that Mondrian composed in 1931, after the untimely death of Theo Van Doesburg.

The New Plastic in Painting
(1917)

"The New Plastic in Painting" ("De Nieuwe Beelding in de schilderkunst"), Mondrian's first published essay, was conceived as a book comprising an introduction, four chapters ("The New Plastic as Style"; "The New Plastic as Abstract-Real Painting: Plastic Means and Composition"; "The Rationality of the New Plastic"; "From the Natural to the Abstract: From the Indeterminate to the Determinate"), and a conclusion: "Nature and Spirit as Female and Male Elements." The work was published in twelve installments in the first year of *De Stijl*, October 1917–October 1918. A supplement, "The Determinate and the Indeterminate," followed in the December 1918 number.

Mondrian began the writing not long after his return to Holland in the summer of 1914, for in September 1915 he informed a friend, Dr. H. van Assendelft: "The book is almost complete; it has become far more comprehensive than I expected." He continued to work on it during 1916, the year when he became associated with Theo van Doesburg and Bart van der Leck, and evolved the rectilinear structure characteristic of De Stijl. Mondrian's completion of the main part of the treatise in the spring of 1917 coincided with his two *Compositions in Color*, 1917 (A and B).

Mondrian wrote "The New Plastic in Painting" in Laren, the village near Amsterdam favored by artists and writers, where he spent most of the war years close to the composer Jacob van Domselaer and the painter Bart van der Leck. Another neighbor was the esoteric philosopher M. H. J. Schoenmaekers, who in *The New World Image* (*Het nieuwe wereldbeeld*, 1915) claimed to reveal the absolute underlying structure of the universe. Schoenmaeker's terms *beeldend* ("plastic, "image-forming"") and *nieuwe beelding* ("new plastic," "new structure") must have influenced Mondrian's choice of *De Nieuwe Beelding* as an alternative name for Abstract-Real Art. (The Dutch verb *beelden* and substantive *beelding* signify form-giving, creation, and by extension image—as do *gestalten* and *Gestaltung* in German, where Neo-Plastic[ism] is translated as *Die neue Gestaltung*. The English *plastic* and the French *plastique* stem from the Greek *plassein*, to mold or to form, but do not quite encompass the creative and structural signification of *beelding*.)

The war years were a difficult time for Mondrian economically. He was, as he wrote the art critic and collector H. P. Bremmer in January 1917, engaged in "a triple labor": copying museum paintings as well as his own earlier representational works in order to survive; pushing forward his latest artistic research; and working nights to complete his book. It was in the spring of 1917, when Van Doesburg was in the process of organizing *De Stijl*, that Mondrian decided to publish "The New Plastic in Painting." He wrote to Van Doesburg on 16 May:

> I have been so busy of late that I've had to let the book alone. It is practically finished, and I have gone all through it with Van der Leck,

who readily suggested improvements. . . . I had intended to seek a publisher. Now that you have come forward with your proposal I am inclined to accept it, for I have confidence in you: I have in mind your pure attitude with regard to the new plastic and your accurate insight into it; also you see the new appearing in precisely the same way I do. So, if you are in favor of publishing chapters regularly in your magazine, I will send you the first. Let me know when you need it. I have only to change something in the introduction. . . . The introduction is followed by an article on Style, and since you call your periodical *De Stijl* it would be most appropriate. Or would it be better to begin with the part on Style, in the first number?

While he was waiting somewhat impatiently for "The New Plastic in Painting" to appear in the initial number of *De Stijl*, Mondrian wrote another to the collector H. van Assendelft, no doubt referring to his art as much as to its theory: "For the moment at least, my long search is over."[1]

1. Introduction[a]

The life of modern cultured man is gradually turning away from the natural: life is becoming more and more *abstract*.

As the natural (the external) becomes more and more "automatic," we see life's interest fixed more and more on the inward. The life of *truly modern* man is directed neither toward the material for its own sake nor toward the predominantly emotional: rather, it takes the form of the autonomous life of the human spirit becoming conscious.

Modern man—although a unity of body, soul, and mind—manifests a changed consciousness: all expressions of life assume a different appearance, a more *determinate abstract* appearance.

Art too, as the product of a new duality in man, is increasingly expressed as the product of cultivated outwardness and of a deeper, more conscious inwardness. As pure creation of the human *spirit*, art is expressed as pure aesthetic creation manifested in abstract form.

The truly modern artist *consciously* perceives the abstractness of the emotion of beauty: he *consciously* recognizes aesthetic emotion as cosmic, universal. This conscious recognition results in an abstract plastic—limits him to the purely universal.

That is why the new art cannot be manifested as (naturalistic) concrete representation, which always directs attention more or less to particular form even when universal vision is present—or in any case conceals the universal within itself.

The new plastic cannot be cloaked in what is characteristic of the particular, natural form and color, but must be expressed by the abstraction of form and color—by means of the straight line and determinate primary color.

These universal plastic means were discovered in modern painting by carrying through the process of consistent abstraction of form and color: once these were discovered there emerged, almost of its own accord, *an exact plastic of pure relation-*

[a] This introduction summarizes a number of articles in which the different concepts outlined here will be further clarified.

ship—thus the essence of all emotion of plastic beauty.

Thus the new art is the *determinate plastic expression of aesthetic relationships*.

The contemporary artist constructs the new plastic expression in painting as a consequence of all previous creation—in painting, precisely because it is the least restricted of the arts.

The growing profundity of the whole of modern life can be purely reflected in *painting*. In painting—in *pictorial*, not *decorative* painting—naturalistic expression as well as naturalistic plastic means become more inward, are essentialized into the abstract.

Decorative painting merely *generalized natural* form and color.

Thus·the feeling for the aesthetic expression of relationship was brought to *clarity* in and by pictorial painting.

The *free* construction of pure relationships may well be limited to this form of painting, which incorporates (existing) decorative art or, rather, becomes "true" decorative art; for although the essence of all art is *one*—and the feeling for aesthetic relationships increasingly seeks more determinate expression in all the arts—not every art can express *determinate relationships* with equal consistency.

Although the content of all art is one, the possibilities of plastic expression are different for each art. These possibilities must be discovered by each art within its own domain and remain limited by its bounds.

Each art possesses its own means of expression: the *transformation* of its plastic means has to be discovered independently by each art and must remain limited by its own bounds.

Therefore the potentialities of one art cannot be judged according to the potentialities or another, but must be considered independently and only with regard to the art concerned.

Each art has its own emphasis, its particular expression: this justifies the existence of the various arts. We can now define the emphasis of the art of painting as *the most consistent expression of pure relationships*. For it is painting's unique privilege to express relationships *freely*—in other words, its means of expression (through consistent and thorough transformation) allow extreme opposites to be expressed as the pure relationships of *position*, without assuming form, or even the appearance of form (as in architecture), through enclosure.

In painting the dualities of relationship can be placed in juxtaposition to one another (on one plane), which is impossible in architecture or sculpture.[2] Thus painting can indeed be the most purely "plastic."

[The freedom to make changes in the plastic position of the means of expression is unique to painting. The sister arts, sculpture and architecture, are less free in this respect.][3] The other arts are even less free in *transforming their plastic means*: music is always tied to sound, however much sound may be tensed into "tone"; dramatic art employs natural form as well as sound and necessarily the word; literary art is expressed through the word, which strongly emphasizes the particular.

Painting is capable of *consistent* intensifying and interiorizing of *its plastic means without overstepping their limits*. The new plastic in painting remains pure *painting*: the plastic means remain form and color—in their greatest interiorization [verinnerlijking]; straight line and plane color remain the pure means of painting.

With the advancing culture of the spirit, all the arts, regardless of differences in their expressive means, in one way or another become more and more the *plastic creation of determinate, equilibrated relationship*: equilibrated relationship most purely expresses the universal, the harmony, the unity that are proper to the spirit.

Through equilibrated relationship unity, harmony, universality are *plastically* expressed amid diversity, multiplicity, individuality—in the natural. When we concentrate upon equilibrated relationship, we can *see* unity in the natural. In the natural, however, unity is manifested only in a veiled way. Although inexactly expressed in the natural, all appearance can nevertheless be reduced to this manifestation. Therefore, the exact plastic expression of unity *can be created, must be created*, because it is not directly apparent in visible reality.

Whereas in nature equilibrated relationship is expressed by *position, dimension, and value* of natural form and color, in the "abstract" it is expressed through *position, dimension, and value* of the straight line and rectangular (color) plane.

In nature, we perceive that all relationship is governed by one prime relationship: that of extreme opposites.

The abstract plastic of relationship expresses this prime relationship *determinately*—by the duality of position, the perpendicular. This relationship of position is the most equilibrated because it expresses the relationship of extreme opposition in complete harmony and includes all other relationships.

If we see these two extremes as manifestations of the inward and the outward, we find that in the new plastic the bond between spirit and life is unbroken—we see the new plastic not as denying the fullness of life but as the *reconciliation* of the matter-mind duality.

If through contemplation we recognize that the existence of all things is aesthetically determined for us by equilibrated relationships, then the idea of this manifestation of unity is already implanted in our [individual] consciousness—for the latter is a particularization of *universal* consciousness, which is unity.

When man's consciousness grows from vagueness to determination, his understanding of unity will also become more and more determinate. The advanced consciousness that has become determinate in an era (that is, the spirit of the age, or the consciousness at which the age has arrived) must necessarily express *itself determinately*. Thus art too *must express itself determinately*.

If unity is seen "determinately," if attention is focused purely on the universal, then particularity, individuality, will disappear from expression, as painting has shown. Only when the individual no longer stands in the way can universality be purely manifested. Only then can universal consciousness (intuition)—wellspring of all the arts—express itself directly; and a purer art arises. However, it does not arise before its time. The consciousness of an age determines the artistic expression: the artistic expression reflects consciousness of the age. Only that art is truly alive which gives expression to the contemporary—the future—consciousness.

If we see man's consciousness—in time—*growing* toward determination, if we see it—in time—*developing* from individual to universal, then logically the new art can never return to form—or to natural color. Then logically the consistent growth and development of abstract plastic *must* progress to its culmination.

While one-sided development, lack of aesthetic culture, or tradition may oppose it temporarily—an *abstract*, a *truly* new plastic expression is necessary for the new man.

Only when the new consciousness becomes more general will the new plastic expression become a universal need: only then will all factors be present for its culmination.

Even so, the need for a new plastic exists since we see it coming into being through the contemporary artist: the essen-

tials for the new plastic of the future are already there.

If the essential of each plastic expression, that which is characteristic in each expression of art, lies in the *transformation of the plastic means*, then we clearly see this essential expressed in the *complete transformation* of the expressive means in the new plastic. The new plastic means testify to a new vision. If the aim of all *art* is to *establish relationships*, only a more conscious vision can bring this aim to clear expression— precisely through the *plastic means*.

If the purely plastic expression of art lies in the proper transformation of the plastic means and their application—the composition—then the plastic means must be in complete accord with what they express. If they are to be a *direct* expression of the universal, then they cannot be other than universal: abstract.

Composition leaves the artist the greatest possible freedom to be subjective—to whatever extent this is necessary. The *rhythm* of the relationship of color and dimension (in determinate *proportion* and *equilibrium*) permits the absolute to appear within the relativity of time and space.

Thus the new plastic is dualistic through its composition. Through its exact plastic expression of cosmic relationship it is a direct expression of the universal; through its rhythm, through its material reality, it is an expression of the subjective, of the individual.

In this way it unfolds a world of *universal* beauty without relinquishing the "universally human."

2. The New Plastic as Style

Painting—which is in essence one and unchangeable—has always manifested itself in very diverse expressions. The expressions of the past—characterized by so many *styles*—differ only by reason of place and time, but fundamentally they are one. However they may differ in appearance, all arose from a single source: the *universal*, the profound essence of all existence. Thus all historical styles have striven toward this single goal: to manifest the *universal*.

Thus all *style* has a *timeless content* and a *transitory appearance*. The timeless (universal) content we can call the *universality of style*, and its transitory appearance the *characteristic* or the *individuality of style*. That style in which individuality best serves the universal will be the greatest: the style in which universal content appears *most determinately plastic* will be the purest.

Although all painting has a timeless content, it is strictly *plastic* expression and can *reveal style* only insofar as this content actually becomes *plastic*.

In painting style must be *made manifest*: it cannot be expressed through subject matter or representation.

The universal in style becomes expressed through the individual in style, that is, through the *mode* of stylistic expression.

The mode of stylistic expression belongs to its time and represents the relationship of the spirit of the age to the universal. This is what gives to each art expression its specific character and distinguishes the historical styles.

On the other hand, the universal in style is eternal, and makes every style *style*. It is the representation of the universal that, as philosophy also teaches, forms the very core of the human spirit even though it is veiled by our individuality. The universal is no more determinate *outside* us than it is *within* us. Although the universal expresses itself *through* nature as the *absolute*, the absolute in nature is plastically expressed only through natural color and concealed or veiled by form. Although the universal is plastically

expressed as the absolute—in line by *straightness*, in color by *planarity* and *purity*, and in relationships by *equilibrium*—it is revealed in nature only as a *tendency* toward the absolute—a tendency toward the straight, the plane, the pure, the equilibrated: through *tension* of form (line), *planarity, intensity, purity* of natural color and natural harmony.

To bring to the fore the absolute, this is what art expresses, this is the content—universal and individual—of all style. The universal in a style makes the absolute *visible* through the individuality of that style. Because individuality of style provides the *mode and the degree* in which the absolute is made visible, it shows the spiritual outlook of the time and is precisely what makes a style appropriate to its period and constitutes its vitality.

Individuality of style therefore cannot be separated from universality of style (we here discuss style as a *duality* only in order to gain a pure conception of its meaning).

Painting can express the absolute in two ways: determinately, as it does *not* appear in the external world, or veiled in form and natural color, as it is expressed in nature. In the first, style appears entirely *in the manner of art*; in the second, it always appears more or less *in the manner of nature*.

In the manner of nature: for nature also shows style. Indeed, nature like art reveals the universality of style through the particular, the individual, for everything manifests the universal *in its own way*. Thus we can say that nature also shows individuality of style, but altogether differently than art. In nature individuality of style is *completely bound* to the particular, to the *natural appearance of things*; whereas in art individuality of style must be *entirely free* from this and is bound only by time and place. Therefore art can express style completely, whereas in nature style remains for the most part veiled. To express style *completely*, art must

so free itself from the natural appearance of things as not to represent them: only in an *abstract appearance* can it represent the tension of form, the intensity of color, and the harmony revealed by nature.

Nevertheless, in one way or another painting always brings the visible style of nature to an expression that moves man. Painting always more or less transforms the style in nature into style in art. The artist's perception of style in nature is so strong that he is automatically compelled to express style. Style in nature unites, as it were, with the artist's sense of style: from the union of inner and outer style the work of art is born. Thus style in nature is so expressed by painting as to become (relatively) perceptible and visible to all.

Artistic temperament, *aesthetic* vision, thus perceives style; ordinary vision, on the contrary, sees it neither in art nor in nature. Ordinary vision is the vision of the individual who cannot rise above the individual. As long as materiality is seen individually, style cannot be perceived. Thus ordinary vision obstructs all art: it does not *want* style in art, it demands a detailed reproduction. The artist, on the contrary *wants* and *searches* for style: this is his struggle. But through this struggle against individuality within and without, his conception of style grows: he expresses more and more consciously the universal—the universality that deep within him is expressed spontaneously and intuitively, that does *not struggle* but effortlessly unfolds.

The universal in the artist causes him to see through the individuality that surrounds him, to see order free from everything individual. This order, however, is veiled. The natural appearance of things has evolved more or less capriciously: although reality shows a certain order in its articulation and multiplicity, this order does not often appear clearly but is obscured by the conglomeration

of forms and colors. Although this natural order may not be immediately discernible to unpracticed eyes, it is nevertheless this *equilibrated order* that arouses the deepest emotion of harmony in the beholder. If profundity of emotion depends upon the degree of his inner harmony, then to that degree there is consciousness of equilibrated order. When the beholder has achieved some consciousness of cosmic harmony, then the artistic temperament will require a *pure expression* of harmony, a *pure expression* of equilibrated order.

If he is an artist, he will no longer follow order in the *manner of nature* but will represent it in the *manner of art*: he transforms order, as we perceive it visually, with the *utmost consistency*. Equilibrated order, limited by our individuality and veiled in the individual then appears as it is actually—as *universal* order: the plastic expression shows *universality of style determinately*. At present, equilibrated order in plastic expression is still very relative; the imperfect cannot reflect the perfect.

In style in the manner of nature, on the other hand, order is always more or less bound to the appearance of nature and therefore cannot be expressed precisely as *equilibrated* order. Style in the manner of nature was required in traditional painting because it directly expressed the particular together with the universal.

For instance, in portraiture a particular type cannot be expressed without naturalistic form or naturalistic color, neither can a particular landscape or a still life—all are particularity.

Because all particularity of appearance has a particular content and produces a particular sensation which, when expressed through the naturalistic appearance of things, does not move us with the force of reality itself, our time has been obliged to adopt *other* modes of expression. But as *style* these

modes will have vitality in the future only *insofar as they assert the expression of the universal over the individual* more determinately. If this is actually achieved, then exact representation of the particular disappears. Thus representation in the manner of nature is *the* painting for the particular appearance of things, and style in the manner of nature will continue to exist as long as particular appearance is demanded in plastic expression.

On the other hand, if consistency of style in the manner of art excludes the particular appearance of objects from the plastic expression, this is not a negation of the objects themselves. For it expresses the *universal*—the core of all things, and thus actually represents things more completely.

Consistency of style in the manner of art is a product of the experience that plastic expression in naturalistic color and form is unsatisfactory. From the viewpoint of the particular, naturalistic representation always remains inferior to actual appearance; from the viewpoint of the universal, naturalistic representation is always individual. No art has ever been able to express the power and grandeur of nature by imitation: all true art has made the universal more dominant than it appears to the eye in nature.

Thus, finally, there had to emerge the *exact plastic expression of the universal*. In order to recognize this plastic as style, it is necessary to perceive that style in art is *aesthetic plastic interiorization*, whereas style in nature is manifested through *plastic* outwardness.

In this lies the opposition between art's relationships and nature's appearance. Only what ordinary vision sees as a certain exaggeration of style in nature generally creates style in art. In the old art, tension of form (line), the intensity and purity of color, and natural harmony were accentuated—sometimes even exaggerated. In the new art, this exaggeration increased to the point

where *form and color themselves became the means of expression.* Where the means were freed of the naturalistic, they could be seen in pure light for the first time, and the *limitations* of form and natural color became obvious. Then followed rapidly the *breakup of form and the determination of color.* In this way the *universal plastic means* were discovered.

The new plastic—consistency of style in the manner of art—begins when form and color are expressed as unity within the rectangular plane. With this universal means, nature's complexity can become *pure plastic, determinate relationship.*

The new plastic, the style of the future, expresses not only man's deeper inwardness, but his *maturing* outwardness (naturalness). It is precisely this more equivalent evolution of inwardness and outwardness, a more harmonious relationship between this indivisible duality, that can create the new style. Our maturing naturalness has transcended the natural and approaches the abstract; it thus becomes homogeneous with the inward, which is abstract. Only the maturing externality within man can produce an abstract vision of the external. Thus is born an expression that is abstract but nevertheless real. It is real because the content and the appearance of things are unveiled: content, because it is expressed determinately; appearance, because it arises from the natural and still preserves the essence of the natural.

Thus the culture of the *whole* man was necessary to lead him to a plastic expression in which natural reality was interiorized as abstract reality.

Although the culture of the natural in man accompanies the culture of his more inward being, the former does not always keep pace with the latter.

This explains why abstract-real plastic is manifested only *now.* From its manifestation we can conclude that equilibrium between man's outwardness and his inwardness, between the natural and the spiritual within him, has only just begun. This new relationship must produce a new style. Whereas style in art has always appeared more or less in the manner of nature, this is now decaying and yields to pure expression of style in the manner of art.

This style can appear only as the aesthetic vision of the determinately universal. Through the equilibrated placement of the newly found universal plastic means, the determinately universal can be plastically expressed, and the new style could thus be established in our own time.

A given culture, a certain stage in the evolution of the universal, becomes visible in the masses only after preparation and maturation in *the individual* of the preceding period: it manifests itself as style long after its existence actually began.

Style is therefore discernible even in a period that lacks culture. We do not need to wait for a period of fully developed culture in order to discern style in the individual. If our time lacks culture (culture understood as unity of the masses), the principles of a culture are nevertheless already developed and expressed in the individual: ready to be manifested as culture—culture which will be expressed in art as the *new style.*

In a period lacking culture, we must recognize the style of the future as that mode of expression which is the most direct, the clearest reflection of the universal—even though it might appear only in a few individuals. In a time without culture, however, a given expression must not be seen as the style of the future simply because it is an expression of the masses: as long as culture

does not become universal, the expression of the masses will exhibit an anachronistic character.

Only in a time of true culture can we expect a generally homogeneous expression in art.

The new culture will be that of the *mature individual*; once matured, the individual will be open to the universal and will tend more and more to unite *with* it.

The time is approaching when the majority of individuals will be capable of this.

Until now periods of culture arose when a particular individual (above and beyond the people) awakened the universal in the masses. Initiates, saints, deities brought the people, as if from without, to recognize and to feel the universal; and thus to the concept of a pure style. When the power of one of these universals was spent, the sense of the universal decayed, and the masses sank back into individuality until new power from other universals could again enter them from without. But precisely because of this relapse into individuality, individuality matured within *man as individual*, and a consciousness of the universal developed within him. Therefore, in art today the individual can be expressed as the determinately universal.

3. The New Plastic as Abstract-Real Painting: Plastic Means and Composition

The new plastic can be called abstract not only because it is the direct expression of the universal but also because its expression excludes the individual (or naturalistic concreteness). We can call its exact expression of

relationship abstract—in contrast to oppression through natural appearance, which it *abstracts*.

If we call the new plastic abstract, the question arises whether the abstract can be represented visually. If it is to be expressed determinately, it is illogical to identify the new art with the vaguely plastic—as is often done.

Following long culture, the idea has matured in painting that the abstract—the universal—can be clearly represented. Through the very culture of representation through form, we have come to see that the abstract—*like the mathematical*[b]—is *actually* expressed in and through all things, although not determinately. In other words, the new painting achieved of its own accord a determinate plastic expression of the universal, which, although veiled and hidden, is revealed in and through the natural appearance of things. Through painting itself the artist became conscious that the appearance of the *universal-as-the-mathematical* is the essence of all feelings of beauty as pure *aesthetic* expression. (The artist developed his awareness through practice; but in the deeper sense it is the action of the spirit of the age to which he gives conscious expression.) As this consciousness grew, he learned to construct appearance through the precise plastic representation of individual things—that is, precisely by abstracting this more and more. He learned to represent *exactly* what is *vaguely perceptible* in nature, he *reduced and destroyed the concreteness* of appearance (by simplification), yet he did no more than carry the *conception of art to its logical conclusion*. And so our age arrived at *abstract-real* painting. The new plastic is *abstract-real*

[b] Aristotle already identified the abstract with the mathematical.

because it stands between the absolute-abstract and the natural or concrete-real. It is not as abstract as abstract thought, and not as real as tangible reality. It is aesthetically living plastic representation: the visual expression in which each opposite is transformed into the other.

Abstract-real painting can create in an aesthetic-mathematic way because it possesses an *exact mathematical means of expression: color brought to determination.*

To determine color involves, first, *the reduction of naturalistic color to primary color*; second, *the reduction of color to plane*; third, *the delimitation of color—so that it appears as a unity of rectangular planes.*

Reduction to primary color leads to the visual internalization of the material, to a purer manifestation of light. *The material, the corporeal* (through its *surfaces*) causes us to see colorless sunlight as natural color.[c] Color then arises from *light* as well as from the *surface*, the *material*. Thus natural color is *inwardness* (light) in its most outward manifestation. Reducing natural color to primary color changes the most outward manifestation of color back to the most inward. If, of the three primary colors, yellow and blue are the most inward, if red (the union of blue and yellow—see Dr. H. Schoenmaekers, *Het nieuwe wereldbeeld*)[4] is more outward, then a painting in yellow and blue alone would be more inward than a plastic in the three primary colors.

But if the near future is still far from this realization of the inward, and if today the time of natural color is not yet over, the abstract-real painting must rely upon the three primary colors, supplemented by white, black, and gray.[d]

In abstract-real painting *primary color* only signifies *color appearing in its most basic aspect.* Primary color thus appears very relative—the principal thing is that *color be free of individuality and individual sensations, and that it express only the serene emotion of the universal.*

The primary colors in abstract-real painting *represent* primary colors in such a way that they *no longer depict the natural, but nevertheless remain real.*[e]

Color is thus *transformed* not arbitrarily but in complete harmony with all principles of art. Color in painting owes its appearance not only to visible reality but also to the vision of the artist: the artist inwardly changes and interiorizes the outwardness of color.

If color expression results from a reciprocal action of the subjective and the objective, and if the subjective is growing toward the universal, then color will increasingly express the universal—and will be manifested more and more *abstractly*.

If it is difficult to understand that expression through line can be abstract-plastic,[f] then it is even more difficult to perceive this in intensified color-as-color (as distinguished from color as black and white—dark and light).

The new plastic's abstract color is *meaningless* to subjective vision: abstract color omits individual expression of emotion—it still expresses emotion, but an emotion dominated by the spirit.

[c] Color is troubled light (Goethe).

[d] Gray, too, because just as yellow, blue, and red can be mixed with white and remain *basic color*, so can black.

[e] That is, they will not imitate astral color, for example.

[f] The taut line without color (i.e., without shading and without thick and thin) may be the most desirable appearance for abstract expression; however, color is necessary for *abstract-real* expression.

The new plastic succeeds in *universalizing* color for it not only seeks the universal *in each color-as-color*, but *unifies all through equilibrated relationships*. In this way the particularities of each color are destroyed: color is *governed* by relationship.

In nature, as in art, color is always *to some degree* dependent upon relationships but is not always governed by them.[g] In naturalistic expression, color always leaves room for subjectivization of the universal. Although color becomes *tone* through relationship (tonal or value relations), color remains dominant.

Only through the exact expression of equilibrated color relationships can color be governed, and can the universal appear determinately.

If the emotion aroused by *colors themselves* is connected with feeling, and *conscious recognition of relationships* is connected with the spiritual, then spiritual feeling—of the future—will make relationships increasingly dominant over color.

As an exact plastic expression of intensified color as well as relationships, the new plastic can express *complete* humanity, that is, equilibrium of spirit and feeling. Equilibrium in plastic art, however, demands a most exact technique. Although the new plastic *appears* to have given up all technique, its technique has actually become so important that the *colors must be painted in the precise place where the work is to be seen*. Only then can the effect of the colors and relationships be precise, for they are interdependent with the entire architecture; and the architecture in turn must harmonize completely with the work.

Insofar as the time is not yet ripe for the complete unification of architecture, the new plastic must continue to be manifested as painting, and this will influence the abstract-real plastic of the present. Each artist must seek his own color-expression, adapting himself to time and place. If he does not reckon with today's environment, his work will be *disharmonious* whenever it is not *seen simply in and for itself*. But perhaps this *disharmony* will open people's eyes to the present environment—as it mostly is—in all its traditionalism and arbitrariness.

Natural color in the new plastic is intensified not only because it is reduced to primary color but also because it appears as *plane*.

Ordinary vision does not perceive color in nature as plane: it perceives things (color) as *corporeal*, as roundness.

Actually things take their visual shape from a complex of *planes* that expresses plasticity through *angularity*; form always appears more or less as a confluent *angularity*. The angularity is not directly perceptible, however, and sometimes it barely exists *visually*, as a photograph or veristic picture shows. The technical development of the painter, even in academic teaching, consists largely in *learning to see* the *planarity* in the appearance of forms, and consequently in the *plastic*, and to *exaggerate* this in representation.

Modern art follows ancient art in accentuating the *planarity* of natural reality, and is only a more consistent expression of the same idea: the plastic conception. After the *accentuation* of planarity there began the fragmentation of the visual corporeality of objects in the painting. (Cézanne—Kandinsky; the Cubist school—Picasso.) Here the plastic conception already becomes more plastic.

Finally, the new plastic *is the manifestation of this conception, the manifestation of the purely aesthetic idea*.

[g] The three primary colors neutralize one another into unity: thus they express light otherwise than in traditional painting.

In general, then, painting creates *plastically* by accentuating angularity. The plastic is necessary in painting because it creates *space*. Because painting expresses space *on a flat surface*, it *requires a plastic other than naturalistic plastic* (which is *not* perceived on one plane).

Painting has found this *new* plastic by *reducing the corporeality of objects to a composition of planes that give the illusion of lying on one plane.*

These planes, by both their dimensions (line) and their values (color), can express space without the use of visual perspective. Space can be expressed in an equilibrated way because the dimensions and values create *pure* relationship: height and breadth oppose each other without foreshortening, and depth is manifested through the different colors of the planes.

The new plastic expresses the essential of space through the relationship of one color plane to another; perspective illusion is completely abolished, and pictorial devices (such as the rendering of atmosphere, etc.) are excluded.

Because color appears as pure, planar, and separate, the new plastic *directly expresses expansion*, that is, directly expresses the basis of spatial appearance. Expansion— the exteriorization of active primal force— creates corporeal form by growth, addition, construction, etc. Form results when expansion is limited. If expansion is fundamental (because action arises from it), it must also be fundamental to plastic expression. If it is to be recognized consciously as fundamental, it must be represented clearly and directly. If the time is ripe for this, then the *limitations of particularity must be abolished* within the plastic expression of expansion, since only then can expansion be expressed in all its purity.

If, in the morphoplastic,[5] the boundaries of form are established by *closed line* (con-

tour), then they must be tensed to *straight line*.

Then the most outward (the appearance of form) comes into equilibrated relationship with the *exact plastic expression of expansion*, which also becomes perceptible to the senses as *straight line*.

Thus by *expansion* and *limitation* (the extreme opposites—see introduction), an *equilibrated relationship of position* is created—the perpendicular relationship. Thus, expansion is realized *without particular limitation*, purely through differences in the color of the planes and the perpendicular relationships of lines or color planes.

Perpendicularity delimits color *without closing it.*

Thus, in the *rectangular* plane, color is for a third time, finally and completely, determined.[h]

Just like the expression of color as *plane color*, rectangular delimitation of color grew out of the *attempt to express the planarity of visual reality*, as found in art of the past.

The new plastic has *realized* the age-old idea of art: *the determination of color.*

Indeed, art before the new plastic determined color only *to a degree*: by intensification, by planarity, by firm stroke or surrounding line (contour). *Form* was delineated and filled in with color, or it was rendered through color (Cézanne). The value of a work of art before our time can be measured by its (relative) determination of color. In times of intense inward (or spiritual) life, color was planar and line tensed. But even in other times, when color was modeled and line capricious, art gave color

[h] Of the three determinations of color, perpendicular delimitation expresses the *most precise* relationship. It also involves the other determinations of color: *planarity* results directly from delimitation; the *primary colors* can be thought of as reducible to the colorless (white).

its *definiteness* and line its *tension* in order to express plastically inner force.

The early modern school of painting is distinguished by strong linear expression (contour)—Van Gogh; and by planar use of color—Cézanne. Later, when color appeared as color, and form as form in its own right (Cubism, etc.), color became even more determinate. From the exact plastic expression of form consequent to the determination of color, there resulted, through the breaking of form, the *complete* determination of color. The breaking of form (contour) did not produce vague or flowing color but led to its essential determination: the determination of straightness.

Thus color became the *plastic means*[i] *of abstract-real expression*, because form (the concrete) is dissolved into color, and color is freed from the naturalistic.

If this plastic means is already inherently universal because it expresses the basic relationship of position and intensified color, then *abstract-real* plastic can become realized only through *composition*. Through composition, exact spatial expression becomes not only *possible*, but also *real*.

If the new plastic is dualistic through its composition (see introduction), *the composition is also dualistic*. The composition expresses the subjective, the individual, through rhythm—which is formed by the relationships of color and dimensions, even though these are mutually opposed and neutralized.[j] At the same time it expresses the universal through the proportions of dimension and color value, and through *continuous opposition of the plastic means themselves*.

It is precisely this *duality* of composition that makes *abstract-real* painting possible.

The universal plastic means would itself *reappear as particularity* if it were not abolished by composition itself; otherwise, being individuals ourselves, we would tend to see individuality again in the universal plastic means.[k] That is why, in the new plastic, composition itself demands full attention.

In all art, it is through composition (as opposed to *rhythm*) that some measure of the universal is plastically manifested and the individual is also more or less abolished. Although composition has always been fundamental to painting, all modern painting has been distinguished by a *new way* of being concerned with it. In modern art, especially in Cubism, composition comes to the forefront and finally, in consequence, abstract-real painting expresses *composition itself*. While in the art of the past, composition becomes *real* only if we abstract the representation, in abstract-real painting composition is directly visible because it has truly *abstract* plastic means.

Through this plastic *expression* of composition, the *rhythm*, the *proportion*, and the *equilibrium* (which replaces regularity or symmetry) can be perceived clearly. The exactness with which the new plastic expresses these laws of harmony allows it to achieve the greatest possible inwardness. True, the old painting is also based on these

[i] We can also speak of the "*plastic means*" plurally, since both line and color are present in the one plastic means.

[j] Although the new plastic interiorizes rhythm and discards its most outward expression, as a repetitive process it remains *rhythm*—which manifests the absolute in the relativity of time and space, and

which makes subjectivization possible (see introduction). Nevertheless, rhythm will become even more inward as subjective vision evolves toward universal vision: this explains why the new plastic is capable of growth—a growth that it constantly demonstrates.

[k] For this reason the new plastic cannot be plastically expressed through the *symbol*.

laws, but it does not give them clear *plastic expression*. Whenever the old art stresses these laws, immediately there is a great inner intensification (as in the art of ancient India, China, Egypt, and Assyria; early Christian art, etc.).

While their composition is *in the manner of nature* (see the preceding part), composition is nevertheless strongly emphasized.

But the new art no longer realizes the laws of harmony *in the manner of nature*: they are manifested *more independently* than in nature. Finally, in the new plastic, they are manifested entirely *in the manner of art*.

In the new plastic the law of *proportion* leads the artist properly to realize the relationships of size and color on the picture plane: *purely and simply through plastic means* and not by any pictorial artifice. Rhythm becomes determinate: naturalistic rhythm is abolished.

Rhythm interiorized (through continuous abolition by oppositions of *position and size*) has nothing of the *repetition* that characterizes the particular; it is no longer a *sequence* but is *plastic unity*. Thus it renders more strongly the cosmic rhythm that flows through all things.[1]

Individuality typically manifests the law of repetition, which is nature's rhythm, as law characterized by *symmetry*. Symmetry or regularity emphasizes the *separateness* of things and therefore has no place in the plastic expression of the *universal as universal*.

Abstract-real plastic has to transform symmetry into equilibrium, which it does by continuous opposition of proportion and position; by plastically expressing *relationships* that change each opposite into the other.

––––––––

[1] The ancient Chinese conceived of rhythm as the life-fluid.

4. The Rationality of the New Plastic

Although the new plastic in painting reveals itself only through the *actual* work—needs no *explanation* in words—nevertheless much concerning the new plastic can be expressed directly in words and clarified by *reasoning*.

Although the spontaneous expression of intuition that is realized in the work of art (i.e., its spiritual content) can be interpreted only by verbal *art* (see introduction), there is also the word *without art*: reasoning, logical explanation, through which the *rationality* of an art can be shown.

This makes it possible for the contemporary artist to speak *about* his own art.

At present, the new plastic is still so new and unfamiliar that the *artist himself* is compelled to speak about it. Later, the philosopher, the scientist, the theologian, or others will *if possible* complement and perfect his words. At present this way of working is perfectly clear only to those who evolved it[m] through practice.

While it is growing and maturing the new will speak for itself, must remain *self-explanatory*—but the layman is justified in asking for an immediate explanation of the new art, and it is logical for the artist, *after creating* the new art, to try to become *conscious* of it.

For *consciousness* in art is another new contemporary characteristic: the artist is no longer a blind tool of intuition. *Natural feeling* no longer dominates the work of art, which expresses *spiritual feeling*—that is, *reason-and-feeling in one*. This spiritual feeling is inherently accessible to understand-

––––––––

[m] A *genuine critic*—simply because of his deep humanity and *pure* vision—can write about the new form of art even though unfamiliar with the method of its creation. But the *genuine* critic is rare!

ing, which explains why it is self-evident that, besides the action of emotion, the action of intellect becomes prominent in the artist.

Thus the contemporary artist has to work in a double field; or rather, the field of artistic activity, which was formerly vague and diffuse, is now becoming clearly determinate. Although the work of art grows spontaneously, as if *outside him*, the artist has to cultivate the field—before and after growth.

Having become conscious of the newly discovered laws of growth, he has no choice but to defend their lawfulness: consciousness so strengthens his intuitive feeling for these laws that he can define them with certainty.

These laws of growth are an aesthetic manifestation of truth, and it is characteristic of truth that it should prove itself also through words. *Truth reveals itself*, says Spinoza, but knowledge of truth can be speeded and strengthened through *the word*.

Truth, then, *reveals* itself—and it is the beauty of life that truth is always *unconsciously recognized* and its every manifestation is *ultimately acknowledged*—even though it may seem otherwise.

That is why the contemporary artist gives explanations *about* his work but not *of* it.

Clarification demands strenuous effort, but at the same time it furthers one's own development. Explaining means that one has reached clarity along the path of feeling and intellect by working and thinking about what has been achieved. Explaining means gaining consciousness, even through clashing thoughts—through conflict. Thus *explanation* about plastic expression indirectly makes it more profound and more precise.

The first thing to stress *about* the new plastic is its *reasonableness*. For the main question that modern man asks about anything is whether it is *rational*. He must see clearly

the rationality of the new plastic as art in general, but especially its rationality *as an art for our time*.

If we define the new plastic as *a plastically determinate aesthetic expression of the universal, or as a direct* (aesthetic) *expression of the universal through subjective transformation of the universal* (see introduction), then it satisfies the fundamental requirements of all art.

All art is *more or less* direct aesthetic expression of the universal. This *more or less* implies *degrees*, and it is precisely this difference of degree (deriving from the subjective transformation of the universal) that raises the new plastic to the purest manifestation of art.

The subjectivization of the universal is *relative*—even in art. A great *heightening* of subjectivity is taking place in man (evolution)—in other words a *growing, expanding consciousness*. Subjectivity remains subjective, but it diminishes in the measure that objectivity (the universal) grows in the individual. Subjectivity ceases to exist[n] only when the mutationlike *leap* is made from subjectivity to objectivity, from individual existence to universal existence; but before this can happen there *must be a difference in the degree of subjectivity*.

This difference of degree is the cause of the differences on artistic expression and makes the new plastic the most direct *aesthetic manifestation* of the universal possible in a period that is still subjective.

Subjectivization of the universal in art lowers the universal on the one hand, while on the

[n] Then what today we call *art* vanishes too—precisely because subjectivization ceases. Then a new sphere comes into being—a new life arises.

other it makes possible the rise of the individual toward the universal.

Subjectivization of the universal—the work of art—can express the consciousness of an age either in its relationship *to the universal*, or its relationship to *daily life*, to the *individual*. In the first case, art is *truly religious*, in the second, *profane*. A high degree of the universal in the consciousness of an age, even if it is spontaneous intuition, can elevate its art above the commonplace; but *truly religious art* already transcends it by its very nature. For the universal—although its germ is already in us—towers far above us; and just as far above us is that art which directly expresses the universal. Such an art, like religion, is united with life at the same time as it transcends (ordinary) life.

This unity and separateness are made possible through unity and separateness of individual and universal in the consciousness of the age: the equilibrated relationship of the inseparable dual-unity, the inward and outward in man (see part 2), can produce only a *pure art*, that is, *direct plastic expression of the universal*.

As long as individuality predominates in the consciousness of an age, art remains *bound to ordinary life* and remains primarily the expression of that life.

However, when the universal dominates, it will permeate life, so that art—so unreal in comparison to that life—will decay, and a new life—which realizes the universal in fact—will replace art.

The universal finds its purest, most direct plastic expression *in art* only when there is an equilibrated relationship of individual and universal in the awareness of an age. For in *plastic expression* the individual can embody the universal. In art, the universal can become visually perceptible without

being tied to the individual (to individual being).[o]

Art—although an end in itself, like religion—is the means through which we can know the universal and contemplate it in plastic form.

Since contemplation springs from the universal (within us and outside us), and completely transcends the individual (Schopenhauer's contemplation), our individual personalities have no more merit than the telescope through which distant objects are made visible.[p]

The artist, then, is only the more or less appropriate *instrument* through which the culture of a people (i.e., the degree of universality in the consciousness of the time) is expressed aesthetically. Aesthetically, because *all* people—insofar as they have matured in this respect—are part of the spirit of an age, and, in one way or another, *all* represent it. Thus, modern art, when it appears *completely in the manner of art* (see part 2), is finally nothing other than the *exact plastic expression of a more inward culture*.

In this art, manifested as *style*, there exists no particular expression of the individual: vision starts from the universal and is colored and subjectivized by culture—whether this is generally apparent or not (see part 2).[q]

For at the beginning of a new cultural era, the new consciousness is *concealed* by the diversity in awareness, by a lingering past and an unrealized future. Yet it is clearly

[o] Art can find this direct plastic expression through its *universal plastic means* (see the preceding part).

[p] This does not exclude the distinctive characteristics of each artist.

[q] Art, like every expression of genius, arises when universal consciousness abruptly bursts, as it were, into individual consciousness.

discernible; it actually manifests *itself as
living reality.*

If art is to be a *living reality* for modern
man, it has to be a pure expression of the
new consciousness of the age. Art can be-
come a living reality for him if and only if
by contemplation he can become one with
the universality it expresses;[r] but art has yet
to become one with his *whole being.*[s]

For an art to be discernible as *style,* it
has to be *one with our entire human nature,*
and therefore also with the natural in us (see
part 2). Our *entire humanity* is expressed in
life and must be reflected in art.

If the new plastic is to interpret the new
spirit, it must show itself homogeneous with
the new spirit's *every manifestation* in life.

Can these manifestations be called
abstract-real?

Can our age of material reality be
simultaneously an age of abstract reality?

If we fail to see in today's awful turmoil
a storm that will bring our outer life into
harmony with our inner life, whose *rebirth*
began quietly long ago; if we fail to perceive
concrete reality as the opposite of that which
is not concretely manifested—then ours is
not an abstract-real age. But if we can detect
the *true* life behind the tumult, if we can see

[r] In this way abstract-real painting can also be *art*
even for those in whom the modern spirit is not
yet determinate, for its spiritual content can be
unconsciously *felt.* But then the *mode* of expression
usually stands in the way of complete appreciation.

The mode of expression is too new and
unusual for a mentality not already open to the
true plastic manifestation of the universal. Thus it
is logical that this consciousness becomes accessible
through reasoning.

[s] For only the universal within him can unite with
the universal outside him.

the consciously abstract spirit at work behind
all concrete phenomena, then our age is
indeed abstract-real. Modern life is no longer
natural but abstract-real. It manifests this
fact.

All modern life bears the stamp of
abstract-real life: its whole outward manifes-
tation *plastically expresses* the abstract spirit.

Although the man of truly modern
culture lives within concrete reality, *his mind
transforms this reality into abstractions, and
he extends his real life into the abstract—so
that he once again realizes this abstraction.*

The artist also does this, and thus he
creates *abstract-real* art.

Despite all external opposition, the true
life of modern man *shows* the deeper thought
that is the sign of culture. It *shows* the more
determinate awareness of our time, *shows*
that the universal can be seen and known
with greater clarity.

In all fields, life grows increasingly
abstract while remaining real. More and
more the *machine* displaces natural power. In
fashion we see a characteristic tensing of
form and intensification of color, which
signifies the departure from the natural.

In *modern dancing* (steps, boston, tango,
etc.), the same tensing is seen: the curved
line of the old dances (waltz, etc.) has
yielded to the straight line, and each move-
ment is immediately neutralized by a
countermovement—which signifies the search
for equilibrium. Our *social life* shows this
too: autocracy, imperialism with its (natural)
rule of the strongest, are about to fall—
where not already fallen—and yield to the
(spiritual) power of law.

Likewise, the new spirit comes strongly
to the fore in *logic, just as in science and
religion.* The imparting of veiled wisdom has
long yielded to the wisdom of pure reason,
and knowledge shows increasing exactness.
The old religion with its mysteries and

dogmas is increasingly thrust aside[t] by a clear relationship to the universal. This is made possible through purer knowlege of the universal—insofar as it can be known.[u]

We thus see an identical conception manifested in all of life's expressions—a conception formulated in *logical thought.*

Long before the new was manifested determinately in life and in art, the logic of philosophy had clearly stated an ancient truth: *being is manifested or known only by its opposite.*

This implies that *the visible, the natural concrete, is not known through visible nature, but through its opposite. For modern consciousness, this means that visible reality can be expressed only by abstract-real plastic.*

It does not seem very *modern* to illuminate the rationality of a new truth by citing an ancient one, but it only seems so, for new truth is nothing other than a new *manifestation* of universal truth, which is immutable (see part 2).

This truth, *true* throughout the ages, was already diversely formulated in ancient times. One of these formulations perfectly defines *the true meaning of art: opposites are best known through their opposites. We all know that nothing in the world can be conceived in or by itself; but that everything is judged by comparison with its opposite* (Philo of Alexandria; Bolland, *Pure Reason*).[6]

Only in our time—with its maturing and growing equilibrium between the inward and the outward, the spiritual and the natural— has the artist come to recognize consciously this ancient truth already reemphasized by logical thought (Hegel).[v] The artist came to this awareness *through the way of art, an outward way.*

Art—as one of the manifestations of truth—has always expressed the truth of oppositions; but only today has art realized this truth in its *creation.* The division between old and new painting becomes apparent as soon as we see that naturalistic painting manifested *this truth in a veiled and disequilibrated way,* whereas the new plastic *expresses it determinately and in equilibrium.*

Painting has always *transformed* the visible (from which it starts) into a beauty that moves man—by bringing to plastic expression within the naturalistic *the opposite of the visible.*[w] But not all painting has

[t] For another, a less abstract consciousness, the forms of religious expression nevertheless remained, and still remain, necessary, just as naturalistic painting remains necessary. It is therefore logical that religious forms and naturalistic painting continue to exist so long as the new consciousness has not yet become general.

[u] In *On the Spiritual in Art* Kandinsky points out that theosophy (*in its true meaning* and not as it commonly appears) is another expression of the same spiritual movement we now see in painting.

[v] Although logical thought generally illuminated this truth in modern times, this was not what prompted the modern artist to express the *reciprocal and opposite action of inward and outward* in the plastic of equivalence. Explanation does not perfect the expression of art, which must perfect itself. The artist *worked* unconsciously: by constantly manifesting the basic truth of opposites, his expression grew more and more exact. The consciousness gained through the process of working produced a more conscious plastic expression.

[w] In every age the artist perceived what is always *one and the same* in and through all things: *a single beauty* arouses his emotion, although his perception of it changes. This unchanging and *unique beauty is the opposite of what characterizes things as things*: it is the *universal* manifesting itself through them. Consciously or unconsciously, the artist endeavors to express plastically this opposite of what he perceives visually—that is why the work of art is so distinctly *other* than nature.

Not only in the new plastic does the work of art differ from nature: Impressionism, Expressionism, Divisionism, Pointillism, Cubism, and Futurism, as well as ancient art, all are other than

shown this opposite in *equilibrated relationship with the natural.*[x]

Clearly, the *plastic* opposite of the *natural concrete* cannot be the most *extreme thought-abstraction* (see part 3): the *plastic* opposite of the *most outward* cannot be the *most inward.* It appears in nature through the means of nature (the most outward) *as relationships of position, size, and value* (see introduction)—*as a plastic expression of relationship,* which is nothing in itself but manifests the *plastic core* of all things.

Relationship, which in nature is indeterminate, is, however, inherently *exact, abstract,* and consistent with this it can be purely expressed only by an *exact, abstract plastic means.* Only then can the mutual interaction of the opposites, inward and outward, attain equilibrated expression.

The *most* external manifestation of things, the natural, veils the pure and direct exteriorization of the inward (the universal), and so veils exact relationship.[y] The latter can find clear plastic expression only in an outwardness that—although not the extreme opposite of the natural—is free enough of (individual) limitation to express purely plastically both the *direct exteriorization of the most inward and the essence of the most outward.*

Exact relationship can find plastic expression only through the abstraction of natural form and color—*color brought to determination* (see parts 3 and 4). This universal plastic means destroys the naturalism of the plastic: *the natural is crystallized into exact relationship, which conversely can be seen as crystallized inwardness. Thus both the most outward and the most inward are abolished through the exact plastic of relationship, and these opposites are plastically expressed as unity in a single outwardness.*

If we see this unity, then we clearly see the unity of abstract-real plastic with visible reality: then we see this plastic, not as an aimless array of color planes and lines, but as an equilibrated expression of man and nature, of inward and outward, in their deepest, their most beautiful and *eternal* significance. Ancient wisdom represented the fundamental inward-outward relationship by

ordinary perception. The artist's inner vision is *other* than visual: this other perception is an inner transformation that one cannot explain by physical abnormality, as some doctors would do. (Some psychiatrists therefore blame it on mental aberration!) This is like the oculist who explained the uniqueness of Rembrandt's art by his nearsightedness because it resembles in some ways photographs taken through a lens of similar characteristics.

[x] In naturalistic painting the expression of the opposite of the natural (relationships) is not equivalent with the *plastic means:* the natural appearance of things is too capricious and attracts too much attention for relationship to be expressed *determinately.* In the new plastic, both relationship and plastic means are in equilibrium: relationship is expressed *exactly,* for the expressive means is *exact.*

[y] The inward that is expressed through *exactly equilibrated relationship* is the *purely universal,* the *immutable*—in contrast to the individual inward-

ness in man. Individual inwardness obscures the purely universal. Although all art stems from the universal deep in man, it is still colored by his individuality. Romanticism, so-called Christian art, etc., color the universal one-sidedly. *Pure realistic art was able to be the most objective and universal: through it resulted the pure expression of pure relationship.*

All subjectivizing veils the pure expression of the *universal-as-the-true.* Art, however, shows us the *universal-as-beauty,* and beauty implies subjectivization of the universal. The *least possible* subjectivization of the universal will most purely approach the true in the beautiful.

The most outward, which always remains the same (nature), finally brings the artist through many subjectivizations to a *unique universal outwardness, which is one with the pure manifestation of (universal) inwardness.*

the cross. Neither this *symbol*, however, nor any other symbol, can be the plastic means for abstract-real painting: the symbol constitutes a new limitation, on the one hand, and it is *too* absolute, on the other.

In moving from naturalistic painting to abstract-real painting, art has realized the law of opposites. All naturalistic painting served this evolution from an expression of the natural to an expression of the abstract and thus to an *equilibrated plastic of extreme opposites* (see introduction).[z]

Seen in its evolution in time, the plastic means of painting were at first *out of harmony with the law of opposites*, for the (most) outward was expressed through the (most) outward; then the naturalism of expression was gradually destroyed; and finally we see the (universal) *plastic means in complete harmony with the law.*

The truth contained in the law of opposites manifests itself in space and time: in time the inward (in man) grows through the outward in and beyond man (in space); in time, the more outward conception of space grows into a more inward one; *in time, opposite becomes known by opposite.*[a]

If we see the necessity of naturalistic painting (as preparation for abstract-real painting), we will not regard it as an error—

no art, no true artist has ever erred: the universal (the source of all art) does not err. The universal is independent of time: seen objectively, it *manifests* itself according to the law of opposites.

And now painting attains what was always its essence but had never before found clear outward expression: *plastic realization of the unity of the mutual interaction of opposites.* Just as the plastic of abstract-real painting is not *abstract* in the ordinary (scientific, intellectual?) meaning of the word, so *its expression of relationship* is not the opposite of naturalistic plastic. For the *exact plastic expression of relationship* is also an *outwardness* and as such still *part of the outward.* But as the *least outward*, it is the *opposite or antithesis of the most outward* (natural appearance).

If, however, we see the exact plastic of relationships as a *direct representation of inwardness* (the universal), then it is an (externalized) *part of inwardness,* and as such a *plastic opposite* of the natural.

In order to understand the new plastic, it is necessary to see the exact plastic of relationship as the (externalized) opposite of naturalistic plastic. This is possible because *the inward, which is not visible in the plastic, nevertheless takes form within it.* (So for example, the ray, which is inward and not actually visible, is a vertical line in the plastic.)[7]

Starting from the visible: *space* is expressed in the new plastic not by naturalistic plastic but by the (abstract) plastic of the plane; *movement* is expressed by movement and countermovement in one[b]; *naturalistic color* is expressed by plane, determinate color; and the *capriciously curved* line by the

[z] In the same way, abstract-real painting in turn serves an evolution toward *nonart*—the end of art as we now know it today—as something that *expresses life* but that is not yet *life itself.* Only when art is transformed into real life will our art come to an end. However, it will take a long time for man to develop fully the new plastic itself. The new plastic, although it involves the end of art, is only *a beginning.*

[a] Only when the outward is known can the inward be known. Although we are still far from knowing inwardness, the consciousness of our time is mature enough to perceive the *inward more purely.* Therefore, it is already possible today for the universal to be given clear plastic expression.

[b] *Rest*, the opposite of movement, is perfectly equilibrated movement and is therefore expressed by equilibrated movement: *unity of movement and*

straight line. Thus the relative finds plastic expression through the *determinate* (a direct exteriorizing of the absolute). Starting from the nonvisible, from the inward: *expansion* is expressed by a (new) spatial expression; *rest*, by equilibrated movement; *light*, by pure planar color. Thus in the new plastic, the *absolute* is manifested through the *relative* (in the composition and the universal plastic means).

Although every age has expressed the law of opposites, the cultivated man of our time, the truly modern man (see introduction) is distinguished by his *consciousness* of *the truth* of this law: *by endeavoring to realize it in himself.* By *pure vision* of the outward, the contemporary artist learns to *express the inward purely.* Thus, by seeing the universal in the outward, he learns to express it plastically, obscuring it as little as possible by the (individual) self.

Thus he learns to perceive that the apparently unbeautiful can be beautiful—that outward beauty is not the highest beauty.[c] *He learns to see this* after having cultivated the natural. It is a mark of the uncultivated man, of the man attached to individuality, to seek the highest beauty and good[d] in what

appears as beautiful and good *to him*. This is due to disequilibrium between the inward and outward, between spirit and nature. And this disequilibrium forms an obstacle to a true understanding of the new plastic. In an age that does not know equilibrium between inward and outward, an *equilibrated plastic of relationship* cannot exist as *style*.

To appreciate the new plastic *completely*, one must know something of the nature and interaction of inward and outward (within us and outside us);[e] for only then can we perceive how inward and outward can be plastically manifested as *a unity of equivalent duality*.

5. From the Natural to the Abstract: From the Indeterminate to the Determinate

The reciprocal action of the opposites, inward and outward (spirit and nature), can lead us to see life—and therefore art—as a constant recurrence (in different ways) of the same thing, as continual *repetition*.

Such a vision of life and art impedes development, for it excludes every idea of growth as *evolution*, as *ascending development*. While not denying *change*[f] in life and in art, this vision denies their *continuous*

countermovement. This unity of movement interiorizes the plastic expression of art. It attains exact expression in abstract-real painting through the unchangeable duality of rectangular opposition and a more inward rhythm (see part 4). Movement and countermovement in music are formed by melody and rhythmic division (tempo) and in modern dance by the music's rhythm and the dance rhythm (steps).

[c] The *straight* and the *plane* are seemingly unbeautiful, while the curved and corporeal are (outwardly) beautiful. (The *S* shape is called the "line of beauty.") *Pure relationship* is also (seemingly) unbeautiful, if one looks for beauty in the *means* through which relationship is expressed.

[d] The beautiful and the good—because aesthetic truths—are expressed consistently with ethical

truths: they are both different expressions of a single truth.

[e] Plastically, the outward is all externality—from the most outward (natural appearance) to the profoundest abstraction of form and color. The *inward* can be plastically expressed directly only as outwardness that is based upon the primary inwardness. Any other inwardness cannot be directly manifested.

[f] Change is also accepted in art: we speak of *trends* and *turning points* in art, but its evolution is emphatically denied.

tendency to depart from the natural: their growth toward the abstract. Precisely the firm belief (based on observation) *in the spirit's rising development through the maturing of the natural in man* is necessary in order to see life and art purely.[g]

However, a true conception of the *meaning* of inward and outward, of spirit and nature, shows this *perpetual return* as the recurrence of *one and the same thing*: the *universal inward* which, although perfect, matures in man precisely through the reciprocal action of nature and spirit. It permits us not to despair of the *evolution of the human spirit* even if each stage of its development founders on materialism. Conversely, it tells us not to despair of the preservation of the outward (the physical, the natural) in man— for it is precisely the human spirit that keeps it intact. While becoming less primitive, the outward remains strong enough to become equilibrated with man's spiritual life.

A true conception of the *essential meaning* of spirit and nature in man shows life and art as a perpetual sacrifice of inward to outward and outward to inward,[h] a conception that enables us to recognize this process as exclusively in favor of the inward and *serving to broaden man's individual inwardness (spirit) toward universal inwardness.*[i]

Thus understood, the opposition of spirit and nature in man is seen as constantly forming a *new unity*—which *constantly reflects more purely* the original unity[j] out of which the opposites, spirit and nature, manifest themselves—in time—as a duality.

Pure vision shows us this original unity as the *enduring force*[k] in all things, as the *universally shared force common to all things*. This *deepest universal element* was termed by Aristotle *substance—that which is*, the *thing-in-itself*, existing of itself, independent of those accidents of size, form, or qualities which constitute only the *outwardness* by which substance is manifested. It is only substance that makes externality into what it is for us.

If substance is the enduring force, then a *direct representation of the universal* (or direct plastic expression of substance) is not merely justified but *required*. For the *constant* force is the valuable one.

In nature the accidents of substance— those of size, of form, of qualities—are indispensable, because substance is not

[g] We see the natural *outside* of man *repeating* itself, for (in this world) nature is bound to the law of repetition (see part 4); but man's spirit is (relatively) free and—in evolving—abolishes this repetition.

[h] The artist's life is also a continual sacrifice of the material to the spiritual and the spiritual to the material.

[i] The universal inwardness in man moves him continually toward a new, deeper individual inwardness—born precisely of the same reciprocal interaction between spirit and nature in which each destroys the other. *Opposites in general, in their deepest sense, have no stability either in themselves or in their opposites.* On the contrary, they *are*

destroyed by their mutual opposition (Hegel; Bolland, *Pure Reason*).

In the artist, universal inwardness is manifested as plastic power; it perishes in form, just as each stage of man's consciousness expires in form, only to rise again and create a *new* form.

[j] Unity, in its most profound essence, *radiates*: it *is*. The radiation of unity's *being* wrecks itself upon the physical—and thus gives rise to life and art. Life and art must therefore be *radiation*. The *ray* is the symbol of radiation (the inward). Although we cannot see the inner radiation, or the *ray*, it is imaged in pure abstract thought. It is represented visually as the vertical in opposition to the horizontal. Since ancient times radiation has been outwardly symbolized in this way. The new plastic expresses inward-outward unity by the perpendicular relationship of position.

[k] Because we perceive the influence of the inward upon the outward (and not the converse), *observation* allows us to call inwardness the actual power.

directly perceptible to the senses. In nature, form (corporeality) is necessary: in nature everything exists for us through form, which is made visible through (natural) color. *Thus nature misleads us into thinking that form is necessary in art too. Nature makes us forget that substance is actually expressed by means of the universal manifested through form and through color.*

In art we have *direct plastic expression of the universal* (the equilibrated plastic of relationships), noncorporeal in its manifestation and therefore free of the temporal that obscures the eternal. Although this manifestation is not *form*, it can nevertheless be plastically expressed. In art the accidentals of substance can be dispensed with: they *must* remain ouside of plastic expression if we are to achieve pure expression of the universal, that is, of substance.[l]

Properly understood, the reciprocal action of the opposites, inwardness and outwardness, shows life and art as *recurring stages of growth on the one hand, and of decline on the other.*

To discern this general truth, we must extend our observation over long periods, go far back into the past and look far into the future; in fact, we must see life as not beginning or ending with this universe.[m]

However, since in this physical world the physical does not change significantly once it has matured, and since spirit develops only in man, we can limit ourselves to tracing the evolution of spirit (i.e., *of consciousness*) in man.

The evolution of consciousness creates form after form—in life as in art.[n] In its evolution of form, art can precede life, in so far as its *form becomes manifestation*—the *natural* becomes *abstract*. If the natural in our consciousness is ripening, if man's individual inwardness is becoming mature and his inner universality is becoming more determinately conscious—then consciousness is growing from the natural to the abstract, and the expression of art will necessarily be abstract![o] When the individual's consciousness expands toward the universal, then the

[l] The universal is limited within existing reality. Nevertheless, it can transcend this limit through *determinate plastic expression* (the new plastic): thus art can be *more than reality.*

[m] The remote past shows that transcendence of the natural is a general evolutionary process. In the Lemurian and Atlantan periods, man was still so dependent upon the environment that the physical possibility of sleep, for instance, depended on the rising and setting of the sun. Man lived in harmony with nature's rhythm. When, however, individual consciousness began to develop in man, there automatically ensued a disharmony between man and nature. As this disharmony increased,

nature drew further and further outside of man (Dr. Rudolf Steiner).[8]

If today man's individual consciousness is maturing, then the lost harmony can be rediscovered, for no longer obstructed by individuality, the *universal (in nature)* can exist *universally—independently, and perceptible* to man.

Abstract-real painting gives an image of this regained harmony.

[n] Evolution involves destruction of preceding form. It *builds* upon previous form, but no sooner is growth complete than a new form already arises. Every new art expression is thus *built upon* a previous one but differs from it in form. Its appearance changes our vision of the earlier art in the sense that it can no longer remain *really vital* for us. In this sense each new expression of art destroys the preceding one.

[o] The new plastic is hostile to natural man, because (apparently) it rejects the naturalistic and does not plastically express *natural appearance*. Because it *destroys* naturalistic form and color, it seems criminal to anyone for whom reality stands or falls with the preservation of natural *appearance*.

The *man of feeling* who lives so close to nature is also temperamentally predisposed against the new plastic. This fact is as natural as he is.

natural—although it remains unchangeable in nature—will *change* for man.p The artist is no longer content with most outward means of expression: he needs a *universal means*. He achieves it by intensifying form and color—in accord with the intensification of consciousness. Thus he reduces the natural to the abstract; thus, he *consciously* expresses the opposite of the natural, so far as it can be plastically expressed. *In abstract-real plastic man has an opposition to the natural through which he can know nature and thus gains knowledge of the spirit.*q *In this way art becomes truly religious.*

If we see that the trend to abstract

———

The new plastic is for the *modern man*, who is an equilibrated unity of nature and spirit (see the introduction). He sees the departure from naturalism in painting not as an attack on, or dissolution (in the sense of loss) of nature, but as its crystallization (see part 4).

p In this sense, the *life of modern cultured man is gradually turning away from the natural and becoming more and more abstract* (see the introduction). Life is becoming *abstract—determinate* and not *vague*—because for contemporary man only abstraction can make the equilibrium between nature and spirit complete. If *life* is moving away from the natural, it is *not* because *modern man* rejects nature. On the contrary, he tries to penetrate nature, for the natural is maturing in him. We see this in science, religion, society.

q As long as the artist (as the interpreter of humanity) has not grown to his full inwardness, and as long as he is an *artist* rather than a (true) *spiritual* person, he must *create an image of the inward in order to establish an opposition to himself. Only from the pure relationship between (plastically expressed) inwardness and the (most) outward (nature), can he consciously grasp the true meaning of inward and outward.* Not until he (and all humanity with him) has *matured* to inwardness (or spirit) will this inward element in him become *absolute*; and only then will *absolute outwardness* also be necessary to form a unity. A renewed and quite other outwardness will then be realized: then the *equilibrated plastic* of outward and inward will have become unnecessary.

plastic expression in modern painting results from *the evolution of the consciousness of our time toward the abstract*, then the striving of modern art in general and of abstract-real painting in particular will no longer be seen as a *decay* of painting, but we will then have to recognize that from this striving a new style *must* arise.

If modern painting is generally permeated by an intensifying and accelerating quest for *freedom from individuality*—and (in the new plastic) *is becoming a clear expression of the universal*—then the new plastic is the *plastic expression of the contemporary age*, although it is in advance of its time.

Our age has reached the climax of individualism: the mature individual can now increasingly find equilibrium with the universal. When our mentality actually *attains* this equilibrium, it will also be clearly expressed in every aspect of outward life, just as it is expressed *abstractly* in the new plastic.

Evolution from the naturalistic to the abstract causes man to see nature differently. He may unconsciously reject the *individual in nature*, but this does not cause him to reject *the natural*. Although he may destroy nature's most outward appearance in his plastic expression, it is still *through nature that the universal becomes living in man.*r

By reducing the natural to the abstract in the plastic, modern man expresses the natural in all its fullness: *for thus both inward and outward find plastic expression.* Thus he displays the characteristics of the truly modern man, *who sees the outward as inward and penetrates the inward through the outward.*

Formerly one only perceived either the

———

r The new plastic seeks to present the visible, or rather the aesthetic emotion arising from the visible, in all its depth. This is why it requires a means in which the *absolute* can be *determinately* expressed and unified with the natural.

outward or the inward: thus one divided the world into the profane and the (so-called) faithful. Modern man, however, is capable of seeing the inward in equilibrium with the outward, and conversely; through relationship he knows both opposites. Precisely in this way, truly modern man sees things *as a whole* and accepts life *in its wholeness*: nature and spirit, world and faith, art and religion—man and God, as *unity*.

The evolution of consciousness causes *beauty to evolve into truth.* We can say that beauty is truth *aesthetically subjectively* perceived.[s] If beauty is subjectivized truth, then art would be destroyed if its subjectivity were completely destroyed. Likewise, the idea of plastic expression would be destroyed, for plastic expression implicitly assumes *subjectivization* (and therefore beauty).

Plastic expression of the purely objective (of truth) is an *other* beauty: a beauty that transcends art.[t] The truth that is manifested subjectively in art is *universal*. It is therefore true *for everyone* in opposition to that truth which, in every pure search, forms the true way for each *individual*. The new plastic can exist as *style*, as *universality*, since it clearly expresses *universal* truth. Art must stress this universal truth if it is plastically to express beauty-as-truth.

"The beautiful is the true in the perceptual mode. And truth is a multiple unity of opposites; if we can find the beautiful in the true, then it must be found as a unity-in-diversity of opposites. We find the beautiful inherent in the multiple unity of what is linguistically and mathematically expressible through proportional relationships"* (Bolland, *Pure Reason* [3d ed.(Leiden, 1912), p. 554, sec. 17]). In the new plastic it is precisely the proportional relationships (of line and color) that are manifested purely. In the new plastic, beauty consists of the equilibrated, equivalent expression of the opposites, inwardness and outwardness.

"The concept of beauty is a relational one—that is, of aesthetic relations, of perceptually agreeable and thus sensibly satisfying relationships, and consequently not a mere linguistic or mathematical concept, but something more, commensurability in a variety of relationships or ratios, etc." (Bolland, *Pure Reason* [p. 554, sec. 16]).

Thus we see that rational thought is in accord with the actual goal of the new painting—whether rational thought recognizes it or not. Both seek beauty not for the beautiful feelings it may arouse, but for beauty *as truth*, that is, as plastic manifestation of pure aesthetic relationships (see the introduction).

While strongly emphasizing truth, the new plastic nevertheless continues to express *beauty*. Therefore, like all art, it remains relative and to some degree still *arbitrary*: if it were to become as absolute as the universal plastic means allow, it would overstep the limits of art; it would pass from the sphere of art into that of truth.[u]

The new plastic expresses beauty *as truth*[v] through the absoluteness of its plastic means: it expresses truth *as beauty* (that is,

[s] Does beauty stand in the way of truth? It does so *in time,* just as in time the outward opposes the inward, the natural opposes the spiritual, the female opposes the male. It is precisely through beauty that truth's aesthetic manifestation—in time—is possible.

[t] At least, it is a beauty transcending what today we call *art.* However, a higher human evolution will find a new sphere of expression in the plastic expression of truth as *truth,* where truth and beauty will be expressed in complete equivalence.

[u] The sphere of truth is *pure* abstraction. That is why the new plastic is *abstract-real.*

[v] In our period of *growth toward* truth, we must keep our eyes open to the danger—in art—of trying to represent truth. The true *artist* will

relativized by beauty), through the rhythm of its composition and the relativity in which its plastic means are manifested (see above, part 3, page 39).

Art *remains* relative, even though the consciousness of our time is rising toward the universal from which intuition—the source of all art—derives; the *artist*, because he unites inward and outward, always remains *human* and cannot completely transcend the subjective.[w]

The adult no longer possesses the objective vision of the child. Children and primitive peoples[x] can still purely objectify their inwardness (their unconsciousness), but they lack the consciousness of the adult, for they lack culture.

Through their unconsciousness they intuitively express the *general*, but not the abstract—or what is here called the *universal*, that is, the most profound manifestation of *all* things.[y]

Beauty *as truth*, then, cannot be expressed *determinately* by naturalistic means: form and natural color limit expression to the individual and veil the truth to such an extent that it can only be expressed vaguely.

From the plastic point of view, form and natural color *bind* expression to the individual and shackle the pure vision of the universal. Moreover, our particular sensations and thoughts (in turn based on particular experiences) become associated with what we see.

Although the observer partially determines the impression of what he sees, what is seen also says something specific because of the form of its appearance. Even the most perfect, most general geometrical forms express something specific.[z] To destroy this limitation (or individuality) of expression as far as possible is the task of art and constitutes the essential of all style (see part 2).

Art, then, is a field of combat against the individual. In life, as in visible nature, there is struggle between universal and individual; but—in time—the universal remains more closely bound to the individual in outward life than it does in abstract life, of which art is the plastic expression.

The union of the universal (as far as it has developed in man) with the individual (as far as it has matured in man) gives rise to the tragic; the struggle of one against the other forms the tragedy of life. Tragedy arises from *inequality in the appearance of the duality by which unity manifests itself— within space and time.* The tragic exists both in inward and in outward life.

Although the greatest tragedy is due to the inherently unequal dualism of spirit and nature, there is also tragedy in outward life. Due to disequilibrated mutual relationships, the tragic exists between male and female and between society and the individual.[a]

always continue to subjectivize, while the nonartist may be ahead of his time in his desire for objectivity. [On his tearsheet, Mondrian substituted "objectivity" for "subjectivity," to correct an apparent error in *De Stijl*—editors] This could lead to an attitude toward art—inconsistent with *our* time—that might obscure the plastic expression of the slow but sure evolution of beauty-as-truth.

[w] This he can do only by becoming a truly spiritual man; but then he would cease to be an artist.

[x] There is even a great difference between the art of children and of primitives: *experience* gives the art of adults a sureness and deliberation (discernible mainly in the technique) that are lacking in children's art (consider African sculpture).

[y] They express the broad contours of things, but not pure (exact) relationships.

[z] Geometric figures, furthermore, are often seen in the light of traditional symbolism, which obstructs pure vision.

[a] The desire for freedom and equilibrium (harmony) is inherent in man (due to the universal in him). Man has an inherent urge to regain the original unity of his duality, and to realize unity in life and in art. He learned to seek unity *within himself,*

The premature union of opposites causes the tragic. Yet only the continual and repeated union of the opposites can bring about the new—progress; which is possible because new form arises through the merging of opposites into each other (see above, p. 49, n. n).

Thus plastic expression of pure (exact) relationship is possible only when the natural in man and the spiritual within him dissolve into each other: thereby his vision of the natural is transformed, that is, it becomes *abstract*.

If the tragic can be destroyed only through (final) unification, this is far less possible in outward than in abstract life. Art can realize the union of opposites abstractly; which is why art precedes real life.

Unity in real life must await the equivalence of opposites. By equivalence is meant the equivalence of (relatively) *pure* opposites. Only after this equivalence develops are the opposites resolved *into* one another and true *unity* really attained.

In advance of its time, the new plastic plastically manifests the turning point of human development—the era of equivalence of opposites. When this time actually comes, art will merge into real life.

Until then, even in art, universality will continue to be dominated by the individual (the subjective)—even though art (through intuition) already expresses equivalence.

If beauty is truth (the universal) subjectively apprehended, then beauty must always express the tragic. And if truth (as universal) is objective—then truth must be free of the tragic. *Although in the new plastic subjective*

vision is reduced to a minimum, it nevertheless remains subjective and still must express *something* of the tragic. It does this through the rhythm of the composition, etc. (see part 3).

We experience beauty and therefore the tragic through emotion, but actually it is also manifested plastically. *Because it manifests itself plastically, the human spirit, which is expressed by aesthetic-plastic, seeks a visual manifestation that is free of the tragic.*[b]

The human spirit, then, seeks *truth* (which is free of the tragic), but in beauty it always finds truth relativized, and therefore more or less tragic. Art nevertheless *leads us* along the path of beauty towards truth, and thus to a manifestation free of the tragic.

Art has the *intention* of plastically establishing complete freedom from the tragic, but its *expression*, the *plastic* created by and for man, lags behind art's intention. How far behind depends on the culture, that is, on the stage of development that the universal has reached in the masses. Culture, then, determines how far individuality is actually transcended in expression.

So long as art continues to use natural appearance as its plastic means, *its expression will emphasize the tragic*. Whereas the result of *style in the manner of art* (see part 2) is the least tragic, *style in the manner of nature* expresses the most tragic. As much as naturalistic painting may try to neutralize the

that is, in inward, abstract life, because the equivalent factors that unity requires are rarely present in outward life. Unity in society (the mass of individuals) will therefore not be realized for some time because of differences among individuals.

[b] The sensitivity of artistic temperament is necessary in order to perceive the plastic expression of the tragic; one must be an artist to express it.

The artist sees the tragic to such a degree that he is compelled to express the nontragic. In this way he finally found a resolution in the plastic expression of pure relationships. He excludes expression of form, not holding (as laymen do) that expression through form can be nontragic if the human spirit is strong enough to annihilate the inherently tragic.

individual in it by establishing equilibrated relationships, natural appearance through form will always plastically express a *limitation* and thereby the *struggle of inwardness for freedom*—the struggle of *expansion and limitation.*

The *tragic adheres to all form and natural color, for the impulse toward freedom is expressed by the tension of line and the intensification of color as a struggle against a stronger counterstruggle. Only when line is tensed to straightness and naturalistic color is intensified to pure plane color—only then is it possible to reduce tragic expression to a minimum.*

Culture, then, more or less *opposes* the natural, just as the universal opposes the individual.

The natural—in time—stands *opposed* to the spiritual; from the plastic viewpoint, natural appearance stands *opposed* to man's spirit. *The former acts on the latter through emotion.* Emotion will therefore remain subjugated by the natural until man's spirit becomes more conscious. Only then will it become spiritual emotion (see part 4) and be able to render outwardness purely. Then the outward is in equilibrium with the inward in consciousness, and conversely; the tragic can be transcended.

Where natural emotion dominates plastic expression, a work of art always emphatically expresses the tragic. It expresses the tragic whenever it stresses sorrow or joy, as in the art of Van Gogh.

Culture transforms emotion and therefore nature: *it brings unity between spirit and nature.*

The natural, the visible in general, expresses the tragic to the extent that it has not been transformed (to universality) by the human spirit. The tragic *in nature is manifested as corporeality*—and this is expressed plastically as form and natural color, as roundness, naturalistic plastic, the curvilinear,

and capriciousness and irregularity of surface (see part 3).

The *atmosphere* in which corporeal objects are seen veils their planar character and heightens their tragic expression. But even when the corporeal is clearly expressed in art, when it is made more inward by an exaggerated tension of natural line, and somewhat neutralized by flatness of color, etc.—even then the visible expresses the tragic through form, position, and size.[c]

The plastic expression of natural appearance—like visible nature itself—is therefore always tragic.[d]

As long as the duality of inward and outward is manifested—whether as nature and spirit, man against man, male and female, or in art as the plastic against the representational content—as long as this duality has not achieved complete equilibrium and recovered its unity, it remains *tragic.* If this duality in art requires *equivalent plastic expression* (see part 4), then the artist must be able to abolish tragic expression (as far as this is possible).

Only unity in the expression of content and appearance (see part 4) can abolish the tragic in the work of art. And this unity is

[c] *Opposition* can partially neutralize the tragic of size and position; but the tragic of form can be abolished only by abolishing form.

Position and dimension *plastically expressed in multiple relationships* of straight lines and rectangular color planes can still have tragic expression through the rhythm thus created; but neutralizing opposition can make the rhythm more inward and to some extent destroy this tragic (see part 3).

[d] Natural appearance (objectively seen) is not always equally tragic. It is less tragic to the extent that it shows greater coherence and clarity; it is more tragic when it expresses fragmentation or disequilibrium. Nor do form and color always express the tragic to the same degree: tragic expression varies accordingly as form (line) is tense or capricious, or as color is pure or mixed.

approached through the *exact, equilibrated* plastic of relationship. *Exact* plastic expression of relationship (through universal plastic means) is necessary, since plastic expression of relationships through form and natural color still have tragic expression; *equilibrated* expression of relationship is required, because only the equilibrium of position and size (through universal plastic means) can diminish the tragic.[e]

All painting has endeavored plastically to express the universal but has not always achieved it to the same degree.

All painting has sought to abolish the individual in expression but has not succeeded to the same degree.

Disequilibrated expression of the universal and individual engendered tragic plastic in all painting. Whereas naturalistic painting has the strongest tragic expression, the new plastic is already almost free of it.

If abolition of the tragic is the goal of life, it is illogical to reject the new plastic.

Then it is illogical always to demand the expression of *form* in painting—*naturalistic* form at that—on the commonly alleged

[e] Only the perpendicular position does not express the tragic. Any other position does, as we see in the figures of Humbert de Superville (the *V* form expresses elation, the *A* form its opposite).

In order for the perpendicular position to be plastically expressed in accord with its inherent character—that is, in equilibrium—the proportions of the lines or planes that express it must also be equilibrated. The multiple relationships of rectangular position must also be equilibrated in order to destroy the tragic as much as possible.

[The Dutch neoclassic painter-theorist D. P. G. Humbert de Superville (1770–1849) associated the lines of the human face—horizontal, or sloping upward or downward—with corresponding emotions of calmness, joy, or sadness (*Essai sur les signes inconditionnels dans l'art* [Leiden, 1827–32])—editors.]

ground that only form can express the spiritual.

On the contrary, when one observes the continuous development of the expression of relationships in art, it is hard to imagine how the evolving element in painting could ever revert to the plastic of form, which obscures relationships.

Abstract plastic, as manifested in Abstract-Real painting (as the expression of *abstract-real life*), is on the one hand only a different vision of the natural, and on the other a determinate plastic expression of the universal. Similarly, *abstract-real life* itself is only another stage of natural life on one hand, while on the other it is *conscious spiritual life.*

Abstract-real life, which vitalizes the wholeness and fullness of life—*actually*, that is, *abstractly*—and in turn realizes this life (see part 4), goes almost unnoticed today amid intellectual-abstract and outward life. Life today generally centers around outwardness and merely skims *the surface of life*; whereas abstract-real life experiences the outward (the individual) *universally* (abstractly)—that is, *in its most essential nature.* Abstract-real life, then, by its very nature realizes its vitality as *the plastic expression of the universal*—whatever form it may take. It has manifested itself as such in Abstract-Real painting; and by Abstract-Real painting the characteristics of abstract-real life are made *perceptible.*[f]

[f] At present, only abstract-real life purely expresses the new consciousness of the age. In intellectual—abstract—life as in outward life, both the natural and the spiritual are confused, because the natural is dominant. Painting learned this through Abstract-Real painting, which recognized that the naturalistic form and color of things veils their essence. It learned that the individual dominates so long as

Abstract-Real painting reveals the *abstract vitality of full and complete life, by deepening the naturalism of its plastic to the really abstract, that is, by making it determinate and by establishing equilibrated composition (or proportion); it realizes this vitality through the rhythm of the composition and through the relativity in which the abstract appears* (see previous parts).

It plastically expresses the interiorization of nature through the duality that forms the essence of the natural matter and spirit. It plastically expresses the unity of the duality through the equilibrated composition of this duality. Thus it expresses man's natural individuality in equilibrium with his spirituality, his universality.

Abstract-Real painting therefore expresses *purified nature and purified spirit in one.* In Abstract-Real painting we see the transition from the naturalistic to the abstract as a transition *from (outward) impure nature to pure inward nature, and from impure spirit to pure spirit (the universal).* Furthermore, Abstract-Real painting shows that although this duality contains unity, it remains relative—in time—and is a *very distinct duality.* For in the duality of position of the right angle we see *exact opposition;* in the duality of perpendicular opposition, we see the most extreme opposites: the natural (female) element and the spiritual (male) element.[g]

Thus we see that because the duality contains *two distinct elements,* their unity can come into being through their equal manifestation, that is, the *degree of equal purity in which the two extremes are opposed.*[h]

If—in time—equality cannot exist *as an element,* then[i]—in time—in life, too, unity

––––––––

equilibrated relationship is not expressed, and the latter can be expressed clearly only when form and naturalistic color are abolished. Thus it showed that individuality's hold on our mentality must be destroyed for equilibrium or unity to become possible in life.

In our time, when individualism is precisely at its peak, general equilibrium cannot generally be reached in outward life. A person may be equilibrated in his own duality, yet his life is not equilibrated with the life around him. The new man's abstract spirit is closer to the cultural life of modern society than it is to elementary natural life, but our cultural life is only superficially *abstract;* it is so only in contrast to natural life but it is not *truly* abstract—it is not abstract enough for *the life of the spirit to become determinate.* Today's cultural life knows only abstraction of *intellect,* which it uses mainly for materialistic or physical ends. Nevertheless precisely this cultural life provides the right soil for the new life to develop. There can be equilibrium in *primitive* life where mind is so undeveloped as not to oppose the natural; but as soon as soul and mind develop, in other words, as soon as consciousness develops in man, while the natural lags behind—because of the unequal duality—equilibrium is impossible. Nor is equilibrium possible between man and nature as it appears visually: for nature must be transformed into the abstract if it is to be reconciled with the human mind.

––––––––

[g] Ancient wisdom identified the physical, the natural, with the female, and the spiritual with the male element.

To achieve pure naturalness, the natural must be interiorized, that is, stripped as far as possible of the most capricious outwardness that obscures perfect naturalness; in other words, it must perfect itself. This does not mean that the natural is to be interiorized to the extent of becoming wholly or partly spiritual. The natural, in time, remains natural, even though evolving toward the spiritual.

In evolving toward the spiritual, the natural is no longer pure or simple naturalness, yet it remains purified naturalness; for what influences the natural, namely, spirit, is not impure.

[h] The new plastic expresses the equal manifestation of inward and outward in *equal absoluteness:* rectilinearity. It expresses *difference between elements* through their perpendicular opposition to each other.

[i] Equality *as an element* comes only after time—

(or equilibrium) must be sought in *the manifestation of the elements*, that is, *in (relatively) pure nature and (relatively) pure spirit*. But since—in time—the elements transform each other into final unity, in other words, since they evolve in time, even the equality of their manifestation is always very relative.[j] Their unity can be really enduring only if the elements continue to transform one another in the same degree.

Yet Abstract-Real painting shows that unity, difficult as it may be to realize in life, has to be sought through *purification of the elements: nature and spirit*.[k]

In time these elements are confused in the unconscious; only in consciousness can their purity be restored. If the new mentality is characterized by greater consciousness, it must be capable of reflecting the elements more purely.

Thus, the new life can better equilibrate the elements, that is, nature and spirit, and greater unity will become possible in the state, in society, and in all life relationships. For this, it is only necessary that the new mentality develops freely: *that it annihilates the old mentality and domination by the individual, natural (or female) element*;[l] that

it frees itself of tradition and dogma and sees only *pure relationships* by seeing the elements purely (see fourth part).

So long as the old spirit is the dominating influence, nations must continue to destroy each other—there must be conflict and suffering: only *pure manifestation of the elements* (in equilibrated relationship) can reduce the tragic in life and in art (see the previous part).

Outward life must evolve into *abstract-real life* if it is to achieve unity. Today it forms the transition from the old era to the new. Abstract-real life is no longer exclusively natural life, although it is not unnatural. Nor is it exclusively spiritual life, although its content is the spiritual.[m] It is the stage of *contemplative realization* after a protracted clinging to nature and a premature striving toward the spiritual. Abstract-real life is not found exclusively in art, science, or religion: it can be realized in them but can also be *lived* through all of life's activities.

Because equilibrium between nature and spirit can be realized in abstract-real life, it can be the phase in which man will become *himself*. He will be *equilibrated and completely human* both in his own duality and in relation to the life around him.[n] He perceives

when space and time have transformed the deepest essence of the natural and have made it one with the spiritual. Only then are the two elements really one.

[j] If unity is very relative, in both inward and outward life, this relativity is also expressed in art—even in Abstract-Real painting. Abstract-Real painting can express the elements in an equivalent plastic manifestation, but it relativizes this unity through the composition's rhythm (see part 3).

[k] This is true socialism: *unity through intensified naturalness and exact spirituality*.

[l] The same idea must have led the Futurists to proclaim hatred of woman in their manifesto. However, it is the *dominance* of the female element in man that causes disequilibrium between nature

and spirit: this results in the feminine, or the natural, domination of art. The natural (or female) element absorbs development but creates no new one: it clings tenaciously to each stage of development and therefore is the element of tradition.

[m] Abstract-real life is as free of the natural as the physical permits—just as Abstract-Real painting is as free of the natural as our individuality permits.

[n] Only by becoming equilibrated can man appreciate or create *pure* art. Being not altogether natural, he is not dominated by nature; he does not desire or express the appearance of nature. Being not altogether spiritual, he remains in equilibrium with nature, but he nevertheless desires or creates art.

and experiences this life *abstractly* and is therefore not bound by its limitations.

Abstract-real life is the life of *truly modern man* (see the introduction) through whom the new mentality is expressed. Truly modern man *consciously experiences* the deeper meaning of individuality: he is the *mature individual*. Because he sees the individual-as-universal, he combats the individual-as-individual. Triumphant over outward individuality, he is thus the *independent individual: the conscious self.*

If Abstract-Real painting is the expression of abstract-real life, this life in turn can be sustained based on the truths brought to light by Abstract-Real painting. These are *very ancient* truths but their exact realization has only become possible today (see part 4). To those thoroughly convinced of these truths *through observation*, they appear no more *dogmatic* than they do to those who evolved the new plastic out of naturalistic painting. To them they are irrefutable truths—truths that they became conscious of through the process of working. For them these truths can never be *preconceived dogma*, since they were arrived at only *by way of conclusion.*

Thus Abstract-Real painting has shown that if *equilibrium and therefore unity are to exist in life, the spiritual must be manifested determinately and the natural must be interiorized so deeply that it reveals its pure essence.*

External life must be interiorized *to the abstract*: only then can it become one with inward life, which is abstract, spiritual, universal. This is possible because life itself transforms the natural in man to (relatively) *pure* naturalness, releases the spiritual (universal) in him, cleansed of individuality—

thus creates (relatively) *pure* spirituality.[o]

Only purified naturalness and purified spirituality can create pure relationships of opposites: only purified duality can make life enduringly harmonious. Thus human duality can evolve to unity.

To *know* unity, we must *recognize* duality in all of life. For whoever sees unity—in time—*as a single phenomenon*, still sees it as vague and undetermined. Only by seeing it as duality can we see *how* unity (or equilibrium) is achieved. Therefore, the new plastic is not an expression of a dualistic view of life: on the contrary, it is the expression of a *matured, conscious sense of unity* which forms the basis of the new consciousness.[p]

In perceiving man's duality, we distin-

[o] Purified naturalness is not nature *in the manner of nature*: it is interiorized naturalness; nature expressed *in the manner of art* (see part 2). And purified spirituality is not spirit *in the manner of mankind*, but spirit manifested objectively—that is, as the universal (see part 4). *Purified* naturalness and *purified* spirituality are the purest manifestations of the absolute in man. *Absolute* naturalness and *absolute* spirituality, however, are the equivalence of nature and spirit beyond time and space. Man's evolution is a return to this unity: his past and his distant future inspire him with the desire for unity, and make him strive for what he can achieve in time: purified naturalness and purified spirituality. In this purified duality there is—in time—harmony. That is why Abstract-Real painting, which expresses this duality—although relatively—has to be the *most harmonious* painting.

[p] The Greeks sought to realize plastically the ideal unity of nature and spirit by enduing spiritual beauty with the most elevated expression of natural beauty. The Middle Ages sought this unity by giving spiritual beauty a naturalistic form, but, apart from ideal natural beauty, only the present (the New Plastic) has brought the nature-spirit dualism to satisfactory unity.

guish not only his spiritual and natural life, but also the *life of the soul*—although they all interpenetrate.[q] The life of the soul is related on the one hand to nature and on the other to spirit: it acts both through emotion and through intellect.[r] To the extent that nature dominates the life of the soul, it is outward emotional life; to the extent that spirit predominates, it is *deepened* or spiritual emotional life. Abstract-real life is the *deepened life of the soul becoming one with spiritual life but nevertheless colored by the qualities of the soul.*[s]

All life has its outward manifestation through which it is known and conversely through which it exists. Abstract-real life finds *abstract* manifestation in Abstract-Real painting but has yet to find its palpable manifestation. The (superficially) abstract life of modern society has its own outward manifestation—it forms the appropriate ground on which abstract-real life can grow, on the one hand, but, on the other, it is exactly what stands in the way of its *pure* exteriorization. Social and cultural life find their most complete outward expression in the *metropolis*.[t] Abstract-Real painting developed under the influence of the completely modern cultural life of the metropolis:

[q] To understand properly the action and the very diverse manifestations of the universal, we must recognize individual inwardness not only as consciousness but also as *soul and spirit*. Art comes into being through the soul, for all true life is lived through the soul. The soul *animates* the work of art, but art originates in the spirit, as does the soul. Spirit is the universal; the determinate expression of the universal springs from it; but it becomes real, it becomes living reality, it becomes *art*, through the soul. If the New Plastic—like all art—arises through the *soul*, it therefore cannot express rigid intellectuality, as is sometimes alleged.

[r] Emotion and intellect are active between the two poles, nature and spirit, between which abstract life evolves. Where intellect is directly combined with spirit, *reason* is manifested and *universal thought* results. Universal thought, animated and experienced through the soul, and thus transformed to the expression of emotion, gives rise to Abstract-Real painting. Therefore, this art cannot plastically express *individual thought*: it cannot arise from intellect, although intellect makes its manifestation determinate. All individual thought is dissolved in universal thought, as all form is dissolved in the universal plastic means of Abstract-Real painting. Universal thought can be plastically expressed determinately only by universal plastic means: form always expresses individual thought (see part 5).

[s] Art always reflects the life of the soul: art became greater to the degree that spiritual life increased in

the life of the soul. Art declined proportionately as the life of the soul turned toward the outward—in outward feeling or in intellect. If we see the life of the soul as feeling and thinking, then feeling and thinking were the two means through which all art arose. For even the genius which expresses itself impulsively by emotion can only achieve mature expression through the faculty of thought. Intellect always collaborates in transforming *what is seen* into *art*.

What is perceptible to the senses is *experienced* through feeling, achieves *clarity* through intellect, is *deepened* by reason, and is recognized in *its essence* by spirit. To what extent the perceptible can act upon the interpenetrating unity of emotion, intellect, reason, and spirit, depends only on the development of the age's consciousness, or in a narrower sense, on man's individual consciousness.

[t] The truly modern artist sees the metropolis as abstract life given form: it is closer to him than nature and it will more easily stir aesthetic emotion in him. For in the metropolis nature is already tensed, ordered by the human spirit. The relationships and rhythm of plane and line in its architecture will move man more directly than the capriciousness of nature. In the metropolis, beauty is expressed more *mathematically*; it is here that the *mathematical artistic temperament* of the future will develop—here the New Style will emerge.

logically, immature natural life could not engender this art.

If man matures through reciprocal action of outward and inward life, his *environment* must be extremely important. The artistic temperament is particularly sensitive to the impact of life's *visual* manifestation. Through *this* the artistic temperament comes to know life and thereby truth: it constantly transforms visual outwardness to abstraction—coming constantly closer to truth. The *plastic artist realizes* visual insight: he constantly destroys it—constantly realizes truth more purely. He lives by *perception*, by inward as well as outward perception. By nature and training, therefore, he is capable of more rapid growth toward the *abstract*. Thus painting achieved in the plastic what the new mentality has yet to realize in outward life.

The transition from the natural to the abstract will be seen either as progress or as regression, according to whether one views nature or spirit as the goal of evolution. So one may either agree with Voltaire, among others, that man perfects himself in the measure that he removes himself from nature, or else one may view the trend to the abstract as a disease.ᵘ Understandably, the

abstract seems abnormal when we fail to discern the unity of nature and spirit; or if we fail to see that (in time) spirit does not exclude nature but can only be realized through it (see the preceding part).

The New Plastic most clearly shows that the abstract spirit takes into account *both nature and spirit*: that *unity of the two* is the ideal of those in whom the new mentality is developing.ᵛ

The *conception of unity* implicit in the new mentality and stressed in the new plastic is not understood by the masses, who fail to see nature *in its totality*. They fail to see the natural as the most outward manifestation of spirit, as the unity of spirit and nature.

If a determinate vision of the unity of nature and spirit is characteristic of the new mentality, we find it manifested in groups; and these *groups* form around individuals. Advances in consciousness are generally achieved by *groups*, and even among these there are various degrees of developing consciousness. Each group goes its own way supporting or contesting the others, even though consciously or unconsciously they all have the same aim.

───────

ᵘ Superficially seen, the gradual estrangement of painting from naturalistic representation of objects appears as decadence. In fact, however, it is an *evolutionary process* that has been developing throughout the ages and is now progressing with great rapidity. If we see art turning away from the common appearance of things at an accelerating pace—however intermittently—we also see that every new period rests on the achievements of an earlier one: the expression of art is constantly becoming *enriched*—precisely through the seeming impoverishment of its appearance. One and the same force leads to construction and destruction, constantly reappearing until this duality becomes unity. Outwardly, then, we can say that one art expression emerges out of another. However, the expression of art never reappears in the same way:

the new is always *different*. If the trend from nature to spirit is seen as evolution, each new art expression must be more abstract, further from nature. Precisely when art is seen from a historical and evolutionary viewpoint, its unity—amid the diversity of its expressions—is most conspicuous. Modern painting's purification of the superfluous, the capricious, and the most outward rests on the toil and striving of all previous painting. There is no aimless superficiality here: it is the way to achieve the determination and the expression of intensification. Once intensified, art will be in possession of its purely pictorial means, determined line and color.

ᵛ Precisely through the *perfecting* of the natural, the natural resolves into the abstract: precisely by reaching the limit of naturalistic expression, painting attained abstract expression.

Even within groups there are diverse paths, and, although general development is certain, it is often impossible to avoid misunderstanding the ways of others. Because of individual differences in temperament and experience, a single way is hard to agree upon—even among more or less equally advanced minds. Thus a *common conception of art* would be virtually unachievable, except for the fact that it is possible to examine rationally what has been achieved in art. Anyone similarly attuned—even if not an artist—will have more or less the same aesthetic capacity and therefore the potentiality for insight into art.

By cultivating their capacity for the *purely (abstract)* plastic, vital plastic vision, the whole group can succeed in following a *single* path despite the differences of their lives.

Thus unity is no longer an unattainable ideal in life and art.

In earlier times everyone followed the same path, for in each cultural era a single religion was dominant. Today the image of God no longer lies *outside* of man: the mature universal *individual* emerges. If he perceives the universal more determinately, then he is capable of *pure plastic vision*. Thus the new era will differ from the old by its *conscious perception*, which will spontaneously realize itself everywhere as *the universal*.

If art manifests the universal clearly, then it will establish itself as *universal art*.

Plastic vision is not limited to art: basically it penetrates all expressions of life. Thus the general unity *of life* is possible. Pure plastic vision leads to a conception of the structure that underlies existence: it enables us to see pure relationships.[w] Thus the new mentality

is based on elementary relationships that are veiled in nature but which are nevertheless visible. If this more inward plastic vision is the content of the new mentality, then it must manifest itself increasingly, because man's consciousness is evolving and it automatically destroys every obstacle, such as tradition, etc. We can be sure that the future will bring greater unity in the expression of art, indeed, the unity of *abstract-plastic that is nevertheless real*.

Abstract-real plastic evolved through and from naturalistic plastic: it emerged directly from an art that was still of the previous generation. The modern artist has performed the arduous task of creating a mode of expression for the future generation, after destroying that of the previous one.[x] The

[w] *The inwardness of everything has a corresponding outwardness from which, if our vision is pure, we* can know its inner aspect. Because of our *individuality*, our universal (or objective) vision is veiled; therefore, we must rely on *actions*, on *deeds*, in order to know—sometimes too late—the inwardness of other individuals. If we could perceive purely, no error would be possible. Through consciousness (of the universal in us) we come to universal and pure vision. To perceive clearly is *to know*. If, as it is said, knowledge is happiness, then pure vision leads to happiness. We can call pure vision *plastic vision*, because it deals only with *what is truly plastic* and is uninfluenced by anything whatsoever. *Plastic expression* is the pure measure of whatever is represented: in nature, too, we see the inward reflected in form, movement, posture, attitude, etc. Inner flaws are expressed along with true qualities.

It is inherent in life that we abolish our inward imperfections by abolishing our outward ones and that we achieve outward perfection by destroying our inner imperfections. Thus the outward is always a clear index for man. In this way plastic vision leads to greater perfection. However, outward perfection does not mean greater perfection of form or of the physical: it is a *different* perfection, which is to these as the straight line is to the curved line of nature.

[x] In his own work the modern artist had to pass through an entire evolutionary process, for he does not live in a time of an established culture but at

artist of the future will not have to follow the path of gradual liberation from natural form and color: the way has been cleared for him; the mode of expression is ready; he has only to perfect it. *Line and color as plastic means in themselves* (i.e., free from particular meaning) are at his command so that he can express the universal determinately.

Increasingly, then, the artist of the future will be able to begin from the universal, whereas the artist of today had to start from the natural (the individual). Our time is to be seen as the great turning point: from now on humanity will *no longer move from individual to universal, but from the universal to the individual through which the universal can be realized.* For individuality becomes *actually* real only when it is transformed to universality.

If it begins with the universal, the expression of art must necessarily be *ab-*

the beginning of a new era. Therefore, he had to construct a new form of art: to transform the very mode of expression in which he began his *own* development into one for the future. He is driven by an *inner* compulsion: by the feeling, by the inspiration of the spirit of his time. *External* influence was only the means to awaken the slumbering spirit of his age in him. The true artist, at every stage of his development, seeks to follow *spontaneously* the path that lies before him; and he leaves it only when by working he finds that another path becomes necessary. One artist passes gradually from one manner of expression to another (we can note that such a change always deepens his expression). Another artist may continue all his life to express himself only in one manner in which there may be some evolution but not such as to go beyond the existing limits of art. This has been the way of the artist up to now. Painting has had its styles and schools, but they deviated little or not at all from naturalistic expression. Only in modern times, through evolution, was a new insight attained and consequently a new, deeper mode of expression.

stract. So long as it begins with the individual, it can only *approximate* abstract expression and can even relapse into comparative naturalism—as we see historically. Moreover, man lives alternately in the universal and in the individual as long as his individuality remains immature. Only when his life becomes an unbroken progression, just as life—*the* life we cannot see—is an unbroken progression, only then can art become *permanently abstract.*

Evolution from the naturalistic to the abstract was fulfilled in painting when it developed from the natural (unfree) to free (abstract) plastic expresson. Once free, painting gradually departed from naturalistic appearance; gradually, by abstracting natural form and color, it achieved its consequence: abstract-plastic. It can be observed that the earliest efforts of free painting are already being recognized as *established art.* Its most extreme outcome—abstract-real plastic—is now far from universally accepted as "*painting*"; but how could it be accepted at a time when the old is still alive and the new is still so poorly known?

What made free painting possible was the unique vitality of modern life, which was strong enough to break with *form.* Since pure *destruction* is impossible, modern life had to *construct* the new: a pure equilibrated plastic expression of relationship. Free painting was able to develop because our time brought recognition that *every expression manifesting life—including art—is good and justified; that all expressions of real life are completely justified, even in their imperfection.* Rightly so, for mankind spontaneously takes the *right way,* the way of progress. In art too: the artist is always a pure reflection of the new consciousness. Each artist is the consequence of another before him whom he thus completes. If today the artist speaks in riddles so far as the masses are concerned,

when the modern spirit cloaks the work of art in an unfamiliar appearance—even then he is completely justified.

Until the modern era, the plastic means of all painting was rather the *natural appearance of objects* than *natural form and color*. Natural appearance was transformed by the prevailing sense of style but always in such a way that the natural remained recognizable. Thus we can understand the astonishment and even anger aroused in recent times when form and color began to be used autonomously and natural appearances were no longer recognizable. One was confronted with the necessity of accepting a new way of seeing. A more conscious vision, which saw form and color as means in themselves, resulted from *conscious* perception of what was previously perceived unconsciously: that beauty in art is created not by the objects of representation but by the relationships of line and color (Cézanne). Despite its greater consciousness, the new era was slow to accept this, so deeply rooted was naturalistic vision.

The increasingly thorough *transformation* of naturalistic form and color rendered each new expression of modern painting more and more incomprehensible to traditional feeling.

Already the Impressionists had begun to deviate from ordinary visual appearances. The Neo-Impressionists followed, and Pointillists and Divisionists went even beyond them in breaking free of "normal" vision. It was as if the sense of vision was moving deeper and deeper within.

Once painting was freed from the imitation of nature, it automatically sought further freedom. It had liberated itself somewhat from natural color—and also to some extent from natural form: now the breaking of natural color and natural form had to follow. This was accomplished in Expression-

ism, Cubism, Orphism, etc. Finally form came to its dissolution in the straight line, and natural color in the pure color plane (Abstract-Real painting).

Throughout modern painting we see a trend to the straight line and planar, primary color. Shortly before Cubism we see the broad contours emphasized as strongly as possible and the colors within them made flat and intense (Van Gogh and others). The technique of painting was correspondingly transformed: the work took on a new appearance, although the inner impulse came from the same source. Naturalistic plastic was increasingly tautened: form was tensed, color intensified. This art often shows more affinity with old Dutch and Flemish art, with Renaissance art such as Mantegna, with early Christian, ancient Eastern, or Indian art than with the art of its direct predecessors.[y] Yet with the ancients intensification was more profound. In fact, the modern age soon abandoned the old way of intensifying nature and tended to proceed from the decorative.

At the same time, the ideas that Cézanne had already established (that everything has a geometric basis, that painting consists solely of color oppositions, etc.) were increasingly stressed and cleared the way for Cubism. The plastic of Cubism is no longer naturalistic: it seeks the plastic, the plastic above all, but in an entirely new way.[z] Cubism still represents particular things but no longer in their traditional perspective appearance. Cubism breaks forms, omits parts, and interjects

[y] A good example of modern intensification is the work of Henri Rousseau.

[z] Cubist plastic can also be composed by projecting naturalistic forms in such a way as to more purely express their essentials (Metzinger).

other lines and forms:[a] it even introduces the straight line where it is not directly seen in the object.[b] Form is brought to a more *determined* expression, to its *own* expression: far more than the old art, Cubism expresses *composition* and already more directly expresses *relationship*. *In Cubism the work of art therefore actually becomes a manifestation that has grown out of the human spirit and is thus integral with man.*

Cubism broke the closed line, the contour

[a] Kandinsky too broke the closed line that describes the broad contour of objects, but as he did not sufficiently tense the natural contour, his work remained predominantly an expression of natural feeling. Comparing the works of Picasso and Kandinsky (see reproductions), one sees clearly how important are the tension of curved line and use of the straight. Kandinsky's generalized expression, like Picasso's, came about through the abstraction of naturalistic form and color: but in Kandinsky line still remains a *vestige* of the contour of objects, whereas Picasso introduces the free straight line. Although Picasso still uses fragments of the contour of things, he carries them to determination, whereas Kandinsky leaves somewhat intact the confluence of line and color found in nature. [Accompanying this installment in *De Stijl* 1, no. 11 (September 1918), were reproductions of Picasso's *Le Violon (Jolie Eva)*, 1912 and of Kandinsky's *Composition 6*, 1913—editors.]

[b] Coming from naturalism, Picasso is the great artist who in his extraordinarily gifted way is able to interiorize outward appearances. He still starts from the natural but plastically represents only what is valuable to him. Whatever he does not find important, he leaves out or fragments, instead of subordinating it (as in older art) to what is important. As in the old art, he constructs by oppositions of forms and colors, but he selects and transforms them in his own way. Thus he obtains a more inward power and a deeper naturalness.

Although he still feels the need to represent parts of things as they appear in nature, the external is never dominant in his work. Abstract-Real painting, which—in our day—no one could attain without having to pass through all previous phases of painting, can be seen as the necessary consequence of what Picasso and others initiated.

that delimits individual form; but because it also represents this *breaking*, it falls short of pure unity. While it achieves greater unity than the old art because its composition has strong plastic expression, Cubism loses unity due to the fragmented character of the natural appearance of things. For objects remain objects despite their fragmentation.

This breaking of form had to be replaced by *the intensification of form to the straight line.*

But in order to achieve this, Abstract-Real painting had to follow the same path as Cubism: by *abstracting natural appearance.*

The path of partial or complete abstraction was followed by the entire Cubist school, although in very diverse ways. Perhaps the closest forerunner of the New Plastic was a plastic of more or less homogeneous (abstracted) forms, with tense curved lines rhythmically composed (Léger). Its already very tense line had only to be made tense—until it became *straight.* (This *straightening* also resulted logically in a more equilibrated composition.)

Alongside Cubism, many other expressions arose using line and color more or less exclusively (some based entirely on color) and all free of natural appearance.

Thus, by perceiving the natural more and more purely, painting achieved plastic expression of *the abstract.* By plastically expressing the visible, it achieved a determinate expression of what is manifested through the visible—the pure plastic expression of relationships.

6. Conclusion: Nature and Spirit as Female and Male Elements

The extreme opposites that find their plastic expression in Abstract-Real painting can be seen not only as outwardness and inwardness, as nature and spirit, as individual and universal, but also as *female and male*

elements.[c] In art too it is important to see the duality of all life in this way, for this duality is then perceived from the viewpoint of *life itself,* and thus the unity of *life and art* within ourselves is clearly revealed. Conversely, the concept of female and male elements, as they are manifested in life, becomes alive in us when they are seen *plastically.* Anything concerning inwardness and outwardness that the new plastic makes perceptible through its *plastic manifestation* also clarifies the female-male relationship and its significance—also in life.

If the new plastic expresses determinately the content of the new consciousness (greater equilibrium in the duality of all life), then it also shows determinately what makes this equilibrium in life possible: it shows how the female element must become related to the male element and conversely; and what appearance they must assume.

In the New Plastic means and composition (see parts 3 and 4) we see the male element represented in whatever expresses the universal, the inward, and the female in whatever expresses the individual, the outward. In the New Plastic we see that equilibrated relationship is achieved by *interiorizing the individual and determining the universal, that is, by intensifying the natural (or female) and by accentuating the spiritual (or male).*

If the plastic of equilibrated relationships is the purest expression of harmony, then this expression of harmony consists of the *interiorization of the female and the determination of the male.* If we see the female and male as the two-forces-in-one that determine life, the New Plastic shows that only through their *interiorization* can these forces— outward as both have become—reveal their original unity in life, and thus bring out determinately the inner harmony of all life. It

can then be seen that only *purified* female and *purified* male elements can bring this about in all of life's relationships.[d]

The purified female element is the *interiorized* female element but remains *female,* that is to say, never—in time—does it become male (see part 5). It is only stripped of its most outward character; or rather, the most outward female is crystallized to a *more pure* female.[e]

[d] See above part 5, p. 56, n. g.

[e] The outward female (the natural) is *beauty,* which is manifestation of spirit (or the pure male). The pure male is *truth* (see part 5). The unbeautiful and the untrue are neither in nature nor in (pure) spirit: they rise—in time—out of the *disequilibrium* between *nature and (human) spirit in subjective vision.*

Subjective vision results from the impure male and has to realize itself as female outwardness, whereas objective vision arises from the purified male realized in the purified female. The objective is the pure male: *the universal.*

Female outwardness is the *emphatically individual,* which, being the manifested male (for nature is manifested spirit), is *in its essence pure,* and only in its *manifestation* does it become impure through subjective vision. When subjective vision grows into objective vision, the appearance of nature becomes more and more pure to us. Then we no longer see nature as individual forms but *abstractly.* The purified vision of pure nature thus becomes *abstract plastic.*

Disequilibrium between the female and male elements in man explains why we usually call human life unbeautiful and untrue, in contrast to other organic and inorganic life—life in which spirit is unconscious. Thus the misery peculiar to *man* results from *the clouding of the male element* (by the impure male), which is in disharmony with the female.

Art before our time expressed to some degree the *pure* male element (or universal) in the outward female. Thus art stood far above impure humanity, above the *impure* male. The artist turned away from impure expression of the impure male, thus from the self-seeking and self-limiting mind he turned to the outward female (nature) and through detached contemplation saw the *pure* male

The purified male element is the male element free from the dominant influence of *outwardness*, that is, of the female element.

Exteriorization therefore diminishes the purity of both female and male elements.

Exteriorization is necessary for the growth of inwardness; but the most outward exteriorization becomes increasingly weakened as the inward becomes more determinate. As the male develops in man, the female in him is deepened, and conversely. By its very nature, however, the female element remains essentially *outward*. Therefore, it can only culminate through *culture of the outward*.

If we see plastically that the purified female is purified *outwardness*, then—in time—it clearly cannot become inwardness, despite its interiorization. *Interiorization* of the female is made perceptible in the new plastic by the *intensification* of naturalistic color and the *most extreme* tensing of form. *Thus it is the controlling, the tensing of the capricious, and the determining of the fluid and the vague.* Just as intensified natural color and naturalistic line tensed to its limit remain *outward* despite their deepening, so the interiorized female remains outward despite its interiorization.

It is important to understand this—for only as outwardness can the female element form an opposition to the male and thus unite with it.

The male element, on the other hand, remains *inwardness* despite its exteriorization. The most purified male comes closest to *the* inward, while the most purified female shows the least outwardness. Thus, through the most purified female and the most purified

male, the *inward* is brought to expression most purely.

If the female element is to mature *within us*, it must be through cultivation of the *outward* in us. It is the male element that cultivates, and by so doing cultivates itself; realizing itself, it founders repeatedly on the outward (see above, part 5, p. 48 n. i). Thus outward culture proceeds in accord with the inward.

Now that the consciousness of our age has attained greater maturity, the era of a *more equilibrated culture of outward and inward* is beginning. Throughout the ages, attention alternated between the two. The outward was expressed in purely *realistic* painting, the inward in *idealistic* painting and *romanticism*. Had we always confined ourselves to outward culture, evolution would have taken much longer; whereas if the reverse had occurred, the universal would never have been definitively realized (see above, part 4, p. 45 n. y).

One cannot cultivate the inward exclusively. Whoever tries this discovers its sterility—as we see in much of our so-called religious and social life. True social life involves outward culture in the first place but also contains culture of the inward. This means that the outward must be *constantly in process of cultivation*, that is to say, life does not tend to the outward *for the sake of the material* but only as *a means for its development*. Thus true socialism signifies *equilibrium* between inward and outward culture.

If art, like society, is an outwardness that has to be cultivated, or rather that *cultivates itself*, then there is one necessity: not to go against this culture. Just as female outwardness becomes purified in life, so art develops from the naturalistic to abstract-real plastic. But whoever concentrates solely on culture of the inward inevitably comes to

unconsciously reflected in it. Thus naturalistic art arose, and by cultivating it the artist achieved more conscious vision of the pure male, which crystallized to more inward naturalness.

negate the evolution of art—and this is a sign that life is only being half lived.[f]

Outward life, however, compels man to take part in culture; this is what reconciles us with life.[g]

If the female element—in man—becomes more pure by *interiorization*, then it becomes more pure by growing *toward* the male, so that it can then *oppose the male more freely*. And if the male element in man becomes purer by *interiorization*, it becomes purer by turning toward the female, in the sense that it can *oppose the female more freely*. This growing freedom of both elements creates a new vision of nature. The New Plastic manifests this insight through the perpendicular duality of its plastic means. (In naturalistic painting, female and male elements are confused—in form.)

[f] We can call the female element in mankind that which is *directed to the outward*, and the male element that which is *directed to the inward*. Mankind needs to direct itself to both outward and inward. In this action lies human equilibrium.

Fully human life (life before inwardness becomes dominant and after extreme outwardness has matured) needs both outwardness and inwardness, female and male. Life's most perfect state is *the most complete equilibrium of the two*. Perfection of extreme outwardness is unattainable, and inward perfection is only for the superhuman spirit.

It is important to realize, however, that perfect equilibrium of female and male presupposes that the two have attained equal degrees of *profundity*. *Profundity*, because the relatively outward female and relatively outward male constitute an *outward* duality and thus cannot constitute true unity. This is seen in the unhappy situation of the relatively physical hermaphrodite. The physical hermaphrodite is the unity of an *apparent* duality, while the spiritual hermaphrodite (the ideal of the ancient philosophers) is the unity of a *real* duality.

[g] Woman, as the archetype of the predominantly female element, can mature *as woman* only by outward culture.

Thus the mutual action of opposites brings about a new unity of a higher order: the purified female and the purified male (see part 5).

If female *outwardness*, in passing from female to male, remains the deepened *female*, it can remain as such even while absorbing the male, for the male—or spirit—is pure. It can become impure only by absorbing what is *outwardly* male, that is, the male obscured by the outwardly female. And the male does not become obscured by uniting with the purified female, but only by uniting with the outward female.[h]

Seen plastically, the purified male can be called *abstract outwardness*,[i] for this comes closest to *the inward*, which is not manifested. Abstract outwardness is *determined* inwardness, equivalent with the most intensified outwardness (see part 4). The impure male, on the other hand, is manifested as the outward female.

The male is completely *pure* only when it *realizes itself through the deepened* female. Consequently, only when the latter becomes *abstract*, can the *realization of the male in the abstract become completely pure*.

The female and male elements, nature and spirit, then find their *pure expression, true unity, only in the abstract*. This is attainable, relatively, in *abstract-real life*,[j]

[h] As long as the elements have not been sufficiently deepened, the female element acts mainly from natural emotion and the male through ordinary intellect. Then only predominantly emotional or intellectual life is possible—but not spiritual life.

[i] The interiorizing of the elements is not discernible—in time—in unconscious nature. Although *abstract*, it becomes discernible in the man whose deepened inwardness is visible through his interiorized outwardness.

[j] Abstract-real life presupposes that the physical is maintained and related to in such a way that it

just as it can be plastically expressed, relatively, in *Abstract-Real painting*. Relatively, since—in life—*time* always upsets complete equilibrium; and—in art—*rhythm* relativizes the pure expression of relationship.

Complete equilibrium, unity, becomes *determinate* expression only through purified female and purified male elements, for only then by its very nature does this duality appear in its equivalent character and in complete mutual opposition. When unity is manifested as a (closed) unity (i.e., as form) in the naturalistic appearance of things, then unity can merely be felt (see part 5). Just as *natural* harmony exists in the visible (see part 2), in life harmony exists between nature and spirit, between female and male, but it is still oppressed by the individual.

Natural harmony is only the most outward manifestation of *pure equilibrated relationship*, which is not expressed in the visible (nature), because in nature both pure female and pure male are manifested only in a very veiled way. *Harmony* exists, however—precisely because both elements are almost equally veiled.[k] But in the natural the

female element (as outwardness) has the strongest *plastic expression*, so that harmony is *felt* rather than *seen*. Art then assumes the task of giving felt harmony a more or less direct plastic expression.

In life, too, harmony is possible between the unpurified female and the impure male elements—again because of (relatively) equal degrees of impurity. In the course of their purification, disharmony arises due to the differences in their different degrees of purification (see part 5).

Because harmony in the visible (nature) and in outward life is very relative, *man is compelled to bring it to a constant and determinate expression*—in one way or another. Thus in Abstract-Real painting, harmony found determinate expression *as pure equilibrated relationship*.

The new mentality is marked on the one hand by the maturing consciousness of the natural, the individual (see part 2), and on the other *by the maturing of the female element*. If the new consciousness is also distinguished by the greater determinateness of the universal (see the introduction), then *the male element is indeed becoming active in our consciousness as spirit, as the universal*. In the new mentality, there is therefore a unity of evolution that *must* realize itself.

But in our time the universal is manifested as little in the male element as mature individuality is manifested in the female. The old consciousness is still influential; it asserts itself despite the presence of the new consciousness.[l]

continues to act harmoniously, so that life can be unity of spirit and nature. The external, the physical, the natural may become more and more *automatic*, but the *new consciousness, turning more and more inward* (see the introduction), indicates that it is turning *as much* to female inwardness as to male. Thus it can appear as the "more autonomous life of the human spirit becoming conscious."

[k] In natural form and color, the expressions of male and female are *confused as one*: this *merging* of opposites gives birth to the visual tragic (see part 5). In the New Plastic, male and female appear *free of each other*, that is, the elements are determinately opposed; their conjoining in the duality of position in the universal plastic means and in composition is not an actual *merging*. Even the deepened rhythm of the New Plastic is not a confluence of natural rhythm (see part 3). In life as in art, the *merging* of the relatively outward female and the relatively outward male gives rise to the tragic.

[l] In our time, oppression by the female, a legacy of the old mentality, still weighs so heavily on life and on art that there is little room for male-female equilibrium. As *tradition*, the female element clings to the old art and opposes anything new—precisely because each new art expression moves further away from the natural appearance of things. Consistently viewed, the female element is hostile

By viewing the expressions of art histori-
cally, we see most clearly that the old men-
tality not only contained impure masculinity,
but also that it was dominated by the out-
ward (immature) female. We see this in the
plastic expression itself as well as in the
representation (or *subject matter*). In natural-
istic painting, plastic expression was pre-
dominatly female outwardness, for natural
color and the capricious undulating line were

———

to all art on the one hand, while on the other it
not only realizes the art-idea but reaches toward
art (for outwardness reaches toward inwardness). It
is precisely the female element, therefore, that
constructs art, and precisely its influence that
creates abstract art, for it most purely brings the
male to expression.

Tradition is as characteristic of contemporary
life as of contemporary art. This is evident in the
organization of government as well as of society
and also of personal life. In contemporary life the
dominance of the female-as-materialistic-element
oppresses spiritual life as much by material want as
by material excess. The female-as-nature or the
female-as-society burden inner life in various ways.
Yet, despite and because of this opposition, the
idea of *pure equilibrium* nevertheless grows—an
idea that will build the new society, just as it has
created the new plastic in painting.

This equilibrium of the male and female
elements, of spirit and nature, constitutes the *new*
in painting and marks the new plastic as the *new
style*. Through this equilibrium, the New Plastic
shows the content of the new mentality, the new
life. It shows that after disequilibrium, equilibrium
is possible; that the *mature individual* no longer
has to *endure a most external* or barren (illusory)
life in individual inwardness; that the *tragic* in life
can be overcome, so far as is possible in time (see
part 5).

To this end, each individual has only to
recognize that the New Plastic expresses determi-
nately: that unity and equilibrium result only from
(interiorized) *nature* and (determined) *spirit*—not
from *nature and nature*. The whole of evolution
consists in going from *nature to spirit*, not from
nature to nature. It is the same with society: when
it evolves to greater outwardness, its evolution is
only illusory; only when it develops toward the
spirit does it truly evolve.

employed as the expressive means. (Only
during periods of intense inner life, inspired
from without—see part 2—, did color
become more planar and primary, line more
tense, the composition more equilibrated.) In
the representation (already female by nature),
woman had an important place, and almost
continuously woman was a vehicle for the
concept of beauty. However, her portrayal
changed with the prevailing spirit of the
time: she is seen, for example, as a worldly
beauty or as a madonna. Although the
representation of woman was typical, this is
not what made the *representation* express the
outward female; representation of *any* kind,
the *portrayal of any aspect of nature,
whether landscape, interior, still life, etc.* can
be defined as *predominantly female* art. If it
is argued in defense of naturalistic painting
that the inward (male element) finds its
expression precisely through the female, in
our time this is a falsely applied truth (see
part 4). *Pure plastic vision* makes us recog-
nize that the inward (the male element) can
never find *pure plastic expression* when
veiled by the female, as it is in the natural
appearance of things. Female outwardness
can animate the male in our spirit, but if the
male is purified in this spirit, then it will
bring the outward female to expression as
purified female. Because the male element is
not expressed determinately in female out-
wardness (the natural appearance of things),
the latter must be *annihilated* in the plastic
and replaced by a plastic of deeper female
and more determinate male character.

As long as the female element domi-
nates, the male has not yet become determi-
nate: *the female can dominate only if the
male element is indeterminate.* In painting as
well, domination by the female element was
abolished when the male element in our
mentality became more determinate. Then art
changed its expression: *representation* disap-
peared, and the *plastic itself* grew increas-
ingly toward *female-male* equilibrium.

7. Supplement: The Determinate and the Indeterminate

The determinate is positive for us, absolute, insofar as we can establish it objectively. We can speak objectively only of *the* determinate—(which is universal, *the* universal). Subjectively we know diverse *determinations*, which are more or less individual.

If the universal—outside of time—is *the determinate*, then the individual, in and through which the universal appears—in time—must be *indeterminate*, and so must be our vision of it.

The indeterminate has the appearance—in time—of being determinate; *the* determinate—in time—of being indeterminate. We always more or less subjectivize the *one determinate* (see part 5), and for us this subjectivization is *the determinate*. We perceive—in time—the *one* determinate with varing degrees of clarity, and each degree of clarity is—in time—*determinate for us.* As the individual in us matures and the universal in us predominates, our various individual determinations grow toward the *one* determinate.

One (individual) determination—in time—is neither more nor less valuable than another: each (individual) determination is for us *the true one*—for the time being. That is also why each subsequent (individual) determination annihilates the previous one, and the degree of clarity with which we perceive —in time—the *one* determinate is not arbitrary: *what seems determinate to us varies according to the age.*[m]

In individual vision, the (one) determination *appears vague*, and the indeterminate real.[n] In time, the (one) determination is *abstract*, the indeterminate *concrete*. Objectively seen—as far as this is possible—in time—the one determination is *abstract-real* (see part 3).

Depending upon the character of our consciousness, we see either the objective or the subjective, the universal or the individual, the abstract or the concrete as *the determinate.*[o] *Thus our life and our art depend upon our conception of the determinate.*[p]

The determinate—in general—demands determination and clarity: that is, it must be clearly expressed if it is actually to be manifested as *the determinate.*[q] In keeping with this requirement, art is expressed with greater or lesser *clarity* either through the (one) determinate or by whatever means through which it manifests itself.

––––––––

[m] In art, every manifestation of subjective determination is a (temporal) Style: that is to say, *an* art expression. *Style* on the other hand, manifests the (*one*) determination.

––––––––

[n] If the individual appears to us—in time—as determinate, and if things appear to us as beautiful, it is because the individual beauty of things has precisely the power to free us from that particular determination and to determine us by the *one determined.* The indeterminate brings us to the determinate (see part 4).

[o] Through our intuition, the universal in us can become so active (in time) that (in time) it pushes aside our individuality. Then art can reveal itself. Art—as the relatively direct manifestation of the universal—has the power to free us from appearance and to determine us by the *one* determination. It is self-evident that we cannot see the universal *clearly* so long as we are dominated by the subjective within; and that it does not reveal itself if the individual—outside us—is dominant. It reveals itself only if the individual—outside us—is annihilated; it is perceivable only when our inner universality is free of subjective limitation (Schopenhauer's disinterested contemplation).

[p] Not just an intellectual concept, but one derived from *experience.*

[q] Greater clarity brings us closer to truth. This is not dogmatic philosophy when we see it articulated in the New Plastic, where the universal (the true) appears more determinate, through its pure expression of relationship.

In art the relatively determinate (that is, the greater or lesser determination in which the (one) determined finds expression) *must be clearly expressed plastically*. Every age has clearly expressed its (relative) determination and thus, more or less, the (one) determined. This is the power of artistic expression. All art has *striven* to clearly express the one determined: even in its unclarity *some degree of determination was nevertheless expressed*.

If determination can be plastically *expressed* through the indeterminate (the concrete), then it inevitably finds its concrete *plastic manifestation*. It is manifested as the *immutable*, and this immutability is *equilibrated relationship*.[r]

Whereas the indeterminate (concrete) is manifested through the *corporeal*, the (one) determined is plastically expressed as equilibrated relationship through position, dimension, and value of color and plane (line).[s]

It is because *equilibrated relationship* is capable of finding actual *visual plastic expression* (although veiled), that we can experience the deepest aesthetic emotion; it is the *plastic expression, the bringing to determination of this relationship*, that makes all art art.[t]

Naturalistic painting, therefore, can express things either in *clarity* or in *vagueness*; the essential is only that it brings equilibrated relationship to determination. Thus the vagueness of *Thijs Maris*[9] is no longer mere vagueness: he represents *things* vaguely, but their vagueness shows a certain degree of determination. Similarly, in *Jan Steen* the representation of objects is not simply a depiction of their visual appearance: he gives their corporeality (see part 3) some degree of determination.

In art—unconsciously or consciously— the *determinate* (i.e., that which is plastically determinate) is the objectively determinate; it is always the plastic expression of relationship that matters, not the representation of things.

Aesthetic emotion is strong to the degree that relationship is plastically expressed determinately; and it is profound to the degree that its plastic expression is equilibrated.

In the course of its culture, painting carried this truth to its most extreme consequence: it has finally achieved the plastic expression of *pure relationship*. *Pure* relationship in painting (see the introduction) of course does not simply mean relationship and nothing more, for such an expression would not be "art." The plastic expression of relationship must fulfill every aesthetic demand if it is really to be "art" and is to awaken our aesthetic impulse.

Having evolved to the point of plasti-

[r] The determinate is the *immutable*, and therefore not what the mutable human (individual) seeks. Man *as individual* seeks the indeterminate; in art, man as individual seeks a veiled beauty. As individual, man seeks the true and the beautiful through their manifold *illusions*; as *individual*, he can seek nothing but these.

 We seek beauty and truth only through our innermost being; this innermost being, the universal, seeks the clearly universal, the immutable.

[s] If in art we seek the expression of relationship in all things, then fundamentally (consciously or unconsciously) we seek the universal in all things, which is basic to man's being.

[t] If relationship is the essential of plastic expression, then the universal is the essential. And if the universal is the essential, then it is the basis of all

life and art. Recognizing and uniting with the universal therefore gives us the greatest aesthetic satisfaction, the greatest emotion of beauty. The more determinately (consciously) this recognition is experienced, the more intense our happiness. The more determinately (consciously) this union with the universal is felt, the more individual subjectivity declines.

cally expressing aesthetic relationship purely (in the above sense), painting is ready to merge with architecture. Since ancient times architecture by its very nature (the mathematical-aesthetic expression of relationships) far surpassed its sister arts. Although it did not always consciously express this, and although its forms were always the outcome of necessity and practical demands, it went far beyond the naturalism of painting and sculpture.[u]

Up to the present moment, sculpture has known no more than a tensing of its form (Archipenko). It was painting (the New Plastic) that brought the expression of *pure relationship* to the forefront.

This does not make New Plastic painting merely an *accessory* to architecture: for it is not *constructional*[v] like architecture. Structural without being *constructional*, and free in its *ability to express expansion*, the New Plastic is the most equilibrated plastic of pure relationship. Architecture always presupposes enclosure:[w] the building stands out as a *thing* against space (a large scale project destroys this to some extent). Moreover, being constructional in character and tied to the demands of its materials, architecture cannot maintain as consistently as painting the

constantly self-annihilating oppositions of position, dimension, and color (value).

If the determinate demands *determination*,[x] then the *plastic expression of relationship* in art must be carried to determination. This is achieved in painting by determining *color itself* as well as the *color planes* (see part 3); this consists in counteracting the blending of colors by establishing boundaries either by the opposition of plane (value) or by line. *Line* is actually to be seen as the *determination of (color) planes*, and is therefore of such great significance in all painting. Never-

[u] Yet architecture, like sculpture, is destined by its very nature to present a more or less naturalistic aspect, for architecture is not a planar but a corporeal plastic. This involves *perspective* vision of its relationships, or of some of them, and thus impairs the pure perception of relationships.

Both architecture and sculpture will gain in purity by becoming planar plastic so far as is possible. Reinforced concrete opens a way for this development of architecture.

[v] See, for instance, [Bart] van der Leck's article ["The Place of Modern Painting in Architecture"], *De Stijl* 1, no. 1 [October 1917].

[w] See *De Stijl* 2, no. 1: "Notes on Monumental Art," by Theo van Doesburg [November 1918].

[x] *Determinateness, clarity* are necessities both in life and in art. *Philosophically*, we find the determinate in knowledge—although only the highest knowledge expresses the universal purely. *Aesthetically*, we find determinateness through pure plastic vision (see part 5). *Religiously*, clarity is faith, in the sense of direct contemplation. As such, faith is identical with the highest knowledge: a knowledge of the universal and a transcendence of aesthetic vision, which can only contemplate the universal through a more veiled manifestation: it is contemplation of the universal in all things. Faith as a humanized, individual vision of God (its common and corrupt form) is *unclear, vague*, and largely misleading. In outward life, evil arises from the *unclear*: good manifests itself as *clarity*. In all activities of life, it is the degree of clarity and determinateness that imparts greater or lesser value, while the capricious and vague obscure the essential. Thus all human life is determined by its greater or lesser clarity. Ancient wisdom symbolized the unclear (indeterminate) in relation to the clear (determinate) as darkness in relation to light.

Therefore, underlying all life, religion, science, and art is the *struggle toward clear vision of the universal*. If all wisdom and human intuition have the expression of the universal as their ideal, then our time necessarily moves toward this expression. Therefore, vague emotion will increasingly yield to higher knowledge (that is, *pure* feeling and vision) which all life and art will show *more and more plastically*.

theless, the plastic is created by planes, and *Cézanne* could say that painting consists solely of oppositions of color. Plastic can nevertheless also be seen from the standpoint of line: planes in sharper opposition form lines. Naturalistic painting thus arrives at the concept of "form," and (with *Gauguin* and others) we can say of determinate *color* that *form creation* is the essence of painting. Form, in this sense, determines, determines color: the more tense the form, the more determinate the color.

If form is expressed through line, then the most tense line will determine color most strongly; when line has become straight line, it will give color its greatest determination. By *consistently* carrying through *color determination,* we leave behind the capricious and the naturalistic.[y]

Accentuating the plastic of relationship led to the exaggeration of the plastic expression of relationship, to abstraction from the natural (Pointillism, Divisionism, Expressionism, Cubism), and finally to the plastic of *pure relationships* (the New Plastic).

If we see the plastic of pure relationships gradually developed out of naturalistic painting by the successive *schools,* we also see its evolution in the development of the founders of the New Plastic. We then see their struggle as the effort to free themselves from the indeterminate (the visual appearance

of things) and to achieve a pure plastic of the determinate (equilibrated relationship). While still expressing the indeterminate, they were drawn to those aspects of nature in which the determinate (equilibrated relationship) appears *determinately,* where relationship is veiled, and they exaggerated these visual relationships. Was it by chance that they found a most appropriate subject matter through which to express their feeling for determinate relationship in an unforeshortened (nonperspective) view of a farmhouse, with its mathematical articulation of planes (its large doors and grouping of windows) and its primary (basic) colors? Was it by chance that they were attracted to *straightness* and—to the distress of ordinary vision—dared to represent a wood simply by a few vertical tree trunks? Was it surprising that, once they had abstracted these trunks to lines or planes, they spontaneously came to express the horizontal—barely visible in nature—thus creating equilibrium with the vertical? Or that, in a rhythmic linear composition of the predominantly horizontal sea, they again expressed the—unseen—vertical in appropriate opposition? Did they do more than *exaggerate* what all painting has always done? Again, was it by chance that they were more deeply moved by the leafless tree, with its strong articulation of line or plane, than by trees in leaf, where relationship is blurred? And is it surprising that in the course of their work they abstracted natural appearance more and more, so as to express relationship more and more explicitly? And that the resulting composition was more mathematical than naturalistic? Finally, was it by chance that after abstracting all that was capricious, they abstracted *curvature* completely; thus achieving *the most constant, the most determinate plastic expression of equilibrated relationship*—composition in rectangular planes?[10]

[y] If we view *form* as the means for firmly establishing color, that is, for bringing color to determinateness, then the new plastic is the last consequence of what Paul Gauguin called "*the search for the true essence of beauty, Form.*" As Gauguin notes, we find in Ingres, among others, *a love of the encompassing line.* The New Plastic shows the same love of line. The New Plastic honors *form* as a concept but opposes it as *corporeality.*

Art had to free its plastic expression of the indeterminate (the natural), in order to achieve pure plastic expression of the *determinate*. Passing through Cubism, this was finally achieved by the New Plastic. This is intuitively *seen and felt* by the sensitive observer: it becomes clarified to him through logical thinking. It becomes convincing in practice whenever one compares the New Plastic with other painting.

Comparison is the standard that every artist consciously or unconsciously uses and that shows him how to express (his) truth as determinately as possible. He compares each new work with a previous one in his own production or in that of others. He compares it with nature—as well as with other art. To make comparison is to exercise one's *vision of relationships*; and the artist is led to see and compare the *basic oppositions*: the individual and the universal.[z] From a clearer and clearer perception of the relationship between this duality, a purer and purer mode of expression emerges. And so it is logical that the New Plastic arose.

[z] In life, too, the establishment of pure relationship (through *pure*, deepened, spiritual emotion: emotion-and-reason-in-one) is superior to involvement with (impure) emotion (see part 4).

Dialogue on the New Plastic (1919)

"Dialogue on the New Plastic" (Dialoog over de Nieuwe Beelding") was probably written in late 1918 and early 1919; it appeared in the February and March 1919 issues of *De Stijl*, a few months before Mondrian's return to Paris.

"In Holland," Van Doesburg later recalled, "we were made to feel like outlaws and outcasts. . . . Every new demonstration, exhibition, lecture brought the wrath of the bourgeois press down upon us."

Mondrian's choice of a singer as interlocutor allowed him to distinguish the harmonic, seen as the constant and universal element, from the melodic, seen as the variable element related to subjective feeling: in his subsequent discussions of musical and literary art, Mondrian futher developed this identification of the vocal with the lyrical, descriptive, and naturalistic. Actually, the Singer's outlook recalls that of critics such as A. De Meester-Obreen (see above, pp. 15–16), who deplored the absence of "emotion" in Mondrian's painting when it ceased to contain superficially recognizable subject matter.

A. *A Singer*
B. *A Painter*

A. I admire your earlier work. Because it means so much to me, I would like better to understand your present way of painting. I see nothing in these rectangles. What are you aiming at?

B. My new paintings have the same aim as the previous ones. Both have the *same* aim, but my latest work brings it out more clearly.

A. And what is that?

B. To express *relationships* plastically through oppositions of color and line.

A. But didn't your earlier work represent *nature*?

B. I expressed myself *by means* of nature. But if you carefully observe the sequence of my work, you will see that it progressively abandoned the naturalistic appearance of things and increasingly emphasized the plastic expression of relationships.

A. Do you find, then, that natural appearance interferes with the plastic expression of relationships?

B. You must agree that if two words are sung with the same strength, with the same emphasis, each weakens the other. One cannot express both natural appearance as we see it and plastic relationships with the same determinateness. In naturalistic form, in naturalistic color, and in naturalistic line, plastic relationships are veiled. To be expressed plastically in a determinate way, relationships must be represented only through color and line. In the capriciousness of nature, form and color are weakened by *curvature* and by

the *corporeality* of things. To give the means of expression of painting their full value in my earlier work, I increasingly allowed color and line to speak for themselves.

A. But how can color and line as such, without the form we perceive in nature, express anything determinately?

B. To express plastically color and line means to establish *opposition* through color and line; and this opposition expresses plastic *relationship*. *Relationship* is what I have always sought, and that is what all painting seeks to express.

A. But painting always used nature for plastic expression and through the beauty of nature was elevated to the ideal.

B. Yes, it rose to the ideal *through the beauty* of nature; but in *plastic expression* the ideal is something other than the mere representation of natural appearance.

A. But doesn't the ideal exist only in us?

B. It exists in us and *outside* of us. The ancients said that the ideal is everywhere and in everything. In any case, the ideal is manifested aesthetically as beauty. But what did you mean a moment ago by "the beauty of nature"?

A. I had in mind, for example, an ancient work, an image said to contain all the beauty of the human form.

B. Well, think for a moment of masterpieces of the so-called realistic schools, which show none of this ideal beauty and nevertheless express *beauty*. Comparing these two types of art, you will already see that not only the beauty of nature but also its so-called ugliness can move us or, as you say, elevate us toward the ideal. Neither subject matter, the representation, nor nature itself creates the beauty of painting. They merely establish the *type* of beauty by determining *the composition, the color, and the form.*

A. But that is not how a layman thinks of it, although what you say seems plausible. Nevertheless, I cannot imagine relationships expressed otherwise than by means of some subject matter or representation and not just through a composition of color and line *alone*; just as I can't appreciate sounds *without* melody—a sound composition by one of our modern composers means *nothing* to me.

B. In painting you must first try to see *composition, color, and line* and not the representation *as representation*. Then you will finally come to feel the subject matter a hindrance.

A. When I recall your transitional work, where color that was not true to nature to some extent destroyed the subject matter, I do see more clearly that beauty can be created, even far more forcefully created, without verisimilitude. For those paintings gave me a far stronger aesthetic sensation than purely naturalistic painting. But surely the color must have *form*?

B. Form or the illusion of form; anyway, color must be *clearly delimited* if it is to represent anything plastically. In what you call my transitional work, you rightly saw that the subject matter was neutralized by a free expression of color. But you must also see that its plastic expression was determined by form that still remained largely true to nature. To harmonize color and form, the subject matter of the painting, and therefore the *form*, was carefully selected. If I aimed, for instance, to express *vastness and extension*, the subject was *chosen* with this in mind. The plastic idea took on various expressions, according to whether it was a dune landscape or the sea or a church that formed the subject. You remember my flowers; they too were carefully "chosen" from the many varieties there are. Didn't you find that they had yet "another"

expression than my seascapes, dunes, and churches?

A. Indeed! To me the flowers conveyed something more intimate, as it were; while the sea, dunes, and churches spoke more directly of "space."

B. So you see the importance of form. A closed form, such as a flower, says something other than an open curved line as in the dunes, and something else again than the straight line of a church or the radiating petals of some other flowers, for example. By comparing, you see that a particular form makes a particular impression, that line has *plastic* power and that the most tensed line most purely expresses immutability, strength, and vastness.

A. But I still don't understand why you favor the *straight line* and have come *entirely* to exclude the curved.

B. The search for the expression of vastness led to the search for the *greatest* tension: the straight line; because all curvature resolves into the straight, no place remains for the curved.

A. Did you come to this conclusion suddenly?

B. No, very gradually. First I abstracted the capricious, then the freely curved, and finally the mathematically curved.

A. So it was through this abstracting that you came to exclude all naturalistic representation and subject matter?

B. That's right, *through the work itself*. The theories I just mentioned concerning these exclusions came afterward. Consistent abstracting led me to exclude the visible-concrete completely from my plastic expression. In painting a tree I progressively abstracted the curves: you can understand that very little "tree" remained.

A. But can't a tree be represented with straight lines?

B. Perfectly true. Now I see something is lacking in my explanation: *abstraction alone* is not enough to eliminate the naturalistic from painting. Line and color must *be composed otherwise* than in nature.

A. Then what the painter calls composition also changes too?

B. Yes, an entirely different composition, more mathematical but not symmetrical, is needed in order to achieve pure plastic expression of equilibrated relationship. Merely to express the natural with straight lines still remains *naturalistic* reproduction even though the effect is already much stronger.

A. But won't such abstracting and transformed composition make everything look *alike*?

B. That is a necessity rather than a hindrance, if we wish to express plastically what all things have in common instead of what sets them apart. Thus the *particular*, which diverts us from what is essential, disappears; only the universal remains. The depiction of objects gives way to pure plastic expression of relationship.

A. Our talk yesterday showed me that Abstract Painting grew out of naturalistic painting. It became clear to me mainly because I know your earlier work. Then Abstract Painting is not just *intellectual* but also the product of *feeling*?

B. Of both: deeper feeling and deeper intellect. When feeling is deepened, in many eyes it is destroyed. That is why the deeper emotion of the New Plastic is so little understood. But one must *learn to see* Abstract-Real painting, just as the painter had to *learn to create* in an abstract-real way. It represents the *process of life* that is reflected in the plastic

expression of art. People too often view the work of art as a *luxury*, something merely *pleasant*, even as a decoration, as something that lies *outside* life. Yet art and life are *one*; art and life are both expressions of truth. If, for instance, we see that equilibrated relationships in society signify what is *just*, then one realizes that in art too the demands of life press forward when the spirit of the time is ripe.

A. I am very sympathetic to the unity of art and life, yet *life* is the main thing!

B. All expressions of life—religion, social life, art etc.—always have a common *basis*. We should go into that further; there is so much to say. Some have felt this strongly and it led one of us to found *De Stijl*.

A. I have looked at *De Stijl*, but it was not very easy for me to understand.

B. I recommend repeated reading. But the ideas that *De Stijl* expounds can give you no more than a *conception* of the *essence* of the New Plastic and its connection with life: the content of the New Plastic can be *seen* only in the *work itself*. Only through intuitive feeling, through long contemplation and comparison, can one come to complete appreciation of the new.

A. Perhaps so, but I still feel that art will be much impoverished if the natural is eliminated.

B. How can its expression be impoverished if it conveys more clearly what is important and essential to the work of art?

A. But the *straight* line alone can say so little.

B. The straight line tells the truth; and the *significance* you want it to have is of no value for painting; such significance is literary, preconceived. Painting has to be purely *plastic*, and in order to achieve this it must use plastic means that do not

signify the individual. This also justifies the use of rectangular color planes.

A. Does this hold for classical painting, in fact for all previous painting, which always represented appearance?

B. Indeed, if you really understand that all pure painting aimed to be purely *plastic*, then the consequent application of this idea not only justifies *universal* plastic means but *demands* it. Unintentionally, naturalistic painting gives too much prominence to the particular. The *universal* is what all art seeks to express: therefore, the New Plastic is justified relative to all painting.

A. But is the New Plastic justified in relation to *nature*?

B. If you understood that the New Plastic expresses the *essential* of everything, you would not ask that question. Besides, art is a duality of *nature-and-man* and not nature *alone*. Man transforms nature according to his own image; when man expresses his deepest being, thus manifesting his *inwardness*, he must necessarily *interiorize* natural appearance.

A. Then you don't despise nature?

B. On the contrary. For the New Plastic, too, nature is that great manifestation through which our deepest being is revealed and assumes concrete appearance.

A. Nevertheless, to *follow* nature seems to me the true path.

B. The appearance of nature is far stronger and much more beautiful than any *imitation* of it can ever be; if we wish to reflect nature, fully, we are *compelled* to find *another* plastic. Precisely for the sake of nature, of reality, we avoid its natural appearance.

A. But nature manifests itself in an indefinite variety of forms; do you show nothing of this?

B. I see reality as a *unity*; what is manifested

in all its appearances is *one and the same*: the *immutable*. We try to express this plastically as purely as possible.

A. It seems reasonable to take the immutable as the basis: the *changeable* provides nothing solid. But what do you call *immutable*?

B. *The plastic expression of immutable relationship: the relationship of two straight lines perpendicular to each other.*

A. Is there no danger of *monotony* in so consistently expressing the immutable?

B. The danger exists, but the *artist*, not the *plastic method*, would create it. The New Plastic has its *oppositions*, its *rhythm*, its *technique*, its *composition*, and these not only give scope for the plastic expression of life, of movement, but they still contain so much of the *changeable* that it is still difficult for the artist to find pure plastic expression of the *immutable*.

A. Nevertheless, in what little I have seen of the New Plastic, I noticed just this monotony; I failed to experience the inspiration, the deep emotion that more naturalistic painting gives me. It is what I fail to hear in the compositions of modern music; as I said earlier, the recent tone combinations without melody fail to stir me as music with melody does.

B. But surely an equilibrated composition of *pure* tone relationships should be able to stir one even more deeply.

A. How can you say that, not being a musician!

B. I can say it because, fundamentally, all art is one. Painting has shown me that the equilibrated composition of color relationships ultimately surpasses naturalistic composition and naturalistic plastic— when the aim is to express equilibrium, harmony, *as purely as possible*.

A. I agree that the essential of art is the creation of *harmony*, but . . .

B. But harmony does not mean the same thing to everyone and does not speak to everyone *in the same way*. That is why it is so easy to understand that there are differences in the modes of plastic expression.

A Then this leaves room for naturalistic painting and melody in music. But do you mean they will be outgrown in the future?

B. The more purely we perceive harmony, the more purely we will plastically express relationships of color and of sound; this seems logical to me.

A. So the New Plastic is the end of painting?

B. Insofar as there can be no purer plastic expression of equilibrated relationships— in art. The New Plastic was born only yesterday and has yet to reach its culmination.

A. Then it could become completely different?

B. Not completely. But in any case, the New Plastic could not return to naturalistic or form expression, for it grew out of these. It is bound to the fixed law of art, which as I said, is the *unity of man and nature*. If in this duality the New Plastic is to create *pure* relationships and therefore unity, it cannot allow the natural to predominate; therefore, it must remain abstract.

A. I now see more and more that I thought of painting as representation of the visible, whereas it is possible in painting to express beauty in quite another way. Perhaps one day I will come to love the New Plastic as you do, but so far . . .

B. If you see both naturalistic painting and the New Plastic from a *purely plastic* point of view, that is, distinct from subject matter or the expressive means, then you will see but one thing in both: the plastic expression of relationship. If from *the point of view of painting* you

can thus see beauty in one mode of expression, you will also see it in the other.

A. Let us go on with our conversation. So it is *reality* that you wish to express plastically—I thought you wanted to express the *soul of things*.

B. Actually, neither one nor the other. If we mean by reality the external, the *appearance* of things, then this cannot be expressed plastically by itself; for man also is *inwardness*, that is, both soul and spirit. Because man is at the same time outwardness, the inward cannot be expressed *by itself* either. Painting has always taken the middle way *to some degree* but because it expressed itself through *form*, it revealed mainly the *life of the soul*.

The life of the soul is the life of human *feelings*. To express the *soul of things* plastically means to express our *soul*. And this is not the highest goal of art.

A. Is it not the soul that makes man *man*?

B. The *soul*? The sages also speak of the soul of *animals*. It is *spirit* that makes man *man*. But the task of art is to express the *super*human. It is intuition. It is pure expression of the incomprehensible force that is universally active and that we can therefore call *the universal*.

A. And yet you place such high value on *consciousness*?

B. Certainly, but I said "*art* is intuition"; the *expression* of art must be conscious. Only when the mind consciously discerns the true nature of intuition can intuition act purely. In *unconscious* man, the "unconscious" is vague and clouded; in *conscious* man it has become clearly determined. Only *conscious* man can

purely mirror the universal: he can *consciously* become one with the universal and so can *consciously* transcend the individual.

A. Can he thus become *objective*, so to speak?

B. Precisely. With our *unconscious* we always *subjectivize* the universal. If we designate the universal as the spiritual, then *pure* spirituality is only possible insofar as we can become objective about ourselves and everything around us.

A. And the Primitives—isn't their art purely spiritual?

B. Yes, but only to the extent that the primitives express spirituality through objective plastic, through *composition*, through *tension of form*, and through *relative purity of color*. Because of its *subject matter*, however, it remains *religious* art.

A. Could profane art then be just as *spiritual*?

B. All true art is *spiritual*, no matter what subject matter it represents. It reveals the spiritual, the universal, as I have said, by its *mode of plastic expression*.

A. I am beginning to prefer spiritual art—the angels and the saints of the Primitives bore me; they strike me as too sentimental. I have more feeling for realistic painting.

B. Realism has the advantage of *purer* objective vision, and I see realism as the basis of the new painting. As a man of today, you prefer realism rather than the primitives because you see the predominating inwardness of their art. But it is also because you do not see *plastically*, you see the *representation* too much. If I stood so far from one of the paintings that I could no longer perceive the composition, the tension of form and purity

of color, I assure you, I too would see only the floating robes and the folded hands. But don't forget that this art was created in a religious age: an age of religious *form*.

A. Then is their art as antiquated as the religion of that time?

B. The art, like the religion, is not outdated for *all*, but only for those who are conscious of a new era.

 Both religion-in-form and art-in-form are still necessary for most people today. Religion-in-form and art-in-form are not only *expressions of life*, but are *its means of development*; like Abstract-Real painting, they exist for the *living* of life.

A. Were the Primitives right for their time, then, just as you think your ideas are right for the future?

B. Most assuredly, religion-of-*form* has a corresponding art-of-*form*: subject matter was highly important at that time. But just as the spirit of the age, and therefore religion, became more *abstract*, so subject matter had to disappear.

A. We have returned to our starting point: *representation*! Although I still cannot accept art without subject, it is now clear to me that this depends on the spirit of the age.

B. Then you will have to agree that logically the age's changing consciousness can cause subject matter to disappear. I repeat: when the spiritual was dominant as *religion*, the spiritual had to come to the fore in that way; later, in a more *secular* age, the worldly had to dominate

expression. Once again, this took place through *subject matter*.

A. Now you blame everything on subject matter! But didn't you say that all art expresses the universal *despite* subject matter—and therefore also *in* subject matter?

B. I already said that in the art-of-form, subject matter also contributes to the expression of harmony insofar as "subject matter" involves the determinants of composition, color and line. For the sake of clarity, I spoke only of our *objection* to subject matter for our time. But I was going to add that as the spiritual began to merge with the secular, it became more and more apparent that the spiritual did not reside in *religious* subject matter *exclusively*; otherwise, with the decline of religious subjects, all spirituality would have gone out of art. The realization that subject matter served only to determine composition, color, and line led to an increasingly pure *aesthetic plastic* vision. Consequently, representation vanished completely, leaving *pure composition in color and line*—and thus relationship—to express plastically both the spiritual and the natural. The New Plastic expresses a more equilibrated relationship of nature and spirit, in the sense of the universal. The universal plastic means is just as much outwardness, nature, as is natural appearance or *subject matter* of any kind. But by being outwardness interiorized to the maximum, it can most purely manifest the inward, the universal.

Natural Reality and Abstract Reality: A Trialogue (While Strolling from the Country to the City) (1919–20)

Mondrian's second essay in conversational form, the Trialogue "Natural Reality and Abstract Reality" ("Natuurlijke en abstracte realiteit") was begun in Holland at the outset of 1919 and completed in Paris after his return there in July of that year. It appeared in *De Stijl* in twelve installments, from June 1919 through July 1920.

The "Trialogue" is comprised of "scenes intended to show the direct connection between art and nature," as Mondrian wrote Van Doesburg on 3 January 1919. The first five scenes take place in distinctively Dutch outdoor settings, each identifiable with a motif of Mondrian's representational period. The seventh and last scene, set in the studio of the Abstract-Real painter and abounding in urban references, was written in Paris.

In a letter to Van Doesburg of 18 April 1919, Mondrian touched on issues that are central to the "Trialogue": the basis of art in visible reality and the gradual evolution of the New Plastic based on intuition rather than on a system. Van Doesburg had expressed some doubts concerning Mondrian's recent adoption of the regular grid as a compositional frame; to which Mondrian replied:

> True, regular division incurs the risk of repetition. But this repetition can be annihilated through opposition. Anything can became a system— irregular division as well as regular: it depends on how one solves it.
>
> If you compare my work *Composition 1918* now reproduced in *De Stijl* [2, no. 5 (March 1919)] with, for example, the diamond-shaped one that you (and I too) think is best, it is clear that the latter is better in every respect. . . . I discovered this method of working gradually, as you can see from the photographs I sent you last year; the work you just reproduced forms precisely the transition to regular division. I think everyone should decide for himself in these matters. . . . The main thing is that we adhere to the basic principles.
>
> As to whether or not one should start from a given in nature . . . I agree with you in principle, there must be a destruction of the natural and its reconstruction in accordance with the spiritual; but let us interpret this rather broadly: the natural does not require a specific representation. I am now busy on a work which is the reconstruction of a starry sky [cf. "Trialogue," scene 3], but I am doing it without a given in nature. Thus he who says one must start from the given in nature can be right at the same time as he who says one should not: I only want to emphasize how dangerous it is to adopt a system.

The studio of the Abstract-Real painter in the last scene of the "Trialogue" describes Mondrian's studio in Paris.[1] Unable to retain his pre-war atelier on the rue du Départ, which belonged to the artist and critic Conrad Kickert, Mondrian moved to a new studio on the rue de Coulmiers in November 1919. He wrote to Van Doesburg:

> I think I was fortunate in moving. The old studio was dark and remained dark no matter what I did to it. Kickert—he of the *modern* K.K. [Moderne Kunstkring, Amsterdam]—had filled it with antique furniture which matched its somberness. Because such people are not serious within themselves, they desire surroundings that are (seemingly) serious.

On 4 December he again wrote Van Doesburg:

> My new piece [the last section of the "Trialogue"] deals among other things with the decorative as suggested by my present atelier, where I have been showing to some extent. Since I can't paint directly on the wall I have merely placed painted cards on it. But I have come to see clearly that it is indeed possible for the New Plastic to appear in a room *in this way*. Of course I had to paint the furniture as well. I don't mind the effort, since it has a good effect on my work. I've now completed something with which I am more satisfied than anything before. Of course I don't mean it is due to the atelier.

A visitor reported: "The walls of this room, itself rectangular, are subdivided by unpainted canvases or canvases painted in solid colors, so that each wall forms a sort of enlarged painting in rectangles."[2]

Mondrian occupied the rue de Coulmiers atelier for almost two years, before returning to 26 rue du Départ in October 1921, where he established his now famous studio.

Y. A Layman
X. A Naturalistic Painter
Z. An Abstract-Real Painter

Scene 1: Late evening—flat landscape—
broad horizon—the moon high overhead

Y. How beautiful!

X. What deep tones and colors!

Z. What repose!

Y. So nature moves you too?

Z. If it didn't, I wouldn't be a painter.

Y. Since you no longer depict nature, I thought that nature no longer moved you.

Z. On the contrary, nature moves me deeply. I do depict nature, but in a different way.

X. I have called your *compositions "symphonies"*; I can see music in them . . . but not nature.

Z. But one should be able to see music in naturalistic painting too. Naturalistic painting also has *rhythm*, although it isn't so clearly expressed as in Abstract-Real painting.

X. True, but Abstract-Real painting appears *without form*; it has this in common with music, which similarly does not use nature in its expression.

Z. I cannot agree with you on that, for combinations of sounds create a certain *form*, at least in traditional music; although you cannot *see* the form you can *hear* it. The audible can be thoroughly naturalistic, as traditional music clearly shows! *Modern* musical compositions, however, in which melody and form are destroyed, are in agreement with Abstract-Real painting, but not in the way that you think. You want to distinguish Abstract-Real from naturalistic painting, but the distinction must be such that neither expression goes beyond the limits of painting. Regardless of their different *appearance*, there is no difference in the *essential nature* of the two. Let us consider the origin of the work of art: *the emotion of beauty*.

Y. Wasn't our emotion basically alike a few moments ago? Remember what we said when we first saw this landscape? You remarked upon its *beauty*; you noticed its *color* and *tone*; and I the *repose* expressed through the beauty of color and tone.

Y. I readily grant that, but . . .

X. But in our art we see very little of that agreement.

Z. But the disagreement is only superficial. You *emphasize* tone and color, whereas I emphasize what these express—repose. But we are all *trying to do the same thing*. Repose *becomes plastically visible* through the *harmony of relationships*, and indeed, that is why I emphasize the

expression of relationships. Your expression of color and tone is also an *expression of relationships*. You express relationship just as I do, and I express color just as you do.

Y. Relationship?

Z. We express ourselves plastically through oppositions of line and color, and this opposition is *relationship*.

X. But in painting, must not relationship appear plastically through natural appearance?

Z. On the contrary, the more the natural is abstracted, the more clearly relationship is expressed. The new painting has shown this and finally came to the expression of *pure relationships*.

X. Nature leads me to express relationships spontaneously. But as for expressing relationships *exclusively*, I am not very sympathetic to that. Still using this landscape as an example . . . I see the relationship of the shining moon, the sky, and the earth. I also see that the position of the moon in the landscape is a matter of relationship. But I don't see why I should abstract everything for the sake of these relationships. It is precisely nature that makes the relationships *alive* for me!

Z. That is a question of conception. For me, plastic relationship is precisely more alive when it is not wrapped in the natural but appears in the plane and the straight. This for me is a much more intense expression than natural form and color. In general, natural appearance *veils* the expression of relationship. If one wants to express relationships determinately, then a more *exact* plastic of relationships is necessary. Ordinary vision cannot perceive the *relationships of position* determinately in this landscape.

Y. What do you mean by "relationships of position"?

Z. Not the relationships of the dimensions of

the lines and planes but the relationship of their *position* with respect to one another. The most perfect of these relationships is the perpendicular, which expresses the relationship of the two extremes.

In this landscape, the horizontal—in relation to us—appears *determinately* only in the line of the horizon. In this way only the one position is expressed determinately. Neither its *opposition, the vertical,* nor any other position is exactly expressed in this landscape as *line.* Nevertheless, the opposition is expressed by the *sky.* Its elevation is expressed *as plane.* The sky asserts itself as an indeterminate plane, but the moon appears on it as *a point,* that is, in an *exact way.* The plane is thus determined *from this point to the horizon;* this defines itself as *a vertical line.* Although it does not appear as such in nature, it is actually a line. Seen in this way, it is the opposition to the horizontal, *determinately* expressed. Thus we see that the relationship of position, even if inexact, is plastically manifested in nature; and that the *equilibrated* relationship of position—the perpendicular opposition of lines and planes—is what gives the plastic expression of *repose.*

Y. Indeed, the rectangular position is *immutable* and must therefore express *repose.*

Z. The feeling of repose in this landscape is so great because both the horizontal and vertical are *plastically manifested* in it. *In natural harmony,* the relationship of position is manifested, although not in a *purely equilibrated* way. The luminosity of the sky accentuates the vertical; the obscured horizon, the horizontal. The oblique is excluded, although we would certainly feel it if some object were to stand out here or there. If a tree, for example, were to project above the horizon, then our glance would involun-

tarily describe a line from it to the moon; this oblique would oppose the horizontal and vertical positions of the landscape in a disequilibrated way, and the *grandeur* of the repose would be destroyed.

X. The relationship of *dimension* is important too: it is directly linked to that of position.

Z. Of course. The relationship of position cannot express equilibrium without equilibrated relationships of dimension. The repose of this landscape is also due to its equilibrated relationships of *dimension.*

X. And what about the relationships of color?

Z. The various values of color as color and color as light and dark are indeed prerequisites for equilibrium, but both the relationships of color and the relationships of dimension are sustained by the relationship of position.

Y. Color *itself* always affects me strongly. A yellow alone, just a blue, opens up a whole world of beauty for me!

Z. Certainly color as color infuses everything with life, and the pure vision of color can elevate us to the highest—the universal. But . . . color as color predominantly conveys so much of the most outward that in contemplating it we run the risk of remaining with the superficial and vague instead of *seeing* the abstract.

X. But color achieves its value only through opposition with another color, through color *relationship,* as you rightly observed.

Z. This relationship gives *determination* to color and removes the vagueness that I just mentioned. But this does not contradict your observation: for example, a red moon would be completely different in its expression from the silver-yellow moon we now see!

X. To me a red moon seems terribly tragic!

Z. That is because, apart from the color, such a moon is usually close to the horizon and the horizontal skyline then dominates the vertical distance between it and the moon. Thus we see that the relationship of dimension again reinforces the expression of the color. However, we must not forget that the color of the sky around the moon's redness also has a plastic value: the blue opposes the red and this already destroys much of its tragic aspect. Further, the more we see the *relationship* of the colors, and the less we see the *individual colors*, the more we become *free of the particular and thus of tragic expression.*

Y. As I listen to you both speaking at length about *relationships*, something is becoming clear to me that I already sensed vaguely: we must see the visible *as a whole* from which nothing can be omitted and of which everything is a part and thus indispensable. Now I can see how the expression of the visible depends on *the placement* of the parts.

Z. Yes, all things are a *part* of the whole: each part obtains its visual value from the whole and the whole from its parts. Everything is expressed through *relationship*. Color can exist only through *other* colors, dimension through *other* dimensions, position through *other* positions that oppose them. That is why I regard relationship as *the principal thing.*

Y. And yet. . . . If, for instance, I contemplate the moon for its own sake, it is already so beautiful in shape and color.

Z. Everything one contemplates *for its own sake* is indeed beautiful, but it has a *limited* kind of beauty. When we see something as a thing-in-itself, we separate it from the whole: opposition is lacking— we no longer see relationships but only color and form. We observe one color, one form. We think we know it, but the more closed the form and the stronger its color, the more our knowledge of it is limited. When we see things as *particularities*, as *separate entities*, we drift into vagueness and uncertainty, into all sorts of fantasy. *One thing can be known only through another*, as all wisdom teaches.

Y. But assuming that only the one is visible, that we see only one thing, how then can we know this one thing through another that is not there?

Z. Just as a whole is one thing plus another, therefore a duality, so it is with any one thing. This one thing *only appears to us* as one. Actually, it is again a *duality, a whole.* Each thing repeats the whole on a smaller scale: the structure of the microcosm resembles that of the macrocosm, according to the sages.

Thus everything that is regarded as a thing in itself, as *one*, must be viewed as a *duality* or *multiplicity*—as a *complex.* Conversely, everything in a complex must be seen as *part* of that complex: as part of a *whole.* Then we will always see *relationships* and always know one thing through the other.

X. Yes, the one is only apparently one: it is part of a whole and at the same time a whole consisting of parts. . . . We see this clearly brought out in all painting.

Y. But what stability is there in all these relationships?

Z. In this *mutability* of relationships there is one *immutable* relationship: plastically, it is manifested by the *perpendicular* position. Plastically, this gives us stability.

Y. Is that why you mentioned the perpendicular position when we were discussing the repose of the landscape?

Z. Plastically, its repose is based on this position. Especially now that it has grown

dark, the details have faded away and all is flattened out, the landscape impresses us deeply with this relationship. Visually we can perceive no more than the mark of the horizon . . . and the moon. We perceive the vertical through them by abstraction: the primary relationship now appears to us. But it appears as *unity*: this is the *expression of nature* that cannot be the *expression of art*. We humans are still obliged to express repose through movement, unity through multiplicity. In painting, it is always the *rhythm* of color and line that makes us experience *reality*. The primary relationship in itself is already a living reality, but for us it can be plastically expressed only through *relativization*—through multiplicity.

Scene 2: Scattered clusters of trees silhouetted against the bright moonlit sky.

Y. How capricious!

X. How majestic!

Z. Yes . . . capricious and grandiose at the same time! In the grandeur of the contours, the randomness of nature is very clearly apparent.

Y. I see all kinds of heads and figures in them.

Z. Now one can clearly see the *relativity* of the appearance of form: everything looks quite different than it did in daylight.

Y. Perhaps because one no longer sees the details. . . . But what is it that makes it all so *impressive* to us now?

X. First, as you already observed, the *coalescence* of the details. Here is an example that we painters can follow. The great difficulty in painting is precisely to keep the details subordinate to the whole.

Y. But I don't see any details!

X. It only seems so: movement, form, and color are still everywhere, but they are all *dominated* by the grand contours.

Z. Yes, the encompassing line of the contours is very powerful here in this landscape. But beyond that, light, particularly when it as as strong as it is now, always *changes* the visual relationships. Consequently, whenever we depict relationships in a photographically naturalistic way, without taking into account the variations of form and color attributable to the light, we fail to evoke that emotion of beauty that we experience from complete reality.

X. In that sense I agree with you: in art we always have to *transform* nature.

Z. The deeper transformation of nature is simply a consequence of this. But to return to our trees: they also seem to be so large because of the *flatness* of their appearance.

X. I thought it was precisely among the tasks of painting to express *volume*.

Z. Relatively, yes. Naturalistic painting does try to produce the *illusion* of volume but actually it produces planes.

X. Yes. All the great masters have kept the modeling more or less flat within the broad contours.

Z. And modern painting is becoming increasingly *conscious* that painting *demands* the plane.

X. When this is exaggerated, painting falls into the *decorative*.

Z. It does not necessarily have to become an art of decoration or ornament, in short, decorative art as commonly understood. Many works of the past, Byzantine mosaics, old Chinese art, etc., are planar but not decorative in that sense. What impresses us in these works is their expression of great inwardness. We can also observe all around us that naturalis-

tic plastic, naturalistic volume, *corporeality*, causes us to see things *materialistically*, so to speak; whereas when they appear as planar, they impress us as far more *inward*. *Modern* painting came to the conviction that *all modeling* in painting turns it toward the *material*. This conviction may seem *exaggerated* to you, but it is now very widely held.

X. There are extremes in everything!

 In principle, I am sympathetic to what you say. But is the planar really necessary? If the broad contour dominates the whole, doesn't it essentially destroy the volume?

Z. It destroys it in part, but not completely. . . . So you dislike extremes. Well then, let us return to the broad outline. Let us see what painting has done with it. Is it expressed in the manner of ordinary vision?

X. No, all the great masters have accentuated its *tension*. . . .

Z. And they *exaggerated* the tension of ordinary vision. . . .

X. Then does the artist never depict ordinary vision?

Z. If we assume that he *transforms* it, then we will agree in principle. But then you must permit a *thoroughgoing transformation*—the most thorough *tautening of line*, which is *its tension into complete straightness*.

X. But that again is an *extreme*. This is what the plane and the straight line *do* in the New Plastic.

Z. The plane and the straight line must be the *means* for doing it . . . it is the artist who must *do* it.

X. On that we agree—but for myself I would rather follow nature!

Z. Then you must also accept the *capriciousness* of nature!

X. The capricious is beautiful.

Z. Beautiful but tragic. If you follow nature, you can only eliminate the tragic from your art in very small measure.

While naturalistic painting does make us *feel* that harmony which transcends the tragic, it does not *express* it determinately because it does not express *equilibrated relationships exclusively*. Natural appearance, form, natural color, natural rhythm, and even in most cases natural relationships, all express *the tragic*.

Y. When I compare this landscape with the previous one, where these scattered clusters of trees were not to be seen, I feel that the capricious natural form cannot produce in us the profound repose to which we inwardly aspire.

Z. True. In these trees you can clearly see that the tensing of contour and the reduction to the plane did not bring the profound repose you spoke about to *direct plastic expression*. You were right in seeing it as far more plastically apparent in the earlier treeless landscape.

Y. Then I could at least *feel* the repose.

Z. And if you will remember what I then said concerning the flat and the straight, and especially concerning *relationships*, then you will clearly understand *how* it became possible for profound repose to be so strongly *manifested plastically*.

Y. That is true . . . *natural appearance* was largely suppressed, there was no modeling, and everything appeared flat and straight—so that, as you say, the *immutable relationship* was accentuated. But do we always have to see *beyond* nature in order to contemplate *repose* consciously?

Z. We must not see beyond nature: rather, we must, so to speak, see *through* nature. We must see deeper, see *abstractly* and above all *universally*. *Then we can perceive nature as pure relationship.* Then we can see the external for what it really is: a reflection of truth. For this we must

first free ourselves from *attachment* to the external; only then can we rise above the tragic and consciously contemplate repose *in all things*.

X. Even in the capricious?

Z. Even in the capricious, but then we will no longer be *depicting* it: we will *express* only equilibrated relationships.

Y. But what is the significance of our personal attitudes toward nature, which remains capricious and tragic?

Z. Deeper vision, it is true, does not abolish *cosmic* tragedy, so to speak. But if we regard *man as part of nature*, then the *alleviation of the tragic in each individual, separately and in all of us together*, is the beginning of this abolition.

Y. So nature's constantly changing appearances ultimately lead us to this deeper vision?

Z. Yes, nature, the most outward, makes us conscious of *our being*, the most inward. Likewise in art: it is not human, individual feeling or thinking but precisely *nature* that brought painting to *purer plastic expression*, toward a more immutable expression of beauty. It leads us to contemplation, to absorption in the universal—to *objectivity*, so to speak. Individual thinking and feeling, man's will, his particular desires—all are *attachments* that lead to tragic expression and make the *pure* plastic expression of repose impossible.

Scene 3: Night—the stars, now in a bright sky, above a broad expanse of sandy beach

Y. How serene! Here is the same tranquil repose as earlier, when we saw only the moon and the earth without the capricious clusters of trees.

Z. It seems to me that we now see an even more complete expression of repose, in form as well as in color.

X. Yes, for example, the color of the sand creates a different impression.

Z. Also the green countryside we saw earlier gave us a feeling that was full and rich, but here the cool sand expresses a still deeper beauty. But what I meant to say was that the *stars* now become so much more important.

Y. Yes, how harmoniously they are distributed!

Z. Plastically, they *fill* the space: they *determine* it and thereby accentuate *relationship*.

X. However that may be . . . how far removed from all human pettiness.

Z. Now we can *see* that there is another "reality" beyond trivial human activity. We now clearly see its insignificance, for here all separateness ceases. We see *an individual whole*; and in contrast to the *changeability* of human *will*, we now contemplate the *immutable*.

Y. . . . I envy your *contemplation*. I do not yet truly *contemplate*; yet vaguely, I do feel beauty.

Z. This contemplation, this *plastic vision*, is most important. The more consciously we are able *to see* the immutable, the universal, the more we see the insignificance of the mutable, the individual, the petty human in us and around us. In *aesthetic vision*, man possesses the means to unite himself with the universal *abstractly*, that is, *consciously*. Through all vision as disinterested contemplation (as Schopenhauer calls it), man transcends his naturalness. Accordingly, everything he does is in order to maintain his individuality better. Even his spiritual aspirations are not purely centered on the universal . . . for he does not know the universal.

But in the moment of aesthetic contemplation the individual as individual falls away. *The universal now comes to the fore; the essence of painting has actually* always been to *make it plastically perceptible through color and line*. If the painting of the new era is distinguished by its greater plastic *determination* of the universal, thus freeing itself of natural appearance, then we can see this as the effect of the new spirit, which, as it becomes more conscious, is increasingly capable of transforming the *moments* of contemplation into one moment, into a *permanent vision*.

Y. That seems ideal, for then life would be continual happiness!

Z. So it is, *in the abstract*. . . .

Y. But in reality?

Z. Isn't the abstract real, if we are able to *perceive* it?

Y. Although I do not yet really perceive the universal, I am nevertheless beginning to understand that it can be plastically expressed . . . and must therefore be real!

Z. Because the universal is so *veiled* in nature, it is difficult for us, who are so *natural*, to recognize it.

Y. You said that plastically it is the *manifestation of the immutable as relationship, based on the perpendicular relationship*. . . . I was able to see this primordial relationship in the first landscape, which consisted solely of the earth and the moon. . . . But here? Is the primordial relationship still dominant in the starry sky?

Z. I will try to show you that it dominates there just as much, and that it is even *easier for us to grasp* precisely because of the *multiplicity* of the stars. Now it asserts itself in multiplicity. We are no longer obliged to *think* of the unique relationship as multiplicity; it is now

visible as such. Thus it appears as the *universal, determinately*. The unique relationship that we could determine only by starting from a determinate point, the moon, is now actually destroyed as a *unity*. For there are now as many fixed points in the indeterminate plane of the sky as there are stars visible, and just as many relationships are accentuated.

Y. So I must apply to the stars what you were saying about the moon?

Z. Precisely, for the stars are determinate sources of light no less than the moon. But the stars have the advantage of appearing as *points* and not as form, like the moon. The multitude of stars produces a *more complete* expression of relationship. As I said earlier, the primordial relationship must be plastically expressed in multiplicity to make us see it as living reality. Simply to represent the horizontal and the vertical as a unity would naturally not be art: it would at best be a *symbol*. Furthermore, the primordial relationship in itself represents, for us at least, something relatively *determined by ourselves*. But the New Plastic seeks precisely not to express anything individually determined. If the purely universal is to be rendered sensible and perceivable, everything that exists for its own sake must be annihilated. That is why the New Plastic must continuously break up, as it were, the primordial relationship, just as one relationship destroys the other in the starry sky. And this is precisely how it so strongly expresses harmony—even more strongly than in the moonlit sky.

Through multiplicity, *rhythm* also arises. This is the *plastic expression* of life, as it were, for us men; it *merges all particularity into unity*, as X will agree. The multiplicity of particularities creates *natural* rhythm, however, which *to some*

extent destroys the capriciousness of individual things, while the multiplication of the primary relationship creates a more *inward* rhythm that in turn *destroys the absoluteness of this primary relationship*. This difference separates the old plastic from the new: the task of naturalistic painting was *to accentuate the rhythm of the plastic*; while the new art precisely serves to *destroy naturalistic rhythm as far as possible*. In the New Plastic, rhythm, even though interiorized, continues to exist; it is, moreover, varied through the inequality of the relationships of dimension by which the relationship of position, the primordial relationship, is expressed. This permits it to *remain a living reality for man*.

Y. X will grasp this discussion of rhythm more readily than I. In any case, for me a starry sky is even more beautiful than the moonlight. The stars appear as points. . . . Can it be that the point, which has no form, frees us from the limitation inherent in form?

Z. Because the stars appear as *points* they *tell less about themselves and more about the primordial relationship*—at least if we are able to see abstractly. But in ordinary vision, the *isolated* point appears mainly as a point of light, which *in itself* expresses nothing. It does not free us from limitation, since it does not tell us anything determinate about the universal. In ordinary vision the isolated point fails to express relationship and so cannot annihilate our individuality. And this individuality is precisely what continually creates *form*—even when it does not appear directly.

However, we do not see a *point* but *points*, and *these* create forms. Between two points the *line* plastically appears and between a number of points a number of lines. The starry sky shows us innumera-

ble points not all equally emphasized: one star twinkles more than another. And now again these unequal light values engender *forms*. Just think of constellations: these too are forms. This simply means that *form is not abolished in the starry sky when we see it as it naturally appears*.

Y. But you still find repose more completely expressed in the starry sky than in the plane of a sky without stars or with only the moon?

Z. As I already said, even though the isolated point is vague, these luminous points make the indeterminate space determinate. In habitual vision they express relationships as *form* or as geometric figures that obscure equilibrated relationship; but if we see beyond their natural connections, then we are immediately enabled to see this relationship. We see the primordial relationship between star and star in the changing relationships of dimension. We have only to order these harmoniously to see a pure expression of *equilibrium*.

Y. It seems to me that the particularly serene expression of the starry sky arises from their geometric connections.

Z. Whatever appears in nature as geometric has the plastic depth inherent in the geometric. But the geometric can appear in the straight or in the curved. The straight is an intensification of the curved, which is more "natural." Many curved lines are discernible in the starry sky, giving it a naturalistic character and demanding intensification to straightness in order to annihilate this naturalism and to bring out its deepest power. In art, just as in pure conscious contemplation, we must *convert the curved to straightness*.

X. Then we have to *transform* what we see in nature. . . . and yet nature is perfect.

Z. Nature is perfect, but *man* does not need perfect nature in art, precisely because nature is so perfect. What he does need is a representation of the more inward. He has to transform natural *appearance* in order to create a purer vision of *nature.*

Y. But isn't there a danger here?

Z. There is a common, a more literal naturalistic vision that to some extent is determined by things themselves. A horse, for instance, is a horse for everyone. This objective vision is true, or rather has the appearance of truth, to the extent that it exists outside of our own human ideas. But there is also a more *subjective* vision that comes from ourselves and that is mainly determined by our limited human ideas. And this vision is very dangerous so long as it remains immature; when mature, it once again becomes *objective* vision, for we have then transcended the subjective. Objective vision is also true for naturalistic man, because it contains the immutable for him too. But for the more inward man the immutable appears differently, *he sees the immutable more inwardly.* To him all things are equally beautiful, for basically all things are one: basically one with ourselves. For *then he sees everything as equally perfect*, and all particularities of appearance cease to exist for him. This is what distinguishes him from those who also *say* that all things are equally beautiful but who are inconsistent enough to continue to represent the variations of appearance.

Y. Now I understand that the New Plastic does not seek subject matter . . . but don't you too prefer this starry sky to the capricious forms of a landscape?

Z. As artists, we still have a great deal of the *natural* in us, and we continue to need *appearance* in order to perceive the absolute, while imperfect appearances impede us. In this starry sky the capricious is already greatly tensed, and this helps us to see the absolute, so to speak.

Y. Now I can understand your choice of subject in your earlier period: the subjects were never capricious. Was *this drive toward the absolute* always the compelling force in your work?

Z. If the absolute is the most profound in us as well as in all things, doesn't that speak for itself?

Y. I too feel the starry sky as the absolute, just as it appears.

Z. It is *the beauty* of life that man is in harmony with his own vision. But even more valuable is *the truth* that man does *not remain* content with this harmony. I am sure that as your plastic awareness develops, you too will be compelled to tense the curved to straightness in your vision.

Y. Then is nature merely a means through which we can become conscious of the absolute?

Z. Yes, the external teaches us to know the inward, the imperfect the perfect—as wisdom has always taught.

Y. What actually is the need for another plastic besides the naturalistic? Can we just as well learn to see naturalistic *plastic* as perfect, just as we learn to see nature as perfect?

Z. Naturalistic *plastic* is not *nature*; moreover, *art is other than nature.* Naturalistic plastic is always much weaker than nature. And with regard to art, *nature does not express equilibrated relationships determinately.* That is what art must express.

Y. I already began to feel that another plastic was necessary when we were discussing the tragic character of the rising moon. So long as we perceive

nature as it manifests itself to ordinary vision, there is no escaping the tragic, it seems to me.

Z. There is no escaping the *tragic* so long as our *vision of nature is naturalistic.* That is why a deeper vision is essential. *One can escape tragic emotion only if one has learned to transform the individual into the universal through pure plastic vision.*

Y. Now I can see why pure plastic expression of the universal as art can advance man, since it would be difficult for the layman to attain by himself a perception of nature so plastic and universal that it transcends the natural-as-individual.

Z. The New Plastic, although an end in itself, leads to conscious universal vision, just as naturalistic painting led to unconscious natural vision.

Y. Natural vision . . . indeed, the beauty of nature never satisfies me completely; nature often makes me feel melancholy despite its great harmony and beauty. I can never unreservedly enjoy a fine summer evening, for instance. It makes me feel clearly how perfect everything could be but at the same time my powerlessness to make it so in my life.

Z. Nobody can be blamed for being egoistic. On the contrary, by being so, one at least is striving toward something—in this case toward beauty. Beauty is realized more purely precisely by assimilating it *completely, by forgetting oneself in its contemplation*: then the beauty that has been assimilated automatically is reflected in everything.

Y. Yes, but one must be capable of this; not everyone is.

Z. Of course, one has to have training or one has to be an artist. The artist, at least at certain times, can completely lose himself in beauty. Yet even for him and

for anyone who sees plastically, there are still causes for suffering, but it is suffering of a different kind. It is caused by *the tragic that is plastically expressed, by the tragic of things outside of us*, and not by the tragedy of our powerlessness when confronted by beauty that transforms our individuality. But in general, as I said, the appearance of nature must continue to affect our human nature because we are human. As human, we are both natural and nonnatural in opposition to nature. We are no longer natural enough to be completely one with nature, and we are not yet spiritual enough to stand entirely free and opposed to it.

Y. I now remember what a thinker said to me in connection with painting. He said that in art we interiorize natural appearance so long as we are not sufficiently inward ourselves.

Z. So he was arguing in favor of nonnaturalistic art?

Y. On the contrary, he maintained that as soon as we become sufficiently inward, the natural could be our means of expression; that in the future, painting would return to the depiction of natural appearance.

Z. The conclusion drawn from his assumption does not seem entirely logical to me. Did he think that once man achieves such a degree of inwardness, he would remain human in this way, as a duality of nature and spirit; that he would continue to desire or to create *naturalistic* art? Besides, when did he think this would come about, this highly developed spirituality that rises so far above nature—in the near future? Wouldn't it be a little more modest *first* to acknowledge ourselves as fallible, imperfect *human* beings; humans who have not yet achieved sufficient inwardness to be able to dispense with

the need to internalize nature in art?

As I see it, your thinker argues for the new art despite himself.

Y. Given a profound enough understanding of "sufficient inwardness," it seems to me you are right.

Z. And without this profound understanding the statement is meaningless, for if one is not sufficiently inward, one cannot transcend the natural! As one evolves spiritually, the naturalism of the plastic is interiorized. As the aesthetically creative man becomes more inward, he necessarily expresses himself through a more inward kind of outwardness; for the artist transforms the outward according to his inner nature. Generally, the more conscious man already sees nature in an "other" way than the more unconscious man, or so to speak the man of mere feeling.

Y. I too believe that the unconscious man is more strongly susceptible to natural impressions, and that the younger we are the more easily we are influenced by nature.

Z. When we are young and unconscious, we are the toy of everything around us. We do not have "in us" the firmness, conviction, and strength to oppose the oppression of what is "outside us." Our inwardness, or what I have called our "subjective vision," is not in harmony with the objective manifestation of nature—the former is weak, the latter strong. As soon, however, as our "inner self" becomes more conscious, we possess a strong inner force to oppose the strong external force, and we can transcend its oppression.

Y. In that case, then, life is *beautiful* . . . happy are the old and strong!

Z. Everyone has his time for being young and weak and his time for being old and strong! The consolation is that we are always *evolving*.

Y. But nature is always equally strong and cruel!

Z. Nature is ahead of man! The physical has reached its apogee, but we "men" will attain our apogee only in the distant future.

Y. It is true; man's physical aspect, his body, is no longer evolving . . . or rather it can be said to evolve only insofar as the spiritual is increasingly reflected in its expression.

Z. In terms of cosmic evolution, we can say that man is now evolving in the opposite direction, away from matter, toward spirit.

Y. But surely you don't mean to separate the physical from the spiritual?

Z. No, for the physical generally is an expression, although a lower one, of the spiritual. However, man is unique within existence: in physical life he attains *self-awareness* and therefore *exists* as a *self-conscious* being. Alongside or, rather, *within* his ordinary life, there is a second, an abstract life. . . . This must be taken into account in order to achieve a pure conception of art. To perceive the evolution of art from the natural to the abstract, we must also perceive that *man's* physical evolution continues as *interiorization*. This evolution can be termed spiritual, but also, seen outwardly in reverse, as physical. In life they are mutually opposed, and their evolution is usually unequal, one working against the other. But *equivalence* between the two opposites is necessary if equilibrium is to be attained. Advanced evolution of the spiritual cannot be truly pure for a man in whom the natural has not matured correspondingly. That is why so many relapse into a superficial spirituality. *Thus in the art of our time, no expression of true spirituality—of inwardness—is possible in (more outward) form.*

Y. I am beginning to see more clearly why the new painting can no longer express itself in the form of natural appearance. . . . I am reconciled, at least in theory, to the destruction of the natural!

Z. Provided that its destruction, as in the New Plastic, simultaneously involves *reconstruction: equivalence in the expression of the physical and the spiritual as unity.* The natural is then not destroyed but only stripped of the *most* external: apparent unity becomes *duality,* and apparent duality can become *pure unity.*

Y. Yes, I have read about this in *De Stijl.* But the superficial opinion prevails that the New Plastic either negates or destroys the natural.

Z. Superficially, of course, this is the way it *appears.* But we can hardly expect everyone to judge what is new to him other than superficially. But a little while ago we were discussing nature and man. There is something that comes from nature and something that comes from ourselves; one might say that while we respond to nature, nature's reply is overwhelming! In short, nature has a plastic expression, whereas we always tend to fantasize. Only in the moment of aesthetic contemplation—then only do we cease to *fantasize.* Then we are open to the revelation of truth; we see pure beauty!

Y. Didn't you say that nature expresses the tragic? Is the tragic beauty?

Z. The tragic can be beautiful: everything can be beautiful, the apparently good and the apparently evil. The revelation of truth can appear cruel to us; and the pretty is not always beautiful. Earlier I said that there were *degrees of beauty.* Equilibrated relationship is a more profound expression of beauty than tragic expression. Nature *manifests* truth as beauty but *plastically expresses* it in natural appearances that are always *veiled,* and this veiling of truth involves the tragic.

Y. Then nature expresses the tragic, and there is always something of the tragic *in us?*

Z. Subjectively, the tragic is caused by the domination of natural *in us.* Objectively, it is caused by the domination of the natural *outside of us.*

Y. And it can only be destroyed by the *evolution of our entire being,* inward and outward, our nature and spirit, as it were?

Z. Destroyed . . . a *more* equilibrated relationship between the two can now be achieved, but total destruction of the tragic *in us* will be achieved only in the very distant future and likewise the tragic *outside of us.* If we see what is outside us *as part of ourselves,* or as I said before, if we see *ourselves as integral with nature,* only then will the interiorization of our whole being be realized in life. This is possible only in the very, very far distant future, for at present this can only occur to us in our consciousness. Then natural appearance will cease to exist; *duality will actually become unity.*

Y. If duality causes the tragic, how can tragedy exist in nature, which appears as unity?

Z. It may appear as unity but it is not. In nature the most external appears more often than the pure plastic expression of the inward. One might say that the purest outward expression of the inward is veiled by the capricious. As I said, tragic plastic exists in everything visible. For inward and outward *appear as unity but actually are not.* Pure unity is plastically expressed as *equivalent duality.* Therefore, if we want to express true unity, we must express it plastically through such an apparent *duality.*

Y. Now I understand your apparent dualism, and I feel that painting must adopt for its plastic means an equivalent duality which replaces natural form and natural color.

Z. *Equivalent duality*—this is what can increase happiness by increasing harmony—in life, in all reality. How, in our time, is equivalent duality to be found? For the duality of man and nature is *not* equivalent. Nature's duality of force and appearance, of inward and outward, is likewise nonequivalent. The duality of the material and the spiritual, the female and the male, is not equivalent in life as a whole. *The resolution, then, is to be found nowhere but in ourselves.* For the equivalence of the *opposites* to become possible, our consciousness must mature to the point where *the natural, the material, loses its power to dominate and the spiritual can find clear expression. In this purified duality, unity is possible.* The outward does not directly change *in itself*, but changes *for us as we experience it abstractly in its most profound essence.*

Y. Is this what causes art also to change in its plastic expression?

Z. This alone. In this state of *abstract experience*, art, in opposition to the naturalistic, naturally becomes *abstract*.

Y. Although I cannot yet perceive the beauty of this new plastic expression, I recognize that it is very *logical and real*.

X. In spite of all this, nature, *just as it appears to me*, seems in certain of its aspects to express the highest possible harmony, and I cannot imagine it expressed more perfectly than through the naturalistic.

Z. As I said before, "harmony doesn't have the same meaning for everyone." It depends on our conception of it. In the naturalistic there is natural harmony, to be sure, but the equilibrated relationship of the abstract is another conception of harmony. That the conception of harmony is relative and *perfects* itself in time—this is shown not only by the successive expressions of art, but also to a greater or lesser extent by the life of every artist. The beauty of the artist's effort is precisely his constant striving for *a purer expression of harmony*. In the expression of each new vision of beauty, he discovers more and more that *the harmony manifested in reality is so strong that mere visual reproduction is inadequate to represent it*. He constantly transforms the visual toward greater plastic harmony. You know this yourself. After ecstasy, dissatisfaction follows—and thus a new plastic expression. *Reflection and comparison* make the artist dissatisfied with the harmony he has established. Although the New Plastic expression of harmony is after all the most satisfying, it too always falls short of our most inward but, alas, still too unconscious *idea* of harmony.

If the harmony of *reality* is so strong, this is due to the *living beauty* of nature that acts on *all our senses simultaneously: it is not the visual aspect of natural appearance alone that moves us.*

Y. It seems right to me that it is a question of the *plastic expression of harmony* and not natural appearance.

Z. This is precisely why art arrived at the New Plastic. In life, too, *the main thing is to achieve harmony*.

X. But assuming that the outward has to be interiorized in art, this is very difficult to achieve in life. I think you fail to reckon with reality.

Z. In life, our evolution precedes contemporary reality. But it is sure to follow! Material dominance must decrease—and is actually decreasing. The idea of *greater*

harmony through equivalent duality is really active in contemporary life; for example, in modern dancing, by which I mean ordinary social dancing. Previously the music and the movement of the dancing couple tended to *flow together*: its expression was the continuous curved line. Now, in the more advanced dance forms and in the music to which—or rather, against which—one dances, *a duality is manifested in which the music and the dance are equivalently opposed.* Its plastic expression is the straight line. The rhythms of the music oppose one another as well as the melody, just as the dance steps oppose each other. *Thus a far greater unity is formed.*

Y. But that is almost impossible: it would . . .

Z. It requires a tremendous amount of effort and training on both sides—*that is always the price of equivalence.*

X. It has always seemed to me that equivalence involves monotony, but when I think of dancing I begin to think this may not be so. Yet in dance the duality is *distinct.*

Z. Very true: a *distinct* duality is just as necessary for art as for the expression of life. *Equivalence does not mean uniformity or sameness,* any more than it means *quantitative equality.* The latter could very well lead to ineffectiveness in life, and to monotony in art. In the New Plastic we have equivalence of *extreme opposites* and therefore a *distinct duality. Rhythm* is the one and the *constant relationship* is the other; the *changeable relationship of dimension* is the one, and the *immutable relationship of position* is the other. In the plastic means, *color* manifests the one and the *plane and perpendicular* the other. In position, the *horizontal* is the one and the *vertical* the

other, and so on. Precisely because the duality is so *distinct,* far more effort is demanded of the Abstract-Real painter if he is to find equilibrium between the opposites. When he chooses to express *the one,* it is at the expense of *the other,* and when he succeeds in expressing *the other* purely, it is to the detriment of *its opposite.* But through the process of his work he ultimately finds a relatively satisfactory solution.

X. But in dance the natural remains despite the tautening.

Z. That is very relative, as you will agree if you compare tautened modern clothing to natural clothing and to nakedness. Moreover, this dancing is not art of the highest order. *Pure* art is more demanding.

X. But I still can't reconcile myself to the idea that plastic expression must be sought outside of nature, outside of reality.

Z. Neither can I—*nor must it be.* It must indeed be sought *in* nature, *in* reality. Painting has actually always done this: *through naturalistic realism it arrived at abstract reality,* precisely by following *pure plastic vision.*

Y. You said earlier that plastic vision means becoming one with the universal. But what does that mean *in practice?* Does it mean seeing things just as they really appear?

Z. To see plastically is to *perceive consciously,* or more precisely, to see *profoundly.* It is to *distinguish,* to *see truth.* It is to *compare* and therefore to *see relationship;* or to *see relationship and therefore compare.* It is to see things *objectively,* so far as this is possible. To see plastically is to be *plastically active.* By seeing plastically *we automatically destroy the naturalistic and reconstruct the abstract appearance of things.* By

seeing plastically we *improve*, so to speak, *our ordinary optical vision*, and thus convert the individual to the universal. In this way *pure plastic vision unites us with the universal*. Pure plastic *aesthetic* vision expresses truth *through beauty*, therefore still veiled. But such beauty can no longer be the most outward beauty, simply because pure plastic vision sees more *profoundly*: ordinary vision sees this beauty as *abstract*.

X. But assuming we could see nature so abstractly, then would not everything seem dead and meaningless to us?

Z. This would be attributable not to abstract appearance but to our naturalness. Moreover, as I said before, "art is other than nature." Now I will add "nature is other than art" and cannot be art. For only *through man* can nature become art. The human spirit *can only transform plastically* what nature causes our *human nature* to experience. Besides, isn't the primarily geometric character of our urban environment already very abstract in opposition to rural nature?

Abstract representations can move us deeply. An example I recollect was a film early in the war showing a large part of the world in map form. Upon this, the invading German forces suddenly appeared as *small cubes*. Likewise a counterforce appeared, the Allies, also as *small cubes*. In this way the worldwide cataclysm was actually *expressed* in all its vastness, rather than in parts or details as a naturalistic portrayal would have shown it.

X. I agree that world events can usefully be represented in this way, but in general a naturalistic portrayal affects us more strongly.

Z. Pure plastic vision sees *everything as a world event*. But admittedly a naturalistic portrayal does have a stronger effect on our *natural* feelings.

X. And speaking of films, I remember one that depicted a crab struggling with a squid. Here too, one saw the clash of two forces seeking to destroy one another, but it was more realistic.

Z. There is no argument here. How we are moved and what moves us most deeply depends on ourselves. I simply wanted to point out that we can be moved by abstract representation. My example did not actually demonstrate abstract *plastic*, since we already *knew about the event*. The plastic expression, which consisted largely of movement and collision, was not free of the *previously known* idea of "combat": it nevertheless shows quite clearly that it is possible to express something by abstract means.

Y. There I agree entirely with you; abstract representation gives a more universal impression. Particularities disappear, leaving only the universal to reckon with. Representation of the natural as a *projection*, like the world in that film, often conveys a more universal impression.

Z. The projected representation has the advantage over naturalistic representation, for it causes us to *see relationships more purely*.

Cubism also realized that *perspective representation clouds and weakens the appearance of things*, whereas projective representation represents them more purely. Precisely because it wanted to represent things as completely as possible, Cubism arrived at projective representation. By using various projections simultaneously juxtaposed or superimposed, the Cubists tried to achieve not only a purer representation but a purer plastic expression—or volume expression as the Cubists called it.

X. But we still continue to see things from one point of view!

Z. According to an individual subjective conception, yes; but from the moment that we regard ourselves as part of *the whole* and no longer judge things only from our *temporary position*, and regard them from all possible positions—in short, as soon as we *begin to see universally—then we no longer see from one point of view.* It is indeed a happy phenomenon that the most recent painting reveals an increasingly conscious search for a pure and many-sided representation of things, because it *expresses* the new and more conscious spirit of our time, which *aspires* to a more determinate expression of *the universal.* This aspiration has been ascribed to our *stronger awareness of the fourth dimension,* a conception that actually does come to the fore in recent art as *partial or complete destruction of three-dimensional naturalistic expression and reconstruction of a new plastic expression, less limited in its vision.*

Y. Did this broader vision arise through the cultivation of vision?

Z. Yes, through visual culture there arose an aesthetically *pure plastic vision* that made the New Plastic possible.

Y. Well then, is plastic vision possible only for aesthetic man?

Z. Even outside of the aesthetic, plastic vision is the way of modern man; it is nothing but the *conscious perception of truth.* Thus thought is exercised plastically. Directly in life too we can endeavor to practice purely plastic vision. It will safeguard us against false illusions and individual judgments. Far more certainly than our intuition, it will teach us to know reality—for our intuition is still clouded. Pure plastic vision will diminish our particularity and allow us to grow toward universality; automatically everything *will be done* from a more universal point of view.

Y. Then this will have great influence on our social life, among other things.

Z. *Pure plastic vision must construct a new society, just as it has constructed a new plastic in art—a society where equivalent duality prevails between the material and the spiritual, a society of equilibrated relationship.*

Scene 4: A windmill seen at very close range; dark, sharply silhouetted against the clear night sky; its arms, at rest, forming a cross

X. This also has grandeur. But of course Z will find it really extraordinary—just look at its arms!

Z. Indeed, I find this windmill very beautiful. Particularly now that we are too close to it to view it in *normal perspective* and therefore cannot see it or draw it *normally.* From here it is very difficult merely to reproduce what one sees: one must dare to try a *freer mode of representation.* In my early work, I tried repeatedly to represent things seen from close by, precisely because of the grandeur they then assume. At that time, to return to this windmill, I was particularly struck by the cross formed by its arms. Now, however, I discern the perpendicular in everything, and the arms of the windmill are not more beautiful to me than anything else. Seen *plastically,* they actually have a disadvantage. To the shape of the cross, particularly when in the upright position, we readily attach ·a particular, rather *literary* idea. The cross form, however, is constantly destroyed in the New Plastic.

X. The blue sky is so pure against the dark windmill!

Z. Yes, the sky is pure, but so is the mill! *Visually* it appears as merely dark and without color. But gradations of light and dark paint are inadequate to render a complete impression of the mill and the sky, as I frequently found. Light and dark may be satisfactory for a drawing but color demands much more. The blue calls for another *color* to oppose it. The Impressionists already exaggerated color—Neo-Impressionists and Luminists went further. To speak from my own experience, I found it satisfactory to paint the mill red against the blue.

X. But surely we don't see that way?

Z. *Inwardly* we see quite otherwise than visually. But inward vision is not always *conscious*, and when it is not conscious—despite the spontaneity and greater freedom of inner vision—in our expression we still cling more or less to optical vision . . . particularly when our first emotion is over. It is due to the power of this first intuitive emotion that naturalistic painters' studies and sketches are often far stronger and more beautiful than their paintings. Let us keep in mind that aesthetic vision is something other than ordinary vision. And in general the one thing that counts in art is to reflect aesthetic *emotion*: to the extent that we feel the purity of color more intensely, we are able to express color more purely. Even in the particular, once we have begun to see in a more consciously aesthetic way, the task becomes to reflect clearly, that is, determinately, our aesthetic emotion. Then we can break *completely* with optical vision.

X. But many magnificent things have been done without this exaggeration!

Z. What is exaggeration for one is merely a weak reproduction for another. If, over the centuries, a *consistent striving toward a stronger and purer representation of the visible* were not discernible in art, then art would appear as merely individual expression. Our time moves with increasing speed, its more rapid tempo produces a more vital emotion, which requires stronger expression. . . . This is how we can describe it from the emotional viewpoint. We can also say, however, that the consciousness of our age moves increasingly away from the vague toward the determinate; or again, that the contemporary spirit demands greater clarity.

X. We do see a great deal of exaggeration today, but it could simply be imitative.

Z. If it were merely that, we would not see the same struggle manifested independently, in so many places. . . . Moreover, people, especially artists, do not take to the new so readily unless they perceive its truth. Such insight is still rare, but where it does exist, the new can be more or less outwardly accepted because there is a readiness for it. In that case we cannot speak of "imitation."

X. But to return to the windmill, if you found it satisfactory to exaggerate the color, why didn't you continue to work that way, why did you discard all forms?

Z. Because otherwise *objects as such* would have remained in the painting—and then the plastic expression would not be *exclusively plastic*. When the "object" dominates, it always limits the emotion of beauty. . . . *That is why the object had to be discarded from the plastic.*

Scene 5: A garden with artificially shaped trees and hedges. A house

X. Here you see a "tautening." . . . But I prefer nature to be left free!

Y. I think the trees make a pretty sight; they go well with the straight lines of the house.

Z. Yes, this is what gives an effect of unity. Man has sought to establish a connection between himself and nature, and so he has "altered" nature. The character of this transformation shows once again man's drive toward intensification.

X. But the tautening we see here is *not to straightness*: notice those rounded forms.

Z. Thus the tautening is only half complete, one might say—actually we cannot speak here of *intensification*. What we see here is for the most part only a *generalization of form*: simply a stronger assertion *of form*—not *its abolition*. Thus we see here, just as in capricious nature, relationship *through form*, not relationship *in itself* and therefore not *pure* relationship.

Y. According to what you said before, I gather that you would prefer another solution. First you want to abolish *form*, and then you would seek equilibrated relationship. But then wouldn't everything have to be *flat*?

Z. This garden takes us from painting to *sculpture*. Sculpture deals with the third dimension differently than painting does: the painter has his three colors and black and white; the sculptor has only black and white. The sculptor has to seek straightness in three dimensions. Therefore his plastic is corporeal, although he can reduce the *roundness characteristic of all form* to the prismatic; and there again he can annihilate form "as particularity" by opposition or fragmentation. It seems to me that the New Plastic sculptor will have to seek the way through prismatic composition.

X. Doesn't sculpture then become architecture?

Z. Not at all. Architecture remains space construction, and must also meet practical requirements. Sculpture is more free.

X. Then is this garden closer to pure sculpture than it is to a "picture," as you see it?

Z. Certainly. In my conception the "picture" in sculpture must be completely discarded.

Scene 6: The facade of a church seen as a flat plane against the darkness, reflecting the light of the city

Z. Here is yet another *reality*—but it is still not an *abstract* reality.

Y. But isn't everything in it *flat and geometric*?

Z. The abstract is *the inward that has become determinate or the most deeply interiorized externality*. . . . It therefore never shows the indeterminateness seen in certain details of this facade; nor does it show *form*, such as we see repeatedly asserting itself here.

Y. But this church is nevertheless built with a certain style—couldn't they find the proper relationships?

Z. The primary concern here was not with *purely* equilibrated relationship but only with balance, with harmony. In architecture the outward is an expression of the internal *structure*. If the latter is not purely equilibrated, then the outward cannot be either. That is why it is essential that *architectural construction become entirely transformed* if it is to become a new plastic expression.

Y. Then all the architecture of the past can only *inspire* you toward abstract-real plastic. . . .

Z. As long as a *completely new* architecture has not yet come into being, where architecture—as commonly practiced—has lagged, painting must lead the way to the expression of pure equilibrated relationship, in other words, to abstract-real plastic.

Y. But isn't architecture *tangibly real*?

Z. The abstract-real can also be tangibly real; in a certain sense a canvas is also tangible. The New Plastic today expresses in painting what will someday actually become our *surroundings* through architecture and sculpture.

Y. Do you believe then that the New Plastic will *universally* prevail in these arts?

Z. Universally . . . but a long time from now. It is always *groups* that must pioneer, after the *individuals*. A few houses have already been built that express the New Plastic . . . but it will take time before these can grow into a city! Our surroundings will fall short of abstract-reality for a long time to come! But meanwhile Abstract-Real painting serves us as a model!

Y. Then you must find our towns and villages quite irritating?

Z. In a sense, yes, particularly in the villages and small towns where individual feeling—which is transitory—asserts itself too strongly for me. It also strongly dominates in many individual buildings in the *big* cities, although here they all dissolve more readily in the whole. In the metropolis the transitory is less assertive and the *beauty of pure utility* is more evident.

Y. But can pure utility be *beauty*?

Z. That the purely utilitarian can be beautiful is demonstrated by many objects of everyday use. A simple drinking cup is beautiful and so is an automobile or an airplane. Likewise, and also of our time,

are the works of modern engineering: bridges, factories, etc., built of steel or concrete. Perhaps the greatest fault of architects is that they *try to create* beauty.

Although the conscious expression of beauty is its highest expression, the conscious search for beauty has many pitfalls. So long as we are incapable of conscious aesthetic plastic expression, it is better to devote our attention to utility. And to do this purely, we must pay attention to life; in other words, to express life is to be concerned with what is useful. Is not art the interpretation of life? Precisely when it fails to interpret life in this sense, art wanders into the "agreeable," the "pretty," the "opulent," the "decorative," and the like.

Furthermore, to return to your questions, equilibrium is a law of nature: by its very nature it is *truth*; all *material* manifestations of *equilibrium* are therefore inherently *beautiful*. If man seeks equilibrium alone, his products will automatically be beautiful.

X. But you reduce the artist to an ordinary man! What about emotion?

Z. An artist need be no more than a pure human being who expresses himself through aesthetic plastic or, if you will, by creating . . . but neither can he be less. And that is not insignificant—it embraces everything!

Such a man is in fact *moved by, and starts from, equilibrium* rather than the accidental. So he is not without emotion! By virtue of "equilibrium" he automatically brings increasing equilibrium to whatever he creates—thus he seeks and creates beauty without thinking about beauty. If the artist isn't like that, then any ordinary plain person without aesthetic emotion is preferable, for *without it* he can produce a certain beauty through pure feeling and intelligence. The

engineer, for example, limits himself to pure construction: pure relationships automatically arise—out of *necessity*, which is *truth*. Consider, for instance, how beautiful is the Paris Métro; the beauty of its construction, which may be too cold to satisfy artistic feeling, becomes animated by light—which is also there because of pure necessity. The products of modern engineering also have the advantage of purely expressing the needs *of our age*: the old forms and styles are progressively abandoned, again through necessity, for new materials demand new construction.

Y. How beautiful that beauty deepens itself of its own accord!

Z. Yes . . . despite everything. We see *pure beauty* arising of its own accord in architectural structures built for utility and from necessity: in housing complexes, factories, warehouses, etc. But as soon as "luxury" enters, one begins to think of "art," and pure beauty is compromised.

X. But then wouldn't everything be barren and simple?

Z. Pure beauty is never barren, and strict simplicity is preferable to capricious luxury as long as true richness and true artistry remain unattainable. Let the rich use costly materials for their homes and furnishings rather than seek richness through capricious ornamentation, etc. Let artists concentrate entirely on the equilibrated relationship of form and color in their work; this would not be impoverishment; the expression will depend upon the materials used. But for this to be generally realized, social life must also become pure; and from this pure life a new beauty will spontaneously arise.

Y. To the new beauty corresponds a "new man"!

Z. The "new man" must indeed be com-

pletely different from the old. The "new man" performs all material activities, but he does so out of "necessity." He performs them just as well, but his relationship to them is different. He lives in the material, but without the old satisfactions or the former suffering. He uses his physical being as a perfect machine . . . but without becoming a machine himself. That is the difference: earlier, *man himself* was a machine, but now he *makes use of* the machine, whether his own body or the machine that he has created. He uses the machine, so far as possible, to perform the rough work so that he can concentrate his *self* on the inward. Ultimately, his soul also becomes a "machine" for him: his *self* becomes *conscious mind*. In art the difference is this: the old art was unconscious plastic expression of harmony through consciousness of the material, whereas the new is plastic expression of pure equilibrated relationship through consciousness of the spiritual.

Y. I don't see very many new men of this kind!

Z. I posit him as a "type"; in reality the type can still only appear in a very relative way . . . but he is appearing! And quite logically, where he does appear, he is alien to the man of the past, alien to all his expressions and to his art. So, for instance, he would feel "alien" to this church.

Y. Nevertheless, it does make a deep impression on me of grandeur, gravity, and repose . . . much as did the starry sky we saw this evening.

Z. We are entirely in agreement here. Such things as grandeur, gravity, and repose are *fundamental* and are not essentially tied to any particular appearance. Yet *what is it* that made this impression on

you? Was it not the *forms* that partly dissolve into the background in the evening light? And are not these fundamentals expressed through *what is veiled in these forms* and is now revealed so much more strongly than by daylight? If you experience your feeling of beauty more consciously, or, which is the same thing, if your vision is more purely plastic, then you will agree with me that the fundamentals are strongly influenced or *colored* by the form of their appearance.

Y. If not by the form, then by us. I remember your saying that we ourselves transform what we see. . . . In that instance it was the stars that we combined into forms.

Z. True—but with one significant difference. In the starry sky we were less closely tied to form, but we could easily lapse into *creating* forms. With this church, on the other hand, our vision is more strongly determined by its form, and it becomes more difficult for us to create forms. In short, the difference is that with the church we are limited by *something outside ourselves* but with the starry sky by nothing but *ourselves*.

Y. To me the starry sky displayed purer beauty. It made an impression "other" than that of the building, but I can't precisely describe it. Sometimes I am inclined to prefer the one, sometimes the other.

Z. Perception is extremely complicated. We have to reckon as much with our selves as with what we perceive. I purposely said "what we perceive" and not "what we see." For all our senses are involuntarily and simultaneously involved. Truth is different in all things and in all men: that is why it is so good that there is such a variety of things and such a variety of

people . . . for in this way we can arrive at *complete* truth.

Y. Then is unity among men impossible? After all, there are "styles."

Z. Within their own time and *group*, people can become relatively "united," and so "style" can arise. And in groups, they seek to progress. . . . One group can advance beyond another; in this way, the old and the new can exist side by side.

Y. When it comes to buildings, the old survives a very long time!

Z. If nothing happens to such a building, it certainly does!

Y. This church takes me back to "other" times . . . however beautiful it is!

Z. Yes. Once we have passed our first aesthetic emotion, so to speak, we are restricted to *thoughts of the past*. We see the forms of a "style" that is not *our own*; stylized forms are always more or less *descriptive*.

X. Well, surely the descriptive can also be beautiful, can't it?

Z. It can, but the descriptive detracts from *pure plastic* beauty. *The descriptive belongs to its own time and therefore changes, changes constantly. All appearance changes, everything is in flux and in process, as the ancients said long ago. Everything changes and so do we: we are always becoming something "other" than what we were.*

Y. Isn't that tragic? Where is our stability?

Z. Outwardly it is tragic; inwardly it is happiness. *For movement is not useless. Deep within the mutable is the immutable, which is of all time* and is manifested as *pure plastic* beauty. This beauty alone—in this building it is veiled by the varied forms—can be a *living reality* for us. It is *universal beauty*. The goal of the New Plastic is to bring this out clearly.

All the styles of the past have served gradually to reveal it. Finally, equilibrium is expressed in a *purely* plastic way, through *pure means: through the relationship of position and dimension of the straight.*

Y. It seems to me that architecture is perfect for this!

Z. I agree. Of course there are great practical difficulties but they can be overcome.

Y. If the modern spirit shows in every way that it seeks clarity, why does art in general lag behind?

Z. Yes . . . why should universal beauty remain concealed in art, whereas science, for example, seeks all possible clarity? Why does art continue to follow nature when everything else leaves nature behind? Why doesn't it appear as something "other" than nature? And which art is best suited to stand constantly before our eyes as "other" than nature? Does any other art surround us more completely? *Architecture's great task is constantly to keep universal beauty clearly before us and thus to collaborate with sculpture and painting as a totality.* As this idea becomes the idea of all humanity, it will become realized and the old will fall away of its own accord—but how those old stones do last! New thinking manifests itself in a new appearance. Exactly how the old will fade away we really don't know. What matters is to have a *clear image of the new*! The great fault generally is that we *continue to think in the old way*! The old environment is partly to blame, although on the other hand the sight of the old drives the new spirit to action in the other direction: the new spirit, *the strong*. The weak—and they control the money for building—will *follow.* It is perfectly natural for modern man to have a certain resistance to all the

old, or rather against everything that "encloses us," and the Futurists expressed this very directly. The difficulty, however, is to create something better, and so long as we are incapable of this, it will be of little use simply to clear away the old. We see this in practice, when war-devastated towns and villages are rebuilt in the old style. Thus we see that as long as the old still exists, there is a *need* for it. Time achieves everything, but let us exert all our strength to shorten the time! It can be shortened.

Y. But how? And who will do it?

Z. Just as I said: *by establishing in ourselves a clear image of the new.* We can all do this, but only architecture can *realize* it. The new must *come from all of us.* Architecture has only to realize tangibly what painting has demonstrated abstractly in the New Plastic. The architect and the engineer are the ones to achieve the future harmony between ourselves and our surroundings. At present we are living in the midst of the old.

Y. And living amid the old, even the strong find it hard not to fall into the same rut.

Z. Very true. What are our present surroundings? We live like strangers in another man's house, with another man's furniture, carpets, utensils, and paintings. If we go into the streets, they too belong to others. When we go to the theater, it is the same. The cinema? Between its antiquated morality and its "naturalism," it too is not of our time.

X. Yet there is "beauty" in all this!

Z. Yes, but childish beauty. *The old art is an art of children, the New Plastic is for adults.* Just as the adult is a stranger to the child, so the new man—for whom the New Plastic exists—is foreign to the old art. Adults have another life . . . but let us return to this later.

Y. But are there not adults who find the New Plastic incomprehensible?

Z. This is due to unfamiliarity or to their inability to see: we achieve different kinds of maturity according to our disposition. I speak about art as art. But to return to the old beauty: if it were not actually so beautiful, then people would not continue to surround themselves with it . . . even while they are still making the transition from child to adult. Of course they are beautiful, those old-style houses, and old-style furniture, but their beauty is of a kind that no longer *affects* us . . . and in actuality is no longer beauty *for us.* Although I appreciate the beauty preserved in museums, I resent just as strongly *being forever surrounded* by objects of largely inferior artistic merit simply because they have the cachet of age.

Y. But isn't it just weakness to be influenced by all that?

Z. *It is precisely for the weak that I am arguing: the strong go their own way, establishing a new beauty*—even if it is not yet concretely realized. In any case . . . where is the new man to find his home or his city? Ignored by society, he is an outcast.

X. Would you have new buildings for each generation?

Z. That is a Futurist architect's idea.[3] But would it not be a better solution for *buildings to be useful at least for several generations?*

X. What if each generation is "other," as you said?

Z. It is nevertheless possible, or at least *it is becoming possible by making buildings that purely express the immutable—which remains the same for each generation.*

Scene 7: *Z's studio*

Y. We have seen so much beauty this evening. What a pity it is over.

Z. The evening is over *but the beauty remains.* We haven't simply "contemplated" visually: an *interaction* has taken place between us and the perceptible. This interaction must have had some result. It has produced more or less definite *images*: images that not only remain with us but gain in power now that we are alone with them and away from nature. *Now these images*—and not the things we saw—*are the true manifestations of beauty for us. If you practice visualizing clearly and retain these images of beauty, then ultimately a single, constant image of beauty will remain with you permanently.*

Y. That seems ideal, but it must be difficult for the layman to achieve.

Z. It is true that artists through their innate drive and their training are constantly preoccupied with forming and preserving images of beauty. The naturalistic painter seeks to form a fixed image of the natural. Because he shapes it according to *his* own particular feeling, his image also differs from ordinary optical vision. Likewise the Cubist seeks to assimilate a fixed image of things. Because he *perceives things completely differently*, his image differs even more from ordinary vision and perspective appearance. And the Abstract-Real painter also forms his fixed image of visual reality: he allows this to react upon him and, in the process of working, achieves an *abstract image of relationship.* In the artist, then, we see the image of beauty developing, so to speak, *freeing itself* of objects. *By freeing itself from the object, it can grow from particu-*

lar beauty toward universal beauty. The abstract image of relationship is the freest from limitation, thus from the tragedy of the material and individual, and is the purest expression of the universal. The universal is generally *unattainable as long as we remain traditionally attached to the particular*; in art, the universal is *impossible to express determinately within naturalistic form.* This ought to be pondered by today's proponents of "universality."

Y. In life that is certainly so; in art I am not so sure.

Z. Just as in life, so in art, and conversely. As we free ourselves from attachment to the particular, our concept of beauty becomes freer, and conversely. *The freeing of our image of beauty both expresses and involves the evolution of our life.* Just as the evolution of our life involves the annihilation of the individual *at each stage of its maturity in us,* so we automatically destroy each image of beauty *when it has matured in us.*

Y. What a pity that evolution is so uneven, that those whose image of beauty is mature stand isolated as individuals among the rest.

Z. Yes, for so long as one's concept of *beauty* remains immature, one *cannot destroy it.*

Y. That is why we cannot hate those who think differently from us.

Z. Of course, but there is a certain way of clinging to tradition that is criminal. From inertia, weakness, or whatever, one does not wish or dare to destroy the image of beauty that has *matured in one's own time.* Then one preempts the place of new life. Man is destroyer as well as creator and conserver—all wisdom has so depicted man's nobility.

Y. But by destroying, one also destroys oneself socially.

Z. To be sure. As society is now generally constituted, one harms oneself materially by breaking with the old form. In fact, we generally do ourselves harm when we break with anything, even if only temporarily . . . but the new is not concerned with this . . . it is not concerned with time.

Y. I think this is another reason why so many artists involuntarily remain with the old without ever realizing it!

X. But isn't it better for them to go on producing the old beauty than to stop creating beauty altogether?

Z. As I see it, the latter is preferable. As you know, I hold rather radical views. But it is nevertheless true that the outlook seems worse for each new expression of art, for art increasingly departs from nature and so becomes more and more unintelligible to the materialist, who in our society has the buying power. Anything new must exist for a long time before it acquires material value: just think of Van Gogh who is still not widely accepted.

Y. It's very sad to think that at first the new is sustained by something that is evil. I have in mind art-market speculation.

Z. So we see that evil, *in terms of evolution,* sometimes is not evil. Generally, everything, good or bad, causes the new to arise: perhaps evil more than anything else.

Y. That evil sometimes thrives on good is quite remarkable. Often we see buyers of art who are opposed to the new yet profit from it . . . once it has become thoroughly established as the "old."

Z. But if we consider that at least unintentionally, they *give material value to the aesthetic*, then once again we must call evil good!

Y. Evil thrives on good in still another way: just think of the critics who largely live by attacking the new!

Z. Nevertheless, the good benefits from this: it also grows from being attacked.

But returning to the destruction of form: we must *constantly discriminate between our images of beauty*, until our image of beauty becomes *purified and inward*. Art shows us a sequence of expressions from the naturalistic to the abstract that could arise only through continual destruction and creation. I already spoke of the naturalistic, Cubist, and Abstract-Real conceptions of beauty in relation to nature. Ultimately, however, the artist *no longer needs a particular starting point in nature in order to achieve an image of beauty*. As the universal becomes more conscious in him because the individual has lost its dominating influence, from this greater consciousness he spontaneously creates equilibrated relationships—complete harmony—the goal of art. *He has then assimilated outwardness into himself*: thus it *remains within him*—to move him.

Y. True. Emotion is an interaction of the inward and the outward.

Z. Yes, of the universal and the individual. However, here the individual has matured. In the aesthetic realm we can say that the *particularity of what is given in nature* has been transformed *into unity through memory*.

Y. In fact, art in general is the expression of memory.

Z. Or the search for plastic harmony between the aesthetically inward or intuitive and memory of the outward.

Y. But is what we remember real?

Z. What was real just a while ago is still real, and you exist now just as you did then. Has the connection between you and the things we saw ceased to exist just because you do not see them any more, or because you see other things? Moreover, isn't the one just as real as the other, and can't the one make the memory, or the retained image of the other, completely real? Doesn't this explain our ability to see beauty constantly?

Y. Exactly! It can be a most powerful faculty, and it is particularly strong in the artist!

Z. But the layman also possesses that faculty, sometimes even to a very considerable extent. Why shouldn't he be able to cultivate an image of beauty? The identical path is open to him—he only lacks plastic experience in the use of the materials, and he has just as much opportunity to practice *abstract* plastic.

Y. Indeed, you have really convinced me of this tonight. But it isn't easy because the layman is constantly preoccupied with other things! How fortunate you are to be able to live you life continually involved with beauty.

Z. *Relatively* fortunate. The artist can be completely happy only *if his concept of beauty is homogeneous with the outward environment in which he lives*. A naturalistic painter can be happy in relation to nature, or in general, in relation to all natural reality.

The Abstract-Real painter, on the other hand, knows another beauty: beauty *that he created plastically* but that he always perceives as veiled in natural reality. Harmony is necessary for happiness: harmony between the outward and the inward. The new man seeks *interiorized outwardness* and only through this

relationship can he be completely happy.

Y. Then isn't the more natural man happier?

Z. No: he enjoys complete human happiness only in relation to the natural—in, with, or through the natural. The new man can no longer be happy in this way because his is a *limited* happiness. The new man's happiness is freer, stronger, more constant. But it is *inward*, and the outwardness that would complement it is still lacking. That is why it is incomplete.

Y. Is this the happiness of the abstract-real life you were talking about?

Z. Yes, this inward life must create its outwardness: abstract-real life will realize itself in outward life, and thus be realized in all outwardness. This is how the new man will find *his* outwardness, and thus his complete happiness.

Y. Indeed, interiorized outwardness is not easy to find today.

Z. But if we do find it, for instance, in a person . . . then other external factors work against us: today everything is dominated by the *most* external, by the materialistic. Thus the contemporary artist is happier than the nonartist only insofar as his outlook leads him more easily to move toward abstract-real life! In this society it is certainly difficult to think about beauty; in the midst of disequilibrium it its difficult to be concerned with equilibrium. But we will return to that. Nevertheless, it depends mainly on us, whether we lose ourselves in material things or succeed in cultivating the image of beauty. This is not a luxury! *A concept of beauty free from materialism must reshape our materialistic society.*

Within society, not only the layman but also the artist is concerned with much more than just his work. You say it is hard for the layman to concentrate solely on beauty—but the artist too is compelled to be overly preoccupied with material life. It is especially difficult for anyone who has broken with the old, as you yourself have remarked.

Y. I'm not in the least surprised that this studio is yours. It breathes your ideas. Most studios are quite different.

Z. And most painters are quite different, the one goes with the other. Most painters further the cultivation of the old and like to surround themselves with antique furniture, old paintings, carpets, and so on.

X. With good reason: painters seek beauty, and such things are beautiful.

Z. Of course they are beautiful . . . but they are antiquated! We have already discussed that. I think it retards the development of a new concept of beauty if the artist turns his studio or house into a kind of museum of ancient art—and not usually of the best at that. This creates an atmosphere that is unsuited to the new and clings to the old. The layman follows the example of the artist. The contemporary artist must *in every way lead the development of his time*. This studio expresses something of the idea of the New Plastic. *To some extent, equilibrated relationship is determinately expressed through color and line alone.* The building itself was not ill-suited to this in the first place. At any rate, the studio has a certain architectural arrangement which, through its structural characteristics, provides a more determinate relationship. This cannot be said of most rooms. Dutch rooms in particular are usually very poorly arranged architecturally and are generally little more than a space bounded by six empty planes with openings for doors and windows. They then have to be articulated by whatever the occupant chooses to place or hang on them. French rooms usually

have more inherent articulation: more attention is given to paneling, built-in fireplaces and mirrors, flooring, and so on; each with its inherent design, as we sometimes see in the homes of our well-to-do. Nevertheless, wall surfaces remain either completely blank or articulated in a disequilibrated way.

Y. That is true. There can be great differences between rooms.

Z. This is caused by the differences in *arrangement and color*. You can see it in many French shopping streets. The various facades *articulate* the street. Through black or white or another definite color, each is *distinct* from the other. Together they form a *composition of color planes* that expresses relationships determinately. I have, however, also been much impressed by the architectural and decorative division found in the farmhouses of Brabant.

Y. Should the *articulation* of a room also accomplish this?

Z. If a room is well proportioned, it can satisfy us at first but not in the long run. This is not enough to make it *livable*. To become livable, to give us *continuous aesthetic* satisfaction, a room has to be more than an empty space bounded by six empty planes facing one another: it must be an *articulated* and therefore a *partially filled space bounded by six articulated planes that oppose one another by their position, dimension, and color.*

This has always been vaguely sensed: rooms were divided by furniture and other objects; walls are divided to some extent, if not by the structure itself, then by the furniture, pictures, and so on. But all this is done in a more or less capricious way and by more or less capricious means, so that articulation, instead of

expressing relationship, rather becomes *decoration*.

Y. Indeed!

Z. The organization should not center on objects that have been brought into the space: *all* the elements must work together as an entity. The various "branches" of art should not try to *replace* one another. Applied art and painting cannot take the place of architecture and vice versa. They can only complete architecture, deepen it, so to speak, and architecture can only support them. But this has been viewed quite differently: architects designed furniture and decorations and painters made *decorative* architecture. They tried to express structural functions through ornament, forgetting that this must be done by the architecture itself. In this way, the plane was used decoratively, as a *limitation*, by having the motifs at the edges act as an enclosing "frame." The *function of architecture*, nevertheless, is to *enclose and limit*: *plastically*, however, the rectangular plane is *expansive* in character.

Y. Can't architecture express expansion, then?

Z. Although its *structural function* is to *cover* space, architecture expresses expansion in *its own way*: through the *multiplicity of its constructive parts* and the *constructive articulation of the whole*.

Y. Now I can see clearly why decorative painting, which is expressed through *form*, can never adequately emphasize the plastic expression of *expansion*.

Z. Pictorial painting is equally incapable of it. Both are basically one. That is why it is quite logical that, *with the purification of both, they will merge into each other*. Painting, when purified, works with *line and color* exclusively. The painting of the past, whether pictorial or decorative, to

some degree always veiled the purely plastic through form and representation, particularly through *representation*. For example, the plastic is expressed more purely in certain ancient Moorish ornament than in the so-called rational ornament of our modern "stylizing" period and its figurative decoration.

Y. And the same ideas apply to the entire contents of the room, to applied art, furniture, carpets, etc.?

Z. Naturally. For only then can there be *unity*. Until now, the objects that articulate the space, instead of being themselves the *means of articulation*, were seen as self-contained, as "individual." The objects had very little actual connection with the form and color of the room. Since the room was decorated to accord with its contents, or the contents were chosen to accord with the room's appearance, a certain "harmony" was achieved but never an *exact expression of equilibrated relationship*. For this, there has to be *equivalence* of the one and the other. If the articulation of the room is not haphazard, neither can the furniture, etc., be haphazard.

Y. To the extent that the furniture is rectangular, it does agree with the rectangularity of the room.

Z. In order *to achieve pure equilibrium*, the *total appearance*, the form and color of funiture, must accord with the *total appearance* of the room, not only in the relationship of form but also in the relationships of dimension and color. In their overall form, naturalistic paintings also accord with the rectangularity of the room—but then you must not look at what is in them! To articulate the wall in a pure way, you would have to turn their painted side to the wall.

Y. Then furniture and everything else has to be designed *in relationship* to the room?

Z. Everything has to be designed in accordance with *the one idea*, the *New Plastic conception*, if *pure* equilibrated relationship is to be exactly expressed in the whole. Then all the arts automatically collaborate. Each art has specific requirements and therefore requires its own specialists. Each specialty demands complete attention and study.

X. But a New Plastic room would be rather lacking in intimacy!

Z. That would depend on how it was executed . . . and on one's personality. What sees intimate to one person may not seem so to another. On closer examination of the word's meaning, one hesitates to use it at all.

X. Frankly, I do not like this "Neo-Cubist" decoration, though I find its colors quite attractive.

Z. "Neo-Cubist" is not a bad term, for the New Plastic is a consequence of Cubism: the term is not inappropriate because Cubism is more widely known today than the New Plastic, and "Neo-Cubist" provides a useful clue.

Y. Perhaps because I am a layman, I favor "Neo-Cubism." I am satisfied with it, but an artist will, of course, have his own more specific conception. You said that the structure of the room itself also contributes to your chromoplastic?

Z. To some degree, yes. The loft, the projecting fireplace and cupboard already provide a division of the interior space and its planes. These planes are articulated architectually by the large skylight in the ceiling, by the studio window in the front wall subdivided into bays, and these again divided into small panes, by the door and the loft on the rear wall, by the fireplace and the window on one side

wall, and by the large cupboard on the other wall. Upon this structural division were based the painterly articulation of the walls, the placement of the furniture and equipment, and so forth.

Y. Yes, I see how all these things help to articulate the room, and so do the ivory curtains that are now drawn open.

Z. The curtains form a rectangular plane that divides the wall surrounding the window. To continue the division, I added those red, gray, and white planes on the wall. Even the white shelf with the gray box and the white cylindrical jar also contribute.

Y. The jar appears as a rectangular plane!

Z. The gray cupboard in the corner is also significant.

Y. Also, the orange-red paint chest below the curtain . . .

Z. . . . seen against the white and gray plane behind it.

Y. The ivory chair looks well against them.

Z. Notice next to it the gray-white work table, and on it a chalk-white jar at one end and a light-red box at the other, seen against the black and white planes on the wall below the window. And next to the table, the black upholstered bench against the dark-red plane on the wall next to the window.

Y. The yellow stool looks fine in front of the black bench.

Z. We could continue in this way throughout the entire studio, but one thing I must point out: there is still a lack of unity.

Y. If the work wall were also treated in color, wouldn't you find that a hindrance?

Z. The easel stands in front of that large cupboard projecting into the room. In this studio it should be painted a neutral color like gray; that would solve the problem here. . . . But an even better solution would be to stop making separate paintings. If we organized our interiors along the lines of the New Plastic, then New Plastic paintings also could gradually disappear. As our complete "surroundings," the New Plastic would be even more really alive. In execution, a painting and an interior are equally difficult. It is not enough to place side by side a red, a blue, a yellow, and a gray, because that remains merely *decorative*. It has to be the *right* red, blue, yellow, gray, etc.: each right *in itself and right in relation to the others*. Everything depends on *how*—on the *how* of position, of size, of color. The color effect also depends on the construction of the room; the way the light is distributed also determines the color.

Y. Our rooms are generally much too dark!

Z. Yes, . . . they are suited to a dark age. But darkness accentuates the need for light; the darkness *around us* diminishes the darkness *within us*, and develops our inner light. Light and clarity must also come into our rooms—and with them color.

Y. Do you really believe that painting will gradually disappear?

Z. It will be possible for the Abstract-Real "painting" to disappear as soon as we can bring its beauty to equal expression through the color articulation of the room.

X. But we have never been able to do without naturalistic painting!

Z. That is because it is altogether different from Abstract-Real painting. Whereas our rooms and everything in them can plastically express mood and natural harmony, all painting-in-the-manner-of-nature specifically expresses *individual emotion*.

That is why the past could not do without it. On the other hand, pure aesthetic plastic expression of the determinately universal, the exact expression of relationship through line and color alone, is far different from painting-in-the-manner-of-nature, and brings Abstract-Real painting continually further from "painting."

Y. But can the same plastic expression be achieved in a room as in a painting? A painting, for instance, can be perceived as a whole all at once, but we cannot do that with a room.

Z. Relatively speaking, the room can also be seen as a whole all at once. Remember that we perceive inwardly otherwise than just visually. We survey the room visually, but inwardly we also form a single *image*. Thus, we perceive all its planes as a single plane. Moreover, is it so desirable to see the plastic expression *as a whole*? Doesn't *painting* still remain too much a "thing"? And isn't the three-dimensional unity of the wall surfaces precisely a means whereby we may move in several dimensions inwardly, that is, more deeply? In a room, I think, the individuality that clings to every form is easier to annihilate.

X. But a room surrounds us *constantly*: is it really desirable to live continuously in such deeply moving beauty?

Z. It is even more so in the room-in-the-manner-of-the-New-Plastic than in painting-in-the-manner-of-the-New-Plastic: the room can be seen *constantly*. Painting-in-manner-of-nature is predominantly individual and therefore cannot satisfy us constantly. The emotion of beauty that is predominantly individual is *transitory*. Only *pure plastic expression of the universal can satisfy us constantly*.

Y. But pure plastic expression *of the universal* does contain the interiorized individual.

Z. Yes, because it contains *everything*. Pure plastic expression of the universal is *equilibrated*: *it is therefore equilibrated duality of the interiorized individual and of the determinate universal*. As opposition to the predominantly individual (naturalistic expression), the New Plastic can also be broadly termed *plastic expression of the universal*. That is why the New Plastic, where individual and universal are *mutually opposed in a equilibrated way* and therefore *in repose*, can constantly surround us. Moreover, the New Plastic is so versatile that each room can be designed according to its own particular requirements. The desired harmony between the room and its purpose can be achieved through the composition and relationships of the color planes, through more or less color, through the character of the color, and so on.

Y. Rooms like these require new men!

Z. New men will someday demand such surroundings. Yes, everything depends on man . . . but man will not forever remain as he generally is today: life will evolve *from the materialistic-real to the abstract-real!*

Y. From what you have just said, I can better understand why the New Plastic pays so much attention to *equilibrated relationship*. However, to meet the objection that a simple aesthetic expression of equilibrated relationship is not art, it might be even better, for example, to speak of "aesthetic plastic expression of the universal."

Z. Truth is many-sided, and in order to describe it as completely as possible, one must illuminate its many sides. Your definition also is good, provided that it is properly understood, and the New Plastic often employs it. Improperly understood, however, it could be taken to mean that

the individual is of no account at all—and that is not possible in art. The determinate plastic expression of the universal is inconceivable without pure equilibrium, and equilibrium is inconceivable without duality. Duality expresses *relationship*. If only one thing is expressed, then the *particular, whatever it may be, dominates*. The determinate plastic expression of the universal is the expression neither of the one nor of the other, but is the plastic expression of *equilibrated relationship between the two*. Therefore, the *aesthetic plastic expression of pure equilibrated relationship* can be art because it includes everything.

Y. Then the definition "equilibrated relationship" is indeed well chosen.

Z. And not only for that reason, but also because the New Plastic wishes to focus attention on the *appearance* of the work: the universal is what it *seeks* to express, but its *appearance* is the equilibrated relationship of the duality of opposites. Today, now that the new has arisen, it is of utmost necessity to focus attention on the *appearance* of the new, so that we can see from its *appearance*, from its *plastic expression*, whether a work is *actually* a pure plastic expression of the universal. Art is a matter of *production*, just as life consists of *action*. In the manifestation of the New Plastic the most external plastic means, form and natural color, are interiorized and in this process become equivalent to the pure plastic expression of the inward. These expressive means, the rectangular color planes, are always purely opposed to each other, and so, in the New Plastic, we can speak of *equilibrated relationship*, as opposed to the old painting, which expressed *harmony*.

X. But isn't harmony also equilibrated relationship?

Z. Naturalistic harmony, the old harmony, is not *plastically expressed* according to the concept of *pure* equilibrated relationship. It is expressed as *relative* equilibrium. It remains dominated by the "repetition" characteristic of nature: it expresses opposition but not the *continuous annihilation of the one and the other*. That is why the New Plastic is precisely *against* the old harmony. To realize the new harmony is the difficult task of the new artist.

Y. That is why I have never believed that the New Plastic artist can have his works executed by others, by nonartists.

Z. What about the architect? Doesn't he produce art *through* others?

Y. Yes, but architecture is different from painting.

Z. The more painting appears as the "*new chromoplastic in architecture*," the more it will merge with architecture.

X. But then we would lose an art!

Z. The time will come when we will be able to dispense with all the arts as we know them today. Their beauty will have matured into something that is concretely real. Mankind has nothing to lose from this. Architecture will need to change the least, precisely because it is so different from painting. Even now, in architecture, the work is performed and the materials are "put in place" by nonartists. Why shouldn't this be done in painting?

Y. But surely color is something very special!

Z. Just as stone, iron, or wood are set into place in architecture, so *panels of color* could be placed in the painting—if only they were available!

Y. But that would not be the same. From the moment that color is applied mechanically or applied by a nonartist, it would become something *other*.

Z. Precisely. In order to achieve that "other-

ness," the New Plastic seeks a method of execution that is other, another technique. Abstract-Real painting already demands another technique, but the new chromoplastic in architecture demands it even more strongly. You say that the color would be other, but you mean *less right*. I agree with the first statement but not with the second, so far as the chromoplastic is concerned. For the beauty it will bring into being will be of another nature.

X. Certainly it would be "colder."

Z. Colder for individual feeling, perhaps, but more intense for universal feeling. Because so much depends on technique, execution, and materials in the new chromoplastic in architecture, it is very difficult at present to give a precise idea of the new beauty while techniques and materials are still undeveloped. The execution that the New Plastic demands, with the assistance of technicians and machinery, will be *other* than execution directly by the artist himself, but it will be better and closer to the artist's intentions. At present it usually falls short of his intentions. For the artist always has difficulty in making himself a *pure instrument* of intuition of the universal within him. He is constantly obliged to weary himself with technique and execution; and this effort more or less dilutes the universal with his individuality.

X. But isn't the artist's hand all important?

Z. In terms of the old art, yes. Then the hand of the artist was everything—precisely because the individual predominated and the universal remained *veiled*. *The new art demands a new technique. Exact* plastic demands *exact* means. What could be more exact than mechanically produced materials? The new art needs adept technicians. The new era is already involved in this search: colored concrete,

colored tile; but there is still *nothing useful for the New Plastic*. As long as this is so, the new chromoplastic in architecture will have to be executed "in paint" by artisans.

Y. But wouldn't that result in *something quite different* even if the artist does determine the colors himself? Isn't a copy of a painting or other art object always something "other" than the original?

Z. That results from the personality of the artist and the particular way he assimilates the technique. Furthermore, ancient art objects were made by techniques often unknown to us, out of different materials or materials altered by time. Nevertheless, a good copy is rather difficult to distinguish from the original—much to the profit of some art dealers! But beyond all that, the New Plastic artist, as I said, aspires to something "other" than he can now accomplish.

Y. If a work of art is to express the universal more determinately and the individual is no longer to be dominant, wouldn't that make it easier to copy?

Z. It would be just as difficult, but there would be a better chance of success precisely because everything would be more under control.

Y. But wouldn't that make it even harder?

Z. In any case, a copy of a naturalistic painting will always "look like" something.

X. But wouldn't this new method of working mean the disappearance of the *personal* element in the execution that characterizes a work of art?

Z. That is precisely one reason why the New Plastic can manifest itself as "style." In all the periods of great style, "personality" was subordinated, and the universal spirit of the age became the force that inspired art. And so it is today. Increasingly the

work of art speaks *for itself*. Personality is displaced; each *work of art* becomes a personality instead of each artist. Each work of art becomes another expression of *the universal*.

X. In such periods of style weren't the works of art executed by nonartists; wasn't everyone inspired by *the spirit of the age?*

Z. It is difficult to confirm or to deny whether the universal emotion of beauty was active in all of them, but I doubt that the Egyptian slaves who built the pyramids were animated by the spirit of their age. Yet works of art were created that to me are greater than those of the Middle Ages, for example, when there was already a more general consciousness of the spirit of the age.

Y. As soon as man becomes more conscious of the spirit of his age, his personality begins to assert itself.

Z. Precisely. The spirit of the age is then rapidly lost in the individual—until it has matured in the individual. Then it resumes its universality and "personality" recedes into the background.

In the New Plastic the personal becomes increasingly superfluous. The more the New Plastic painting merges into reality itself, *the more it is transformed into total architecture*, and the more the personal element recedes.

X. Then won't painting become something like what we now call *decorative art?*

Z. Only in technique. In its very essence and expression the New Plastic cannot be ornamental. Decorative art *fills, covers, embellishes*; the new chromoplastic in architecture is *living reality as beauty*.

Y. Would machines, machine-made objects, and artisans or technicians simply be the *means?*

Z. Of course. The artist must control everything if he is to achieve the *highest*

beauty. But this, as I said before, does not prevent the man who is not an artist from creating beauty simply by following the basic laws, such as equilibrium, necessity, and function.

Y. Then wouldn't this beauty be the same as we find in nature?

Z. That depends on the kind of beauty one creates: a rustic shelter is close to nature; a work of modern engineering is not. The latter to some extent compels man to express *equilibrated relationship*.

Y. That is true. Some things are beautiful even though they have never been touched by the hand of an artist!

Z. So you see that the artist's hand is not so completely indispensible!

Y. But what about music? We have the instruments but there must be artists to play them.

Z. Again, that was true for the old music; the new music has other requirements. The closer music comes to pure expression of equilibrated relationship, to determinate expression of the universal, the more it will find itself limited by the existing instruments. We must look for new instruments—or for machines!

Y. In order to escape the individual, just as in painting?

Z. In order to escape the *domination* of the individual. What absolute attention is required both of conductor and musicians in order not to falter during the performance! Wouldn't it be splendid—and far more reliable—if there were a machine to which the real artist, the composer, could entrust his work?

X. But then something would be lacking. Think of the violin, for instance. The best of the new ones doesn't have the tone of a well-used old one!

Z. I think what you say is true, but only for the old music. Old music and old violins

don't mean very much to me; I far prefer the jazz band where the old harmony is broken up. That, at least, is a beginning. The new concert music is concerned with the same thing but goes about it differently.

Y. I feel that because the new beauty is very different from what we have known up to now, it may be that different means and. different techniques become necessary in art.

 However, we don't just *see!* A great deal reaches us through *touch!* And isn't it possible that the visible acts upon us invisibly? I have in mind a new scientific hypothesis, an ether theory, which holds that through human touch matter undergoes a permanent transformation that varies with the mental attitude of whoever touches it. According to this hypothesis, it would not be the same when an artist, so to speak, projects his emotion of beauty on canvas or wall and when a workman unreflectingly spreads his paint over a surface!

Z. The question is whether we can *see* this transformation of matter. The occultists even teach that whoever touches an object affects it with his own aura. If this is true, then it might also explain the strange feeling we sometimes have in museums, that the aura of the old art is opposed to that of the new, and conversely. However that may be, inward and outward are deeply interwoven: what appears to us as "an object" is also a force, just as man is a force and also an object. That one force can apprehend another is quite possible, even if we can't be completely *certain* of it.

 Wouldn't it be better to confine ourselves to the *certain*? Our senses are suited to the physical world, not the ethereal, or astral, sphere. So long as we possess no other or deeper senses, let us confine ourselves to what is manifested outwardly. What we cannot perceive is a question of knowledge of feeling. For us, higher knowledge is relative, and as for individual feeling, only physical sensation is universally certain. Universal feeling that has become clearly determinate far transcends all other feelings, but it can only *manifest* itself when particular, individual emotions do not interfere. That is why the new art excludes them.

X. So you don't exclude emotion altogether?

Z. It is *another* kind of emotion, just as it is another kind of beauty.

Y. Yes, our ordinary emotions are unreliable.

Z. Life has only two expressions upon which we can build, given *pure* vision: *action and plastic expression. Pure* plastic expression can be regarded both as *silent* action and as *silent* outward plastic expression. Everything is contained by and begins with this pure plastic expression, which itself remains motionless. It is movement *in pure equilibrated relationship* that expresses *repose.* In life, action as well as plastic expression is usually veiled and unclear. The great task of the new era is *to manifest both clearly.* Thus *truth* is revealed. Our age teaches truth, just as the previous age taught love. Previously *love concealed truth*; today *love is concealed*—within truth. Love has grown into truth.

Y. Yes, everything changes; but basically everything remains the same.

Z. This is the great revolution; the reason why the old era is opposed to the new, and vice versa. The old—in its own way—wants *love*, but it does not want *truth*. And as long as the old is the more powerful, then the advance of the new in life and art will be very slow.

Y. Because truth appears to us through what is perceptible, I can see why the plastic

appearance of things is so important.

Z. And the more purely we perceive truth, the more the most external recedes—and the more abstractly we can see and express ourselves plastically.

Y. Now I can *really* see the abstract in this room. I have the sensation of being surrounded by flowers, or rather I experience the beauty of flowers even more strongly than if I actually saw them! And all this exclusively through the color planes, or in your way of thinking, these colored volumes. For me, that red cupboard is like red poppies in the sun. In this way I see the New Plastic as the consequence of naturalistic painting, which has always sought intensification. I am thinking of Van Dongen's flowers, which were simply round flat patches of color.

Z. The abstract beauty that moves you here is the beauty of *all things*. You thought of flowers, of their beauty: true, it is their beauty, but their deepened beauty. Naturalistic flowers are for children and the feminine spirit. Flowers best express the outward, the female. Here the feminine is expressed more *inwardly*; thus it is in equivalence with the *interiorized* expression—interiorized in relation to the outward expression of the masculine spirit, which is also manifested here. *This equivalent duality forms a true unity* . . . You see what a strong aesthetic emotion it could evoke in you. Color, interiorized, is pure . . . perhaps that is exactly why it reminded you of flowers. But all naturalistic color when intensified is *pure*, just as all line when intensified is *straight*, and all form when intensified is *plane*.

Y. When you see things this way, everything is far more beautiful . . . everything is more joyous!

Z. The most profound beauty should no longer be spoken of as *joyous*. Joy is only one element of life's duality: joy and suffering, which appears plastically as *expansion and limitation*. In profound beauty *both are opposed in equivalence*, thus destroying the particularity of both joy and suffering: *repose* ensues. Once beauty is freed from the dominance of the tragic, this deepened beauty enables us to experience the feeling of freedom, which is joy. . . . In this respect you are right.

Y. And the domination of the tragic is abolished by the annihilation of form?

Z. The limitations imposed by form oppose expansion: this is the tragic. If limitation were completely abolished, the tragic would disappear, but so would all appearance that is real to us. Therefore, limitation cannot be completely abolished from the plastic but its *dominating power* can. Limitation must be interiorized; form must be tensed to straightness.

Y. And what about expansion?

Z. In form, expansion is usually expressed *vaguely* in contrast to the definiteness of limitation. Therefore limitation dominates. Expansion, the *plastic manifestation of life force*, must be brought from vagueness to determination if it is to be *plastically* effective, if it is to oppose interiorized limitation in equivalence.

Y. Then the New Plastic is plastic expression of *interiorized limitation and of determined expansion*?

Z. Yes. I have already explained that this expression consists of the straight and the planar: *only the straight can express expansion and limitation equivalently*. These two opposites appear plastically through the most extreme difference of position: *the perpendicular*.

Y. And how are expansion and limitation expressed by color?

Z. Through *color relationships* but also through *color itself*. Just as line must be

open and straight in order to express expansion determinately, color must be *open, pure, and clear.* When it is, then it radiates the life force; but when it is closed and unclear, then it resists the life force and predominantly expresses limitation, the tragic.

The New Plastic, because of its technique and in particular its planarity, can achieve *equivalent* expression of the opposites with color too.

Y. These things you said about line and color are *universal truths*! How strange that their truth has not been universally recognized!

Z. That is because of subjective vision: how we see line and color, how we see expansion and limitation depends on the nature and development of the life force in each of us. And this is what determines which manifestation we will recognize as "truth."

Y. And we create our environment in accordance with our vision?

Z. Certainly. If we are to live in harmony, our surroundings must be in accord with our inner life force. With regard to art, everything that surrounds us must be such as to reflect the character of our life force. For aesthetic man, a house or a room that is consistent with his nature are as necessary to him as food and drink, for him *the aesthetic is equivalent in value to the material.*

In contemporary society people are *actually* concerned only with the natural, even when they appear to be doing otherwise.

Y. Indeed! Everything revolves around the physical.

X. Well, how could it be otherwise? It is still the prime necessity!

Z. To be sure: that is exactly *why man's physical need should be guaranteed*

without his having to concentrate upon it exclusively. If our material well-being were more easily assured, *it would automatically lose its excessive importance.* In the new society, the material will be there to serve us, so to speak, automatically— for it will still be important enough to require at least an equilibrated relationship with our spiritual, our *human* needs.

Y. But how is this to be achieved?

Z. By having the strength to begin to subordinate the material . . . but that requires sacrifice! We must begin by sacrificing ourselves for an ideal, because at present the new society is no more than that. *In everything we do* we must begin by *creating an image of what society must one day make a reality.*

In our discussion, I limited myself to the interior, but the exterior is also important.

Y. Our outdoor surroundings are even harder to change than our interiors, and we have even fewer means to achieve this.

Z. Therefore, for a long time to come, the new in us will fail to find its echo in our streets and cities! But their largely tragic character is not altogether unavoidable. Although color is still harder to apply and maintain outdoors than indoors, and the horizontal so easily dominates in a street, for example, nevertheless in a future society with greater equivalence between the material and the aesthetic, the city will be able to assume a completely new appearance and meaning.

X. But a city of age-old culture, like Paris— how beautiful it is and how distinguished its overall grayness!

Z. Very beautiful. A mature culture possesses a profound and distinguished beauty. But does *our spirit* simply terminate in a mature culture? Hasn't it outwardly opened the way for the new? Does the

image of the new *in us* always take the same form, just as it does outside us *in nature*? Man and nature are no longer so united. Consider, particularly, the city. Hasn't man continually created new forms and isn't it largely due to sheer economic impossibility that we do not see even more renewal?

Mature culture is beautiful in its perfection, but *perfection* also includes death and decay. To resist decay is therefore a sin against perfection, and it means that the old occupies the place of the new, preventing *greater perfection*.

X. You are very persuasive, but that doesn't help me understand why the mature culture, which is visually apparent in our big cities, has to disappear.

Z. It is because the mature culture of *form* has now reached its end. It is apparent everywhere in all its beauty but it opposes *what originated in this form-culture*, namely, the *clear, pure, equilibrated plastic expression of equilibrated expansion and limitation*, which is the reflection of the *new stage of the human life force*. At this stage, the city must be a plastic manifestation of the *equivalence of nature and nonnature as one*, for this is now the content of the life force. This cannot be achieved by dividing the city into streets and parks, or by filling the city with houses and trees or plants. . . . No, the streets (i.e., complexes of houses) *themselves must* plastically express interiorized nature and exteriorized spirit in equivalence.

X. That is essential only for your man of the future!

Z. Most assuredly; and that is why our cities are not like that now.

X. You are indeed revolutionary!

Z. Furthermore, if man tries to bring his surroundings into harmony with the character of his life force, and if this life force is deepened, then he will necessarily seek renewal. And when the duality in the life force has achieved greater equilibrium, then pure *equilibrium* will become its expression. When the new man has transformed nature into what he will have then become (*nature-and-nonnature-in-equilibrated-relationship*), then mankind—including you—will have achieved the earthly paradise of the new man.

Y. You are giving me a vision of the joy that life could be!

Z. Paradise always evokes the joy of living! But what I have described is to some degree quite attainable . . . don't regard it simply as a daydream. The city of children will one day be a city of mature men—we have only to wait until the children grow up!

Y. That would be safe to say but only if the individual indeed *matures* toward the universal! I remember a friend of yours, who seemed to understand the New Plastic well, saying that when he contemplated its work, he *felt nostalgia for the universal, for the most profound part of himself.*

Z. That very well expresses the nature of the New Plastic: it can awaken the most deeply inward, the universal in us, not only strongly but determinately. Otherwise the "universal, plastically expressed determinately" would not evoke nostalgia. Most people can recognize the universal only in and through the vague, because of the vagueness in themselves. They cannot recognize the universal in its *pure* plastic manifestation because the universal has not become *conscious* in them. However, as soon as we have formed a *determinate image* of the universal in ourselves, we can recognize it in a determinate plastic expression. Once again, you see that the

spirit of the age, through which the universal becomes clear, manifests itself, even if only in a few. It is a sign of the new era that the universal has become so conscious in us that we yearn for its pure manfiestation. . . . Yes, we do have a nostalgia for the universal! This nostalgia must bring forth a completely new art.

Y. Then the necessity for a New Plastic expression for the new era is clear. But I would like to return once again to our earlier subject: why in practice it is so difficult today to find surroundings in harmony with ourselves.

Z. Yes, the new chromoplastic in architecture is hard to find today, but I still prefer it to separate paintings in-the-manner-of the New Plastic.

Y. You said such architecture is more truly vital for us.

Z. We discussed that, but there is something more: such a room is always *just right* in its effect, even with people in it. A painting is effective only when seen from one viewpoint. A New Plastic painting especially will look wrong if it is not seen from the right distance: its relationships are so precise that they must also be properly related to the room itself, if we are going to take the room into account. Something of the individual always remains in painting . . . and, as I said before, a painting is actually made to be seen by one person at a time. A room can be for a number of people simultaneously. Decorative art, as conceived by the New Plastic, is an integral part of social life.

Y. But what sort of social life does it express? I have heard the New Plastic described as "a typical expression of the decadent bourgeoisie"!

Z. That is quite remarkable! The New Plastic is precisely free of "bourgeois" characteristics. Isn't overwhelming individualism, a petty attachment to material things, and so on, exactly what characterizes the bourgeoisie?

X. *Yes, attachment to the material is precisely what makes the bourgeoisie so desirous of an art of form.*

Y. And what about the aristocracy?

Z. Likewise, because for the most part its culture embraces *only the materialistic.* In some cases its material security enables it to transcend individualism; then the aristocrat is also an "aristocrat of the spirit." But usually the aristocracy merely achieves a certain "refinement" in its material life and therefore *clings to a "refined" art of form.*

Y. And the workers? Couldn't we expect their craftsmanship to engender a new art?

Z. No, that was possible *in the past,* in the Middle Ages, for instance. Today the worker's production is and must be mass-production. It is guided by intellectuals or artists, and it is to them that we must look for the new art. The worker is too much of a "machine," and, like the bourgeoisie and the aristocracy, he is too exclusively preoccupied with material things. It is from the *new man,* emerging from worker, bourgeoisie, and aristocracy *but altogether different from them,* that the New Plastic must arise and to whom it belongs. Only the new man can realize the new spirit of the age as beauty, both in society and in plastic expression.

X. But I do not understand why you wish to experience beauty so concretely—you who talked about abstract-real life!

Z. I said that abstract-real life was only *preliminary* to the transformation both of our social life and of the appearance of our environment.

X. When you put it that way, I understand. But does the inward man pay that much attention to his surroundings? Doesn't he usually live in a rather austere setting?

Z. The new man is "inward" in a different way than you think: he is also interiorized *outwardness*. And his other side, *a more conscious inwardness, makes him seek a more conscious expression, which lies precisely in the outward. In fact, the new man is precisely distinguished by the complete attention he gives to all outer things.* He will not rest until they express *purely* both the *inward and outward* together.

X. Then why are there so many "inward" people who don't seem to have this need?

Z. What I was saying applies only to the *new man* who has learned to see plastically and who is more *completely* man. To be without this need is to be incomplete, one-sided. To be complete is to be *totally* "true." It means that one's inwardness and outwardness are completely equivalent and so form a *unity*. Then the outward is an image of the inward that is reflected in *all* outwardness. That is why I am suspicious of the spirituality of anyone in our time who surrounds himself with capricious objects and who prefers capricious art in his life.

X. The new era is very demanding: one must concern oneself with everything. Despite its inwardness, the new era is nevertheless quite outward!

Z. The new era demands *pure* vision: that is all. And as to its character, its *artistic expression* reveals the *evolution* of the new man and the stage of inwardness he has achieved. It shows that equivalent plastic expression of inward and outward is the stage of greater equilibrium . . . and what do we seek more than *equilibrium*? The old era, the old art sought equilib-

rium by means of *form* . . . isn't that even more outward? All the suffering of all the artists of the past was caused by their inability to give the inward its pure expression *within form.*

X. But is that really what they sought?

Z. It was, *unconsciously.* It is what intuition, the source of all art, always seeks.

Y. Then will the artist who does not use form suffer less?

Z. Less, but he too suffers because he too must express himself through *outwardness,* even if a deepened outwardness. He continues to suffer because he still remains outward despite his interiorization of the outward. He suffers because he still remains part of the whole. He suffers artistically as well as socially because the majority lags behind; he is compelled to live surrounded by the art of others, and he is forced to participate in the injustices of our society. Suffering continues because the universal cannot find completely pure plastic expression even in the New Plastic; because so much of the new has yet to mature. But suffering is continually diminished to the extent that equilibrium is found between the inward and the outward, to the extent that man becomes more *complete.*

The life force is continually manifested more purely, more deeply, more freely.

Y. Equilibrium between inward and outward—yes, that is what we must find. We tend to judge everything from outwardness alone and on this we base our image of the life force.

Z. Or form *our* inwardness alone! That is just as dangerous as long as we are not complete.

Y. If we contemplate all things from the most outward viewpoint, the most forceful representation of the most outward,

just as it appears to us, seems to be the strongest representation of the life force.

Z. And if we contemplate the life force from our inwardness, then we are likely to have a completely false impression of it—again precisely through the most outward.

Y. So must our inwardness and outwardness become one in order for us to recognize the life force in its purely plastic expression?

Z. Fortunately, that is possible even before they have become completely one; for the man of our time already recognizes the greater completeness of the new spirit even in his own incompleteness. In this way, despite our incompleteness, the New Plastic, the art of the new era, could arise.

Y. The majority fails to see the New Plastic as a pure expression of the life force. I have heard it called "antiseptic art" and so forth!

Z. From their viewpoint they are right. One should not be offended by children who are unable to understand the life force in its expression by adults.

Y. But the character of the life force is very different in the man of the past and in the new man.

Z. In the new man, the life force can be called a *conscious radiation of the universal.* Generally it is expressed as wisdom rather than joyfulness, but it is actually both in one. In art, it appears as the aesthetic plastic expression of pure equilibrium, as pure plastic expression of repose, we could say, although this does

not simultaneously convey its richness, simplicity, and many other qualities.

Y. Although the new era has *evolved* out of the old, the two are absolutely distinct!

Z. Through evolution—and mutation—this much is clear: *evolution outwardly prepares a new form, but by mutation the new suddenly emerges as something quite other.*

Y. The man of the past and the new man are clearly distinguishable; they live in different spheres.

Z. What mainly distinguishes the old era from the new is that the old wants and seeks the tragic. In art, it also seeks the tragic, the lyrical, the sentimental, and feels most at ease with them.

Y. Resulting from the domination of the natural?

Z. Yes; and it is noteworthy that as the new era progressively frees itself, the man of the past resists it more and more strongly. This *can be seen* from the fact that the New Plastic meets with more and more resistance as it abolishes the tragic, the lyrical, the "sentimental."

Y. The new era goes far beyond these.

Z. Yes, because the individual has matured into the universal; and the new man can live only on the plane of the universal.

Y. This is what frightens the man of the past, and makes him feel ill at ease.

Z. Exactly. There we see *the complete* and essential difference between the old and the new: the new is a more advanced stage of the one life force.

[Two Paris Sketches]
(1920)

These two vignettes of urban life were composed in the sping of 1920, the first after Mondrian's return to Paris.[1] Unique in his writing, they reflect Cubist fragmentation as well as Futurist simultaneity of the visual and the auditory. Disjunction and sound-poetry were also features of Dadaist writing and performance.

In late February to early March, Theo van Doesburg spent a fortnight in Paris and consulted with Mondrian on the formulation of a second *De Stijl* manifesto: "On Literature."[2] Dada activity was then at its height, and the two men delighted in the *soirées* they attended (for some time afterward their letters would open with the greeting "Dada-Does" or "Dada-Piet"). They probably also had a friendly meeting with the Futurist leader F. T. Marinetti. Around this time Marinetti inscribed a copy of his *Mots en liberté futuristes* (1919): "P. Mondrian, simpátia futurista."

A few months earlier Mondrian had suggested (in a letter to Van Doesburg of 22 November 1919) that *De Stijl* reprint an article by Marinetti: "I don't recall his name, the chief of the Futurists. . . . It was on the new form of literature and typography. In regard to *form* it seems to be in the right direction. . . . I have myself discovered something concerning form in writing, and later I'll try and see if it works; but first I must finish this ["Trialogue"] series."

Mondrian began "Les Grands Boulevards" while Van Doesburg was staying with him. Van Doesburg wrote to Oud (4 February 1920):

> I am sitting across from Piet, who is deeply absorbed in his Boulevard chronicle. It took considerable persuasion on my part, for, while liking the idea, he had many reservations. This noon, happily, we were on the Boulevard des Capucines, where we observed the working of the incredible machine that is Paris. It was a beautiful spring day, and we sat outdoors. One could cross the Place de l'Opéra only with the greatest caution, but Mondrian did it as calmly as if he were in his atelier. The beauty [of Paris] is that it is so spontaneous, unplanned, whereas what is intentional is for the most part baroque, overladen.

Signed 21 March, "Les Grands Boulevards" appeared about a week later in *De nieuwe Amsterdammer*, for which Van Doesburg was art correspondent. According to him it "gave the editor bad dreams," so that the second piece, "Little Restaurant—Palm Sunday" ("Klein Restaurant—Palmzondag"), completed on 12 April, was rejected, and remained unpublished in Mondrian's lifetime.

"Les Grands Boulevards" nevertheless aroused the interest of a prominent man of letters, Lodewijk van Deyssel (1864–1952), the fiery leader of symbolism in Dutch literature in the 1890s. Van Deyssel now edited the influential *De nieuwe gids*, where, in a review-article entitled "Futurisme,"

he praised Mondrian's experiment for its kaleidoscopic imagery, its vivid re-creation of events as they impinge on awareness.[3]

Mondrian acknowledged Van Deyssel's review on 28 June 1920:

> I very much appreciate the attention you paid to my Boulevard article, and would like to acquaint you further with my ideas on the new in art. They are not altogether apparent from my literary work, which is still so unperfected. I nevertheless enclose a second effort ["Little Restaurant— Palm Sunday"] which I have been unable to place. I do not venture to offer it to *De nieuwe gids*; but would offer instead a conventionally reasoned exposition of my ideas on the new—especially in literature— such as I wrote in *De Stijl* on painting. It will not be ready for a month; I hope to send it to you then.

The "conventionally reasoned" piece was a section of *Le Néo-plasticisme*," which Mondrian had begun to develop at about the same time as his two experiments in literary art. Van Deyssel's reply can be gathered from Mondrian's letter of 23 August: "I feel honored that, as you write, you find my article ["Little Restaurant—Palm Sunday"] quite suitable for *De nieuwe gids*. But it might have to wait two years. . . . In Holland, it seems, one counts in centuries: in two years I'll most likely be writing in a quite different way. . . . Consequently the "reasoned article" I wrote you about will also for the time being find no place in *De nieuwe gids*.

Les Grands Boulevards

Ru-h ru-h-h-h-h-h. Poeoeoe. Tik-tik-tik-tik. Pre. R-r-r-r-r-uh-h. Huh! Pang. Su-su-su-su-ur. Boe-a-ah. R-r-r-r. Foeh . . . a multiplicity of sounds, interpenetrating. Automobiles, buses, carts, cabs, people, lampposts, trees . . . all mixed; against cafés, shops, offices, posters, display windows: a multiplicity of things. Movement and stand-still: diverse motions. Movement in space and movement in time. Manifold images and manifold thoughts.

Images are veiled truths. Manifold truths make truth. Particularity cannot describe everything in a single image. Parisiennes: refined sensuality. Internalized outwardness. Tensed naturalness. Was Margaret[4] like that? Yet Margaret went to heaven. But was it through her outwardness?

Ru-ru-ru-u-u. Pre. . . . Images are limitations. Multiple images and manifold limitations. Annihilation of images and limitations through manifold images. Limitations veil truth. Riddle: where is truth in truth? Limitations are as relative as images and as time and space. After today there will be other days and images, and this boulevard is not the only boulevard. Days form centuries, and the airplane has abolished distance. Time and space move: the relative moves and what moves is relative. Parisian: fashion transforms the boulevard from year to year. Every age has its expression. Although a man is still a man and art is still art—I see the expression of art changing. What is temporal moves; what moves is temporal. Separation is painful. The moving moves and changes with motion, in time. Displays change more rapidly than shops, and I see architecture lagging behind. Why is a stone so hard and a purse so small? Yet even immobility varies for the man in the car and the slow pedestrian. Even immobility is relative. Everything on the boulevard moves. To move: to create and to annihilate. Everyone creates—who dares annihilate himself again and again? On the boulevard one thing annihilates the other, visually. In fast and in slow tempo. Rapid change of particularity breaks the sensual tension. Relationship is through multiplicity. Rapid motion breaks the unity of masses and all distinctness. To annihilate the particular is to achieve unity, say the philosophers.

Negro head, widow's veil, Parisienne's shoes, soldier's legs, cart wheel, Parisienne's ankles, piece of pavement, part of a fat man, walking-stick nob, piece of newspaper, lamp post base, red feather. . . . I see only *fragments* of the particular. Together they compose another reality that confounds our habitual conception of reality. Together these parts form a unity of broken images, automatically perceived. A Parisienne. Does everyone see "broken" images, and does everyone grasp fragments "automatically"? *Plastically* seen, everything fuses into a single image of color and form. An image images something: color and form alone image something—what? Where is truth in truth? The particular disappears *in the plastic image*; does it in society too? The plastic image can be a bit ahead of us. A student is waiting for a girl. A long wait. Time passes slowly. How fast that car's wheel is turning. Is it round in order to turn or does it turn because it is round? There is round and there is straight on the boulevard, in movement. Money is round and the earth is round. Round too was the serpent in Paradise. The table top before me is round, but I don't see it turning. The auto wheel is round, and the *spokes in it* are straight. The straight *in the* round.

Everywhere? The round moves the straight, the straight moves the round. The

outward and the inward: both are necessary.
The wheel turns fast: I do not *see* the
spokes. Nor do I see the motor that moves
the car. The wheel moves and its hub stands
still. Is the hub motionless then? Is the most
inward, seen from without, always still?
Souscrivez à l'Emprunt de la Paix: [Buy
Peace Bonds!] In red and blue and white.
War-Peace. Is the outward ever still? Ruh!
ru-ru-h-h. There is stillness in the desert—so
long as we are not in it. Multiplicity of
sounds is the annihilation of sounds and
thoughts.

Poeoe-pang . . . one sound breaks the
other. A new harmony arises. Sound is
motion: sounds change in space and time.
Beggar. Owners. Owners, small and big.
Without ownership there is no movement; no
ownership without movement. Everything
owns, everything moves. Diverse movement,
diverse ownership.—Who owns not moves
not but is moved. Who is moved does not
own. The lamp post is a king—it stands still
(for the moment at least)! A Parisienne. The
outward is ahead of the inward on the
boulevard. But not everywhere.

Nevertheless the one is the other. The
policeman at the intersection imposes order.
Poeh-oeh-h. Puh! The cars too. The police-
man is no Mengelberg[5] but he conducts. "A
concert," as a friend of mine said. Without
the musical instruments, my grocer says it is
no concert. Raymond Duncan[6] tries to create
rhythm and so does Dalcroze.[7] Dalcroze
starts from music and Duncan from handi-
craft. Can there be handicraft, after the
boulevard? Duncan is far ahead of the
boulevard—if you are looking backward.
Pretty shoes; black patent leather; gray
stitching. Gray stockings. Parisienne. Duncan
wants neither shoes nor stockings. Yet the
policeman, Raymond Duncan, Dalcroze, the
automobile, and an engineer, and the Pari-
sienne all are doing the same thing: creating
rhythm. *Un cassis à l'eau, un Turin à*

l'eau. . . . People drink alike, but not the
same things. The sidewalk under the awning
is a refuge. The sidewalk—under the awning
or not—the car, the policeman, all organize
outward rhythm. Who organizes inward
rhythm? If only one were always equal to
another? Is the stroller moved or is *he* the
mover? The artist *causes* to move and *is
moved*. He is policeman, automobile, all in
one. He who creates motion also creates rest.

What is brought to rest aesthetically is art.
Rest is necessity, art is necessity. Hence dilet-
tantism. Movement is a necessity. Hence
the boulevard and art too. That child over
there is watching the boulevard. I too am
watching. Parisienne. She would not be at
home in the desert. One belongs to the
other. Why can one never leave one's "own
kind"? Is that why it is so hard to find one's
"own kind"? Parisienne. Officer. Captain.
Parisienne. Parisienne alone. Two Parisiennes
alone. Why is the foreigner sitting there
alone? Flowers and vendor. The flowers on
that hat are another kind. Picture postcards,
plans of Paris. Many foreigners on the
boulevard. The boulevard is international.
Language not yet. Language lags far behind,
in much it is ahead. In literature: why must
one always *de*scribe and *circum*scribe? A
Negro—the boulevard is international. Not
all internationals understand one another.
There are many religions at the same time.
There is one fashion at a time. Parisiennes—
one is like another in face and dress. An
unconscious chastity: With color, the face is
covered. Did Margaret do this? Particular
preference persists. Particular preference is
pleasant for the chooser and the chosen and
unpleasant to others—like personal property.
A rich man. I see no thief. Thief and rich
man both want individual possessions. The
artist gives the universal universality. What is
here on display is more universally wanted.
Everything here is *real*: art often is not.

Everything here on the boulevard is of actual importance, everything here is necessity. Luxury too is necessity. The baker thinks it's a shame the state has doubled the price of bread but not admission to dance halls. He does not yet understand movement as a whole: he does not understand the boulevard. The boulevard is the movement of the cultivated. The movement of fancy rolls is something else again. Perhaps he is secretly taking lessons from Raymond Duncan and hates the tango. Huh-huh! The particular carries me away: that is the boulevard. Now I see a woman in a donkey cart. One cannot always see everything in its wholeness—or shall I see particularities too "as a whole"? Then at least I cannot see the woman and the car as foreign to the boulevard. Tugboats go slowly. Tradition is strong and not all purses are equally big. The captain. His head is still a soldier's but dress has changed since the war. I have just read that the local undertakers are demanding a costume more in keeping with the times. Nature is more perfect than the human spirit. *Paris Sport! La Presse!* Man works upon nature and spirit. My table is getting wet, it is raining. It is not raining in the church. The boulevard is open, the church is closed. Is that why it is so cold in the church? At a recent exhibition of paintings in the Grand Palais it was just as cold. In the Métro people are a bit too warm, however. *L'Intransigeant, La Liberté,*

Le Populaire. A different sound than *Les Rameaux* [Psalms] or *Réveillon* [Christmas Eve]. The kaleidoscope shows us the most diverse things. But *au fond* is everything so different? Or in time does one thing become the other? On the boulevard one thing follows another but yet they dissolve into one another. A quiet moonlight night makes everything possible. Toot, toot. So can the automobile (on the inside). Seen from the outside on the boulevard, it is part of the whole. Ru-huh! The boulevard! What always draws me to the particular? The boulevard is more concentrated! I see the colors and form, I hear the noises, I feel the warmth of spring, I smell the spring air, the gasoline, the perfumes—I taste the coffee. The boulevard is the physical turning outward and the spiritual turning inward. The spiritual sublimates the physical, the physical sublimates the spirit. *Trois cafés!* Who sublimates, sublimates everywhere, and who drinks coffee alone on the boulevard drinks coffee alone in the country. One coffee and another are both coffee, but the boulevard and the outdoors are not identical. Ruh-ruhh-r-r-r. The Cubist on the boulevard. Courbet in his studio[8] and Corot in a landscape . . . everything in its place. Place transforms man and man transforms nature. Hence the word "art." On the boulevard there is already much "artifice," but it is not yet "art."

Little Restaurant—Palm Sunday

Chairs, yellow and blue. White-decked tables—carafes—blue siphons—people, under the terrace awning and indoors. The glass wall open: the little restaurant opens itself to the sun. The whole framed by evergreens in boxes that also are green. Inside and outside: the owners and the people asking for an eight-hour day or night (says *L'Intran* in my hands). Workman and intellectual. A family. "Sunday best." I think of "Sunday" in the provinces. A Parisienne. "*Une banane.*" "*Une chopine de rouge*" [a pint of red wine]. "*Une religieuse.*" "*Quatre sous de pain.*" Worse bread, higher priced, *after* the war. Behind the evergreens on the sidewalk, people to the right and people to the left. Most to the right. "*Voici, monsieur.*" "*Merci, mademoiselle.*" On the right the Métro and also the Barrière [city gate]. The Barrière leads out and the Métro leads in. Left are the church of Montrouge and the city. For a long time Montrouge was beyond the Barrière. Bing-bang—bing—bang—Montrouge church is still where it was. Black silhouettes behind the green shrubs. The sun shines equally on the dark figures of people—darker on Sunday than on other days—and on the white tables—whiter on Sunday than on other days. On working days it is quite different at this hour. An hour later: different again. No people: the chairs, the tables, the carafes, the siphons are again "themselves." Who is "himself"? Pang. A glass of wine knocked over. Who experiences everything and stays unchanged? In winter the restaurant is different again. The lace curtain in front of the glass wall refines what is outside: TNAR—UATS—ER, gigantic letters on the three glass panels above the white. The words tell their meaning on the outside: RESTAURANT. The ornament on the white below has no special meaning. It is what it is, from both inside and out. "*Une pomme purée.*" A beggar. He is *dans la purée* [in the soup]. "*Un mendiant*" [a dessert, a beggar]. Better to eat a "mendiant" than to be one. Union Centrale—an archway—des Grandes Marques. The great factory gate across the way is closed on Sunday. On Sunday, who is "open"? A woman trolley conductor. The green shrubs leave an opening. Two soldiers. Everything has its "sphere." Restaurant, things, and men. One thing is at the expense of another. "*Dix sous la botte, pas cher!*" [Ten sous a bunch, cheap!] Flowers on the pushcarts by the sidewalk. Carts with apples. Carts with oranges. Carts everywhere. "*Caisse*" [cashier]. The "*caisse*" is still operating—thanks to money. Heads and hats above the evergreens. Evergreens about as tall as the normal man. What is normal? "*Un bifteck aux pommes.*" Who is normal? The French are not tall: in England the hedge would have to be taller. That soldier over there comes above it, so does that lady and so does that priest. A little man with a stiff leg is near me. An abnormal foot. Among the normal, the abnormal. What is abnormal? A young woman with a pointed hat. Abnormal only "here." The crowd decides. But the taller person can see more. A car on the left, a perambulator to the right. Both reach their destination. The evergreens in boxes: neither to the left nor to the right on Palm Sunday. Straight up. The green shrubs are not palms. Today sprigs of boxwood [buis] serve as palms. The *buis* is blessed by the church. The shrubs, to what blessing do they owe their blessing? Re-re-re-re—t-toe-oeh! There is a particular blessing

in the green of the shrubs. These chairs, these tables, these dishes, these people—who blesses them? Three men with palms. The flower vendor also has palms. A widow, a child, a decorated soldier, all with palms. How did the soldier earn his palm? A poet without a palm. Two ladies with palms and parasols. People like to protect themselves. Two, three, four young girls with palms. The dove of the Ark carried such a green branch. *"Merci, madame." "L'addition, s'il vous plaît."* Montrouge—Gare de l'est—Gare de l'est—Montrouge in red on yellow. Coming and going. Ebb and flow. Both the trams alike but their content is different. Outside, a child is spelling: A-lec-san-dre. From the inside, I see ERDNAXELA on the flap of the awning against the light. But it is not Hebrew. ALEXANDRE reversed. The word is changed but some of the letters remain unchanged. Who is the same from the inside and from the outside? And yet each letter remains itself: inside and outside are one. Yet the outward remains the inward—the outward is made up of the inward and the inward of the outward. But the outer side seems to be the one we understand first. "Une orange." Orange outside and orange inside. The orange from outside is other than the orange from inside. *"Un petit suisse."* Equally white outside and inside. *"Voilà, monsieur."* Orange on the white plate on the white napkin. Purity through one color and purity through fullness of colors. Purity by reflection and purity by absorption. Who absorbs *purely* and reflects *purely*? The orange is a feast in the sun. Yet sometimes one is afraid of pure color. White envelope on white napkin. 10 cts. A deaf-mute through the green shrub. Pink paper: *Horoscope*. Re-re-re-re-h-h—Montrouge—*St. Augustin* in red on yellow. The deaf-mute hears no noise from outside. Does he hear from within? *"Du pain, s'il vous plaît."* *"Merci, madame."* Everyone talks. They hear noises from outside—is that why they speak? The deaf-mute can see well enough. Does he see more? Rhoe-aeh-hae! This automobile he does not see. *"Qu'est-ce que vous prenez, madame?"* The *fille de salle* is not deaf-mute. The orange was deaf-mute. Which "speaks" most? My *boeuf bourguignon* was also deaf-mute. Yet it too "spoke." But differently. The orange was orange and the beef was brown. I would not have liked either the other way round. *"Une blanquette de veau!"* Each thing according to its nature. Everything is good if it is good of its "kind." Every kind is good if "the kind" is good. Yet each thing and each kind is capable of improvement—but then doesn't it cease to be "of its kind"? The beef was "beef" and the orange was "orange"—who is actually what he is named? The orange is no good before it is ripe, nor the beef before it is ready. When are we ripe and ready? Beef is beef and orange is orange. A gourmet is a gourmet even in the church of Montrouge. Yet a businessman is often a man of very little business and an artist is often very little an artist. A man is sometimes a woman and a woman sometimes no woman. *"Un boeuf gros sel." "Une pomme dessert."* The coarse and the fine. Both are necessary. Can they take each other's place? Each costs money: each has value. *"Elle n'est pas très bonne,"* the apple is of little value, yet it costs money. *"Deux cafés, deux!"* I see the pink paper again. *Horoscope* . . . a legacy; but the horoscope is for a woman, not for me. An automobile. A Sunday hat blows off. I feel the wind along the glass screen behind me. The sun is shining and the wind is cold. The good and the bad together. The sun is shining on the flower carts, on the *oranges*, on the avenue. A poster across the way: *Fabrique de sommiers.* The factory is necessary like the restaurant. Behind me, through the glass, a bit of the fortifications—posters in front. Behind the fortifications *apaches* are

asleep on the grass. But one is not yet out of the city. *Apache*, city, police: each exists through the others. The avenue runs on beyond the Barrière. At night, no individuals. Only the crowd is moving but the avenue is alive. A freight train is running on the trolley rails: with produce. Without provisions, no city, no restaurant. Everything is linked. But the link "between pig and tong" is hard to find. *"Un café vieux marc."* This workman does not permit himself any luxury: liqueur neutralizes wine. The young woman puts water in her wine. The man does not put water in his wine, yet takes no liqueur. The pharmacy still has *charbon naphtolé granulé* and *vin de Pepsine Byla*. Everything has a remedy and each remedy has its disease. Buttermilk helps one's stomach too. Where there is nothing, even the king has no rights: there is no buttermilk in Paris. *"Dix sous la botte."* The flower seller doesn't water her wine but her flowers in the sun. Her flowers come from outside Paris and so does she. So does the little woman with the *coeurs à la crème*. She has lunch and does business with the restaurant. A *coeur à la crème*: a heart of buttermilk in milk. White in white and yet not the same. Buttermilk in Paris! We find the same thing everywhere in different form. Many *coeurs à la crème* take the place of liqueurs and medicines. The liqueurs and the medicines in turn replace many "hearts." *"Je vous donne mon coeur"*—she has many of them, *la bonne femme*. *"Ma fille! . . .* At one time she had just one heart. The couple over there are sharing one *coeur à la crème*. This *petit trottin* [messenger boy] has two *coeurs à la crème*. The foreigner over there is eating his *coeur à la crème* alone. A soldier. Has he a *coeur à la crème*? A *coeur à la crème* is not only soft but also white. *"Vous avez terminé, monsieur?"*

Neo-Plasticism:
The General Principle
of Plastic Equivalence
(1920)

Le Néo-Plasticisme: Principe général de l'équivalence plastique was written mainly during the first half of 1920. It marked the first appearance of Mondrian's essential ideas in French—and of the term *Néo-Plasticisme*, which transposed the Dutch *Nieuwe Beelding*. The fourteen-page pamphlet was published in the first weeks of 1921 by the Galerie de l'Effort Moderne, directed by the progressive art dealer Léonce Rosenberg.

It was Léonce Rosenberg (1881–1947) who took over the role of Daniel-Henri Kahnweiler, the eminent supporter of the early Cubists, when World War I compelled Kahnweiler to leave France. Rosenberg was the only French dealer to show Mondrian in the early twenties, and included him in the major exhibition "Les Maîtres du cubisme" (1921).

Mondrian's conception of literary art that reflected Neo-Plastic principles was strongly influenced by Futurist writing (see above, p. 124) and Dadaist poetry. Before Van Doesburg's visit to Paris in the spring of 1920, Mondrian wrote him (9 February): "I will show you a short piece on 'le mouvement Dada.' " Whether the author was Mondrian himself is, however, uncertain.

The beginnings of *Le Neo-Plasticisme* can be more certainly placed not long after this, in March 1920. "I have made a condensed adaptation [of the ideas in the "Trialogue"]," Mondrian wrote his friend and collector Salomon Slijper on 4 April; he was in fact so absorbed in writing that he had done no painting for three weeks.

Mondrian informed Van Doesburg on 30 June:

I think I have found a solution for literature as New Plastic, and would like to hear your opinion. It was again quite a lot of work: I see now that although I came close to it in my two pieces[1] [completed by mid-April], it is necessary to go somewhat further. Briefly, it seems to me that the only way to deepen word and meaning is by the juxtaposition of opposites. . . . Only nouns have opposites, don't they? But does every noun have an opposite? My idea can be exemplified thus:

> man — woman
> boy — girl
> soldier — merchant
> etc. etc.

Are these really opposites? . . . Not everything is so clear cut. . . . I have put it all briefly in the article, and I show the difference [of Neo-Plasticism] from the Cubists and the Dadas. Also I go into the question of how Neo-Plasticism applies in literature and the other arts.[2]

In August Mondrian translated his Dutch text of *Le Néo-Plasticisme* into French: "It has become more clear," he wrote J. J. P. Oud (25

August). Immediately after its publication, the French version was excerpted in *De Stijl* (February 1921). In German translation, it formed the title essay of Mondrian's Bauhaus Book no. 4, *Neue Gestaltung* (1925).

Eleven years after *Le Néo-Plasticisme* was published, Mondrian wrote Lodewijk van Deyssel (18 March 1932): "Since then [1920] I have done nothing further in writing than to clarify my conception of art and life. I found that in literature I could not go beyond a deepened Futurism—thus still descriptive. I see no possibility of 'pure plastic' in literary art."[3]

While Mondrian stressed that "the New Plastic first found complete expression in painting," in "Neo-Plasticism" he does not deal with painting as such. Nevertheless, the essay's key concept, equilibrated opposition, was becoming increasingly important in his paintings.

In Mondrian's discussion of the New Harmony, two contemporaries served as catalysts. The Belgian sculptor-painter Georges Vantongerloo (1886–1965) had published his theories imbued with mathematical ideas in *De Stijl* since 1918. In April 1920 he moved to France and began his lasting friendship with Mondrian, despite Mondrian's misgivings about the mathematical approach to art. When *De Stijl* carried an article by Wilhelm Ostwald affirming the merits of his system of color harmony, Mondrian promptly suggested Vantongerloo as the person to write an evaluation of it from the *De Stijl* point of view (to Van Doesburg, 12 June): "I remember that he thinks Ostwald wrong in the matter of toning down with black and white, and that he favors his own method using what he calls a 'gridded disk.' You are more knowledgeable about this; I do it by intuition, which is what I also said to Vantongerloo. Still, I think the theoretical approach can have great value *generally* for the New Plastic."[4]

Mondrian asked Vantongerloo for his views on the harmony of colors. When he received a lengthy reply, he wrote Van Doesburg on 5 September:

> [Vantongerloo] now writes me that he has invented an entire system based on the eternity, or rather the unity of the seven colors and the seven tones!!! As you know, he uses all seven of them, for goodness sake, just like the rainbow. With his Belgian intellect he has created an operative system which, as I see it, is based on nature. He hasn't the faintest idea of the difference between the *manner of nature* and the *manner of art*. Now I see how I was right to distinguish conscious from unconscious: with his ordinary consciousness he has to subject everything to calculation. . . . I had expected him simply to say something from a sculptor's point of view, and concerning the technical aspect of color. . . . He approaches it just like an ordinary Theosophist.

After his return to Paris, Mondrian had also been seeing the Franco-Russian painter Léopold Survage (1879–1968). Although rather obviously representational, and composed around a center in the traditional way, Survage's Synthetic Cubist work was nevertheless praised in *De Stijl*

(November 1919) for its crisp, frontal planarity. Mondrian described Survage's reaction to his own recent canvases to Van Doesburg on 15 June 1920:

> First I showed him the little square one, precisely that which you and I find so good. He thought it lacked equilibrium; the yellow was not in harmony with the red, and so on. And the two small blues had no corresponding blue below (I mean that, among other things, this made the composition eccentric). So I told him that we were in search of a different harmony. To which he answered that there existed only *one* harmony. . . . He began also to talk about colors in a very theoretical way. Then I said that, precisely equilibrated relationship does not require harmonizing colors; and I set about writing something more on the subject.

Encouraged by Van Doesburg's views, Mondrian became more and more confirmed in his opinion that "the new harmony must be different" (to Van Doesburg, no date [September 1920]): "I too have a liking for dissonants. Now I remember that Survage and Vantongerloo always commented on the disharmoniousness of my recent paintings. I believe that *equilibrated relationship can exist* with dissonants. Don't you? This is in direct opposition to Vantongerloo—it is through him, precisely, that I became clear on the subject, especially after what you wrote me."

Although art is the plastic expression of *our* aesthetic emotion, we cannot therefore conclude that art is only "the aesthetic expression of our subjective sensations." Logic demands that art be the *plastic expression of our whole being*: therefore, it must be equally the plastic appearance of the *nonindividual*, the absolute and annihilating opposition of subjective sensations. That is, it must also be the *direct expression of the universal in us*—which is the *exact appearance of the universal outside us*.

The universal thus understood is that which *is* and *remains constant*: the more or less *unconscious* in us, as opposed to the more or less *conscious—the individual*, which is repeated and renewed.

Our whole being is as much the one as the other: *the unconscious and the conscious, the immutable and the mutable, emerging and changing form through their reciprocal action.*

This action contains all the misery and all the happiness of life: misery is caused by *continual separation*, happiness by perpetual rebirth *of the changeable*. The immutable is beyond all misery and all happiness: it is *equilibrium*.

Through the immutable in us, we are united with all things; the mutable destroys our equilibrium, limits us, and separates us from all that is other than us. It is from this equilibrium, from *the unconscious*, from *the immutable* that art comes. It attains its *plastic expression* through *the conscious*. In this way, *the appearance of art* is plastic expression of *the unconscious and of the conscious*. It shows *the relationship* of each to the other: its appearance changes, but *art* remains immutable.

In "the totality of our being" the individual or the universal may dominate, or equilibrium between the two may be approached. This latter possibility allows us *to*

be universal as individuals: to exteriorize the unconscious consciously. Then we see and hear *universally*, for we have transcended the domination of the most external. The forms of external appearance we see, the noises, sounds, and words we hear, appear to us otherwise than through our universal vision and hearing. What we *really* see or hear is the *direct manifestation of the universal*, whereas what we perceive outside ourselves as form or sound shows itself weakened and veiled. In seeking plastic expression we express our *universal perception* and thus our *universal being as individuals*: therefore, the one and the other *in equivalence*. To transcend the limitations of form and nevertheless to use limited form and descriptive word is not a true manifestation of our being, is not its *pure plastic expression: a new plastic expression is inevitable, an equivalent appearance of these opposites, therefore plastic expression in equilibrated relationship.*

All the arts strive to attain an aesthetic *plastic* of the relationship existing between the individual and the universal, the subjective and the objective, nature and spirit: therefore, all the arts without exception are *plastic*. Despite this, only architecture, sculpture, and painting are considered as plastic arts because we ordinarily experience them through individual consciousness. But for *the unconscious*, musical or verbal expression is no less *plastic* than the other arts. *Pure plastic* expression is manifested through the unconscious, while *plastic expression in limited form* is created by and represents individual consciousness.

Until the present, none of the arts has been purely plastic because individual consciousness dominated: all were more or less *descriptive, indirect, approximative.*

The individual, dominating within us and outside of us, "describes." The universal *in us* also describes but only if it is insufficiently conscious in our (individual) con-

sciousness to manifest itself purely.

Whereas the universal *in us* becomes more and more conscious and the indeterminate grows toward the determinate, *things outside of us* retain their indeterminate form. Hence the necessity, in the measure that the unconscious (the universal in us) approaches consciousness, *to continually transform and to better determine* the capricious and indeterminate appearance of natural phenomena.

Thus the new spirit *destroys limited form* in aesthetic expression and reconstructs *an equivalent appearance of the subjective and the objective, of the content and the containing: an equilibrated duality of the universal and the individual*; and this "duality-in-plurality" creates *purely aesthetic relationship.*

It is usually thought that literature and music, through description and paraphrase, have followed the so-called plastic arts. But the converse is equally true: the plastic arts seem to have followed the romantic and symbolic spirit of literature and music. As long as natural form was used as a plastic means, this tendency toward description was understandable, especially in sculpture and painting. Natural form veils direct plastic expression of the universal because it does not express the subjective and objective *in plastic equivalence* and their plastic expressions *become confounded.*

Natural plastic appearance presents itself as corporeality (see "The New Plastic in Painting," part 3).

This is plastically expressed as the spherical *seeking to be plane* or as the *plane forced to be spherical; as curve tending toward the straight* or as *the straight forced to be curved.*

This plastic expression is therefore not equilibrated.

Similarly, the plastic means of *verbal art* has become impure (form) and consequently follows the same path as the so-called plastic

arts. Here too one tried to express *the whole content* by paraphrase and not through the *word* itself. Words—assembled into sentences—were weakened as a homogeneous plurality. Expression was dependent upon symbols. There nevertheless exist *a few, perhaps even a number of words, which, by their inherent strength and their mutual relationships*, can express the two principles of being.[5] In all the arts objective fought against subjective, universal against individual: *pure plastic expression* against *descriptive expression*. Thus art tended toward *equilibrated plastic*.

Disequilibrium between individual and universal creates the *tragic* and is expressed as *tragic plastic*. In whatever exists as form or corporeality, the natural dominates: this creates the tragic (see "The New Plastic in Painting," part 5).

The tragic in life leads to artistic creation: *art*, because it is abstract and in opposition to the natural concrete, can anticipate the gradual disappearance of the tragic. The more the tragic diminishes, the more art gains in purity.

The new spirit can manifest itself only in the midst of the tragic. It finds only the old form, for the new plastic is yet to be created. Born in the environment of the past, it can be expressed only in the *vital reality of the abstract* (see "The New Plastic in Painting," part 5).

Because it is part of the whole, the new spirit cannot free itself entirely from the tragic. The *New Plastic*, expressing the vital *reality of the abstract*, has not entirely freed itself from the tragic but it has ceased to be dominated by it.

In contrast, in the old plastic the tragic dominates. It cannot dispense with the tragic and tragic plastic.

So long as the individual dominates, tragic plastic is necessary, for that is what creates its emotion. But as soon as a period of greater maturity is reached, tragic plastic becomes insupportable.

In the vital reality of the abstract, the new man has transcended the feelings of nostalgia, joy, delight, sorrow, horror, etc.; in the *"constant" emotion of beauty*, these feelings are purified and deepened. He attains a much more profound vision of perceptible reality.

Things are beautiful or ugly only in *time and space*. The new man's vision being liberated from these two factors, all is unified in one *unique beauty*.

Art has always *desired* this vision but, being plastic *form* and following natural appearance, was unable to realize it purely, and it remained tragic plastic while intending to be the contrary.

Verbal art strongly reveals this intention. Tragedy, comedy, epic, lyricism, romanticism *are but diverse expressions of tragic plastic*.

So far as was possible, and so long as it did not degenerate into actual Impressionism (another form of tragic plastic), the tragic found its first opposition in *pure realism* because of its more objective vision.

In *painting*, Neo-Impressionism, Pointillism, Divisionism attempted to abolish the corporeality dominant in the plastic by suppressing *modeling and habitual perspective vision*. But it is only in *Cubism* that we find this built into a system. In Cubism, the tragic plastic lost most of its dominating power through *opposition of pure color and abstraction of natural form*.

Likewise in the other arts, Cubism, like Futurism and later Dadaism, have purified and demolished the dominating tragic in the plastic.

But *Abstract-Real painting or Neo-Plasticism* "freed itself" by being a *really new* plastic. At the same time it transcended the old values and conceptions that require tragic plastic.

It is generally not realized that *disequi-*

librium is a malediction for humanity, and one continues to cultivate ardently the feeling of the tragic. Up to the present, the most exterior has dominated in everything. The feminine and the material rule life and society and shackle spiritual expression as a function of the masculine. A Futurist manifesto proclaiming hatred of *woman* (the feminine) is entirely justified. The *woman* in *man* is the direct cause of the domination of the tragic in art.

The old conception, which desires the tragic, predominates in the masses. Because of this we have art as we know it, our theaters, cinemas, and concerts such as they are. Tragic plastic is a negative force by which the old conception imprisons us. It serves in moralizing, preaching, and teaching. . . . Let us not forget that our society wants *the useful along with the beautiful!*

Nevertheless, *the old transforms itself and grows toward the new.* We have seen the birth of *the new*: it arises in all the arts to some degree.

The old is harmful only insofar as it is an obstacle to the new. Only when confronted by the new does it no longer count. There was a moment in the past when all varieties of the old were "new" . . . but they were not *the new*.

For let us not forget that we are at a turning point of culture, *at the end of everything ancient: the separation between the two is absolute and definite.* Whether it is recognized or not, one can logically foresee that the future will no longer understand tragic plastic, just like an adult who cannot understand the soul of the child.

At the same time as it suppresses the dominating tragic, the new spirit suppresses *description* in art. Because the obstacle of form has been destroyed, the new art affirms itself as *pure plastic*. The new spirit has found its *plastic expression*. In its maturity, the one and the other are neutralized, and they are coupled into unity. Confusion in the apparent unity of interior and exterior has been resolved into an *equivalent duality forming absolute unity.* The individual and the universal are *in more equilibrated opposition.* Because they are merged in unity, description becomes superfluous: *the one is known through the other.* They are plastically expressed without use of form: *their relationship alone (though direct plastic means) creates the plastic.*

It is in *painting* that the New Plastic achieved complete expression for the first time. This plastic could be formulated because its principle was solidly established, and it continues to perfect itself unceasingly.

Neo-Plasticism has its roots in Cubism. It can equally be called *Abstract-Real painting* because the *abstract* (just like the mathematical sciences but without attaining the absolute, as they do) can be expressed by plastic reality. In fact, this is the essential characteristic of the New Plastic in painting. It is a composition of rectangular color planes that expresses the most profound reality. It achieves this by *plastic expression of relationships* and not by natural appearance. It realizes what all painting has always sought but could express only in a veiled manner. The colored planes, as much by position and dimension as by the greater value given to color, plastically express only *relationships* and not forms.

The New Plastic brings its relationships into *aesthetic equilibrium* and thereby expresses *the new harmony.*

The future of the New Plastic and its true realization in painting lies in *chromoplastic in architecture* (see "Trialogue," scene 7). It governs the interior as well as the exterior of the building and includes everything that plastically expresses relationships through color. No more than the "New Plastic-as-painting," which prepares the way for it, can chromoplastic be regarded as

"decoration." It is *entirely new painting* in which all painting is resolved, pictorial as well as decorative. It unites the *objective* character of decorative art (but much more strongly) with the *subjective* character of pictorial art (but much more profoundly). At this moment, for material and technical reasons, it is very difficult to foresee its exact image.

At present each art strives to express itself more directly through its *plastic means* and seeks to *free* its means as much as possible.

Music tends toward the liberation of *sound*, *literature* toward the liberation of *word*. Thus, by purifying their plastic means, they achieve the *pure plastic of relationships*. The degree and mode of purification vary with the art and the epoch in which they can be attained.

In fact, the new spirit is revealed by the plastic means: it is *expressed* through *composition*. Composition must express *equilibrated plastic as a function of the individual and of the universal*. Dominating tragic must be abolished by composition and plastic means together: for if plastic appearance is not composed *in constant and neutralizing opposition*, the plastic means would return to the expression of "form" and would be veiled anew by the descriptive.

Thus *Neo-Plasticism* in art is not simply a question of "technique." In the New Plastic, and *through it*, technique changes. The touchtone of the new spirit, next to composition, is precisely what is so often lightly called "technique."

"It is by *appearance* that one judges whether a work of art is really pure plastic expression of the universal" (see "The New Plastic in Painting," part 4).

Because sculpture and painting have been able to reduce their primitive plastic means to *universal plastic means*, they can find effective plastic expression *in exactness*

and in the abstract. Architecture by its very nature already has at its disposal a plastic means free of the capricious form of natural appearance.

In the New Plastic, painting no longer expresses itself through the *corporeality* of appearance that gives it a naturalistic expression. To the contrary, painting is expressed plastically by *plane within plane*. By reducing three-dimensional corporeality to a single plane, *it expresses pure relationship*.

However, the plastic means of architecture as well as sculpture have an advantage over painting through their other possibilities.

By its plastic means, *architecture* has an aesthetic and mathematical appearance, which is therefore *exact* and *more or less* abstract. *Being a composition of contrasting and self-neutralizing planes, architecture is the exact plastic expression of aesthetic relationship equilibrated in space*. The New Plastic does not regard architecture, any more than painting, as *morphoplastic*. That was the old view. Although form does appear in architectural plastic, it is not closed and limited form—any more than is the composition of rectangular color planes in the New Plastic of painting. *Real form is closed or round or curved* in opposition to the apparent form of the rectangle, where lines *intersect, touch at tangent, but continue uninterrupted*.

Seen as *equilibrated opposition of expansion and limitation in plane composition*, architectural expression (in spite of its third dimension) ceases to exist *as corporeality and as object*. Its abstract expression appears even more directly than in painting.

However, *the abstract* is not realized through stylization, it is not produced merely through simplification and purification. For the *abstract* remains *plastic expression in function of the universal*: it is *the most profound interiorization of the outward and the purest exteriorization of the inward* (see

"The New Plastic in Painting," part 3).

Today we see architecture becoming purified and simplified but little *realization of the plastic expression of the abstract*.

As direct appearance of the universal, abstract plastic neutralizes the individual. Present-day attempts toward generalization only accentuate the "particularity" of the architectural work. As with every form that is stylized or reduced to its geometric expression, the particular emerges the more strongly as the capricious is more completely eliminated. In our time we even see buildings in the severe style of temples, but this is not *the new*.

The new spirit abolishes *the particular*. It is not enough that form be reduced to its quintessence, that the proportions of the whole work be harmonious: on the contrary, the entire work must be only the *plastic expression of relationships and must disappear as particularity*.

Building by masses is preferable to building by units. In the first, the particular is already suppressed by the composition that is automatically formed. But properly speaking, composition is equally the prime condition in construction by units: just as in painting, it is above all *composition* that must suppress the individual.

However, from the very beginning, architecture by its very nature was unconsciously striving toward abstract plastic expression. In fact, it was not possible for architecture to distort the plastic means so radically as in painting and sculpture. It was only by calling upon the latter for assistance that the mathematically shaped stone occasionally took on a natural appearance. And only in its decadence did it assume the more capricious aspect of things in nature.

In contrast, painting had to rise from natural plastic to abstract plastic. Its path toward *the exact plastic of relationships* was more difficult. We therefore understand that

whereas architecture, through the very facility of its plastic means, came close to pure plastic expression without being aware of it, it was painting that first achieved the clear conception that *art is at its purest in the plastic expression of aesthetic relationships alone*.

Although sculpture possessed an exact plastic means in *the prism*, like painting it preferred more or less natural plastic. There were times when sculpture achieved stylization and even spiritualization of form, but it always remained *morphoplastic*.

Natural appearance gradually gained such prerogatives that in the end it came to be considered indispensable to the arts. Even architecture shared this fate. It is generally not recognized as "art" if it expresses beauty through the pure plastic of relationships and if it refuses to be inspired by nature or to cloak itself in sculpture and painting. We thus can see how far the aesthetic conception has become impure: only plastic expression cloaked by limited form is recognized as "art."

Thus the New Plastic in painting is sometimes called "decoration" because, instead of negating the individual in the plastic, it has reduced it to rectangular color planes. While on the one hand the old conception continues to be an obstacle to recognition and continues to be the greatest enemy of the spirit, on the other hand many artists fear the great difficulty of having only such simple plastic means at their disposal for creation.

In any case, *the new spirit* must be manifested *in all the arts without exception*. That there are differences between the arts is no reason that one should be valued less than the other; that can lead to *another* appearance but not to an *opposed* appearance. As soon as one art becomes plastic expression of the abstract, the others can no longer remain plastic expressions of the

natural. The two do not go together: from this comes their mutual hostility down to the present. The New Plastic abolishes this antagonism: *it creates the unity of all the arts.*

Sculpture can no longer be the servant of architecture, as it often was under the old conception. It is no longer plastic representation *of ideas or of things*: it no longer can exist morphoplastically. Through its quasi-abstract plastic means, it is possible for sculpture to become *aesthetic plastic expression through equilibrated opposition of expansion and limitation*—precisely when it is free of utilitarian or structural exigencies.

If the old sculpture and architecture to some extent determine space that would otherwise be empty and undefined, then the new sculpture (and equally the new architecture) determines it much more by reducing the capriciousness of the natural *through equilibrated composition* and by *focusing all its attention upon relationships.*

Sculpture and architecture, until the present, destroy space *as space* by dividing it. The new sculpture and architecture must destroy *the work of art as an object or thing.*

Each art possesses its own *specific* expression, its *particular nature.* "Although the content of all art is one, the possibilities of plastic expression are different for each art. Each art discovers these possibilities within its own domain and must remain limited by its bounds. Each art possesses its own *means of expression*: the *transformation* of its plastic means has to be discovered independently by each art and must remain limited by its own bounds. Therefore the potentialities of one art cannot be judged according to the potentialities of another, but must be considered independently and only with regard to the art concerned . . . " (see "The New Plastic in Painting," part 1).

"With the advancing culture of the spirit, all the arts, regardless of differences in their expressive means, in one way or another become more and more the plastic creation of determinate, equilibrated relationship: for equilibrated relationship must purely express the universal, the harmony, the unity that are proper to the spirit." (see "The New Plastic in Painting," part 1).

If the so-called plastic arts express themselves through more or less gross material, *music* and *verbal art* (insofar as it is "sound") use far more tenuous materials. This is a capital difference that makes them entirely dissimilar arts.

If *noise* is transformed into *sound,* the properties of noise remain unchanged. Does noise take on limited form? If color takes form, it can be neutralized by opposition of color or of straight line: is the same reduction possible for *sound?*

Verbal art is the plastic *of sound* and *of idea.* Even the written word contains sound, although we do not hear it. In the present use of word, *purely abstract appearance* is veiled, confused by *materialized sound, traditional plastic exteriorization,* and *bastardized idea.* Verbal art therefore cannot be *the direct plastic expression of the universal* through the plastic means now at its disposal. And yet . . . it is clearly evident that abstract beauty will ultimately reveal itself in this art too. Just like music, verbal art will have much further to go than the so-called plastic arts in order to attain a truly new plastic.

It follows that the more easily the plastic means of an art can be purified, the more quickly it can attain the New Plastic. The different arts do not come to equal profundity at the same time, for being different appearances of the universal, they do not mature at the same time.

Verbal plastic will free itself far more slowly than painting from the domination of limiting form.

Indeed, the word arouses *the individual* in us far more than does the natural appearance of the thing it expresses. The word has become *our representation* of perceptible reality. The word is also *utilitarian* (as an element of language). Because *the individual* dominates everywhere in the world, language finds its principal basis in the individual. Thus, attachment to individuality obsures the pure expression of the word. And even if the new spirit, in growing, succeeds in severing this attachment, the word will still preserve its individual *plastic expression*.

Nevertheless, the word, as an element of language, remains necessary to designate things. Separation between word-as-language and word-as-art would probably drive verbal art too far outside of life.

That is why, where the so-called plastic arts are able to nullify form *directly*, verbal art will have to destroy form *indirectly* . . . at least in the immediate future. The idea that a word signifies in our consciousness will be transformed through *a contrary plastic*, for this alone can free a word of its limitation. Then, by a natural transition, the new idea will approach the suppression of form. In the far distant future, the word will have to be *re-created without form*—it could become *"sound" of a new character, not limited* either as sound or as idea. The word could also be represented by image alone. Sounds, signs, or images would have to be created anew as "sound plastic," which would be *pure plastic exteriorization of the universal*, therefore of the most profoundly individual. Then only would verbal art have a *pure plastic means* making it possible through composition to express *relationships in function of their equilibrium*.

For the moment, we will have to limit ourselves to the *indirect* suppression of form as it is individualized in the word today. To do this, it would have to be opposed to *what it is not, even while being part of it—its*

contrary. One becomes *two*: *"the one"* and *"the other."* The one is known, *is seen*, through the other (see "The New Plastic in Painting," part 4). Thus the limitation of the word is suppressed, its content enlarged; it is plastically expressed *in its totality*. Thus, by showing the action of things completely and clearly, approximate description and the dominating tragic disappear through *plastic equilibrium*. From the instant things are shown in complete clarity, they are suppressed as ideas: only *the plastic of relationships* remains. Verbal art thus becomes *plastic expression in equilibrated relationships* . . . despite whatever limitations the plasitic means may have.

In painting, the New Plastic employs exteriorizing color, although plastic expression through duality of position and straight line is the purest. In verbal art equally, the plastic (at least for the present) will still remain close to the exterior. In order to achieve definiteness, verbal art will have provisionally to make use of its present means. It will have to express itself plastically through the *multiplicity* of varied relationships. Just as the New Plastic in painting makes use of its dimensional relationships, in verbal art the New Plastic uses not only this but also *content* as the relationship of opposition. Any given thing will become better understood through its multiple aspects and its different relationships; a mutiplicity of words will be expressed in a more determinate plastic. The new art of the word will itself determine to what extent it can make use of the opposition of contraries. The essential is that *the principle of opposites rules the work as a whole* as much in its composition as in the equilibrated relationship of its plastic means. Each artist will have to seek the best way to achieve this. He will use and improve the contributions to syntax, typography, etc., already discovered by the Futurists, Cubists, and Dadaists. He

will use equally all that life, science, and beauty offer. But above all he will be guided by *pure plastic perception* (see "Trialogue," scene 3).

In classical and romantic literature we also find the action of contraries expressed . . . but without verbal plastic and veiled by description. Dr. H. Schoenmaekers sought to show that in *Candida* Bernard Shaw opposes psychological contraries. Similarly, in the literature of ancient India we often see two things that seemingly destroy each other. Thus verbal art remains *morphoplastic* because the contraries are not yet manifested as the *plastic expression of word.* By concentrating upon "the outward" there was recently evolved a plastic expression by *analogies,*[6] simply by placing them side by side. Then the object and its action change, become broadened in expression; but this plastic transformation does not yet contain *completely equilibrated plastic.* Nevertheless, the old conception of composition is demolished and the new can make its appearance. From the maturing "outward-individual" things are born *in totality,* and thanks to this the universal attains *direct plastic expression.*

Being more abstract than natural appearances, the word represents the content and the appearance of everything that exists. It compresses a whole world of beauty into a few signs or sounds. *The new art wishes to express this world plastically in a precisely determinate way.* At present, the word alone is vague. This vagueness is somewhat clarified by composition and proportion but nevertheless remains veiled by form. The word, as form, is a *limitation,* and this limitation depends partly *on ourselves.* Each of us sees a sphere in his own way, but a sphere remains a sphere for everyone. By seeing the content of things in relation to *our own content,* we penetrate somewhat closer to the universal and thus partially resolve our personal vision. A sphere is a world in

ourselves and a world outside the self: our *personality* only sees a part of it. It only sees the part that reaches our consciousness resulting from our outward life. Thus the sphere becomes a representation of *our subjective thought* as a function of this sphere.

Art transcends particular thought as the unconscious (the universal) transcends individual consciousness. In the moment of aesthetic creation, when the universal (the unconscious) pierces the conscious, when *the complete vision of things as a whole* is finally achieved, the particular no longer matters. For this reason art's mission resides in the *plastic suppression of particular thought.*

The Futurists wanted to free word from idea. D. Braga writes: "Art henceforth will dispense with ideas. Ideas are fraught with the past. They freeze perceptions, give them the logical form that allows them to persist in the brain. Marinetti hates intelligence.[7] But if our consciousness attributes to words a content, a meaning, this can reach us only through our intellect. If modern man experiences aesthetic emotion, how can we disregard intelligence? The *new man* combines *feeling and intellect in unity.* When he thinks, he feels; when he feels, he thinks. Both are in him, despite him, automatically alive (see "The New Plastic in Painting," part 4). *The emotion of beauty constantly vibrates throughout his being*: thus he achieves abstract plastic expression of *his whole being.*

In the mentality of the past, sometimes intellect, sometimes feeling, was active: each in turn dominated the other. This mentality separated the two and bred their antipathy. If the Futurists hate intellect, it is because their thinking about this problem still follows the old mentality. Through the new spirit, feeling and intellect *change their nature*: particular thought ceases to exist. For partic-

ular thought is quite different from *concentrated and creative thought,* which is a contemplative awareness. The former produces *descriptive and morphoplastic art,* the latter, *purely plastic appearance*: the universal as opposed to the individual.

The New Plastic is in accord with Futurism in seeking to eliminate the "self" in art. It goes even further than they do. The art of the Futurists shows that they do not understand the consequences of the New Plastic. For now exhausted "human psychology" they would substitute a "lyrical obsession with matter." "Futurism calls above all upon sensation. It is the frenzy of environment or, according to Marinetti's own formulation, a lyrical psychology of matter." (D. Braga).

Thus "their" lyricism remains descriptive, and in painting the Futurists even fell into symbolism. Despite their penetration of matter, they did not attain plastic expression of *all matter* (*matter and energy*). They did not achieve *expression of the one and the other in equilibrated relationship.*

Depending on the emphasis, "thinking-in-beauty" or "feeling-in-beauty" may therefore predominate in the work of art, or both may be united into a single entity. The first mode produces *prose,* the second, *poetry,* and the third, *the new art of word.*

Thinking that tends exclusively toward *truth* remains in the domain of pure reason and is not art. However, creative thought is *plastic.* Philosophy like art *plastically expresses the universal*: the first is expressed *in truth,* the second *in beauty.* Since truth and beauty are basically one, it is not logical to deny the obvious kinship of these two plastics. Art is the *plastic expression of man in his totality*; therefore, nothing must be lacking.

Some advanced minds reject logic completely: is that the liberation of art? Is not art the *exteriorization of logic?*

Nor is it possible to free words from thought by stringing them together without any connection, as the Dadaists have claimed: "each word-unit shall stand out sharp-edged on the page. It will be set down here (or just as well there) like a pure touch of color, nearby which other pure touches will resonate, but with so little relationship as to allow no thought association. Thus—at last—the word will be set free of all previous meaning, and all evocation of the past" (André Gide, on the Dada movement.)[8]

In the music of the past, we see, just as in the plastic of the other arts, a confusion of active and passive, although occasionally there is a more evident structure, more marked opposition (in the fugues of Bach, for example). But for the most part constructive plastic is veiled by *descriptive melody.* As in pictorial or sculptural plastic, most often rhythm was capricious. This was acceptable at a time when individual feeling dominated: this was its appropriate expression. It is now no longer acceptable. In music as elsewhere, the new spirit requires *an equivalent plastic of individual and universal governed by equilibrated proportion.* To achieve this it is necessary *to reduce the individual and assert the universal* in order to attain equivalent, opposing, and neutralizing duality. In sound this duality must be plastically exteriorized just as the New Plastic in the so-called plastic arts is exteriorized by a (mathematically) normal[9] duality of opposition: *active and passive, interior and exterior, masculine and feminine, mind and matter* (which are one in the universal). But in sound that remains noise, in *rounded undulation,* how will it be possible to bring forward the one and to interiorize the other? Music will have to seek it, is already finding it. In the new music, isn't the descriptive, the old melody, already losing its dominating power? Has there not appeared

in music "another color," less natural, another rhythm, more abstract? Does not music show the beginning of neutralizing opposition (for example, in some of the "experiments in style" by the Dutch composer Van Domselaer)?[10]

And yet the old mentality will be an obstacle to the new spirit for a long time to come: especially in music, for music lends itself admirably to tragic expression. But life continues: everyday life through its real necessities will influence art, which will evolve all the more rapidly. Alas, art is the ideal place—for the weak—to slumber in traditional beauty, lulled by the rounded rhythm of the agreeable and the pretty.

The multiplicity of life, even outside of art, will erode the old music and sustain the new. In the midst of traditional music in our time there appears, perhaps somewhat brutally, the *jazz band*, which dares abrupt demolitions of melody and dry, unfamiliar, strange noises that oppose rounded sound; although the old instruments have not yet been abandoned, it nevertheless opposes to them other, more modern ones. Traditionalists will cry in vain; the new spirit is advancing, and nothing will stop it.

If financial power were not in the hands of the past, the new spirit (become conscious only in the few because it is largely repressed by the many) would show itself more clearly and more widely. Today, however, the new spirit has nothing to gain from a total upheaval of our society: as long as men themselves are not "new," there is no place for "the new."

Without deprecating music's effort toward "the new," we must admit that even if there have already been many innovations, *the great renewal* has not yet taken place. This is equally true of painting before Neo-Plasticism. We can never appreciate enough the work and the achievement of the Cubist, Futurist, or Dada movements; but as long as they continue to use morphoplastic, even if refined or stylized, they will never attain the new mentality or completely demolish the old.

It is clear that the Neo-Plasticists want "the new" in *all* the arts and devote all their strength to this. The new is impossible to realize *experimentally* without financial means. If social and material circumstances were favorable, it would not be impossible because all the arts are basically one. But today each art needs all its own strength. The time of the Maecenas is past, and the Neo-Plasticist cannot imitate da Vinci. All he can do (and even that is not permitted him) is to use logic to expound his ideas on the other arts.

As we have said, *the plastic means of music must be interiorized. The musical scale* with its seven tones was based on morphoplastic. Just as the seven colors of the prism unite in natural appearance, so the seven tones in music merge into *apparent unity*. In their natural order, the tones, like the colors, express *natural harmony*.

Modern music has tried to annihilate this by a proportional plastic, but because it dared to touch neither the natural scale or the customary instruments, it continued natural plastic in spite of all.

The old harmony represents *natural harmony*. It is expressed in the harmony of the seven tones but not in the *equivalence of nature and spirit*, which for "the new man" is all that matters. The new harmony is a *double* harmony, a duality of spiritual and natural harmony. It is manifested as inward harmony and outward harmony: both *in interiorized outwardness*. For only *the most* outward can be plastically expressed by natural harmony; *the most* inward cannot be plastically expressed. The new harmony therefore can never be as in nature: it is the *harmony of art*.

This *harmony of art* is so totally differ-

ent from natural harmony that (in the new plastic) we prefer to use the term *equivalent relationship* rather than "harmony." However, the word "equivalent" must not be taken to mean symmetrical. Equivalent relationship is plastically expressed by *contraries*, by *neutralizing oppositions*, which are not harmonious in the old sense.

The three fundamental colors, red, yellow, and blue, remain prismatic colors in spite of the distance that separates them in the spectrum, and despite Neo-Plasticism, which does not express them as they appear in the spectrum. If we express these colors according to their scientific or natural laws, we only express natural harmony in another way. Becáuse the New Plastic wants to abolish the natural, it is logical that it places the three colors in painting, and the corresponding tones in music, in quite *different relationships of dimension, strength, color, or tonality* while still preserving aesthetic equilibrium. Can it be objected that the New Plastic is not harmonious (in the old sense of the word), that it does not express unity—precisely when *in reality it expresses unity to greater perfection?* Does it not suppress the apparent unity of the natural?

This "disharmony" (according to the old conception) will be fought and attacked everywhere in the new art so long as the new harmony is not understood. In our time, which is everywhere characterized by the striving for unity, it is most important to distinguish *real unity* from *apparent unity*, *universal* from *individual*. Thus we distinguish *aesthetic harmony* from *natural harmony*. As human beings we tend to conceive of unity as an *individual vision*, as an *individual idea*. Our "conscious self" seeks unity but in the wrong way. Our "unconscious self," being itself "unity," brings it naturally toward clarity, at first veiled, then clearly (when the unconscious becomes conscious, as seen above). Thus we see apparent unities

(therefore natural harmonies) successively destroyed until the moment when *true unity, real harmony* is revealed.

Individual consciousness employs only naturalistic expression, even when it wants to proceed logically, even when it "reasons." But the unconscious in us warns us that in art we have to follow a special path. And if we follow it, it is not the sign of an unconscious act. To the contrary, it shows that in our ordinary consciousness there is a greater awareness of the unconscious: the unconscious pushes aside individual consciousness with all its knowledge. In art we cannot ignore the human being himself; it is his *relationship* to "what is,"—not "what is" alone—that creates art.

We have a tendency to apply the old conception to art, that is, the natural conception of harmony. And it is this conception that makes us cling to the natural sequence and relationship of the seven colors of the spectrum and the seven corresponding tones. But the art of the past already showed the way by having broken the natural sequence of colors and tones. Music too, within its old conception, is also seeking another harmony in several ways (but without achieving clarity).

If, as in Gregorian music, one tried to deepen the dominating natural by simplification and purification, one would only achieve another form of sentimental expression. Modern music has tried to free itself from the old form but instead of constructing a new appearance it simply "ignores" the old. This is the result of a structure that always preserves the old foundations. Any art movement goes astray that does not clearly represent *the new spirit*.

Nevertheless, by searching one finally attains truth—but not before its time has come. Superficially one hopes to find it by searching, but in reality it will be found only when *the new spirit* has matured.

When we listen to modern musicians who have not broken radically with sentimental instrumentation, it seems indeed that our time is not yet mature enough for the new music. Nevertheless, we see the new appearing through the old, and we see a need for it expressed by some. This fact must suffice us.

The old tonic scale, along with the usual instruments, must be banished from music if the new spirit is to be plastically expressed. Besides *new composition, other plastic means* must be created in order to attain a *new technique,* as in the so-called plastic arts.

As with color in painting, sound in music *must be determined* both by composition and by plastic means, if sound is to serve as *exact universal plastic means.* Composition will achieve this through a *new, double harmony in neutralizing opposition.* The plastic means will achieve it through sounds that will be *definite, plane, and pure.* Each fundamental tone must be sharply *defined* both *by its opposite* and by *its inherent character*; for each instrument, through its characteristics and its construction, has a *timbre* that, more than the vibrations themselves, makes its sound more or less "natural."

Strings, winds, brass, etc., must be replaced by a *battery of hard objects.* The structure and material of the new instruments will be of the greatest importance. Thus "hollow" and "rounded" will be replaced by "flat" and "plane" because timbre depends upon the form and material used. This will require much research. For *production of sound,* it will be preferable to use *electric, magnetic, mechanical* means, for they more easily prevent the intrusion of the individual.

The content of the new work of art must be a *clear, equilibrated, and aesthetic plastic exteriorization of sound relationships and nothing more.*

In *theater and opera* the arts combine into *dramatic art.* In *gesture and mime,* since plastic exteriorization of the individual always remains dominant, the primitive conception of theater will more gradually disappear in the new art. No matter how gestures and mime are deepened, the fact remains that their motion describes "form" and does not purely and plastically express *individual-and-universal-in-equilibrated-relationship. Dramatic art,* as plastic expression of an action or a state of mind dependent upon the human figure, creates a reality within which *plastic expression of abstract reality* becomes impossible.

For the new man, theater is superfluous if not an embarrassment. As it approaches its culmination, the new spirit will interiorize gesture and mimicry: it *will realize* in daily life what theater *showed* and *described* through the outward.

However, until this point is reached, theater will retain its reason for being: it answers a need by continuing the tragic, although the latter has lost its dominating power. But in its new appearance it must be *transformed.*

The Futurists strongly felt and expressed this in their manifesto. A logical transformation is nevertheless impossible as long as the arts that collaborate in theater have not evolved into *New Plastic.*

For many of its spectators, the theater still has its reason for being as a union of all the arts that, by acting simultaneously, gives theater the power to move us more strongly and more directly than each art alone. It can arouse emotion *through beauty and through plastic exteriorization of the tragic.* That is what characterizes the theater and opera *of the past and of the present.* In fact, if we also take scenery into account, theater is a threefold, opera a fourfold plastic expression of the tragic.

The New Plastic no longer wants tragic plastic but the *plastic expression of beauty—*

of beauty as truth. It wants to exteriorize *abstract beauty*. It could create an environment of abstract beauty through the *new chromoplastic in architecture*, which would replace the old scenery. The new music would do the same for opera.

The new art of the word could precede the "beautiful-as-truth" through the contraries of the verbal plastic. Words could even be "spoken" without any appearance of the human figure.

In this way the theater could become a great instigator of "the new" by presenting performances in the "New Plastic." But it will be a long time before this comes about, because of the great material difficulties involved: since everything will have a different appearance, this will involve tremendous preparation.

The theater will therefore have to wait until the other arts are transformed: then it will follow quite naturally.

The equilibrated relationship of which the old theater was the *negative* plastic exteriorization appears in the new. The striving toward harmony does appear in the old tragedy but it plastically *expresses itself* through disharmony or fictitious harmony.

In the new art, *dance* (ballet, etc.) follows the same path as gesture and mime. It passes from art into life. Dance as a spectacle will be relinquished, for everyone will realize *rhythm* through himself. In the new dances outside of art, the tango, fox trot, etc., we can already see something of the new idea of *equilibrium through opposition of contraries*. Thus it becomes possible to experience equilibrated reality physically.

The decorative arts disappear in Neo-Plasticism, just as *the applied arts*—furniture, pottery, etc.—arise out of simultaneous action of new architecture, sculpture, and painting, and are automatically governed by the laws of the new plastic.

Thus, through the new spirit, man himself creates a new beauty, whereas in the past he only painted and described[11] the beauty of nature. This new beauty has become indispensable to the new man, for in it he expresses *his own image in equivalent opposition with nature*. THE NEW ART IS BORN.

The Manifestation of Neo-Plasticism
in Music and the Italian Futurists' *Bruiteurs*
(1921)

The original Dutch version of this article appeared in the August and September 1921 issues of *De Stijl* as "De 'Bruiteurs Futuristes Italiens' en 'Het' nieuwe in de muziek" (The 'Italian Futurists' *bruiteurs*' and 'the new' in music). A French translation by Mondrian himself in *La Vie des lettres et des arts*, April 1922, bore the slightly altered title "La Manifestation du Néo-Plasticisme dans la musique et les bruiteurs italiens futuristes" ("The Manifestation of Neo-Plasticism in Music and the Italian Futurist's *Bruiteurs*"). A translation of the French text into German by Max Burchartz appeared in the March and April 1923 issues of *De Stijl* and was reprinted in Mondrian's Bauhaus Book no. 5 (1925).

Music (particularly jazz and its dance) was mentioned in each of Mondrian's essays before its fuller treatment in *Le Néo-Plasticisme*. The present article is the first of three he wrote between 1921 and 1927, for which music provided the starting point.

In *Le Néo-Plasticisme* Mondrian had discussed the Futurists' contribution to literary art but without mentioning their innovations in music. Within months of its publication, however, he attended a Futurist concert, one of three given—despite Dadaist sabotage—at the Théâtre des Champs-Elysées, Paris between 17 and 24 June 1921: after an introductory lecture by F. T. Marinetti, works employing twenty-three of the mechanical noise-makers (*intonarumori; bruiteurs*) here described by Mondrian were presented by the painter and composer Luigi Russolo (1885–1947).

Russolo had given his first *bruitiste* performance at Modena in June 1913, at which time he published his manifesto *L'Art des bruits*. Not all Russolo's noise-makers produced recognizable sounds: "The Art of Noises," he wrote, "must not be limited to reproductive imitation."

Mondrian's known interest in new music dates from 1915–16: during his wartime stay in Holland he enthusiastically endorsed a concert of works by the Dutch composer Jacob van Domselaer (1890–1960), with whom he had been friendly in Paris. Mondrian's conception of horizontal-vertical duality inspired certain of Van Domselaer's *Stijlproeven* or *Experiments in Style* for piano. After 1916, however, Van Domselaer lapsed, as Mondrian saw it, into the melodic. In Paris in the early twenties, Mondrian was in contact with the Dutch modernist composer Daniel Ruyneman; and around 1930 he occasionally met Russolo in the context of the Cercle et Carré group. In Mondrian's estimation no other music rivaled jazz.

In sending "The Manifestation of Neo-Plasticism in Music" to Van Doesburg (ca. July 1921), Mondrian wrote: "Enclosed is another bombshell I would like you to load into your gun. How does it strike you? Think how people will be appalled to see everything shot away—and in music where everything was so quiet up to now! . . . I half owe this music

bombshell to Oud, who took me to various "jazzbands"—I think in that
way I came to see clearly through the old mess."

After appealing to Oud for unity on Neo-Plastic principles in his
letter of 17 August (p. 165 below), Mondrian went on: "As for myself, I
have just done my share by writing an article on the New Music, entirely
based on Neo-Plastic principles. Does [Van Doesburg] wrote me that he
would publish it in *De Stijl*. It will be published also in French."

Mondrian translated "The Manifestation of Neo-Plasticism in Mu-
sic" with the help of his friend Dr. Van Eck. He then took it to the
periodical *L'Esprit nouveau*, although anticipating—correctly, as it turned
out—that "despite their friendliness, they will exclude me." The article
was accepted, however, by the bi-monthly *La Vie des lettres et des arts*.
Here Mondrian gave it a more appropriate title, "since it deals more with
Neo-Plasticism than with the bruiteurs," as he wrote Van Doesburg on 7
February 1922; "I was also able to improve it in translation. . . . in
French everything must be said *exactly*."

Basic reforms in the expressive means of art are rare but they do occur from time to time. The performances of the Italian Futurist *bruiteurs* are an example. However, those who demand *pure expression* of the new spirit must be patient and content to see it emerge step by step. For just as the Futurists took only one step in painting, they did no more in music. But that is already a great deal.

The *pure manifestation of the new spirit* remains unchanging and identical in life as in art. It is *an exact and conscious plastic expression of equilibrium* and therefore of *equivalence between the individual and the universal, between the natural and the spiritual*. In both respects, the man of the past is an "*unbalanced whole*." Continually maturing and growing, man achieves understanding of the "*equilibrated whole*" and becomes capable of revealing the new spirit.

The new music will therefore be the *pure expression of this equilibrium*. This will be

neither by enrichment nor by refinement, nor by reinforcement of sound—as Luigi Russolo, inventor of the *bruiteurs*, believes when he says: "Musical art today is seeking the amalgamation of the most dissonant, strange, and strident sounds. We are moving toward sound-noise."[1] Nevertheless, this does bring us closer to the music of tomorrow. By completing sound with noise, and by interiorizing sound by means of instruments with new timbres, the *bruiteurs* have taken a first step. *But "pure" expression of the new spirit requires more than that.* Indeed, it appears in music even more slowly than in painting, probably because music has not been considered as "plastic art" until now. *For only through the plastic can true art be achieved.* Even painting, although viewed as "plastic art," has only in our time achieved "pure plastic expression of the universal."

The universal for the new man is not a vague idea but a *living reality expressed plastically*: visibly and audibly. Recognizing

that it is impossible to express "the very essence of objects and of beings" because this essence is a pure abstraction and beyond all plastic representation, man conceives the universal as manifested *by means of the individual, through which it appears.* The mistaken belief that one can plastically express the most interior essence of an object or a being precipitated painting into symbolism and romanticism—into "description." The realists are quite right to say that it is only through "reality" that everything is revealed. We are dealing, then, with the *appearance* of reality. The new plastic requires a reality *that expresses both the totality and the unity of things:* therefore, *an equilibrated duality that annihilates the appearance of palpable reality and every expression where the natural dominates.* Objects and beings are thus reduced to *a universal plastic means* that "expresses" them but does not presume to represent them. This new reality in painting is *a composition of color and noncolor*; in music, of *determined sound and noise.* In this way subject matter does not interfere with the composition's exact appearance. The composition becomes "reality." The whole is *"the equivalent"* of nature, which plastically can show only its most outward aspect.

Neo-Plasticism found the new reality in painting by *abstracting what is most outward and by determining (or crystallizing) what is most inward.* It established this new reality through the composition of *rectangular planes in color and non color,* which replaced limited form. *Through this universal means of expression the great eternal laws, of which objects or beings are but veiled representations,* can be exactly expressed. Neo-Plasticism expresses these laws, these "invariants," through the *constant relationship of position: the perpendicular relationship.* To achieve this it uses the "variable," that is, *relationships of dimensions (measure),*

relationships of colors, and relationships of color (sound) to noncolor (noise).

In composition, the invariant (the spiritual) is expressed by *straight line and planes of noncolor (white, black, and gray),* while the variable (the natural) is expressed by *color planes and by rhythm.*

In nature, all relationships are veiled by matter appearing as form, as color, or as natural sound. It is this morphoplastic that was followed unconsciously in the past by music just as by painting. Thus in the past these arts were "in the manner of nature." For centuries painting plastically expressed relationships through natural form and color, and only in our time has it achieved *"the plastic of pure relationships."* For centuries painting was composed by means of natural form and color, and only today has composition itself become *"plastic expression," "image."* The long tradition of art's culture shows that *a purer and a more determinate* expression of relationships is possible and that a *universal* plastic means of *equivalent duality* is now necessary.

By stressing natural relationships, the old art already partially demonstrated *that the universal is expressed not by the natural itself but only by relationships.* Because it showed relationships in a more or less veiled way and because it followed nature too closely, its expression was "descriptive," and it was dominated by the individual (see "Neo-Plasticism," 1920). After Cézanne, painting increasingly freed itself from nature. Futurism, Cubism, and Purism achieved another plastic. *Nevertheless, as long as a plastic uses form, it can never establish relationships purely.* For this reason Neo-Plasticism freed itself *completely from morphoplastic.* Thus painting succeeded in expressing itself through a *purely pictorial* plastic means: *pure color, plane within plane.* Painting became an art creating "in the manner of art."

Thus painting *demonstrated* the meaning of the "abstract" in art and that this is estab- and nature; in other words, through the maturation of the individual.

Thus painting *demonstrated* the meaning of the "abstract" in art and that this is established by *the most profound interiorization of the outward and by the purest (most determinate) exteriorization of the inward* (see "Neo-Plasticism," 1920). The New Plastic is more mathematical than geometrical. It is "exact." Neither in music nor in painting does it negate reality. It is real in its abstraction, while retaining its capacity to establish an "image."

The meaning of words has become so blurred by past usage that "abstract" is identified with "vague" and "unreal," and "inwardness" with a sort of traditional beatitude. Thus, most people do not understand that the "spiritual" is better expressed by some ordinary dance music than in all the psalms put together. The conception of the word "plastic" has also been limited by individual interpretations. It has been narrowed to mean "morphoplastic"; but in a deeper and broader sense, "plastic" means "what produces an image" and only that.

An image depends solely on its maker, and its plastic expression does not have to follow conventional morphoplastic exclusively. The plastic of "plane within plane" is no less plastic than is morphoplastic. Not only is it a more profound, less corporeal plastic, it is moreover *the true plastic of painting*—because painting can be expressed only through "color," not "volume." To the contrary, matter and morphoplastic confuse the color and veil all relationships. In painting, a plastic without limited form might seem to lose itself in "decoration." Far from it: the profundity of its abstraction—the oneness of individual and universal—prevents it from degenerating into decoration.

Although using primary elements, such a plastic is not without human resonance. The latter (individuality) is expressed by its richness of color, by the personal technique of the artist, by the variable relationships of dimension, and by rhythm. In short, a plastic is limited only by the *expressive means* it employs. The means of architecture and sculpture are volume and matter; it follows that these arts have a different plastic. Like color, sound is without volume. Music can therefore follow painting more directly.

Like the word plastic, everything must be interpreted according to the new spirit if it is to be understood at all. Pure reasoning can help purify our concepts, but only *pure plastic* has the power to "show" things "as they are." Neo-Plasticism in painting clarifies and purifies; it can influence the whole of life because it is born of life's totality. Thus it can renew music too—starting from the same principles, followed by the same consequences. We must begin by regarding music as plastic art and, by interiorizing it, raise it to *pure plastic*.

It is quite possible for music to become "abstract" and cease to be dominated by the natural to the extent that its expressive means (sound) allow. Sound can also be interiorized far more than it has been. But it must be done differently than in painting. Pure expression of the new spirit in music comes naturally by *interiorizing composition and the expressive means as profoundly as possible*.

The traditional means of music veil pure relationships by their individual character. Sound and the scale itself are based on the natural, the animal (see "Neo-Plasticism," 1920). The timbre of conventional instruments is basically animal and individual in character, like the human vocal organs that they more or less imitate. Such means of expression dominate or veil composition; thus rhythm, the natural, dominates—despite the spiritual intention. As soon as the com-

position is stressed and the rhythm becomes more absolute, the expression becomes more universal (the fugues of Bach, for example, or in modern music Van Domselaer's "Experiments in Style"). The oppression of the individual is felt as much in music as in painting, and from it arise comparable efforts toward freedom. Thus a new "color" was introduced into music like that of the Luminists and Neo-Impressionists in painting—freer and lighter (Debussy). Finally, by various methods and means, music will succeed in expressing the new spirit in all its purity.

The new art springs from an aesthetic conception quite different from the old; the absolute difference between them lies above all in the new art's clearer and more advanced consciousness. "Art is always an interrogation," someone said recently. "As an interrogation of fate, an attempt to know ourselves, art is the last word in human awareness." This aptly describes the *old spirit*. The new spirit, on the other hand, is distinguished by "certainty." Instead of a question, it brings a "solution." Man's consciousness clearly reflects the "unconscious," and its expression in art shows equilibrium in such a way as to annihilate all doubt. The tragic ceases to dominate. The old painting was of "the soul" and therefore tragic, whereas the new painting is of the "spirit" and therefore beyond domination by the tragic (see "Neo-Plasticism," 1920).

This absolute difference necessitates an altogether new aesthetic based on the fundamental principle: *equivalence between the natural and the spiritual, the inward and the outward.*

"Beauty" and "art" are relative concepts. *Beauty* is so great, so profound, so inexhaustible that it can always be manifested in new ways, always increasing in power. The art of the future will owe its superiority to this, relying only on the superiority of its conception.

What beauty and art were to the man of the past they no longer are for the man of the future. As man changes, his conceptions change. Yet man changes only a little at a time—or otherwise no one would know how to play or hear the old music. The inequality of the masses makes one style for everyone impossible and justifies the existence of the old art side by side with the new.

Nature, because it changes for the new man, also changes its reality. Another, less natural reality, has sprung up beside it, visible and audible. The picturesque is replaced by the more or less mathematical: the song of birds by the noise of the machine. Luigi Russolo writes: "Not only amid the clamor of cities but also in the once silent countryside, the machine has created so many varieties and combinations of noises that the meagerness and monotony of pure musical sound can no longer arouse emotion in the hearer." So profound and total a change, however, must be manifested by something more than the reinforcement and complication of sound.

Attempts to create a New Plastic remain dominated by the old spirit as long as the new spirit has not become conscious in man, who thus uses his new creations in the old way. True plastic appears by "mutation" when "evolution" has done its work.

Man has changed nature but nature has transformed man. Because he experiences emotion in quite a different way, the man of the future needs a quite "other" reality to satisfy his aesthetic need. Above all, he must find a reality *equivalent with himself*, for his feeling for equilibrium constantly drives him to seek an *equilibrated duality*.

Transformed, man will express himself plastically in a "totally different" way, which obviously will represent a completely different view of nature. In this conception, *nature, from mineral to animal, is expressed less and less abstractly, less and less purely.* In its appearance, as in matter itself, *it shows*

an increasing outwardness. It becomes less and less absolute, more and more *capricious*, more and more *animal*. In opposition, the individual as he evolves frees himself from the capricious and the animal. His plastic expression must prove this, for everywhere man creates in his own image. As long as the natural, the material, and the animal dominate in him, this is what he expresses plastically. Although born of the material, art remains basically hostile to the material. This hostility grows as the material becomes more outward. The most profound art cloaks itself in the least capricious appearance. In music, the expression of art becomes almost "mineral." *Thus, Neo-Plasticism expresses the reconciliation of art and matter.*

But the multitude recognize inwardness only in its most outward and basically "animal" form. They appreciate art only when it is cloaked in the natural. They understand nothing of "interiorized" outwardness and "exteriorized" inwardness. Only through this unity-in-duality are mature individuality and conscious universality expressed.

The multitude now think themselves adult. Art, on the contrary, shows that they are dominated by animality. This animality does not appear in its primitive state but as somehow refined and adorned. Where animal purity is absent there can be no human purity. Intuition tries to express itself purely, but fails, because it is confused by the state of the masses. For man the artist, the instrument of intuition, is impure. Only when he has attained complete maturity will the truly "human" man free himself of his animality and achieve pure exteriorization of his deepest "self." Only then will animality be destroyed in art. *After this there will be no need either for the old plastic means or for the vocal organs of man.* Man will prefer sounds and noises produced by inanimate nonanimalized materials. He will find the noise of a machine more sympathetic (in its

"timbre") than the song of birds or men. Depending upon how it is produced, a given rhythm will affect him as being more or less individual. Rhythm produced mechanically by matter alone will echo his individuality less than the rhythm produced by the human voice: *with regard to its timbre,* the rhythm of a pile driver will affect him more deeply than any chanting of psalms. Thus, the new man is automatically compelled to seek truly "new" instruments. Inevitably—for only new instruments can fulfill the requirements of pure art.

Pure art annihilates not only the exclusively animal but also all *domination by the natural. Continuous fusion and repetition are the principal characteristics of the natural.*

Sounds in nature are the result of *simultaneous and continuous fusion.* The old music partially destroyed this fusion and continuity by decomposing noise into tones and ordering them in a definite harmony. But this did not transcend the natural. *This definiteness is not sufficient for the new spirit.* "Scale" and "composition" show regression to natural sound, fusion, and repetition. *To achieve a more universal plastic, the new music must dare to create a new order of sounds and nonsounds (determined noise).* Such a plastic is inconceivable without new technique and new instruments. *Mechanical intervention* will prove necessary, for the human touch always involves the individual to some degree and prevents the *perfect determination of sound.*

To neutralize undulation and fusion—thus the domination of the individual—other instruments are inevitable. If we are *to abstract* sound, the instruments must first produce sounds *as constant as possible in wavelength and number of vibrations.* Then they must be so constructed *that all vibration will stop when the sound is suddenly broken off.*

Some of the *bruiteurs* do break the continuity of sound. However, they preserve

repetition. Some are built along the lines of the old instruments. Luigi Russolo says: "My *bruiteurs* can produce diatonic and chromatic melodies in all possible tones of the scale and in all rhythms." But in this way the old mode of expression persists—which the new music will not permit. To the contrary, it requires a *constantly annulling opposition*: destruction of repetition. The old music expressed opposition either by repetition or by a pause, that is, by "silence." This "silence" should not exist in the new music. It is a "voice" immediately filled by the listener's individuality. Even a Schönberg, despite his valuable contributions, fails to express purely the new spirit in music because he uses this "silence" (in his pieces for piano). The new spirit demands *that one should always establish an image unweakened by time in music or by space in painting*. Only in this way can the "one" destroy the "other" and eliminate domination by the individual. The existence of continuous mutual opposition has as its principal condition the construction of a duality whose components are equivalent but not homogeneous, and that neutralize each other. The new music can achieve this duality through *sound and noise carried to abstraction*.

In the new music not only the expressive means but also the composition must be interiorized *as deeply as possible* (see above). It is through *composition* that the "universal plastic means" must be expressed in continuously self-neutralizing plurality (and not by repetition "in the manner of nature"). Without seeking symmetry "in the manner of nature," equilibrium must nevertheless predominate. Then composition, the plastic expression of equilibrated relationships, can express the universal more purely. *More purely*, because the plastic of relationships is *aesthetic* and therefore relative. The emotion it evokes, although not that of the old music or of the old painting, nevertheless exists. It

alone can produce the most profound aesthetic emotion.

Due to the character of their instruments and their attachment to the old scale and the old composition, the Italian Futurists do not achieve the "new" music. Neither does the *jazz band* despite all its innovations. The Futurists achieve in a different way what the jazz band does. The jazz band also uses new instruments along with the old, although they are less complicated than the *bruiteurs*. Although the *bruiteurs* sometimes form an orchestra exclusively of new instruments, most often they adopt a combination of the old and the new. The jazz band does the same but is more successful in annihilating the old harmony—probably because it is not preoccupied with "art." Without the mechanical advantages of the *bruiteurs*, jazz surpasses them by the freedom it allows for intuition suddenly to intervene. Thus the flow of sound can be intuitively interrupted and expression can already become more universal—until the time when instruments are created that will be *adequate to meet all the demands of the New Plastic*.

The jazz band also has the advantage of being supported by modern dancing. "The straight" is already strongly evident in the rhythm of new dances such as the shimmy, etc. In any case, there are no obstacles to jazz performances even if they are treated as barbaric. But most people regard the *bruiteurs'* performances as an attack on art itself.

Some ten years ago Marinetti proclaimed the necessity of speed. Since the idea of speed is expressed plastically in "the straight," it is surprising that the Italian Futurists have not rigorously applied this truth either to painting or to music. Absolute speed expresses in time what "straightness" establishes in space. Speed destroys the oppression of time and space and thus the domination of the individual: hence its

importance for the pure plastic expression of the universal. That is why *the power of speed can transform music's expression to greater inwardness, not only through measure and tempo but also through composition and the plastic means.*

What the *bruiteurs* express plastically is not absolute speed: they merely show the (old) relative speed in a new guise. Yet the pure new spirit "manifests itself," even if elsewhere. It "appears" regardless of how it is accepted.

The *bruiteurs* were invented in 1910 by Luigi Russolo, painter, musician, and physicist. In 1913, three *bruiteurs* were demonstrated to the public. In 1914, Russolo gave twelve concerts in London with *bruiteurs* that were still unperfected. Interrupted by the war, he afterwards collaborated with the Futurist Ugo Patti in building thirty-five *bruiteurs*, of which twenty-nine were perfected.

The *bruiteurs*, of various sizes and proportions, take the shape of rectangular prisms with a horn for amplification, a lever for adjustment, and a crank to be turned. Seen in the rear of the stage during a performance, these instruments, painted in primary colors, contrasted vividly with the old instruments standing in front of them.[2]

Just as the invention of photography dealt a "mortal blow" (André Breton) to the old modes of expression in art, so the invention of the *bruiteurs* dealt a blow to music. For the *bruiteurs* uncovered the naturalism

and individualism that remained concealed in music. Naturalism, in the sense of the imitation of natural sounds (including machines), causes degeneration in music. Reality was introduced into music with the intention of making it more universal; but by following reality too closely, music on the contrary became more individual. *Natural reality did not achieve its true expression because it was not transformed into abstract plastic.* This is clearly shown by the *bruiteurs* whose noises remain reproductions of natural sounds. One need only think of the names given to *bruiteurs*: screechers, growlers, cracklers, graters, howlers, buzzers, cluckers, gluggers, poppers, hissers, croakers, and rustlers.

Whereas the classical instruments artificially disguise natural sounds, the *bruiteurs* reproduce them almost in their everyday nakedness.

The bruiteurs unconsciously demonstrate the need for instruments that do not imitate natural reality (see "Neo-Plasticism," 1920). They demonstrate that "art" is quite different from "nature." Nevertheless, their music, using old harmonies despite new instruments, will deeply influence the coming music. It shows clearly the valuelessness for our time of the old harmony. Perhaps it will hasten understanding of the fact that the old music actually corresponds to the painting of the past. Music thus conceived may move more rapidly toward its final goal of "equivalence with nature"—the goal that Neo-Plasticism in painting has already achieved.

Neo-Plasticism: Its Realization in Music and in Future Theater (1922)

This essay, Mondrian's second on music, dated January 1922, appeared in *De Stijl* for January and February with the title "Neo-Plasticism (The New Plastic) and its (their) Realization in Music" ("Het Neo-Plasticisme [De Nieuwe Beelding] en zijn (hare) realiseering in de muziek"); it was subtitled "Supplement to 'The Italian Futurists' *Bruiteurs* and 'The' New in Music.' " Like its predecessor, it was translated into French by Mondrian himself for *La vie des lettres et des arts* (August 1922), with a revised title: "Neo-Plasticism: Its Realization in Music and Future Theater" ("Le Néo-Plasticisme: sa réalisation dans la musique et au théâtre futur"). A German translation was included in Mondrian's Bauhaus book *Die Neue Gestaltung* (1925).

After completing "The Italian Futurists' *Bruiteurs*" in mid 1921, Mondrian had set to work on a continuation: "I am now busy writing on Neo-Plastic music itself and describing the instruments. But I'm in no hurry; everything takes so much time," he reported to Van Doesburg on 3 October 1921. And on 28 December: "I have really worked on the articles, and I hope soon (perhaps in two weeks) to send you the conclusion on Neo-Plastic music": "I was pleased that Nelly [Van Doesburg] wrote me from Vienna confirming that in music 'rest' is the opposite of sound . . . and I will attempt to refute this. . . . I am not able to work out my Neo-Plastic music completely, because the instruments do not exist; but I will try to indicate everything."

"Here at last is one of the articles," Mondrian wrote Van Doesburg on 7 February 1922. This, the first of two parts, appeared in *De Stijl*'s January number: it was "so long and so late"

> because I wanted to deal with the whole situation once and for all. I think I have covered all the actual points of our relationship to the Cubists, to the Purists. . . . I hope you do not think it too risky to speak of a system, but it seemed the best way to put the matter clearly. For my part I am well-satisfied with this article, which I hope to translate into French and to push under the noses of those gentlemen.
>
> . . . If you think it better for the movement that I take this music of Neo-Plasticism on myself alone, as a *personal* conception, this could be done through a small alteration.

In the same letter Mondrian turned to an issue discussed in his essay: the fallacy of elaborating artistic theories on the basis of proportional or other numerical calculations:

> Have you read the article about Severini's book [*Du cubisme au classicisme: Esthétique du compas et du nombre* (Paris: J. Povolsky, 1921)]?[1]

It seems I was not wrong in calling him a schoolmaster when he stood at the easel expounding his theory. It seemed to me the same error that Vantongerloo made, and is perhaps still making. I deal with this in the part of my article on canons and numerical ratios, which give one merely the appearance of being abstract.

Mondrian returned to the subject in a summer 1922 letter to Van Doesburg, adding his thoughts on other backward-looking tendencies: "I am slightly acquainted with the little book of Severini's through an extract in *La Vie des L[ettres]*. It made me so angry that I spoke out against it (without mentioning his name) in my next to last article [the first part of "Neo-Plasticism: Its Realization in Music and Future Theater"]. For meanwhile Vantongerloo has taken the same path (of intellect)."

Neo-Plastic music of the future, as its name suggests, will be completely "outside" traditional music, just as Neo-Plastic painting can be regarded as completely "outside" morphoplastic painting. Yet in reality these Neo-Plastic arts are not outside music and painting. Assuming that true music and true painting require the use of *pure plastic means*, it is to the contrary *traditional* music and painting that are "outside."

Neo-Plasticism is not for artists who are "content" with morphoplastic expression, nor is it for laymen who have found a satisfying mode of plastic expression: the two conceptions cannot exist together. Since a sudden change of conception is illogical as well as impossible, Neo-Plastic art or ideas can only be disturbing to them. While Neo-Plasticism can have meaning for the inquisitive artist or layman, it is the plastic expression appropriate for those who have outgrown *morphoplastic*. Let Neo-Plastic painting or sound be addressed only to them, for only they can understand all that has been and is to be written on the subject.

Although Neo-Plastic painting has actually existed only for a few years, there is already a group which regards this expression of art as "theirs." The same will foreseeably happen with Neo-Plastic music even before the auditory realization of Neo-Plasticism. The realization of this music is only a question of time and money.

Because Neo-Plastic music stands outside tradition, it will be denied as "music," just as Neo-Plastic painting is denied as "plastic." Both denials are equally illogical if music is not limited to one system, or if plastic expression is not exclusively limited to morphoplastic (see preceding essay). Neo-Plastic differs only in its *deepening of the same thing*: for all plastic derives from the same source. Only because of this "deepening" is Neo-Plastic art "outside" traditional art and does it become *pure* art.

It took many centuries for morphoplastic to culminate in Neo-Plasticism. Neo-Plasticism was attained only through continuous struggle of the extremes (physical–spiritual). Plastic expression demonstrates this clearly. Already in antiquity the flute opposed the lyre (Bacchus–Apollo), just as in the music of our time the "jazz band" confronts the "concert orchestra." Automatically, *from this opposition, Neo-Plastic music will arise.*

Evolution of the individual tends toward "completeness," for in "complete man" the universal arises through the individual's annihilation the individualistic. Man then begins to see and hear *universally*. This new state of consciousness always requires *determination*. Thus the need for exact plastic expression of the universal. This is only possible *outside of morphoplastic*, which is not exact. It is only possible with a more profound plastic expression: Neo-Plasticism.

Because it is the most profound image (plastic expression) leading toward an *equilibrated duality, physical–spiritual*, Neo-Plasticism can become the *expression specifically appropriate to the complete man of the future*. Since even then the physical seeks to dominate, only abstract art can be the counterweight. Conversely, morphoplastic is essential to the individual dominated by the individualistic. It matters little whether this is manifested collectively (church, communism, etc.) or individually: harmony is not achieved. One clings to morphoplastic because the physical (the material) predominates.

Although the transition from morphoplastic to Neo-Plasticism was gradual, the separation between the two is very definite. Hence the violent struggle. From the beginning of the deepening, when the differences were so small that they produced only greater refinement, until Neo-Plasticism— which is the extreme degree of the deepening of the individual—innovations were accepted and sought because the individual remained predominant. But as soon as innovation became *pure expression of the new spirit*, the two were in direct and mutually hostile opposition. In Neo-Plasticism the individual is no longer evident because it is annihilated in the image.

Nevertheless, the beauty of life remains intact. Despite all, *everything grows toward pure expression of the new spirit*, therefore toward *harmony*, toward *unity*.

Just as we have termed Neo-Plastic painting "*Abstract-Real painting*," we can term Neo-Plastic music "*Abstract-Real music*." Both might better be understood as "Real Art," except for possible confusion due to the traditional conception of the word "real." The old art also called itself "real" even though it was so only in its appearance. Yet it did not show reality ("self" and "nonself") as it is, but gave only an illusion of reality, or showed it only in part. It showed reality neither totally nor purely. As morphoplastic, both music and painting showed only *the appearance of the most exterior as well as of the most interior*. The artist always showed *himself* . . . but his deepest "self" was not manifested.

As soon as life becomes equilibrated—when the physical and the spiritual become equivalent—the old art no longer has any reason for being. Because it is more or less an illusion, a fantasy, and no longer truly real (in our sense of the word), it remains *outside* of life.

We all know that complete life is not predominantly physical, even though it may appear to be. We also know that it is not predominantly spiritual, but is a unity comprising the two. But few realize that this unity is possible only through equivalence of the physical and the spiritual. "Modern" people claim only to recognize unity and they decry as outmoded dualism any attempt to separate these elements. Superficiality, fear based on misunderstanding of the past, blinds them to true unity, which consists of the *annihilating opposition* of the duality. Their life, their art have *only apparent unity*.

Modern man has transcended nature only despite himself. For despite the evolution of external life and changing circumstances, his inmost self remains dominated by the natural. He is therefore unhappy in the stage of modern life where nature is transcended. He cannot see the beauty of this life but regards it as "abstraction"—as denaturalized. Consequently he hates abstract art, he looks for a counterweight, his own kind of beauty in nature, and only a more or less naturalistic expression can satisfy him in art. He does not perceive the *new life* coming, already emerging from today's chaos: *abstract-real* life. Thus he also fails to see it reflected in *Abstract-Real* art.

It is impossible for physically dominated man to fully experience "physical-spiritual" equivalence. He cannot even have a pure conception of this equivalence. He experiences everything *physically*. If he is sensitive, he will experience more profoundly but nevertheless physically. His art is also the expression of physical, therefore *animal*, vitality (see the preceding essay). How far will physical predominance be veiled, spiritualized, sought or accepted? That will depend on the degree of refinement or profundity. Nevertheless, in art "physical life" is more or less deepened by the power of intuition: plastically, this deepening is manifested by the *mode of transformation of the means of expression*. In each period the transformation of the means of plastic expression reveals itself as *a system*, determined by the stage of human evolution. *Each phase of evolution creates a new system resulting from everything that preceded it.*

It is criminal to maintain intentionally an old system once its usefulness has ended. Yet the mass does this consciously or unconsciously, even though the new spirit has already been manifested by a group. This is done in good faith by art academies, by

artists, by critics as well as by laymen. Hostility can be fought against, but "good faith" can only be overcome by time and by the example of the few. Second only to the power (mainly material) of the mass, precisely this "good faith" would bring things to a halt, if that were possible. The artist, born of the past, advances as far as his intuition permits. The critic compares everything to the past, based on what has already been created. The layman depends on the past, on the critics, and on art; moreover he is too far "outside" art to be capable of discernment. The mass merely want a system of art that makes nature or the natural understandable and perceptible in a more or less naturalistic way. The more vivid this manner of rendering, the more they are moved, and the more they regard it as "art."

Life really begins only with the natural, the physical. At first, in infancy, man is almost entirely physical "nature." Then the "individual" is born, and with it the disequilibrium of the "physical-spiritual." That is why the natural system moves us most strongly at first. But as soon as life becomes more abstract, a more abstract system is necessary. But one way or another the individual reasserts itself. The natural is so strong that the majority of people—even artists who have contributed to a more abstract system—constantly return to the natural system. From the viewpoint of evolution this regression is, *at the least, weakness*. It is difficult to decide how much this regression is due to the artist and how much to the public. Clearly, the material side of life greatly influences this, even if only indirectly. Nevertheless, it is important to note that the natural system is basically "primitive," compelled to turn away from the natural. We see this clearly when we observe that the senses are first directed toward the external and turn inward only after prolonged contact with the natural. In

other words, we perceive this more clearly according to the degree that human progress asserts itself. Only incomplete evolution explains why so many who are involved with abstract endeavors remain confined by the natural system.

This attachment to building on natural appearances is not only expressed as "naturalism": it can also be continued in an abstract mode. Even in antiquity the laws of proportion were based on the human body. Aesthetic canons (measure and number) were also based upon the natural. Intellect shackled the mind. One seemed to follow the law of art, but in reality one followed the law of nature. Likewise today, intellect appears to discard the natural but in fact remains entirely dominated by it. *The intuitive-mathematical is displaced by the scientific-mathematical*, based on "phenomena" and "observation." Thus only the "perceptible" is defined by *measurement and numbers*. If a precise, deepened mathematical expressive means is employed to this end, then it is through the strength of the means (and not through laws of composition) that the image is freed from the domination of the natural. But the "system" continues to be natural, for within a system the expressive means and the composition are homogeneous.

Thus, in art, the degree of aesthetic profundity is determined by the system, which in turn contains other degrees of profundity: a system of art evolves in its own terms. It "modifies itself" within a given spiritual environment: "mutation" occurs only when another life becomes possible. *It modifies itself while the physical is predominant, it mutates when "physical-spiritual" equivalence becomes possible.*

Until Neo-Plasticism the system merely modified itself. Plastic expression was and continued to be the expression of natural appearance, more or less transformed. Even

modern artists, including the Cubists and Purists, did not go beyond a certain purification of natural form and color. Even in an abstract image, they continued, more or less, *to express physical life*.

This revelation, clearly seen in painting, also appears in music and the other arts. The system continues, while deepening and purifying the natural, to "veil" its predominance, but no more than that. The natural continues to dominate until *form is annihilated in the expressive means and composition.*

The great importance of "system" in art becomes clear when in music, for example, a work of art is performed by someone who is not an artist. Lacking the enchantment of talent—necessary to raise any system to the heights of art—the "system" is exposed. In music system is again revealed when symphonic music is represented in dance (for example, Isadora Duncan or Lystikoff). The naturalistic character of the old musical system is then manifested in visual plastic. This visual-plastic exteriorization can be regarded as a last revival of the old music. It is exactly the opposite of modern dance music (of the dance halls, etc.), where in contrast the new spirit is beginning to reveal itself. In any case *the system of "music" is predominantly individualistic*. It depends entirely upon the artist.

The artist has complete freedom to deepen, *more or less*, the natural in color or sound. Thus the *system* itself inevitably makes art individualistic.

In contrast, the more abstract the system becomes, and the more it manifests itself through *its proper means*, the less can the artist's individuality intervene. Finally, when the system is really abstract (which assumes that the artist employs universal plastic means in equilibrated composition), *plastic expression of the immutable is guaranteed,*

*and with it the plastic expression of the
universal.* But, if the execution is not to
become merely "system without art," here
the *pure talent* of the artist must be shown.
Much is then demanded of the artist, for
when one creates with universal plastic
means in equilibrated composition, *the
individualistic means of the natural system*
cannot be used. Pure intuition must be
manifested *directly*, by the clear aesthetic
vision arising from the universal in man.

*The abolition of form in the expressive
means and composition, the replacement of
form by universal plastic means, the creation
of equilibrated composition*, these make Neo-
Plasticism a really new system. Through the
equilibrium created by the constant opposi-
tion of the two elements of this system, true
"physical-spiritual" equivalence is possible
and plastically realizable.

In Neo-Plastic painting the plastic means is
determined color, the *duality of color and
noncolor*. In the Neo-Plastic music of the
future, the direct plastic means should be
determined sound, the *duality of sound and
nonsound* (noise). "Sound" is here used to
signify in the auditory what is expressed by
color in Neo-Plastic painting—more or less
in the sense of "tone" in music. And the
word "nonsound" is chosen to signify what
in Neo-Plastic painting is expressed as *non-
color*, that is, white, black, and gray. Thus
"noise" denotes percussive sound [*coup*]
rather than an assemblage of diverse sounds
incapable of forming a harmony in the old
sense. (The meaning of the two words can be
better understood by carefully reading this
and the preceding essay.)

For color to become determined it must be
(1) *plane*, (2) *pure* (primary), and (3) *exactly
defined without being limited*. That is why
color is employed in *rectangular planes*.

Curved line would be limiting and would not
make it possible to create an *equilibrated
relationship of position*. The *rectangular
position*, as expression of the immutable, is
the core of the Neo-Plastic plastic means.
From this the power and equilibrium of the
image derive.

Similarly in music, it will be necessary to
seek reduction to *the plane, to purity, and to
exact definition*, as far as sound and noise
permit. The new music must first achieve the
means of reproducing sound and noise,
which as much as possible will no longer
have the *round* or *closed* character of form
but, on the contrary, will have the character
of the *straight* and *unlimited*. This will
require *instruments of new design* (see "Neo-
Plasticism," 1920).

The limitation of sound will be found *in
sound itself* (see the preceding essay). This
will be "strengthened" by abrupt interrup-
tion, just as in painting the limit of a color
is strengthened by the straight line. This
interruption never becomes the "silence" of
the old music. One sound is directly followed
by another, which, being its "contrary," is its
real opposition. This "contrary" cannot be
silence, because silence produces no "image."
In Neo-Plastic music *nonsound will be in
opposition to sound*, as color is opposed to
noncolor in Neo-Plastic painting. "Non-
sound" will be *noise*, not sound. It should be
possible to create nonsound from noise
which, through its timbre and manner of
production, achieves *deepest purity and exact
determination*. It should be understood that
this "purity" will be entirely different from
the purity of traditional harmony. Thus
"nonsound" will be opposed to equally
purified "sound." The latter will always
retain its "color" regardless of its degree of
deepening, just as pure color in Neo-Plastic
painting retains the "outwardness" of color.
That is why it remains the *outward element*
in the duality of the plastic means. Con-
versely, nonsound, the new element in music,

will be a noise replacing the "silence" of the past, forming its equivalent as the *inward element*.

Both sound and noise will be manifested as *fundamental sound* and *fundamental nonsound*, like color and noncolor (white, black, gray) in Neo-Plastic painting. Their number will be determined by practice: probably three sounds and three nonsounds (as in painting: red, blue, yellow; white, black, gray).

The strength and duration of the sounds and nonsounds will be controlled unvaryingly (by an electrical apparatus) *in a composition of equilibrated relationships*. Through this composition the universal plastic means will be manifested "universally." The plurality of the plastic means should not create form: on the contrary, through plurality it should lose any characteristic of the *separate image*.

The composition will be found by the artist, just as it is he who will direct the construction of the plastic means. His intuition will lead him to correctly apply the Neo-Plastic laws. He will "study" but not copy pictorial composition. For example, by repeating sounds in different relationships, it will be possible to express with a minimal number of sounds and noises the richness and fullness that Neo-Plastic painting achieves with its few basic colors. Although of brief duration, the composition will allow the formation of an "image." It is just as when in painting, we look at a Neo-Plastic work and perceive successive relationships; after the first general impression our glance goes from one plane to its oppositions, and from these back to the plane. In this way, avoiding traditional repetition, we continually perceive new relationships which produce the total impression.

If the composition is to express equivalence and to neutralize its two elements, then its "plane" sounds (in the language of painting) should not have the same intensity or be similar in character. A very loud sound can be opposed by a relatively slight but *altogether different* noise. In this way it is impossible to produce vagueness or monotony.

The elements of the duality of the plastic means—which in theory may seem a bit arid—merge with each other to form a unity that is lost in the whole. Composition and plastic means create a "rhythm" different from natural rhythm and comparable in expression to the rhythm of Neo-Plastic painting. Here too, the artist's hardest task will be to oppose the "invariable" in equivalence with this rhythm.

In Neo-Plastic art, rhythm is the *external element of composition*, just as color and sound are the external elements of the plastic means (see above).

Modern dance music (shimmy, fox trot, tango) already shows us that mere stress upon duality in the tempo is not sufficient to create art. Nevertheless, in the shimmy as "dance" the opposing duality (heel-toe), as well as the rapidity of its tempo, are quite remarkable. Although the new spirit is beginning to show itself in this dance, it remains rather banal, especially because of the superficiality of its tempo. Its banality increases when the duality is put in relief by the highly accented meter in two or in three, or when "melody" is added. Even though this accentuation is partially annihilated by multiple oppositions, it *individualizes* itself. It draws attention to itself: it *limits*.

It is also interesting to note that, in modern dance, intuitive life leads to the universal precisely *through* the individual: the *individual is annihilated as soon as it materializes*. For example, certain figures (like the "corte" in the tango) were at first strongly accentuated (double corté), whereas today the accentuation *has almost disappeared*. Figure follows figure so rapidly that one annihilates

the other. Even so, the duality in modern dance music is not an opposition of *true contraries*—although in the jazz band we sometimes hear sounds which by their timbre and attack are more or less opposed to traditional "harmonious" sounds, and which clearly demonstrate that it is possible to construct "nonsound."

The place for the performance of Neo-Plastic music will have to satisfy new requirements. The "hall" will be completely different from the traditional "concert hall." There are different possibilities for the building and for the hall. All this will not be realized immediately. Even if the building cannot yet be constructed in perfect accord with the Neo-Plastic conception, it will nevertheless follow this conception as much as possible. Whatever is at first lacking in aesthetic expression can be compensated for by appropriately located Neo-Plastic paintings. Their *inherent expression* will satisfy aesthetic needs, for they cannot be considered as "decoration." The hall will be readily accessible. It will be possible to come and go without disturbing others, to hear and to see comfortably. The electrical sound equipment will be invisible and conveniently placed. The hall will meet the new acoustical requirements of "sound-noise."

In short, the hall will be neither a theater nor a church, but a spatial construction satisfying all the demands of beauty and utility, matter and spirit. No ushers or staff: an automatic buffet, or better yet no buffet at all, for one might leave the building without missing anything. Indeed, compositions could be repeated, just as modern cinemas schedule the same film at stated times. There could be long intermissions: for those who stay the interval could be filled by Neo-Plastic paintings. When it becomes technically possible, these could also appear as projected images. Artists and sponsors will no longer have to devise endless variations of program or to hunt for something "novel."

Neo-Plastic painting and Neo-Plastic music will thus have the same plastic expression. In the future, yet another art is possible: an art situated between painting and music. Since it is expressed by color and noncolor, it will be painting; but because the colors and noncolors will be shown in time and not in space, it will approach music. Because time and space are only different expressions of *the same thing*, in the Neo-Plastic conception music is *plastic (i.e., expression in space)*, and the *"plastic" (painting) is possible in time*. Thus rectangular planes of color and noncolor can be projected separately and successively. The planes and their composition cannot be taken directly from Neo-Plastic painting, for their expression in time (as in music) has different requirements. The same aesthetic image must be created by a different use of the plastic means and by another kind of composition. For us to assimilate such an aesthetic image by abstraction, it *will probably* be necessary to attain a stage of abstract evolution even beyond that now required by Neo-Plastic painting and music: true unity of the "physical-spiritual."

The Realization of Neo-Plasticism in the Distant Future and in Architecture Today (1922)
(Architecture Understood as Our Total Nonnatural Environment)

Written in the last half of 1921 and the beginning of 1922, "The Realization of Neo-Plasticism in the Distant Future and in Architecture Today" appeared in the March and May 1922 issues of *De Stijl* under the title "De realiseering van het Neo-Plasticisme in verre toekomst en in de huidige architectuur (Architectuur begrepen als onze geheele [niet natuurlijke] omgeving)." A German translation was included in Mondrian's Bauhaus Book no. 4, 1925.

The immediate stimulus for this essay was an article by the architect J. J. P. Oud, published in June 1921. *De Stijl*'s early leading contributor on architecture, Oud became city architect for Rotterdam in 1918. His low cost housing complexes for that city (completely without ornamentation, but not otherwise identifiable with De Stijl) soon became internationally famous as models of functionalist design. Mondrian's friendship with Oud began with their correspondence at Van Doesburg's suggestion in January 1920, and it was cemented by Oud's visit to Mondrian in Paris the following summer. On all significant matters there seemed to be a complete meeting of minds.

Oud's article, "Building in the Future and Its Architectural Potentialities,"[1] praised the purification ensuing from the strictly utilitarian use of industrial materials without any decorative embellishment (exemplified by photographs of a locomotive and an automobile). In just this way, advanced architecture was turning away from the handicraft aesthetic toward the steel and glass aesthetic of the modern factory. A comparable process of purification and liberation had taken place in art (illustrated by a Futurist painting of Severini's, a Cubist-derived landscape by Survage, and a 1918 Neo-Plastic canvas by Mondrian). Absent from Oud's piece, however, was any mention of the architectural ideals of De Stijl—or of Mondrian's conception of future architecture as set forth in the "Trialogue" or more recently in "*Le Néo-Plasticisme.*"

Also drawing Mondrian's attention to architecture in 1921 was Léonce Rosenberg's proposal in March that a house be designed for him by the De Stijl "group." Mondrian wrote Oud on 9 April:

> You have heard of Rosenberg's great plan. It seems to me unfeasible, since there is as yet no unified De Stijl group, or rather there is no De Stijl group. . . . I told Does that it seemed feasible only if you and Does were to collaborate on a plan with me as consultant. . . . For my part I take the decoration very seriously, and I told Does that I could not make designs gratis. For me it would be an enormous undertaking.

In this connection Mondrian stressed, as he does in his essay, the desirability of maquettes "made of wood and sheet-metal or cardboard."

A third stimulus was the visit in the fall of 1921 of a Belgian artist,

Jozef Peeters. Whereas Mondrian strongly opposed any tendency to the "decorative," Peeters's typographical designs consisted of angular elements forming complex ornamental patterns. In this they recalled the stylized decoration and fantasticated architecture of the crafts-oriented Amsterdam School, which received considerable patronage from that municipality. The group's handsome publication *Wendingen* (1918–31) was contemporary with *De Stijl*. Mondrian wrote Van Doesburg on 3 October 1921:

> Whatever [Peeters] has taken from Neo-Plasticism, it has nothing to do with it. But not only from Neo-Plasticism: he borrows from everywhere, so long as it is "flat." It is a good thing I spoke with him, for I will now come out against him and others, in the architecture article. I mean *against* l'art appliqué. Oud has written me on architecture, but since I was unable to make everything clear to him, I am doing an article.

Mondrian first reacted to Oud's article with the gentle rebuke (17 August 1921):

> You write so cautiously of a new and purer art that is to evolve from Cubism. Wouldn't it have been better to name Neo-Plasticism directly as the principle of *all expression* (of our time)? We can speed the new only by starting from the fixed principle that Neo-Plasticism discovered in painting. If we of De Stijl fail to unite on this *one thing*, then everything will go very slowly.

He recognized, however, that an overt discussion of De Stijl and Neo-Plasticism might have been "too much" for Oud's public. Having evidently received an answer from Oud, Mondrian replied (30 August): "After reading your letter it became clear to me where the difficulty lies. We can be pure only if we once again regard architecture as *art*. Only as art can it satisfy the aesthetic requirements of Neo-Plasticism." But since pure Neo-Plastic architecture still lay in the future, he would do an article on the difference between the present day and that future: "for therein lies the crux of the matter."

On 12 September Mondrian again wrote:

> I like what you say in your letter, that you like N.P. [Neo-Plastic] as artistic conception. But how can you fail to accept its applicability to architecture? Why do you judge such an application to be individualistic? You write: "is N.P. now being offered as something self-sufficient?" By this you doubtless mean, "will it become a particular expression?" Or do you mean, "will it appear in a building as something separate and apart?" But I see no possibility for it at present in an entire city!! Precisely because N.P. is not something separate, but a whole.

He would send Oud his article in the fall: "Perhaps we will be able to agree once more."

Having begun the article, Mondrian elaborated to Oud (18 September): "So-called 'practice' can never create Neo-Plastic architecture. That in itself would demand a completely different kind of 'practice'—which is simply impossible for us given existing conditions (money-power). I do not mean that Neo-Plastic architecture should proceed apart from life, but it can move toward *another* life."

After a delay caused by moving his studio back to rue du Départ, Mondrian resumed his attempt to "make everything clear as to the difficulty of applying Neo-Plastic principles" (6–7 December 1921). He summarized his position when writing (23 December) to Van Doesburg, who had himself just broken with Oud on a similar issue:

> I saw then that he [Oud] was convinced of the great significance of N.P., but was unable to apply it in practice (not surprisingly, of course, if you are the architect for Rotterdam). And I wrote him that it was now clear to me that in order to remain pure, architecture must be separated into two parts: that which is completely art, and that which is nonart. The [part that is] nonart could represent N.P. to whatever extent possible.

When he sent the first part to Van Doesburg (7 February 1922), Mondrian expressed the hope that its publication would coincide with the retrospective exhibition planned for March at the Stedelijk Museum in honor of his fiftieth birthday; it would be "my manifesto: I intend it as a protest." He expected that Oud would find this part "very idealistic," but the second, he hoped, would "meet all your objections" (5 May).

After reading both parts Oud must have made unmistakably clear his refusal to accept Neo-Plasticism in architecture. To which Mondrian replied (in August or September): "I cannot understand how you arrived at the traditionalistic idea of dividing building from painting—and dividing a person from his ideas." Although Mondrian had been "wounded in my holiest ideals" (as he told Van Doesburg around August 1922), he resumed correspondence with Oud after a year, and their friendship remained unimpaired.

The "art of architecture" gradually passes into "*construction*"; the "decorative arts" progressively yield to "*machine production*"; "sculpture" becomes chiefly "ornament," or is absorbed into *luxury and utilitarian objects*; "theater" is displaced by the *cinema* and the *music hall*; "music" by *dance music* and the *phonograph*; "painting" by *film, photography, reproductions*, and so on. "Literature" by its very nature is already largely "*practical*," as in science, journalism, etc., and is becoming more so with time; as "poetry," it is increasingly ridiculous. In spite of all, the arts continue and seek *renewal*.

But the way to renewal is also their *destruction*. To evolve is to *break with tradition*—"art" (in the traditional sense) is in the process of progressive dissolution, as is already evident in painting (in Neo-Plasticism). At the same time, *outward life* is becoming fuller and many-sided, thanks to *rapid transportation, sports, mechanical production and reproduction, etc*. One feels the limitation of spending "life" creating art, while *the whole world is going on around us*. More and more, life commands our attention—*but it remains predominantly materialistic*.

Art is becoming more and more "vulgarized." The "work of art" is seen in terms of a *material value* that progressively declines unless "boosted" by commerce. Society increasingly opposes *the life of intellect and feeling*—or employs them in its service. *Thus society opposes art too*. But this predominantly physical outlook sees only decadence in the evolution of life and of art. For society today regards feeling as its flower, intellect as its power, art as its *ideal* expression. Our surroundings and our life show impoverishment in their incompleteness and stark *utilitarianism*. Thus art becomes an *escape. Beauty and harmony* are sought in art because they are lacking in our life and in our environment. Consequently, beauty or harmony becomes the "ideal," something *unattainable*, set apart as "art" separated from life and environment. Thus the "ego" was freed *for fantasy and self-reflection, for the self-satisfaction of self-reproduction*: creating beauty in its own image. Attention was diverted from *actual* life and *true* beauty. This was inevitable and *necessary, for in this way art and life freed themselves*. Time *is evolution*, despite the fact that the ego sees this too as "ideal," *unattainable*.

Today the majority deplores the decay of art while they nevertheless *oppress it. The physical predominates in, or seeks to dominate, their whole being: thus they oppose the inevitable evolution*—even while it is being accomplished.

In spite of all, both art and the reality around us show this precisely as the *beginning of a new life*—man's eventual *liberation*. Although created by the flowering of our dominantly physical being ("feeling"), art is basically *pure plastic expression of harmony*. Arising from the *tragic of life*—caused by the dominance in and around us of the physical (the naturalistic)—art expresses the yet imperfect state of our deepest "being." The latter (as "intuition") seeks to narrow the *gap*—never to be *completely* bridged as long as the world endures—that separates it from the material-as-nature: it seeks to change disharmony to harmony. Art's *freedom* "permits" harmony to be *realized* despite the fact that physically dominated being cannot *directly* express or attain pure harmony. Indeed, the evolution of art consists in its achievement of a *pure* expression of harmony: art appears only *outwardly*, as an expression that (in time) *reduces* individual feeling. Thus art is both the *expression* and (involuntarily) the *means of material evolution: the achievement of equilibrium between nature and nonnature*—between *what is in us and what is around us*. Art will remain both expression and means of expression until (relative) equilibrium is *reached*. Then its task will be fulfilled and harmony will be *realized* in our outward surroundings and in our outward life. The domination of the tragic in life will be ended.

Then the "artist" will be absorbed by the *"fully human being."* Like him, the "nonartist" will be equally imbued with beauty. Predisposition will lead one person to the aesthetic, another to the scientific, someone else to yet another activity—but the "specialty" will be an *equivalent* part of the

whole. Architecture, sculpture, painting, and decorative art will then merge, that is to say, become **architecture-as-our-environment**. The less "material" arts will be realized in "life." Music as "art" will come to an end. The beauty of the sounds around us—purified, ordered, brought to the new harmony—will be satisfying. Literature will have no further reason to exist as "art." It will become *simply use-and-beauty* (without lyrical trappings). Dance, theater, etc., as art will disappear along with the dominating "expression" of tragedy and harmony: the movement of life itself will become harmonious.

In this image of the future, life will not become static. On the contrary: beauty can never lose by intensification. But it will be a different beauty from the one we now know, difficult to conceive, impossible to describe. Even the Neo-Plastic "work of art" (which remains to some degree individual) still imperfectly expresses this, its own realization. It cannot directly express the fullness and freedom of life in the future. *The Neo-Plastic conception will go far beyond art* **in its future realization.**

Just as the contours of the human figure cannot be straightened except by clothing, there are some things that do not permit the most extreme intensification and, if forced, would lead to rigidity. In today's architecture, for instance, a dinner service does not require a specifically prismatic form: a tautened round form will suffice. These details will be automatically absorbed by the strength and completeness of reality as a whole. In any case, such utensils need be kept in sight only when they are in "use." *Simplicity* will make everything more convenient. This efficiency will come automatically by perfecting the use of materials, machines, transportation, etc. Man will then become *free:* labor makes him a *slave.* He will also be more free, both inwardly and outwardly, because of his environment. Perfection of the

outward together with simplification of the inward creates harmony (harmony in the sense of *perfect action*, not in the old sense of pastoral repose. On the new harmony, see my pamphlet "Neo-Plasticism," 1920.)

Will the backwardness of the masses make *perfect life* impossible even in the remote future? This is of no importance to *evolution*, which continues regardless, and with evolution alone must we reckon.

Throughout the centuries art has been the *surrogate* reconciling man with his outward life. "Represented" beauty sustained man's belief in "real" beauty: beauty thus could be *experienced perceptibly*, although in a limited and narrow way. Whereas "faith" requires a superhuman abstraction to produce the experience of harmony in life, and science can produce harmony only intellectually, art enables us to experience harmony *with our whole being.* It can so infuse us with beauty that we become *one* with it. We then *realize* beauty in *everything: the external environment can be brought into equivalent relationship with man.*

The material world around us is gradually becoming *transformed* to this end. This "transformation" is necessary, for both art and surrounding reality show that in order to achieve *actual* harmony it is not enough for our humanity alone to become mature. (Harmony is then merely an *idea.* Precisely by his "maturing," the individual outgrows natural harmony: he must create a *new* harmony.) Reality as well as art shows that it is also necessary to *reduce* the outward around us and, so far as possible, to *perfect* it around us so as to harmonize with man's full humanity (reduced outwardness and intensified inwardness). Thus there arises *a new concept of beauty, a new aesthetic.*

In the reality of our environment, we see the *predominantly* natural gradually disappearing through *necessity.* The capricious forms of rural nature become tautened in the

metropolis. In machinery, in the means of transportation, etc., we see natural materials become more harmonious with man's gradually evolving maturity. *Precisely by concentrating on the material,* external life is moving toward freedom from material oppression. Material pressure destroys the *sentimentality of the ego.* Thus it serves to achieve purification of the ego—through which art also is expressed. Only *after* this purification can equivalent relationship, equilibrium—and therefore *pure* harmony—arise.

Art also evolved from the natural to the abstract; from the predominant expression of "sentiment" to the *pure* plastic expression of harmony. Being "art," it could actually go beyond the reality of our environment. Painting, the freest art, advanced in the most purely "plastic" way. Literature, music, architecture, and sculpture became active almost simultaneously. In various ways *Futurism, Cubism,* and *Dadaism* purified and reduced individual emotion, "sentiment," the domination of the ego. Futurism struck the first blow (see F. T. Marinetti: *Les Mots en liberté Futuristes*). Consequently *art as ego expression* progressively broke down. Dadaism still aims at the "destruction of art." Cubism *reduced natural appearance in plastic* expression, and thus laid the ground for Neo-Plasticism's *pure plastic.* Materialistic vision was deepened and *the plastic of form was annihilated.*

What was achieved in art must for the present be limited to art. Our external environment cannot yet be realized as the pure plastic expression of harmony. Art advances where religion once led. Religion's basic content was to *transform the natural;* in practice, however, religion always sought to harmonize man *with nature,* that is, with *untransformed* nature. Likewise, in general, Theosophy and Anthroposophy—although they already knew the *basic symbol of*

equivalence—could never *achieve the experience of equivalent relationship, achieve real, fully human harmony.*

Art, on the other hand, sought this *in practice.* It increasingly *interiorized* natural externality in its plastic expression until Neo-Plasticism, where nature *actually* no longer dominates. Its expression of equivalence prepares the way for full humanity and for the end of "art."

Art is already in partial disintegration—but its end *now* would be premature. Since its *reconstruction-as-life* is not yet possible, a new art is still necessary, but *the new cannot be built out of old material.* Thus, even the most advanced of the Futurists and Cubists more or less retreat to the old, or are not free of the old. The great truths they proclaimed are not realized in their art. *It is as if they were afraid of their own consequences.* Even those who initiated the new seemed unprepared for it. Nevertheless, *the great beginning has been made.* From this beginning pure consequences could be manifested. From the new movement *Neo-Plasticism* arose: *an entirely* **new art—a new plastic.** As purified art, it shows clearly the *universally valid laws* on which the new reality is to be built. For the "old" to vanish and the "new" to appear, a universally valid concept must be established. It must be rooted in feeling and in intellect. That is why, some years ago, Theo van Doesburg brought *De Stijl* into being: not to "impose a style," but collaboratively to discover and disseminate what in the future will be *universally valid.*

Once realized in painting, the Neo-Plastic concept was manifested in sculpture (Vantongerloo's prismatic compositions). A few architects aligned themselves with the "New Plastic": seeking to realize it in practice, they theoretically followed the same path. Some were truly convinced of the *necessity* of a

new architecture "that realizes everything our time has to offer by way of spiritual, social, and technical progress" (lecture by J. J. P. Oud, February 1921). It speaks well for Neo-Plasticism that the most advanced minds outside the movement are seeking in the same direction—without, however, achieving the same "consequence." **The consequence of Neo-Plasticism is frightening.** One doubts the possibility that the Neo-Plastic idea can achieve realization-as-architecture today: there is "creation," but without *conviction*.

The architect today lives at the level of "practical building"—**from which art is excluded.** Thus if he is responsive to Neo-Plasticism at all, he expects to realize it directly in that kind of building. But the fact that Neo-Plasticism has first to be created as the "work of art" is not appreciated, for its content is not completely felt or understood. Only as "work of art" can Neo-Plasticism be realized as "our environment."

In our time, each work of art can only remain isolated. Neo-Plasticism, to be sure, will be fully realized only in complexes of buildings, the *city*. But there is no reason to reject Neo-Plasticism just because it cannot be realized today. At present even Neo-Plastic painting has to stand alone—this does not therefore make it individual. For its plastic makes it determinate.

The practice of architecture today is generally not *free*—as Neo-Plasticism demands. Today freedom is found only through individuals or groups who wield material power. One is therefore limited to the *individual building*—which then asserts itself in contrast to its environment, to nature, to traditional or miscellaneous building. It is nevertheless a "plastic expression," *a world in itself*, and thus is capable of realizing the Neo-Plastic idea. Therefore, the Neo-Plasticist must *abstract* the environment, for he knows that harmony can exist only through *equivalence*; for him, any harmony between nature and man's constructions is a *fantasy—unreal, impure.*

Even as a "work of art," however, Neo-Plastic architecture can be realized only under certain *conditions*. Besides *freedom*, it requires a kind of *preparation* not possible in ordinary building practice. If the founders of Neo-Plasticism in painting succeeded in fully expressing the "new" plastic only at great sacrifice, to achieve this in the ordinary architecture of today is *virtually impossible*.

Execution in which every detail must be *invented and worked out* is too costly or impossible under present circumstances. *Absolute freedom for continuous experimentation* is necessary if an art is to be achieved. How can this be possible within the complex limitations of conventional building in our society? First, there must be the **will** and the **power** to realize the Neo-Plastic idea. A school to meet all research requirements must be founded.[2] A specially designed *technical laboratory* would be needed. This is far from impossible; they now exist but they are academic—superfluous because they merely *reproduce* what already exists. Today, the architect is compelled to create a "work of art" more or less hastily and under constraint; he can develop it only on paper.

How can he solve every new problem a priori? A plaster model is no real study for an interior design; and there is neither time nor money for a large-scale model in metal or wood. *Time* will make possible what we should be able to do today. Long and diversified research will finally create the completely Neo-Plastic work of art in architecture.

"Building" and "decoration" as practiced today are compromises between "function" on the one hand and the "aesthetic idea" or "plastic" on the other. This is *due solely to circumstances: under previously mentioned conditions the two can be united.*

Utility and beauty *purify each other* in

architecture. That is why architecture through the ages, although bound by other limitations, has been the prime vehicle of "style." By *necessity* architecture—bound by materials, technology, function, and purpose—was not the most suitable ground for the expression of "feeling." For this reason it retained a greater *objectivity* (known as "*monumentality*"). Yet, precisely for this reason, it could not evolve as rapidly as the freer arts.

Utility or purpose indeed affects architectural beauty: Thus, there is a difference between the beauty of a factory and of a home. Function can even *limit* beauty: some utilitarian things (such as factory installations and machinery, or wheels) may require a round form, although the "straight" expresses the profoundest beauty. Roundness in such cases usually takes the form of the pure circle, which is far from capricious nature. *The architecture itself* can nevertheless dominate the whole; still, some "relativity" always remains.

The entrenched belief that architecture deals only with three-dimensional "plastic" helps to explain why the "plane" expression of Neo-Plasticism is regarded as impossible for architecture. That architecture must be **form-expression** is a *traditional view*, however. *It is the (perspective) vision of the past*, which Neo-Plasticism abolishes (see "Neo-Plasticism," 1920). The new vision (even before Neo-Plasticism) does not proceed from one fixed viewpoint: it takes its viewpoint *everywhere* and is *not limited to any one position. It is not bound by space or time* (in accord with the theory of relativity). Practically, it takes its position *in front of the plane* (the most extreme possibility of plastic intensification). Thus it regards architecture as a *multiplicity of planes*: once more the *plane*. Thus this multiplicity composes itself (abstractly) into a *plane* image. At the same time, practice demands a visual-aesthetic

solution (through composition, etc.) that remains relative, due to the relativity of our physical movement.

As a *plane-plastic*, Neo-Plastic architecture requires **color**, without which the plane cannot be a living reality for us. Color is also necessary in order to reduce the naturalistic aspect of materials: *the pure, plane, determinate (i.e., sharply defined, not fused) primary or basic* colors of Neo-Plasticism and their opposition, *noncolor (white, black, and gray)*. The color is supported by the architecture or annihilates it, as required. Color extends **over the entire architecture**, equipment, furniture, etc. Thus, the one annihilates the other within the whole. But we thus also come into conflict with the **traditional conception** of "structural purity." The idea is still current that structure must be "revealed." Recent technology, however, has already dealt this notion a blow. What was defensible in brick construction, for example, is no longer so for concrete. If the *plastic concept* demands that the structure be neutralized plastically, then the way must be found to satisfy the demands both of structure and of plastic. Neo-Plastic architecture requires not only an "artist" but a **genuine** *Neo-Plasticist*. All problems must be solved in a *genuinely Neo-Plastic way*. Neo-Plastic beauty is **other** than morphoplastic beauty, just as Neo-Plastic harmony is *other*, and is not harmony for conventional feeling (see "Neo-Plasticism," 1920).

Another beauty is also being manifested in our outward surroundings independently of Neo-Plasticism. "Fashion" in dress, for instance, shows the abolition of natural structure and the transformation of natural form: *an annihilation of nature* that does not impair beauty but *transforms* it. *Today structural and aesthetic purity merge in a new way. We also see it in art.* Whereas naturalistic expression required that anatomy (structure) be expressed, there is no place for

this in the new art. Neo-Plastic architecture will take advantage of the latest technical inventions without loss to the plastic conception. Art and technology are inseparable, and the further technique develops, the purer and more perfect can Neo-Plastic art become. Technology is already working hand in hand with the Neo-Plastic idea. For where brick construction needed curved vaulting to enclose space, reinforced concrete gave rise to the flat roof. Steel construction itself also offers many possibilities. Will expense stand in the way of Neo-Plasticism in architecture? The cost would be much lower if research were performed by the special institute we mentioned. And how much Neo-Plastic architecture could save on ornament and stone carving, etc! Yet expense is a main reason why this new architecture will for some time to come remain limited to the "work of art." Nevertheless, many aspects of the *Neo-Plastic conception can already be realized in current construction.*

Ornament is already much reduced in advanced modern architecture, so it is no surprise that Neo-Plasticism *excludes it altogether.* In such architecture, beauty is no longer an "accessory" but *is in the architecture itself.* "Ornament" has been *deepened.* So too sculpture has been absorbed in the design of the interior (furniture, etc.). Utilitarian objects become beautiful through their basic form, that is, *in themselves.* Yet they are nothing in themselves: they become *part of the architecture* through their form and color.

In the interior, empty space becomes "determined" by the so-called "furniture," which in turn is related to the spatial articulation of the room, *for the two are created simultaneously.* The position of a cabinet is as important as its form and color, all of which are in turn as important as the design of the space. Architect, sculptor, and painter find their **essential identity in collaboration** or are all united *in a single person.*

The Neo-Plastic conception that utilitarian objects, etc., must merge into the whole and neutralize one another is totally opposed to certain modern tendencies that would elevate utilitarian objects into objects of "decorative art," thus aiming to create a "social art," to "bring art into life." In fact, however, this is simply a return to making "paintings" and "sculptures"—but in an impure way, for art requires freedom. Such tendencies can never "renew" our environment. Attention is dissipated in details. Efforts of this kind are equally *detrimental* to pure painting when they adapt pure plastic elements. For they employ painting decoratively where it should be *purely plastic.* Neo-Plasticism *seemingly* lends itself to decoration (through its planarity), but actually the "decorative" has no place in the Neo-Plastic conception.

Architecture and sculpture have been discussed from the point of view of painting: this is possible because in architecture they form a *unity.* Morever, the Neo-Plastic aesthetic originated in painting, but once formulated, the *concept is valid for all the arts.*

Is Painting Inferior to Architecture? (1923)

"Is Painting Inferior to Architecture?" ("Moet de schilderkunst minder-waardig zijn aan de bouwkunst?") appeared in *De Stijl* in late 1923.

Whether the new architecture should be shaped by architects or by painters—by the requirements of architecture or by the aesthetics of Neo-Plastic painting—was an issue that repeatedly divided De Stijl. It led to the early defection of Van der Leck, and later to the break between Van Doesburg and Oud, as well as the temporary break between Oud and Mondrian.[1]

The exhibition of De Stijl architecture held at the Galerie de l'Effort Moderne from 15 October to 15 November 1923 perhaps gave Mondrian the occasion for this short piece similar to his "The Realization of Neo-Plasticism in the Distant Future and in Architecture Today" (1922), which concludes that "the aesthetic for architecture is that of the new painting."

That in Mondrian's view painting still held lessons for architecture seems implicit in his comment written to Oud (12 November 1923): "The exhibition of Dutch De Stijl architecture is chiefly interesting as a demonstration: it could be considerably improved in practice."

Because of the growing concentration on practical life today, painting is regarded by many as "play," as "fantasy." In contrast to architecture, which is regarded as having practical and "social" importance, painting remains a mere "amenity of life." This is a widely held view. The Larousse dictionary lists under *agrément*: "arts d'agrément: music, painting, dancing, riding, fencing." Disregard of the plastic in art is the logical result of obscuring the purely plastic. Thus it is a reaction to the misuse of art.

Obscuring the purely plastic by form or by capricious rhythm turns "art" into "play." The lyrical (sung or described) beauty thus created is play. Lyricism is a vestige of the childhood of mankind, of an age familiar with the lyre but not with electricity. The desire to preserve lyricism in painting turns it into a pretty game, both for those who want or must choose the "practical," and for those who demand "purely plastic" art. The former "wish" for play and fantasy along with the starkly practical; the latter are unmoved by capricious play in art. Has not the time come for those who want play and fantasy in art to find this in the cinema, etc., if they do not see it or find it in life itself? Is it not time for art to become pure *art*?

Although not regarded as play, architecture today is also treated as a mere amenity of life but in a different way. Architecture is usually seen as the practical and painting as the ideal expression of man's subjectivity rather than as expression of plastic emotion. Plastic emotion is thus seen as secondary rather than primary—just as it was in all the old art: all Morphoplastic subordinates the purely plastic.

The purely plastic is not imitation of life but its opposite. It is the immutable and absolute as opposed to the changing and capricious. The absolute is expressed in the

straight. Painting and architecture in the new aesthetic are consequent realizations of *composition of the straight in self-annihilating opposition, thus a multiple duality of the constant rectangular relationship.*

A new aesthetic and a new art are prerequisites for *the realization of universal beauty.*

Architecture was purified by utilitarian building with its new requirements, technology, and materials. Necessity is already leading to a purer expression of equilibrium and therefore to a purer beauty. But without new aesthetic insight this remains *accidental, uncertain;* or it is weakened by impure ideas, by concentration on nonessentials.

The new aesthetic for architecture is that of the new painting. Architecture that is now purifying itself is prepared to achieve the same consequences that painting realized in Neo-Plasticism after the purifying process of Futurism and Cubism. Through the unity of the new aesthetic, architecture and painting can together form one art and can dissolve into each other.

Neo-Plasticism
(1923)

"Het Neo-Plasticisme," in Dutch, dated August 1923, appeared in *Merz* (Hanover), no. 6 (October 1923). The present translation incorporates Mondrian's corrections on his printed copy.

Merz was the little magazine published irregularly by the artist and poet Kurt Schwitters, the most notable representative of the Dada spirit active in Germany. This issue, with identical "front" covers at either end, was coedited by Hans Arp. In *Le Néo-Plasticisme* (1920) Mondrian had applauded the Dadaists' breaking of traditional form in literature. Neo-Plasticism also shared with Dada the wish to see "beauty-in-art" (as Mondrian here puts it) replaced by "beauty-in-life." After the publication in April 1920 of the "Manifesto on Literature" in *De Stijl* (co-signed by Mondrian), Van Doesburg began to inject a strong Dadaist element into his journal. This was most conspicuous in the contributions of one "I. K. Bonset"—actually Van Doesburg's pseudonym as Dada poet. Mondrian, who was kept ignorant of the deception, remarked to Oud on 1 August 1922: "He [Van Doesburg] is an excellent editor even if there is too much Bonset in it. [Still] the Dada element is good, precisely as a counterweight to what now prevails."

De Stijl's link to Dada was further strengthened when in 1922–23 Van Doesburg put out four numbers of *Mécano* with the collaboration of Arp, Tristan Tzara, and Schwitters. And in early 1923 Schwitters joined Theo and Nelly van Doesburg in giving provocative Dada performances in a number of Dutch towns. Hans [Jean] Arp, besides contributing poetry to *De Stijl*, collaborated (as did his wife, Sophie Taueber-Arp) on the transformation of the Café Aubette in Strasbourg organized by Van Doesburg (1926–28).

Among Mondrian's papers was an imperfect English translation of this article in another hand. A transcription of it by Mondrian himself is preserved among the Katherine Dreier papers, Beineke Rare Book and Manuscript Library, Yale University. The Societé Anonyme Museum of Modern Art was initiated and developed by Katherine Dreier and Marcel Duchamp beginning in 1920. This great pioneer collection, now permanently housed at the Yale University Art Gallery, includes 169 artists representing 23 countries. The Brooklyn Museum gave the collection a memorable exhibition in 1926; it was the first showing of Mondrian's painting in the United States.

On the back of the last page of the first-mentioned translation Mondrian drafted a letter in Dutch, for translation into English, offering an article—presumably "Neo-Plasticism"—to an American journal, *Futurist Aristocracy*,[1] "of which I have learned through 'Noi' " (see below, p. 190). "Since it is with the aim of disseminating my ideas, I require no honorarium, but I would like it to be published soon."

The time is approaching for beauty-as-art to be replaced by the beauty of life. The transition must be a gradual one: at present the beauty of life cannot be realized in a pure way. For what we understand by "life" is not the subjective life of the individual but the manifest social life of at least a *group*. Real beauty does not arise through subjective vision: the latter gives an illusion of beauty that serves only as preparation for real beauty. If by beauty we understand unity through the equilibrium resulting from an equivalence in the polarity of life, then the time of its realization is still remote. While its highest and truest realization resides in the distant future, a certain realization is nevertheless possible today—in the pure beauty of our surroundings. Thus we can prepare this true life. Beauty in our surroundings can be prepared only by art, for art is *free* and *disinterested*. Thus, before art can be realized in our surroundings, art will have to come to its end—in an art that expresses our mature humanity and is therefore a plastic expression of the equilibrated relationship of the polarity of life.

It must therefore be a specifically new art with a definitive aesthetic. It will offer to the future a pure image of beauty that will transform our surroundings as well as our life—now dominated by the natural—into an equilibrium between nature and nonnature. Pure beauty can be achieved only through this equilibrium between us and our surroundings, between content and appearance. To discount appearance and emphasize the ego was the old idea that remained necessary as long as the natural was dominant. But as soon as the natural is deepened so as to become equilibrated with the inward through reciprocal action, appearance ceases to be a neglected factor.

The mature individual sees content as *appearance*. Thus content can find exact plastic expression. Description (the lyrical) is eliminated: appearance itself manifests everything—free of place and time.

A *determinate* plastic expression with *determinate* plastic means is an inherent unity. For in everything relative there is an absolute, immutable content. All differences of form disappear: the absolute has its *determinate appearance*. It can be called objective or abstract in contrast to the varying appearance of the changeable. But for the new man it is real. A new plastic arises in art. The old plastic of form inevitably expresses the tragic of nature and nonnature, the tragic arising from their duality. This is an expression of evolving and maturing life. Once matured, nature and nonnature transform each other. Pure equilibrium arises, for their duality is resolved through the equivalence of opposites.

Neo-Plasticism[a] expresses this unity. It expresses the equivalence of nature and nonnature—interiorized outwardness and exteriorized inwardness through the plastic expression *of the straight line in vertical and horizontal position*. This plastic expression of planes is determined by the straight and is realized in pure primary colors (yellow, blue, and red) opposed to noncolor (white, black, and gray). In the visual plastic arts, which are preparing our future visual environment, Neo-Plasticism expresses itself as a multiplicity of rectangular planes or rectangular prisms in color and noncolor. The same consequences are more or less possible in the nonvisual arts. It therefore employs *universal plastic means* neutralized by multiple oppositions, and thus through composition becomes universal plastic expression.

Neo-Plasticism evolved from the preceding art movements and took its definite form in painting; and *precisely in painting* it *encounters the strongest resistance*. Even the most advanced tendencies *do not accept its*

[a] Chiefly known through the journal *De Stijl*.

principle in painting. The necessity of the straight and of the plane is not generally understood. The use of the plane is accepted only as decoration. Nor is the *unity of the arts recognized*. We can therefore conclude that the impure adoption of Neo-Plasticism in architecture does not reflect pure plastic vision, but is either superficially borrowed or grows out of the inherent character of architecture. The preference in painting for the curved line, even in its most abstract form, the circle, stresses the fact that we are still dominated by the natural, even if natural perspective vision has already been abandoned. The curved and the closed, however, always express form and therefore limitation in time and in space. The straight, on the other hand, is plastic expression of the greatest speed, the greatest power, and so leads to the annihilation of time and space.

Whatever lies outside of time and space is not *unreal*. At first only an intuitive concept, it becomes *real* as our intuition grows purer and stronger. The new plastic is intuition that has become plastically determinate.

No Axiom but the
Plastic Principle
(1923)

Dated 1923, "No Axiom but the Plastic Principle" ("Geen axioma maar beeldend principe") appeared, along with "Blown by the Wind," in *De Stijl* in 1924. These were Mondrian's last contributions to the journal.

Mondrian's defense of the immutable and absolute against overemphasis on the changing and relative may be understood in part as a reaction to Van Doesburg's increasingly voiced concern with *time* (the "fourth dimension") as a factor in art. It can furthermore be viewed as a refutation of Dadaist skepticism. Not long before Georges Ribemont-Dessaignes had boasted in *De Stijl* that the Dadaists "regard no human opinion as serious or true. There is no truth whatsoever. . . . There are no aesthetic laws, any more than there are scientific laws"[1]—a view that could not be further from Mondrian's.

Our time considers it impossible to have universally valid principles. It sees as untenable a fixed view of the perceptible, an unalterable conception. No human opinion is accepted as serious or true. Everything is seen "relatively." This view grew out of art, philosophy, science (the theory of relativity, etc.), and practical life itself. We are beginning to break with tradition. We no longer want to build on doctrines or even on logic. Nevertheless, by understanding the relativity of everything, we gain an intuitive sense of the *absolute*. Moreover, the relativity, the mutability of things creates in us a desire for the absolute, the immutable. The human ego desires the immutable. Because this is unattainable, we return to the relative and try to perpetuate it. Since that is impossible, we again seek the immutable and even ignore the mutable. So it has been throughout the centuries.

The *desire for extremes* causes the tragic in life (in art, expressed through the lyrical). Until the present, culture was based on the relative or on a traditional representation of the absolute which has become axiomatic. This representation of the absolute is *form*,

just as the relative is form, and it constantly changes. In art, both were always cloaked in form: thus *the relative always dominated*. Therefore, art was always more or less *descriptive* (lyrical) even when symbolic. In the symbolic, the purely plastic becomes impure because the symbolic manifests itself not as art but as truth—therefore impure, untrue, because then the element of form becomes "a form" (in the cross, for example).

Today we observe resistance to such "representation," this concealment of the absolute, as well as to the naturalistic capriciousness of the relative. The masses, however, recognize only the relative, since it is directly perceptible. Although they deny it, they unconsciously, intuitively, feel the need to emphasize the absolute and to abstract the natural. They are also compelled by external pressure, by the new necessity. Our products show this, as well as the general search for clarity and purity in everything. The relative in our environment, at first predominantly natural, is now assuming an increasingly mathematical appearance. *Thus the absolute is beginning to be expressed more purely* all around us. There is increasing homogeneity

between man—now outgrowing his once dominant naturalness—and his environment. Within this relativity *a new relativity is slowly growing in which the absolute is also expressed.* This greater equilibrium already plastically expresses the character of the future. Thus the search for extremes is abolished: equivalence between relative and absolute becomes possible. But far more purely than in our environment, equilibrated relationship between the relative and the absolute has been achieved in art, the field of intuition.

The freest art, painting, could be the most consequent. Gradually but rapidly, natural appearance was abstracted in the plastic: in form as well as color. In Cubism, form was broken up and tensed. Neo-Plasticism broke with form altogether by abstracting it and reducing it to *the pure elements of form.* The closed curved line, which did not express plastic relationship, was replaced by the straight line in the duality of the constant perpendicular position, which is the purest plastic expression of relationship. From this, Neo-Plasticism constructed its *universal plastic means, the rectangular color plane.* Through the duality of position of the straight it expresses equi-librium (equivalence) of relative and absolute. It opposes the color plane to the noncolor plane (white, gray, and black), so that through this duality the opposites can annihilate one another in the multiplicity of the composition. The perpendicular position expresses the constant; the rhythm of the composition expresses the relative.

Thus painting shows *plastically* that the manifestation of both relative and absolute can be plastically expressed through *the straight.* Therefore equivalence, as well as opposition and variety. This is possible only through *the straight.* The straight cannot be made more abstract: it is the most extreme possibility of the purely plastic.

Thus in Neo-Plasticism, *a principle* has been plastically expressed: immutability, constancy. Color and line and composition have fixed laws.

This principle of *equilibrated relationship of relative and absolute,* seen *purely plastically,* can become a general principle of life. It shows that for the complete man pure equilibrium can be achieved only through *the most deeply interiorized naturalness within us and around us, and by intuition becoming conscious* within us. Thus, through the equivalence of the dissimilar.

Blown by the Wind
(1924)

"De huik naar den wind" (literally, "The Cloak [hung] to the Wind," i.e., "setting one's sail to every wind"), appeared in *De Stijl* in 1924.[1]

The postwar era saw the adoption of figurative and classicizing modes by many artists once at the forefront of abstraction; this was defended in some quarters as "The Return to Order." Mondrian noted the effects of this reaction when he wrote to Van Doesburg in mid-1922:

> Today I put on my good suit and went to see [Léonce] Rosenberg. . . . he was very friendly. He told me that buyers now tend to want naturalism, but he hoped the situation would improve within a year. He appears still to favor the abstract *for himself*, and to be involved with naturalism for reasons of survival. He mentioned [Auguste] Herbin (who is back to naturalism) as "doing very well." The one abstract artist he was selling at all was [Georges] Valmier, but not so Gleizes. (undated letter, probably June–July 1922)

> [Rosenberg] now expects to sell only "classical" at present. Well, one can't blame a dealer for that. (undated letter, probably August 1922)

For himself, Mondrian drew an absolute line between his "own work" and work he undertook for sale: copies in museums, or the flower watercolors he reluctantly executed down to the mid-1920s. He reflected (to Van Doesburg, 7 Febuary 1922): "Were I ever to become convinced that I never could live from my Neo-Plastic work, then I would give it up altogether. I would rather go to the South and pick olives: there I'd earn twelve francs a day and live as one of the people."

Anyone familiar with the vigorous movement of renewal in painting and sculpture in Paris before the war will be doubly offended—if he has any sympathy with the new—by today's stagnation and retreat. The action of breaking with the old and preparing the new has slowed down, except among a steadfast few. Action, we know, is followed by reaction; action is almost precluded at present by external material circumstances that make it almost impossible to be effective in new ways. The primary cause is financial and moral exhaustion in every country after the war.

Confusion of the new art with the many flawed and abortive social reforms has aroused considerable anxiety. Lack of material things during the war period has created a present craving for them. The "uncultivated" who have become rich can spare nothing for *cultivated (abstract)* art; the cultivated are spiritually weakened by their material prosperity or by their lack of economic power. Many find logical reasons for today's stagnation and retreat: it is necessary, they say—and therefore good. *A further stage of the new is nevertheless in preparation.* We do not protest the stagnation and

retreat, which are but temporary and apparent. We do protest the *traitorous attitude of those who pioneered the new*. We protest that many of them *equate the new with the old*.

Many, perhaps, act in good faith. Their vision of the new and their power to achieve it were perhaps transitory and rather limited. If so, they were never at one with the idea: they realized it only intuitively, and partially.

Be that as it may, by "new" we mean *abstract* art, even if some artists deny it. They claim to have "evolved," but have in fact only returned to their former level. Or they say there is no evolution in art: the old is no different from the new. Their work nevertheless has an *appearance of newness*. By intuitive chioce they could not altogether let go of the new—not to speak of those who feared losing the public's confidence if there were *total* retreat.

In any case, they *blur the distinction between the old and the new, between naturalistic art and abstract art. Material pressures* are no doubt the main cause. Those in a position to buy are worried. In spite of all, one can preserve the distinction between old and new in order to keep one's "own art" pure. The artist has few chances to earn money outside his own field: if the buyers demand naturalistic art, then the artist can produce this with his skills, but *distinct* from his "own work."[2]

If artists now reject the new conception, critics and dealers reject it even more strongly, for they are more directly exposed to the influence of the public. The sole value of abstract art, they openly assert, was to raise the level of naturalistic art: the new was thus a *means*, not a *goal*—an open denial of the essence of the new, which was to *displace and annihilate* the old. They too swing with the wind and follow the lead of the general public. Though quite understandable, this is temporarily disastrous for the new, for its essential nature is thus *lost from sight*.

But strongly balancing this, at the same time we see a resurgence of the new spirit in almost all countries. Despite retreat on one side, there is on the other side a noticeable demand for, and diffusion of abstract art, showing that this is the true expression of the new era, which *must* thrive against all opposition: it is a true *necessity for life*. In spite of all, the struggle of the ideal against the material strongly shows that evolution does exist in art: that it is *development* and not *regression*. Abstract art, which evolved out of naturalistic art, cannot possibly return to its starting point.

Abstract art can evolve only by *consistent development*. In this way it can arrive at the *purely plastic*, which Neo-Plasticism has attained. Consistently carried through, this "art" expression can lead to nothing other than its *realization in our tangible environment*. For the time will come when, because of life's changed demands, "painting" will become absorbed into life.

Homage to Van Doesburg (1931)

Owing to personal, philosophical, and artistic differences with Van Doesburg, Mondrian ceased contributing to *De Stijl* in 1924. He did not formally resign, however, until December 1927—after Van Doesburg went so far as to assert that "had the Stijl idea remained tied (as with Mondrian) to a closed, dogmatic, and completely static experience, this not only would have barred the way to further development: it would also have made it arid and introverted" (tenth anniversary number of *De Stijl*, 1927). A reconciliation of sorts nevertheless followed.

Van Doesburg died of tuberculosis in March 1931, and a memorial issue of *De Stijl* appeared in January 1932. Among the tributes was Mondrian's "Homage," written in French and dated April 1931.

Even in Holland the great war was a time of sombreness and distress. International contacts and human feeling—especially in the artist—made it inevitable that the depression and anguish of war would spread even where there was no fighting. Nevertheless, in Holland there could still be a concern with purely spiritual problems. Thus art continued and evolved: it could do so, it is important to note, only by continuing in the same direction as before the war—toward pure abstraction. I refer only to art's cultural development: its evolution as aesthetic plastic.

While nothing can remain untouched by external events, everything evolves in accordance with the universal law of evolution, which determines progress. Evolution creates events and is not determined by them.

Visiting Holland a fortnight before the war broke out, I remained there to its end, continuing my research toward an art free of naturalistic appearances. Earlier (like the Divisionists and Pointillists) I had suppressed the natural appearance of color. In Paris the Cubists had shown me that it was possible to suppress also the natural appearance of form. I continued my research, increasingly abstracting form and purifying color. In the course of my work, I succeeded in suppressing the closed appearance of abstract form, expressing myself by means of nothing but the straight line in rectangular opposition: thus rectangular planes of color, of white, of gray, and of black. It was at this time that I met artists whose spirit was close to my own.

First Van der Leck, who—while still working figuratively—painted in unified planes and pure colors. My more or less Cubist, therefore more or less painterly, technique was influenced by his exact technique. Soon after this I had the joy of meeting Van Doesburg. Filled with vitality and zeal for the already international movement known as "abstract," and sincerely appreciative of my work, Van Doesburg asked me to collaborate on a periodical he was planning to publish, named *De Stijl*. I was happy to publish the ideas on art that I was formulating; I saw the potentiality of contact with efforts consistent with my own.

I pay homage to the ability and admirable courage of Van Doesburg, who, in addition to his own work in painting, architecture, and literature, advanced the cause of

abstract art, and for years was able to keep the journal *De Stijl* going. I speak only of the period of my collaboration.

In connection with Van Doesburg, I also recall with feelings of joy and friendship other *De Stijl* collaborators: the architects Oud, Van 't Hoff, and Wils, the sculptor-painter Vantongerloo, the painter Huszár, and the writer Kok, with all of whom I was acquainted in Holland or in Paris.

PART II

After De Stijl
1924–38

After 1924, when he ended his collaboration with *De Stijl*, Mondrian found other journals, chiefly in France and Holland, receptive to his views.

Vouloir (Lille), established in 1924 as a "constructive monthly for literature and modern art," was edited in 1926 by the artist and interior designer Félix Del Marle (1889–1952). Under the influence of Mondrian, Van Doesburg, and Vantongerloo, Del Marle reoriented the journal toward pure abstract art and "environment"; the last issues, before the publication ended in 1926, were subtitled "A Monthly Review of Neo-Plastic Aesthetic." Mondrian wrote three pieces for *Vouloir*, all in 1926: "Purely Plastic Art," "Home—Street—City," and the unpublished "General Principles of Neo-Plasticism."

In the spring of 1925 the young writer Arthur Müller-Lehning broached to Mondrian his plan for an interdisciplinary journal which became *i 10: internationale revue* (January 1927–July 1929), "an organ for all expressions of the modern spirit, a documentation of new trends in art and science, philosophy, and sociology." Besides pledging his own cooperation, Mondrian put Müller-Lehning in touch with J. J. P. Oud, who assumed editorship for architecture and the plastic arts.[1] Links were also established with the Bauhaus: László Moholy-Nagy, the editor for photography and film, also designed the magazine. All of Mondrian's contributions to *i 10* appeared in 1927—the two important essays, "Home—Street—City" and "Jazz and Neo-Plasticism," in the first and the last issues for that year, and his brief comments on photography in June.

In the mid-twenties nonfigurative art was overshadowed by the School of Paris, always dependent to some degree on representation. The growing strength of abstract tendencies was manifested for the first time in December 1925 at the Art d'Aujourd'hui exhibition—in part a response to the massive Arts Décoratifs show of that year, from which the Stijl movement had been excluded by the Dutch government in favor of the "Amsterdam School" of architecture and applied art.

The year 1926 saw the advent of a lively new journal published, like *L'Architecture vivante*, by Albert Morancé; the wide aesthetic range, contemporary orientation, and fine reproductions of *Cahiers d'art: Revue de l'avant-garde artistique dans tous les pays* inaugurated a new era in art publishing. Edited by Christian Zervos, Picasso's friend and biographer, *Cahiers d'Art* represented the School of Paris and exotic or archaic art, but treated more abstract tendencies as peripheral.

Mondrian published three times in *Cahiers d'art*: in 1926, describing the nature and origins of Neo-Plasticism ("The New Plastic Expression in Painting"); in 1930, responding to a major critic's assault on abstraction ("Cubism and Neo-Plastic"); and in 1935, answering an *enquête* into the seeming crisis in art ("Reply to an Inquiry").

From his avant-garde period in Amsterdam to his last years in New York, Mondrian supported artists' organizations more or less consonant with his aims. Cercle et Carré was the first association to represent a range of nonfigurative tendencies. It was founded in 1930 by the Uruguayan painter Joaquín Torres-García and Michel Seuphor, the poet-critic who, having met Mondrian in 1923, became his foremost supporter in France and (in 1956) his first biographer. Cercle et Carré's membership of about eighty constituted a majority of abstract artists working in Paris. A notable exception was Theo van Doesburg, who was organizing his own group, Art Concret, which, because of his sickness and death, barely outlasted 1930. Similarly, because of lack of funds and Seuphor's health, only three issues of the journal *Cercle et Carré* appeared: 15 March, 15 April, and 30 June 1930. It had meanwhile printed texts by Fernand Léger, Luigi Russolo, Georges Vantongerloo, Jean Gorin, and Mondrian. The lead article of *Cercle et Carré's* April 1930 number (which also served as catalogue for the group's exhibition) was Mondrian's major essay "Realist and Superrealist Art."

For the first number of *Cercle et Carré*, Mondrian composed these few lines, dated December 1929:

Not to be concerned
with form and color-as-form
—this is the new plastic in art.

Not to be overdominated
by the natural-physical
—this is the new mentality.

To focus exclusively on relationships
by creating them
and by searching for their equilibrium
in art and in life
—this is the great work of our time:
to prepare the future

Mondrian also contributed to little magazines such as *Bulletin de L'Effort moderne, Manomètre, Noi,* or *transition,* and wrote short pieces in connection with exhibitions (Zurich, 1929; Amsterdam, 1938). His major effort, however, was "The New Art—The New Life," the "book on art and society" he wrote in 1930–31. After this, breakthroughs in his art left him less time for writing. While still in Paris he nevertheless composed "Plastic Art and Pure Plastic Art" for *Circle* (London, 1937), which further confirmed his status as leading spokesman for the purely abstract.

The Arts and the Beauty of Our Tangible Surroundings (1923)

Completed by November 1923, "The Arts and the Beauty of our Tangible Surroundings" ("Les arts et la beauté de notre ambiance tangible") appeared in *Manomètre* (August 1924).

Manomètre, an irregular quarterly (Lyons, 1922–28), was, after *Merz*, the most informal of the little magazines to which Mondrian contributed. It was edited (in a somewhat Ubuesque spirit) by the painter, graphic artist, and dramatist Emile Malespine (1892–1952). The title ("pressure gauge") recalls the machine metaphors of Dadaism. Malespine was keenly interested in popular as well as experimental theater (Théâtre du Donjon, Lyons). In 1926 he unsuccessfully planned to produce Michel Seuphor's play *L'Ephémère est l'éternel*, for which Mondrian designed a Neo-Plastic stage-set.

Art and practical life are so disparate today that they appear to be following two different paths toward the same goal.

In practical life outside of art, a purer beauty is arising spontaneously. It answers new demands, especially for *purer equilibrium and for less rustic materials*. A new beauty is being created. As yet, "pure plastic" beauty has not appeared *complete*—beauty expressed solely through *equilibrated relationships of basic lines and colors*.

In practical life we search in all directions. From the point of view of plastic, we alternately advance and regress because our way of seeing is not *plastically pure*.

Intellect confuses intuition. Tradition also exerts its influence. For lack of *plastic understanding*, the new materials are badly used. For example, reinforced concrete is used to produce "form," instead of being used "constructively" to create a "composition of planes" that neutralize one another and destroy limiting form.

The idea of "pure plastic" is not relative. It is clearly determined by art. Purely plastic beauty is possible only through a *pure plastic of equilibrated relationships*. And this requires "pure" *plastic means*. Natural color and form generally are "impure" means of plastic expression. Pure plastic has its *definite laws* that are opposed to the traditional laws of superannuated harmony.

Today this beauty cannot attain its full consequences in practical life. But not so with art. Painting, the *freest art*, is able to present this *new beauty*. Thus it was painting that created a new aesthetic.

Architecture, while following the same lines, has been too preoccupied with demands other than the "plastic."

Down with
Traditional Harmony!
(1924)

"Down with Traditional Harmony!" ("A bas l'harmonie traditionelle!") is clearly directed to a Futurist audience. On 22 January 1924 Mondrian sent the French text to Enrico Prampolini, editor of the journal *Noi*, in Rome, explaining:

> I have received three numbers of your sympathetic review *Noi*. I regret that for financial reasons it is quite impossible for me to subscribe.
>
> I am sending you an article that I hope you will be able to include in the next issue of *Noi*. I wrote it in order to spread my ideas, and require no remuneration. I would be grateful to hear from you.

Noi soon ceased publication, however, and the article never appeared in print.[1]

Enrico Prampolini (1894–1956), painter, architect, and scenic designer, joined the Futurists around 1914: with Giacomo Balla and Fortunato Depero he emerged as one of the leading painters of the postwar phase. *Noi*, founded by Prampolini in 1917, appeared intermittently until January 1920; Mondrian's copies must have been sent to him when it was briefly revived in April 1923. The previous year Prampolini was twice represented in *De Stijl*: in July by his manifesto on the aesthetic of the machine, and in August by his statement before the Congress of Progressive Artists in Düsseldorf. In 1925 a friendship grew between Mondrian and Prampolini in Paris; he is the one Futurist artist whom Mondrian names (in *The New Art—The New Life*) as not having reverted to figuration.

Through *Noi*, Mondrian apparently learned of an American publication, *Futurist Aristocracy* (see above, p. 175).

This "disharmony" (according to the old conception) will be fought and attacked everywhere in the new art so long as the new harmony is not understood.

("Neo-Plasticism," 1920)

Everything that really springs from the new spirit—therefore from the future—is only disharmony for conservative feeling. And everything that the Futurists have said concerning harmony, equilibrium, equilibrated relationship, etc., is precisely the *contrary* of the time-honored conceptions of the past. Nevertheless, the uninterrupted beauty of life is confirmed by the great fundamental and hidden truths that remain independent of time and place.

In art, the *truly plastic* has always

expressed itself in the same way, although this might seem doubtful at first sight.

The truly plastic has always been expressed through the *equilibrated relationships of planes*. But modeling, perspective, the softening of lines and colors—in short, the whole superficial *trompe-l'oeil* technique of traditional art—have veiled the truly plastic. The new art protests against such debasements, which originate in individualism, the lower intellect, and natural instinct. (By individualism we mean the state of the individual who is limited and dominated by his own "ego.")

Intuition, the strongest quality in art, preserved the truly plastic over the centuries. In our time, modern man's *conscious* intuition frees this plastic from every impurity.

Our present thought is still full of imperfection. Impurities accumulated over the centuries dull the clarity of our vision. We must *recover our clear vision and renew our conception*.

The conception, the comprehension of anything, modifies its content and its significance for us. We need words to name and designate things. But we have only a *static language* with which to express ourselves. The most advanced minds as well as the least advanced are obliged to *use the same words*. If we adopt new words, it will be even more difficult—if not impossible—to make ourselves understood.

The new man must therefore express himself in conventional language and rely on the developed intuition of those who can understand.

Neo-Plastic writing speaks of harmony, equilibrium, pure plastic, the abstract, the universal, etc. This has caused much misunderstanding and will cause more. When Neo-Plasticism speaks of the *abstract*, it does not mean the indefinite or vague, but on the contrary *the most determined, the most real*. When it speaks of *equilibrated relationship*,

Neo-Plasticism does not mean symmetry but *constant contrast*. The traditional conception of words is so deeply rooted that relative errors have occurred even in Neo-Plasticism itself. For example, some have tried to find equilibrated relationship by subdividing the canvas into rectangular planes proportional to it. Although composition afforded a certain degree of freedom in forming contrasts, such pre-established proportions were constricting. Others have followed scientific laws for the proportions of line and color. When intuition is obscured by inferior intellect, error is inevitable. The domination of this intellect is fatal to art because it is based on the past and on superficial observation of nature.

Only through clarity of intuition does intuition cease to manifest itself in the manner of the past, as unregulated freedom. Conscious intuition requires no supervision by the inferior intellect: it is capable of regulating itself.

The new art, and through it the future, can be seen and understood *exclusively* through pure and intuitive contemplation that is free of the limitations of time and space.

It is clearly evident that the harmony and disharmony referred to by Neo-Plasticism are not at all what people of the past understood by these words. Neo-Plastic harmony in art is a plastic and aesthetic expression of *pure unity*. On the contrary, as understood by the past, unity is an *individual vision or idea*, something that arises from and is limited by the individual "ego." It is an *illusion*. In the past, the conscious ego sought unity but along too restricted a path. Therefore, down with individual unity, so that our unconscious ego (integral with pure unity) can express itself more purely!

Traditional and natural unity and harmony are only *apparent*. They arise from the illusions of imperfect man. They are based

on *visual appearances* and vanish with them. These appearances ("representation" in art) bind us to the past and prevent us from clearly seeing truth.

Abolishing appearance from the plastic means coming closer to true unity, true harmony. Thus *through pure beauty* we begin to comprehend truth.

The new harmony can exist today only as the expression of art. Art will prove itself worthy of its privilege and will manifest itself as *pure plastic expression of the universal.*

Not only has Neo-Plasticism in painting shown that it is possible to achieve this plastic, but it also presents itself as a *universal movement.* Neo-Plasticism at present, however, cannot claim to be an art for everyone. While the mentality that feels the universal (by freeing it from the domination of the individual) is found everywhere, it is still *so unusual* that it appears as a *personal* expression. But if one takes the word *individual* to mean "personal," we can agree with Marinetti in urging: "Everywhere unleash and arouse the orginality of the individual."

The Evolution of Humanity Is the Evolution of Art (1924)

"The Evolution of Humanity Is the Evolution of Art" ("L'Evolution de l'humanité est l'évolution de l'art") appeared in *Bulletin de l'Effort Moderne* (November 1924), a publication of Léonce Rosenberg's Galerie de l'Effort Moderne.

Rosenberg was an idealistic supporter of the "new spirit." "Cubism"—by which he meant a wide spectrum of abstract or near-abstract art—would "save the individual from imitativeness and from sentimental, individualistic anarchy"; it would "give a new style to the epoch."

Appearing monthly from 1924 through 1927, *Bulletin de l'Effort Moderne* presented writings by Albert Gleizes, Gino Severini, Theo van Doesburg, Maurice Raynal, Henri van de Velde, and Fernand Léger. Its covers were designed at first by Georges Valmier and later by Auguste Herbin, two artists whom Rosenberg especially admired.

Previously published in the journal was an optimistic essay by Dr. Hélan Jaworski, who saw a parallel between social and biological evolution: the Middle Ages represented our adolescence, the coming era our maturity.[1] It is to this scheme that Mondrian refers here.

The second number of the *Bulletin de l'Effort Moderne* (February 1924) carried brief statements by Severini, Léger, Herbin, Lurçat, Van Dongen, and Metzinger, in reply to the question "Whither Modern Painting?" Mondrian's answer ran as follows:

> Morphoplastic painting first broke with natural forms thanks to Cubism. In Neo-Plasticism, painting is expressed by means of the rectangular plane, the universal synthesis of constructive elements. Painting thus becomes increasingly abstract: Neo-Plasticism is preparing its end. The ultimate consequence of this *pure plastic of relationships* will be painting's transition to plastic realization in our material environment.

Humanity is generally considered mature: as fully mature, at its culmination, or as over-mature, decaying. Dr. H. Jaworsky sees it otherwise; he sees humanity as still very young, in its seventeenth year (see *Bulletin de l'Effort Moderne*, nos. 1 and 2 [1924]). A beautiful thought, full of hope and *joie de vivre*, where the customary view sees only death. To be young is to grow. To grow is to live: evolution, *continuous growth*, is perpetual life. To view life as evolution and not as finality—this is the true solution for life and for art.

This article is concerned with only *one* side of life: form in its evolutionary aspect, therefore with the *changeable* and not with the *unchangeble*—although the latter is equally manifested in life.

Most people see human growth as already accomplished. They think of man as

193

adult because they discern no change in the appearance of things, since they observe only superficially.

The elements of matter are still imperfectly understood; we can see very little of time and space, and even in history we perceive clearly only a small part of human existence. Nevertheless, all wisdom and science establish the evolution of matter in a time and space whose limits they recognize as only apparent and fictitious. Those capable of discerning evolution understand it as an ascending line. They know that the stages and forms of evolution are not repeated, although we are superficially led to believe they are.

If there is a parallel between the individual and humanity (see the article mentioned above), and if humanity is now in its seventeenth year, *the same must be true of art.* The official art of our time proves this fact, for it fails to express adulthood. Just as the seventeen year old is not yet fully transformed, so it is with official art. Nevertheless, "art" precedes life. That is why outside of its official expression, art can already express the *advanced stages of humanity.* It is one of the privileges of our time that art is able to realize this anticipated maturity.

Dr. Jaworsky writes, "The importance of our seventeenth year is that it leads to the eighteenth, the age of emancipation, and enable us to foresee future stages."

If we view humanity as approaching manhood, we can understand the *necessity* of the modern movement in contemporary art, and we can understand why it could be manifested neither earlier nor later.

Some years ago, in speaking of art, we noted: "We are at a turning point in culture, at the end of everything ancient; the separation between what has been and what will be is absolute and definitive" ("Neo-Plasticism," 1920).

Just as man has ceaselessly changed while remaining adolescent, so art up to now has continually changed while remaining *naturalistic.* This is most understandable if we observe that man is dominated by the natural until he reaches maturity. That is why in *De Stijl* we have described naturalistic art as "an art of children." Our approaching maturity demands a *truly new* art.

The *mutation* of art has been manifested in our time. The different movements, such as Futurism, Cubism, and Dadaism, have interiorized the natural, and in painting—the freest art—have already produced a *purely abstract art.* There was no other possibility for a true renaissance in painting than by the abstraction of natural color and form. *For the plastic interiorization of the natural is the abstract.*

It is perfectly clear that abstract art is not the plastic expression of our seventeenth year. That is why it is attacked, resisted, and disapproved of by the majority, who still see through the spectacles of the past. But if our new age can see a little further into the future, abstract art can serve as a guide. If art has the unconscious goal of *elevating* us, only the art of the future now has any reason for being.

There is a similar parallel between art and play. Both must become more *interiorized* as man matures. Play to the child is not simply play: it is his serious occupation and true means of expression. Through play he expresses his feeling for beauty, and realizes his life. As man approaches maturity, play tends to disappear. In part, other games replace it; in part, it is discarded. More and more, the pleasant game becomes "reality." Then, little by little, beauty begins to disappear because material life is incomplete and distorted. Thus, in our time, art is increasingly overwhelmed by the great exigencies of life. But without beauty, life becomes arid.

Like play, art must continue. Both must continue until, in the distant future, mature humanity is able to convey beauty into life and into our material surroundings so that they become beautiful in themselves. To this end, then, they must be *renewed* before the past dies and before the future is born.

The Neo-Plastic Architecture of the Future (1925)

"The Neo-Plastic Architecture of the Future" ("L'Architecture future Néo-Plasticienne") appeared in *L'Architecture vivante* (Autumn 1925). Perhaps written the year before, this succinct statement of Mondrian's views on architecture was his last article to be published in the context of *De Stijl*. Two exhibitions of De Stijl architecture organized by Theo van Doesburg—that of fall 1923 at L'Effort Moderne, and another in spring 1924 at the Ecole Spéciale d'Architecture—led, after some delay, to an issue of *L'Architecture vivante* on modern architecture in Holland associated with the movement.

L'Architecture vivante was a handsome portfolio of plates and text published quarterly by Albert Morancé and edited by the progressive architect Jean Badovici. Beside Mondrian's essay, the issue included a description and estimate of Neo-Plasticism by Jean Badovici, Van Doesburg's and Van Eesteren's 1923 manifesto on architecture, "Vers une construction collective," and an essay by Van Doesburg, "The Evolution of Modern Architecture in Holland."

At present, our material environment cannot be realized as *pure plastic expression*: it cannot achieve the Neo-Plastic idea. Because it is "free," the *work of art* is necessary today to satisfy our sense of beauty, but in the future the new beauty will be revealed equally *outside of art*.

Today the *aesthetic that was discovered and established by art* must be given primacy. True plastic beauty cannot be achieved merely by obeying the demands of utility, materials, construction, etc.

Today, because the architect is not an artist, he is unable to create the new beauty. The new beauty will be realized only by the *artist* collaborating with the *engineer* who is responsible for the technical side. It is essential that the aesthetic be the starting point. Not traditional aesthetic, for this caused the decadence of architecture, but the new aesthetic that came into being through the evolution of art. This new aesthetic abolishes the old laws of natural harmony, symmetry, classical composition. It establishes *pure plastic*.

To achieve pure plastic beauty, we must *aesthetically construct pure equilibrated relationships* through *pure expressive means*. This can be achieved in accordance with all the possible demands of our age. Every problem of technique and utility can be resolved in perfect harmony with plastic vision. The two viewpoints are always complementary.

If, to the contrary, we start from technical, utilitarian demands, etc., we compromise every chance of success, for intellect then clouds intuition. That is why in today's practice architectural construction is seen groping in all directions. From the viewpoint of the purely plastic, sometimes it advances, sometimes regresses. Architecture today is already becoming purified and simplified, but only rarely does it achieve a pure plastic expression.

The new beauty is created by *equili-*

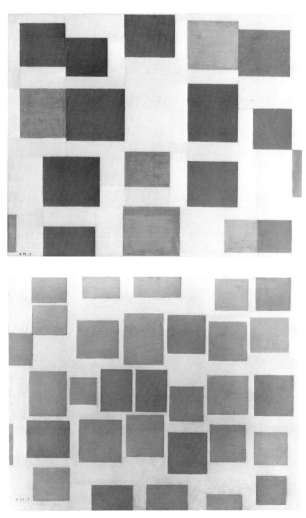

132 *Composition with
Color Planes B,
1917.*

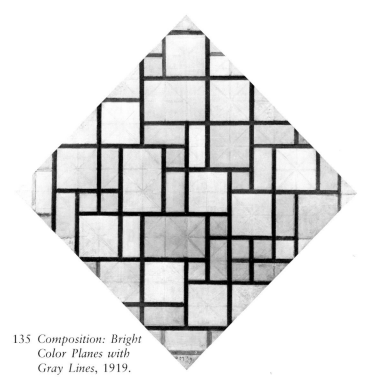

133 *Composition with Color Planes no. 3, 1917.*

135 *Composition: Bright
Color Planes with
Gray Lines, 1919.*

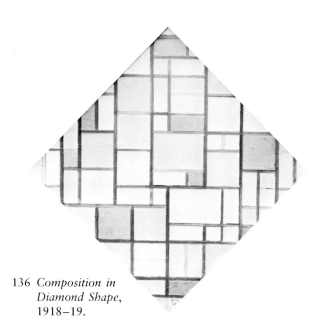

136 *Composition in
Diamond Shape,
1918–19.*

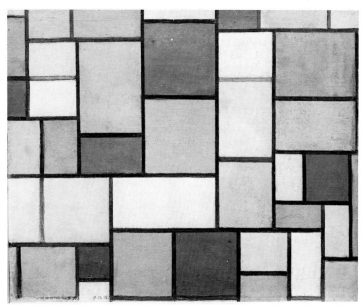

134 *Composition: Color Planes with Gray Contours, 1918.*

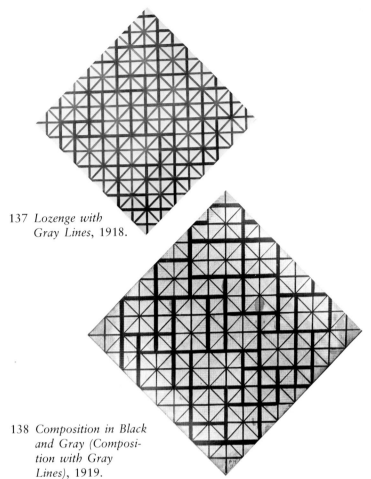

137 *Lozenge with Gray Lines*, 1918.

138 *Composition in Black and Gray (Composition with Gray Lines)*, 1919.

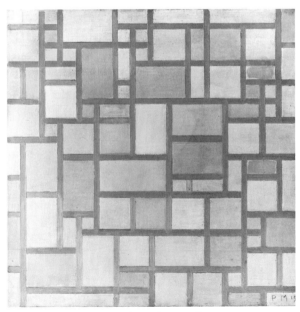

139 *Composition in Black and Gray*, 1919.

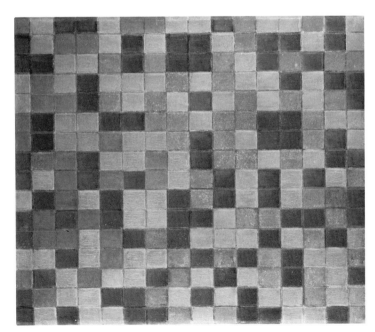

141 *Composition: Checkerboard, Dark Colors*, 1919.

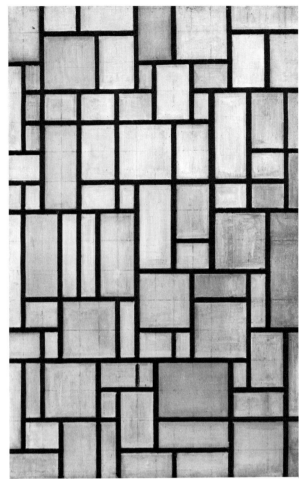

140 *Composition: Bright Colors with Gray Lines*, 1919.

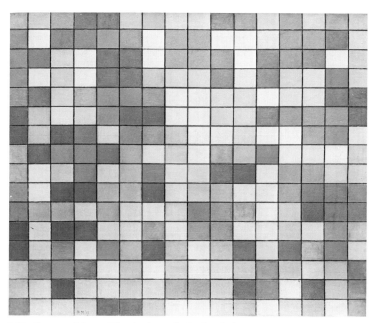

142 *Composition: Checkerboard, Light Colors,* 1919.

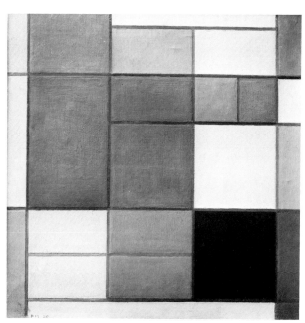

144 *Composition,* 1920.

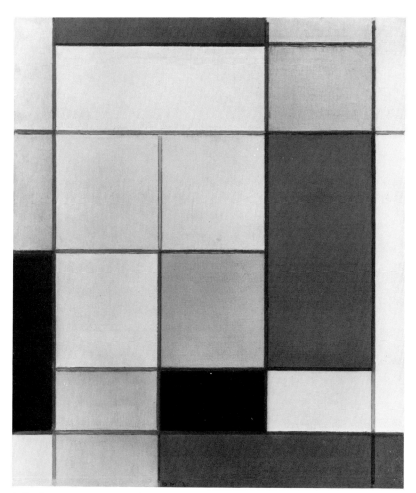

143 *Composition in Red, Blue, and Yellow-Green,* 1920.

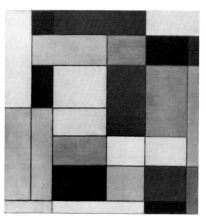

145 *Composition in Gray, Red,
Yellow, and Blue,* 1920.

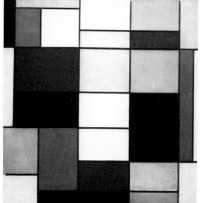

146 *Large Composition A,* 1920.

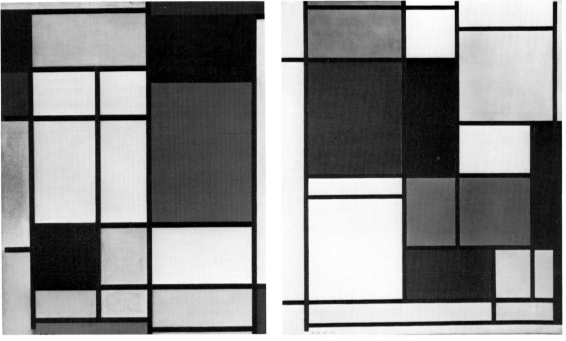

147 *Composition*, 1921.

148 *Tableau II*, 1921–25.

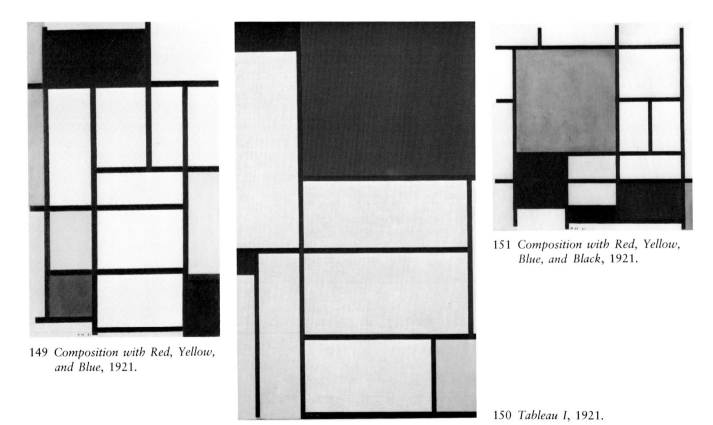

149 *Composition with Red, Yellow, and Blue*, 1921.

150 *Tableau I*, 1921.

151 *Composition with Red, Yellow, Blue, and Black*, 1921.

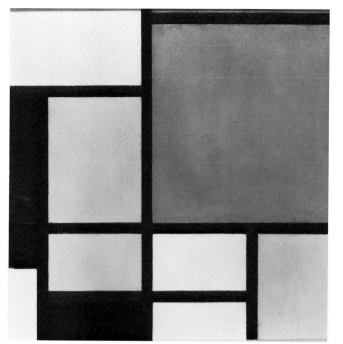

152 *Composition,* 1921.

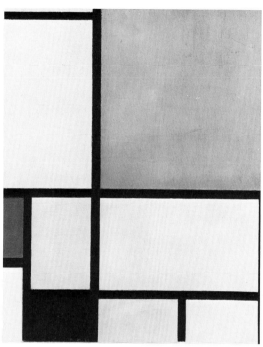

153 *Composition in Gray, Blue, Yellow, and Red,*
1921.

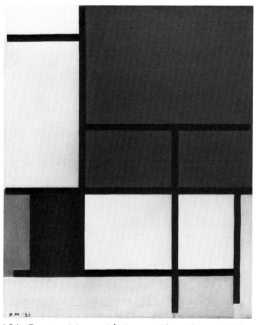

154 *Composition with Large Blue Plane,* 1921.

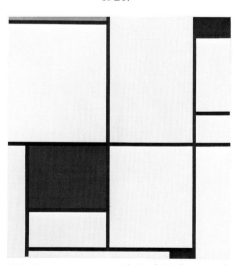

155 *Composition I with Red, Yellow, and
Blue,* 1921.

156 Mondrian, ca. 1922.

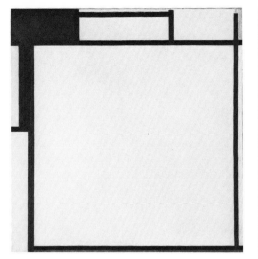

157 *Composition in a Square*, 1922.

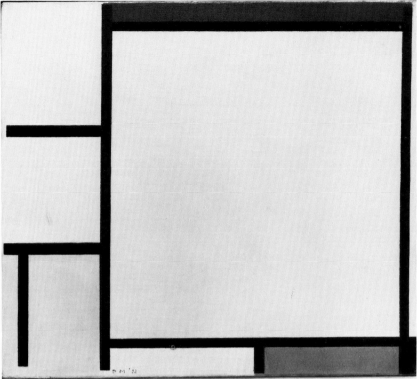

158 *Composition with Red, Yellow, and Blue*, 1922.

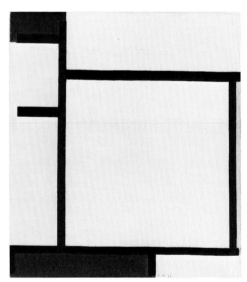

159 *Composition with Red, Yellow, and Blue*, 1922.

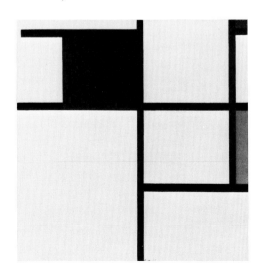

160 *Composition*, 1923.

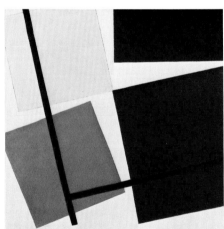

161 Theo van Doesburg. *Simultaneous Counter Composition*, 1929–30.

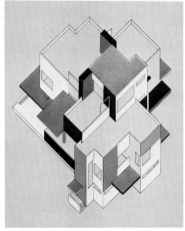

162 Theo van Doesburg and Cornelis van Eesteren. *Maison Particulière*, axonometric drawing, 1923.

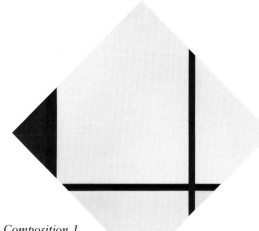

163 *Composition I*
with Blue and
Yellow, 1925.

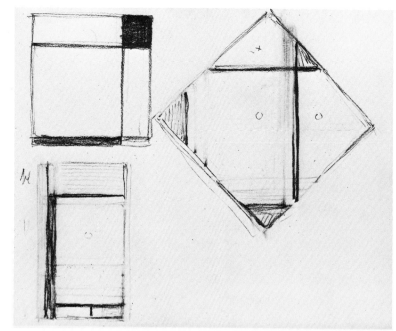

164 *Notebook page*, ca. 1926.

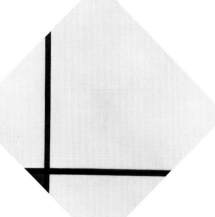

165 *Composition*
with Blue, 1926.

166 *Notebook pages*, ca. 1926.

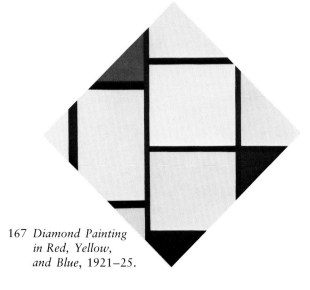

167 *Diamond Painting*
in Red, Yellow,
and Blue, 1921–25.

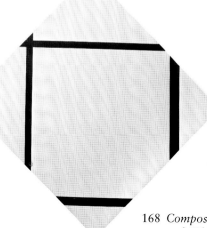

168 *Composition in Black*
and White, 1926.

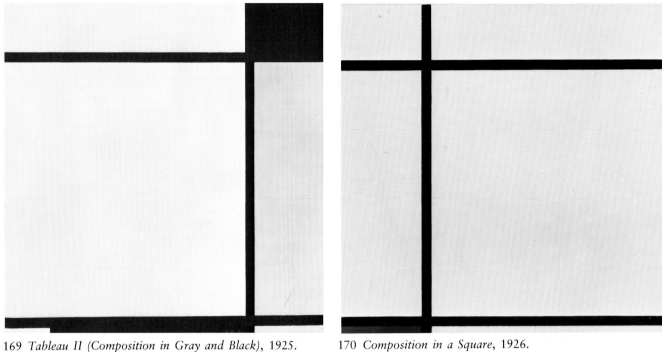

169 *Tableau II (Composition in Gray and Black)*, 1925.

170 *Composition in a Square*, 1926.

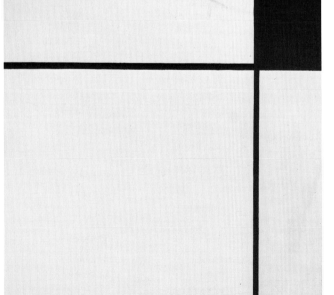

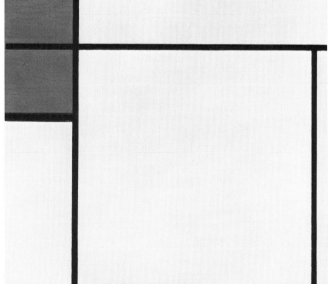

171 *Composition with Black and Red*, 1927.

172 *Composition with Red, Yellow, and Blue*, 1927.

173 *Notebook page*, record of works sent to exhibition at Kuhl and Kuhn, Dresden, 1925.

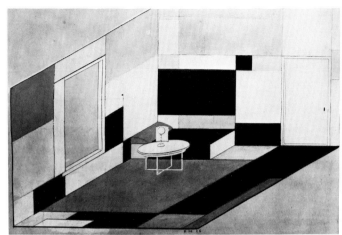

176 Piet Mondrian. *Salon de Mme. B . . ., à Dresden*, 1926.

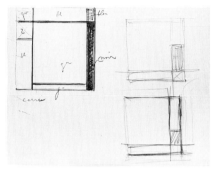

174 *Notebook page*, ca. 1926.

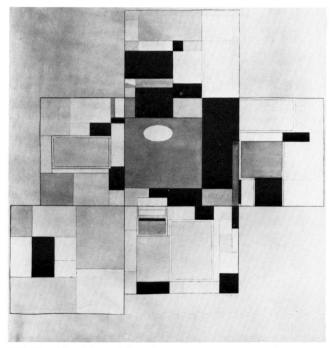

175 Piet Mondrian. *Salon de Mme. B . . ., à Dresden*, 1926.

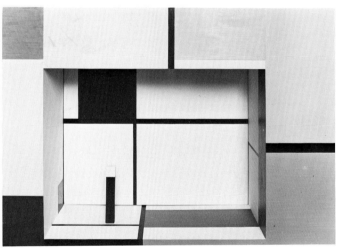

177 Piet Mondrian. *Set design of Michel Seuphor's play "L'Ephémère est l'éternel."*

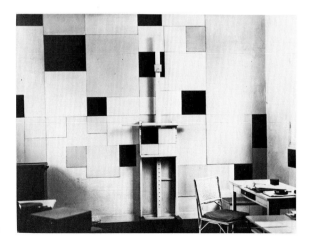

178 Mondrian's studio, rue du Départ, Paris, late 1920s.

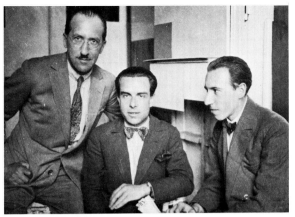

179 Mondrian with Michel Seuphor and Enrico Prampolini in his rue du Départ studio, ca. 1928.

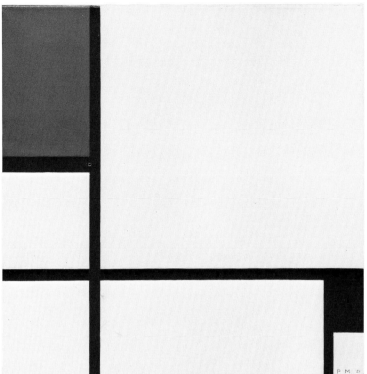

182 *Composition*, 1929.

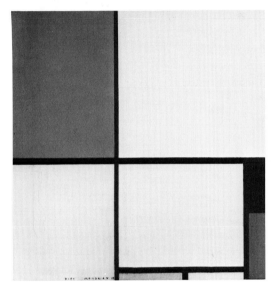

180 *Composition with Red, Yellow, and Blue,* 1928.

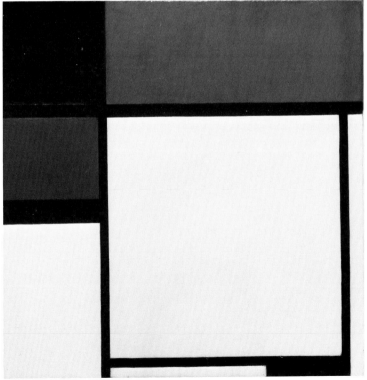

183 *Fox Trot B*, 1929.

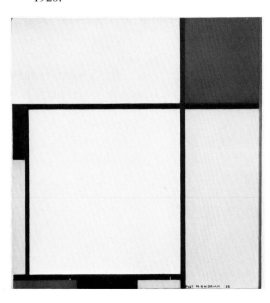

181 *Composition with Red, Yellow, Blue, and Black,* 1928.

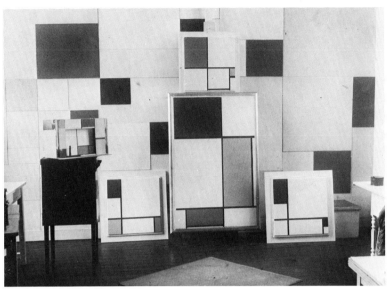

184 Mondrian's studio, rue du Départ, Paris, ca. 1929.

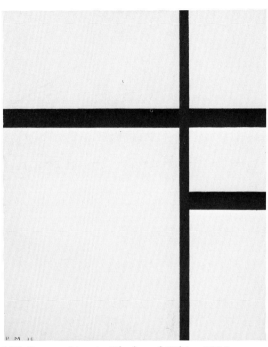

185 *Composition in Black and White, 1930.*

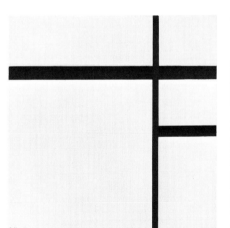

186 *Composition no. II with Black Lines,* 1930.

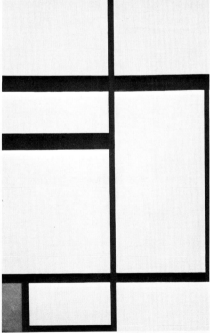

187 *Composition with Red, Black, and White,* 1931.

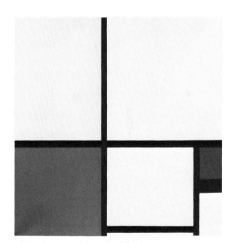

188 *Composition I, 1931.*

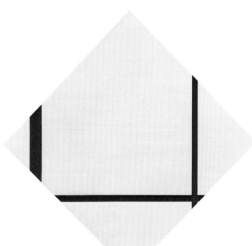

189 *Fox Trot A*, 1930.

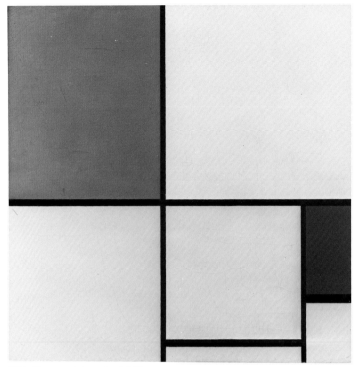

192 *Composition A*, 1932.

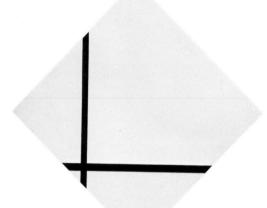

190 *Composition with
Two Lines*, 1931.

191 *Composition with
Yellow Lines*, 1933.

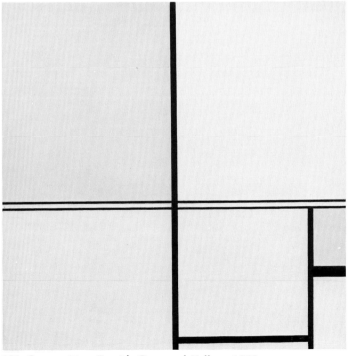

193 *Composition B with Gray and Yellow*, 1932.

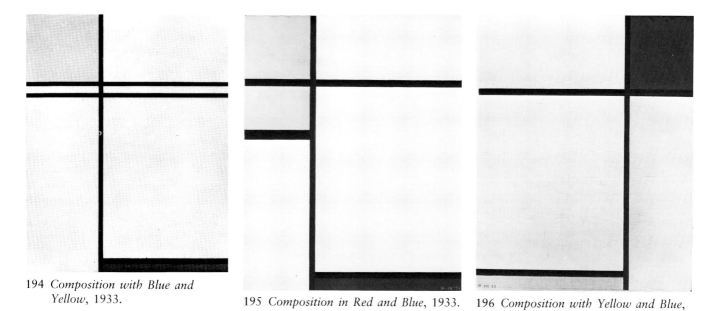

194 *Composition with Blue and Yellow*, 1933.

195 *Composition in Red and Blue*, 1933.

196 *Composition with Yellow and Blue*, 1933.

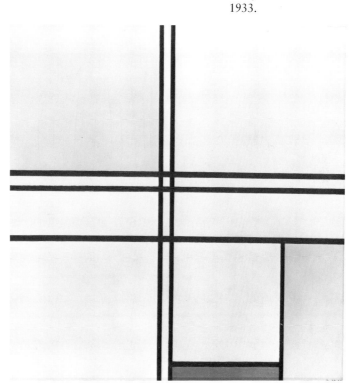

197 *Composition with Gray and Red*, ca. 1933.

198 *Composition Gray-Red*, 1935.

200 Mondrian in his studio with the British painter Gwen Lux, early 1930s.

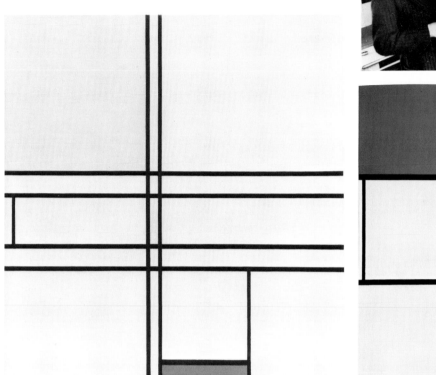

199 *Composition with Yellow and Blue*, 1935.

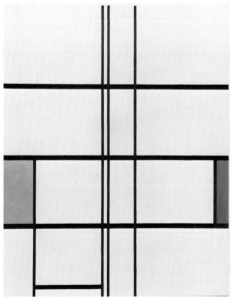

201 *Composition B with Red*, 1935.

202 *Composition with Red and Black*, 1936.

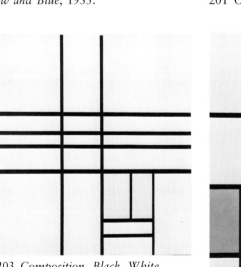

203 *Composition, Black, White, Yellow*, 1936.

204 *Composition with Red and Blue*, 1936.

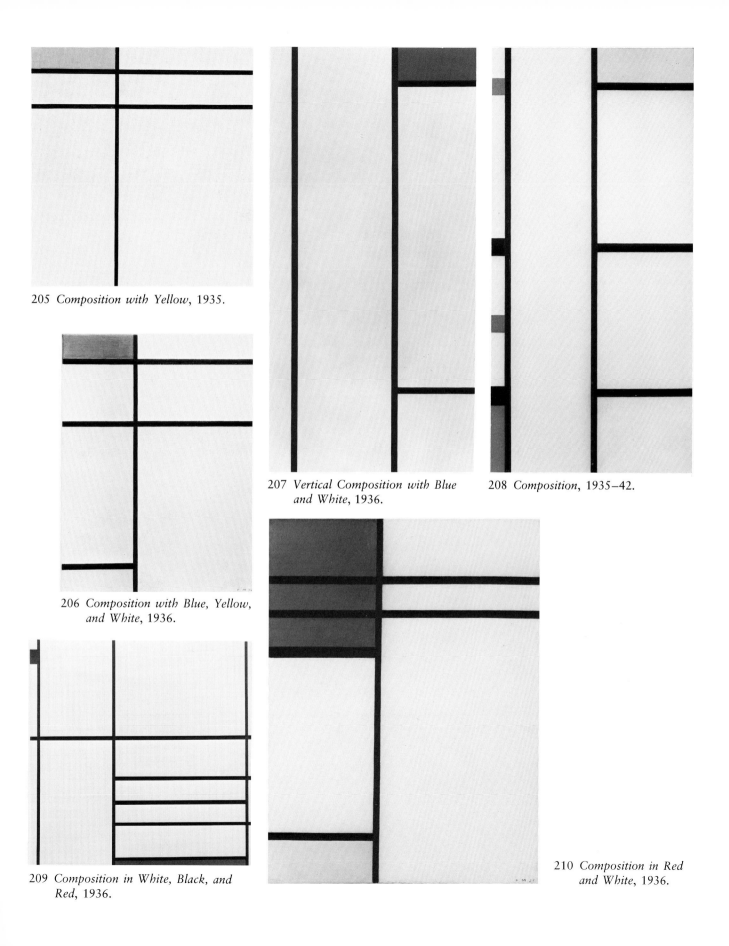

205 *Composition with Yellow*, 1935.

207 *Vertical Composition with Blue and White*, 1936.

208 *Composition*, 1935–42.

206 *Composition with Blue, Yellow, and White*, 1936.

209 *Composition in White, Black, and Red*, 1936.

210 *Composition in Red and White*, 1936.

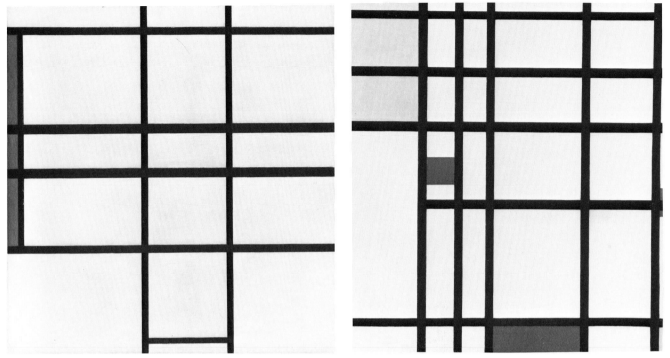

211 *Composition with Red, 1936.*

212 *Composition with Red, Yellow, and Blue, 1936–43.*

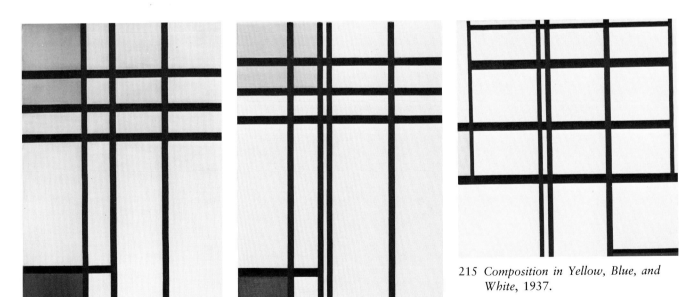

213 *Composition in Blue and Yellow, 1937.*

214 *Composition with Red and Yellow, 1937.*

215 *Composition in Yellow, Blue, and White, 1937.*

brated relationships of perpendicular lines and planes. If either horizontal lines or vertical planes dominate the expression, the tragic regains ascendancy.

Neo-Plasticism, which grew out of Cubism and Futurist ideas, is based, in painting, on the great law it has revealed: that of *pure equilibrated relationship*. The architecture of the future will follow these same directives without any difficulty, as a few architects have already demonstrated. The new architecture will furthermore not exclude color or treat it as merely "accessory." Color will be integral to the architecture itself.

It is important, however, to point out that by "equilibrium" Neo-Plasticism means something altogether different from the equilibrium of traditional aesthetic. Neo-Plastic harmony arises from *constant oppositions*. The harmony of Neo-Plasticism is therefore not traditional harmony, but *universal* harmony, which to the eyes of the past appears rather as discord.

It is understandable that applying the Neo-Plastic aesthetic to architecture arouses resistance at first. [For one thing, the entrenched idea that architecture must always reckon with the three-dimensional system may cause the *planar* plastic of Neo-Plasticism to seem unfeasible. Yet morpho-plastic architecture is a traditionalistic

conception: it is the perspective vision of the past, which the Neo-Plastic conception no longer retains. *The new (abstract) vision does not start from a single given point, but takes its viewpoint everywhere, from no fixed place. It assumes independence of time and place.* In practice, its viewpoint is always *in front of the plane*: the ultimate possibility of plastic deepening. Thus the work of architecture appears as a multiplicity of planes,][1] not of prisms as in "volumetric construction." Nor is there any danger of lapsing into "facade-architecture"; its ubiquitous "point of view" prevents this error. Because it is exclusively abstract, this plurality of planes becomes a *plane image*.

There is also resistance to the Neo-Plastic conception of color. Yet, as plastic expression of the plane, Neo-Plastic architecture *irresistibly calls* for color, without which the plane cannot be *living reality*. Color is equally necessary to annihilate the natural appearance of materials. Neo-Plastic colors—which are pure, planar, determined, primary, and basic (red, yellow, blue)—are in opposition with "noncolors" (white, black, gray).

As painting has already demonstrated, a minimal color area often suffices to produce equilibrated relationship with noncolor. Thus there is no need to fear confusion from an excess of color. But the difficulty is to find true aesthetic equilibrium.

Purely Abstract Art
(1926)

Dated March 1926, this essay appeared in *Vouloir* of that month. It was titled by the editor: $\dfrac{\text{ART}}{\text{Pureté} + \text{Abstraction}}$. On his tearsheet Mondrian restored his own title: "L'Art purement abstrait."

Mondrian's relationship with Félix Del Marle and *Vouloir* began in January 1926, when he "read with enthusiasm" Del Marle's review of the Art d'Aujourd'hui exhibition held the previous month (to Del Marle, 25 January 1926).[1] A visit by Del Marle and his wife to Mondrian's studio led to the writing of "Purely Abstract Art." The essay ends with remarks on environment and the interior, an area in which Del Marle was professionally active. Mondrian wrote him on 2 March: "Only yesterday I finished the article which I began after you left, inspired by our talk, and especially by what you and Madame said concerning my studio. . . . I hope you will be able to correct the French; it does not have to be fine French (on the contrary), but it has to be correct. . . . I think it can be useful for the movement."[2]

After the essay was published, Mondrian expressed dissatisfaction with aspects of the presentation in a letter to Del Marle (2 April):

Dear Sir and Friend:

I hesitated to express my dissatisfaction. One of the photos was printed transversally [a "diamond" composition with its edges turned horizontal-vertical]. . . . And I do not like the title. Purity is for the Purists, and "abstraction" is not "abstract art," as I even think I pointed out in the article. . . . I was also rather surprised to find myself alongside Van Doesburg, with whom I no longer collaborate on *De Stijl*. . . . I am willing, with your good help, to do an occasional article for *Vouloir*.

The present translation generally follows a signed manuscript in Mondrian's hand, dated "Paris, March '26," that is more direct in expression than the version printed in *Vouloir*.[3]

The passages of "Purely Abstract Art" in which Mondrian opposes the return to naturalism may be related to a project he described to Oud in an undated letter of summer 1925: he "once started an essay on 'the subject *must be banished.*from art,' " which he might presently find time to finish.

Regression toward more naturalistic art in the pejorative sense, art oriented toward the apparent and therefore superficial forms of nature, is now an undeniable fact in the modern movement. This is not surprising, for have not many artists done abstract work unconsciously? And isn't public ignorance still a retarding influence? Nevertheless, art continues to evolve and manifest its trend to the abstract.

To reveal its importance, the best each of us can do is to help it become better understood.

To realize the importance of this, we must first understand the preeminence in art of *appearance*, of *image*. Its appearance is what creates the impression we form of an object or a work of art, even though we may cloak it with our own ideas. The appearance or characteristic form of things manifests itself without regard to us and is independent of the observer—relatively so, for it depends on whether he can observe it as it is manifested, on whether he will see it more, or less, "purely." There therefore exists an "objective" beauty that is distorted only by our limited and subjective vision. Once convinced of this, we can no longer accept that a curved line may arbitrarily replace a straight one, or that blue may be justifiably substituted for green. For the regression from abstract to naturalistic art means just this. Naturalistic art finds its most perfect expression in this disordered fantasy completely opposed to the spirit of abstract art.

Since everything has its inherent character, there are *appropriate forms, colors, and images* which evoke in us corresponding feelings and ideas. Conversely, our ideas and our feelings must be expressed by an *appropriate appearance*. That is why the modern mentality expresses itself in its own way. It cannot be expressed in the naturalistic form of the past, for the new spirit—engendered by the new form of life—frees itself of domination by nature. Both tend toward equilibrium of matter (the physical) and of spirit. The abstract image which expresses this equilibrium is therefore crucial. Seeking clarity, our time requires that the function of art be no longer veiled in representation but that it be clearly expressed. Now the fundamental function of art is to express beauty *plastically*. *Plastic* beauty "exists," and all art results from it. As the plastic expression of vitality, this beauty expresses and arouses the energy of life, thus the joy of life. Since this force is within us as much as outside us, its expression *changes* with the evolution of humanity. The vitality within us is increasingly manifested as less veiled by our personal feelings and individual ideas (our personality); that is why the man of today needs a different expression of beauty than the man of the past; and as man becomes adult, he needs a beauty that is more *clear and direct*. Personality, the individual, finds itself and is reflected in the individual, in Nature: the two are in equivalence. But by freeing ourselves from the personal, from the individual, we free ourselves from naturalistic constraint and we create our own "equivalence" within ourselves. The task today, then, is to create a direct expression of beauty—clear and as far as possible "*universal*." It will be a purely plastic beauty, that is, beauty expressed exclusively through lines, planes, or volumes and through color—a beauty without natural form and without representation. *It is purely abstract beauty.*

This beauty is already manifested in art, principally in painting and sculpture—although in sculpture, so far as we know, only the prismatic compositions of Vantongerloo attain purely abstract art. Painting and sculpture, because they are free, have more easily thrown off the constraint of naturalistic form and have created works of art with pure and constructive expressive means. Employing the universal plastic means—the rectangular plane in color and noncolor for painting and the rectangular prism for sculpture—Neo-Plasticism achieves purely abstract art.

Naturalistic beauty is now purified and returns to its origin: "pure intuition." Created beauty is no longer vague and imitative, but conscious and creative. It is sometimes at variance with cerebral logic but always in accord with pure logic. Hence this uninhibited power, this clear new beauty which

shows the universal as equivalent with the individual.

How deplorable that such timeworn, conventional language must serve to express the new beauty: to describe the means and the goal of purely abstract art, we are compelled to use the same terms that we use for naturalistic art—but with what a difference in their meaning!

When we speak of "harmony," we do not mean anything like traditional harmony. Everything that for us springs from the new spirit—and is therefore of the future—appears rather as disharmony to conservative feeling, even though it is pure equilibrium. The harmony of purely abstract art is a pure, complete, and equivalent expression of unity, whereas the harmony of traditional art is rather a "suggested" unity, for one of the two principles that create unity (the outward) is dominant. The words "equilibrium," "pure plastic," "abstract," "universal," "individual," etc., can be similarly misunderstood, not only because we use words of the past, but because we look at things in their outward aspect and regard only the naturalistic as real and concrete. Certainly, the natural is concrete, but only in contrast to energy, the abstract and invisible force. To express the latter, other plastic means are available, which may have a geometric appearance. It is this very concrete manifestation that we have in mind when we speak of the abstract. Although in art this geometric appearance is arrived at through "abstraction," abstract art is not made solely through abstraction: it also requires "creation." In the work of Picasso, we already see lines that have nothing to do with reduction of forms by abstraction, but are necessitated by the demands of new creation.

Equilibrium achieved through relationships alone reveals their beauty more clearly than does the old art or nature, and sometimes also differently. Purely abstract art excludes, for instance, the symmetry that abounds in nature—further evidence that external and traditional laws can no longer satisfy the new spirit. Even though the great fundamental and hidden truths remain independent of time and space, appearance changes so continuously and rapidly that we are obliged to establish new laws and a new aesthetic for the new art.

All art employing naturalistic appearance becomes weakened in its true function. All representation, even using abstract forms, is fatal to pure art; that is why purely abstract art is expressed *exclusively through relationships*. The plastic means is only a "means." This was also the intention of the old art, but in it the "means" assumed a dominant role. Through its pure relationships, purely abstract art can approach the expression of the universal, of expansion, of grandeur, of energy as beauty, and thus fulfill art's true function. We then see more clearly manifested the force that animates joy of living—which says almost all that need be said concerning purely abstract art. What manifestation could be more necessary in this world of ours? Whatever the future may hold, our material life at present is still far from perfect.

In our disequilibrated society, with its antiquated surroundings, everything drives us to search for that pure equilibrium which engenders the *joie de vivre*. To achieve this, the "painting" of purely abstract art is not enough; its expression must necessarily be *realized in our material environment* and thus prepare the realization of pure equilibrium in society itself. Only then will "art" become "life." Dangerous? Not at all. On the contrary, this realized art will be more living than ever. Some at present cry "Down with Art!" But what emptiness would prevail if we were to sever ourselves from art as the *plastic expression of beauty*? Art thus purified, and plastically expressing its true

function, is moreover in accord with all pure construction born of necessity and therefore of utility—provided that it too stems from conscious intuition. Therein lies the possibility for pure art to truly become a living and real expression.

Purely plastic and abstract beauty is really "construction." This new construction does not imitate natural organization but follows an organization that can be called "equilibrated or natural-human." For the organism of the new man is an equilibrated duality of "matter-spirit."

This has present importance because, in architecture also, the new movement sometimes appears too quick to follow natural organization. The new construction must therefore be a duality of construction and destruction. This it achieves by creating a counterconstruction that reduces naturalistic construction,[4] in buildings just as in paintings. The importance of purely abstract painting is to achieve this while at the same time showing the richness and fullness that are expressed in and are requisite to the joy of living. Purely abstract painting equally destroys the naturalistic even in denaturalized materials.

Due to backwardness in the technique and manufacture of colors, particularly for exterior use, we are at present generally limited to the interior: the interior in which we "live" and which must inspire us, that is, sustain us in a "fully human" way.

Thus art has succeeded in expressing itself through very simple means. So simple that some cannot believe them capable of achieving the plastic; but the manifestations of art itself have amply refuted this. Besides the simplicity of the plastic means, there is also *rhythm*, which animates the composition and opposes the constructive elements of the plastic means. For rhythm is the individual element in the duality, opposing the plastic means, which is the universal element; just as, within the plastic means, color opposes noncolor (black-white-gray).

Well executed, works of purely abstract art will therefore always remain fully human, not "although" but precisely "because" their appearance is not a naturalistic one.

Is art nearing its end? There is nothing to fear. What is this—still distant—end of art but humanity's liberation from the dominance of the material and physical, thus bringing us closer to the time of "*matter-spirit*" equivalence?

The New Plastic Expression
in Painting (1926)

In the first issue of *Cahiers d'art* (January 1926), the editor, Christian Zervos, discussed the December 1925 exhibition "Art d'Aujourd'hui" organized by Victor-Yanaga Poznanski. This was the first major manifestation of the growing strength of abstract painting, which accounted for about half of the 250 works shown. The Neo-Plastic tendency, with several new works of Mondrian's, drew a large share of attention. Zervos wrote:

> The Neo-Plasticists undoubtedly start from Léger. Neo-Plasticism is Cubism carried to its ultimate consequence. Cubism was essentially intellectual in nature: on the example of engineering architecture, it tends to suppress all sensuous and imaginative appeal. Neo-Plastic work reveals a total disdain for images born of sensuous passion in life. Van Doesburg, [César] Domela, Mondrian suppress all natural and human meanings. . . . Their work always disregards our attachment to things in their outward appearance.
>
> Neo-Plasticism makes architecture the central art, and painting its humble servant—something explained by the fact that Holland was the country of greatest architectural accomplishment in recent times. The purpose of painting, as the Neo-Plasticists see it, is to accentuate where necessary the volumes created by the architect.
>
> It is too early to foresee the outcome, but the movement can be faulted for operating through abstraction and for being dominated by its own system. . . . The logic and the science brought to bear by Cubists and Neo-Plasticists are [nevertheless] needed if instinct is to be reinstated and spontaneity perhaps recovered in the coming generation.

While clearly intended as a reply, Mondrian's "The New Plastic Expression in Painting ("L'Expression plastique nouvelle dans la peinture"), *Cahiers d'art*, July 1926, gives a markedly nonpolemical account of the movement's aims and origins.

Although the New Plastic expression[a] was born in the north, its character is not completely "Nordic";[1] Latin influence predominates. First, not all its founders were purely Nordic; besides, it shows the influence of Paris, the gathering point of all races. Paris, birthplace of Futurism and Cubism, the metropolis that, despite its old conventions and old buildings, tended strongly toward the abstract because of its intense and accelerated life and material environment, was equally an influence on pure abstract art, the New

[a] "Abstract-Real art" and later "Neo-Plasticism" were terms for the New Plastic that I thought helpful in defining my personal conceptions of the movement. The New Plastic in general is also known as "pure plastic," and Van Doesburg has recently called it "Elementarism."

Plastic. Thus the new art shows the reflec-tiveness of the north and the clear spirit of the south.

Shortly before the war, when Cubism was at its peak in Paris, a few artists in Holland were drawn toward a manner of painting that was *more appropriate to the plane surfaces* of a canvas or of a wall: a painting of *plane within plane*. Nevertheless, this painting still remained naturalistic. While it "stylized" natural appearance, this styliza-tion did not contain *the abstraction* of appearance. However, their art soon became far less "pictorial" and more "architectural" or "constructive." Pure color appeared, perhaps because some of the artists were also concerned with interiors, not in the sense of decoration but in a more or less constructive way, using planes of pure color (Van der Leck, Huszár, Van Doesburg). This preoccu-pation with the interior was perhaps at the origin of Neo-Plasticism's architectural chromoplastic. Quite possibly this emphasis on the "plane" led the artists toward the abstraction of natural appearance, but here other influences are to be noted. First of all, the influence of Cubism is undeniable. Then, during the war, a mode of painting from Paris was added to the group. This tendency was still more or less Cubist, but having passed through Luminism and Divisionism, and while regarding Cubism's achievement as the highest form of painting, it nevertheless found Cubism illogical insofar as it was composed of heterogeneous elements, abstract forms together with natural appearance. The new tendency no longer used natural appear-ance and had already achieved the total abstraction of curved lines; its expression was through color, which was not yet pri-mary, and through the straight line in its two principal oppositions (Mondrian). Neverthe-less, it was still too pictorial because it tried to express a certain volume (although already much reduced) in the Cubist sense. It was

from the successive but rapid union of these two tendencies that *the universal expressive means* was born: the rectangular plane of primary color.

At first the artists composed these elementary means on a white or black ground. But through the process of their work they intuitively perceived that the true unity of painting requires *total equivalence between planes and ground*, or better yet, the old "background" of the picture should not exist at all. Thus they sought only *the equilibrium of planes in color and noncolor (white, black, or gray)*. The two contrary and mutually annihilating (neutralizing) opposi-tions were established *in equivalence*.

The plane as the sole plastic means is now of the greatest importance in painting. The plane suppresses the predominance of the material, whose absolute expression is three dimensional. Although the third visual dimension disappears in the new painting, it is nevertheless expressed by the values and color within the plane.

The tendency developed in Paris showed the influence not only of Cubism but also of Paris as a city. The enormous planes of the buildings, often colored by advertising, also encouraged painting in *planes*. This was only one of the external causes—basically it was *the spirit of the new age* that was being manifested in many countries in many differ-ent ways but always homogeneous in their trend to the abstract.

The organization of the group in Hol-land was the work of Van Doesburg, who founded and edited *De Stijl*. Besides painters, the group included architects who were moving in the same direction (Oud, Van 't Hoff, Rietveld, Wils). But the new plastic and therefore the new aesthetic originated in painting, perhaps because painting could concentrate on *the plane*, and because it is freer than architecture.

The journal *De Stijl* was equally con-

cerned with literature, theater, and music.[b] It attracted to the group artists in other countries who had evolved toward abstract art by different paths. First the sculptor-painter Vantongerloo; much later Domela (who came to painting through Constructivism), and Van Eesteren in architecture.

It is of small importance whether De Stijl still exists as "a group"; a new style was born, a new aesthetic created; it needs only to be understood—and cultivated.

The abstraction of natural appearance begun by Cubism, the exclusion of the third (visual or perspective) dimension, and the use of pure color—and even the universal plastic means itself—constituted only a partial abolition of the old painting. To become truly new, painting had also to discard composition in the manner of natural appearance.

Sustained work brought the group to composition based exclusively on the *equilibrium of pure relationships*, springing from *pure intuition* through the union of deepened sensibility with heightened intellect. Although these relationships are formed in nature and in our minds according to the same basic and universal laws, *in our time* the work of

art appears quite different from nature. For in our time, the work of art must try to express only the essential in nature and only the universal in man. Individual expression, the consequence of our nature, is always present. Thus *new laws are brought to light*. For example, in the new art the repetition we see in natural appearance is destroyed. The new composition is based upon *permanent, contrary, and neutralizing oppositions*. Line is *straight* and is always placed in its two principal opposite positions, which form *the right angle*, the plastic expression of the constant. And the relationships of dimension are always based upon this principal relationship of position. In this way the new plastic is an "equivalent" of nature, and the work of art no longer visually resembles natural appearance.

It would be a great mistake, however, to think of Neo-Plastic work as totally abstracted *from life*. Precisely through its relationships and pure plastic means, it can express life *more intensely*. Abstract art does not transcend the limits of the plastic, nor does it lead to pure abstraction in the realm of thought. Abstract art is expressed by a most concrete image—by the most reduced and elementary form.

Because of its universal nature, the New Plastic will be manifested as painting, sculpture, architecture, music (once the means of expression are found), and will create, in the future, a more equilibrated society where matter and spirit will be in equivalence.

[b] Among the contributors to *De Stijl* were F[rederick] A. Kiesler (theater); [George] Antheil (music); [Antony] Kok, [I. K.] Bonset, and [Hans] Arp (poetry).

Home—Street—City
(1926)

Completed toward the end of 1926, this essay appeared in the first number of *i 10* (January 1927) under the title "Neo-Plasticisme: De woning—de straat—de stad" (The dwelling—the street—the city).

The French version appeared soon afterward in *Vouloir* (no. 25, early 1927)—a special number that was to prove its last, devoted to "l'ambiance." There entitled "Le Home—la rue—la cité," it was illustrated with Mondrian's design for an interior (never executed), *Salon de Madame B. . . . à Dresden.*

In "Home—Street—City," Mondrian expounds his conception of a society and an environment that would be everywhere open, unified, and equilibrated. His contact with Arthur Müller-Lehning and *i 10* led him toward the social theme, just as his simultaneous link with Felix Del Marle and *Vouloir* led him toward the environmental.

Of *i 10*'s editor, Mondrian wrote Oud on 22 May 1926:

> [Müller-Lehning] is an anarchist, but not of the anarchist party. . . . He is very broad-minded . . . and in our own direction (against convention, capitalism in the wrong sense, bourgeoisie, etc. . . .).
>
> *i 10* is not an art periodical, which is good. I plan to write on Neo-Plasticism in society. Like myself, Müller-Lehning wants to assist in the creation of a new society, along the path of ideas.

With "Home—Street—City," and later "Jazz and Neo-Plasticism" in the same journal, Mondrian fulfilled his aim.

The environmental theme was no doubt suggested by Del Marle, to whom Mondrian wrote around the same time: "I am willing to do a little article on the designated subject for *Vouloir*. . . . I am grateful for your appreciation of my ideas" [9 May]. And retrospectively [30 December]: "You gave me considerable trouble (by requesting this article), but I am grateful to you for compelling (!) me to do it. I hope that in some small way the *future* will benefit from it."[1]

The article was "almost finished in July"—when its completion was delayed by the addition of new material: "The article has become rather long," Mondrian wrote Del Marle, probably in September:

> I have also taken up the question "whether or not Neo-Plastic is 'classical' " (as Van Doesburg asserted in the last *De Stijl*).
>
> This is also the question of which [César] Domela speaks. He vacillates between my conception and Van Doesburg's. . . . I do not know what he means by "labile": the contrary of "stable," I think, because Van Doesburg wants an opposition to the stability of nature. Anyhow you will see my opinion in my own article.[2]

Differences had emerged between Mondrian and Van Doesburg in 1924, when Van Doesburg introduced the oblique into his compositions,

tilting their lines to form a 45° angle with the horizontal/vertical. This revision of Neo-Plastic principles he termed "Elementarism." In the *De Stijl* article Mondrian most likely had in mind, Van Doesburg had written:

> The classical notion of art was plastic expression of the polarity as an equilibrated unity [horizontal-vertical]. But this solution proves inadequate to express the modern spirit, which is inevitably characterized by strong opposition to nature, to physical structures, and to all symbolic romanticization of these.
> . . . The ineluctable need for evolution requires a new point of view toward this equilibrium. . . . A new culture based on such an equilibrium would make no further evolution possible. . . . Established equilibrium would then be absolute instead of relative . . . it would be eternal and immutable.
> . . . This unity was expressed in painting that was horizontally-vertically determined, within the horizontal-vertical determination of architectural construction. . . . In contrast-painting (countercomposition) the color planes and the lines develop in opposition to natural or architectural structure.[3]

Mondrian's public response is found in those paragraphs of "Home—Street—City" where he reaffirms the principles of Neo-Plasticism ("six Neo-Plastic laws") and—in connection with the law of perpendicular opposition—proceeds to discuss the oblique in painting and in architecture.

Mondrian's characterization of the fourth dimension as belonging to the mental rather than the plastic realm refers to a belief of Van Doesburg's that Mondrian had resisted since the early days of De Stijl: that the elements of time or "fourth dimension" could find a place in plastic expression. Elementarist countercomposition using the oblique was related to this idea.

Mondrian had uninhibitedly expressed himself on this question in an interview of October 1924. He had certain doubts concerning the De Stijl architecture show of 1923–24, but

> what I utterly fail to appreciate is this loose talk of the fourth dimension. Someone has written that Euclidean geometry is of no further use in determining points of support in the new architecture, that this is easy to do by means of non-Euclidean geometry in four dimensions. In the new architecture they moreover seek to express not only space, but time (plastic aspect of space-time), and to express both relationships through color. Who can make head or tail of it?

In *i 10* Mondrian's comments on the oblique were illustrated with one of his lozangiques, or "diamond" shaped compositions. As with all his work in this format, the lines of the composition remain horizontal-vertical. Only the framing edges are oblique.

Also touched on toward the end of "Home—Street—City" is the question whether function and materials should be directly expressed in architecture. The subordination of plastic expression to functional purpose—the subject of Mondrian's controversy with Oud—is here ex-

plained as a fear of beauty. As for the need to "denaturalize" materials (change them from their raw state to plane and primary color), Mondrian later commented to the architect Alfred Roth (26 June 1933): "You say that synthetic materials such as aluminum, concrete, etc., accord well with pure color, and with white, gray and black. True, they accord well, but this is not yet the ideal: the materials remain as materials. On a higher level of architecture they must be annihilated."[4]

Today, just as in the past, the home is man's true "refuge." But there never was any, and there still is no equivalence between the home and the street, and therefore neither harmony nor unity in the city. This is due partly to climate and partly to lack of equivalence between individuals. Inequality among men created the natural tendency to avoid each other; but the cause of all disharmony is in the individual himself. So long as in mass he remains as he is today, he will be unable to create a harmonious material environment.

In early times communal life was facilitated by greater equality among the masses. The people were clearly separate from the more advanced (kings, priests, etc.), and they used the home only as a refuge from the weather. They preferred to live outdoors. This changed with the course of civilization. Then came the natural and logical instinct to feel oneself an individual. Consequently, collective life ceased to be possible. People became more and more concerned with the home, and the outdoors became merely a place for transit (the street) or for breathing some fresh air (the park). All this was in keeping with mankind's progress and the evolution of the individual, so that he developed by concentrating upon himself without being hindered or disturbed by others. Today, heirs of this thinking, we are individualists even though we are seeking and developing a universal outlook.

Let us, then, separate ourselves from the masses. And here I would like to add a personal note. I have always fought the individualist in man and have tried to show the value of seeing in a universal way; but this does not mean I believe in full collectivism for the present. That is the dream of the future. Already in our own day there are groups who could live communally if they were not scattered throughout the world. But we cannot expect this of the broad masses. Everything today is created in and by the individual, and for myself I applaud Marinetti when he said: "Long live inequality! Let us increase the differences among men! Let us everywhere unleash and arouse the originality of the individual. Let all things be differentiated, transvalued, disproportioned."

As man matures, he himself becomes more the creator, opposing physical and natural matter and those still under its domination. Man will choose or create his own material environment. He will not regret the absence of natural appearance, that aspect of nature which most people still regret even as they are forced against their will to abandon it. The truly evolved human will no longer attempt to bring beauty, health, or shelter to the city's streets and parks by means of trees and flowers. *He will build healthy and beautiful cities by opposing buildings and empty spaces in an equilibrated way.* Then the outdoors will satisfy him as much as the interior.

Unfortunately, today it is very difficult to "create," and we are forced to live amid *the plastic expression of the past.* Individuals and

groups who have detached themselves from the grip of the past suffer from its *depressing expression*. They have discovered a new world as yet unrealized. Yet, even while they suffer, they are attaining the realization of their ideas; for them each creation (so far as the backward majority allows) is a brilliant proof. The majority prefers to live in the past. Since they possess the power and since building materials are long-lasting and costly, it follows that a general and speedy renewal of the environment is almost impossible today. But thanks to the power and vigor of new individual creations, and also to the new and imperious demands of life, the old way of building will die its own death.

Neo-Plasticism therefore views the home not as a place of separation, isolation, or refuge but *as part of the whole, as a structural element of the city*. And this is the great difficulty at present: the city is still unchangeable in contrast to the home, which is being renewed. We must have the strength and courage *to face a period of disharmony*. Fearing disharmony, we fail to advance today; still worse, we adapt to the past. *We must not adapt, we must create.*

We must think of the home very differently than we did in the past. So long as man is ruled by his fleeting individuality and does not cultivate his true self, which is universal, he will neither seek nor find anything but his own personality. The home thus becomes the place where this fleeting individuality is fostered, and the home's plastic expression reflects this petty concern. *The outward manifestation of this concentration upon the self has so far been fatal for our whole epoch.* If our material environment is to be pure in its beauty and therefore healthy and practical, it can no longer be the reflection of the egotistic sentiments of our petty personality. In fact, it need no longer be lyrical in expression but purely plastic.

Leaving aside purely philosophical trends and speaking only of the movements based on plastic expression, we see that Futurism has been one of the most effective in reducing the naturalistic lyricism of the past (*Les Mots en liberté futuristes*, by F. T. Marinetti). The Cubist, Purist, and especially the Constructivist movements have also demonstrated the idea of *universalized self*. But it was Neo-Plasticism that *replaced lyricism with the purely plastic*. Through the intensified but variable rhythm of relationships in an almost mathematically pure plastic means, this art can come close to the "superhuman" and certainly the universal. That is possible, even today, because art anticipates life. Neo-Plastic art loses something of the superhuman as it becomes realized in life in the form of material environment, yet retains it enough for the individual no longer to feel his petty personality but to be uplifted through beauty toward universal life.

Many people today are afraid of the idea of "beauty." Is it not because the past completely separated beauty from life by establishing a conventional aesthetic? An aesthetic that negated the pure beauty of construction so that it seemed right to build in disregard of the organic and the functional in the thing constructed. But by following *naturalistic* organization one soon goes astray, and as a result equilibrated relationships are lacking. Today's architecture clearly proves this. *We therefore need a new aesthetic based on the pure relationships of pure lines and colors, for only pure relationships of pure constructive elements can result in pure beauty.* Not only is pure beauty necessary for us today but it is the only means purely manifesting the universal force that is in all things. It is identical with what the past revealed under the name of the divine and is indispensable if we poor mortals are to live and find equilibrium. For things in

their natural state stand against us, and the most external conditions of matter oppose us.

A new aesthetic has sprung from Neo-Plastic painting. In the design of a few interiors and in a few buildings whose construction is free of tradition, we can discern the new spirit and detect the newly created laws. These laws revolutionize the old notions of architecture, which have become purified and simplified by new materials and by the daring efforts of a few architects.

Whereas, especially in the metropolis, the character of the street has been transformed by the myriad artificial advertising lights, by colored billboards, by well-composed window displays, by utilitarian buildings—the home, on the other hand, requires a special and conscious effort. To defeat the still so powerful influence of the past, *we must concentrate first and foremost on the plastic expression of the home*, on the dwelling and its rooms, and we must leave the technical problems of construction to the engineers.

At present, I see no chance of achieving perfect plastic expression by simply following the structure of what we build and studying its utility alone. For that, our intuition, still weighted with the past, seems insufficiently developed. If it is difficult enough for us to express these equilibrated oppositions in simple buildings, we are even more at a loss with the more complex structures. For instance, utility often requires repetition in the manner of nature (as in a group of low-cost dwellings), and here the architect must have some notion of plastic expression and know how to balance what the utilitarian need seems to require. For it is always possible to find structural solutions that satisfy both the utilitarian goal and the aesthetic aspect.

The pure and logical plastic conception is always in accord with practical demands, for both are simply a matter of equilibrium. Our time (the future!) demands pure equilibrium, and to it there is only one road. There are endless ways to express beauty, but pure beauty, the expression of pure equilibrium, can be manifested only *through pure plastic means*. That is one of the most important laws of Neo-Plasticism for the construction of home, street, and city. But pure means alone do not suffice to produce Neo-Plastic expression. *They must be composed in such a way that they lose their individuality and through neutralizing and annihilating opposition form an inseparable unity.*

1. The plastic means must be the rectangular plane or prism in primary colors (red, blue, and yellow) and in noncolor (white, black, and gray). In architecture, empty space can be counted as noncolor, denaturalized material as color.

2. *Equivalence* in the dimension and color of the plastic means is necessary. Although varying in dimension and color, the plastic means will nevertheless have an equal value. Generally, equilibrium implies a large area of noncolor or empty space opposed to a comparatively small area of color or material.

3. Just as dual opposition is required in the plastic means, it is also required in the composition.

4. *Constant equilibrium* is achieved by the relationship of position and is expressed by the straight line (boundary of the pure plastic means) in its principal, perpendicular, opposition.

5. *Equilibrium that neutralizes and annihilates the plastic means* is achieved through the relationships of proportion in which they are placed and which create vital rhythm.

6. Naturalistic repetition, symmetry, must be excluded.

Here, then, are six Neo-Plastic laws that

determine the pure plastic means and how they are used.

Concerning the fourth law: In architecture *exact plastic expression of cosmic equilibrium* is manifested through vertical or horizontal lines or planes. This is precisely what distinguishes architecture from nature as such, where these planes and lines remain confused within the *forms*. By *abstracting* from *natural appearance*, and not by copying architecture, Neo-Plastic painting also succeeded in plastically expressing cosmic equilibrium. This explains the perfect unity of Neo-Plastic painting with the new architecture, and also its constant equilibrium. Thus it contrasts with earlier painting, which almost never used the vertical or horizontal. Although past art favored the curve, the large lines of its compositions were oblique, and nearly all earlier architecture expresses the vertical and horizontal position through the oblique.

It is therefore astonishing that recently Neo-Plasticism was accused of being classical, and of trying to follow natural appearance (even though abstractly). *Neo-Plasticism is classical only insofar as it is the true and pure manifestation of cosmic equilibrium from which, as human beings, we cannot separate ourselves.*

Some points might at first sight seem to support the accusation. An explanation is therefore necessary, especially since the use of the oblique in architectural chromoplastic would destroy the Neo-Plastic unity of architecture and painting.

Based on a misunderstanding of the vertical and horizontal, it has been claimed that "the new painting must stand in contrast to the new architecture." Is that really logical? If the new painting is opposed to the new architecture, of what would the renewal of architecture consist? Must not architecture be renewed equally and homogeneously with painting? And does this not demand the unity of the arts?

It should be noted, however, that in Neo-Plastic art the essential question is not of vertical or horizontal, but of the perpendicular position—and the relationship thus obtained. For it is this relationship that express the immutable in contrast to the mutable in nature. Very fine things can therefore be created by turning this relationship to the oblique. The oblique is naturally relative and depends upon our position or the position of things. But despite all relativism, man's eye is not yet free from his body. Vision is inherently bound to our normal position. Only the mind can know anything of the forth dimension and detach itself from our poor physical body!

As men, we must deal with *man's equilibrium*; if we upset it we create nothing! Plastic expression is determined by our physical and spiritual equilibrium. One cannot deny the naturalistic and capricious character of the oblique. Moreover, its disequilibrated expression cannot be annulled by the opposition of another line. Although it is possible in this way to produce an expression of stability, the plastic expression of the oblique remains an expression of external movement, therefore of natural appearance. This is where superficial attempts to find a New Plastic expression lead: without desiring to, we return to nature.

On the contrary, the vertical and horizontal in the retangular relationship produce a plastic expression of inner strength and repose. When united in the "appearance" of a cross, these lines express a form—although abstractly; but in Neo-Plastic composition they are really opposed, thus annihilating all form. In this composition they express the movement of life, matured by a deeper rhythm arising from relationships of dimension. And since opposition to nature can be achieved only by these relationships, it is in them and them alone that we must seek the culmination of Neo-Plasticism.

General observation: Since denaturaliza-tion, is one of the essential points in human progress, it is therefore of primary impor-tance in Neo-Plastic art. Neo-Plastic painting has shown its power by plastically demon-strating the need for denaturalization. It denaturalized the structural elements as well as their composition. For this reason it is *true abstract painting*. To denaturalize is to abstract. By abstracting one achieves pure abstract plastic expression. To denaturalize is to deepen. Denaturalization takes place consciously or unconsciously. The progress of fashion exemplifies the latter. Aren't our clothes becoming purer in form, even op-posed to natural forms? Doesn't the use of cosmetics show a dislike of the natural appearance of skin?

In architecture, matter can be denatural-ized in various ways; and here technology has not said its last word. *Roughness, rustic appearance* (typical of materials in their natural state) *must be removed*. Therefore:

1. Surfaces will be smooth and bright, which will also relieve the heaviness of the materials. This is one of the many cases where Neo-Plastic art agrees with hygiene, which demands smooth, easily cleaned surfaces.

2. The natural color of materials must also disappear as far as possible under a layer of pure color or of noncolor (black, white, or gray).

3. Not only will materials be denatural-ized in their use as plastic means (construc-tive elements) but so will architectural composition. Neutralizing and annihilating opposition will destroy natural structure.

Application of these laws will destroy the tragic expression of home, street, and city. Physical and spiritual happiness—prerequisite for health—will be furthered by equilibrated oppositions of relationships of proportion and color, matter and space. The creation of a sort of Eden is not impossible

if there is the will. To be sure, this cannot be done in a day, but by giving all our effort, we can not only achieve it in time, but we can begin to enjoy its benefits tomorrow. The abstract spirit cannot be annihilated by the past that we still see everywhere; conscious of its strength, it admits only the expression of the future. Assembling all its expressions now scattered in space, it constructs (ab-stractly) this earthly paradise, and in these creations it is realized; and it transforms without destroying.

The application of Neo-Plastic laws is the path of progress in architecture. This is confirmed by reality itself as it emerges and develops through the force of necessity—new requirements of life, new materials, etc. In fact, what is today most advanced in tech-nique and construction is precisely what comes closest to Neo-Plasticism. Neo-Plasticism is more at home in the Métro than in Notre Dame, prefers the Eiffel Tower to Mont Blanc.

In this article I have discussed certain "ideas" and their embodiment in basic laws. I have said little about the details of execu-tion because I know that external life is forever changing—air transport, for instance, may require a very different type of architec-tural construction. But the plastic laws that we have set forth will in no way be affected; on the contrary, the most advanced construc-tion increasingly confirms them.

The demands of the new life will modify all details of execution; but these are insigni-ficant before the *new conception*, which is paramount.

So I conclude: the home can no longer be sealed, closed, separate; nor can the street. While fulfilling different functions, home and street must form a unity. To achieve this, we must cease regarding the home as a box or a void. The idea of the "home"—"Home, Sweet Home"—must be destroyed at the same time as the conventional idea of the street."

Home and street must be viewed as the city, as a *unity formed by planes composed in neutralizing opposition that destroys all exclusiveness.* The same principle must govern the interior of the home, which can no longer be a conglomeration of rooms—four walls with holes for doors and windows—but *a construction of planes in color and noncolor unified with the furniture and household objects, which will be nothing in themselves but which will function as constructive elements of the whole.*

And man? Nothing in himself, he will be part of the whole; and losing his petty and pathetic individual pride, he will be happy in the Eden he will have *created*!

General Principles of Neo-Plasticism (1926)

Even before publishing the special number of *Vouloir* on "ambiance" that carried "Home—Street—City," Del Marle planned another, centered on Neo-Plasticism and Elementarism. In this connection he circulated a questionnaire among present or former members of the Stijl circle. Except for Mondrian's text, dated December 1926,[1] neither the questionnaire nor the answers have survived, though the questions can be inferred from the four headings of his reply.

As Mondrian explained in a letter to Del Marle of 10 December,[2] this reply was a composite or condensation from earlier writings. His point 1, "General Principles of Neo-Plasticism," consists of the "six Neo-Plastic laws" stated in "Home—Street—City."

I. General Principles of Neo-Plasticism

1. The plastic means must be the rectangular plane or prism in primary colors (red, blue, and yellow) and in noncolor (white, black, and gray). In architecture, empty space can be counted as noncolor, denaturalized material as color.

 2. *Equivalence* in the dimension and color of the plastic means is necessary. Although varying in dimension and color, the plastic means will nevertheless have an equal value. Generally, equilibrium implies a large area of noncolor or empty space opposed to a comparatively small area of color or material.

 3. Just as dual opposition is required in the plastic means, it is also required in the composition.

 4. *Constant equilibrium* is achieved by the relationship of position and is expressed by the straight line (boundary of the pure plastic means) in its principal, perpendicular opposition.

 5. *Equilibrium that neutralizes and annihilates the plastic means* is achieved through the relationships of proportion in which they are placed and which create vital rhythm.

 6. Naturalistic repetition, symmetry, must be excluded.

II. Neo-Plasticism and Form

In nature, relationships are veiled by matter appearing as *form*, as *color*, or as *natural-sound*. This "morphoplastic" was unconsciously followed in the past by all the arts. Thus, in the past, art was "in-the-manner-of-nature." For centuries painting plastically expressed relationships through natural form and color—until our time, when it is achieved by the *plastic of pure relationships*. For centuries painting was *composed* by means of natural form and color, until today, when the composition itself has become "plastic expression," "image."

III. Neo-Plasticism and Color

Despite its "interiorized" plastic expression, Neo-Plasticism is still "painting." Its means of expression is *pure and determinate color*, where the planes remain equivalent with the surface of the painting, that is, color remains plane within the plane. It is not weakened by following modulations of form; it is therefore stronger than in morphoplastic. Color finds its equivalent opposition in noncolor, that is white, black, and gray.

IV. Psychological and Social Consequences of Neo-Plasticism

Equilibrium through *equivalence* of nature and mind, of what is individual and what is universal, of the female and the male—this general principle of Neo-Plasticism is not only applicable to the plastic but is also realizable in man and therefore in society. Equivalence between what pertains to matter and of what pertains to mind can create a harmony in society unknown until now.

 By *interiorization* of what we know as matter and by *exteriorization* of what we know as mind—overly separated until now—matter-mind comes to unity.

 Neo-Plasticism demonstrates *exact order*. It demonstrates equity, for equivalence of the plastic means in the composition indicates that, furthering human evolution, art has demonstrated rights possessing the same value despite their differences. Equilibrium through contrary and neutralizing opposition

annihilates individuals as particular personalities, and creates a future society as *true unity*. [The unity underlying] natural appearance that art reveals signifies the greater clarity of human consciousness in our time—and confirms human evolution.

Painting and Photography (1927)

In April 1927 *i 10* published "Painting and Photography" by Ernst Kállai, editor of the Bauhaus journal. Comments on the article by several artists appeared in the June issue of *i 10* under the title "Diskussion uber Ernst Kállai's Artikel 'Malerei und Fotographie.' " Among them were these few lines by Mondrian.

The question of representation in photography was keenly debated at this time, particularly in Germany where Albert Renger-Patzsch championed the precisionist "New Objectivity." At the Bauhaus, László Moholy-Nagy (who was photography editor for *i 10*) introduced photomontage, cropping, and cameraless photography or "photograms." Moholy-Nagy's influential *Malerei, Fotographie, Film* (Painting, photography, film) was published as Bauhaus Book no. 8 (1925).

Although I largely agree with Mr. Ernst Kállai's interesting remarks on "painting and photography," I think one must not overlook the fact that the "artist," not the "means," creates the work of art.

Certainly the means is highly important and closely tied to the plastic expression of a work, but it is the artist who essentially decides whether it is *purely plastic* and not imitative.

Photography, however, seems to me rather more imitative than plastic in character. Photography in the usual sense is the appropriate means for *reproduction* of objectivity, and all art is *creation*. But it is difficult at present to predetermine the evolution of photography—indeed such great accomplishments have been realized in the realm of pure plastic that everything may also be expected of photography. It is quite possible that the technique of photography will change, just as the technique of painting has changed; and Mr. Ernst Kállai's comparisons and observations may help bring this about.

Jazz and Neo-Plastic
(1927)

"De Jazz en de Neo-Plastiek" appeared in Dutch in the December 1927 number of *i 10*.

Here Mondrian's musical, painterly, social, and philosophical concerns converge in the collective environment of the "bar," or nightclub. That his preoccupation with environment was a major impulse for "Jazz and Neo-Plastic" appears from two letters of summer 1927. On 25 August Mondrian wrote Del Marle that he had worked over two months on his studio interior: "I learned a great deal, or rather so much became violently clear to me that I was impelled to write an article."[1] And he informed Oud a couple of days later (27 August): "I am busy with an article on Neo-Plastic chromoplastic in architecture. . . . I only take jazz as the starting-point; it does not deal with music."

"Have you read my *i 10* article?" Mondrian subsequently asked Oud (4 December). "It seems to be of cultural importance, as you once said of my work in a lecture. . . . I would like to do a whole series: a sort of artistic-philosophical working out of Neo-Plasticism."

The previous year, hearing that the Charleston might be banned in Holland on account of its "sensuality," Mondrian indignantly told an interviewer:

> Yes, danced nervously, as it is by Europeans, it often appears hysterical. But with the Negroes, a Josephine Baker, for instance, it is an innate, brilliantly controlled style. All modern dance appears limp beside this powerfully sustained concentration of speed. How can they think of prohibiting this spirited dance in Holland? The dancers are always so far from each other, and have to work so strenuously, there is no time for amorous thought. If the ban on the Charleston is enforced, it will be a reason for me never to return.[2]

Strangers amid the melody and form that surround us, jazz and Neo-Plasticism appear as expressions of a new life. They express at once the joy and the seriousness that are largely missing from our exhausted form-culture. They appear simultaneously with movements in various spheres that are trying to break with individual form and subjective emotion: they appear no longer as "beauty," but as "life" realized through pure rhythm, which expresses unity because it is not closed. Many movements have actually set out to abolish form and create a freer rhythm. In art, Futurism gave the major impulse. Cubism led painting to *break form* and to *organize it anew*. Less bound by form than the other arts, painting was able to carry this through consistently to Neo-Plasticism: a *new* organization through a *new* plastic means. Literature, on the other hand, was limited by words and sentences; but as *art*, it too could to some extent become *plastic expression of pure rhythm*. By excluding logic—which makes nonsense of rational

literature, but is quite feasible in art—form was broken, annihilated, and rhythm was set free.

Nevertheless, like form in Cubism, words or sentences retained their individual meaning. If this meaning is annihilated by the reduction of words to pure sound, then literature loses its meaning as such and comes closer to music. Its potentialities are thus limited. Music too was influenced by the spirit of the age and comparably reformed. Yet music did not achieve results equal to those of painting, for it clung to conventional principles and to existing instruments. With new conceptions and techniques, music too could be expressed as *pure plastic* (see *Die Neue Gestaltung*, Bauhaus book no. 5). *The more an art is limited by form, the less easily can it attain universal plastic expression, the new order.* Obviously, then, life itself can approach purity and universal order only with the greatest difficulty. More and more, however, life is seen to be *distinct from the material* and is experienced more and more abstractly. What can be realized in art is becoming increasingly possible in life. *Culture will progressively free life from the oppression of matter*, until it matures into a new culture.

Jazz—being free of musical conventions—now realizes an almost *pure rhythm*, thanks to its greater intensity of sound and to its oppositions. Its rhythm already gives the illusion of being "open," unhampered by form. But on the other hand Neo-Plasticism actually shows rhythm free of form: as *universal rhythm*. Because Neo-Plasticism realizes the principles of Neo-Plastic painting in the totality of our constructed environment, it is the beginning of a new more universal order *realized in life*.

Hence Neo-Plasticism's importance for culture: its material realization is convincing. The idea of universal order was "formulated" long ago both in intuitive and in rational philosophy. But only in our time has this idea entered consciousness and found its echo in society. Its material realization is only now becoming visible. Purity and order are appearing in many areas. Many setbacks have reflected a lack of the cultural profundity necessary for the new order in life. Such profundity is unequal among unequal individuals, and for a time the new culture will only be the expression of a small group. The masses lag behind: they are in the process of becoming cultivated. It is logical that they cling to the old culture and oppose the new.

Universal rhythm in the new culture expresses *fully human* life. In its deepest sense, however, universal rhythm is not realizable in our world. The old culture attempted its realization, thereby separating nature and spirit; it divided life into the spiritual and the material. Or, seeing that the deepest universality was impossible to realize, it concentrated upon material life alone. The old culture was not mature enough to resolve this duality.

The signs in life that point to cultural maturity are still few and uncertain, and the degree of consciousness is difficult to gauge. But phenomena seen for the first time in the whole of culture cannot be doubted. The fact that, having broken with form, art is nearing its end and is prepared to pass over into life itself is one of the undeniable signs of a maturing form-culture.

Everything thus suggests that we have reached a *turning point in human culture*. Our mentality shows clearly that, for it, "form" has come to an end. This means we no longer want the limitation of form, though we continue where necessary to perfect the form of material things. Morally, then, we are *at the end of form-culture* and at the *beginning of a new culture* that has come unconsciously to expression through form—that is, through *relationships*. The culture of relationships will lead to *universal*

relationship, which alone can completely annihilate all form.

This passage from art to life is seen most clearly in jazz and in Neo-Plasticism. True, both remain in the auditory and visual sphere, but this sphere is now so closely bound up with life as to be concrete for us.

Jazz and Neo-Plasticism are revolutionary phenomena in the extreme: they are destructive-constructive. They do not destroy the actual content of form: they only deepen form and annihilate it in favor of a new order. Breaking the limitations of "form as particularity," they make universal unity possible.

Syncopated American, or Negro, jazz is quite well-known, even if hard to find. Great American and European jazz bands can be heard on records, and jazz is also found in the "bar" [nightclub]. In contrast, pure Neo-Plastic is realized only approximately, here and there. Its content, however, can be readily grasped from Neo-Plastic painting, which is fairly well known. The character and degree of its realization are of little importance. More essential is the fact that it has been realized and is the expression of a group that accepts or creates it consciously, insofar as conditions allow.

Like the culture of form, the *psychology of form* is ending. Once form is abolished, all things are as one. Man no longer lives in a private world and for himself alone but *within* the world: he is truly part of it, separate yet active. He is no longer a machine but consciously and fully "human." He uses the machine and is not misused by it, as at present. *The machine is not the new culture.* It is one of the means through which maturing form-culture acts—today either for good or for evil—but in the broad line of culture, both for good. The machine levels as militarism levels. It can reduce individuality—and can also kill it. As the machine is now used, it does not abolish individuality. Mechanical rhythm is *repetitive*: like nature's rhythm. This has its place in nature but not in fully human life. If natural rhythm were also human rhythm, man would be either a higher animal species or else would have a dual being, half natural and half nonnatural: disequilibrated. *As a dualistic being,* he could never achieve full humanity. Man has a rhythm *unique to man*. He opposes his rhythm to nature's rhythm and creates his *own environment*—in opposition to nature. The machine's rhythm can be accelerated and nothing is changed. Accelerated rhythm without the opposition of relationship is devastating to man. The new culture will have to assimilate the machine properly to its own rhythm. The perfected machine is indispensable to the new culture, just as is the sublimated physical in man.

The psychology of form is human psychology. It expresses physical-spiritual unity. The psychology of form is pure because form is directly plastic. This is possible because even the most outward form can be deepened. Complete knowledge of form can be gained through purely objective vision, that is, vision unmixed with subjective feeling. Thus the new culture, whose mentality holds deepened emotion in equivalent relationship with consciousness (or intellect), can discern form, deepen form, abolish form. The new mentality was actually created by a deepening process, which the old culture accomplished together with physical deepening. Without physical as well as inward deepening, full humanity could not be achieved. We have been thoroughly natural: we must become thoroughly human. In the long course of culture, we see that the physical grows less "physical" without weakening, while the nonphysical becomes conscious.

Culture irresistibly furthers human evolution. Culture sometimes advances in roundabout ways—but it never errs. Our

mentality, however, often does. The old culture believed that full human life was attainable in this world by merging the completely natural with the completely spiritual. It tried to achieve both. . . . but in vain. Beside the fact that the natural is no longer to be found in its perfect state, *the spiritual can never be completely expressed, because it must be externalized in order to be manifested.* Externalization, from the point of view of spirit, is degradation. Therefore, the spiritual can never join with the completely natural in equilibrated relationship.

In the beginning of culture, the natural, although imperfect, nevertheless dominates the mind while the spiritual remains unconscious. We see this in the plastic arts. In form there is no equivalence of opposites. Form must be reduced to the duality of position of the straight line in order to realize equilibrium.

The natural must therefore lose its hold on our mentality, which consists of both physical and spiritual. *The physical must be transformed and the spiritual must become conscious.* Culture apparently moves in opposite directions: *reducing the physical, intensifying the spiritual.* Reduction of the physical, however, means the creation of another physical aspect, not its weakening. It could be called refinement, although this might be misunderstood. In any case, *the physical must retain its full function* in order to unite with conscious spirit. In due time, culture will achieve complete unity, complete humanity will be attained through physical-spiritual equivalence, and equilibrium will be realized in *actual life*.

Form determines the particular character of all things. It becomes "plastic," first through the character of the surface; second through its color; third through the relationship of position; fourth, through the relationship of size. The plastic expression of form is

determinate: unchangeable when considered outside of time; in time everything is mutable. Outside of time all form is equally beautiful. In time there are degrees of beauty: the ugly and the beautiful. Outside of time everything is good; in time there is good and evil. Outside of time morality is unchangeable; in time the *forms of moral life* change. Outside of time psychology is unchangeable; in time man's mentality, and therefore psychology changes. That is why in form-culture morality can be based on the psychology of form, just as Richet bases it on psychology.[3] We now discover that the basis of form is *not unchangeable* as the old culture thought. The new culture abolishes form, together with the old morality. The new culture will not be without morality, however. *The new morality will be based on universal relationship.*

Time is culture: form changes in the course of culture. Forms change at varying tempos. Thus, during form-culture, forms become related to one another in dissimilar, therefore, disequilibrated relationships. Only when the multiplicity of forms has become uniformly deepened, so as to establish *equilibrated relationships*, can forms annihilate one another in multiplicity. At that point the new culture appears.

The physiognomy and the psychology of forms are known and accepted. Each form, each line, each color has its own character and significance. Physiognomy is not confined to the face. We can study the most outward manifestation of every form, as physiognomy, through the abstractions of the psychology of form. Physiognomy is most prone to error, for in natural form much is either confused or undeveloped. Thus beauty can arise under particular conditions of nature, which sometimes tends toward perfection independently of inner or outer influence. And yet if only we could see purely, uninfluenced by conventional ideas, every form would reveal its

content. Physiognomy and psychology belong to the old culture but are still necessary in order to prepare the new and show us its logic. The various degrees of the abstraction of form give an image of human evolution. That is why study of form is important now but will be of no importance in the new culture itself. As the new culture evolves, all philosophy and all art will gradually become superfluous. Mature man will be able to live by intuition: all "thinking-and-feeling-in-form" will dissolve into the unity of deepened emotion and intellect.

Many moderns consider themselves already at that stage of development: but it is still too early. Alas, we must continue to philosophize, to create art . . . thinking and feeling in form.

Jazz and Neo-Plasticism are already creating an environment in which art and philosophy resolve into rhythm that has no form and is therefore "open."

Almost always at present, we find the inward and outward intensified separately. In one individual the nonphysical is becoming more conscious, while his external culture remains undeveloped; in another we find *a more external* culture but without spiritual culture. Thus there is no equilibrium within individuals or in their mutual relationships. So for the time being universal rhythm cannot be experienced.

We cannot directly control the abstraction and abolition of form in the spiritual as we so clearly can in the worldly. Whatever form-culture accomplishes today in the worldly sphere can strongly influence the spiritual just as it has influenced the worldly.

In the metropolis, unconsciously and in answer to the needs of the new age, there has been a liberation from form leading to the open rhythm that pervades the great city. All manner of construction, lighting, and advertisements contribute. Although its rhythm is disequilibrated, the metropolis

gives the illusion of universal ryhthm, which is strong enough to displace the old rhythm. Cathedrals, palaces, and towers no longer constitute the city's rhythm. The noise of vehicles, etc., contains opposing relationships, whereas church bells have only the rhythm of repetition. Unconsciously the new culture is being built here. For some time yet, unfortunately, the tolling of bells and many other signs will remind us of the old culture.

The rhythm of the metropolis, however, visually and audibly expresses the *oppression of labor*. One senses the unequal opposition between forced labor and free being. One senses the *struggle for existence*: the tragedy of the material and the moral in disequilibrated relationship. By relating the material and the moral in equilibrium, the new culture will create a totally new metropolis, although it will use the same means that the old culture now misuses. A new rhythm of sight and sound will result: the tragic will disappear. Already the tragic is noticeably less strong in the metropolis than in the country, the village, or the small town—simply due to the destruction of form. "Form-as-particularity" dominates the country and small town, and the natural prevails.

Jazz does not know the oppression of work. The orchestra works as if it were at play. In the bar we already see a vision of what the new culture may bring in another, more sublimated way. Then the oppression of work will be unknown, as in the bar today. In the bar we find the childlike experience that eludes the people of modern society with their grim seriousness—although already they are less "serious" than those before them. They oppose joy to seriousness; they wear a smile when they dance and look grave when they go about their business. In the bar, happiness and seriousness are one. Equilibrium is there, for everything is subsumed by rhythm. There is no emptiness, no boredom: rhythm fills everything without

creating new oppression—it does not become form. No link with the old remains, for in the bar only the Charleston is seen and heard. The structure, the lighting, the advertisements—even in their disequilibrium—serve to complete the jazz rhythm. All ugliness is transcended by jazz and by light. Even sensuality is transcended.

Free of limiting form, sensuality *opens*. So does spirituality. The two opposites have the same action in their different spheres. Sensuality deepened to the extreme is spirituality and conscious spirituality is expressed sensually. In the bar sensuality is not sufficiently deepened: it is refined but not spiritualized.

Jazz above all creates the bar's open rhythm. It annihilates. Everything that opens has *an annihilating action*. This frees rhythm from form and from so much that is form without ever being recognized as such. Thus a haven is created for those who would be free of form.

Everything in the bar moves and at the same time is at rest. Continuous action holds passion in check. The bottles and glasses on the shelves stand still, yet they move in color and sound and light. Are they less beautiful than candles on the altar? They both have the same abstract form: height dominant over breadth. The dancers with made-up faces move and come to rest. No room for particular emotion. The makeup and clothes are culture too; but the bar reflects our culture's lack of deep inwardness. In the bar, the bias to individuality ceases; there are only men and women. All dance well: all are part of one rhythm. Drinking has another meaning here: it is not for the sake of drinking. Dance is not for the sake of woman. There is no room for business, politics, money. For these have another rhythm, a closed one; their rhythm is expressed in form-psychology by a multiplicity of oblique lines: tense, but disequilibrated, restless, accidental. In the bar natural rhythm takes on a new aspect: without the capriciousness of the curved line. It is even hostile to natural rhythm, which does not exclude the flowing line; for fluidity is closer to the rhythm of subjective emotion: the curvilinear is thus consonant with the rhythm of nature—although even nature sometimes resists subjective feeling. Basic to all rhythm is the rhythm of horizontal and vertical. That is why everything is pervaded by an element of rest. But even this inward rhythm remains "natural" if it is not opened by form-annihilating relationships, which jazz rhythm is already attaining.

Why especially in the bar? The people have not matured in their culture; the bourgeois even less, being bound by convention, and the aristocracy should have. Individuals of every class can express mature culture. A group within the mass. The individual is exploited. The bar is an exploitation. But without money culture cannot go forward. By use and misuse money will find its just use. Jazz is an "attraction." And so jazz is now in the bar.

Pure Abstract Art
(1929)

"Pure Abstract Art" ("Die rein abstrakte Kunst") appeared in Switzerland's foremost daily newspaper, *Neue Zürcher Zeitung*, in connection with the exhibition of "Abstract and Surrealist Painting and Sculpture" held at the Zurich Kunsthaus in October 1929.

In Zurich there were articulate spokesmen for modern art and architecture, notably the cultural historian Sigfried Giedion, general secretary of CIAM (International Congresses for Modern Architecture); his wife, the writer on contemporary art Carola Giedion-Welcker; and the architect Alfred Roth. All were friends of Mondrian and acquired his works; the Zurich exhibition was inspired by Giedion. Swiss and Germans were among Mondrian's collectors in the 1920s, and contributed substantially to the establishment of abstract art.[1]

All art is essentially the pure "plastic of relationships": aesthetic plastic through line, color, or volume.

Only in its appearance has it been a plastic expression of form and naturalistic color. Appearance has deceived us; in traditional art, naturalistic representation of objects predominated. But in our time our eyes have gradually opened.

Through the centuries of their culture, form and color were increasingly abstracted and the corporeality of form was annihilated. The basic elements of form emerged and thus the plastic expression of relationships.

The basic elements of form are not attained through mere stylization. Clear plastic expression arises from the process of abstraction, through disassociation, that is, through the annihilation of closed form—the duality of straight line in perpendicular relationship. But this duality again becomes form or symbol whenever it is not plastically expressed as a multiplicity of mutually annihilating oppositions.

Art that is naturalistic, abstracted, or geometric in form can be called "morphoplastic art" and art that is concerned with the basic elements of form can be called "pure abstract art." It is abstract because it can form absolutely equivalent relationships, for straight lines and planes can be mutually equivalent. Pure line and color are just as "real" as form. For the plastic artist, abstraction represents the highest degree of determination, and pure abstract plastic has the greatest strength.

All art based on form creates relationships through the nonequivalent, whereas pure abstract art creates relationships through equivalent opposition. For only the universal plastic means of pure abstract art can be composed in pure equivalence. The equivalence apparent in the composition of morphoplastic art achieved harmony but not pure equilibrium. Only complete equivalence, which constitutes the essential content of art, can produce actual harmony. In its way of expressing plastic relationships, art shows the

relationship of man to his environment. Our mentality—our thinking and feeling, our humanity, which is different in each period—also varies in relationship to the environment of each period. Thus we see enormous differences in artistic expression from earliest times to the present. Superficially seen, it is continuous change; in fact, it is cultural continuity determined by the interaction of mentality and environment.

Pure abstract art becomes completely emancipated, free of naturalistic appearances. It is no longer natural harmony but creates equivalent relationships. The realization of equivalent relationships is of the highest importance for life. Only in this way can social and economic freedom, peace, and happiness be achieved.

The concept of equivalent relationships is characteristic of our spiritual outlook today. Traditional moral feelings and concepts have already become unrealistic due to the changed conditions of life. Fundamentally, the old morality already contained them: love, brotherhood, friendship, etc. It is the idea of justice. In the economic sphere, this is realized through equivalent exchange (pure trade).

Inequivalent relationships, on the other hand, the domination of one over another or over others, have always led to injustices. Inequivalent moral and material relationships are the cause of all past and present suffering. Only through independent and free relationship to everyone and everything can man attain truly human life. However, in order to realize our innate feelings of equivalence, we must be free of all tradition, just as pure abstract art is free of naturalistic form and color.

Pure abstract art is therefore of great cultural value. It is not dogma but the product of culture. It reflects human nature but transcends it. For art is always the forerunner. Pure abstract art reveals princi-

ples that until now have remained veiled and concealed by the diversity of forms. Because it is purely plastic, it reveals basic truths without describing them. Without explaining, it clarifies and illuminates them.

Pure abstract art has a definite direction and definite plastic laws. But these are no more dogmatic than are the laws of nature and of naturalistic art.

Just as pure abstract art is not dogmatic, neither is it decorative. Superficially it may appear decorative because of the simplicity of its means. The essential of all art is the plastic expression of relationships, and this determines whether or not it is decorative. What may seem decorative (such as Byzantine mosaics) can be pure art—while paintings (much so-called art) can be merely decorative.

But with such simple means it is difficult to achieve the deepest plastic expression: nothing can be left to accident; the most exact technique is required. Theoretically it should be easy to reproduce a pure abstract work, but experience shows how difficult this is. Theoretically, mechanical execution would be desirable, but it is still impossible in practice. Through its simple means, pure abstract art can attain the objectivity of ornament, the purity of geometric construction, the spontaneity of the child. But to be art, the subjective must be manifested through the objective, the apparently mathematical must be free, spontaneity must be consciously expressed.

Pure intuition becomes conscious through long culture and creates pure abstract art, which arises neither from intellect nor from vague intuitive feeling.

The plastic mode of pure abstract art has been carried over into applied art . . . but pure abstract art itself cannot be applied. On the contrary, it includes everything—our entire material surroundings. Its consequence is the union of all the plastic arts. Only in

the beginning does it manifest itself separately in the various fields of art. The painting of pure abstract art is still a surrogate for chromoplastic, and its sculpture is still a surrogate for the plastic of volumes in the architecture of the future.

The commonly shared technique and the determinate universal means of expression of pure abstract art lead many to believe that its creators imitate each other. It is negated as universal and collective expression and regarded as being merely a private expression.

Indeed, the simplicity of the means of pure abstract art may not seem to permit the many distinctions and endless nuances of naturalistic form and color. Nevertheless, it allows for the personal, insofar as our time still requires it. The demand for the personal conception of the artist derives from an individualistic orientation. But this will no longer be important for the more universal conception of the future. It speaks well for pure abstract art that opposes personal expression.

Life as a whole moves toward the collective. Our cultural life proves this in its fashions, cosmetics, and many other outward expressions of social life where individuality is increasingly lost in the whole.

Pure abstract art has grown directly from the culture and refinement of mundane life; from culture—imperfect as it may be. It does not come directly from isolated philosophical or religious thinking or feeling. Fashion has a deep meaning: fashion is cultural expression. Although it may be an exteriorization, like the various forms of art, it nevertheless shows inner content.

It is now commonly accepted that the content of our age is expressed by its outwardness. Art shows precisely that its plastic expression interprets the content; and futhermore, that the mode of expression and the means of expression are of the greatest importance.

The "outward" is of the greatest importance in art, just as it is in life.

[A Note on Fashion]
(1930)

Among Mondrian's papers was this untitled tearsheet from an unidentified French publication, ca. 1930, with comments on fashion by several leading writers and artists. Mondrian always expressed a lively interest in the evolution of styles of dress.

Fashion is not only the faithful mirror of a period, it is one of the most direct plastic expressions of human culture.

In fashion, however, just as in free art, we see a tendency to return to natural appearances. Nothing is more unhuman than regression. In order not to fall back merely into a new expression of the past, it is therefore most important for fashion to create an appearance expressing "man-nature" in equivalence . . . to oppose the undulating lines and soft forms of the body with tautened lines and unified planes so as to create more equilibrated relationships.

Realist and Superrealist Art
(Morphoplastic and Neo-Plastic)
(1930)

Dated March 1930, "L'Art réaliste et l'art superréaliste (La morphoplastique et la Néo-Plastique)" was written for *Cercle et Carré*, appearing on the front page of the second number (15 April 1930). Mondrian devised the term "Superrealist" in answer to the "Surrealists'" claim to reveal a superior reality.

The original twenty-four-page typescript (followed in the present translation) was cut to about half length in *Cercle et Carré*: the omitted passages are here placed in square brackets. Mondrian had originally intended to publish "Realist and Superrealist Art" as a pamphlet comparable to *Le Néo-Plasticisme* (1920). "I have made a new brochure for a better understanding of Neo-Plasticism," he wrote Alfred Roth on 25 March. "Part of it will appear on 15 April in the second number of *Cercle et Carré*. It [*Cercle et Carré*] is a bit 'mixed,' but it attempts to be broader than the generality of reviews . . . *Enfin*, some breadth is necessary if one is to be in touch with the public."

Part of the typescript text of "Realist and Superrealist Art" appeared in an anthology of writing by contemporary Dutch artists: *Palet* (1931), edited by Paul Citroen.

Neo-Plastic—painting of relationships through line and color alone, completely free of limited form or of particular representation—is this still "painting"? Or is it merely decorative painting? It is certainly not picturesque or traditional. If it fails to achieve the fullest possible plastic expression in and through line and color, then it is indeed merely decorative painting. But if, on the contrary, it succeeds in obeying the principal law of painting, which demands *the expression of relationships through line and color alone*, then it is not only painting but *true painting* that does not rely on limited form which weakens pure plastic expression.

Every true artist has always been unconsciously moved by the beauty of line and color and their relationships for their own sake, not for what they represent. The artist has always sought to express all the vitality and richness of life by these means alone. Consciously, however, form was followed. Consciously, one tried to express the corporeal sensation of form through modeling and technique. But unconciously, painting was expressed *through planes, the tension of line was increased, color was purified*. Thus, the culture of painting through the centuries gradually led to the total *abolition of limited form and representation of the particular*. Thus, art today is free of whatever prevents it from being truly plastic. This freeing is of the greatest importance for art, whose mission is to transcend individual expression and to show—as far as possible—the universal expression of life, which is above the tragic.

[Although Neo-Plastic through its universal plastic means and composition can

achieve *maximum plastic expression*, we must note that this maximum has meaning only on the scale of plastic evolution. We all stand in different positions on this scale, and each position is real and true for each group. "Beauty" to one is not always beauty to another. Thus, the highest degree of one plastic evolution can be lower than another on this scale. It may be that the maximum is not always the most preferable, so that it is a great mistake to wish to impose a single plastic expression for all. Each group has its own conception of beauty and therefore its own artists.

To those who love tragic form, line, and color, Neo-Plastic is not only a divergent expression but is emotionless: sterile, dead.

The emotion we experience from anything depends partly on ourselves. From this viewpoint, therefore, there can be no general law for establishing universal beauty. Thus we need only answer to ourselves and only seek or create expression that satisfies us. In this way every plastic expression of beauty would then have equal value. But things also have their own expression: *their inherent plastic expression*. In the culture of the plastic in art—on the scale of its evolution—*everything has a different value*.

Although completely opposed to the others,] every expression of art has its own laws, which are in accord with the principal law of art and life: equilibrium. Upon these laws depends the degree to which equilibrium is realized and therefore how far disequilibrium (tragic expression) is destroyed. This becomes clear if we compare the different expressions of the art of the past and of today. All have tried to express equilibrium but always in different ways—even when seeking and creating tragic expression.

[The magnificent movements of modern art, Futurism, Cubism, Constructivism, Dadaism, Surrealism, show this clearly.]

The aspiration toward equilibrium and the aspiration toward disequilibrium are continually opposed within us. This tragic is only the movement of *culture-toward-equililbrium*, which advances in the measure that we feel the oppression of the tragic—oppression caused by the two polarities of life—and our desire to be free of it.

The oppression of the tragic—feeling of endless suffering—we experience at dawn: an emotion felt by every artist and expressed by the landscape painter.

At dawn, night still prevails. The feeble light seeks to overcome it. One feels the oppressiveness of disequilibrium, night-day, light-dark. It is the aspiration to equilibrium. Hope-despair.

Absence of certainty. Waiting for daylight.

Daylight: unity through the equivalence of light and shadow, night-day.

Night-day: physical matter and subtle matter—duality of a single thing.

Night-day: nature as much as man.

Night: the past.

Daylight: the future—man and nature unified.

The present: dawn . . . dawn, the end of night.

[Let us today live in the dawn: let us not think of living in the night. Let us not think of living in the twilight, which is the coming of night.

The mentality of the past still lives in the night. It fears night, dawn and day. But it loves the twilight. It loves the hopelessly tragic.

Hope despite the tragic—that is dawn. Like dawn, twilight arouses a tragic emotion, but in reverse. It is not the day coming: it is night falling. It is the end of full daylight . . . of life. It is decadence.]

Dawn, on the contrary, is evolution.

[If the day is dawning, how can we be in twilight? And how can full daylight—which we await—be ending? How can night be falling?]

Night, however, is sometimes brightened by the pale light of the moon: reflected daylight. Sometimes even forming a fantastic harmony.

This is how we must understand the great classics of the past: as works created in the harmonious light of the full moon. Their creation was not possible in full daylight. If such work can still be produced today, at dawn, it is because of night's reflection and because the conception of full daylight is not yet clear. But just as artificial light increasingly conquers night, the man of complete daylight will conquer night. Night—unrepresentable and without plastic expression. Day: unrepresentable, having inexact, confused plastic expression. Night-day, nature: not representable and having inexact plastic expression—how can art follow it and achieve exact expression of *our sensation and our conception* of full daylight?

Let us try to reproduce nature. Let us create.

Let us create in art a plastic expression opposed to the form of the apparent night-day unity. For varied forms themselves create the tragic (disequilibrium), which actual daylight vainly tries to transcend but can only neutralize.

Even in full daylight, the reality of form is not real for us who live in the full daylight of our conception and its exact equilibrium. No form, even that created by man, can realize the true content of full daylight, absolute equilibrium. Man can attain its approximate realization only *by creating a superreality of relationships.*

[In true daylight it is a sin against nature to try to follow nature; just as it is a sin against the light of day.

Let us now live in full daylight, so that we can create.]

Today, at dawn, let us live in the spirit of the approaching day. As dawn ends, our conception of complete daylight is no longer a speculative ideal. For now the light is strong enough to realize it abstractly from a physical viewpoint, but in reality for our minds.

Let us now perform the work of daylight—strengthened by the sleep of the past, satiated with the tragic of dawn.

Let us await full daylight—the future.

Let us await our own maturity.

But to wait for it one must love it. And to love daylight one must have loved the night, must have known the dawn and still love them: to hate the tragic, one must have lived long. Then we learn that *natural life is a continual repetition of night-day, life-death (the tragic), and that the life of "man" is only evolution toward the equilibrium of his duality.*

This equilibrium is clearly not that of an old gentleman in an armchair or of two equal sacks of potatoes on the scales. On the contrary, equilibrium through equivalence excludes similarity and symmetry, just as it excludes repose in the sense of immobility.

Real liberation from the tragic is not possible in nature. And in life, where physical form remains necessary and is of the greatest importance, equilibrium will always be very relative. But man, evolving toward equilibrium of his duality, *will increasingly (in life too) create equivalent relationships, therefore equilibrium.*

Social and economic life today already show strivings toward exact equilibrium. Our material existence will not always be threatened and made tragic by the material-spiritual disequilibrium in social life. And the life of the mind will not always be shackled by the oppression and domination of material life. Increasingly, science maintains and sustains us physically. Technology will continue to conquer primitive matter and bring it closer to man. Human life, although it depends on the physical, the material, *will not always be dominated by nature.*

Equilibrium *through equivalence of relationships* will be approximated in every *pure plastic* creation. Within the limits of the plastic, man can create a *new reality: a*

superreality. In the full daylight of the future, he creates this not only *in opposition to natural life but in relationship to it*.

At first he creates it as "art." In the audible it is manifested as new poetry or new music. Here, however, pure plastic expression will be very relative, for word and sound remain form. In the visual he creates it in a more real way as new painting, sculpture, or architecture. Then it will be realized in our whole material environment, which due to its own exigencies, already tends toward equilibrium through equivalence, and toward exact execution.

Through the influence of this superreality, human life, until now for the most part natural, will more rapidly become *truly human* life.

The new painting, although called abstract, is abstract only in comparison with natural reality. And if, as Neo-Plastic, it is preparing the superreality of the future, it is "real" because it expresses this reality. Neo-Plastic could even better be named "Superrealist painting."

Realist art and superrealist art demonstrate that there are two totally different ways to experience life, depending on whether one conceives it as individual or universal. In both cases we see life's manifestation in palpable reality as *plastic expression*, that is, as an image of three-dimensional, varied forms. But if *we create* an image in order to realize our life, *our own plastic* will depend upon our *conception of life*. If we conceive it as individual, our plastic will be a plastic of form. The artist, however, quickly perceives what appears in nature only as veiled in form: universal plastic expression. How can this be expressed by using limited form? And how to establish an exact image of what we see as veiled and distorted by form; or rather, how to establish an image of what we experience as *alive in living nature*?

Only after long culture of aesthetic plastic *another plastic has been discerned within the plastic of limited form*: closely bound to the plastic of form but entirely opposed to it. After centuries of the culture of form, art today has succeeded *in establishing this plastic in an exact way. It is the clear realization of free rhythm, universal rhythm, which is distorted and concealed in the individual rhythm of form*.

[Free plastic rhythm is the conscious expression of life's rhythm reflected in us. A rhythm established at night by the stars but recognizable as "free rhythm" only after night is past, when the full daylight of the future illuminates us. Art, preceding life, already shows it.

Free, open rhythm has a plastic expression that cannot be the *abstraction of visual forms*, which always remains limited, closed. The expression of purified, more or less abstract visual form is "Purism." To generalize particular vision is an admirable aim. However, this not only leaves morphoplastic expression intact but reinforces it—abstract form is a more absolute expression of natural form. Not even composition opposed to natural appearance can neutralize this expression. Likewise in a compostion of abstract forms, the expression of limited form remains unchanged even when it is broken up by other constructive elements—as in the great Cubist movement. Abstract form (even when it is the plastic expression of a very exact technique) that remains closed and limited becomes rigidly monotonous—especially if, as in Purism, pure color is feared and only somber, mixed colors are used. It is logical to leave this expression in order to seek a freer rhythm, a more living expression. But by employing the curve and using it in the manner of nature, one returns to nature, which one sought to leave behind in the first place. From too cold a painting, one fell into a too frivolous one.

The failure to which all Purism is destined applies equally to a plastic of varied geometric forms. These most generalized forms express limited form even more strongly than natural abstract forms. Geometric forms are the means of expression of mathematics but not of art. Free rhythm is exact and logical like mathematics and *once created* it must be followed just as consciously.

Mathematics, the science dealing with properties of magnitude insofar as they can be calculated or measured, has nothing to do with the creation of free rhythm in art. Possibly, as Vantongerloo holds, in a deep sense, mathematics has a relationship to the expression of free rhythm in art. (This sentence was crossed out by Mondrian in his manuscript.—Editors.) "Mathematics" that uses morphoplastic means such as geometry (therefore limited form) has a natural character in spite of its abstract appearance. But because free rhythm and mathematics both use the straight line as a means of expression, and because both show the same exactness and certainty, it may still be possible to use mathematics after having created the composition, as, for example, Vantongerloo claims.

Because science, like morphoplastic art, is based on natural appearance, it is not a "creation" by man. Until now, in both the visible and the audible, art has been based on forms manifested in space. These were purified, ordered, composed—but nowhere was free rhythm created. Music was based on a plastically established form that produced the tonic scale. Although purified, *this form has a completely naturalistic character*— for it is to be found in other phenomena, for example, as in the rainbow. Hoyack, in his book *Retour a l'univers des anciens*,[1] claims that the astrologer's zodiac is a series of twelve equal intervals, that is, the diapasons of the fixed stars form a kind of chromatic scale.

Modern music, like modern painting, has already tried to free itself from this naturalistic form. But because sound waves, like words, are so closely interconnected, and therefore difficult to control, it has not yet been possible to achieve free rhythm in music. Nevertheless, modern concert music and, above all, jazz reveal splendid efforts toward this realization—which painting has already attained.

Although the rectangular plane is also a geometric form, it does not appear as such in Neo-Plastic: composition annihilates its morphoplastic character. The fact that Neo-Plastic uses only the rectangular plane and not varied geometric forms proves that it has another purpose than to establish form.

Neo-Plastic is as destructive as it is constructive. It is quite wrong to call it "Constructivism."] It is a great mistake to think that Neo-Plastic constructs rectangular planes set side by side—like paving stones. The rectangular plane should be seen rather as the result of a plurality of straight lines in rectangular opposition. In painting the straight line is certainly the most precise and appropriate means to express free rhythm. As expression in space, that is, in architecture and sculpture, the Neo-Plastic means can only be the rectangular plane with "walls" of appropriate thickness. In principle this plane is not based on the prism, although the composition of planes forms prisms. This is a subtle conception. but it is of the greatest importance for the execution of the work.

The path to creation by the new plastic of free universal rhythm was prepared by various art movements, especially Futurism and Cubism, in literature as well as in sculpture and painting. Art had to discard limited form, because the latter cannot express free rhythm exactly. Far from neglecting our individual feeling, far from losing "the human note" in the work of art, Neo-Plastic is on the contrary the union of

individual and universal expression. For free rhythm is composed of these two aspects of life in equivalence.

[The great struggle for every artist has always been to create an equilibrium between individual and universal expression. Since form is individual, how can expression through form achieve exact individual-universal equilibrium? Clearly everything in art depends upon the artist, but he cannot realize the impossible. Art itself shows that expression also depends upon *the character of the plastic means*.]

Art has found the means to achieve exact equilibrium by creating a single plastic means composed of total oppositions. The two oppositions (horizontal and vertical) are in equivalence, that is, they have the same value: a primordial fact for this equilibrium.

By abstraction, art interiorized form until the curved line was reduced to its most profound and strongest expression: the straight line. Through rectangular opposition, the constant relationship, art established universal-individual duality: unity. In Neo-Plastic composition, this constant relationship expresses immutability. It is universal expression in opposition to the *relationship of dimension*, which is variable and constitutes the individual expression in Neo-Plastic work.

The constant relationship is therefore living and real for the mind that tends toward universal-individual equivalence; because the different proportions in the opposed duality of the straight line produce a rhythm always varied by the relationships of dimension yet at the same time constant through its constant relationships. If it succeeds in not establishing form, it is because *this free rhythm is the plastic hidden in the plastic of form. It is created independently of natural appearance through the conscious feeling of the universal equilibrium within us.*

It is the expression of palpable reality on a higher plane: therefore, the expression of a superreality.

It is the expression of the beauty of human life—unchangeable but always moving—detached from trivial pleasures and passing discomforts.

Consistent with the open character of free rhythm, the expression of Neo-Plastic (or Superrealist) work must be light and precise, in contrast to the limited form of palpable reality—which is closed and always more or less confused. This is fully in accord with what life is beginning to show. The dark and heavy expression of the past changes more and more into one that is light, living, moving, and at the same time exact. [Today's mentality is therefore moving toward a life that is optimistic yet serious, manifesting in everything clarity, certainty, precision, equity, straightness, speed associated with stability, and above all, truth.]

Color serves to realize this free rhythm in a more living way, equally purified and opposed by noncolor: white, black, or gray. Color loses its natural appearance because it is defined by the rectangular planes it occupies, inevitably formed by the perpendicular opposition of straight lines. The planes are only *the means: only the relationships themselves are expressed.*

[Through conscious intuition, art gradually discovered the universal plastic means by abstracting the natural appearance of form, without any premeditated intellectual calculation.]

If we dare today to abolish form completely, this is only the consequence of what art has always done. Art not only has always tried to express itself through the plastic means—but has always tried to find the *plastic proper to itself*. The degree to which each era has changed naturalistic plastic depends upon its specific mentality. But one law always governed: the need to deepen natural appearance, but always through the

same means. Always, the attempt was to paint more or less *with planes, with tensed line, with purified color, always the effort was toward a composition of equilibrated opposition.* Always one sought *to establish the purely plastic*—even through form.

But as long as form is used in art, individual expression remains dominant. The expression of changing life reveals itself just as form reveals itself. Because form always tells us something, it is descriptive. But some will object: if the universal expression in a work of art is strong enough, then its descriptive expression—form—is not disturbing. Indeed, the beautiful works of past and present argue for this conclusion. But why, then, use form, which can only weaken pure plastic expression especially if it simply "is not disturbing"?

In any case, everything depends on the epoch in which we live. In the past, form in the plastic was logical. That is why it is not disturbing in masterpieces: on the contrary, it sustains them. But because every manifestation of our time shows the desire to be free of limited form, form becomes an obstacle—also for plastic expression.

Is it tradition, perhaps, and the fact that palpable reality is manifested "as form" that impels us to express and to demand form in art? But above all, there is an inner cause: love of the tragic—love of disequilibrated feeling. This love must exhaust and transform itself—like all individual love. It will be exhausted through its inherent tragic, just as war must exhaust itself. It is only a question of time, of culture: the desire for disequilibrium will remain in us until the broad daylight of human life.

[Art itself shows that the plastic in art (as opposed to the plastic in nature) is *a human conception*: it varies according to the mentality of the time and must satisfy this mentality. Today it must already satisfy our mentality of tomorrow. Art precedes life, and

if our mentality is tending toward equilibrium of equivalent oppositions, then form (which still dominates) cannot endure much longer in today's plastic.

Plastic expression of limited form falls outside pure art. It remains very useful for science and all practical life. Basically, this practical life has very little to do with our true "human" life, which it serves only to realize and to develop. Most men, however, are concerned only with practical life and this too from a materialistic viewpoint. Similarly, one may be compelled to sacrifice truly human life by becoming absorbed with abstractions, art, science, philosophy. Lack of equivalence in life causes separation of the concrete and the abstract. Today we are compelled to sacrifice one for the other. Thus one or the other is neglected and we do not achieve complete life. But what is this life? How to define it clearly? It is nothing and it is everything. More accurately, perhaps, its meaning is to realize unity in everything. But this is quite impossible to describe—precisely because it has no limited form. But "to live" does not depend on ourselves alone! Men have become machines, concerned only with what necessity imposes upon them. Woman—perhaps by nature—is in a better position. She—true woman—still knows the meaning of "living," the quest for "happiness." But she seeks it within the disequilibrium of life. She too always wants to create a limited form—which is precisely what prevents the realization of "life."]

Everything we establish individually is very relative and is often in great error. Unfortunately, it is in our nature to want to establish, to create limited form. This is in absolute opposition to what free rhythm demonstrates. And because this rhythm without limited form can be established only plastically, what it expresses can give us some insight into its real manifestation: truly human life.

To establish anything individually is to offend against truth, against universal expression, because we cannot see all sides of truth and because our "ego" is individual. We can never completely comprehend truth, universal expression: we are moved by it only through the composition of mutually annihilating relationships concealed in individual appearance.

The different religions and philosophical systems clearly show that once they assumed their form, each could establish only one side of truth. Hence the many doctrines and dogmas that seem to contradict each other. The true mystic abstains from establishing any form and expresses universal truth by concentrating only on the free rhythm of life. Parallel to art and social life, contemporary religion and philosophy are moving toward a universal conception by basing themselves solely on what is manifested "through" form.

[Art has demonstrated all this to us. Until the present, life and art sought to create limited form: unconsciously, they were therefore based upon the tragic, whereas the new art and the new life seek to become free of it.]

Pathetic lyricism is the artistic expression of the tragic. It tries to reconcile man with nature: to neutralize the disequilibrium that exists between these two polarities. And it truly does clothe tragic life with strange beauty. But the beauty it creates is fictitious: an illusion. [It does not "realize" beauty.] That is why it will disappear in *the super-reality of the future*. Until now man has lulled himself with pathetic lyricism, which is *fatal for man's evolution*: fatal to the action, to the struggle necessary for equilibrium. From another viewpoint, pathetic lyricism has surfeited man with the tragic: it has sung the tragic until man wants it no longer. Today we can already see the effort to suppress it in artistic representations. Thus, despite everything, art attains its goal: it

impels evolution toward equilibrium.

Pathetic lyricism is manifested in and through limited form; therefore, like limited form it is always more or less descriptive—literary. It is basically naturalistic and is thus opposed to the pure plastic expression of art. Nevertheless, tragic emotion is strong enough to have created masterworks of the past and present and then to have led (by reaction) to almost complete liberation from pathetic lyricism. For this lyricism is only a reflection of the unconscious desire to be free from the oppression of disequilibrium: a profound desire for equilibrium.

[Until Neo-Plastic, all art—even the most modern—expressed itself through a more or less pathetic lyricism. To destroy it, the effort of the vanguard must continue (like Neo-Plasticism) to free art not only from *traditional* pathetic lyricism but from every kind of pathetic lyricism, and through free rhythm to create *a free lyricism*.

This is pure lyricism: the song of universal beauty—of equilibrium. It must be song without words, painting without limited forms. If this is achieved, beauty is not manifested by the meaning of words or by the expression of forms. *Rhythm expresses beauty*. For beauty to be universal, rhythm must be pure, free. With this goal in mind, Neo-Plastic seeks to express beauty *without saying anything* through limited form.

Free lyricism therefore has nothing of the literary. And that is why Neo-Plastic is attacked particularly by writer-poets of pathetic or traditional lyricism. It is fatal for the pure conception of painting for literary artists to interfere and make themselves critics of purely plastic art.

But it is also very difficult for the Neo-Plastic painter to avoid particular expression in his work and to realize free lyricism while trying to express "the human note."

If Neo-Plastic has not lost "the human note," this is precisely why it has not yet

achieved the universal expression that the future will demand. When the artist gives pure color and line their full richness and power, he risks falling into a more or less individual expression—and when he does not, he risks falling into decorative painting. It is, therefore, very difficult to find the proper mean. But intuition that has become conscious has great strength: it uses mind as well as feeling.

In Neo-Plastic, not only technique but also composition can lead to too individual an expression; this risk that endangers all plastic expression is nowhere more clearly shown than in Neo-Plastic.

Beyond personal artistic expression, each "style" emphasizes the special but generalized idea of its epoch. It does this plastically through composition, and especially through the *relationships of dimension*. For example, the idea of elevation is expressed in the Gothic by stressing the vertical dimensions. This is one of many examples that show how tragic expression is often achieved unintentionally: the idea of elevation contradicts the tragic idea expressed (unintentionally) by exaggerated emphasis of the vertical dimension. This shows us that the idea of elevation is only a particular expression. In principle, it is a universal expression, but our conception makes it become individual. To become closer to universal expression, *it is necessary to express all oppositions of relationships in equivalence*. A most difficult task, even for Neo-Plastic.

Tracing the history of art, we can observe with pleasure how particular tragic expression diminishes more and more: how man, supported by the new demands of life, slowly frees himself from the tragic.]

Our palpable environment (architecture, utilitarian objects, etc.) is more easily freed from tragic expression than is art. The work of art demands a stronger plastic expression than material reality, which has its own

plastic functions. This reality is created first by necessity, utility, and function, and then by aesthetic conception. Although today some would suppress the aesthetic, it is nevertheless a necessary guide for every realization. Ideally the two should be joined in order to satisfy both our physical and our spiritual requirements.

It follows from Neo-Plastic principles that the palpable environment in which we "live," and which so greatly influences our mentality, expresses the *conception of equivalence*. In the future, the Neo-Plastic idea will increasingly move from the work of art toward its realization in palpable reality— then it will be more living. But for this, our mentality—at least within a group of individuals—must turn toward a universal conception and free itself from the oppression of nature. What a happy future when we will no longer need the artifices of "picture" or "statue," when we will live in realized art!

If we conceive truly human life as continuous joy through seeking and creating concrete equilibrium, then this life is essential for the Neo-Plasticist. And he regards all of life's abstractions, like science, philosophy, etc., and all abstract creations such as art, *as so many means for achieving this concrete life*. He sees practical life as having the identical goal. Today both the one and the other serve to build and enrich *the true life of mankind*.

Art, being only an artifice as long as beauty is lacking in life, will disappear in the measure that life gains in beauty. But science and technology, on the contrary, will increasingly evolve while remaining indispensible in order to sustain and to create this beauty. Today art is still of the greatest importance—because it demonstrates *plastically, therefore directly and free of our individual conception, the laws that are fundamental to human life!*

Cubism and Neo-Plastic
(1930)

"Cubism and Neo-Plastic" ("Le Cubisme et la Néo-plastique") is from a typescript dated 25 March 1930; one copy was subtitled "Réponse a M. Tériade." The most overtly polemical of Mondrian's essays, it was completed within two weeks of a bitter attack on abstract art in the daily newspaper *L'Intransigeant* (11 March). That piece, "Hygiène artistique"—a title aimed at the supposed aridity of abstract painting—was by E. Tériade, a leading contributor to *Cahiers d'art*, and later connected with the lavishly illustrated *Minotaure* and *Verve*. It was the condensation of an article (one of a series) by Tériade already published in *Cahiers d'art* (January 1930): "Documentaire sur la jeune peinture: III. Conséquences du Cubisme." The *L'Intransigeant* piece coincided with the first number of *Cercle et Carré* (15 March), shortly preceding the group's exhibition in April.

Abstract painting as depicted by Tériade was a sadly misguided attempt to extend the process begun by Cubism: "A work is valid in itself; it can never be perfected by another work. . . . The idea of perfecting a given oeuvre is an academic solution that destroys the uniqueness, the essential and spontaneous qualities of that work. . . . Art cannot take its starting point in an aesthetic created for the purpose. . . . This is calculation, and nothing could be further removed from creation." Unlike the Cubists, "whose sure instinct stopped them well short of the abyss," the proponents of abstraction were advancing into "an arid wilderness where they try to make something out of nothing." Yet in art, Tériade claimed: "one must know when it is time to stop and rest in the creative sleep of patient gestation. But those who march relentlessly forward, their gaze fixed on a remote chimerical goal—they alienate themselves from the gifts, the needs, the warmth of life. They do not sleep: they are dead."

Mondrian's reply was not published until January 1931, when it appeared in *Cahiers d'art*, slightly abbreviated, under the title "De l'art abstrait: réponse de Piet Mondrian." (The omitted passages are here shown in square brackets.) Preceding it was this editorial statement:

On Abstract Art

Faithful to their rule of impartiality, the editors of *Cahiers d'art* have asked leaders of the abstract movement to defend their art against charges that

1. It is excessively cerebral, thus contradictory to true art, which by nature is sensuous and emotive.

2. It substitutes for emotion a more or less clever and refined—but at all times objective—exercise in pure color and geometric design.

3. It has narrowed the possibilities of painting and sculpture to the point where art becomes a mere play of decorative form, suitable at best for posters and advertisements.

4. It has led art into an impasse without possibility for evolution
and growth.

Mondrian's response was followed in successive numbers of the jour-
nal by those of Fernand Léger, Willi Baumeister, Wassily Kandinsky, Hans
Arp, and Alexander Dorner, director of the Landesmuseum, Hannover.

[In *L'Intransigeant* of 11 March, M. Tériade
quite rightly speaks out against empty and
superficial imitations of Cubism. But the
same objection can be made to any
painting—that (as he himself says) it can
turn into "sadly stereotyped, rote formulas
used without individual responsibility." M.
Tériade therefore acknowledges that in Neo-
Plastic, as elsewhere, there are creators and
there are imitators.

Indeed, perhaps no tendency has been
more wrongly applied, more vulgarized in
advertisements, in decoration, in architecture,
etc. . . . And this brings me to what I think
is a failure of understanding in M. Tériade's
view that Neo-Plasticism itself is not true
painting. As he has stated even more clearly
in a later publication, for him it is "sheerly
decorative."]

Neo-Plastic is neither decorative painting
nor geometric painting. It only has that
appearance. To explain this, we must show
how Neo-Plastic arose from Cubism.

It is true that the "work" of the Cubists
cannot be continued, cannot be perfected: it
is perfect in itself. But it is inaccurate to say
that Cubism, *as plastic expression*, cannot be
perfected or continued. On the contrary, the
history of art clearly demonstrates that the
plastic is continuous evolution. This does not
result from calculation: calculation, as has
been said, is "far from creation." Plastic
evolution is produced by *continuous creation*.

In every epoch there are creators and
imitators. But there are the creators of the
species of plastic and the creators of the
genre of the work. While the latter are only
preoccupied with "the work" and only
slightly modify the plastic that has been

created, the former establish the species of
plastic of an epoch. *And this plastic is
continued by other creators of the following
epoch.*

However, until now, even the creators of
species of plastic (excepting those of Neo-
Plastic) have only been able to "modify"
morphoplastic expression. Thus, considered
on the historical scale, works of art show
continuous culture toward pure plastic. This
reveals itself today as a "total renewal" of
the plastic.

By pure plastic we mean the plastic of
relationships alone, expressed by line and
color also alone, that is to say, without any
limited form. The latter always disturbs pure
plastic expression and adds to it a descrip-
tive, literary expression.

As your publication has often main-
tained, "the glory of contemporary painting
is that it has succeeded in detaching itself
from the requirements of literal figuration."
Nevertheless, neither Cubism nor Purism has
brought this detachment to reality. Only
Neo-Plastic has done this. In this way it has
continued both Cubism and Purism, just as
these movements continued the effort of the
preceding periods.

The means of expression and technique
being the essentials of the plastic, Cubism
has been of enormous value, because it
introduced into painting purely plastic ele-
ments and a new technique. Here resides the
true value of Cubism.[a]

The value of the Cubist oeuvre is only

[a] It clearly follows that M. Tériade has noticed only
the appearance of the Cubist oeuvre and not its
function

secondary. The value of each individual's work is only temporary and therefore transitory compared to the value of the work on the scale of plastic evolution.

Plastic expression depends upon the epoch: it is its product. The mentality of each epoch therefore requires a different plastic. This does not mean that the value of each work is lost—otherwise museums would be ridiculous. But clearly we like to surround ourselves with works that correspond to our mentality. However, even within the same period the diverse mentalities vary widely in character. Happily we need not grope in the dark: if we observe the different plastic expressions, they show us their corresponding mentalities. The greater the number of those who create or seek a certain plastic, the more united will be the corresponding mentality.

In our time, more or less naturalistic plastic is in the majority. Next, a more or less abstract morphoplastic: Cubism, Purism, etc. And then, almost unknown, Neo-Plastic reveals itself. It is so little known that it is quite natural that its true content is not perceived.

One must become thoroughly familiar with Neo-Plastic work to know that, like all other painting, it expresses *the rhythm of life*, but in *its most intense and eternal aspect*. The difference between morphoplastic and Neo-Plastic is that the latter represents rhythm *itself*, therefore in an exact way and not, as in morphoplastic, clothed in limited form. The consequence is that the eye is not charmed at first, at least the eye of those who seek the complicated beauty of form. They see only straight lines and rectangular planes. But those who are open to a more interiorized beauty, and who are not blinded or bound by tradition, experience the pure expression of free rhythm without thinking or knowing or understanding. But in this

case we are already beyond morphoplastic.

However, this implies long education, which is achieved in practice by comparing the different tendencies of art; and then by knowing the aesthetic—an entirely new aesthetic founded by the creators of Neo-Plastic after they had created the work—an aesthetic too complex to elaborate here. But it arose uniquely from the Neo-Plastic work created by increasing abstraction of limited form—therefore by continuing the Cubist and Purist effort. This clearly establishes that Neo-Plastic was not born of calculation or philosophic reflection.

It is therefore inaccurate to say that "the imitators want to establish an aesthetic and an oeuvre in the wilderness." In any case, only an aesthetic arising after the work of the creators and resulting from it is effective and can diminish the danger of retreating toward naturalistic plastic or of falling into superficial imitation. Therefore, I do not agree that "all statements about painting are valid only for true painters and otherwise have no purpose."

One can never appreciate enough the splendid effort of Cubism, which broke with the natural appearance of things and partially with limited form. Cubism's determination of space by the exact construction of volumes is prodigious. Thus the foundation was laid upon which there could arise a plastic of *pure relationships*, of *free rhythm*, previously imprisoned by limited form.

If there had been sufficient consciousness of the extent to which limited form is hostile to true plastic and of the extent to which it is individual and tragic, there would have been less risk of falling back into romanticism or classicism, as generally happens to modern movements.

Cubist plastic pushed to its limit, that is how Neo-Plastic finds itself on "the edge of the abyss." This is very true, for all plastic

until the present could be developed, continued toward pure plastic. But once this has been created, one can go no further in art. But will art always be necessary? Is not art only a poor artifice, so long as beauty in life itself is lacking? Beauty realized in life . . . that must be more or less possible in the future, in view of the march of human progress that is to be observed if one's vision is not too superficial. Then it will be quite natural for life itself to cast art into the abyss, toward the edge of which it is already advancing in our time. But it will be a long time before art comes "to its end," and for very long it will continue to reconcile us with the imperfect life that we know. Naturalistic, morphoplastic art is still in full flower; Cubism, Purism, etc., are still only very little appreciated and Neo-Plastic still less. . . . Art is therefore not at its end!

Once "art" is cast into the "abyss," its true content will still exist. Art will be transformed, will be realized, first in our palpable environment, later in society . . . in our whole life, which will then become "truly human."

Neo-Plastic prepares all this. Thus, we see already in our metropolises so many noteworthy efforts but also so many weak realizations originating from more or less Neo-Plastic ideas.

This will probably continue for centuries before a more equilibrated future, therefore real beauty, is born—but what a great work it is for art to prepare this future! The edge of the abyss is therefore not so "barren" as some believe, and the abyss itself does not threaten the true content of art.

Therefore, there is no reason today to "stop and rest." If some are tired, let others take their place . . . just as in life. To "march relentlessly on, intent on some distant and chimerical goal"—that is exactly what we must do. But this goal is not

"chimerical," and in this way we do not become "alienated from life with its gifts, its needs, its warmth." To the contrary, this distant goal is directly related to life today; not only is it clearly drawn in our minds, but it is already realized as art. Neo-Plastic work is deduced from life, from which it is also produced: from continuous life, which is "culture"—evolution.

The Cubist work, perfect in itself, clearly could not be further perfected after its apogee. Two solutions remained: either to retreat to the naturalistic or to continue Cubist plastic toward the abstract, that is to become Neo-Plastic.

Logically the Cubist artists themselves could not take this last step: it would have denied their very nature. Just as they succeeded Cézanne, others had to continue Cubist plastic. And this has been done.

Generally, once the artist finds the plastic expression proper to himself, he does not push it any further—as it was possible to do until the present. But in Neo-Plastic this is no longer possible because Neo-Plastic is the *limit of plastic expression*. The plastic means, that is, straight line and primary color, cannot be further interiorized, and composition will always remain necessary in order to neutralize these means.

Those who try to perfect Neo-Plastic's *plastic* are, therefore, wrong. In Neo-Plastic the question is to perfect *the work*, therefore just the contrary of what occurred in Cubism and in morphoplastic art generally. Although Neo-Plastic remains within its aesthetic limits, Neo-Plastic work can appear in different ways, varied and renewed by the personality of the artist to which it owes its strength.

Because the creation of free rhythm is its content, Neo-Plastic is true painting. For the will and the effort to realize this rhythm despite form has been the content of paint-

ing. We get some idea of what Neo-Plastic understands by free rhythm, which is opposed to natural rhythm, by listening to "American jazz," where it is approximated but not realized—because melody, that is, limited form, is not entirely destroyed.

Neo-Plastic aesthetic gives all the reasons why Neo-Plastic is neither decorative nor geometric. It is sufficient to say here that this is not possible when the Neo-Plastic work is carried to its extreme, that is, when "all" is expressed in and by line and color and when all the relationships in the composition are equilibrated. Then the rectangular planes (formed by the plurality of straight lines in rectangular opposition, which are necessary in order to determine color) are dissolved by their homogeneity and rhythm alone emerges, leaving the planes as "nothing."

If a Neo-Plastic painting results in a cold and decorative expression, the fault is in the artist, not in Neo-Plastic *plastic*. However, the expression of a painting also depends upon the observer. Kandinsky has aptly observed that "cold" can become "hot," so to speak (just as "hot" can seem "cold").

To express free rhythm, *it is necessary* to use means as simple as straight line and primary color. And the *relationship of position*—the rectangular relationship—is indispensable in order to express the immutable in opposition to the variable character of the *relationships of dimension*. This is not to show a lack of "instinct for preservation" (!) or to be "governed by exasperated cerebrality." It is, on the contrary, "to create" a reality that is concrete and living for our senses, although detached from the transitory reality of form. That is why I would prefer to define Neo-Plastic as *Superrealism*, in opposition to Realism and *Surrealism*.

In opposition to the Neo-Plastic use of simple and precise means, M. Tériade has written that "the purist search for the invariant, the general, the absolutely stable, could

succeed only if it employed to this end the most variable means, the least calculated elements, the most humbly particular facts, in short, the moving feeling of life."[1] This contradicts the logical conception of the plastic, which expresses everything by the means that correspond to it and not by contrary means. To express oneself by such contraries is merely an imaginary contrivance.

If it is true, however, that the Purist search was for the invariable, for the absolutely stable, Neo-Plastic does not seek this. Neo-Plastic tries to express the *invariable and the variable at the same time and in equivalence*. Precisely for this reason it must have a universal means. Its search is not for the absolutely stable, which cannot be expressed "plastically," and *it opposes itself to the stable in nature*.

[Although Neo-Plastic originated in Holland during the war, it is not Nordic in character, precisely because it sprang from modern international movements—especially Cubism—through direct or indirect contact by its creators. Their publication, *De Stijl*, became even more international after the war, and some Neo-Plasticists returned or moved to Paris. In fact, all the movements of modern art originated or developed in Paris, that prodigious international center of civilization. The new spirit can be realized only through the shared values of peoples and races.

An old culture gives rise to a powerful tradition that—strange contradiction—is actually opposed to its own creation: the new conception. But a young culture runs the risk of producing superficial work.

The Neo-Plastic movement was also propagated by the periodicals *Vouloir* and *i 10*, and now the magazine *Cercle et Carré*. The Neo-Plastic group, although small, included painters, sculptors, architects, writers; while it has increasingly dispersed, the movement has never ceased, and al-

though it follows differing interpretations, it continues to the present.

Among other reasons, a fear of "looking alike" limits the number of Neo-Plasticists. There first has to be mentality oriented to a more universal conception.

Because it is neither derived from nor determined by ethnic factors, Neo-Plastic is international, universal. Clearly, the French, with their admirable feeling and instinct for equilibrium, are most likely to comprehend its full value as soon as they are released from their marvelous traditions in art and their aesthetic taste is liberated.

Finally, I would like to thank M. Tériade for having defended Cubism—and therefore Neo-Plastic.]

An International Museum of
Contemporary Art
(1931)

"An International Museum of Contemporary Art" ("Un musée contemporain international") is from an unpublished manuscript dated August 1931.

In *Cahiers d'art* of July 1930, Christian Zervos called for the establishment of a museum representing contemporary artists of all tendencies and nationalities living in Paris; there would also be rooms for artists based in other countries.

Le Corbusier's concept for such a building appeared in *Cahiers d'art* for January 1931. It took the form of an expandable spiral—like his 1929 project for a museum of human achievement that would have formed part of the "Mundaneum," an international cultural complex proposed by the Belgian Paul Otlet, near the League of Nations in Geneva.

Discussion of an international museum for modern art advanced further by the summer of 1931: "Through our friend [Sigfried] Giedion you must already know about the conference on a contemporary museum," Mondrian wrote Alfred Roth on 6 August. "A good idea, is it not? I have sent M. Giedion my answer to the proposal." The project was deferred, however, due to the depression. "I did not submit a design (since I am not an architect), but I outlined its organization . . ." (to Roth, 19 November).

Both Mondrian's and Le Corbusier's conceptions are linear, and both stipulate independence from government or academy support.

I would regard a contemporary museum as *truly international*[a] and therefore generally useful only if established in Paris, the center of Western civilization. Everyone visits Paris, everyone could benefit from it. All countries should therefore collaborate in building this "unique" museum. Because the basic problem is "money," funds could be raised through *national committees*, which would remit them to an *international executive and financial committee*. There *should also be an international art committee* to meet periodically in Paris, composed of architects, painters, and sculptors, the leading representatives of the various new tendencies in art. This committee would choose one or more architects to design a modern and practical building for the new museum. The art committee would judge the acceptability of the project, which should make possible the following:

1. The museum should have a permanent exhibition of several examples of the best works by artists of every tendency since naturalism (conventional or Impressionist)—the point from which art decisively began to transform natural vision.

2. The work should be exhibited in a series of galleries arranged successively from naturalism to the most abstract art—Neo-

[a] Although every museum is international, I think it necessary to add and stress that word.

Plastic, which appears as the end of painting. To show that this end is only a beginning, it is essential that

3. This series of galleries be followed by a room in which painting and sculpture will be realized by the interior itself: *dissolved as separate objects and projected directly into life*. Thus, Neo-Plastic architecture and chromoplastic are shown as a unity determining everything in the room, and demonstrating that what is lost for art is gained for life. This room could therefore be designed for use as a lecture room, a restaurant . . . as a bar with an American jazz band.

4. The series of exhibition galleries should be preceded by rooms of various uses (library, music room, reception room, entrance hall, etc.) and of diverse aesthetic conceptions, demonstrating that the evolution of architecture in the broadest sense—the evolution of our entire material environment—*goes hand in hand with the evolution of free art*. In order to observe and study the development of general aesthetic culture, not only in the conception of the interior itself, furniture, etc., but also in *all existing varieties of useful objects and machines*, the best examples of all such utilitarian objects should also be exhibited in photographs. Applied art will be seen as losing itself in the process of life's aesthetic evolution . . . in the process of artistic evolution: in the evolution of free art.

Such a museum will clearly demonstrate the trend of artistic and utilitarian evolution, and therefore *the trend of all human culture*: it will become clear that we are constantly moving further from primitive nature and constantly coming closer to the establishment of truly "human" reality.

The New Art—The New Life:
The Culture of Pure Relationships
(1931)

Mondrian signed the typescript of this, his last "book," in December 1931. It remained unpublished in his lifetime. The title page of the ribbon copy and two carbons left in this estate read

L'ART ET LA VIE
Par
P. MONDRIAN

The first text page was headed

L'ART NOUVEAU—LA VIE NOUVELLE
(La Culture des Rapports Purs)

THE NEW ART—THE NEW LIFE
(The Culture of Pure Relationships)

This is the title used here. Mondrian's letter to Lodewijk van Deyssel of 18 March 1932 makes his intentions clear: "I recently completed a little work in French, 'L'Art nouveau—la vie nouvelle,' the beginning of a series, 'L'Art et la vie.' " Later, however, he revised the title page of one copy to read:

L'ART ET LA VIE
LA CULTURE DE LA FORME ET DE SES RAPPORTS
VERS UNE EQUIVALENCE UNIVERSELLE

Art and Life:
The Culture of Form and of its Relationships
toward Universal Equivalence

Mondrian wrote this work over a period of almost three years, but had meditated the idea over the preceding decade. As early as the summer of 1922, after deploring the *passéisme* of supposedly advanced art, he continued in his letter to Van Doesburg (p. 157 above):

> Meanwhile, I have begun an article "Neo-Plasticism as the Basis of a New Life"; it goes to the center of life. I wanted to postpone it, but I think it is badly needed—and who knows, circumstances may prevent me from doing it later on. . . . I have years of documentation. It was also prompted by a letter from my brother who became a Roman Catholic, in which he says he "no longer appreciates abstract art as he used to." The damned wish for "truth to nature" is expressed everywhere!

Four years later Mondrian informed Oud (22 May 1926) that he planned to write for *i 10* on "Neo-Plasticism in society. . . . Being human is number *one*, and then art (or nonart) arises of itself." The following

year he had as yet no time to work out "the other big article, or series, about Man and Society" (to Oud, 27 August 1927). But by 14 March 1929, he could inform Oud that he was busy with a book in which he distinguished "the old and the new cultures."

On completion at the end of 1931, the typescript and two or three carbon copies were neatly bound and circulated: "a book about society, based on truths found in art. . . . "the little work into which I have compressed all that I believe and hope for" (to Roth, 6 August 1931; 17 February 1932).

Efforts by Mondrian and his friends to find a publisher were unavailing.[1] He concurrently worked on minor revisions and an introduction (p. 277 below). In 1933 he was still "noting down ideas for the completion of my book," but then pivotal advances in his art drew his attention away from writing altogether (to Roth, 26 June 1933). "Some years ago," Mondrian wrote Van Deyssel (26 September 1924), "I promised to send you my book L'Art et la vie," but it fell short of my intention, and in the last years I was extraordinarily absorbed by developments in my painting. The book must wait until I have time." Only in the later thirties did he return to the task of improving "The New Art—The New Life" with its publication still in mind. From London he wrote Holtzman on 6 May 1940:

> Perhaps you remember that I just had made a little book when you were in Paris. There was an economist who wanted to have it published[2] but I found that form not what I want, so I did not accept it. Then the last summer I was in Paris [1938] I began again, but then I went to London and since I did not write. Now I succeeded better I think. I have still to copy it and send it to the [Ben] Nicholsons to ask what they think of it. His wife [Winifred Nicholson] will correct the English and perhaps they know a way to publish it.

No such English translation by Mondrian has come to light.

All contemporary art is generally considered "new art."

But is contemporary art truly new if its manifestation is not definitively different from the art of the past? Moreover, are we aware that the plastic expression of the fine arts, after its long culture, is capable of a mutation that can produce an art of completely different appearance?

Art itself shows that to be new it must realize a positive change in its representation of the essential in art's manifestation; that is, a positive change in the representation of *purely plastic expression*—which does not subsist in figurative representation but is created by *relationships of line and color or of the planes they compose.*

By the fact that it has accomplished this change, art proves that it is not only possible but necessary.

The fine arts reveal that their essential plastic means are only *line, plane surface, and color.* Although in composition these means inevitably produce forms, these forms are far from being the essential plastic means of art. For art, forms exist only as secondary or auxiliary plastic means and not in order to achieve particular form. However, by following the varied forms established by natural appearance, and despite the desire to

represent these forms only for their plastic value, the art of the past established them as individual in character and more or less naturalistic.

In contrast, the new art uses forms in the manner of art (not in the manner of nature): it employs them only for their purely plastic value. It has realized what the art of the past attempted to do. In the new art, *forms become increasingly neutral* in the measure *that they approach the universal*.

Whereas in the new art, line, plane surface, and color are revealed as more or less *free* in the measure that the forms are more or less universal, in the art of the past the plastic means are bound to particular form.

But the new art differs from the art of the past also from the viewpoint of relationships. If purely plastic expression is created by "the relationships" of line, plane surface, and color in their purely plastic values, then these means *exist only through their relationships*. Therefore, relationships are just as important as the plastic means.

In the art of the past, because of the oppression of naturalistic form, *relationships are veiled and confused*; the composition exists only through the varied forms in which it is lost. In the new art, composition is clearly manifested by neutral or universal forms precisely separated.

Relationships are clearly opposed to the plastic means and are realized through them. Thus the new art attains what the art of the past attempted but could not establish.

Although in general the new art is distinguishable from the art of the past only by its clear and equivalent expression of the plastic means and relationships, this difference has great importance for art. It opens the way for art *to establish plastic expression purely*. No longer veiled by natural appearance, it can achieve the expression of real equilibrium.

Although this freeing of purely plastic expression determines the new art, all modern art since Impressionism, by having so frankly transformed natural vision, can claim to be considered new art—had not the art of the past also transformed natural vision.

Although the profound content of art reveals itself identically in the new art and in the art of the past, their expressions are opposed. The art of the past, having matured and become the new art, is no longer recognizable; and the new art finds itself a stranger to that from which it was born. This is the phenomenon of all life.

Because the plastic expression of art springs from these two factors—the plastic means (forms, lines, and colors) and their inherent mutual relationships—we can envisage the evolution of art from two points of view: the viewpoint of plastic means and the viewpoint of relationships.

Thanks to these two viewpoints, we can foresee the mutation of the whole culture of the art of the past into new art. With increasing clarity we see the new form establishing itself.

From the viewpoint of plastic means, we see since the beginnings of culture that art:

1. while cloaking itself in the natural appearance of reality, nevertheless opposes it and somewhat transforms it;

2. increasingly departs from appearance, frees itself, and thus accentuates relationships;

3. frees itself from subject matter and from natural form, thus freeing relationships;

4. by manifesting itself through purified forms, fragments of these forms, and purely constructive elements, frees itself from the oppression of particular form, thus showing relationships;

5. by freeing line and color from particular form, expresses itself through neutral forms, through the universal and unique

plastic means, and thus tends toward or creates equivalent relationships.

From the viewpoint of relationships, art:

1. seeks, despite the natural appearance of reality in which it cloaks itself, to heighten the relationships of line and color, so that natural appearance is neutralized;

2. annihilates natural appearance and particular form through purer and purer relationships;

3. realizes equivalent and exact relationships, so that neutral or universal forms are destroyed and line and color are manifested freely.

By observing this evolution of plastic expression in art, we can clearly determine the new art. Let us place its beginning where *it commences to free itself from naturalistic oppression*, that is, where *the plastic means no longer have the natural appearance of things, and where relationships no longer follow naturalistic composition*.

Through the evolution of plastic expression described above, we recognize evolutionary stages in the new art. In painting, the true mutation, the *new form of art*, can be defined in general terms as *the pure manifestation of line and color by neutral or universal forms in pure and equivalent relationships*.

We distinguish various tendencies in the new painting. First, there is the tendency in which more or less purified form is so decomposed, transformed, or broken that the composition no longer renders natural appearance. This tendency uses particular forms, whole or fragmented, curved or straight lines as well as geometric forms. Of this tendency, the strongest examples are, on the one hand, the works of Picasso and Braque and, on the other, those of Kandinsky and Malevich. Then there is the tendency toward purified forms and a more or less abstract rendering. This is represented, on the one hand, by Léger, Ozenfant, Jeanneret [Le Corbusier] (Purism), and on the other, by Lissitzky, Moholy-Nagy, Vordemberge-Gildewart, and—insofar as they are not figurative—the Futurists (Prampolini). Next we note the tendency created chiefly by Arp: neutral forms on a neutral ground; reduced, abstract forms that are beyond determination and are thus free of particular form. At the same time, there is the tendency expressed by a rhythm of curves or of curved and straight lines rather than abstract forms (Delaunay, Herbin, Valmier, Gleizes). Finally, there is the tendency that seems to express itself only by rectangular planes in color and noncolor, but that fundamentally expresses only equivalent relationships by straight line in rectangular opposition and by primary colors. This unique means (the rectangular plane) annihilates itself as form by the fact that there is no opposition from other forms (Neo-Plastic).

Corresponding tendencies are manifested in sculpture, and we find them equally in architecture.

Through its centuries of culture art thus demonstrates that plastic expression of the relationships of line, plane, and color was manifested at first veiled and confused, and later in an increasingly direct way. Although these two modes of èxpression are merged during their transitional periods, *a mutation definitively separates them*, thus creating an art of the past and a new art.

Having reached this separation, the culture of art also changes its character.

Although basically, in art as in life, there is only a single culture—that of pure relationships, we see in all art two simultaneous cultures that support each other: the culture of plastic means and the culture of relationships. But in the art of the past these two cultures are confounded and their actions are

obscured and veiled so that they appear as a single action: the cultivation of particular form.

Although basically their actions are homogenous, in reality the culture of relationships suffered from the culture of form, which, being particular, dominated it. But as soon as art undertook to establish pure relationships, *the culture of relationships opposed the culture of particular form.* Art needed pure plastic means. It found them in the neutral forms that the culture of particular form had slowly developed.

The culture of particular form thereby neared its end.

The culture of art continued: freed from the oppression of particular forms, *the manifestation of relationships became increasingly prominent.* Because pure plastic means now required that the equivalence of their relationships be expressed exactly and not vaguely as in the past, we can call *the new culture the culture of equivalent relationships.*

By opposing particular form, the culture of equivalent relationships runs counter to the culture of the past. This explains the implacable struggle between the art of the past and the new art—although the former engendered the latter.

Just as the new art is now manifested amid the art of the past prolonged into our time, we see the new life being born within the culture of the past. Art can reveal how this new life is born: while liberating itself from *natural oppression* it frees itself *from the domination of particular form of every kind, and seeks the realization of pure and equivalent relationships.*

In the same way as concrete life, science, philosophy, and religion are progressively broadening themselves and dogmas are relinquished, we tend increasingly toward a clear representation of the universal.

The new conception represents the various truths *as pure relationships* stripped of their limiting disguises; thus they can achieve equivalence of position, so that they can annihilate each other, and "truth" can be experienced directly, without intermediary.

The new life undertakes the same struggle as the new art. In life the two cultures confront each other with the same hostility as in art.

The new mentality asserts itself everywhere and in everything; the new life has begun.

If art is an expression of life and anticipates it, we can state that the new life is *the culture of equivalent relationships.*

Just as with the plastic means in art, it is evident that for this life our mentality must become more or less purified, not in an old-fashioned puritanical way, but so as to rise above the oppression of limiting, particular forms. Thus in the same way as art, life reaches a state of real equilibrium *through pure and equivalent relationships of increasingly free individuals.*

It is logical that the new art should employ the new plastic means in the manner of art, that they should be *brought into equivalence.* For neither the New Plastic means nor the pure relationships are the essential in the plastic expression of art, but rather *the equilibrium that can be realized by these means.* The new culture is not only that of pure relationships but also of neutral form. Because the search for the equivalence of pure relationships *necessitates greater and greater abstraction of form, only universal forms can be composed in real equivalence.* Through this necessity, Neo-Plastic found its universal means of expression: the rectangular plane. Although Neo-Plastic has thus neared the end of the culture of equivalent

relationships, all research through neutral forms is part of this culture, and all such tendencies belong to the new art.

Art demonstrates that the new life is not simply the creation of new forms and new, more just relationships in individual, social, political, and economic areas, but the purification of forms and relationships makes them increasingly capable of establishing an *entirely new organization, which through equivalent relationships destroys any particular interest detrimental to the others.*

In exploring the culture of the fine arts, we see that in the different styles of the past, although subject matter was more or less dominant, each of these styles reveals the truth that it is not the subject that creates the essential expression of the work. These styles show that the *purely plastic manifestation*—line and color alone and the planes they create—constitutes the work of art, and that subject matter and particular form are only secondary means vis-à-vis plastic expression.

Today we see subject and particular form, once of such great importance in the work, rejected not only as being a primitive means of expression, but also as limiting expression.

Until now their use has been prolonged by tradition and necessity—equally by convention and inertia.

The mentality of the past needed these means, originally closely bound to the purely plastic expression. That this state of affairs has endured so long and still continues in our day can be understood only by relating this phenomenon to the whole of human culture, which moves but very slowly toward freedom from primitive conceptions. Or by bearing in mind that intellect often distorts the truth, so that pure intuition, by which humanity evolves, is realized only after centuries.

In the new art, the effort to suppress subject and particular form shows that, for the new mentality with aesthetic sensibility, these are a cause of weakness and obscurity. In contrast, for the mind of the past, purely plastic expression—if not born of these means—was in any case very closely linked to, heightened, and vitalized by them. If we consider the new not as the error of a few but as expression of new life, then art shows us that mankind has changed. If the new art is an error, it is difficult to understand why it agrees with so many new movements in life and not only persists but increasingly spreads.

Nevertheless, those who do not suppress subject and particular form are not wrong either: all art is necessity, and the necessity is not yet equal for all. Moreover, if we speak of an art and a mentality of the past, and of a new art and a *new mentality*, this does not mean that those who love or produce figurative art and cling to the limiting forms of life are all of the past. An individual's mentality can be ahead of his expression. It is quite possible to belong to the new life but not yet to have found its manifestation, or one may realize it in other areas. They will probably achieve exact expression of the new life sooner than those in art who are not convinced of the necessity for exact and neutral means or relationships and employ them superficially. Moreover, many have never learned about plastic content or are not conscious of it. In life every sincere effort leads to human evolution, and it is the same in art. Rightly seen, there remains *a single path of evolution* that, regardless of time, *is identical for life and for art.*

In the evolution of art, if we see purely plastic expression—which is universal—increasingly freeing itself from subject matter, freeing form from its individual limitations,

then we see that mind is *freeing itself from the oppression of the individual and is tending toward the universal.*

This fact that art demonstrates is of great importance for life, because it forms the basis of progress and shows its path.

If we follow the culture of the plastic in art, we see that not only in its origins, but in all figurative art, purely plastic expression is wedded to subject matter. The conscious basis of religious art was belief in the existence of a god or gods. This basis created and determined subject matter, and through this largely the work itself. Secular art based upon concrete life chose other subjects, which produced a quite different kind of beauty. But the subject was always determinate, established, and limited, and the more so as subject came to represent determinate action. We see, then, that in the course of centuries of plastic culture, subject matter was increasingly limited to the simple representation of things in their natural state. Although romanticism long continued to depict the subject in action, realism freed itself from this by representing only bodies, heads, landscapes, still lifes. By concentrating upon the objects themselves, and therefore on their universal aspect, realism was the direct basis and beginning of the new art.

Nevertheless, let us not forget that all the art of the past collaborated in building the new art and that all the different qualities of the art of the past brought it into being.

The phenomenon that art was at first not only closely bound to subject matter, but arose from it, is explained by observing that man by his very nature has an instinctive need not only to create but to establish, to describe, to explain, to express what he sees, feels, and thinks. He wants to create, but his conception of reality remains primitive and too closely tied to his natural instinct. Nevertheless, where intuition is still pure, true art can arise—but in a primitive way—for purely plastic expression is preponderant in the work. We find this in the art of "savages" and of children. The same phenomenon occurs when a superior force influences a more or less primitive period: kings, saints, and initiates have elevated the intuition of peoples. Egyptian, Greek, and primitive art show numerous examples of this.

In a more or less primitive period, as soon as intellect intervenes and veils intuition and man begins to calculate, to compare his work with nature—as soon as one tries to follow natural appearance—pure plastic expression is weakened. The art of the insane also shows how intellect can hamper this expression.

At the beginning of plastic culture, there is a consciousness of particular expression, but universal expression of reality (in art, purely plastic expression) is only intuitively felt and manifested; true creation of art is achieved despite the artist.

But precisely for this reason the work of art can be of the highest order.

Human progress, leading man toward a more conscious state, had inevitably first to bring about *a degeneration of pure plastic expression and a perfecting of natural form.* But in developing man's intuition, this progress equally produced the evolution of purely plastic expression. Thus art finally attained *conscious expression of the purely plastic.*

It should be noted that only primitive intelligence obstructs pure plastic expression: cultivated intelligence produces a superior art. The fine content of the culture of art is to have realized in the work the complete union of intuition and intellect.

If we recognize the progress of art in the progress of concrete life, we clearly see that

the perfecting of every kind of particular form, as well as progress in science and technology, only appears to obstruct moral evolution and the evolution of intuition. We see, on the contrary, that they achieve a new, free form of life that is precisely capable of *realizing* moral life and of transforming man's vague intuition into consciousness.

Although the creation of the essential in plastic expression is always intuitively manifested in art, it is nevertheless logical in our time for this manifestation to be consciously established and controlled. In our time, through practice and through aesthetic analysis, we have come to understand why plastic expression is established in a direct or in a confused way. We have perceived that by following nature one inevitably obtains a more or less vague representation of purely plastic expression, which is realized through a *rhythm of continuous opposition of lines and colors.*

By fixing his attention first on the subject, later upon the various forms, the artist of the past neutralized these through the relationships of value, position, and dimension borrowed from nature. Through these relationships, a composition of forms was established but not manifested independently either of the subject or of the natural appearance of reality.

Although not using means appropriate to purely plastic expression, the artist nevertheless achieved a perfect but imprecise harmony. His task involved a true tour de force, which the art of the past admirably performed.

By using subject matter or even particular form alone, figurative art always shows a descriptive, literary side that veils the purely plastic expression of line, color, and relationships.

Particular representation in any form,

even if it may be generalized and give a vague feeling of the universal, is nevertheless individual expression, opposed to universal expression of the true content of art. That is why the art of the past could not directly manifest this content. But despite its figurative representation, the art of the past has hidden within it the intention of the purely plastic: universal equilibrium is but vaguely shown. To realize it in an increasingly real way, to establish rhythm more and more exactly— this is the content of the culture of the art of the past, which has continued into our time and which gave rise to the new art.

Subject matter—figurative art—arises from particular form; *this form,* even after the suppression of subject matter, by its very character veils the pure manifestation of plastic expression. This form, expressed at the expense of the rhythm of line and color—which directly express the essential of the work—is destroyed in the new art. Century after century, the art of the past proceeded toward this destruction. It prepared a dual task for the new art: *to reveal pure relationships and to transform particular form by reduction.* The goal of this action is to *free the purely plastic means and to realize equivalent relationships.* Nevertheless, we must understand that the plastic means and even pure relationships are not the essential of the work of art. As said above, the work of art is *purely plastic expression* created "by" these means.

What art makes us see and feel by this expression is not easy to define. Through it art expresses beauty, truth, goodness, grandeur, and richness—the universe, man, nature . . . universal equilibrium.

The aesthetic of the past designated the essential expression of art by the word "harmony." Although the content of this word may be universal in the most profound sense of art, the conception of harmony is

expressed differently in each epoch.

The new art reveals that its plastic expression of harmony is entirely different from the harmony of the past; that is, it manifests the same content altogther differently. That is why the new aesthetic speaks of "equilibrium" instead of harmony. Moreover, while the "harmony" of the past expresses a veiled state, the equilibrium of the new art denotes an exact state.

However, even in the new aesthetic, the word equilibrium has caused many misunderstandings and repeated errors. The only way to correct them will be by attentive study of the plastic expression of the new art. It will be seen that the equilibrium in the new art is not a static state without action, as is generally thought but, on the contrary, *a continuous and mutually annihilating opposition of equivalent but unequal elements.*

In our epoch, so full of movement and action, when real or imaginary demands absorb us almost completely, we may ask ourselves whether this essential expression of art is really useful to life. We have only to observe the distress, the disequilibrium of life, the "emptiness" of our epoch, to be convinced that it is still necessary.

Although the art of the past, conceived as beauty apart from life, is no longer desirable, the new art through its new expression is still necessary for us because it impels us *to realize a new beauty in life that is real*, both materially and morally.

Especially the exact expression of the rhythm of equivalent oppositions makes us feel deeply *the value of vital rhythm* and by its exact representation gives us some understanding of the true content of life.

Today, it is not only the fine arts that show the rhythm of basic oppositions; the new music and especially American jazz, as well as modern dancing, also tend to express it

emphatically. The content of our time is to experience the value of concrete, practical life; let us try to perfect it by realizing what is essential in human life; let us try to realize its profound rhythm everywhere.

To understand fully the equilibrium of the new art, we must carefully analyze what the new plastic expression reveals. It shows that neutral or universal forms and their relationships create rhythm through the very character of these forms, exclusively through line and color in their mutual relationships.

This rhythm realizes equilibrium and determines its specific character. How it achieves this is a question almost too subtle to resolve: on the one hand, it is the manner of execution, the use of the plastic means; on the other, it is the nature of these means and of the relationships composing the work.

The rhythm of line and color itself, rhythm free of particular forms, was not represented in a profound and living way by the art of the past. When it established rhythm without subject matter, it generally did so superficially, as ornamentation. But rhythm was still tied to particular forms. However, as in Byzantine art, there are rare exceptions where despite these forms rhythm is so profoundly expressed that the work rises above ornament and becomes true art. That is why, despite the centuries that separate them from the new art, these works are directly linked with it.

Through its neutral or universal forms and pure relationships, the new art established rhythm free from the oppression of form. Because rhythm dominates in all new art, and not neutral or universal forms, its plastic expression through the strength of its pure means (line and color) is stronger than the art of the past—for the new mentality.

Nevertheless, rhythm is revealed in

different ways in the different tendencies of the new art. But unconsciously or consciously, all seek to express *the principal opposition of rhythm*; the two opposed aspects found, for example, in the two directions (height and width) of a work. However, only by approaching *real equivalence of all the oppositions in the work* can we approach exact equilibrium and achieve it with maximum strength.

Among the diverse tendencies of the new art, two seem to oppose each other by the different charater of their rhythm: the tendency expressed through rhythm established by curved or concentric lines, and the tendency that manifests rhythm through straight lines in rectangular opposition. The first produces undulating rhythm, the second, rhythm through cadence. Although concentric curves cannot express contrary oppositions in an exact way, the two tendencies are opposed only through the different means they employ. The tendency using curves establishes neutral forms that lead to the same contrary opposition that the other tendency expresses in an exact way. The two tendencies therefore basically manifest the same intention: *the search for equivalent contrary opposition.*

But some aestheticians deny the value of rhythm expressed through the cadence of straight lines and recognize only undulation as rhythm. They are probably not conscious of the value of the exact expression of contrary opposition. Or is it the influence of the past that followed nature and thus established more or less natural rhythm? In any case they argue that the rhythm of curves is also found in certain masterpieces of the past. From the point of view of aesthetic analysis, acknowledging that the artist can produce art with any means, we can assert that the rhythm of the cadence of straight lines in rectangular opposition is purely aesthetic expression and that the rhythm of undulating curves is more or less naturalistic. In nature, these undulations are manifested, for instance, when a stone is dropped in water or in the cross section of the tree trunk, etc. In contrast, the cadence of straight lines in rectangular opposition has to be created by man. There is no reason to believe that this cadence is more monotonous than undulation; both expressions require *variations of measure.* But the cadence of straight lines is expressed *exactly and equivalently.*

Art's culture demonstrates that in natural appearance equilibrium is not manifested in an exact way because its rhythm is realized *not* by pure plastic means but by particular form.

Clearly, primitive man in his natural physical state lived in harmony with nature and was in harmony with natural rhythm. Consequently he sought to express this in art. However, primitive man must contain in embryo man at his apogee, and therefore contain his rhythm, even though it is more or less hidden. In his evolution toward the "human," man then increasingly opposes natural-physical rhythm. Thus his disequilibrium, interior and exterior. The more man progresses, the more the rhythm deep within him asserts itself and the more his natural-physical rhythm is transformed. Thus a "rhythm of man" is created that is at once physical and mental. The more the two oppositions of this rhythm balance each other, the more man attains a state of equilibrium and becomes integrally human.

It is evident that throughout his evolution man's rhythm is more or less opposed to the natural rhythm outside him—in the measure that he progresses. It is therefore logical that—to the extent he could—man transformed natural appearance and natural life in

order to create outside himself a rhythm corresponding to his own.

This effort is reflected in art and—on its abstract and free ground—helps explain man's imperative need to transform natural appearance and particular form. But it is even more important for man to transform the rhythm of the life of which he is part. It is therefore logical that although man, as he evolves, tries to reduce natural appearance and physically dominated life, he is not always conscious of this necessity.

Many are even opposed to a nonnatural life and environment. But they too are men who evolve. They often regard man's progress only as spiritual. They lack a feeling for the "real" and obviously in this way cannot achieve the *integrally* human state—cannot achieve complete evolution. But life itself advances in spite of all, and the culture of the physical is fulfilled as well as the spiritual.

The physical aspect of man, of life, diminishes in opposition to the spiritual aspect, which becomes stronger.

Art demonstrates this by its *interiorization of natural appearance and its exteriorization of the "human" aspect in the work.* It reveals that during the culture of particular form, the progress of civilization, with all its defects, accomplishes the task of *reducing the oppression of the natural-physical aspect precisely by cultivating the material side of life.* In this context, the problems of alcohol and tobacco take on a different meaning from the ordinary. By *transformation (in the sense of a reduction) of the physical, the physical is re-created in a superior aspect.* Thus accelerated, the rhythm of life and of man will tend toward mutual equivalence.

There is, therefore, no reason to be opposed to the accelerated rhythm of our period; its tempo, faster than that of natural rhythm, is explained by the fact shown by science that every more inward and refined "life" is more rapid in its pulsations.

On the contrary, we must *oppose every limitation by the various forms that oppress the rhythm of life*, because, just as in art, *these limitations cause the disequilibrium of life.* And again, just as in art, the liberated, purified forms must be brought through pure relationships toward *the state of mutual equivalence. This dual action of art is reflected everywhere in life.*

It is therefore of great importance for humanity that art manifest in an exact way the constant but varying rhythm of opposition of the two principal aspects of all life. The rhythm of the straight line in rectangular opposition indicates *the need for equivalence* of these two aspects in life: *the equal value of the material and spiritual, the masculine and feminine, the collective and individual, etc.* Just as the vertical line differs in character from the horizontal, so in life the two aspects have their inherent and opposed character. But just as in art these lines have different dimensions, so individuals and their groups differ in strength or size. *Art demonstrates that life, through equivalence of its opposed aspects—despite their different nature—can approach real equilibrium.*

Just as the rhythm of the cadence of straight lines in rectangular opposition reveals the content of art's rhythm, this simple rhythm clearly reveals the content of the profound rhythm of all existence. It discloses something of the real life deep within man and the essentials of practical life. Real life, which is as simple as this rhythm, cannot be fully realized in man before he reaches the integrally human state: the equivalence of his two aspects.

This real life, being man and life at their apogee, has nothing of the supernatural or the metaphysical about it, but is constrained

by physical oppression and by particular forms, by the limitations of mind and matter. It is the basis of practical life, and therefore of both the life of the past and the new life. By "new life" we mean life insofar as it is free from natural and primitive oppression and insofar as it constitutes pure and equivalent relationships, thus as a superior state of present-day life.

Just as art comes closer and closer to pure expression of its true rhythm, life also comes closer to the realization of its true rhythm. Real life will not always be imaginary; although its true realization lies hidden in the remote future, it is already being realized to some degree in the present. That is why it is important not to lose sight of real life in practical life, through which and in which it is realized.

Art demonstrates that the true realization of real life requires *individual liberty*. The new life will attain this liberty materially and spiritually. Although joined to others by mutual equivalent relationships, the individual will be no less free, because of the equivalence of these relationships.

The new art gives *independent existence* to line and color in that they are *neither oppressed nor deformed by particular form*, but establish their own limitations *appropriate to their nature*. Likewise, in future life society will allow each individual an *independent existence consistent with his own character*.

Art in its end shows that individual liberty— until now an "ideal"—will become reality in the distant future. This requires a stage of evolution in which man will no longer abuse his liberty. Is this why life today does not yet provide it? Could this be why tyranny is permitted?

Because of the inequality among men

today, one suffers because of another. Only development, education, the culture of man, can free us from this suffering; they offer the only solution for achieving individual liberty, because they bring us closer to mutual equality.

If the independence of cultivated individuals can create a superior life, lack of independence in the past and present has retarded mankind's evolution. If we clearly see what underlies almost all the defects in our social and private life, we find that dependence is our downfall. It is not always the weakness, frailty, or wickedness of man that leads him into dishonesty or disasters. On the contrary, *they generally arise from the need to protect his existence.*

Above all, material or spiritual dependence produces the degradation of life, the degeneration of man, and retards human progress.

One of man's worst vices is mutual exploitation. Because we are too weak or powerless to secure our own existence, we seek the help of others. If we replace the values or efforts we have received by equivalent values or efforts, there can be no objection. But generally one abuses others; one profits while others suffer. Mutual exploitation is practiced so cunningly in our society that it is not punished; no one is untouched by it. Yet it is as much a crime as those that are punished; it is really theft. But such protests will do little to change the detestable social situation that permits mutual exploitation. It will be changed only by life itself. The progress of civilization, which often creates this situation, will finally make it impossible.

To guarantee man a materially and spiritually independent life is the most urgent task, at which we must all work.

If the new life frees man, it is only through continuous cultivation of the individ-

ual and his mutual relationships. In this way, the real life basic to man is increasingly realized in concrete life. Because this life is universal, man has the right to aspire to it and the duty to work for its future realization.

As so marvelously portrayed by Adam in the Paradise story, perfect man is entitled to live without care, even without working. In this state, he really breathes, he feels his rhythm at one with the vital rhythm everywhere and in everything. The constant, contrasting, cadenced opposition of this rhythm being equilibrated, he lives in perfect equilibrium.

Life is basically simple. It may grow more and more complex, but it need not lose this simplicity.

Complexity needs to be perfected: simplicity is man's perfect state.

By following the rhythm of the two contrary oppositions of the straight line, we can say that the real life basic to man is simply the action of equilibrated opposition—for example, the double movement of respiration, which is contrary and complementay. It is a pure expression of vital rhythm, that Dr. Jaworsky[3] defines as a dual movement of interiorization and exteriorization, which ancient wisdom spoke of as the action of expansion and compression or limitation. What Dr. Jaworsky says about this is interesting:

> The two movements, interiorization and exteriorization, combine and counterbalance each other without ever becoming confused, and this perpetual rhythm, this intertwining of two contrary currents without confusion, is found everywhere.

Only in fully human man, in man at the apogee of human culture, is this equilibrated rhythm realized at once physically and spiritually. Art, being freer than life, has already manifested it.

Integrally human man is perfect primitive man, but become conscious. Adam, the perfect primitive man, was not conscious of life; how could he have realized it? To become conscious, man needs culture, experience, and knowledge. From birth to death, this is the content of every human life.

To acquire experience and knowledge, man needs total opposition. As shown by the creation of Eve in the Paradise story, primitive man's nature requires not only outside opposition—contrary but homogeneous—but also *the upsetting of his equilibrated state*, which was originally *particular* equilibrium. He thus becomes *conscious of his own duality, of the opposition inherent in his own rhythm.*

In the course of evolution, the reciprocal action of the two oppositions of man's rhythm, after having become disequilibrated, returns to the equivalence of its oppositions and therefore to equilibrated rhythm, thus associating man with universal rhythm.

Art abstracted the contrary opposition of the straight line from particular forms. As the universal representation of these forms, art shows that more or less natural reality still remains "reality" when transformed into its more universal appearance.

However, the real life basic to man has not yet become concrete. Although equilibrated, this real life is realized within us and outside us as disequilibrated. Nevertheless, as the equilibrated rhythm of contrary oppositions in art shows, it does exist; and it is not only the culmination of human life but also the profound content of the life we all live.

When we understand the equivalence of contrary oppositions of art's rhythm, we work more consciously to build truly human life. For least attention is given to establish-

ing equilibrium through *equivalence of the two fundamental oppositions.*

Nevertheless, this equivalence creates individual liberty, frees us from suffering, liberates us from material and spiritual limiting forms.

There is already much concern with purified forms and relationships, but we are not sufficiently aware that there must be research toward the construction of their mutual and real equivalence. We see this in life and in our material environment, especially in modern architecture. The appearance of our material environment has great influence on the mind, and to be seriously concerned with it is neither unproductive nor a luxury. *Only through equivalent relationships can the oppression of particular form be annihilated so that the tragic in life ceases to be reflected in our palpable enviroment.*

In architecture and in our whole palpable environment today, purified forms, tensed or straight lines, pure colors are coming to life everywhere. But they generally are expressed as particular forms.

Or we see the search for more or less equilibrated relationships, but by the use of particular forms. Despite their novel appearance, the particular equilibrium of these works shows that they belong to the past; either they are not "open" because they lack purified forms, or their forms are not *annihilated* by equivalent opposition. Despite all their qualities of technique and construction, and their new materials, these works are depressing to the new mentality, for they take us back to the past.

It is the same in contemporary life. A new mentality is becoming established; the search for stable equilibrium has begun. But universal equilibrium cannot be reached by *personal and mutual nonequivalence.* Because of nonequivalence, the mind remains a closed limiting form, or remains in limiting forms of all kind, in transitory interests. With regard to limiting forms, it is not only conventional forms that constitute obstacles to the new life, but so do most of the new forms arising in political, social, and economic areas. For instance, aristocratic limitations are re-created under democratic forms, and "socialism" often proves synonymous with bourgeoisie. And with regard to equivalence, we can say that modern man, although cultivated and refined, despite his spiritual improvement is not of really new mentality if he fails to seek equivalence.

The new life is nevertheless heralded by our material environment as well as by our private and public life. Purification of form and the search for pure relationships can be seen not only in buildings but in everything modern man creates—utensils, furniture, transportation and communication, window displays, advertising and street lighting, etc.—all give proof that the new culture parallels art. Life itself shows an identical path: the culture of pure relationships will destroy whatever opposes the equivalent relationships that will be created.

Art's effort is already reflected in life. Universal equilibrium is increasingly sought in real life. *It is opposed only by old particular forms cultivated by tradition and by individual and collective self-interest.* Until now, it was possible temporarily to establish an apparent harmony that concealed the suffering of the larger part of humanity; but even the harmony of the art of the past could not be created *in life.* That universal equilibrium is nevertheless being slowly achieved is a fact of bewildering complexity, even harder to show in life than in art. But increasingly we will see the light: art too, has shown its true content only in our time, at the end of its culture of particular form, at the beginning of its culture of equivalent relationships. Art

precedes life, and what we perceive at present is only a prelude to the new life.

Let us observe the course of human culture in the free domain of art: *progress toward real freedom from forms and toward equivalence of their mutual relationships— toward a life of real equilibrium.*

If we see that progress in art is based on freedom from the oppression of forms, we can understand why *progress in life can never lead to the reconstruction of primitive and oppressive forms.*

Despite the fact that progress liberates us, there is today a strong tendency to regress toward primitive life. This is not always the sign of a backward mind or a more or less primitive mentality. Many sincere, cultivated, even learned men, justifiably disgusted with the present state of civilized life, are turning toward a healthier and purer life, hoping to find it in natural life. On the other hand, many "moderns" who are ecstatic about the progress of civilization remain unaware of its true content and unconsciously love it only for the advantages and comforts it offers them.

But the first—who want the fruits of progress immediately—are they not too hasty? Is not good also created by evil? They seem to overlook the content of progress; they lack confidence in life as it manifests itself. And in truth, if we fail to see life's deformations as so many transformations, it is most difficult to say: whatever is, is right.

Whoever expects to see the new life become realized today is plainly mistaken. We must exclude speculative and ideal ideas and try to see things clearly as they are: *to explore reality.* If even now we can discern signs of the new life of the future, we will have the strength to prepare this life. Let those who can discern strive *to cultivate a new mentality capable of realizing equivalent relation-ships, and let them try even now to establish purer and purer mutual and individual relationships.*

Most of us no longer love war. But for many, a truly equilibrated life seems equal to "death." Conservative aesthetic condemns the new art for identical reasons. If the new art does not seem living to those who love figurative art, it is because they do not see the essential expression of the new plastic. And if its abstract means are no obstacle, this is because the essential expression of art has always been communicated through the rhythm of relationships of line and color alone. If this rhythm is represented by "the artist," his work cannot be empty. It is the same with life: if the new life expresses vital rhythm, it cannot resemble death.

Despite all our civilization's defects—and sometimes precisely because of them—the liberating phenomenon in art is also appearing in life. Although still oppressed by forms of every kind, the new life is slowly freeing itself of them. Whoever doubts this, whoever denies that this evolution will not only continue but will result in a higher state, has only to follow the course of art's plastic evolution to its end. Thus he will better understand the somewhat disconcerting appearance today of the progress that increasingly emancipates us from traditional forms and from life's physical and spiritual oppression. Let us observe, for example, the individual and mutual separation of varied forms. It demonstrates that the loss of the life of the past in all its social, economic, and spiritual aspects; the decline of old-fashioned life and its advantages of intimacy of homeland and family; the charm of traditional friendship and love—all this *is no real loss* since it leads to a superior life.

But how beautiful our present life would be if we could realize these high ideals of all

time, such as disinterested love, genuine friendship, true goodness, etc.!

The new mentality rejects these ideals, not because it scorns them, but because it sees that they have degenerated into limiting and false forms.

The mutual separation of particular forms is the beginning of the independent existence of line and color, because thus freed, they lead to the creation of neutral forms (and consequently of free lines) that are above limiting particularities. It is precisely *this separation* that brings to light the limited character of all form, presses toward its liberation, and creates the real unity of the work. This has already been achieved, relatively, through *equivalent composition* with other forms. But the complete freeing of closed form is achieved only through its decomposition, another separating action. Then line and color are free.

Thus, art demonstrates that the mutual separation of individuals leads to individual and social liberty—if, after separation, they compose themselves in *equivalent relationship*. Art also shows that in mankind the different qualities that are confounded in primitive man must be purified and ordered by mutual opposition, that is, by the action of separation. In this way man achieves the equivalent opposition of these qualities: the equilibrium of completely human man.

We all have a tendency to lean on one another. This tendency produces false friendship. But man is born alone and dies alone; he is destined for independent existence. And by its perpetual constraint life itself finally gives us not only the desire but also the strength to be independent.

Nevertheless, social life is based on mutual help. But let us not forget that such help must be *mutually equivalent in order to make the individual independent.*

Although mutual separation is necessary for man's evolution in life as in art, we should not and cannot abandon limiting forms before we have become mature enough to devote ourselves to the culture of equivalent relationships. But then we must abandon limiting forms, because they oppose the actions necessary for individual and collective progress.

Just as traditional aesthetic truths reappear in the new art but are expressed differently, so the new life reveals traditional philosophic ideas and concepts, but practiced differently.

By abolishing first particular form and then purified form and neutral form, the new art has liberated line and color: the essential means of plastic expression. Likewise, after long culture, the true content of man and of life is in the process of freeing itself by abolishing every kind of limiting form. This abolition involves suffering but, being necessary, is inevitable. But it is always accompanied by joy, for abolition also involves creation: new life.

Whether we conceive life as joy or as suffering depends on which is most important to us: abolition or creation.

The beauty and the misery of concrete life consists precisely in the fact that we can escape neither abolition nor creation, thus neither joy nor suffering. Beauty equally contains our desire for release from suffering, for precisely this stimulates us to create and to achieve happiness. That happiness in turn engenders suffering is unimportant. We live through this repetition in the eternal search for happiness.

Abolition and creation constitute transformation—thus the action of both joy and suffering. But in concrete life, just as the actions of abolition and creation are separate, so joy and suffering are experienced

separately. This darkens life, but only because joy and suffering, creation and abolition are in disequilibrated relationship.

Because it is complete unity, real life in its equilibrated opposition is basically neither abolition nor creation; it expresses neither joy nor suffering. As in all equivalent opposition, each destroys the other.

If evil is synonymous with abolition and thus with suffering, and if good is synonymous with creation and thus with joy, then in real life good and evil destroy each other.

But in concrete life good and evil oppose each other. And it is also a characteristic of life's beauty and misery that we can escape neither one. If we are able to achieve what is good for us, our effort to preserve it can eventually turn it into what is evil for us; and conversely, something experienced as evil may later become good. For in pursuing only the good there would be no action, no evolution—no life.

Through its two aspects, the material and the spiritual, the concrete life that we live further complicates the opposition of good and evil. Through these nonequivalent oppositions we not only learn, but by trying to bring these oppositions toward mutual equivalence, we transform ourselves.

In figurative art, the beauty of the whole conceals the limiting effect of particular form. The new art reveals that in this way equilibrium is not realized exactly. Similarly in life, we try to conceal evil as much as possible and thus good also is concealed. By trying to shut out suffering we do not experience the joy of life, and thus we do not try very hard to lessen misery. Precisely because we try to banish from our thoughts the evil that does exist, it takes us by surprise. Almost universally we fail to recognize life's dangers: disease, the seeds of war, etc. This is human weakness. But it is also sickness to fantasize nonexistent evil, to create suffering where there is only joy. The new art shows us how *to see reality clearly as it is and not as we conceive it to be*. Life with its marvelous progress in science and technology is gradually becoming capable of this vision.

But the new art also reveals another thing of the greatest importance: *to show ourselves as we really are*. It reveals that frankness and sincerity are the primordial conditions for the new life.

The new art in its extreme (Neo-Plastic), makes us see that by concealing the exact expression of the principal oppositions of rhythm, we cannot attain its pure manifestation. Likewise the new life demands the recognition and creation of its real implications.

Nothing is more unfortunate for life than the concealment of reality: truth. Since life is truth, life is then concealed. To conceal the true content of life, even of practical life, is to retreat into a particular form, is to become separated from life, to enclose oneself. Oscillating between life and death in the obscurity of existence, we naturally enclose ourselves in groups, in small, more or less homogeneous circles of the same social condition. Through sensitivity or selfishness, it is logical that we try to avoid the clashes and conflicts that abound in life. It is understandable to frequent only one's "friends," to live with "pals," and to be as little as possible concerned with humanity outside our small chosen circle. That is why we enjoy ourselves as much as we can, eating, drinking, feeling, and thinking according to our particular taste and nature. Thus we cling to warmth and avoid cold; we read only what is agreeable to us, sympathetic in thought and feeling. Finally, it is logical that we do not want to concern ourselves with troublesome political or economic situations and problems. All this is very "human," if it derives spontaneously from one's own in-

stinct and intuition for "living." But if it is a calculated attitude intended to conceal the true state of things, then it is ostrich policy.

Let us not forget that this narrow egoism is not the egoism by which we evolve. By enclosing ourselves within the small circle of what is agreeable to us, we unjustly separate ourselves from others, from universal life and all its beauties, which then remain concealed.

But in reality there is danger everywhere, which if not combated leads to ruin.

But like all particular forms, the little circles of our life destroy themselves. And once again life pitilessly thrusts us out of the warmth into the cold.

Disoriented, facing concealed opposition, we feel unhappy. But we "learn" and are forced to fight. From the struggle finally comes victory: a new form of life that is more open.

The progress of civilization is part of concrete life; and therefore with its good and its evil it brings abolition and creation, joy and suffering. And just as these oppositions slowly destroy themselves in the course of time as they approach equivalence, so progress slowly approaches the equivalence of good and evil, thus human equilibrium.

The actions of creation and abolition will become increasingly united, so that more and more we will be able to create by abolishing.

Gradually the long periods of abolition and of creation will diminish; gradually peace and war will become one and will annihilate each other. As we approach *equivalence of the two contrary aspects within us and outside us*, we will gradually be less "lived by" life and become more capable of "living."

The culture of art clearly shows that life is *continuous transformation* in the sense of growth from birth until death. Nothing recurs in the same way, nor remains the same. Thus *life itself is opposed to all conservatism*. Only for a time do the new forms recur in a similar way. Yet, are they actually similar? The fact that they often seem identical sustains the conservative mentality, and causes error.

Certainly, conservative action is present in life but always opposed to creative action, so that each annihilates the other, and progress—growth—continues.

If, in a secular culture, the artist has relentlessly transformed and reduced natural appearance and particular form to *equivalent oppositions of line and color*, then we can see that life is an artist, a goddess who mercilessly *transforms man into superior states and finally frees him from all self-imposed limitation*.

Nevertheless, the artist only follows the course of life, as every man must. By following this course, man—just like the artist—does not reproduce natural appearance, which remains untransformed; rather, he transforms his material and spiritual environment . . . even while protesting against the change.

Man follows the course of life, but generally without seeing it clearly. Only at the end of a culture, by the continuous liberation of successive forms, does the content of that culture become apparent.

The culture of life is far from complete, but in a few works the culture of plastic art is ending. That is why this art can enlighten us.

By following the evolution of the plastic, we see that it is a great mistake to believe—as many do—that the progress of Western civilization is pushing man toward the abyss. In art, the perfecting of form has never destroyed its true nature. Similarly, the

material and spiritual perfecting of life's diverse forms does not cause the ruin of life but of life's primitive expression.

In art, the perfecting of technique was not only necessary for its evolution but was the means for this evolution. In the same way, life demands the perfecting of all technique; everything gains by it: hygiene, science, etc. . . .

The perfecting of science is one of the principal ways by which human progress leads to a more equilibrated state. Who can deny the enormous influence of science and technology on international relationships through progress in the use of steam and electricity? And if some of the things that have evolved—such as poison gas—fill us with horror and terror, human evolution will still result. As others have recently shown, such things will eventually abolish war; the very development of weapons will make it impossible. Thus *through concrete achievements* real equilibrium will be generated.

Every day we witness the marvelous discoveries and growing profundity of medicine. Here we truly see that knowledge creates happiness! Its progress has already done much to diminish the tragic in life, to reestablish the state of equilibrium, that man must lose as he gains other qualities.

The progress of medicine is therefore of utmost importance to mankind. Evidently this progress coincides with man's evolution; but this requires time!

Therefore, it is not the perfecting of science and technics that hampers truly human life but quite the reverse: the fact that they are not sufficiently perfected, and above all, that their organization or application is still imperfect and often terrible.

Life today is made disequilibrated by the wrong use of science and technology. Wonderful things like machinery, means of transportation, etc., employed by the mental-ity that favors private interests at the expense of others—this is what darkens life.

In order to free life—by *destroying or displacing bad organization* by just relationships—we cannot do better than create conditions worthy of man.

In all areas of life, social and economic, we must create new organizations—not in the old way, dominated by other organizations—but as true socialism envisages, *self-governed organizations composed of producers and consumers in equivalent mutual relationships.*

The machine above all is a necessary means for human progress. It can replace man's brute primitive strength, which must be transformed in the course of human evolution.

The creation of the machine itself proves that man has already lost much of his animal force and has therefore sought to replace it. The machine can free man from his state of slavery.

This cannot happen in a single day. But in time the machine can restore man to himself. For man *does not live in order to work; he works in order to "live."*

Obviously due to badly organized methods of production—so common today—the machine enslaves man anew. While we cannot strive too much toward just organization, it must be observed that if life is retarded, man's general evolution is held back; and who knows when he will be ready to be free? But precisely because we do not know, let us try to give him the leisure to educate himself if he is capable of it.

Most probably in the future, when man is further evolved, the machine will be properly used and work will be better organized.

The invention of the machine allows man to

see his brute strength as separate from himself and thus to understand it. This primitive side of man, opposed to him and now external to him, will transform him.

Not just the machine, *but all reality created by man himself transforms him.*

In order to transform man integrally—physically and spiritually—*in order to create a new mentality, everything that life creates contributes and is necessary for it.* In order to become real, spiritual qualities such as precision, exactness, orderliness, etc., as well as faculties such as concentration, thought, reflection, etc., must, so to speak, be physically realized in us.

Just as, if one is to become a good dancer, dance must become "part of one's self."

The progress of western civilization is precisely in order to "realize" concretely. If Occidental culture is more concerned with the material side than the Oriental is, this opposition proves necessary for the complete evolution of humanity, which will slowly achieve equivalence of spiritual and physical culture.

Whereas Western culture—by developing the sense of reality as well as intellect—mainly cultivates the external side of life, the Orient has always extolled the domination of the external by man's inner force. Evidently, the external side of life also evolves in this way; but is the result real enough for the two sides of man's nature to oppose each other in equivalence? And in the Oriental, is not the external side of all existence more or less "neglected"?

In any case, fine theory requires much inner strength and spiritual practice, which, for most in our civilization, is difficult or almost impossible.

In the West only a few minds have been strong enough to realize these great spiritual qualities and thus advance and precede civilization.

Although the Oriental conception—propounded by the highest wisdom of the world and containing the inverse of Western evolution—may be good in principle, it has never achieved realization in concrete life. Art reveals this. The art of the Orient has never realized what the art of the West has achieved: freedom from the oppression of particular form, the creation of neutral forms and pure relationships, and finally, equivalent expression of the two aspects of all existence.

The great truth of the constant and absolute opposition of these two aspects, plastically expressed, remained hidden at first and was later popularized as a limited doctrine of symbols.

The content of Western culture is above all to make man conscious.

Man was not originally conscious of the life deep within him, which we have called "real life" (the essential in man). He was more or less conscious of the concrete side of life—the physical, the sensual, the intellectual. *Therefore, concrete life is our actual human life, and it is logical that we are constrained to give it first attention.*

We must not forget that it is the reciprocal action of concrete life with our most essential being that makes us conscious of this being, therefore of the real life deep within us. And precisely the progress of our civilization, through perpetual change, gives vitality to the concrete life outside of us and presents it as a real opposition, at the same time as a line of conduct. Contrary to this progress, primitive natural life—which always remains the same for us—does not provide the opposition necessary for our evolution.

Whereas life is continuous action, natural life lulls man to sleep.

Because concrete life is real for us, it is logical that the expression of plastic art

becomes more and more "real." In art, however, we must conceive this reality not as a reproduction of the appearance of reality around us but as a reality created by man.

Then we can understand that the expression of art, as it becomes more and more abstract with regard to nature, becomes more and more concrete from the viewpoint of art. It is no longer preoccupied with naturalistic appearance or with the vague feelings that man so avidly cultivates.

It constructs, it composes, it realizes. The expression of art follows life, not nature.

Whereas man's nature inclines him to venture into romantic conceptions, life compels him more and more to concentrate on the reality it creates and constantly deepens.

The new art demonstrates that true life, real life—"our life"—will not always be debased and obscured by the cares of practical life. It demonstrates that the joy of living it engenders does not depend on primitive nature, but to the contrary frees itself in the measure that it departs from nature. All the means already exist for the new life to realize the joy of living.

The sun, often obscured, is now supplemented by all kinds of artificial light. Man has already harnessed the forces of nature for his benefit. Science increasingly stabilizes health. Technology makes the world increasingly habitable—the whole progress of civilization is here: we have only to develop the results and use them justly.

The primitive and natural manifestation of beauty—that marvelous and direct expression of the joy of living, of true life—is already replaced by the consequences of art's culture. Plastic art is now ready to be realized in our palpable environment; the song of the birds is humanized in reality by American jazz.

Then is it logical for man to continue working like a machine, to create without joy of living merely from the need to survive? Does the new art demonstrate in vain that we can free ourselves from limiting forms and from animal instinct?

Let us see what exclusive concentration upon utility and practical life will produce. The future will establish true beauty and true life—and in a new form.

If life and art demonstrate that evolution takes place through the action of creation and abolition, then all the miseries and all the advantages brought by the progress of civilization *are so many necessities for man's evolution.* But we generally see only one or the other of these two actions: thus life is seen either as declining or as unchanging. Creation alone would mean no change, and abolition alone would mean ruin. But those who see both actions as reciprocal understand life *as eternal growth.*

It is nevertheless difficult to see universally as long as one is limited either inwardly or outwardly by a particular form of life. Thus one sees only one side of reality. Each sees another side, and each sees differently; each is therefore relatively right—as in Zola's fable of the white and black cow.

But despite all, in the course of time man's evolution is manifested in two ways: as evolution toward the fully human state and as decadence of the primitive physical state. We can therefore speak of the decline or of the evolution of life.

Indeed, in man and in life we see natural force opposed to human force. And the new art demonstrates that the reciprocal action of this opposition finally produces a superior state. In art, reduction of the natural to the "human" realizes a superior state through the reciprocal action of relationships and pure forms.

The more human progress asserts itself, the

more violently does natural instinct fight against it. For progress involves *diminishing the privileges of the natural state.*

This explains the present hostility to all manifestations of progress and the reactionary efforts in art and in life.

These arise from a narrow conception, from a failure to see clearly. One does not see the improvement progress brings. One is not aware that despite all its defects—which are simply vestiges of man's primitive state—the true content of life not only remains intact but sheds its harmful disguises.

Is it possible that the progress of civilization counts for nothing? Is it possible that life is mistaken?

Man can make transitory errors, can distort progress for a time; for us life itself represents truth.

Nevertheless, many see grave consequences in progress, so that they oppose it in everything and seek the natural life, which they no longer recognize as primitive but regard as ideal.

The unsatisfactory social conditions arising from the progress of Western civilization are seen as permanent or leading to humanity's ruin, rather than as a transitory phase.

It is said, for example, that grain is better harvested by primitive methods than by machines. Is it not that the machines have not yet been sufficiently perfected?

Is not much that we see being created around us only tentative? We cannot grasp everything at once and can understand even less. If today the men or animals who eat the grain are inadequately or improperly nourished, is it certain that this hinders "man's" progress? Life will oblige him to find what is necessary to his real existence.

Because human life must be realized by man himself, we can never strive enough to create what is necessary to "man." Just as in art, the artist can never strive enough to establish purely plastic expression.

Through its harmony of diverse forms, art reveals that despite the poor organization shown by the progress of civilization today, even the inequality among men does not prevent creation of a more or less harmonious organization through which more real equilibrium can gradually be achieved.

If all men were just and honest, all would be well and universal equilibrium would be spontaneously established. If kings were just, a republic would be no better than a monarchy. It would be like the appearance of nature and of art, where perfect forms spontaneously create harmony. But, just as in art we have not thought to transform these forms, precisely because of this acquired harmony, so in life we could remain static because of this natural and particular equilibrium.

In life as in art, we must reckon with reality. Not all men are just. That is why those who are just must try *to elevate the true and the just in man, must strive to create situations favorable to this development, and must attempt to establish a mutual organization that prevents disequilibrium and constrains man to be just in his social relationships.*

By transforming social organization, we transform the individual. Those who attempt to oppose the new order will nevertheless be obliged to follow it. There will be nothing despotic in this constraint. And in a probably distant future, order will be imposed only by *mutual necessity.*

The day will come when the individual will be capable of governing himself. The new art demonstrates all this. In opposition to the art of the past, where particular forms dominate one another, the neutral and universal forms of the new art do not assert

themselves at one another's expense.

But it is evident that we will not reach this state of mutual equivalence until a significant majority achieves a mentality corresponding to this new order.

Although we are still far from this, the age of crowned tyrants is behind us. We live in a republic, in an age of unions and federations—an age in *search of pure and equivalent relationships*. If there is still much tyranny and wrongdoing in life, this is due to the lack of mutual equivalence and to the particular forms that still oppress us.

General concentration upon proper and mutual relationships is the way to solve all the problems of society.

Justifiably disgusted with the misery of concrete life, sincere men have always taken refuge in the action of creation or contemplation in art of mutual relationships of planes, lines, and colors, which, by neutralizing the descriptive properties of forms, establish beauty independently of concrete life. Thus landscapes, still lifes, views of cities—subject matter not tied to the particular life of man and society—are chosen in order to be free from this life and to enjoy the manifestation of pure relationships.

If pure relationships can move us so much in art, why are they so neglected in life? Transitory interests that nevertheless temporarily serve man's evolution are the cause—transitory interests peculiar to concrete life, which we are happy not to find again in art.

Concentration on the mutual relationships of social life will change our conception of life, and thus our efforts. Instead of complaining, for instance, that men of our time are interested only in making money by any means, we must try to create social and economic circumstances that not only prevent them from resorting to unjust means, but will actually impose just means and make

them possible. Because of corrupt conditions, man is often pressed, if not forced, to become exclusively preoccupied with money. Money, that invaluable means of civilization, should be only a "means of exchange" and not assume a *limiting form* that oppresses and debases other forms of life.

Capitalism as cultivated until now is a limiting form that is abolishing itself and will be abolished in the culture of equivalent relationships. Already, today's disequilibrated social and economic conditions show that this form has matured and is about to transform itself. This form, instead of becoming open, so as to make possible an equivalent distribution of values, will probably remain a "form"—as art clearly shows by its transformation of particular form into purified form before its destruction of all limited form. Although a more stable world equilibrium will follow, the new form will still be too dominated by money to allow it to spread equivalently through the world. For the future, Neo-Plastic demonstrates for every area *an organization of equivalent relationships and not a new form*.

Another nonequivalent form of the culture of particular form is commerce. Seen today as one of the causes of economic disaster, it will become *equivalent exchange* in the culture of pure relationships. Especially favorable to equilibrated life will be the *equivalent exchange of material values against spiritual values, and vice versa*.

Every work of art provides us with an example of a more or less mutually equivalent exchange of varied values. Life too is a perpetual exchange: the exchange of material values, or the exchange of material and spiritual values. But life today has degenerated into "big business." Let us at least be good businessmen and not speculators or exploiters.

Society being nothing but an exchange, *social equilibrium depends upon the mutual equivalence of this exchange.*

Until the present, all aspects of life have been confounded. Material and spiritual or moral values are likewise confounded. Moreover, fictitious merits are often added to things offered in exchange to make them seem more valuable or to conceal their shortcomings.

Love and friendship play an important role in mutual nonequivalent exchange. The new art demonstrates that in order to achieve real equivalence the oppositions of a relationship must be pure. To become pure they must first be separated, that is, disengaged from whatever they are confounded with.

When the two aspects of life are confounded, hypocrisy controls and betrays us. This is why it is enormously important for the new art to establish *purified forms and pure relationships*: *they do not conceal, they are real and show themselves for what they are.* Through them it is possible to achieve a more or less equivalent exchange, a more or less stable equilibrium. But the establishment of universal equilibrium *demands strictly equivalent exchange, mutual equality.* Just as in art neutral forms circumscribed by curves must be broken and reconstructed into universal form, so in life the varying appearances of its values must be reduced *to a constant value.* Thus, spiritual values can be in equivalent exchange with material values, and vice versa.

In communal life the question will always arise whether all are capable of contributing equivalent value if they lack the physical or mental power; physically, for example, old people, children, and especially the sick. A just solution must be found, for all human beings are basically equal and all are entitled to an equivalent existence. This is not achieved by charity or love or friendship, for

these qualities cannot create pure relationships. *The essential value of each individual entitles him to an existence equivalent to that of others*; if disabled, he must be supported *in keeping with the value* that he is unable to realize: he is a communal responsibility. This is important not only for those who are incapable of contributing equivalent values, but also for the others who, being assured of a livelihood, will have the strength to cultivate themselves, to live their own lives, that is, to give up their dependence upon limiting forms. The entire community would thus benefit.

Finally, not to mention the patriotism that engenders it, there is a particular form that is most inhuman and dangerous for the new life: militarism. In the culture of the past militarism was needed to maintain the appearance of equilibrium and to guard or strengthen the developing particular forms. But just as in art, as soon as new and neutral forms are created by a new life, they must be maintained by *equivalent mutual relationships*, and all constraints become superfluous, even harmful.

At present, with international relations far from equilibrated, far from pure, and the varied forms—the nations—far from even approaching the "neutral" state of the neutral forms of the new art, the question is raised whether complete disarmament is possible. Obviously, without arms, aggression and mutual oppression would no longer occur. In any case, the success of total disarmament will depend on the equivalence agreed upon by the different states seeking unity; but above all on the positive or negative opposition by old particular forms, by personal and collective interests. Although this intention and all the efforts of the League of Nations prove that the culture of pure relationships has begun, we still have every reason to be afraid.

Why do we not outlaw all arms making and destroy all weapons now existing in our "civilized" society? With weapons outlawed, it would be far less easy for men to kill each other. But in our society so many make their fortunes or live by these barbaric instruments. Again, it is *particular interest* that sustains war. Is it not the task of those who seek equivalent relationships to establish them, and thus oppose this primitive form now cultivated to its ultimate extreme? And should not the science and technology that lend themselves to this infernal culture be guided into paths leading to the world's happiness? But an unarmed civilized world would be defenseless against a noncivilized one that might attack it. So we see again that life itself with all its flaws is wiser than we are and surely has reasons for its slow progress.

It is logical that our time strives toward material and spiritual perfection of the particular forms created by the culture of the past; but let us observe that its essential content requires that we be primarily concerned with the mutual relationships of these varied forms. The content of the culture of the past—the culture of particular form—was to create form and to concentrate on it with little concern for mutual relationships. But the mistake was to believe that equilibrated life could be achieved only by perfecting form itself. Life reveals this mistake and so does the art of the past. Concentration was always on particular form, and by perfecting form it was thought possible to create the work of art. But the artist had already felt the value of relationships and, as we have said, the expression of relationships nevertheless evolved unconsciously, in art as in life.

Thus, concentration on particular form, while it risked remaining in the domain of the individual, had the effect in art of opening particular form to become unified with the whole work, and in life with the whole world.

To become conscious of the necessity for a new social organization, one must study closely what the culture of art demonstrates. The essential content of art, we repeat, involves *destruction of the individual oppression of form* as well as *creation of the universal expression of rhythm*.

We must repeat that the new art is not just the art of the past in a new disguise. It is precisely through such disguises that the art of the past was prolonged century after century, even in our new era. In art as in life it is not sufficiently seen that the new era involves a *new* culture and that the culture of particular form is nearing its end. Despite the fact that the new mentality is established in only a very few, the culture of equivalent relationships is ready to achieve its goal: *the creation of universal equilibrium*.

In life, reorganization must not be limited to individual forms, each for its own sake, but must be extended universally throughout life.

In politics it is not enough to work toward internally equivalent relationships, we must above all achieve equivalent relationships of international order.

In art, Neo-Plastic demonstrates this necessity most exactly. Through intersecting lines, the mutual relationships destroy each plane's separateness so that all unite completely.

The rectangular planes of varying dimensions and colors visibly demonstrate that *internationalism* does not means chaos ruled by monotony but an ordered and clearly divided unity. In Neo-Plastic there are, in fact, very definite boundaries. But these boundaries are not really closed; the straight

lines in rectangular opposition constantly intersect, so that their rhythm continues throughout the whole work. In the same way, in the international order of the future the different countries, while being mutually equivalent, will have their unique and different value. There will be just frontiers, proportionate to the value of each country in relationship to the whole federation. These frontiers will be clearly defined but not "closed"; there will be no customs, no work permits. "Foreigners" will not be viewed as aliens.

Despite its diverse relationships of dimension, Neo-Plastic is based on *the rectangular relationship of position*, which is constant. This suggests that in the future order, despite diverse quantities, there will be constant quality throughout, the basis of complete unity.

Although Neo-Plastic establishes the goal of human culture, this goal points the way for tomorrow. And if the mutual equality that Neo-Plastic manifests cannot be realized in life today, the new art nevertheless shows that pure forms and relationships can be established, and thus a *new organization* that already makes possible a freer and more really unified life.

Consistent with the destruction of particular form in art, in life we already see many limiting conceptions of the past being destroyed.

Religion became a limiting form, as the church, but shows its true content as it progressively frees itself from its trappings in the course of human culture. If art demonstrates that the mutual separation of forms increases their intrinsic value and produces a more perfect union, we can also note with satisfaction the separation of church and state, the separation of religion from learning or philosophy. Liberated and restored to

independence, everything more easily achieves profundity.

All the old limiting forms, like family, country, etc., long cultivated and protected by church and state and still necessary today, are seen by the new mentality, in their conventional sense, as obstacles to truly human life. In their present form they oppose the establishment of pure social relationships and individual liberty.

Even for the new mentality it is difficult to abandon the particular forms from which it arose. But if these forms are recognized as oppressive, this is no sacrifice. Besides, life drives us forward and our free will is not always involved.

Just as art itself has slowly created a new plastic expression of more real equilibrium, life itself will slowly create this equilibrium in a new social and economic organization.

The path that life will take will depend not only on the efforts of the new mentality but also on the kind of resistance by the mentality of the past. But life's course is constrained by necessity, and the new demands press more and more toward universal equilibrium. Necessity creates the progress that carries man forward. While progress (in science, technology, etc.) is too advanced for most men to follow, some misuse it and often all mankind suffers by it. Therefore, experience and education are two imperatives.

The fact that man is increasingly obliged to concentrate on himself for survival, and that life becomes increasingly difficult, can undermine belief in the progress of civilization. But if we recognize that this is imposed by necessity and is caused by the culmination of particular form as it nears its end— therefore as a transitory, external constraint—then it becomes clear that freedom is approaching.

Although for man actual existence, individual and collective, comes first, nothing is more childish than to wish for the impossible. Precisely by trying to force its realization, we miss the goal. To create a really human existence we must have courage, effort, patience. Is this time wasted? Let us not forget that the essential for man is to cultivate his true being as man; transitory existence will come to his aid. By cultivating his true being, he will gain strength and with it the transitory life consistent with this being.

To create this existence for ourselves and for others, will we have the strength, not only to suffer if necessary, but also to create the ruin of our apparent existence, to sacrifice those interests and conditions that favor it?

Art has already done this by destoying particular form, sacrificing its beauty to purely plastic expression.

Even while cultivating our true being—that is to say, real life—we are forced to be selfish. The past concealed this, the new mentality avows it. It sees egoism as justified and necessary for the creation of our own life and that of others. Yet conventional morality would deny all egoism. It cultivates sacrifice: the world benefits and suffers.

Conventional morality, however, is not the pure expression of high universal morality. Just as in the figurative work of art, purely plastic expression is not only confused but distorted, so in life conventional morality is confused and distorted by enclosing itself within its various forms.

Until the present, just as the culture of particular form and the culture of relationships are confounded, so two opposed actions are commingled in conventional morality: concentration on individual forms and union of these forms with the whole. Selfish action and altruistic action are thus imposed simultaneously, but they are made to appear only as altruistic. This morality created by church and state, while basically intended to elevate humanity above its limitations, actually imposed these limitations. It was forgotten that evolution is perpetual and not limited to any given time.

What high universal morality—which is an expression of human evolution—requires is precisely *the same thing that life*—which is equally an expression of this evolution—demands. But conventional morality immediately demands qualities that can be acquired only in the future. This is the great mistake of most spiritual movements, although they spring from the highest principles.

High universal morality missed its goal because of the limited understanding of men, whose very nature must oppose it. This is very logical because high universal morality is not the essential expression of the culture of the past, which is characterized as the culture of particular form. Despite the fact that high universal morality could not be realized, men nevertheless sought to impose it in the form of conventional morality. Thus arose all the hypocritical and corrupt conditions for which life has been the scene. But since everything is necessity—even unrealizable efforts—and since everything results in human evolution, there is nothing to criticize.

High universal morality finds its expression in the apogee of the culture of equivalent relationships. Art in its end demonstrates that only line and color free from all oppression of form can constitute equivalent relationships. Thus in life only the free individual and groups of free individuals can form a mutually equivalent organization and become capable of realizing the content of high universal morality, which prescribes that we live for each and for all.

But art equally reveals that before this end is reached, that is, during the "culture"

of equivalent relationships, high universal morality can nevertheless be expressed in life in a more real way than in the past. For—like the neutral forms freed from their particularities in the new art—individuals freed from their harmful egoism can establish just relationships and thus live for one another.

If the culture of equivalent relationships is already declaring itself, then high universal morality is approaching its realization. It is the fine content of the new life, already discernible.

Nevertheless, at the beginning of the culture of equivalent relationships, high universal morality does not express itself completely. For in view of the widespread oppression of particular forms, its chief task is *to destroy this oppression in order to establish equivalent relationships*. Whereas until now morality has proclaimed the cult of particular form, from now on it will proclaim its destruction, and thus free its real content to become capable of establishing equivalent relationships. In the new era, its action is therefore *to proclaim and to reinforce the culture of equivalent relationships*. Thus it finally achieves realization of the content of high universal morality—the true content of love, friendship, brotherhood, and all their synonyms.

If the culture of particular form creates and cultivates this form and equally destroys it, morality must accord with this double action. *It must accept evil as well as good.*

But the distorted or confused morality of the past could not accept evil and considered it to be abnormal, a disease, a defect of life.

Although our personal acceptance of evil is restricted by our physical limitations and our sensibility, to distinguish the two oppositions in morality can teach us not to ask the impossible of others, that is, not to demand good during the moment of evil. Furthermore, this distinction explains how evil and good destroy each other, precisely because they are oppositions.

Art demonstrates that at the beginning of the culture of particular form, the action of creation and cultivation is dominant, while toward the end the action of abolition apparently becomes all important. If the same is true in life, then the two oppositions of morality must become accentuated in the same way. While good predominates at the beginning of human culture, toward the end evil must be accepted. Toward the end of the culture of particular forms, high universal morality—which basically contains only good—appears to dictate that we must do evil to these forms. But actually, it envisages only the establishment of pure and equivalent relationships, and therefore requires purified forms. Although limited particular forms must abolish themselves, the establishment of these relationships will—as much as possible—realize this abolition.

The new morality therefore demands that we *accept the abolition of oppressive particular forms*; in this sense it is for a time *a morality of evil*. But it is against the mutual abolition of particular forms to the point of their total destruction, because the new culture needs *what is essential in these forms* for its new creation.

The new morality therefore requires that we recognize evil as being basically good. For high universal morality transcends the limitations of time.

Toward the end of the culture of particular form, the morality of evil—although it always existed—then takes precedence over good. Evidently, evil becomes dominant, because particular form is in dissolution at the end of its culture; for concrete

reality does not permit both creation and abolition at the same time. As with high universal morality, this double action is also independent of time. If evil is dominant during this period, this explains the terrible and painful conditions in which we now live. Nevertheless, creation, the other of the two oppositions in human culture, is simultaneously active. Opposition by the morality that corresponds to creative action thus imposes creation at the same time. That is why creative action seems to await the result of the abolition of oppressive particular form: a new form capable of realizing the new action, that is, *the establishment of just, mutual relationships.*

In the measure that limiting particular forms are abolished, the creative action of the new culture is realized, reinforced by a *new morality of good*. It is then that morality can become realized, because only equivalent mutual relationships can realize good for everyone. It is slowly becoming the morality of good, but good in a quite different sense than in the past. *Whereas until the present, good for everyone was imaginary, in the new culture it becomes real.*

If today we live in individual and collective obscurity, we can nevertheless rejoice in the great prospect for humanity and the fine task before us. By helping to abolish the hindrance of particular forms, by establishing pure mutual relationships, we can achieve their future equivalence and thus the future happiness of all. By being in accord with life as it progresses, transitory morality comes closer to expressing life's true content: high universal morality.

It is the beauty of our time that the two oppositions of morality have become clarified, and that we can discern two moralities as two expressions of two cultures. Thus, we can understand morality and apply it.

Because of his need to cultivate himself, man is egoist by nature and has the duty to be so. It is therefore logical that conventional morality opposed egoism in vain. If it did not sacrifice transitory or real existence, in reality it certainly cultivated hypocrisy.

Due to the development of particular form in disequilibrated relationship with other forms of the same kind, the past permitted egoism only to the detriment of others. But today, because the culture of particular form is not yet ended for all and mutual relationships are not yet equilibrated, even justifiable selfishness can still be harmful to others.

Until a certain equality of mentality is attained, justifiable egoism cannot help others directly (in actuality). Neo-Plastic, which expresses this equality, gives each color and noncolor its maximum strength and value; and precisely in this way the other colors and noncolors achieve their own strength and value, so that the composition as a whole benefits directly from the care given to each separate plane. It is the same in morphoplastic, but here—due to lack of mutual equality—the attention paid to one form is often detrimental to the other forms.

In the past one was justifiably egoistic to the detriment of others. Justifiably, one cultivated one's "self" and inevitably often harmed others. The old morality, the defense of others, seemed superfluous. But in reality it was necessary, like all that life engenders. It was an indispensable counterweight, interposed when needed for man's real life. Let us not forget that this life is developed mainly through evolution—through good and evil.

During the culture of particular form, if we understand the goal of morality as the creation, the maintenance, the cultivation of particular form, then it was not wrong

but was the just expression of culture.

But if on the contrary, we imagine its real aim to be improvement of others, we are mistaken. Even now, when the culture of particular form is not yet ended, morality is wrong if it would have us believe that we live for others. In reality we live for ourselves, and *by the fact of our own improvement* we live for the improvement of others.

Because of the need to secure his personal existence, man, egoist by nature, will remain so throughout his evolution. But in the course of evolution, egoism at the expense of others is increasingly transformed into egoism directly benefiting all.

Morality itself is also transformed in the course of human evolution. It is increasingly opposed to conventional morality—in complete accord with human progress. The closer we approach the moment of the maturing of particular form, the more it will be destroyed, and the more will suffering become inevitable. This not only makes today's difficult life bearable but, despite all hardships, gives us certainty that a new life is appoaching.

In a society of unequal mentalities, everything is perforce nonequivalent. Individual qualities or values are in a relationship comprised of hostile or disproportionate contraries. Injustice rules. For the given values are contradictory or nonreciprocal. Thus hate is returned for love.

As long as these hostile oppositions exist, the one annihilates the other.

As long as hatred exists, true love is impossible. Hence the lack of true love, brotherhood, friendship. It is therefore logical that in such a society these fine qualities must inevitably abolish themselves.

By abolishing the natural appearance of form, art demonstrates that life will produce what man vainly strives for or refuses to do in life. By abolishing love, for example, life is realizing its true content in a more exact way.

From the viewpoint of the new morality, which demands justice, none of these human qualities can exist unless they are reciprocal. Given the inequality among men, the new morality cannot therefore demand these qualties before a certain degree of mutual equality is reached. For the time being, it can demand only the establishment of pure relationships and the proper education to create the equality that logically leads to the realization of these qualities. Today's mentality is not capable of realizing them, but it is capable of *observing the logic of justice.*

Mainly because of the harshness of life today, little kindness remains. Should we try to re-create it where intellect and circumstances exclude it? Should we turn against the progress of civilization and oppose its consequences? We must allow life to deepen intellect, to transform social conditions, so that we can regain true feeling and true kindness. Let us try to become homogeneous with evolving life.

Every day we are astonished by the complete absence of true love, friendship, brotherhood, kindness. Centuries and centuries ago the great message of universal love was proclaimed: although its influence is undeniable, man has not changed.

Therefore, let us not insist upon what has shown itself as unrealizable. Art demonstrates that *life impels humanity toward equivalence of its two opposed aspects and thus toward the destruction of individual limitations.* This is how life can realize the high ideals proclaimed so long ago.

Because we are surrounded by all kinds of limiting forms, dying and decomposing, we can hardly discern the new era, which is nevertheless visible in an action that has not yet been realized, only because of its temporary oppression by these forms.

As the new life approaches, a new morality is clearly being established, clearly founded on the new culture revealed by life and by art. During the culture of equivalent relationships, it will be based on the apogee of this culture, that is, on the realization of *equivalent mutual relationships* that the new life will attain.

The new morality is that of *social life* in contrast to the morality of the past, which strove toward the same goal but in reality fostered only particular life, individual or collective. While the morality of the past was sustained by church and state, the new morality is sustained by society. Its content, conceived abstractly, is *universal international justice*. For while the old morality, despite its essential content, in reality sustained the different particular forms—each at the expense of the others—the new morality is capable of realizing the equivalent relationship of the civilized world.

That a new life is arising is confirmed by the fact that life today shows this often terrifying opposition to the old culture and its morality. Because man still retains much of the crude and the animal in him, excesses and even crimes occur. Instead of trying to justify them, let us emphasize the establishment of pure relationships and purified forms, which will keep these vestiges of man's primitive state to a minimum, so that the new life can develop without terrible upheavals. But the exigencies of present-day life and the different situations it creates also increasingly destroy the morality of the past. Spiritual qualities such as kindness, disinterested love,

friendship, charity, etc., become increasingly difficult to practice in life today. The individual, increasingly concerned with material cares, has no strength to spare; but it is no longer defensible for one man to profit at another's expense simply because of their inequality.

If the fact that man is increasingly compelled to maintain and protect his own life seems to contradict evolution or to deny the progress of civilization, let us not forget that we are at the end of the culture of particular form and must therefore feel the effect of the dissolution of the forms of the past. Previously the individual was sustained by these forms, but now that they are endangered, they can no longer sustain him and he too is endangered. But in this way he rediscovers his "self," and, depending upon his strength, he will sooner or later achieve his own freedom through the establishment of free forms. The imperative necessity is upon him: man must create.

Although the new morality and reason can guide us, and art can lead the way, let us emphasize that, in art as in life, "realization" is foremost and that the new life is created by qualities that might seem simple and insignificant but have the highest value. The new art demonstrates that its values of exactness and purity of execution can exist in life.

Although all works of art are realized through exactness and purity of execution, in the new art these qualities are not only developed to their limit but are conceived quite differently than in the art of the past. In the art of the past, despite all its precision, everything is confounded. In the new art, on the contrary, everything is shown clearly: neutral forms, planes, lines, colors, relationships. Through its exactness and

precision of execution, the new art establishes in a real way the mutual equivalence of the composition: equilibrium.

Thus art shows life the truth that new forms and mutual relationships have real value only when they are realized exactly and precisely.

Exactness is one of the most urgently needed means for realizing the new life. In many manifestations of modern life we can already see that precision and exactness are increasingly sought, imposed by necessity. For example, the traffic in our great cities; the Place de l'Opéra in Paris gives a better image of the new life than many theories. Its rhythm of opposition, twice repeated in its two directions, realizes a living equilibrium through the exactness of its execution. In life, spiritual qualities are not enough; they have to be realized.

The whole progress of civilization (actual life) is moving unconsciously and often falsely toward the new life. By clinging to the spirit of the past and by concentrating on varied forms, we have not yet become conscious that in this way we inevitably create unjust relationships. Disequilibrium results. But at the same time we can rejoice to see that even in the field of politics there is sincere concentration on mutual relationships that can destroy harmful limiting forms and their pernicious consequences.

Until now sustained by tradition, by state and church, and by most family, social, and religious institutions, these primitive forms are slowly perfecting themselves, changing their appearance. To maintain the contrary and to believe—as is so often done—that today's new conditions are degenerate forms of the past, is to reverse the course of progress, is not to see the content of life, which,

despite everything, art and concrete life reveal as *liberation from the particular and union with the universal.*

Nevertheless, the new mentality—free from the oppression of particular form and therefore capable of striving toward the realization of equivalent relationships—is now a small minority. But, as mentioned earlier, this minority is supported by the unconscious action of a much greater number. Together we are moving toward the construction of pure relationships leading to the realization of equivalent relationships. In fact, we are all reaching toward the abolition of limiting forms, toward the progress of mankind.

All are moving counter to the culture of the past, the culture of particular form; and all are already in the culture of the new era, the culture of equivalent relationships.

This truth, which art demonstrates plastically and therefore visibly, is of great importance in order to understand the complex course of civilization's progress, in order to accept evil as well as good in life and not become lost in pessimistic criticism of the life that causes so much suffering.

But let us note that art—even on an abstract level—has never been confined to "idea"; art has always been the "realized" expression of equilibrium.

Although ideas may be at the basis of everything in us, and humanitarian principles have enormous power, the main problem is *the realization of happiness in life.*

While ideas are strong at the beginning of a culture, toward its end they not only become outworn, but they also demand to be realized. At the beginning of the culture of art, equilibrium was still more or less veiled by individual conceptions. Toward its end, art has established it—relatively—*really.* With this potentiality before us, why should we despair about life?

Much that pertains to the new organization pointed to by the new art would seem to be in process of realization more directly in Russia[4] than in other countries. But each country has its unique characteristics and needs, and what is possible or desirable for one country is not always so for another.

Nevertheless, the great line of evolution is universal and is the same for each country. In general terms, we can say that if the new organization of a country is too advanced for the individual to follow, or if the inequality of individuals opposes it for a while, life will provide the just solution, will point out the road to be taken.

If we look carefully we see that analogous phenomena are evident in all civilized countries. But their evolution is generally slow; its manifestations are veiled in traditional forms and are more complex than in Russia. Is their evolution less advanced? Life will show us: *life is truth*.

Introduction to
"The New Art—The New Life"
(1932)

Some six months after completing "The New Art—The New Life," Mondrian supplemented it with this introduction, a French manuscript dated June 1932. He wrote to his friend, the architect-planner Cornelis van Eesteren:

> I have added an introduction to my little book, for people do not understand why a painter should concern himself with the laws of life; they do not see that the laws of life are perhaps most clearly realized in art. These are vague in the art of the past, but in modern art and especially my own work they are clearly shown. . . . I have built everything upon observation, but observation implies an entire culture, and it is painting that is so well suited to show equilibrium and happiness. . . .[1]

In a time such as ours, when social, political, and economic conditions demand efforts based on reality, it is logical that there is no general understanding of the enormous influence that art exerts or might exert upon practical life. Because of its conventional character or from ignorance of its true content, art has always been regarded as a search for ideal or decorative beauty; but there is a failure to see how it can point the way toward equilibrium in social, political, and economic relationships, and how it can create real and concrete beauty in practical life. Today necessity compels us to seek world equilibrium, but do we believe that there is need for real beauty in life? Is not beauty the most perfect expression of equilibrium?

It is true that the new exigencies, the harshness of modern life, appear to suppress the search for beauty. But in art as in life— do not these very factors purify beauty, strip it of its idyllic and lyrical character, and clearly display its real value?

It is true that beauty and art in the conventional sense are not directly useful in the everyday life of our present society. Rather than being concerned with art, we are now justifiably concerned with utility. For life is compelling and necessity is a fact. If our actions and intentions were pure, we would easily achieve equilibrium in our search for the useful, because what is really useful is equilibrated. But facts demonstrate that we continually make the mistakes that create disequilibrium. And how can we tell what is really and universally useful? Indeed, equilibrated life demands the *useful for everyone*. This often seems opposed to individual usefulness and is why universal utility and universal equilibrium are not sought. Consequently the world suffers. We are not yet conscious of the inutility of the art of the past, and we do not realize that purified beauty and purified art are imperative needs for the civilized world.

It is therefore of the greatest importance that we understand this, that we conceive

beauty and art completely differently than we did in the past: that we understand that art, the culture of beauty, not only followed human progress but anticipated it; that it has already achieved the creation of pure beauty, which can directly enter our palpable environment, not as decoration but as a *new architecture* that does not exclude color but includes all the plastic arts. But it is even more important to know that the new art at its apogee can influence practical life through individual works and through the re-creation of our environment; that this pure art *complements society* not as propaganda or as applied art but *by its plastic expression alone*. To understand this it is necessary to know what this pure art involves, to know that it is a *genuine and living expression of universal equilibrium*.

Art has always sought to establish universal equilibrium. But in reality the art of the past, by using particular form, created instead an individual equilibrium that the new art destroys because of its opposition to universal equilibrium. Out of chaos, universal equilibrium has arisen.

It is the same in life, which slowly follows the course of art. As "man," as "individual," man seeks individual equilibrium despite his vague consciousness of the need to achieve universal equilibrium—this is his work. In this way he not only sustains himself, develops, and fulfills himself but also destroys himself. He must destroy himself: universal equilibrium demands it because it opposes individual equilibrium.

The fact must be emphasized that for art and for life it is a matter of *universal* equilibrium and not of individual equilibrium. The latter is symbolized by the empty scales. This antiquated symbol of justice causes error and perpetuates the doctrine of retaliation that fosters vengeance. The search for particular equilibrium (personal interest)

thrives on hate, produces death. Thus we see in politics and everywhere else, even among those seeking equilibrium, the concealed or open hatred that creates disequilibrium. But universal equilibrium is completely different: in art it does not know symmetry, in life it does not seek sameness but only *mutual equivalence*; it knows only love and creates unity.

Through ignorance, through false egoism, man is hostile to universal equilibrium because he does not understand that it includes every true individual interest. We have not succeeded in building world equilibrium, despite the evident efforts which have only been attempts to establish particular equilibrium. The League of Nations is proof of this. The culture of art demonstrates that only *man's development* in the distant future can create universal equilibrium through the *establishment of equivalent relationships*. These relationships are already realized in pure art—art free from figuration and all limiting form—expressing the beauty of equivalent relationships exclusively through pure line and color. This art is an image of the ideal human goal toward which humanity is moving.

For those who follow art in life, life can only continue its own way, but somewhat more enlightened by art. Having sprung and always springing from life, art cannot be a dogmatic model showing the course of life from the height of its abstraction. Pure art is only the image of contemporary life, but extended and increasingly purified, so that today, at the end of plastic culture, this image can demonstrate the underlying structure of life.

Certainly science also increasingly demonstrates the laws of existence, but it differs from art in that it cannot study what is manifested plastically in a determinate way; it has to penetrate into matter, therefore, the invisible.

Art remains in the light and deals only with what is revealed as "image."

But simple observation of nature is insufficient. It does not show us everything together or at the same time. Thus we are bound by place and time. To perceive the great line of life that is "evolution," we must compare all that has been learned during the culture of the plastic and discern its apogee; this is possible only in art, which has now reached the end of its culture. For proof, we need only observe the fact that, as pure plastic ends, it achieves the maximum of expression with the minimum of means. The scale of plastic evolution being complete, we can clearly see *the way toward exact expression of universal equilibrium.*

Through visual observation, art has unveiled the laws of existence: the laws of universal equilibrium. Art has discovered the principal *law of equivalence of oppositions* and has progressively brought to light its implications and requirements. In its centuries of culture, art has revealed that the realization of this law, although different in each epoch, *is manifested more and more exactly in the measure that man develops and becomes more conscious.* It is therefore clear that although the law of equivalence always remains intact, *each epoch has its different subsidiary plastic laws.* Art shows that the new conditions of life are not created by chance and are not wrong, but are ruled by fixed laws and are therefore necessities, the consequences of the changed relationships of man and his environment. The culture of art demonstrates to us that all these modifications in the realization of the law of equivalence serve finally to achieve its pure realization, the construction of "equivalent relationships."

Thus art shows us that there is no absolute truth but that there are nevertheless *immutable truths for each stage of human evolution: fixed laws that determine life.*

Although "life," existence—truth—are hidden from us, the law of equivalence is increasingly revealed. By progressively revealing the principal law, by constantly discovering the subsidiary laws of each new appearance, man increasingly approaches truth. This progress is *the culture of equivalent relationships.* For as art shows, there is progress in *the manifestation of equivalence.* Whereas the art of the past had a veiled and confused equivalence, the new art finally shows exact and pure equivalence. If, as we have said, art has always sought to establish universal equilibrium, which is created according to the law of mutual equivalence, then all art sought to express equivalence. We emphasize this because only the law of equivalence leads directly to universal equilibrium in life as well as in art.

Let us therefore not look for equality, liberty, or fraternity: let us look for equivalence in everything. Equivalence creates these ideals that, instead of remaining only ideals, will be realized through it in the future.

In art, as in life, equivalence is created *through relationships and through the means (objects, images).* Through them we become conscious of space and time. Consistent with his changing mentality, *man creates or transforms the means and their relationships,* and each new spatial appearance becomes the basis of the following appearance. Thus, reciprocally, the relationships and the means create the mentality.

It would therefore be impossible to understand why the culture of relationships is neglected—even in our own time—if it were not so clear that it is suppressed by the false egoistic use of the means. We tend to forget that relationships perfect the means and that the proper means demand homogeneous relationships. We forget this in politics and in economic and social life. Is it also forgotten in science? Does not the secret of medicine and chemistry lie in the precise equiva-

lence of relationships as well as in the means used or created?

All the tendencies of the new art—the consequence of the art of the past—have unconsciously led to pure plastic, that is, to the exact realization of universal equilibrium. Having heightened the content of life, in the free field of art the new tendencies can continue the culture (progress) of life and thereby anticipate it. And if one wonders whether it is wrong to posit pure art as the idealized image of life, we need only ask whether universal equilibrium is not the ideal of practical and concrete life. What do we seek in politics, in economic and social life, if not to establish equilibrium? But whereas life demands and seeks to produce universal equilibrium, which is vital and always creative, man naturally tends toward individual equilibrium, which is static and therefore mortal. If he becomes aware of this, he tends to reject all equilibrium, because universal equilibrium is alien to him. Thus he seeks life in the disequilibrium of transitory events. Fortunately, even if we confine ourselves within diverse and limiting forms—which obviously oppose each other in disequilibrium and therefore impede universal equilibrium—life itself frees us. Life shows the paths toward equilibrium, but due to the bewildering complexity of practical life, they become difficult to discern. We know very little about life, and much of it remains completely obscure to us; we clearly cannot impose dogmas and we cannot foresee or direct the course of events. We must always follow life, but let us try to follow "life" and not its events.

Until now the search for universal equilibrium has been neglected in favor of individual interests. Art demonstrates that, as long as these dominate, world equilibrium cannot exist. To achieve universal equilibrium, the new art had to sacrifice the beauty of limiting and particular form in order to establish equivalent relationships through their universal aspect of color and line.

Let us therefore free ourselves from the false conception of beauty and of art, and let us not look upon beauty or art as mere "amenity" but as the most vital expression of universal equilibrium. And while we examine beauty in the culture of art, let us move toward what it has finally revealed; thus, we will have a solid basis for practical life. And if it is true that the culture of beauty and the search for utility in life itself can in time help us to find world equilibrium, why choose the road of error and obscurity rather than follow the proven one?

Let those of our time, the men of action who insist upon immediate results, who are so strongly oriented to concrete realization, who are so hostile to so-called abstract art, let them understand through this art that the realization of anything depends *upon the means employed, and that only with pure means* can universal equilibrium be established. This is not recognized because, in life as in art, beauty is created by every means. Thus, one may be satisfied with vague beauty and illusory equilibrium. But life is not satisfied, and it constantly destroys these until "beauty," therefore universal equilibrium, is actually realized. This is the progress of humanity toward consciousness.

[Three Statements for *Abstraction-Création*] (1932–34)

Founded in 1931, Abstraction-Création was an international *salon* that presented a broad spectrum of the different abstract tendencies. By 1935 the association counted 416 members. Mondrian exhibited with it, and wrote three short statements for the yearbooks.

At its inception he thought of Abstraction-Création as filling the role of the short-lived Cercle et Carré, although he considered it overinclusive (as he did to some degree the earlier organization): "All the same," he wrote Alfred Roth on 6 August 1931, "the Création-Abstraction [*sic*] movement strikes me as rather contrived."

Mondrian's statements for the yearbooks (which were edited successively by Jean Hélion [1932], Auguste Herbin [1933], and Georges Vantongerloo [1934]) became increasingly brief. He did not contribute to the 1935 and 1936 annuals.

Neo-Plastic

All painting—that of the past as well as the new painting—shows that its essential plastic means are exclusively line and color.

Although these means, in composition, inevitably produce forms, forms are not the essential plastic means of art. For art, these forms exist only as secondary or auxiliary means of expression and not as a means to achieve particular form. Although the art of the past expressed itself through particular form, it transformed the latter's appearance as: "visual reality" by representing it in a more universal way.

The art of the past increased the tension of line and the purity of color, and sought to transform natural plastic into plane. As it approached its end, it tried to free line and color from natural appearance.

The new art continued and concluded the culture of the art of the past so that the new painting—by employing "neutral" or universal forms—expresses itself solely through relationships of line and color.

Whereas in the art of the past these relationships are veiled by particular form, in the new art, through neutral or universal forms, they are shown clearly.

Because forms are more or less neutral in the measure that they approach the universal state, Neo-Plastic uses only a unique neutral form: the rectangular plane in varied dimensions.

Because this form, in composition, is completely annihilated by the absence of varied forms, line and color are completely freed.

Through the exclusive use of the straight line in rectangular opposition, Neo-Plastic achieves the creation of exact relationships and "mutually opposes" them in an equivalent way: to establish an equilibrated rhythm and through it attain real equilibrium.

[Artistic Efficacy]

The artistic efficacy of a work is determined not only by its artistic value but also by the character of its figurative representation: subject matter, natural or abstract forms.

Although artistic value is identical in every work of art, eternal and independent of figurative representation, representation is nevertheless significant enough to completely determine the expression of this value. Because it is always changing, figurative representation continually transforms purely artistic expression: in the course of time, artistic initiative continually uses or creates different forms.

Two values must be distinguished in this reciprocal action: artistic value and the value of the means of expression.

It is therefore clear that for the modern mentality, work that has a mechanical or technical appearance has greater artistic efficacy, due to its more abstract figurative representation—that is, due to its more precise form and the absence of classical or romantic lyricism, etc. Nevertheless, its artistic value determines the extent to which this new "figuration" is annihilated and transformed into a work of art.

[Reply to a Question]

What do I want to express in my work? Nothing other than what every artist seeks: to express harmony through the equivalence of relationships of lines, colors, and planes. But only in the clearest and strongest way.

The True Value of Oppositions
in Life and Art (1934)

"La Vraie Valeur des oppositions dans la vie et dans l'art," dated December 1934 on a French manuscript, was written at a time of economic and political crisis—the deepening depression, the Nazis' seizure of power, the failure of disarmament conferences. Mondrian nevertheless persisted in his optimistic vision.

Mondrian originally intended "The True Value of Oppositions" for "a new little English review" (letter to Alfred Roth, 28 December 1934)—in all likelihood *Axis: A Quarterly Review of Contemporary Abstract Painting and Sculpture* (London, 1935–37), edited by Myfanwy Evans; it never appeared there, however, presumably because of the editor's reservations. A couple of years later, writing to Winifred Nicholson (5 November 1936) apropos his new essay "Plastic Art and Pure Plastic Art," Mondrian expressed the hope that the translation would "be as good as the one you did last year, despite Miss Evans' remarks! Some months ago I asked that it be returned to me, and I now have it." An English version of "The True Value of Oppositions" in Mondrian's estate, typed on paper with an English watermark and with corrections by Mondrian, is almost certainly the translation made by Mrs. Nicholson.

"The True Value of Oppositions" first appeared (in Dutch translation) shortly after the outbreak of the second World War, in *Kroniek van hedendaagse kunst en kultuur* 5, no. 3 (15 December 1939).

Good and evil—the two principal oppositions of life—all the world knows them, all the world suffers or is happy because of the one or the other. But not everyone realizes the true value of this opposition, and in general we do not even see their necessity: we demand good, and avoid evil as much as possible.

Intuitively, man wants the good: unity, equilibrium—especially for himself. Thus he falls back into the search for false ease and static equilibrium, which is inevitably opposed to the dynamic equilibrium of true life. He satisfies himself with false unity and in seeking it rejects the duality of oppositions, which, while difficult to perceive, is nevertheless very real to us.

It is evident that until the present man generally has felt the profound unity of true life, but living in this disequilibrated world he does not accept the two oppositions simultaneously: he does not live life as a whole so that the duality can be resolved. For such a life we need a more perfect reality, further development—longer culture. That is why we are satisfied with apparent unity and continually confine ourselves within all kinds of particular forms. Living among nonequivalent oppositions and being himself a complex of these oppositions, man

has no certainty that real harmony is possible in life. It is quite natural that he seeks only "the best" among the oppositions that life offers, and this is what he experiences as unity. However, life shows us that its beauty resides in the fact that precisely these inevitably disequilibrated oppositions compel us to seek equivalent oppositions: these alone can create real unity, which until now has been realized only in thought and in art. Thus it is in reality. But also on the moral plane, the opposition of ideas and conceptions brings us closer to truth: unification, the annihilation of opposites.

When he creates apparent unities, man is trying to go too fast; but when he stops at these, he goes too slowly. The compelling need is to purify and mutually to separate false unities: particular forms. Thus the oppositions are revealed as pure relationships. Once their equivalence is found, rhythm is freed, the way is clear, open to life.

If we imagine that we can live in true unity now, and if we fail to see the existing disequilibrium, we will become disillusioned.

Art demonstrates that we have to "create" this unity, and that this can be done only by separating, by breaking, and by reconstructing the apparent unities that exist or that readily appear everywhere. Being within this reality, we must deal with it; but in order to do so, we must perceive it clearly and observe that it is not a complete and closed form, but the perpetual movement of changing oppositions.

Life, history, science, and art teach us that only by discerning and experiencing oppositions do we gradually achieve unity, complete life; and that life is only the constant deepening of the same thing: continual progress.

Fortunately, modern man no longer simply believes, he observes. It is therefore of the greatest importance for us, amid the chaos and fullness of life, to find established in the free domain of art the true way to achieve the equivalence of oppositions that, relatively, creates complete life, harmony, happiness. Art confirms plastically what is difficult to define verbally.

Generally, in life, we readily perceive oppositions as particular forms, but we fail to see them as "relationships." Yet it is precisely the mutual relationships between the elements themselves that determine the whole.

Plastic art has never failed to search for these "relationships," or failed to break the static appearance that reality imposes. In plastic art, the artist distinguished and carefully studied the oppositions of reality; he sought to compose line, form, and color in proper and equivalent relationships in order to create the dynamic equilibrium that annihilates the static equilibrium of things. Thus, the work of art moves us through its harmony (the unification of good and evil); thus, we rediscover the unity of suffering and joy—thus, it is complete.

In plastic art the principal oppositions are absolute, constant. They are expressed by the rectangular relationships (whether determinately established or not). But this absolute relationship of "position" (height and breadth) achieves a relative and living expression through the secondary relationships: relationships of dimension and of value, always varying. The work never shows repetition of the plastic means but always their constant opposition.

Although these relationships were always established intuitively, the artist naturally sought to express only the beauty of particular forms, but became more and more conscious of the value of their inherent and mutual relationships. Thus, through the centuries there arose a "culture of relationships" that is unfolding today. In the past

this culture was opposed to the culture of particular form, and through the reciprocal action of these two cultures we can now consider the culture of particular form as nearing its end: the search for relationships annihilated particular form by increasingly separating and breaking it, while neutral form, pure line, and color became the only means for expressing relationships. The culture of "pure" relationships has begun.

It is therefore through the "culture" of particular form and not by its neglect that art—the new art—achieved the culture of pure relationships. For centuries and centuries form never lost its naturalistic appearance, until in modern times (since Impressionism), when form was first modified and then annihilated.

Let us rejoice to live in the age when plastic art has freed itself from the domination of particular forms. Particular forms prevent full enjoyment of the unity that only neutral form, pure line and color can establish clearly when these "means" lose themselves in composition.

The study of art's culture makes us certain that we are approaching a life no longer dominated by particular forms, nor by disequilibrated relationships (oppositions): a life of pure and equivalent relationships—a "human" life.

To the objection that art has always shown harmony, we can reply that, as the new art demonstrates, only the power of genius (intuition) enabled the art of the past to express a veiled harmony. Although the art of the past had an equilibrated expression, there was always something that dominated the forms and the relationships. For example, the predominance of faces and figures in painting and the expression of height in the Gothic, etc.

From antiquity to the present, art shows us that we are moving toward a life that is open, clear, free, even though we are still surrounded by the life of the past, where everything is confused, where parts dominate, where everything is mixed: good and evil, benevolence and malevolence, love and hate—where all is only a seeming unity.

It could be said that the artist composes the work of art, but that life composes life, and we are as if cast into the world. But we must not forget that in his work the artist is also impelled by life, and that we are all part of life—the life not concerned with time and space, but, like art, always basically the same. Life has only to develop in us. Even despite ourselves, we are part of the great perfect composition of life, which when clearly seen establishes itself in accord with the development of art. Let us not forget that the present is a unity of the past and of the future!

[Reply to an Inquiry]
(1935)

In 1935 Christian Zervos, editor of *Cahiers d'art*, queried leading artists and writers concerning the current situation in art.

The younger generation, he averred, was drifting without aim or purpose. Beyond its legitimate preoccupation with plastic values, should not art admit a wider range of experience? Should it not seek to integrate form with content and—following the example of science—with broader aspects of thought? By including the world around us, would not art become clearer, more accessible to the masses? Young artists were tending to prettiness, to merely decorative combinations: should one not encourage them to work more forcefully, even crudely? Was there not also the danger of following programs laid down a priori by persuasive writers? Finally, given the profusion of revivals (Neo-Realism, Neo-Redonism, etc.), had not the time come to reexamine the broad basic problems tackled by the previous generation?

Answers appeared in a single issue of *Cahiers d'art* 10, nos. 1–4 (1935). The other respondents were Georges Rouault, Georges Braque, René Huyghe, Julio Gonzalez, Will Grohmann, Alberto Magnelli, Henri Laurens, Amedée Ozenfant, Marc Chagall, Louis Fernandez, Léonce Rosenberg, Wassily Kandinsky, Pierre Loeb, Jean Hélion, Wolfgang Paalen, Fernand Léger, Jacques Lipchitz, Herbert Read, and Anatole Jakowski.

It is a happy fact that our generation has not only been much preoccupied, but "effectively occupied" with the plastic. It has thus created a pure plastic, a plastic without sentimental, literary, or descriptive connotations. Form and color have been put to their proper use: henceforth they are only the means of "plastic" expression, and will no longer dominate the work as they did in the past.

This is how they become integrated as content: they increasingly enter into equivalent opposition with the whole, thus producing more real equilibrium.

This is achieved, not by following the example of science, but under the influence of progress in science and in all of life.

True art does not have to make itself clear: it is always clear by its very nature. But this is not perceived by the multitude.

Because the expression of art is always changing, only an elite understands its continuous evolution. Through this elite, true aesthetic culture is formed. The multitude are conservative: they do nothing but impede evolution, while following it from a distance.

The artist is concerned neither with the elite nor with the multitude: he follows his intuition, which, through the progress of life, becomes more and more clear—so clear that it is usually confused with intellect. Only in this way can the artist gradually raise the multitude to a deeper and deeper understanding of life.

True art is always created by the reciprocal action of the world around us and the artist,

who can never therefore allow himself to become isolated within preconceived formulas. Yet in the course of time the opposition of these two factors reveals itself not as an arbitrary action, but as an evolution that follows the immutable laws of nature: laws hidden in nature, but that must be discovered through the continuous culture of life, science, and art. These laws may appear to be formulas, but they are not at all personal: being universal, they are valid for all art.

Consciously or unconsciously, the true artist works in conformity with these laws, and never yields to the demands of the public— even the most intelligent public. It is for the public to "see," to recognize in his work the expression of life that cannot be defined or described.

To see it is to understand it.

The true artist does not need advice. The young must always work forcefully, even crudely. They cannot do "pretty" work.

While they will adhere to the plastic laws, these young artists cannot establish their program a priori, for they cannot know in advance exactly where their intuition will lead them.

They cannot return to the past, for they experience life as it evolves.

They develop through the researches of the present. While remaining true to their nature, they intuitively know what level to choose on the scale of plastic evolution. Logically at present there is no need to retreat or to search in every direction. One need only continue what has already been done. One need only "express oneself" through the means that have already been discovered. The great simplification of the plastic means has already been accomplished: the young have only to choose.

Neutral line, color, and form (which no longer have the particular appearance of things) have been established as the general means of expression. Now that the means have been simplified to the last degree, it is for the young to maintain, compose, and establish them according to their nature. Along this path, some stay with pure art (that is, continue to make paintings or sculpture), while others depart toward a realization that is more or less architectural. But all are preparing the way for the plastic arts to merge in a new architecture. There is still much to be done and developed, but in our palpable environment, as well as in social life, we can already see that the end of painting and especially of sculpture is approaching, and that these arts will become absorbed into a new architecture containing them all. The way for this new architecture is already well prepared by existing architecture. But the new will be richer and will satisfy aesthetic no less than utilitarian requirements.

There is therefore no reason to fear that the young have lost the way. The true artist will always try to express himself according to his true being; he will find an expression appropriate to himself. Some artists scarcely move along the path of plastic evolution, while others advance more rapidly. However that may be, living art (true art) is never in danger: its own content sustains it.

Plastic Art and
Pure Plastic Art
(1936)

When abstract art began to flourish in England during the early 1930s, Mondrian was recognized as a major figure of the modern movement. In 1934 he was visited in Paris by the abstract painter Ben Nicholson, who was active in the British groups, Axis and Circle.

Nicholson, Naum Gabo (in England since 1935), and the architect Leslie Martin jointly edited the volume *Circle: An International Survey of Constructive Art* (1937), for which "Plastic Art and Pure Plastic Art" was written. Their purpose was to bring together viewpoints "which appear to have one common idea and one common spirit: the constructive trend in the art of our day," and to show this trend's "relationship to the social order." Other contributors were Henry Moore, Barbara Hepworth, László Moholy-Nagy, Walter Gropius, Marcel Breuer, Richard Neutra, Lewis Mumford, Herbert Read, and Sigfried Giedion.

Mondrian had "done no writing for a long time" (letter to the sculptor Jean Gorin, 18 November 1936). But in a letter to his friend Winifred Nicholson of 4 September 1936 (courtesy of Andrew Nicholson), he reported: "I am now chiefly occupied with the article. . . . Because there is so much confusion in the modern movement, I would like to try and clarify a little the content of art." "It was very difficult, but I think I have succeeded," he wrote her on 24 September.

On 5 November, he again wrote Winifred Nicholson: "I am pleased to hear [Ben] Nicholson liked it. He has written me so himself. I too think I have brought some order to the chaos of the tendencies! Everywhere one seeks and seeks in darkness. Yet it is so simple if only one understands a little the great laws that are more or less hidden in natural appearance." The present essay, he added, was "more direct and topical" than an earlier one he had sent to England—probably "The True Value of Oppositions" (1934). In letters to Gabo and Ben Nicholson of December 1936 and January 1937, owned by Sir Leslie Martin, Mondrian declared himself pleased with the translation and editing, and added some corrections of his own.

Mondrian's frequent mention of "constructive elements" no doubt relates to the orientation of *Circle*. He was in fact not only friendly with the Constructivist pioneers Naum Gabo and Antoine Pevsner, but sympathetic to their work. He wrote to Gorin on 21 November 1939: "I like your latest work, just as I like that of Pevsner. I like the great consistency (logical conception) it expresses."[1]

The phrases quoted by Mondrian toward the end of this essay are typical of contemporary French criticism hostile to abstract art. Several are from Christian Zervos's introductory statement to *Cahiers d'art*'s 1935 "Enquête" (see "Reply to an Inquiry," also "Cubism and Neo-

Plastic," above). "Plastic Art and Pure Plastic Art" was widely read by abstract artists in England and especially in the United States.

Part 1

Although art is fundamentally everywhere and always the same, nevertheless two main human inclinations, diametrically opposed to each other, appear in its many and varied expressions. One aims at the *direct creation of universal beauty*, the other at the *aesthetic expression of oneself*, in other words, of that which one thinks and experiences. The first aims at representing reality objectively, the second subjectively. Thus we see in every work of figurative art the desire, objectively to represent beauty, solely through form and colour, in mutually balanced relations, and, at the same time, an attempt to express that which these forms, colours and relations arouse in us. This latter attempt must of necessity result in an individual expression which veils the pure representation of beauty. Nevertheless, both the two opposing elements (universal—individual) are indispensable if the work is to arouse emotion. Art had to find the right solution. In spite of the dual nature of the creative inclinations, figurative art has produced a harmony through a certain co-ordination between objective and subjective expression. For the spectator, however, who demands a pure representation of beauty, the individual expression is too predominant. For the artist the search for a unified expression through the balance of two opposites has been, and always will be, a continual struggle.

Throughout the history of culture, art has demonstrated that universal beauty does not arise from the particular character of the form, but from the dynamic rhythm of its inherent relationships, or—in a composition—from the mutual relations of forms. Art has shown that it is a question of determining the relations. It has revealed that the forms exist only for the creation of relationships: that forms create relations and that relations create forms. In this duality of forms and their relations neither takes precedence.

The only problem in art is to achieve a balance between the subjective and the objective. But it is of the utmost importance that this problem should be solved, in the realm of plastic art—technically, as it were—and not in the realm of thought. The work of art must be "produced," "constructed." One must create as objective as possible a representation of forms and relations. Such work can never be empty because the opposition of its constructive elements and its execution arouse emotion.

If some have failed to take into account the inherent character of the form and have forgotten that—untransformed—form predominates, others have overlooked the fact that an individual expression cannot become a universal expression through figurative representation, which is based on our conception of feeling, be it classical, romantic, religious, surrealist. Art has shown that universal expression can only be created by a *real equation of the universal and the individual*.

Gradually art is purifying its plastic means and thus bringing out the relationships between them. Thus, in our day two main tendencies appear: the one maintains the figuration, the other eliminates it. While the

former employs more or less complicated and particular forms, the latter uses simple and neutral forms, or, ultimately, the free line and the pure colour. It is evident that the latter (non-figurative art) can more easily and thoroughly free itself from the domination of the subjective than can the figurative tendency; particular forms and colours (figurative art) are more easily exploited than neutral forms. It is, however, necessary to point out that the definitions "figurative" and "non-figurative" are only approximate and relative. For every form, even every line, represents a figure, no form is absolutely neutral. Clearly, everything must be relative, but, since we need words to make our concepts understandable, we must keep to these terms.

Among the different forms we may consider those as being neutral which have neither the complexity nor the particularities possessed by the natural forms or abstract forms in general. We may call those neutral which do not evoke individual feelings or ideas. Geometrical forms, being so profound an abstraction of form, may be regarded as neutral; and on account of their tension and the purity of their outlines they may even be preferred to other neutral forms.

If, as a conception, non-figurative art has been created by the mutual interaction of the human duality, this art has been *realized* by the mutual interaction of *constructive elements and their inherent relations*. This process consists in mutual purification; purified constructive elements set up pure relationships, and these in their turn demand pure constructive elements. Figurative art of today is the outcome of figurative art of the past, and non-figurative art is the outcome of the figurative art of today. Thus the unity of art is maintained.

If non-figurative art is born of figurative art, it is obvious that the two factors of human duality have not only changed, but

have also approached one another towards a mutual balance, towards unity. One can rightly speak of an *evolution in plastic art*. It is of the greatest importance to note this fact, for it reveals the true way of art; the only path along which we can advance. Moreover, the evolution of the plastic arts shows that the dualism which has manifested itself in art is only relative and temporal. Both science and art are discovering and making us aware of the fact that *time is a process of intensification*, an evolution from the individual towards the universal, of the subjective towards the objective; towards the essence of things and of ourselves.

A careful observation of art since its origin shows that artistic expression seen from the outside is *not a process of prolongment but of intensifying one and the same thing*, universal beauty; and that seen from the inside *it is a growth*. Extension results in a continual repetition of nature; it is not human and art cannot follow it. So many of these repetitions which parade as "art" clearly cannot arouse emotions.

Through intensification one creates successively on more profound planes; extension remains always on the same plane. Intensification, be it noted, is diametrically opposed to extension; they are at right angles to each other as are length and depth. This fact shows clearly the temporal opposition of non-figurative and figurative art.

But if throughout its history art has meant a *continuous and gradual change in the expression of one and the same thing*, the opposition of the two trends—in our time so clear-cut—is actually an unreal one. It is illogical that the two principal tendencies in art, figurative and non-figurative (objective and subjective), should be so hostile. Since art is in essence universal, its expression cannot rest on a subjective view. Our human capacities do not allow of a perfectly objective view, but that does not

imply that the plastic expression of art is based on subjective conception. Our subjectivity realizes but does not create the work.

If the two human inclinations already mentioned are apparent in a work of art, they have both collaborated in its realization, but it is evident that the work will clearly show which of the two has predominated. In general, owing to the complexity of forms and the vague expression of relations, the two creative inclinations will appear in the work in a confused manner. Although in general there remains much confusion, today the two inclinations appear more clearly defined as two tendencies: *figurative and non-figurative art*. So-called non-figurative art often also creates a particular representation; figurative art, on the other hand, often neutralizes its forms to a considerable extent. The fact that art which is really non-figurative is rare does not detract from its value; evolution is always the work of pioneers, and their followers are always small in number. This following is not a clique; it is the result of all the existing social forces; it is composed of all those who through innate or acquired capacity are ready to represent the existing degree of human evolution. At a time when so much attention is paid to the collective, to the "mass," it is necessary to note that evolution, ultimately, is never the expression of the mass. The mass remains behind yet urges the pioneers to creation. For the pioneers, the social contact is indispensable, but not in order that they may know that what they are doing is necessary and useful, nor in order that "collective approval may help them to persevere and nourish them with living ideas." This contact is necessary only in an indirect way; it acts especially as an obstacle which increases their determination. The pioneers create through the reaction to external stimuli. They are guided not by the mass but by that which they see and feel.

They discover consciously or unconsciously the fundamental laws hidden in reality, and aim at realizing them. In this way they further human development. They know that humanity is not served by making art comprehensible to everybody; to try this is to attempt the impossible. One serves mankind by enlightening it. Those who do not see will rebel, they will try to understand and will end up by "seeing." In art the search for a content which is collectively understandable is false; the content will always be individual. Religion, too, has been debased by that search.

Art is not made for anybody and is, at the same time, for everybody. It is a mistake to try to go too fast. The complexity of art is due to the fact that different degrees of its evolution are present at one and the same time. The present carries with it the past and the future. But we need not try to foresee the future; we need only take our place in the development of human culture, a development which has made non-figurative art supreme. It has always been only one struggle, of only one real art: to create universal beauty. This points the way for both present and future. We need only continue and develop what already exists. The essential thing is that *the fixed laws of the plastic arts must be realized*. These have shown themselves clearly in non-figurative art.

Today one is tired of the dogmas of the past, and of truths once accepted but successively jettisoned. One realizes more and more the relativity of everything, and therefore one tends to reject the idea of fixed laws, of a single truth. This is very understandable, but does not lead to profound vision. For there are "made" laws, "discovered" laws, but also laws—a truth for all time. These are more or less hidden in the reality which surrounds us and do not change. Not only science, but art also, shows us that reality, at first incomprehensible, gradually reveals itself, by the

mutual relations that are inherent in things. Pure science and pure art, disinterested and free, can lead the advance in the recognition of the laws which are based on these relationships. A great scholar has recently said that pure science achieves practical results for humanity. Similarly, one can say that pure art, even though it appear abstract, can be of direct utility for life.

Art shows us that there are also constant truths concerning forms. Every form, every line has its own expression. This objective expression can be modified by our subjective view but it is no less true for that. Round is always round and square is always square. Simple though these facts are, they often appear to be forgotten in art. Many try to achieve one and the same end by different means. In plastic art this is an impossibility. In plastic art it is necessary to choose constructive means which are of one piece with that which one wants to express.

Art makes us realize that there are *fixed laws which govern and point to the use of the constructive elements of the composition and of the inherent inter-relationships between them.* These laws may be regarded as subsidiary laws to the *fundamental* law of equivalence which creates *dynamic equilibrium and reveals the true content of reality.*

Part 2

We live in a difficult but interesting epoch. After a secular culture, a turning point has arrived; this shows itself in all the branches of human activity. Limiting ourselves here to science and art, we notice that, just as in medicine some have discovered the natural laws relating to physical life, in art some have discovered the artistic laws relating to the plastic. In spite of all opposition, these facts have become movements. But confusion still reigns in them. Through science we are

becoming more and more conscious of the fact that our physical state depends in great measure on what we eat, on the manner in which our food is arranged and on the physical exercise which we take. Through art we are becoming more and more conscious of the fact that the work depends in large measure on the constructive elements which we use and on the construction which we create. We will gradually realize that we have not hitherto paid sufficient attention to constructive physical elements in their relation to the human body, nor to the constructive plastic elements in their relation to art. That which we eat has deteriorated through a refinement of natural produce. To say this appears to invoke a return to a primitive natural state and to be in opposition to the exigencies of pure plastic art, which degenerates precisely through figurative trappings. But a return to pure natural nourishment does not mean a return to the state of primitive man; it means on the contrary that cultured man obeys the laws of nature discovered and applied by science.

Similarly in non-figurative art, to recognize and apply natural laws is not evidence of a retrograde step; the pure abstract expression of these laws proves that the exponent of non-figurative art associates himself with the most advanced progress and the most cultured minds, that he is an exponent of denaturalized nature, of civilization.

In life, sometimes the spirit has been over-emphasized at the expense of the body, sometimes one has been preoccupied with the body and neglected the spirit; similarly in art content and form have alternatively been over-emphasized or neglected because *their inseparable unity* has not been clearly realized.

To create this unity in art *balance of the one and the other must be created.*

It is an achievement of our time to have

approached towards such balance in a field in which disequilibrium still reigns.

Disequilibrium means conflict, disorder. Conflict is also a part of life and of art, but it is not the whole of life or of universal beauty. Real life is the *mutual interaction of two oppositions of the same value but of a different aspect and nature.* Its plastic expression is universal beauty.

In spite of world disorder, instinct and intuition are carrying humanity to a real equilibrium, but how much misery has been and is still being caused by primitive animal instinct. How many errors have been and are being committed through vague and confused intuition? Art certainly shows this clearly. But art shows also that in the course of progress, intuition becomes more and more conscious and instinct more and more purified. Art and life illuminate each other more and more; they reveal more and more their laws according to which a real and living balance is created.

Intuition enlightens and so links up with pure thought. They together become an intelligence which is not simply of the brain, which does not calculate, but which feels and thinks. Which is creative both in art and in life. From this intelligence there must arise non-figurative art in which instinct no longer plays a dominating part. Those who do not understand this intelligence regard non-figurative art as a purely intellectual product.

Although all dogma, all preconceived ideas, must be harmful to art, the artist can nevertheless be guided and helped in his intuitive researches by reasoning apart from his work. If such reasoning can be useful to the artist and can accelerate his progress, it is indispensable that such reasoning should accompany the observations of the critics who talk about art and who wish to guide mankind. Such reasoning, however, cannot be individual, which it usually is; it cannot arise out of a body of knowledge outside

plastic art. If one is not an artist oneself one must at least know *the laws and culture of plastic art.* If the public is to be well informed and if mankind is to progress it is essential that the confusion which is everywhere present should be removed. For enlightenment, a clear demonstration of the *succession of artistic tendencies is necessary.* Hitherto, a study of the different styles of plastic art in their progressive succession has been difficult since the expression of the essence of art has been veiled. In our time, which is reproached for not having a style of its own, the content of art has become clear and the different tendencies reveal more clearly the progressive succession of artistic expressions. Non-figurative art brings to an end the ancient culture of art; at present, therefore, one can review and judge more surely *the whole culture of art.* We are not at the turning-point of this culture; *the culture of particular form is approaching its end. The culture of determined relations has begun.*

It is not enough to explain the value of a work of art in itself; it is above all necessary to show *the place which a work occupies on the scale of the evolution of plastic art.* Thus in speaking of art, it is not permissible to say "this is how I see it" or "this is my idea." True art like true life takes *a single road.*

The laws which in the culture of art have become more and more determinate are *the great hidden laws of nature which art establishes in its own fashion.* It is necessary to stress the fact that these laws are more or less hidden behind the superficial aspect of nature. Abstract art is therefore opposed to a natural representation of things. But it is *not opposed to nature* as is generally thought. It is opposed to the raw primitive animal nature of man, but it is one with true human nature. It is opposed to the conventional laws created during the culture of the partic-

ular form but it is one with the laws of the culture of pure relationships.

First and foremost there is the fundamental law of *dynamic equilibrium* which is opposed to the static equilibrium necessitated by the particular form.

The important task of all art, then, is to destroy the static equilibrium by establishing a dynamic one. Non-figurative art demands an attempt of what is a consequence of this task, the *destruction* of particular form and the *construction* of a rhythm of mutual relations, of mutual forms of free lines. We must bear in mind, however, a distinction between these two forms of equilibrium in order to avoid confusion; for when we speak of equilibrium pure and simple we may be for, and at the same time against, a balance in the work of art. It is of the greatest importance to note the destructive-constructive quality of dynamic equilibrium. Then we shall understand that the equilibrium of which we speak in non-figurative art is not without movement of action but is on the contrary a continual movement. We then understand also the significance of the name "constructive art."

The fundamental law of dynamic equilibrium gives rise to a number of other laws which relate to the constructive elements and their relations. These laws determine the manner in which dynamic equilibrium is achieved. The relations of *position* and those of *dimension* both have their own laws. Since the relation of the rectangular position is constant, it will be applied whenever the work demands the expression of stability; to destroy this stability there is a law that relations of a changeable dimension-expression must be substituted. The fact that all the relations of position except the rectangular one lack that stability also creates a law which we must take into account if something is to be established in a determinate manner. Too often right and oblique angles are arbitrarily employed. All art

expresses the rectangular relationship even though this may not be in a determinate manner; first by the height and width of the work and its constructive forms, then by the mutual relations of these forms. Through the clarity and simplicity of neutral forms, non-figurative art has made the rectangular relation more and more determinate, until, finally, it has established it through free lines which intersect and appear to form rectangles.

As regards the relations of dimension, they must be varied in order to avoid repetition. Although, as compared with the stable expression of the rectangular relationship, they belong to individual expression, it is precisely they that are most appropriate for the destruction of the static equilibrium of all form. By offering him a freedom of choice the relations of dimension *present the artist with one of the most difficult problems.* And the closer he approaches the ultimate consequence of his art the more difficult is his task.

Since the constructive elements and their mutual relations form an inseparable unity, the laws of the relations govern equally the constructive elements. These, however, have also their own laws. It is obvious that one cannot achieve the same expression through different forms. But it is often forgotten that varied forms or lines *achieve—in form—altogether different degrees in the evolution of plastic art.* Beginning with natural forms and ending with the most abstract forms, *their expression becomes more profound.* Gradually form and line gain in tension. For this reason the straight line is a stronger and more profound expression than the curve.

In pure plastic art the significance of different forms and lines is very important; it is precisely this fact which makes it pure.

In order that art may be really abstract, in other words, that it should not represent relations with the natural aspect of things, the law of the *denaturalization of matter* is

of fundamental importance. In painting, the primary colour that is as pure as possible realizes this abstraction of natural colour. But colour is, in the present state of technique, also the best means for denaturalizing matter in the realm of abstract constructions in three dimensions; technical means are as a rule insufficient.

All art has achieved a certain measure of abstraction. This abstraction has become more and more accentuated until in pure plastic art not only a transformation of form but also of matter—be it through technical means or through colour—a more or less neutral expression is attained.

According to our laws, it is a great mistake to believe that one is practising non-figurative art by merely achieving neutral forms or free lines and determinate relations. For in composing these forms one runs the risk of a figurative creation, that is to say, one or more particular forms.

Non-figurative art is created by establishing *a dynamic rhythm of determinate mutual relations* which *excludes the formation of any particular form*. We note thus, that to destroy particular form is only to do more consistently what all art has done.

The dynamic rhythm which is essential in all art is also the essential element of a non-figurative work. In figurative art this rhythm is veiled.

Yet we all pay homage to clarity.

The fact that people generally prefer figurative art (which creates and finds its continuation in abstract art) can be explained by the dominating force of the individual inclination in human nature. *From this inclination arises all the opposition to art which is purely abstract.*

In this connection we note first the *naturalistic conception* and the *descriptive or literary orientation*: both a real danger to purely abstract art. From a purely plastic point of view, until non-figurative art, artistic expression has been naturalistic or descrip-

tive. To have emotion aroused by pure plastic expression one must abstract from figuration and so become "neutral." But with the exception of some artistic expressions (such as Byzantine art)[a] there has not been the desire to employ neutral plastic means, which would have been much more logical than to become neutral oneself in contemplating a work of art. Let us note, however, that the spirit of the past was different from the spirit of our own day, and that it is only tradition which has carried the past into our own time. In past times when one lived in contact with nature and when man himself was more natural than he is today, abstraction from figuration in thought was easy; it was done unconsciously. But in our more or less denaturalized period, such abstraction becomes an effort.

However that may be, the fact that figuration is a factor which is unduly taken into account, and whose abstraction in the mind is only relative, proves that today even great artists regard figuration as indispensable. At the same time these artists are already abstracting from figuration to a much greater extent than has been done before. More and more, not only the uselessness of figuration, but also obstacles which it creates, will become obvious. In this search for clarity, non-figurative art develops.

There is, however, one tendency which cannot forego figuration without losing its descriptive character. That is surrealism. Since the predominance of individual thought is opposed to the purely plastic it is also opposed to non-figurative art. Born of a literary movement, its descriptive character demands figuration. However purified or

[a] It should be noted that despite their profound expression of forms, lacking dynamic rhythm, such works remain more or less ornamental.

deformed it may be, figuration veils pure plastics. There are, it is true, surrealist works whose plastic expression is very strong and of a kind that if the work is observed at a distance, i.e. if the figurative representation is abstracted from, they arouse emotion by form, colour and their relations alone. But if the purpose was nothing but plastic expression, why then use figurative representation? Clearly, there must have been the intention to express something outside the realm of pure plastics. This of course is often the case even in abstract art. There, too, there is sometimes added to the abstract forms something particular, even without the use of figuration; through the colour or through the execution, a particular idea or sentiment is expressed. There it is generally not the literary inclination but the naturalistic inclination which has been at work. It must be obvious that if one evokes in the spectator the sensation of, say, the sunlight or moonlight, of joy or sadness, or any other determinate sensation, one has not succeeded in establishing universal beauty, one is not purely abstract.

As for Surrealism, we must recognize that it deepens feeling and thought, but since this deepening is limited by individualism it cannot reach the foundation, the universal. So long as it remains in the realm of dreams, which are only a re-arrangement of the events of life, it cannot touch true reality. Through a different composition of the events of life, it may remove their ordinary course but it cannot purify them. Even the intention of freeing life from its conventions and from everything which is harmful to the true life can be found in surrealist literature. Non-figurative art is fully in agreement with this intention but it achieves its purpose; it frees its plastic means and its art from all particularity. The names, however, of these tendencies, are only indications of their conceptions; it is the realization which matters. With the exception of non-figurative

art, there seems to have been a lack of realization of the fact that it is possible to express oneself profoundly and humanely by the plastic alone, that is, by employing a neutral plastic means without the risk of falling into decoration or ornament. Yet all the world knows that even a single line can arouse emotion. But although one sees—and this is the artist's fault—few non-figurative works which live by virtue of their dynamic rhythm and their execution, figurative art is no better in this respect. In general, people have not realized that one can express our very essence through neutral constructive elements; that is to say, we can express the essence of art. The essence of art of course is not often sought. As a rule, individualist human nature is so predominant that the expression of the essence of art through a rhythm of lines, colours and relationships appears insufficient. Recently, even a great artist has declared that "complete indifference to the subject leads to an incomplete form of art."

But everybody agrees that art is only a problem of the plastic. What good then is a subject? It is to be understood that one would need a subject to expound something named "Spiritual riches, human sentiments and thoughts." Obviously, all this is individual and needs particular forms. But at the root of these sentiments and thoughts there is one thought and one sentiment: these do not easily define themselves and have no need of analogous forms in which to express themselves. It is here that neutral plastic means are demanded.

For pure art, then, the subject can never be an additional value; it is the line, the colour and their relations which must "bring into play the whole sensual and intellectual register of the inner life" . . . not the subject. Both in abstract art and in naturalistic art colour expresses itself "in accordance with the form by which it is determined," and in all art it is the artist's task to make forms

and colours living and capable of arousing emotion. If he makes art into an "algebraic equation," that is no argument against the art, it only proves that he is not an artist.

If all art has demonstrated that to establish the force, tension and movement of the forms, and the intensity of the colours of reality, it is necessary that these should be purified and transformed; if all art has purified and transformed and is still purifying and transforming these forms of reality and their mutual relations; if all art is thus a continually deepening process: why then stop halfway? If all art aims at expressing universal beauty, why establish an individualist expression? Why then not continue the sublime work of the Cubists? That would not be a continuation of the same tendency, but on the contrary, *a complete break-away from it and all that has existed before it.* That would only be going along the same road that we have already travelled.

Since Cubist art is still fundamentally naturalistic, the break which pure plastic art has caused consists in becoming abstract instead of naturalistic in essence. While in cubism, from a naturalistic foundation, there sprang forcibly the use of plastic means, still half abstract, the abstract basis of pure plastic art must result in the use of purely abstract plastic means.

In removing completely from the work all objects, "the world is not separated from the spirit," but is on the contrary *put into a balanced opposition* with the spirit, since the one and the other are purified. This creates a perfect unity between the two opposites. There are, however, many who imagine that they are too fond of life, particular reality, to be able to suppress figuration, and for that reason they still use in their work the object or figurative fragments which indicate its character. Nevertheless, one is well aware of the fact that in art one cannot hope to represent in the image things as they are, nor even as they manifest themselves in all their

living brilliance. The Impressionists, Divisionists and Pointillistes have already recognized that. There are some today who, recognizing the weakness and limitation of the image, attempt to create a work of art through the objects themselves, often by composing them in a more or less transformed manner. This clearly cannot lead to an expression of their content nor of their true character. One can more or less remove the conventional appearance of things (Surrealism), but they continue nevertheless to show their particular character and to arouse in us individual emotions. To love things in reality is to love them profoundly; it is to see them as a microcosmos in the macrocosmos. *Only in this way can one achieve a universal expression of reality.* Precisely on account of its profound love for things, non-figurative art does not aim at rendering them in their particular appearance.

Precisely by its existence non-figurative art shows that "art" *continues always on its true road.* It shows that "art" is *not the expression of the appearance of reality such as we see it, nor of the life which we live,* but that *it is the expression of true reality and true life . . . indefinable but realizable through the plastic.*

Thus we must carefully distinguish between two kinds of reality; one which has an individual and one which has a universal appearance. In art the former is the expression of space determined by particular things or forms, the latter establishes expansion and limitation—the creative factors of space— through neutral forms, free lines and pure colours. While universal reality arises from determinate relations, particular reality shows only veiled relations. The latter must obviously be confused in just that respect in which universal reality is bound to be clear. The one is free, the other is tied to individual life, be it personal or collective. Subjective reality and relatively objective reality: this is the contrast. Pure abstract art aims at

creating the latter, figurative art the former.

It is astonishing, therefore, that one should reproach pure abstract art with not being "real," and that one should envisage it as "arising from particular ideas."

In spite of the existence of non-figurative art, one is talking about art today as if nothing determinate in relation to the new art existed. Many neglect the real non-figurative art, and looking only at the fumbling attempts and at the empty non-figurative works which today are appearing everywhere, ask themselves whether the time has not arrived "to integrate form and content" or "to unify thought and form." But one should not blame non-figurative art for that which is only due to the ignorance of its very content. If the form is without content, without universal thought, it is the fault of the artist. Ignoring that fact, one imagines that figuration, subject, particular form, could add to the work that which the plastic itself is lacking. As regards the "content" of the work, we must note that our "attitude with regard to things, our organized individuality with its impulses, its actions, its reactions when in contact with reality, the lights and shades of our spirit," etc., certainly do modify the non-figurative work, but they do not constitute its content. We repeat that its content cannot be described, and that it is only through the purely plastic and through the execution of the work that it can be made apparent. Through this indeterminable content, the non-figurative work is "fully human." Execution and technique play an important part in the aim of establishing a more or less objective vision which the essence of the non-figurative work demands. The less obvious the artist's hand the more objective will the work be. This fact leads to a preference for a more or less mechanical execution or to the employment of materials produced by industry. Hitherto, of course, these materials have been imper-

fect from the point of view of art. If these materials and their colours were more perfect and if a technique existed by which the artist could easily cut them up in order to compose his work as he conceives it, an art more real and more objective in relation to life than painting would arise. All these reflections evoke questions which have already been asked many years ago, mainly: is art still necessary and useful for humanity? Is it not even harmful to its progress? Certainly the art of the past is superfluous to the new spirit and harmful to its progress: just because of its beauty it holds many people back from the new conception. The new art is, however, still very necessary to life. In a clear manner it establishes the laws according to which a real balance is reached. Moreover, it must create among us a profoundly human and rich beauty realized not only by the best qualities of the new architecture, but also by all that the constructive art in painting and sculpture makes possible.

But although the new art is necessary, the mass is conservative. Hence these cinemas, these radios, these bad pictures which overwhelm the few works which are really of our era.

It is a great pity that those who are concerned with the social life in general do not realize the utility of pure abstract art. Wrongly influenced by the art of the past, the true essence of which escapes them, and of which they only see that which is superfluous, they make no effort to know pure abstract art. Through another conception of the word "abstract," they have a certain horror of it. They are vehemently opposed to abstract art because they regard it as something ideal and unreal. In general they use art as propaganda for collective or personal ideas, thus as literature. They are both in favour of the progress of the mass and against the progress of the elite, thus against the logical march of human evolution. Is it

really to be believed that the evolution of the mass and that of the elite are incompatible? The elite rises from the mass; is it not therefore its highest expression?

To return to the execution of the work of art, let us note that it must contribute to a revelation of the subjective and objective factors in mutual balance. Guided by intuition, it is possible to attain this end. The execution is of the greatest importance in the work of art; it is through this, in large part, that intuition manifests itself and creates the essence of the work.

It is therefore a mistake to suppose that a non-figurative work comes out of the unconscious, which is a collection of individual and pre-natal memories. We repeat that it comes from pure intuition, which is at the basis of the subjective-objective dualism.

It is, however, wrong to think that the non-figurative artist finds impressions and emotions received from the outside useless, and regards it even as necessary to fight against them. On the contrary, all that the non-figurative artist receives from the outside is not only useful but indispensable, because it arouses in him the desire to create that which he only vaguely feels and which he could *never represent in a true manner without the contact with visible reality and with the life which surrounds him.* It is precisely from this visible reality that he draws the objectivity which he needs in opposition to his personal subjectivity. It is precisely from this visible reality that he draws his means of expression: and, as regards the surrounding life, it is precisely this which has made his art non-figurative.

That which distinguishes him from the figurative artist is the fact that in his creations he frees himself from individual sentiments and from particular impressions which he receives from outside, and that he breaks loose from the domination of the individual inclination within him.

It is therefore equally wrong to think that the non-figurative artist creates through "the pure intention of his mechanical process," that he makes "calculated abstractions," and that he wishes to "suppress sentiment not only in himself but also in the spectator." It is a mistake to think that he retires completely into his system. That which is regarded as a system is nothing but constant obedience to the laws of the purely plastic, to necessity, which art demands from him. It is thus clear that he has not become a mechanic, but that the progress of science, of technique, of machinery, of life as a whole, has only made him into a living machine, capable of realizing in a pure manner the essence of art. In this way, he is in his creation sufficiently neutral, that nothing of himself or outside of him can prevent him from establishing that which is universal. Certainly his art is art for art's sake . . . for the sake of the art *which is form and content at one and the same time.*

If all real art is "the sum total of emotions aroused by purely pictorial means," his art is the sum of the emotions aroused by plastic means.

It would be illogical to suppose that non-figurative art will remain stationary, for this art contains *a culture* of the use of new plastic means and their determinate relations. Because the field is new there is all the more to be done. What is certain is that no escape is possible for the non-figurative artist; he *must stay within his field and march towards the consequence of his art.*

This consequence brings us, in a future perhaps remote, towards the end of *art as a thing separated from our surrounding environment, which is the actual plastic reality.* But this end is at the same time a new beginning. Art will not only continue but will realize itself more and more. By the unification of architecture, sculpture and painting, a new plastic reality will be created.

Painting and sculpture will not manifest themselves as separate objects, nor as "mural art" which destroys architecture itself, nor as "applied" art, but *being purely constructive* will aid the creation of a surrounding not merely utilitarian or rational but also pure and complete in its beauty.

Three Notes
(1937)

The "Three Notes," translated by J. J. Sweeney, were published in *transition* (no. 26, 1937), the avant-garde magazine of literature and art (1927–38), edited in Paris by Eugène Jolas. The present text follows Mondrian's handwritten French draft.

The new art gives an independent existence to line and color. No longer tyrannized or distorted by particular forms, they establish their own limitations—limitations appropriate to their nature.

In the painting of the past, particular forms are generally confused or lost in the background of the picture. In the new art they are shown with increasing clarity on a plane that is no longer the naturalistic background of the past but the abstract representation of space. On this "ground" the forms become determinate, distinctly separated, and display their inherent mutual relationships.

The mutual separation of particular forms is the beginning of the independent existence of line and color. Precisely this separation brings to light the limited character of particular form and forces the search for neutral forms that transcend the limitations of particularity. These forms are created by another act of separation: the decomposition of particular form. Now the search for mutual equivalent relationships becomes essential. Finally, the decomposition of neutral form—complete separation—leads to the complete liberation of line and color.

Art without Subject Matter
(1938)

In April 1938, the Stedelijk Museum, Amsterdam, presented an extensive exhibition, "Abstract Art," curated by W. J. H. Sandberg, later the museum's director, with the assistance of Petro [Nelly] van Doesburg, widow of the artist. Its catalogue formed a roster of major figures associated with abstract painting and sculpture.

"Kunst zonder oderwerp" ("Art without Subject Matter"), dated March 1938, Mondrian's contribution to the catalogue, appeared with other essays dealing with the substance and role of abstraction by Wassily Kandinsky ("Abstract or Concrete"), Jean Gorin, Georg Schmidt ("Constructivism"), H. Buys, and Sigfried Giedion.

The topicality of the theme is illustrated by László Moholy-Nagy's article with a title comparable to Mondrian's: "Subject without Art," *Studio* (London), 4 November 1936. Moholy-Nagy took the position that there is "no opposition of principle between representational and nonrepresentational art, provided either fulfills its formative and educational tasks."

The present translation follows Mondrian's heavily amended manuscript dated 1938.

Everybody knows that painting and sculpture are concerned with the expression of the essence of art and not with the representation that cloaks it. But not everyone is convinced that the essence can be plastically expressed exclusively through line, color, form, and their mutual relationships, thus without any particular subject matter.

The essence of art cannot be described. Therefore, the use of particular subject matter in plastic art makes it more or less descriptive and gives a false or limited impression of its essence. The essence of art expresses or evokes our emotion of beauty. It is universal and lies outside our subjective vision. The more that subjective vision is excluded, the purer the expression of art. All true art arises intuitively from the universal. The essence of art is the plastic expression of life, which is equally indescribable in its richness and fullness. Its deepest expression has always been called harmony. Harmony has always been regarded as the first requirement of art. It is established through relationships of line, color, and form. The artist strives to achieve equilibrium through the rhythm of the composition. In composition—the plastic expression of relationships—rhythm is primary, whereas the plastic means are secondary.

Obviously harmony is achieved most purely through the purest, that is, the clearest, plastic means. Therefore, all attempts to cloak art in individual forms or representations are harmful to the pure expression of art. Nevertheless, lines and colors necessarily create forms. Thus, even with the purest plastic means, the main problem is still to annihilate all particular form through continuous opposition of line and color, that is, through the plastic expression of relationships.

The purification of art through the purification of the plastic means is therefore always relative. It is nevertheless a fact that the less the forms have an individual character, the purer is the expression of art. The culture of art leading to the purest and most real expression of the essence of art inevitably led to art without subject matter. We can call the forms used in this art neutral because they have no limiting character. Geometric forms can also be considered neutral because of their universal expression. Perpendicular intersecting lines can be described as the most thorough annihilation of individual form, because the intersection of perpendicular lines inevitably forms right angles.

Regardless of the plastic mode, the plastic means must never dominate in art. It is logical that the less the means assert themselves, the less they dominate.

If we follow the culture of art through its successive periods, we see that it is a developmental process directed toward a goal and that it increasingly approaches this goal. Thus we see the rationality of all the successive expressions of art. The culture of art shows at first (until Impressionism) the construction of naturalistic form and color realized to the maximum degree; then the destruction of these plastic means until and including Cubism; following their destruction, a construction and purification of denaturalized form and color.

Thus we see a continuous deepening of the plastic means: nonfigurative art—the achievement of a more direct and stronger expression of the essence of art. Painting and sculpture have always more or less transformed reality. Until modern times, however, the naturalistic vision of things was more or less maintained in the plastic. Impressionism was already a big step on the way toward the actual transformation of nature. Many tendencies went further along the way opened by Impressionism. Shortly before Cubism we see a great abstraction of the natural appearance of reality. We see naturalistic modeling and atmosphere disappearing from plastic expression; we already see abstract forms. These tendencies might have become decorative had not the profundity of their plastic expression maintained them on the level of pure art.

After the simplification and abstraction of the plastic, Cubism arose and broke more consistently with naturalistic vision, expressing objects in their multiple aspects. Nevertheless, objects still remained present until nonfigurative art: art without subject matter annihilated the object. Thus, we see a continuous deepening in the culture of art: a trend to more objective, more universal plastic expression—the achievement of a clearer plastic expression of the essence of art.

That it is possible to create a moving expression of beauty exclusively through line, color, and neutral form is proved by the architecture of the past. We have only to think of the grandeur of this art, which far surpasses the beauty of traditional painting and sculpture. Nevertheless, architecture has a highly subjective side. It often strongly asserts individual feeling. That is why it is so heartening that the new rational architecture, under the pressure of the practical demands of our time and inspired by new materials, virtually excludes the expression of subjective feeling. Although today it cannot be "art" for practical and economic reasons, it is much closer to the universal expression of art than the "art of architecture" of the past. For from an aesthetic viewpoint it has now become the plastic expression of pure spatial relationships. Thus the new architecture is in

accord with painting and sculpture.

It is a fortunate fact that the new architecture excludes painting and sculpture, for it is now widely admitted that if each one did not perfect itself separately, all would degenerate into decorative or applied art. Architecture differs from the others in that it not only must satisfy organic and practical requirements but originates in them. Nevertheless, architecture, painting, and sculpture possess the common means through which the essence of art can be plastically expressed in a pure way.

Neo-Plastic
(1938)

Dated March 1938, this condensation of Neo-Plastic principles appeared in German in the August number of *Werk*, journal of the Swiss Architectural League and the Swiss Werkbund.

In the March issue of the journal, its editor, Peter Meyer, had described nonrepresentational expression as an art of "negation, weariness . . . a complete renunciation of the aim of making art." In view of protests by a number of Swiss intellectuals, *Werk* gave the artists "the opportunity of presenting their own arguments." Mondrian's untitled text appeared together with short statements by Vantongerloo, Gabo, Pevsner, Kandinsky, and an essay by Max Bill, "On Concrete Art." The present title is taken from the French draft in Mondrian's hand.

All plastic art reveals that its essential content moves us aesthetically through the expression of vital equilibrium. All plastic art achieves this by establishing a dynamic rhythm of forms, lines, colors, and relationships. These forms, lines, and colors are only the "means" for establishing rhythm. These means determine its character, but it is their mutual relationships that create its dynamic expression. The less the forms, lines, and colors create limiting and particular forms, the purer is the expression of their relationships and the purer the rhythm. That is why nonfigurative art neutralized particular form, and Neo-Plastic pushed this effort to its greatest extreme.

In the search to establish dynamic rhythm—which is the essential in plastic art—in a strong and determined way, Neo-Plastic reduces particular form to its fundamental elements, that is, to straight lines in rectangular opposition. We then can say that Neo-Plastic annihilates limited form and creates pure relationships. For in Neo-Plastic composition, the straight lines constantly intersect each other, so that the rectangles apparently formed are not asserted as such. The relationships are established determinately. Color is primary. Because of the inherent consistency of the plastic means, there is real equivalence between these means and the space represented by the ground [*le fond*]: the work is a unity. The relationship of position—the right angle—is constant. Through opposition, the relationships of dimension vary continually so that all symmetry can be destroyed. Precisely through these variable relationships in Neo-Plastic composition, the static character of the constant relationship is annihilated and the work can be dynamic and truly human.

Part III

England and the United States 1938–44

The 1930s brought widening interest in Mondrian's work and writings from Amsterdam, London, and New York. His departure from Paris to London in September 1938 was welcomed by his friends in England; but the bombings that followed the outbreak of war a year later finally persuaded him to leave for the United States. From the moment he arrived in New York, on 1 October 1940, he felt completely at home. He often said to Harry Holtzman: "I have never been so happy as I am here."

Mondrian's first exhibition at the Valentine Gallery, January–February 1942, received wide recognition. The Museum of Modern Art acquired the *Broadway Boogie-Woogie* from his second Valentine show March–April 1943.

He first lived at 353 East 56th Street, moving in September 1943 to his last studio, at 15 East 59th Street. The five months before his death on 1 February 1944 were intensely stimulating and productive, during which he devoted his high energy to two major efforts: the completion of *Victory Boogie-Woogie*, and the design of his studio. Concerning *Victory Boogie-Woogie*, he told Holtzman in January 1944: "Now it is finished, I have only to replace the tapes with paint." The 59th Street studio afforded Mondrian his first satisfactory opportunity, since leaving his Paris atelier at 26 rue du Départ, to plastically compose his environment.

In London and New York, Mondrian continued to draft new writings, for which he constantly made notes. Among his papers were the unfinished essays "The Necessity for a New Art Teaching in Art, Architecture, and Industry"; "A New Religion?"; "Plastic Art: Reflex of Reality"; and "Space-Determination in Painting, Scupture, and Architecture"—all published here for the first time. Mondrian's completed essays in English from 1937 on were assembled in *Plastic Art and Pure Plastic Art* (1945).

The Necessity for a New Teaching in Art, Architecture, and Industry (1938)

"The Necessity for a New Teaching in Art, Architecture, and Industry" was written in 1938, when Mondrian was first planning to move to the United States, but was never completed for publication.

From London, where he had been living since September 1938, he wrote Holtzman (13 January 1939): "In Paris . . . I also made a plan for a *real* modern aesthetic school . . . this because the New Bauhaus [was] not sufficient." Before leaving Paris, Mondrian had begun to correspond with László Moholy-Nagy, hoping to find a teaching post at Moholy-Nagy's New Bauhaus in Chicago. His letter (in English) to Moholy-Nagy from London (6 June 1939) offers significant insights:

> I don't know if you see my relation to architecture and industry. I see by your letters that you are thinking that I could do good work at the Bauhaus in the future. But why did you not think of me firstly? I am, among the different artists[,] perhaps the most free from "art" and the most near to the "reality" and its aesthetic construction; the most near to architecture and industry. I have studied the most consequently that what only create[s] reality's true beauty, that is *pure relations of planes, lines, and colors.*
>
> Good relations comes first under discussion is it not?
>
> Future life—more real, more pure—needs more real, more pure aesthetic construction. This construction is the research for pure constructive elements and pure relations of them.
>
> The research for good *forms* was the work in the past: the research for good *relations* is the gleam of the present. It is true, good forms create good relations, but *the way how to create them* is different. Relations must come first. This is very important in teaching. . . .
>
> Nice architecture and nice objects must be created: not nice forms. Nice drawings are useless. That is why I see the usefulness of an artist at the Bauhaus only in this way that he is able to teach *how to make more perfect the material constructions.* A "painter" and a "sculptor" are of no use at the Bauhaus: [however] well their capability to teach all about forms, colors and their relations.
>
> "Art" must be forgotten: beauty must be realized.
>
> The material realizations: this is what is under discussion.
>
> I think you have always well understood all this. But—at the old Bauhaus—Kandinsky and Klee p[ar] ex[ample] have teached in the way to maintain the separation of art and reality (architecture and industry), architecture and all what belongs to it, furniture, utilitarian objects, machines, etc., is what most occupy us. Pictures, sculptures, decoration are of no use in new life and are an obstacle to realize it now in the present. Because I am sure that you feel most of this above as I do feel it, I do not understand that you have spoken to Mr. [James Johnson] Sweeney, as he told me, not only about me, but also about Arp to have at the Bauhaus. Arp is a great artist, but nothing for our future environment. At that time you did not know perhaps his latest work.

Archipenko is a sculptor also, but [Jean] Hélion told me that he does not teach his "art" but develops the sense for good forms and composition of them. I think this is very good. And I am sure that Hélion shall work for color and form in the same good way.

By this fact I have seen that you are creating a "new" Bauhaus.

I heard from Hélion also that you intended to create a workshop for architecture and were looking for an architect. Why should you not go a new way and take an engineer with an aesthetic collaborator. This latest must be an artist but an artist *free from "art."*

But all this is perhaps not possible now. You know that better as I do.[1]

Introduction

Those who desire to fulfill aesthetic demands in the future creation of everything that forms part of our material environment must abandon the idea of making sculpture or painting. And they must not seek to make or add anything decorative whatsoever. All must be found in the things they make, and before making them, they must become practiced with the significance and value of form and color and of the relationships that they have or produce.

It is necessary to gain experience in a new way. Objects must no longer be studied, but rather the essentials of which they consist. In this way a pure structure is attainable. The personal conception also gains from this, being freed from tradition and bound only by aesthetic laws and the demands of utility.

Work Program

1. The nature of the plastic (falsely understood as modeling)
2. Form and color 2. Development of the plastic
3. Practical experimentation
4. Comparison of plastic expressions
5. Consequence: personal expression

The Nature of the Plastic

For those who are preparing to create an aesthetically sensitive but rational environment—architecture and all included utilitarian objects, machines, etc.—it is of the highest importance to understand the nature of the plastic, the significance of form, line, color, and their relationships. The problem is not to "say something," to express a feeling, to depict an emotion, but to create something real that is useful and at the same time beautiful. Everyone knows that the organic and the really utilitarian are beautiful when they are purely felt, for pure feeling also contains the aesthetic. We will not discuss here whether the two aims are compatible; in the course of our study, it will become clear that they are.

Let us not rely on our uncertain feelings but study how and why a utilitarian object is, or is not, beautiful. A building can be aesthetically too high or too wide and still be useful. The nature of the plastic is therefore "exclusively plastic"—not expression, but "plastic expression." Expression on a flat plane is also plastic.

As an exercise, on canvas or paper execute a work based on something real: a house, a chair, a jar.

The plastic is expressed not only through the picture or the object itself, but also by what surrounds it: space.

The picture, the object, and the space create relationships.

The object itself has its own relationships, but space is empty and without relationships.

The object is a limited space with relationships.

The object (form) is produced through line.

Color characterizes, alters, or animates the object, or aesthetically annihilates it. This is also true of things in nature (a red field of grass). Utilitarian objects permit freedom insofar as they are not traditional in character.

Thus we have the two factors of the plastic: form and relationships.

Everyone knows that various forms have various expressions. The same is true for the relationships of these forms within themselves and among one another.

But not everyone studies this in the continuous way which is absolutely necessary in order to create an aesthetic whole corresponding to the practical demands of the time. There is an aesthetic logic that can be known only through the comparative study of forms and relationships. There are laws, inescapable limitations, but there is also freedom.

Freedom is necessary because of the differences between individuals.

There is universality, because basically all is one.

Differences and similarities, but always the same laws.

The same laws are realized in varying degrees in plastic expression. There is a scale in plastic expression that varies with the nature of the individual. But freedom is always relative and resides in the combination of the two. Truths always remain the truths of both form and relationship.

The organic, the useful, and the aesthetic require "tension" of line (bridges) and intensity of color (posters). They involve load and support: the two fundamental oppositions.

The degree to which these are manifested depends on *purpose* and personal conception.

To the extent that this opposition is harmonious, the object is equilibrated. But this equilibrium still creates a "thing."

The "thing" must be annihilated by multiplicity in order to be destroyed as something separate. A building is not a totality. A city is more of a whole—everything is relative. In a building there are rooms: the rooms form the building.

This resolution into a complete whole is dynamic equilibrium. It annihilates the static equilibrium of the "thing" alone.

Dynamic equilibrium arises through relationships. The nature of this equilbrium is determined by the forms and colors.

Their rhythm creates dynamic equilibrium.

We can distinguish forms and relationships:

1. from fantasy

2. of natural or human creation

3. of geometric forms

The forms are constructed by lines and colors which can be similarly distinguished.

All forms, lines, and colors have a plastic expression . . . although they are on a flat plane and expressed in a planar way . . . the plastic is not limited to three-dimensional structure. By plastic we understand that which "creates an image."[2]

The forms, colors, and lines of no. 1 can be purely plastic as long as they do not

express objects. Those of no. 2 are never purely plastic, precisely because they do. Those of nos. 1 and 3 can be relatively purely plastic, if they are composed in multiplicity so that their particular character is lost.

A naturalistic representation thus can be as plastic as one of geometric forms, the difference being that natural objects immediately suggest more to us than geometric: that is, they are more individual. Therefore, geometric forms and lines and pure colors are preferable.

Conclusion

Whatever creates limited form is not purely plastic. In the traditional academic sense, "plastic" means to create forms.

Separated lines or colors independent of one another are thus the most purely plastic, but they are not constructive when [they are] properly seen as hovering [indeterminately] in space. This can be resolved in painting but not by [naturalistic] realism.

But form is created because the ground constitutes a whole on which things are detached as particularities and therefore [it] does not have unity. This can be resolved: (1) by breaking it with line and color, (2) by causing the lines to intersect each other. Of course, limited forms seem to result, but because the limiting line is continuous, there is openness despite the limitation. However, some forms, such as the circle, become closed off into separate wholes in which no intersection is possible. The greatest openness is produced by mutually intersecting perpendicular lines, for these never meet, never become closed.

The former type of composition is no more than decoration without *personal expression*. Personal expression is necessary if the work is to be sustaining and moving.

The quality of emotion created depends upon the depth of the personal expression.

Consequently, human expression can be purely plastic only if it is not limited by "saying something," for we then approach the domain of literature. But pure plastic demands that the rhythm of forms, lines, and colors speak for itself. Rhythm arises through the relationships of the plastic means.

Practical Instruction—Planes[3]

Achieved by free experimentation on the part of the student

I. *Form and Color*

1. an expression of lines and forms from fantasy in relationships of fantasy

colors

2. the same with a single form; with varied forms
3. with geometric forms and lines

colors likewise

4. the same, with a single kind, with several kinds
5. with geometric lines

colors likewise

6. the same, with a single kind, with several kinds

separate (unconnected)
intersecting (connecting)

constructive

Study of equivalence and equilibrium by relationship of dimension. Conclusion: exact relationship [leads] to architecture. But its consequence can develop just relationship.

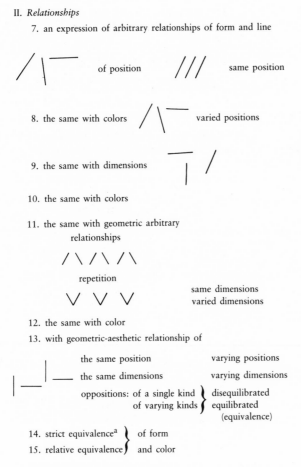

Art teaching begins at school and ends at the academy. At school students receive the fundamental instructions which, for [a] long or short [period], determine their conceptions and direct their feelings about "art."

At school students are taught how to establish forms correctly. First simple, then more and more complicated forms, geometric forms, natural forms, and their composition, then discussion of proportions, and a little of mutual relationship. But always "forms" are the objective. Whereas a child begins at home to "express himself" or to represent the impression of "what he sees" (very mixed actions), at school more and more he tends to the establishment of "what reality represents to everyone."

Thus the drawings become similar and without personal or deeper expression; clever draftsmen or painters can be formed—but not artists. Of course, the school does not intend to form them [artists], but the influence of school teaching is not easy to change.

That this influence is fatal to art becomes clear when we understand that art must grow out of the reciprocal action of artist and reality and that this is what leads to the *transformation* of reality's aspect. This is not permitted at school, and is allowed at the academy only to a very limited degree.

The academy more or less develops what is taught at school. And in this way, notwithstanding the admirable capacities it cultivates, the academy is fatal to the creation of "art." Real artists detach themselves from its influence but it is a long time before they find their own way.

Because of all this we find that there is no equivalence in the teaching of forms and of their relationships. Form is put first, if not above everything else. At the academy there is a separate course in composition, but the study of form receives most attention. Modern art has shown very clearly in abstract art that form stands in the way of the study of pure relationships. It has shown that relationships can only be studied when *form is decomposed and reduced to its fundamental elements*. Here it must be remarked that the school does just the reverse: school begins with the elements and ends with the *construction* of forms—and the academy aims at *perfection* of form. Modern art has revealed the great truth that is in all art: it has shown that only *line, plane, space, color, and relationship are the expressive means of art*.

The academy has lost sight of this truth or veiled it in its search for form perfection. Not until the principal claim of art is realized, thus when *limited form* is broken (decomposed), will art be free to establish itself.

[a] is clearly expressed in architecture.

The academy has to cease teaching the establishment of limited form, and its comcomitant, natural color. School also, for it is the birthplace of conceptions.

Since there is a need to construct forms in present practical life, special schools must remain or be created, but they should be exclusively for this purpose, separated from art and all aesthetic conceptions.

New Teaching Program

1. Expressive means:
 plane forms, plane spaces, and their determinations: lines, colors, and noncolors.
2. Proportions and mutual relationship (relationship of position and of dimension)

Planes and Space[4]

A single plane stands as a "form" in a vague space: *a*

Several planes determine the space more but not completely: *b*

Space completely determined (space and colors equivalent: thus unity): *c*

Single plane, no exact relationship, neither with space nor forms: *a*

Exact relationship between two planes and vague relationship with space: *b*

Exact relationship between forms and space: *c*

Exact relationship: *a* Inexact: *b*

Conclusion by Teacher[5]

Fantastic relationship risks being unbalanced
a: can be only relatively balanced.
b: can be equivalently (exactly) balanced.

Decomposition of forms. Abolish their particular appearance and create proportion and mutual relationship.

Only figure *a* enables exact relationship.

Construction with fragments: *a* and *b*

a: free, for there is no exact relationship;

b: bound, for there is exact relationship.

Viewed plastically, there are *no lines without planes*.

Plastically lines are *determinations and limitations* of *planes* (*a* and *b*). These planes determine the empty space. Their reciprocal mutual action establish[es] the aesthetic expression of it. Space and objects become planes of color or noncolor. In this way [we have] complete unity of space-object. Technically art is not only determination of space through planes but also expression of the mutual and reciprocal action of these planes.

Natural space is *empty* without determination as stars, moon, hills trees, houses, man in it. It is the same in [the] plastic. Determination is necessary to create pure relationship; to recreate the vague in [the] concrete. But [the] plastic in art must not follow nature. There [in art] determination establishes itself through planes, for it requires pure relationship.

Any line made in empty space divides it in *two parts*:

This in figure *g* is indeterminate; for the lines are not complete.

More lines in a plane divide it into more parts [figure *h*]. Expression remains vague; space is not determined.

Viewed in the way of art-plastic, lines are part of planes, established or not.

a: established *b*: not

In art-plastic lines are determinations or limitations of planes. This can be in harmonious or inharmonious ways.

b: determination of *c*: limitations
empty plane of plane.

In plastic art planes and not lines determine the empty space.

In nature and in naturalistic art these planes are in relief.

In nature and in naturalistic art *no pure relationship is possible*.

If plastic art is to establish pure relationship, it must not follow nature.

In painting it must keep to the planeness of the canvas, in sculpture and architecture it must create planes by moving around the work so that no perspective vision establishes itself.

Plastic art must create planes. In ultimate consequence it must do this in pure relationship to the canvas.

Natural space is empty without determination of that space in it (stars, moon, hills, trees, houses, etc.).

a: empty *b*: determined

In plastic art it is the same. But when pure relationship is required, the *determination must be exact.*

Lines in empty space divide it completely or incompletely.

z and *x*: incompletely
h and *y*: completely

Any line drawn in a plane *changes its expression*: figure *a*.

It *abolishes the plane.*

Viewed in the way of art-plastic, lines are part of planes, established or not.

c is no line, for it is part of another plane.

A plane is exactly determined only *when the lines forming planes end in the circumference.* Figure *x*: *d, e, f, g.* (This only in Neo-Plasticism.)

Plane *y* is not completely determined by *h, i, j.*

Viewed plastically, there *are* no so-called "plastic" (3 dimensional) forms.

Until here [now], plastic is not determined [defined] as it ought to be, as "forming an image," but as "modeling an object" (thus 3 dimensional).

Plastically this is an error. This error is the cause of the weakness of naturalistic painting and sculpture.

An object viewed plastically *loses* its perspective aspect by the fact that it then is seen not from one side but *from all sides separately* ([by] moving around it). In this way, by (the) moving around [it], an object becomes *a series of plane-expressions.* This for sculpture and architecture. Architecture *is not a combimation of prisms,* but *a composition, an intersection of planes.*

Misunderstanding has created *frontal style* or *block composition.*

Only the plane can establish *pure relations and forms.*

In painting, the canvas requires plane forms. Only through the straight line [can] pure relationship [be] establish[ed].

Technically, plastic art is not only the determination of space through planes but also the aesthetic expression of the reciprocal and mutual action of planes.

A New Religion?
(ca. 1938–40)

Written in pencil in a small notebook, this undated manuscript in English was probably sketched during the early part of Mondrian's stay in London, which extended from 1938 to 1940. It appears to be related to the ethical concerns of "Liberation from Oppression in Art and Life" (1939–40).

In this time of predominant materialism, men of good will and pure thought are asking themselves whether humanity does not need a new religion.

They see traditional religion annihilated by Nazism and Sovietism and replaced by a religion of state, work, and daily life.

It is important to explore this state of affairs. Seen superficially, it might seem that the Nazi-Soviet new religion can create a better life, better men. But then we see that the Nazis and Soviets take account only of daily life, which is only a part of life.

In earlier articles, I already showed that actual life is not a pure expression of "Life." We have stated that Life is All in All. Now we can state that to follow Life is true religion. Then we see that by taking daily life as religion we create a false religion. We have to transform incomplete daily life into the pure expression of Life, which is complete in itself.

The past personified Life and called it God.

But it also put its essence outside daily life. It is clear that in the Nazi and Soviet way it never can be brought back into daily life.

Life expresses itself in daily life to the extent that it is free of all oppression. The new Nazi and Soviet religion is oppressive, just like the old traditional religion. Logic is false if it [merely] expresses the development of events in time. Logic is an indispensable means to express Life's manifestation in time. Then the true logic of Life unveils itself.

Then we see the great Laws of Life.

These laws impose upon us what can be called a new religion; a new morality is created.

For this religion and morality are not merely the old religion, the old morality free of all oppressive veiling; they now become *living reality*.

Thus it is better not to speak any longer of religion or morality but only to *follow Life's pure expression*: to obey its Laws—to realize these laws in daily life.

Those who cannot see them have to follow those who can see. Not by oppression, but by the necessity created by pure forms and pure relationships, by those who are able to see the laws.

Men revolt against religion when it *oppresses* them.

Faith remains: faith in Life. But it grows out of inner life and no longer comes to us from outside. It is what it was in the "*fond*" [the depth] of all religion.

But this is the domain of darkness for us.

It is the great inner power that strengthens us where reason cannot see.

It is one with intuition, which guides us when we are not oppressed; that makes us *feel* truth.

Intuition makes us feel what is right.

Reason realizes, finds out the laws.

The new religion without churches is the old religion *free of all oppression.*

The new art is the old art *free of all oppression.*

Modern buildings which evoke the sense of beauty replace churches.

In this way art becomes religion.

The new religion is faith in life.

The new religion is for those capable of abstraction. For Realists like to have a concrete idea of God.

New life—is actual life so bad? Yes and no. It is a mixture. Real human life is there, but is oppressed by all sorts of things.

The highest state of progress is generally misused; few appreciate it, see it in its true value.

Life as beauty could exist at present if there were freedom in the real sense of the word: if there were no oppression. The certainty that the beauty of Life is to be enjoyed and found in this *present* life is our great joy. It gives us the strength to seek our happiness *in this life* despite all, to struggle— always to create "better."

Liberation from Oppression
in Art and Life (1939–40)

"Liberation from Oppression in Art and Life" was begun ca. 1939 during the London "blitz" and completed in December 1940, about two months after Mondrian's arrival in New York. Intended for *Partisan Review* (but withdrawn by Mondrian when he was asked to shorten it drastically), the essay first appeared in the volume of Mondrian's essays in English, *Plastic Art and Pure Plastic Art* (1945). On 13 February 1940 Mondrian wrote to Holtzman from London: "I am making a short article by impulse of the actual world situation; I am trying to make clear that art shows the evil of nazi—and communist—conceptions. . . . The article would be useful for America too."

This manuscript, dated May 1940 and entitled "Art Shows the Evil of Nazi and Soviet Oppressive Tendencies," was the first formulation of "Liberation from Oppression in Art and Life." Its opening section (included here as an introduction to "Liberation from Oppression") was subsequently deleted by Mondrian. In New York he told Holtzman that he was withholding direct mention of the dictatorships, as the U.S.S.R. had become an ally against the Nazis (in July 1941). The Soviets had endorsed abstract art (Constructivism, Suprematism) earlier in their regime, and Mondrian preferred to "wait and see what will happen after the war."

Art Shows the Evil
of Nazi and Soviet
Oppressive Tendencies

Introduction

The evil of Nazi and Soviet oppressive tendencies—long obvious to the whole world—is now a terrible "fact." Reality has manifested this evil, writers and thinkers have shown it in all its depth and have considered its consequences. Although at present the destruction of these actual oppressive powers is most important, all that can help to unveil the evil of all oppression is useful to present and future. Evil must be seen and well understood unless it is to continue in another form after the war. Destruction is followed by construction. It must be seen now as it really is, if it is not to create false pessimism or false optimism. It must be observed in all aspects of life.

Plastic art is a free aspect of life. *Not being bound* by physical or material conditions, it does not tolerate any oppression and can resist it. It is disinterested, its only function is to "show." It is for us to see what it reveals.

It cannot tell anything new, but its presentation can evoke conviction.

In these dark days, concentration on the evil of oppression in its deeper sense is difficult but necessary. Amid a terrible reality it is difficult to think of our future. Pessimism comes over us: seeing actual events, confidence in life's progress weakens. Where to find, in spite of all, a true optimism about humanity's future?

Plastic art, in its culture, can enlighten the future of mankind.

If we see the culture of plastic art as continuous growth toward the full realization of its freedom, which contains a struggle against oppression, then one way for optimism is open.

However, the first thing to understand is that art is not mere entertainment, an enjoyment amid daily life, or a simple expression of that life, but an aesthetic establishment of complete life, unity—free from all oppression in general.

We feel the complete life that art establishes as the pure expression of life (*élan vital*). We see this life in art as dynamic movement-in-equilibrium.

Art's culture reveals it to us as continual growth, irresistible progress.

Daily life is "life," but oppressed by all sorts of things. Therefore, it is not the complete life that we enjoy in art.

Many do not see art and human life as continual progress. They see it only as continual change.

The Facts. Art Killed

It is generally known that not only have a great many works of modern art been rejected by German and Soviet rulers but that these rulers exercise a tyrannic censorship over actual art production. It is known that they have viewed art as their propaganda, using it for political education. But the fact that in this way the progress of art is stopped, therefore killed, is not always seen.

The Soviets were the first to tyrannize art. While at the beginning of the Russian Revolution, modern art also was seen as a revolution and therefore was accepted, soon afterward it was rejected as not being "real." They did not see modern art as freeing itself from passing events and feelings, capable of establishing a more true reality. It is evident that when art is forced to be a representation of daily life in its common aspect—directly understandable by the mass—then modern art's free vision is not acceptable.

Certainly, daily life is our reality. But at present—apart from the actual war!—it is incomplete. At present, daily life is not an expression of life in its fullness: there is no balance between material and moral terrains. If the Soviets intended to improve daily life by creating better material conditions, better education, of course they were right. But is this possible by protecting only one class and tyrannizing another? By the glorification of "work" and the degradation of art?

Later than the Soviets, Nazi rulers exercised an analogous tyranny in Germany. Before the Nazi dictatorship, art in Germany was as free as anywhere else. Modern art was rejected or appreciated according to individual feeling and conception—just as in the rest of the world. The most modern art was not only in private collections but was also acquired by museums. However, the most advanced art was imported from abroad or created by foreign artists living in Germany. Some of them already had fled from Russia. Then tyranny cut all off.

Nazi leaders claimed to purify art, to bring it back to its classic value. Art production was censored, modern art ws chased out of the country.

Nazi leaders dictated the way art had to go. Whereas its way is continual progress, art had to retrogress.

It lost its living value: modern artists had to leave Germany if they would continue their work.

Fortunately, the world is greater than Germany: art continued its way.

Not all the works doomed in Germany are lost. Pictures expelled from German museums now hang in a New York museum.

Never before has art known such constraint as Soviet and Nazi domination imposed.

History reveals despotism in state and religion—even in science (Galileo)—but art was free.

Despotism, arising from egoism and fear, did not fear art. In the past, art itself was more or less veiled by oppressive factors—it was often in the service of state and religion. Plastically, art's freedom was not so manifest as in our time. Plastic culture was halfway.

Liberation from Oppression in Art and Life

In the present moment, oppression is so clearly evident that everyone must regard it as one of the greatest evils. But does everyone see this evil in its real significance, in its positive and negative factors?

Events pass, but oppression remains as long as it is not individually and actively opposed by an equal force. To be opposed, it must be viewed realistically, observed and studied. It must be basically understood, if it is not to continue in new forms. Destruction is followed by construction.

Especially at present, it is important to see that throughout the course of history, human culture is constructive. This is its essential action. But each epoch always has and always needs its oppositions of destruction and construction.

In all ages, oppression destroyed culture and life—at least for a time. At any time, oppression robs us of the individual and common freedom necessary to cultural construction.

Freedom constitutes our personal well-being as well as the well-being of the whole of society: it constitutes life. Oppression retards human progress: the constant movement toward the better, the deeper, the more intense—toward the balance of destruction and construction. However, oppression also creates by its negative action; it strengthens opposition to itself. The result is freedom.

Human life is oppressed by internal causes—both physical and moral—as well as by external factors. It is necessary to fight against both. All that can help us to understand the evils of oppression is useful to present and future. Therefore, it is essential to demonstrate that plastic art can help to clarify this evil.

Plastic art shows that in life and in art, we experience objective oppression from the reality around us and that we suffer subjective oppression from our personal, limited vision. Plastic art reveals to us that in order to vanquish objective oppression, existing elements and forms must be selected carefully, or if possible, transformed. To master subjective oppression, the transformation of our mentality is needed. To accomplish this, human development, time, experience, education are indispensable.

To the layman, it may seem strange to hear that the culture of plastic art shows a progressive liberation from oppressive factors. Actually this statement is based on technical facts revealed to artists through their practical researches. A real comprehension of plastic art can only be obtained through a technical understanding. The technical aspect consists in the use of the expressive means—volumes, planes, lines, colors—and in the development of these expressive means toward their pure state.

Although the evil of oppression is clearly manifested in life, it is not always clearly discernible in relation to its basic causes, for it is veiled by all manner of particular complications in the appearance of things. This also applies to art. If art follows life or nature in terms of representation, oppression disguises itself in all kinds of particular forms and relationships, and therefore seems nonexistent. But in art, time and movement are fixed; thus contemplation is easier and oppression can be studied in a purer way.

Because of its camouflaged appearance in life and in art, there is the danger of accepting oppression; oppression does not always cause revolt. Does there not exist in human nature this powerful opposition: the desire for oppression and the desire to be free of it, this opposition which causes that long and continual struggle that life and art show until human equilibrium is neared?

Plastic art is an abstract, a free domain of life; the causes and consequences of its expression are purely for study. It does not tolerate oppression and can resist it, for art is not bound by material or physical conditions.

Writers and thinkers have deeply explored the facts and the causes of the tragic realities created by oppression. Art has been used for immediate and personal purposes: it described events, persons, battlefields; war camouflage and propaganda were made. But the function of plastic art is neither descriptive nor cinematic. It is not merely a means of enjoyment amidst an incomplete life, or a simple expression of that life even in its beautiful aspect. All this is incidental.

Art is the aesthetic establishment of complete life—unity and equilibrium—free from all oppression. For this reason it can reveal the evil of oppression and show the way to combat it.

Plastic art establishes the true image of reality, for its primary function is to "show," not to describe. It is up to us to "see" what it represents. It cannot reveal more than life teaches, but it can evoke in us the conviction of existent truth. The culture of plastic art can enlighten mankind, for it not only reveals human culture, but being free, advances it.

When we view the tragic events of war, pessimism overtakes us and makes it difficult to think of culture. The effect of actual events weakens our confidence in the progress of life. Where is to be found, despite this, a true optimism concerning humanity's future?

If we are able to understand the culture of plastic art as a continuous growth toward the full utilization of its freedom to express pure life, then one way to optimism is open to humanity. The culture of art reveals to us that life is a continual growth, an irresistible progress. In spite of all, human culture must

manifest what the culture of art demonstrates: continual progress. But subjective factors prevent this from being seen. It is seen only as continual change.

Through its culture, plastic art shows a growth toward the culmination of limited form, then a *dissolution of this form and a determination of the freed constructive elements* (planes, colors, lines). If we observe this fact, we can conclude that our whole culture equally reveals the same process.

The question whether this process in life and in art is a progress or a decay is answered when we consider that it is the *liberation of life and art from all obstacles toward a clearer manifestation of their real content*. This is not merely a reduction or elimination, but it is an intensification. This freeing is an abstraction; it is a realization. In abstract art, we see this clearly. There the elements of form are no longer veiled by the limited form but appear as the *expressive means*. This fact is undeniable progress. For all art reveals that limited form is narrative, symbolic, and that its constructive elements— planes, colors and lines—establish art. Nevertheless, from the naturalistic viewpoint, the loss of limited form is decay. We find analogous decay in life; at first, the diminution of the physical force of man; then the fact that humanity as a whole differentiates itself from natural primitive life. In spite of this, humanity is developing, but is it recognized sufficiently that this is due partly to facts which appear as decay?

We can conclude that plastic art shows a *double action* manifested in life and in art: an action of decay and an action of growth a progress of intensification and determination of the fundamental aspect of forms, and a decay through the reduction of their external aspect. Art and human life show that this reciprocal action does not destroy but manifests the intrinsic value of form. By establishing greater equivalence of the oppos-

ing factors, a possibility of approaching equilibrium is created.

When we think of the masterpieces of the past, this statement concerning progress may seem to be untrue. But then it is necessary to see that in art the *culture* of *particular forms* is culminated and completed, and that art has undertaken *the culture of pure relationships*. This means that particular form, freed from its limitations and reduced to more neutral form, can now establish purer relationships. Art is freeing itself from oppressive factors that veil the pure expression of life. What is true in art must also be true in human life.

It must be stated that plastic art contains two co-existent cultures: that of limited form and that of relationship; they develop together until the oppression of limited form is ended. When the elements of form become more or less freed, then relationship becomes a special culture. This change is created by *the whole of modern art* but is realized in abstract art.

The principal preoccupation with the relationship of more neutral expressive means is clearly manifested in all modern art. Whatever our conception may be, this change must be recognized. Only this recognition can prevent errors. It must be equally recognized that an analogous change must have taken place in life.

Throughout history, human life, oppressed by material and physical factors, by particular forms, frees itself from these factors by means of the purification of these forms as well as by the determination of these relationships. The changing conditions of human life in experience, education, science, and technics are reducing the brutish, primitive force of Man and are transforming it into a real human force. A less animal physical constitution and a stronger mentality is making Man more "human."

Progress is a continual "real" change.

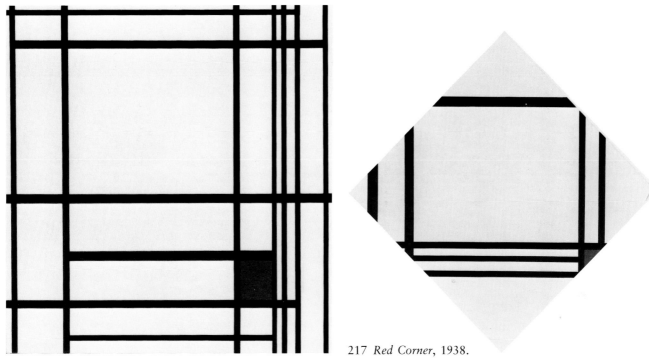

216 *Composition with Blue,* 1937.

217 *Red Corner,* 1938.

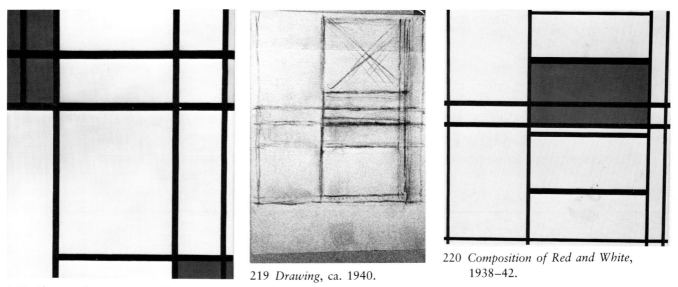

218 *Abstract Composition,* 1939.

219 *Drawing,* ca. 1940.

220 *Composition of Red and White,* 1938–42.

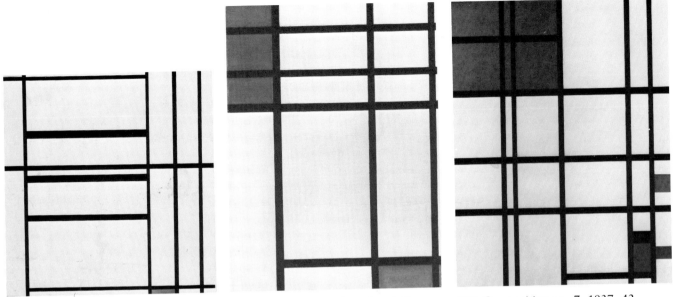

221 *Composition, 1939.*

222 *Composition with Red and Blue,* 1939–41.

223 *Composition no. 7, 1937–42.*

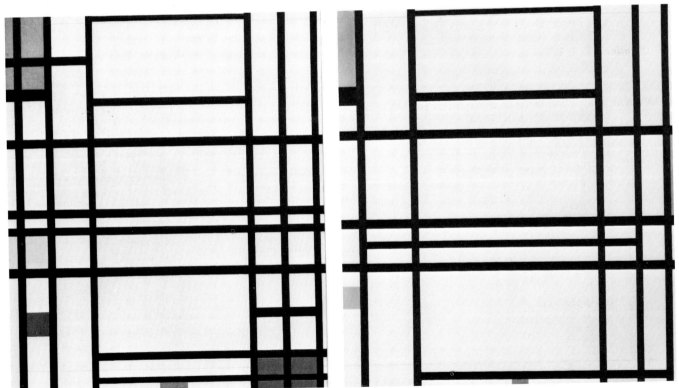

224 *Composition, 1939–42.*

225 *Composition with Red, Yellow, and Blue, 1939–42.*

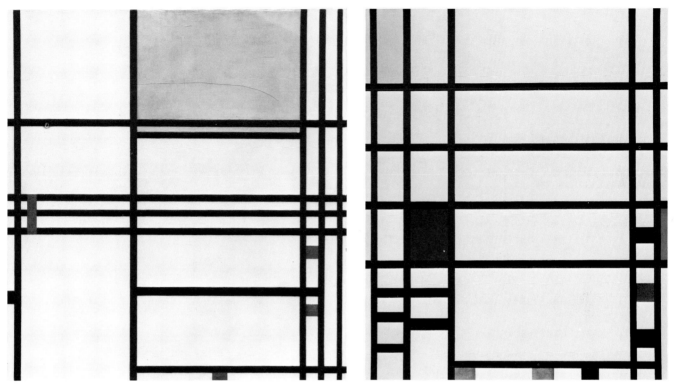

226 *Painting no. 9, 1939–42.*

227 *Trafalgar Square, 1939–43.*

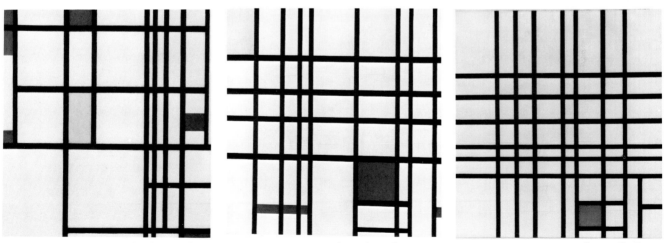

228 *Composition in Red, Blue, and Yellow, 1937– 42.*

229 *Composition with Red, Yellow, and Blue, 1938–42.*

230 *Composition 12 with Small Blue Square, 1936– 42.*

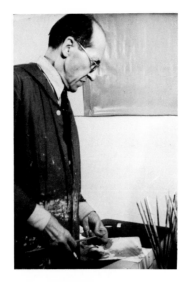

231 Mondrian in his studio, New York, ca. 1942.

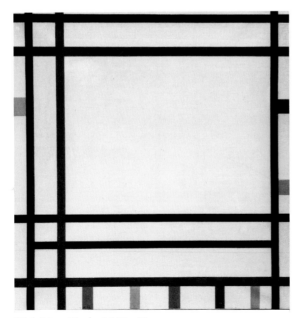

232 *Sketch for a Composition*, London, ca. 1939–40.

233 *Place de la Concorde*, 1939–43.

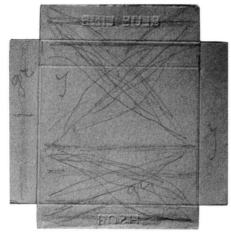

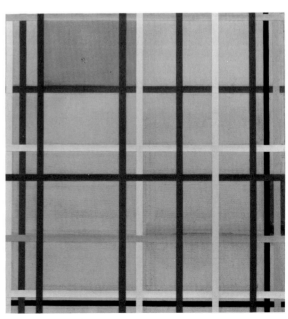

234 *New York*, 1941–42.

235 *New York—New York City*, 1941–42.

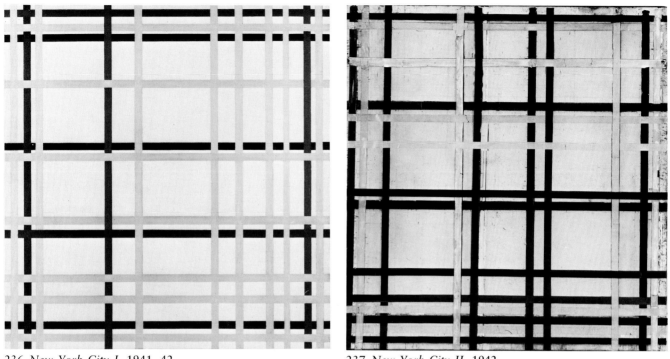

236 *New York City I*, 1941–42.

237 *New York City II*, 1942.

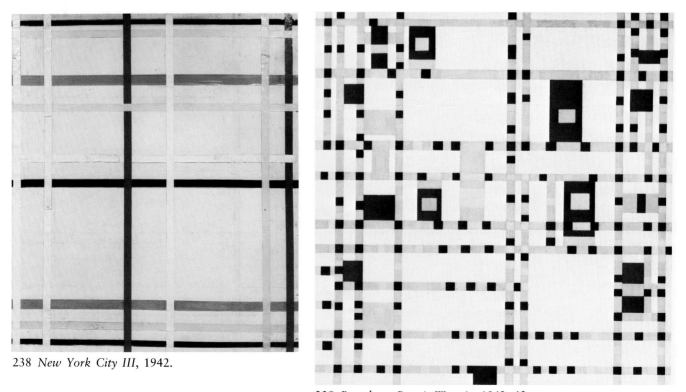

238 *New York City III*, 1942.

239 *Broadway Boogie-Woogie*, 1942–43.

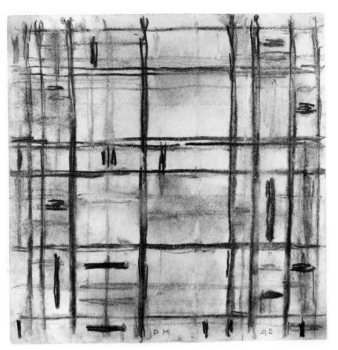

240 *Study I: Broadway Boogie-Woogie*, 1943.

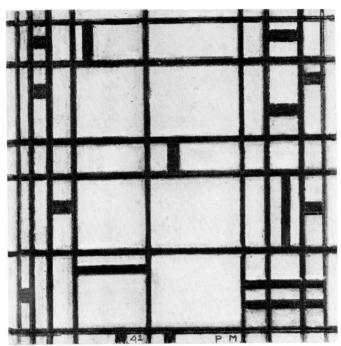

241 *Study II: Broadway Boogie-Woogie*, 1943.

242 Mondrian, ca. 1940–41.

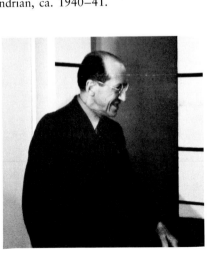

244 Mondrian with Harry Holtzman, in Holtzman's studio, ca. 1940–41.

243 Mondrian in Harry Holtzman's studio, ca. 1943.

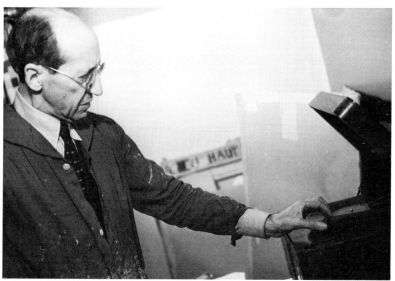

246 *Composition Study for Victory Boogie-Woogie*, 1943.

245 Mondrian in his studio, 1942–43.

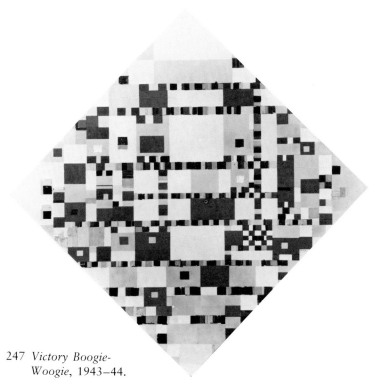

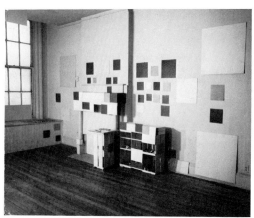

248 Mondrian's studio, 15 East 59th Street, New York, October 1943–February 1, 1944.

247 *Victory Boogie-Woogie*, 1943–44.

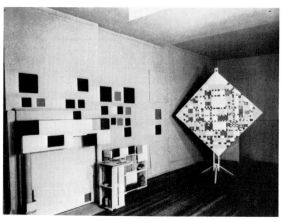

249 Mondrian's studio, 15 East 59th Street, New York. East wall, with *Wall Works I, II,* and *III,* and *Victory Boogie Woogie.*

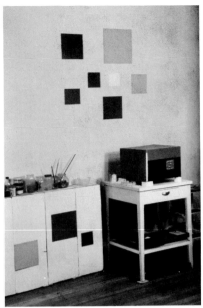

250 Mondrian's studio, 15 East 59th Street, New York. West wall, with *Wall Works VI* and *VII*.

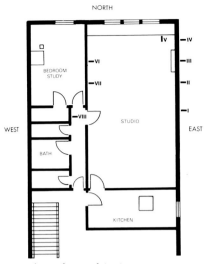

252 Plan of Mondrian's studio, 15 East 59th Street, New York, 1943–44, showing location of the *Wall Works*.

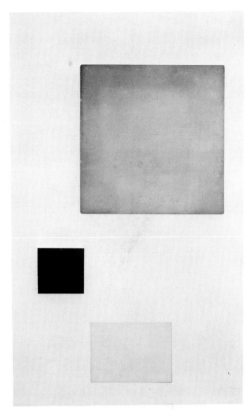

253 *Wall Work IV*, 1943–44.

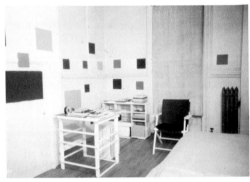

251 Mondrian's studio, 15 East 59th Street, New York. Bedroom/study.

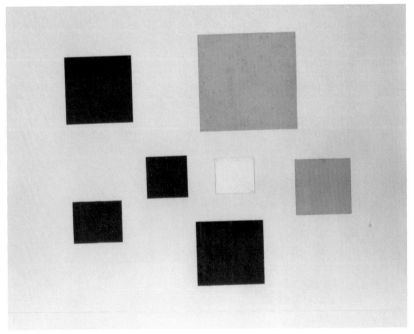

254 *Wall Work VI*, 1943–44.

Every new period appears as a sudden mutation after a long evolution by construction and destruction. In the line of progress, modifications are important and necessary, but insufficient. Possibilities of expressing the content of life in a stronger and purer way are to be created. New possibilities astonish the masses but the masses have helped to create them.

Progress for humanity consists in the conquest of oppression; it parallels the progress of art. Oppression destroys itself but not without humanity's continual struggle against it. At present, we see the facts of mutual oppression: political, economic, domestic. Art suffers from the ignorance of the public, educated by incompetent writers, critics, teachers, museum committees, etc. By the study of the forms and relationships that art and life show, the complicated causes and consequences of all oppression can be understood. Then we can see the necessary function of oppression.

The Art of the Past and Modern Art

We have to see whether modern art is really progress or decay. We must compare both the new and the old expressions in the culture of plastic art. But where is the boundary between *the old and the modern?* If we follow the development of plastic art from the past to the present, we see *a gradual detachment from the natural vision and a progressive determination of the real expressive means.* We see no sharp division between the art of the past and modern art. The two expressions dissolve into each other, until in modern times, *a real difference of expressive means*—forms, colors, spatial relationships—is created.

However, everyone feels a difference in the conception of the two expressions, even when the subject in both is identical. It cannot be otherwise, because the men of the past, living under quite different conditions, obviously must have had different conceptions. Much that was veiled in the past is now clearer. Plastic art, as well as life, makes this apparent. Human culture—science, technics, the whole of our daily life—has developed with this result: it has created another reality out of the past. Plastic art, as well as life, is emerging from ignorance toward understanding. If this statement seems contradicted by destructive events, both art and reality reveal that it is nevertheless true. But we must remember that life, which is continuous growth, is free from time and space, and that it creates through destruction and construction.

For modern man, the great art of antiquity reveals itself more or less as *darkness,* even when it is not dark or tragic; a white marble statue expressing peaceful, dreamy romanticism, a devout religious conception, can be as oppressive as a dark, murky picture.

In general, all particularities of the past are as oppressive as darkness. The past has a *tyrannic* influence which is difficult to escape. The worst is that there is always something of the past *within us.* We have memories, dreams—we hear the old carillons; enter the old museums and churches; we see old buildings everywhere. Fortunately, we can also enjoy modern construction, marvels of science, technique of all kinds, as well as modern art. We can enjoy real jazz and its dance; we see the electric lights of luxury and utiility; the window displays. Even the thought of all this is gratifying. Then we feel the great difference between modern times and the past.

Modern life and art are *annihilating the oppression of the past*. Progress in communication, production, concurrence in trade, the struggle for livelihood have created a lighter

environment, even where the inevitable remains of the past dominate. Electric signs, posters, technical constructions of all kinds, compensate for the dearth of new architecture.

In war many relics of the past are destroyed, among them many beautiful specimens of art. Obviously it is hard to see beautiful things disappear. But life, as continuous progress, is always right. Eventually another environment nearer to our present mentality will be created. But where? In the same places? In the same countries? It is important to understand that the *new constructions must not be created in the spirit of the past; they should not be repetitions of what has been previously expressed.* It must become clear that everything should be the true expression of modern times.

Like our environment, modern art reveals change. All modern art shows a conception that conforms to the time, and this is true even of the academic art which continues to express itself in the traditional way.

It would be erroneous to limit modern plastic art to narrow frontiers. Two principal expressions exist: one of them uses more or less *naturalistic forms and colors*; the other employs more or less *purified means of expression.* These two expressions appear under different names, but all names are approximate, partial, and therefore misleading.

It appears as though these two expressions oppose each other, but when we observe that in different ways both show the same search for freedom, then we see their unity. For all modern art reveals a *liberation from the oppression of the past.*

Modern art rejects the methods of expression used in the past, *but continues its real content. It continues what the art of the past began: the transformation of natural vision. What the art of the past accomplished more or less invisibly due to the oppression* *of the epoch, modern art accomplishes more visibly.*

All the art of the past shows an exaggeration of the tension of lines and forms, changes in the natural colors and proportions: a transformation of reality's natural aspect. Art has never been a copy of nature, for such a copy would not have been strong enough to evoke human emotion. The *living beauty of nature* cannot be copied: it can only be *expressed.*

Modern times create a greater transformation of reality; sometimes by means of freer composition, freer colors and forms (academic art, realism, surrealism) and sometimes by a more consequent transformation of forms and their relations (abstract art). Bound together by unchangeable plastic laws, the different tendencies of modern art continue the struggle for a more real establishment of the true content of art. But to accomplish this, freedom is necessary.

Art and Life Need Freedom

Plastic art shows that whatever conceals its real content *suppresses* art. Art's *progress* contains and therefore requires deliverance from this oppression. The culture of art is the *continual search for freedom.* As in human life, it is *continually in search of freedom of thought and action.* But human culture is long and complicated by the fact that men are individual and different and new human beings are continually being born. *Each new generation has to obtain its own experience,* to begin its *individual culture from that point which progress has already reached.* The choice seems to be between past and present, but in reality *progress must be followed.* It is obvious that because of the inequality of men, *simultaneous, equal progress is impossible. But progress continues—it does not wait.* Fortunately everything is moving in a more

accelerated tempo, for the light of modern times makes the way clearer.

The inequality of men is also manifest in art and is an obstacle to simultaneous progress. Artists are mutually different and new artists continually come into being. Instead of continuing and developing art's real progress, young artists would seek for something "new." But because art is intuitive creation in a free domain, all obstacles are more easily overcome than in life.

It is right that a new generation should be opposed to convention and go its own way. But there is a danger when there is conflict with existing progress, and this is what often happens in art and in life. Conflict arises out of personal convictions and personal interests, and thus progress is delayed. The inequality of men does not, however, involve the degradation of society. As long as freedom exists, progress can be continued. This does not mean that egoism is excluded. To a certain degree, the difficulty of maintaining and creating an existence and livelihood requires it. Particular interest is one of the factors that prevents social life from being free. Art is disinterested and for this reason it is free.

Humanity is constantly developing toward freedom. More and more, the world becomes conscious that unity must be created as in art; by the establishment of purer forms and purer mutual relationships. Time proves that humanity, despite all its deviations, is always moving in the right direction. Better social forms and mutual relations are evolving—the consequence of necessity. But as long as tyrannical powers seek to create a false unity by force, no better world order is possible. Humanity, as well as art, needs freedom. Just as in art, where freedom can be approached by equivalent relationships of varied forms, social life can approach freedom in spite of the inequality of men. But the culture of plastic art shows that real freedom requires mutual equivalence.

Plastic art shows that real freedom is not mutual equality but mutual equivalence. In art, forms and colors have different dimension and position, but are equal in value. In the same way, through greater mutual equivalence of individual elements, our life can be better than it is now. By its freedom, art always creates a certain mutual equivalence of its composing forms, and shows the need for this freedom in human life. However, because of the inequality of men, a certain constraint always governs our social life. Reality manifests that this can exist without tyranny. But the most important constraint is that which social life itself imposes upon the individual. For this a certain amount of individual development is needed.

The Real Content of Art

History, actual events, and above all, the real expression of plastic art clearly show the evil of oppression and the need for freedom. The problem "What is art?" cannot be solved by explaining our personal conceptions, for these will vary according to individual feeling. Actually, plastic art is manifested in two principal tendencies: the "realistic" and the "abstract." The first is viewed as an expression of our aesthetic feelings evoked by the appearance of nature and life. The latter is an abstract expression of color, form, and space by means of more abstract and often geometric forms or planes; it does not follow nature's aspect and its intention is to create a new reality.

These definitions are incomplete and often misleading. Even the most abstract art does not arise from an inner source alone. As in all art, its origin is in *the reciprocal action of the individual and environment* and *it is inconceivable without feeling.* Realistic art as well as abstract art is an expression of form and space: the difference results from different conceptions and the use of different

expressive means. In spite of particular definitions, art shows only one necessity: the expression of the beauty of vitality, which is obscured in life. Beauty is relative because men are different. The fact that the perception, feeling and conception of beauty continually progress, parallel with all progress, is too much neglected. Attachment to a merely conventional conception of beauty hinders a true vision of it. When the conception of beauty does not change in a progressive direction, there is something wrong in human life: it is either at a standstill or in regression.

Art is the expression of truth as well as of beauty. We do not know what complete truth is. We only observe many truths, all transient and changing. Plastic art shows us that the purest expression of truth is the purest expression of vitality; it is the most constant expression in art, the most free of subjective and objective oppressive particularities. As the aesthetic expression of vitality, pure life, all art is true, but it shows truth in different degrees of clarity. It is the same in human life. When self-interest stands in the way, truth is suppressed and life appears to degenerate temporarily. But the age-long culture of art shows that life destroys all that is untrue.

To make a descriptive definition of the deepest content of art is as impossible as it is to define the deepest content of life. Art is created through intuition. In our daily, social, and intellectual life, all of which are only partial expressions of vitality, intuition can lose its force due to many forms of oppression. But in art intuition is free, insofar as it is not oppressed by subjective factors.

In art, the expression of vitality—pure life—is that "something" which is identical in all art. That "something" is also revealed in Nature, in all reality. Due to different causes (such as changes of light) the appearance of nature and reality is not constant. In plastic expression, a work of art is constant. Vitality reveals itself as dynamic continuous movement in equilibrium. A study of plastic art shows us that it establishes dynamic equilibrium through a rhythm of forms, lines, and colors in a manner that evokes aesthetic emotion. It depends upon our individual conception "how" dynamic equilibrium will be established and "how" it will be seen. The expressive means by which the rhythm of forms, lines, colors is established are not only these, but also the empty space between them. Plurality of forms, lines, colors and empty spaces creates relationship. In single forms, the proportions of the different parts of these forms represent the relations that create rhythm. It should be emphasized that forms, colors, lines, spaces are as important as the relationships, and conversely, all means of expression determine the character of the rhythm. The same is true in social life: the constituent elements are as important as their mutual relations.

We have already seen that the culture of plastic art, from its origins, shows a progressive determination of relationships, until today relationship can be established only through the elements of form, purified color and determined space. On the other hand, we see a *progressive reduction of forms and colors* and a *growing determination of space*. This reduction of form and color—a freeing of form and color from their particular appearance in nature— is necessary to free rhythm, and consequently art. Clearer rhythm produces clearer equilibrium.

In nature, the appearance of things is so expressive, so "living," that the tendency is to feel only harmony and to ignore rhythm. If art is to give us the feeling of reality, it cannot follow reality's aspect. Art has to accentuate rhythm, but in such a manner that rhythm dissolves in unity.

The purest rhythm must be the purest expression of life. But seeing and creating are

always more or less subjective. In art, although the individual emotions are always differently evoked, all expressions of rhythm are true. But objectively, all particularities of forms and colors oppress pure rhythm. Whatever our feelings and conceptions may be, the culture of plastic art shows the way of progressive expression. This, however, can only assist us to strengthen our conception and to control our feeling—it cannot make us create Art. It is the same in life. Nothing can tell us what we have to do. Religion, philosophy, science and art express the general paths of human progress. These paths can be a help or a hindrance according to individual development but they cannot dictate this development.

The art of the past established rhythm not only veiled by subject matter and particular forms, but oppressed by the spirit of the Past. When we became more liberated from this oppression, Modern Art was born. In our time, rhythm is more and more accentuated, not only in art, but in mechanized reality and in the whole of life. Marvelously determined and full of vitality, it is expressed in real jazz, swing, and Boogie-Woogie music and dance.

As a consequence of the accentuation of rhythm and the reduction of natural forms and colors, the subject loses its importance in plastic art. For some, this fact is a gain; for others it is a loss. For some, the subject is a help; for others it is an obstacle to the enjoyment of the real content of art. Objectively, the subject is more or less tyrannical. It thrusts plastic art into literature, psychology, philosophy—narrative. To enjoy the pure plastic expression of a work of art, one has to rule out the psychological factors that the subject awakens.

All Modern Art is distinguished by a greater relative freedom from the oppression of the subject. Impressionism emphasized the impression of reality more than its represen-

tation. After the Impressionists all art shows a relative negation of Nature's aspect: the Cubists delivered a further blow; the Surrealists transformed it; the Abstract artists excluded it.

Whether obscured or clarified, rhythm expresses dynamic movement through the continual opposition of the elements of composition. By this means, plastic art expresses *action* in a real plastic way. It creates action by the tension of the forms, lines, and the intensity of the colors—and in this is its force. In art, we distinguish oppositions of position and dimension. The principal, the most exact, and the only constant opposition of position is the right angle, in which two straight lines are opposed. In all art, the function of rhythm is to prevent static expression through dynamic action.

In art, as in life, it is the *equivalence and not the equality* of opposite factors that creates unity. Art shows that difference in power and capacity exist and are necessary, but abuse of these factors is fatal. Art and life show that oppositions produce the continual destruction and construction of forms necessary to approach the establishment of complete life. In plastic art opposing factors annihilate each other in such a manner that there is no oppression: the result is unity. In human life, we see oppositions mainly as Good and Evil. The reciprocal action of these oppositions forms the rhythm of human life: it brings life toward unity. Thus, seeing Evil perform its purpose, the acceptance of it becomes obvious. But plastic art affirms that to create unity, we have to oppose Evil with what is called Good.

In plastic art we see the mutual oppression of forms and colors annihilated by the creation of mutual equivalent values. Whereas in art this is a moral struggle, in life, the struggle is physical as well. In life the physically strongest seems to dominate. How is oppression to be vanquished? How is

330 Part III: England and the
United States: 1938-44

equilibrium to be created? How are equivalent values to be established? Time must solve these problems. For those who can see it, the way is revealed in life and in art. Life being intrinsically in equilibrium, ends oppression through the resistance created by itself. Then a new and better life becomes certain.

The liberation from oppressive factors can be clearly seen in the development of architecture. In general, architecture of the past absorbed painting and sculpture in order to create works of art. In this way, architecture was oppressed by painting and sculpture, and painting and sculpture were oppressed by architecture. Modern architecture attempts to free itself from this oppression, compelled to do so by practical and economic exigencies. Through reciprocal action, it developed its essential character simultaneously with painting and sculpture. However, in this way, the purification of modern architecture has not reached the completeness necessary to satisfy our moral as well as our practical exigencies.

In order to reach completeness in a new way, modern architecture has to realize in its buildings the essential content of painting and sculpture. It must establish pure relationship through the pure means of expression: form and color. This signifies that it has to establish equlvalent proportions and not employ color merely as decoration, but as a constructive part of the building.

Transformation of the traditional means of enrichment—paintings and sculptures—is insufficient. These remain harmful to pure architecture. Displacing easel paintings with mural paintings is even a greater destruction of the architectural construction.

Only planes and volumes in pure color can conform to the new constructive means. To accomplish pure expression "painters and sculptors" are necessary, because the capacities obtained in painting and sculpture can lead to the completeness of the technical part of building.

For those who would live in this architecture, the existence of pictures and statues—and with them their oppression—would be ended. We can see "art" as the substitute that compensates for lack of beauty in life.

Abstract Art
(1941)

Dated November 1941, "Abstract Art," was prompted by Peggy Guggenheim's request for a short essay by Mondrian for *Art of This Century*, a catalogue of the collection of contemporary art that she had begun assembling in London shortly before the war.

To house the collection and promote contemporary work, in October 1941 Guggenheim opened her Art of This Century Gallery on 57th Street, New York, with an innovative design by Frederick Kiesler. When, after the fall of France, a powerful nucleus of Parisian artists gathered in New York—Fernand Léger, Marcel Duchamp, Max Ernst, and André Breton among others—Art of This Century became the focus of avant-garde activity.

The catalogue appeared toward the end of 1942: "To my great surprise," Peggy Guggenheim later observed, "it had become an anthology of non-realistic art covering the period 1910 to 1942." Two further essays, among other documents, represented the leading tendencies: André Breton's "Artistic Genesis and Perspective of Surrealism" and Jean Arp's "Abstract-Concrete Art."

Slight variations from the *Art of This Century* text (which was reprinted in *Plastic Art and Pure Plastic Art*, 1945) are based on the original manuscript signed and dated November 1941. The essay is preceded here by two shorter statements to which Mondrian had given the same title: the first from an undated manuscript; the second from a typescript with his handwritten corrections, dated October 1941.

Abstract Art (1941)

Many "abstract" artists protest against the denomination "Abstract Art." Some prefer the name "Concrete" Art. Certainly, Abstract Art is concrete because of its determined means of expression, and even more than Naturalistic Art. However, the denomination "Concrete" makes for confusion. Abstract Art is not concrete in the way of natural perception. The name concrete opens the doorway to natural expression, that of "abstract" emphasizes the universal expression of Art.

Abstraction is the reducing of particularities to their intrinsic universal aspect. However, through this action we do not produce Abstract Art. It is only the way through which the establishment of Abstract Art becomes possible. It makes the means of expression—volumes, planes, lines, color—more concrete. Observing this fact, it is clear that abstraction does not lead to a vague expression. It does not surpass the expression of substantial, palpable reality.

Abstract Art is in opposition with our

natural vision of nature. But it is in accordance with the plastic laws which in nature are more or less veiled. Abstract Art is in research toward the expression of intrinsic reality by the complete manifestation of its objective existence.

In order to accomplish this action, starting from the transformation of the natural appearance of things, Abstract Art has continued the way of Naturalistic Art insofar as it is the expression of dynamic movement created through the continuous opposition of form and color.

Parallel with every expression in human culture that is influenced by modern life, science and technics, plastic art reveals the necessity to continue the abstraction of form and color until the means of expression become more or less neutral. In this state, the plastic means reach their most objective expression. Then they are adequate to constitute true abstract art.

Abstract Art
[Non-Subjective Art]
(October 1941)

The fact that in abstract art the natural aspect of representation is transformed to a certain degree and is rendered more or less unrecognizable leads many to consider that this is what makes it "abstract." It must, however, be recognized that there are different degrees of abstraction, which makes every tendency appreciable. Naturalistic art is also an abstraction.

Not every one is conscious that in abstract art the transforming of natural appearance by which things are rendered more or less unrecognizable is not sufficient to create abstract art. As abstraction is reducing things from the individual to the universal, the universal expression of reality is indispensable.

Plastic art shows us that, in all these degrees, simple abstraction of forms and colors does not really change the essential expression of a work but merely modifies it. While the abstraction of natural appearance may produce more clarity and different plastic values, it does not in itself "create" abstract art. It does demonstrate more directly the conception and the feelings that lead to the creation of a work of art, and makes us see what is confused and vague in natural representation. This may be the reason why in modern times *plastic values* or their absence are so clearly analyzed.

When we realize that the essential in all works of art is the universal expression of reality, and that this essential is created through abstraction of the subjective vision of things and not through abstraction of the things themselves, it becomes clear that this is what makes a work of art really abstract. Then we see abstraction not merely as simplification but as *intensification*.

Abstraction has emphasized the old truth that art *must be universal*, just as *true reality is*. It shows more clearly that our subjective vision obscures true reality so that we do not see things as they intrinsically are in all their complex beauty. Consciousness of this truth was developed slowly. Only after centuries of search and transformation, more visible abstraction of particular forms emerged. If we understand this, we see the unity of all art from its earliest origins to our own time and recognize that modern art has developed out of the art of the past. All these stages of development had inevitably to be lived through.

For centuries our vision has been increasingly enlarged by science, technics and economic life. The faculty of intuition, which creates art, has become more conscious in man. But only when man becomes less subjective can art be more objective. It depends upon the use of the purer expressive means obtained through abstraction. In this way the real content of art—the expression of true and universal reality—now can be established more directly.

Pure abstract art is the logical conclusion of all art culture. It aims to represent reality in its closest approximation. It endeavors to express the dynamic movement of life in equilibrium solely by means of lines, planes, volumes and pure color, seeking to avoid the creation of all limiting particular forms which evoke particular feelings.

When the question may arise whether abstraction of natural appearance is preferable to natural representation, the answer is affirmative because it can diminish the number of obstacles to the universal vision of things. It is possible for a naturalistic work of art through its composition to be more universal than an abstract work. But the principal problem in art is not to avoid the representation of objects, but to be as objective as possible. However, it is never possible for a naturalistic work to be as direct and clear as a truly abstract work of art.

Here one may state that the conception of art depends not only on the epoch in which it is created, but also on personal character. Not many people value a clear and direct expression of true reality. Generally they prefer to see it veiled by subjective feelings and their need for romanticism or symbolism—for the expression of the tragic in daily life.

Although subjectivity can never be excluded completely, and is necessary to every human expression, pure abstract art aims at the utmost possible objectivity. For this reason it may be called objective rather than non-objective art. Actually it is *non-subjective* art. Under this heading we may include all true abstract art as found in Constructivism, Suprematism, Neo-Plasticism, and even in naturalistic art if it were possible for us to divest ourselves of our subjective feelings and conventional conceptions. It is in this order of ideas that abstract art becomes "concrete" for us and is true Realism.

Abstract Art
(November 1941)

Not everyone realizes that in all plastic art, even in the most naturalistic work, the natural form and color are always, to some extent, transformed. Actually while this may not be directly perceived, the tension of line and form, as well as the intensity of color are always increased. Plastic experience demonstrates that the natural appearance of things is not to be established in its natural realism, but must be transformed in order to evoke aesthetic sensation.

In the course of centuries, the culture of plastic art has taught us that this transformation is actually the beginning of the abstraction of natural vision, which in modern times manifests itself as Abstract art. Although Abstract art has developed through the abstraction of the natural aspect, nevertheless in its present evolution it is more concrete because it makes use of pure form and pure color.

Consciousness of the necessity of abstraction in plastic art was developed slowly. Originally it was practised intuitively. Only after centuries of increasing transformation of the natural aspect, more apparent abstraction emerged, until finally plastic art was freed from the particular characteristics of subject and object. This liberation is of the greatest importance. For plastic art reveals that particular characteristics veil the pure expression of form, color and relationships. In plastic art, form and color are the essential expressive means. Their properties and mutual relationships determine the general expression of a work. Abstraction not only establishes form and color more objectively but also reveals their properties more clearly. Thus we can see that the abstraction of form and color merely "modifies" a work of art,

but that Abstract art, just as naturalistic art, must create the general expression by means of the composition. Through the composition and other plastic factors, it is possible for a naturalistic work of art to have a more universal expression than a work of Abstract art which lacks the proper use of these factors.

We come to see that the principal problem in plastic art is not to avoid the representation of objects, but to be as objective as possible. The name "Non-Objective Art" must have been created with a view to the object, [but] that is in another order of ideas. Plastic art reveals that the principal expression of a work of art depends on our subjective vision, which is the major obstacle to objective representation of reality. Objective vision—as far as possible—is the principal claim of all plastic art. If objective vision were possible, it would give us a true image of reality.

For centuries, our vision has been increasingly enlarged through the development of life, science, and technics. Consequently it has become possible to see more objectively. However, intuitively, plastic art has always aimed at the universal expression of reality. All plastic art establishes this expression through a dynamic movement of forms and colors. In opposition to naturalistic art, abstract art can do this clearly and in conformity with modern life. It must be stated, however, that the judgment of a work of art depends on the individual vision of it. What is clear for one, is vague to another. This fact explains the existence of different tendencies in the same epoch. Abstract art manifests clearly the conception and feelings which give birth to a work of art as well as

the laws which dictate its creation. Consequently, it is evident that in modern times it has become possible to study and analyze these laws more exactly.

If we study the culture of plastic art during the course of centuries, we see that Abstract art is a product of that culture. It becomes apparent that modern art, while coinciding with all modern progress, has developed out of the art of the past through practice and experience. We see the culture of plastic art as *consistently progressive*; changes in tendencies follow one another in logical succession. Periods of progress and periods of regression or standstill produce an increasing development of expression towards a more direct representation of the essential content of plastic art. The periods of regression and standstill act as negative factors in the course of the general progress of plastic art.

[Notes for an Interview]
(ca. 1941)

The following notes were written by Mondrian in preparation for an interview (early 1941) with Charmion von Wiegand, who was planning to publish an article about him.

M.[ondrian] sees architecture, music, dance going the same way as painting and sculpture, and freeing themselves from sub[jective] and ob[jective] oppression.

In several articles already long ago published in European reviews but lost in the turbulence of daily life, he shows the unity of all Art and its real content.

Theater and literature as art, now more or less representations of daily life, as subjective visions of true life, he sees them marching toward pure expression of true life, freeing themselves from the same obstacles [as painting and sculpture]. He sees daily literature then separated from lit.-as-art and becoming purely commercial, scientific, or technical.

Another example of cultural interest is M.'s vision of Art. He sees even the most abstract [art] as a *substitute* for what he calls "true life." (True life he defines as human life freed from external (obj[ective]) or internal (subj[ective]) oppression.)

He sees human life as slowly marching toward true life and men steadily fighting for that state of life.

Even art he sees as an oppression, for it "replaces" true life as an abstract domain. In human culture, in art, and in everything else, he sees the way of abstraction as the means to near [to approach] freedom.

In the far future he sees art being dissolved as "Art" and the artist's capacities helping to create an environment compatible with true life. This capacity concerning color, proportion, and relationships will join architectural capacities, creating together our real "human" environment. Now, we still are living "opposite" pictures or wall decorations, or "opposite" empty walls, [no matter] how purely they may be conceived and executed. Now, commercial interests still detain human progress: true culture cannot go too fast. In the far future there will be created a more complete life, in a less accelerated tempo.

M. says his art is sensual. He said, [in answer to the writer's comment that she saw it as *sensuous*,] "when sensuous means a deeper grade of the sensual, then the definition sensuous will be just what I mean to say. But will it be directly understood in this case that sensuous remains unified with sensuality?" The word sensual embraces the whole human sense-faculty and art is produced by this whole.

Every art must be expression of our whole being and can be approached only with our whole being. But the kind of expression depends on the grade of profoundness that sensuality has. This fact explains the culture of art toward pure abstraction. For true abstraction is not rejection or the elimination of parts of the

whole of reality, but the intensification of it.

The culture of art is a continuous effort toward greater profoundness.

M. says, not on philosophical grounds but based on pure plastic and technical experience, that it cannot be emphasized enough that abstraction is not rejection but intensification. Thus an abstract work is not the creation of another reality but another vision of one and always the same reality.

This fact makes the work living and concrete.

Through the rectangular opposition of straight lines, he expressed the completely balanced reciprocal action of the opposite forces of life manifested in the reality around us.

Thus is established not a new reality but reality as it intrinsically is. For it is clear that the world could not exist without being in equilibrium. His art thus can be called true realism: Of course it is an abstraction from what we see around us in ordinary vision: art is not daily life but its deepest plastic expression.

This abstraction cannot be negation of daily life and surrounding (environment) out of which it has grown: it is its product.

M. already has works in several American museums before he came here [1940]. Next season he will have a show at Valentine Gallery.

Toward the True
Vision of Reality
(1941)

"Toward the True Vision of Reality," Mondrian's only explicitly autobiographical essay, was written in spring 1941 and published as a pamphlet by the Valentine Gallery, New York, in connection with his first exhibition in the United States (January–February 1942). The exhibition established his rapidly growing influence in America.

I began to paint at an early age. My first teachers were my father, an amateur, and my uncle, a professional painter. I preferred to paint landscape and houses seen in grey, dark weather or in very strong sunlight, when the density of atmosphere obscures the details and accentuates the large outlines of objects. I often sketched by moonlight—cows resting or standing immovable on flat Dutch meadows, or houses with dead, blank windows. I never painted these things romantically; but from the very beginning, I was always a realist.

Even at this time, I disliked particular movement, such as people in action. I enjoyed painting flowers, not bouquets, but a single flower at a time, in order that I might better express its plastic structure. My environment conditioned me to paint the objects of ordinary vision; even at times to make portraits with likeness. For this reason, much of this early work has no permanent value. At the time, I was earning my living by teaching and commercial drawing.

After several years, my work unconsciously began to deviate more and more from the natural aspects of reality. Experience was my only teacher; I knew little of the modern art movement. When I first saw the work of the impressionists, van Gogh, van Dongen, and Fauves, I admired it. But I had to seek the true way alone.

The first thing to change in my painting was the color. I forsook natural color for pure color. I had come to feel that the colors of nature cannot be reproduced on canvas. Instinctively, I felt that painting had to find a new way to express the beauty of nature.

It was during this early period of experiment that I first went to Paris. The time was around 1910 when Cubism was in its beginnings. I admired Matisse, van Dongen, and the other Fauves, but I was immediately drawn to the Cubists, especially to Picasso and Léger. Of all the abstractionists (Kandinsky and the Futurists), I felt that only the Cubists had discovered the right path; and, for a time, I was much influenced by them.

Gradually I became aware that Cubism did not accept the logical consequences of its own discoveries; it was not developing abstraction toward its ultimate goal, the expression of pure reality. I felt that this reality can only be established through the *purely plastic*. In its essential expression, the purely plastic is unconditioned by subjective feeling and conception. It took me a long time to discover that particularities of form and natural color evoke subjective states of feeling, which obscure *pure reality*. The appearance of natural forms changes but reality remains constant. To create pure reality plastically, it is necessary to reduce natural forms to the *constant elements* of form and natural color to *primary color*. The aim is not to create other particular forms

and colors with all their limitations, but to work toward abolishing them in the interest of a larger unity.

The problem was clarified for me, when I realized two things: (a) in plastic art, reality can be expressed only through the equilibrium of *dynamic movement* of form and color; (b) pure means afford the most effective way of attaining this.

When dynamic movement is established through *contrasts* or oppositions of the expressive means, relationship becomes the chief preoccupation of the artist who is seeking to create equilibrium. I found that the right angle is the only constant relationship, and that, through the proportions of dimension, its constant expression can be given movement, that is, made *living*.

During this period of research in Paris. I made many abstract paintings of trees, houses, plants and other objects. They were exhibited at the Salon des Indépendants. Shortly before the outbreak of the first World War, I went back to Holland on a visit. I remained there for the duration of the war, continuing my work of abstraction in a series of church facades, trees, houses, etc. But I felt that I still worked as an Impressionist and was continuing to express particular feelings, not pure reality. Although I was thoroughly conscious that we can never be absolutely "objective," I felt that one can become less and less subjective, until the subjective no longer predominates in one's work.

More and more I excluded from my painting all curved lines, until finally my compositions consisted only of vertical and horizontal lines, which formed crosses, each one separate and detached from the other. Observing sea, sky, and stars, I sought to indicate their plastic function through a multiplicity of crossing verticals and horizontals. Impressed by the vastness of nature, I was trying to express its expansion, rest, and

unity. At the same time, I was fully aware that the visible expansion of nature is at the same time its limitation; vertical and horizontal lines are the expression of two opposing forces; these exist everywhere and dominate everything; their reciprocal action constitutes "life." I recognized that the equilibrium of any particular aspect of nature rests on the equivalence of its opposites. I felt that the tragic is created by unequivalence. I saw the tragic in a wide horizon or a high cathedral.

At this point, I became conscious that reality is form *and* space. Nature reveals forms in space. *Actually all* is space, form as well as what we see as empty space. To create unity, art has to follow not nature's aspect but what nature really is. Appearing in oppositions, nature is unity: form is limited space concrete only through its determination. Art has *to determine space as well as form* and to create *the equivalence of these two factors*.

These principles were evolved through my work. In my early pictures, space was still a background. I began to determine forms: verticals and horizontals became rectangles. They still appeared as detached forms against a background; their color was still impure.

Feeling the lack of unity, I brought the rectangles together: space became white, black or grey; form became red, blue or yellow. Uniting the rectangles was equivalent to continuing the verticals and horizontals of the former period over the entire composition. It was evident that rectangles, like all particular forms, obtrude themselves and must be neutralized through the composition. In fact, rectangles are never an aim in themselves but a logical consequence of their determining lines, which are continuous in space; they appear spontaneously through the crossing of horizontal and vertical lines. Moreover, when rectangles are used alone without any other forms, they never appear

as particular forms, because it is contrast with other forms that occasions particular distinction.

Later, in order to abolish the manifestation of planes as rectangles, I reduced my color and accentuated the limiting lines, crossing them one over the other. Thus the planes were not only cut and abolished, but their relationships became more active. The result was a far more dynamic expression. Here again I tested the value of destroying particularities of form and thus opening the way to a more universal construction.

The unity resulting from the equivalence of opposites, I felt must be expressed in a *clear* and *strong* way. In accord with the spirit of modern times, it seemed to me that this unity could be created in a more real way than it had ever been done in the art of the past. Through my plastic experiences, I became cognizant of the truth that *the abolition of all particular form* is the only way to accomplish this.

In 1915, Theo van Doesburg, a Dutch painter and writer, was making analogous researches. Together we formed a small group of artists and architects: the De Stijl Group. Through the medium of *De Stijl*, a magazine edited by van Doesburg, the group exerted a great influence throughout Europe. We called our art "de Nieuwe Beelding" or "Neo-Plasticism."

Simultaneously in Russia and Germany, Constructivism came into existence, founded by Malevich, Lissitzky, Pevsner, Gabo and others. Later, Constructivism was continued in Paris and in London where it became homogeneous with Neo-Plasticism. However, there always remained differences in viewpoints.

We also had the idea that collective art might be possible for the future. We hoped to make the public aware of the possibilities of pure plastic art and endeavor to demonstrate its relationship to and its effect on modern life.

Modern architecture and industry responded to our influence, but painting and sculpture were little affected. These seemed to fear that Neo-Plasticism might lead them into "decoration." Actually there was no reason for this fear in pure plastic art any more than in any other art expression. All art becomes "decoration" when depth of expression is lacking. In painting and sculpture, one must also fear eclecticism. All this is more obvious in genuine abstract art. But in every period of art, the expressive means are used in *common* and it is not the expressive means but the *use* of them that reveals personality.

I expressed these ideas not only in *De Stijl* but in other European publications, after *De Stijl* deviated from its original conception. Van Doesburg kept the rectangular relationship of the vertical and horizontal lines, but turned them to a 45 degree position. This in opposition to the natural aspect of reality. He called his conception "Elementarism." In this way, he put the accent on the expressive means, while I saw relationship of equal importance with these means.

Later, when I went back to Paris to live, I published a pamphlet called "Le Néo-Plasticisme" (1920). As in *De Stijl*, I termed the logical development of plastic art "neo" or new plastic, because the expressive means we used were new and the relationships were purely established.

Here, I may add, that as far as pure means have been employed to any degree in the art of the past (Byzantine art, for example), it was used in a different way. There the particular form was always evident and the composition included symmetry and repetition.

While Neo-Plasticism now has its own intrinsic value, as painting and sculpture, it may be considered as a preparation for a future architecture. It can complete existent new architecture in the way of establishment of pure relationships and pure color. Actually

it is an expression of our modern age. Modern industry and progressive technics show parallel if not equal developments. Neo-Plasticism should not be considered a personal conception. It is the logical development of all art, ancient and modern; its way lies open to everyone as a principle to be applied.

It is my conviction that humanity, after centuries of culture, can accelerate its progress through the acquisition of a truer vision of reality. Plastic art discloses what science has discovered: *that time and subjective vision veil the true reality.*

Despite oppressive factors, the great plastic art of the past has made us feel true reality: it has always struggled to abolish the barriers that prevent expression of this reality. In plastic culture, from the remotest past down to the present, we see a growing evolution toward freedom, from the limitations of time and subjectivity. Despite cultural lags and breaks, there exists a continuous progression in the disclosure of true reality by means of the abstraction of reality's appearance.

It has become progressively clearer that the plastic expression of true reality is attained through dynamic movement in equilibrium. Plastic art affirms that equilibrium can only be established through the balance of unequal but equivalent oppositions. The clarification of equilibrium through plastic art is of great importance for humanity. It reveals that although human life in time is doomed to disequilibrium, notwithstanding this, it is based on equilibrium. It demonstrates that equilibrium can become more and more living in us.

Reality only appears to us tragical because of the disequilibrium and confusion of its appearances. It is our subjective vision and determined position which makes us suffer. Although tragical manifestations and feelings exist only in time, for us human beings, time is reality. Our subjective vision and experience made it impossible to be happy. But we can escape the tragical oppression through a clear vision of true reality, which exists, but which is veiled. If we cannot free *ourselves*, we can free our *vision*.

In our present mechanized world, where the opposing factors of life are so strongly accentuated that only combat can bring a solution, it is illogical to attempt to experience reality through fantastic feelings. At the moment, there is no need for art to create a reality of imagination based on appearances, events, or traditions. Art should not follow the intuitions relating to our life in time, but only those intuitions relating to true reality.

Even in this chaotic moment, we can near equilibrium through the realization of a true vision of reality. Modern life and culture helps us in this. Science and technics are abolishing the oppression of time. But these advances used in a wrong way still cause great dislocations. Our way leads toward a search for the equivalence of life's unequal oppositions. Because it is free of all utilitarian limitations, plastic art must move not only parallel with human progress but must advance ahead of it. It is the task of art to express a clear vision of reality.

Pure Plastic Art
(1942)

Written in March 1942, this essay was Mondrian's contribution to the catalogue of the exhibition, "Masters of Abstract Art," assembled by Stephan C. Lion, and held at the New Art Center in New York from 1 April to 15 May 1942 under the sponsorship of Helena Rubenstein for the benefit of the Red Cross. Other statements were by Fernand Léger, George L. K. Morris, Stuart Davis, Hans Richter, Carl Holty, and Harry Holtzman.

Unconsciously, every true artist has always been moved by the beauty of line, color and relationships for their own sake and not by what they may represent. He has always tried to express all energy and all vital richness by these means alone. Nevertheless, consciously he has followed the forms of objects. Consciously, he has tried to express things and sensations through modelling and technique. But unconsciously, *he has established planes; he has augmented the tension of line and purified the color.* Thus, gradually through centuries, the culture of painting has led to *the total abolition of the limiting form and particular representation.* In our time, art has been liberated from everything that prevents it from being truly plastic. This liberation is of the greatest importance for art, the purpose of which is to conquer individual expression and to reveal, as far as possible, the universal aspect of life.

Every expression of art has its own laws which accord with the principal law of art and of life: that of equilibrium. On these laws depends the degree of equilibrium that may be realized, and therefore, at what point disequilibrium may be destroyed. This is clear to us if we compare the different expressions of past and contemporary art. In diverse ways, both have always tried to express equilibrium and both have sought identically to create a universal expression. The aspiration toward equilibrium and that toward disequilibrium constantly oppose each other. This is only the expression of *culture moving toward equilibrium.* Culture progresses in the measure that we feel the oppression of the tragic—an oppression caused by the unequivalence of these two polarities in human life.

In Nature, a complete deliverance from tragic feeling is not possible. In life, where the physical form is not only necessary but of the greatest importance, equilibrium will always be very relative. But man, evolving toward the equilibrium of his duality, *will create in ever greater degree, in life as in art, equivalent relationships and therefore, equilibrium.* Social and economic life today already demonstrates his effort toward an exact equilibrium. Material life will not be forever menaced and made tragic. Nor will our moral life always be oppressed by the domination of material existence. Increasingly, science succeeds in maintaining our physical well-being. Through superior technics, primitive materials are brought closer to the needs of man. Human life, although dependent on the physical and material, *will not always remain dominated by uncontrolled Nature.* Through the equivalence of relationships, equilibrium will be approximated in every purely plastic creation. Within the limits of the plastic means, man can create a new reality.

It is only after a long culture that within

the plastic expression of the limiting form, one perceives another plastic expression closely allied with it, but, at the same time, opposed to it. Art today, after a secular culture of limited form, has succeeded in establishing this plastic expression: *it is the clear realization of liberated and universal rhythm distorted and hidden in the individual rhythm of the limiting form.* The way toward the creation of a new plastic expression, that of liberated rhythm, in literature as well as in sculpture and painting, has been prepared by different movements in art, above all, by Cubism, Futurism and Dadaism. Art demands release from the limiting form because the latter prevents the expression of liberated rhythm. Far from ignoring our individual nature, far from losing "the human note" in the work of art, pure plastic art is the union of the individual with the universal. For liberated rhythm is composed of these two aspects of life in equivalence. Hence art has to attain an exact equilibrium through the creation of pure plastic means composed in absolute oppositions. In this way, the two oppositions (vertical and horizontal) are in equivalence, that is to say, of the same value: a prime necessity for equilibrium. By means of abstraction, art has interiorized form and color and brought the curved line to its maximum tension: the straight line. Using the rectangular opposition—the constant relationship—establishes the universal individual duality: unity.

In the pure plastic composition, the constant relationship expresses immutability. It is the universal expression in opposition to the *relationship of dimension* which is the diverse and individual expression in the pure plastic work of art. This constant relationship is therefore living and concrete for a mentality that ends toward universal-individual equivalence. The different proportions of the opposing duality of the straight line produce a rhythm always varied by the relationships of dimensions and at the same time, constant through the constant relationship. When it avoids establishing limiting form, *this liberated rhythm is the plastic expression hidden in reality, created through conscious feeling for universal equilibrium. It is the expression of palpable reality on a more elevated plane: the expression of true reality and of truly "human life"—constant yet always changing.*

Limiting form always tells us something: it is *descriptive.* As long as it is emphasized in the work of art, individual expression dominates. It could be objected that if the universal expression in the work of art is strong enough, the descriptive element, the limiting form, will not interfere. In fact, many present and past works of art seem to plead for this conclusion. But why employ the form if it weakens the pure plastic expression? Everything, however, depends upon the epoch in which we live. In the past, the limiting form was logical in plastic art. For this reason it is not disturbing in the masterpieces of art; on the contrary, it sustains them. In our epoch, every manifestation in life as well as in plastic expression, shows a desire for liberation. The limiting form then becomes an obstacle. The fact that palpable reality is revealed in limiting form, and also the effect of tradition, encourages the use of limiting forms in art. Above all, there exists another cause: the unconscious love of tragic, disequilibrated feelings.

Our actual environment (architecture and utilities, etc.), which is more easily liberated from tragic expression, sometimes necessitates a more complex plastic expression than the work of art. Although qualified by aesthetic conceptions, our environment is, above all, created by necessity, utility and function. In our time, there exists a tendency to suppress aesthetic feelings. Nevertheless, these are essential in order to guide any realization, so that our physical and normal needs may be satisfied. A new aesthetic for our actual environment, which exerts such a profound

influence on our mentality, can be deduced from the principles of pure plastic expression in art. In the future, the realization of pure plastic expression in palpable reality will replace the work of art. But in order to achieve this, orientation toward a universal conception and detachment from the oppression of nature is necessary. Then we will no longer have the need of pictures and sculpture, for we will live in realized art.

If we conceive of truly human life as continuous enjoyment in discovering and creating concrete equilibrium, then this equilibrium becomes essential for us. All abstract expressions in life, like science, philosophy, and all abstract creations like art, may be regarded as only so many means to attain equilibrium.

"Art" is only a "substitute" as long as the beauty of life is deficient. It will disappear in proportion as life gains in equilibrium. Today art is still of the greatest importance because it demonstrates plastically in a direct way, liberated of individual conceptions, the laws of equilibrium.

A New Realism
(1942–43)

"A New Realism," Mondrian's last completed essay, was read on his behalf by Balcomb Greene before a crowded meeting of the American Abstract Artists at the Nierendorf Gallery, New York, on 23 January 1942, a few days after the opening of Mondrian's first Valentine Gallery exhibition.

The paper was apparently revised by Mondrian in April 1943 for publication in *American Abstract Artists* (1946), but it first appeared in the collection of his essays in English: *Plastic Art and Pure Plastic Art* (1945).

It is comprehensible that some abstract artists have objected to the name Abstract Art. Abstract Art is concrete and, by its determined means of expression, even more concrete than naturalistic art. In spite of the fact that the denomination "Abstract Art" is right (abstraction means reducing particularities to their essential aspect) both names are equivocal; naturalistic art is also concrete. "Non-figurative Art"—another denomination— is equivocal because abstract forms are figures as well as naturalistic forms. The intention of indicating the destruction of the particularity of forms, which this name expresses exactly, may not be understood. It is the same with the name "Non-Objective Art," which indicates that objects are not the means of expression, while Abstract Art strives for objective, that is, universal expression. "Constructivism" might also be misunderstood, since Abstract Art requires destruction of particular form.

Evidently every denomination is relative. However, it can be stated that all art is more or less realism. Men are conscious of life by the manifestation of reality. Reality here is understood to be the plastic manifestation of forms and not of the events of life.

Compared with such tendencies as Symbolism and Romanticism, Realism reveals itself as more objective, thus a purer expression of reality. But viewed in relation to our time, the plastic expression (the action of forms and colors) is weakened by the naturalistic representation; the objective vision is more or less obscured by particular feelings. Therefore, the culture of plastic art (the continuous and reciprocal action of life and art) produced greater transformation and abstraction of the natural aspect of reality. However, the confusion caused by particular feelings and the use of naturalistic means is not ended. This fact is logical. Art is not only the expression of the plastic manifestation of reality, but also an expression of men. Only through intuition does a work of art rise above more or less subjective expression. Different periods produce different conceptions and feelings, and in each period men differ. Consequently different art expressions even in a single period are not only logical but a tribute to the general development of art. Intuition always finds the way of progress, which is continuous growth toward a clearer establishment of the content of art: the unification of man with the universe.

It is important to observe that art is not a manifestation of instinctive faculties but arises through intuitive capacity. The expres-

sion of intuitive capacity is not similar to that of instinctive faculties. We can state that instinctive faculties are of animal nature while intuitive capacities are human. In animals, instinct is pure. Through confusion with human faculties it becomes impure in men.

Instinct reveals itself as self-concentrating, self-edifying; it is limitation. Intuition produces self-denial, self-destruction; it is expansion. Culture can develop both. If it develops instinct, animal nature appears. Then culture destroys the intuitive capacity which men have even in a primitive state. Both actions are unified, but they should not be confounded.

Human culture reveals an opposition: diminution of the instinctive faculties and development of the intuitive capacity. A cultivation of instinctive faculties produces human degeneration; a cultivation of intuitive capacities creates human progress.

Culture develops as well as envelops: environment, education, experience, make men conscious of passing reality but overwhelm their intuitive capacity when this is not very strong.

Primitive expression lacks consciousness, the product of centuries of human culture. But this expression is not veiled in all kinds of things. In a primitive state, both the intuitive capacities and the instinctive faculties are strong. However, culture has not developed the consciousness of the intuitive capacity nor diminished the force of the instinctive faculties. Therefore, primitive art in abstract forms differs from abstract art of today, which reveals a relative balance of intuition and instinct. We find the same difference between children's art and Abstract Art.

Culture produces relative consciousness of the changeable expression of reality. When this consciousness is attained, a revolt takes place: the beginning of the deliverance from

that expression of reality. Destruction of its limitation follows. The culture of the intuitive faculties has conquered. A clearer perception of constant reality is possible. A new realism appears.

All this is manifested in the course of the culture of plastic art. We see the culture of the form ending in a struggle for the deliverance from the limitations of form. We see the movements Futurism, Dadaism, Surrealism develop this action. We see Cubism bring the great blow to the limiting form. Then we see the different manifestations of a new realism.

Limiting form is here understood as limiting our vision by the individual character of objects, creatures, etc., in such a way that this character appears predominant to us. Evidently all forms are limiting to a certain degree and thus deliverance from their limitation is relative. However, we can distinguish forms as closed and open forms. We may consider closed forms those in which the circumference has neither beginning nor end, such as the circle. When the circumference shows a beginning and an end, it can be considered an open form, such as a segment of a circle. It is clear that the open form is less limiting than the closed form. Forms composed of straight lines are more open than those in which the circumference is a curved line. They are established by intersection and not by continuation.

The new realism shows a greater consciousness of the plastic exigencies in art. Being more objective, it endeavors to be a clearer expression of intrinsic reality. Therefore it can be called "New." Through its clearer means and determined structure, it is a new kind of plastic. For this reason, its ultimate establishment appeared as "neo-Plasticism."

In plastic art, the reciprocal action of determined forms and determined space establishes the objective expression of reality.

This action constitutes the dynamic movement that expresses intrinsic life. The objective representation evokes a universal emotion, indescribable and therefore constant.

Only insofar as Abstract Art, Cubism, and Surrealism are objective expressions, in other words, insofar as they are purely plastic, can they be considered to be New Realism. Abstract Art is its purest plastic expression. It is conscious of the importance of an objective manifestation. It is conscious of the fact that reality reveals itself by substantial, palpable forms, accumulated or dispersed in empty space. It is conscious that these forms are part of that space and that the space between them appears as form, a fact which evidences the unity of form and space. Here it is important that the forms are in categories and that each category has its particular expression existing independently of our perception; that decomposed, the elements of form have a particular aspect; that every fragment, every plane, every line has its proper character. Evidently the objective appearance of forms can change through transformation of the position in which they are or through the changing of our position. A square placed standing on one of its corners appears to have a diamond shape. And this shape can be reduced to square form by standing it on one of its sides or by changing our position.

The predominance of our subjective vision makes the objective existence of forms more or less relative. Nevertheless, while our perceptions and feelings may change our impressions, the forms conserve their proper expression. This fact emphasizes that in order to establish a true image of form and space, an objective vision is necessary. Consequently, all plastic art shows the importance of the choice of the plastic means and the need to transform the natural aspect. For nature cannot be copied and the predomi-

nance of our subjective impression has to be conquered. These plastic exigencies produced Abstract Art.

Abstract Art has grown out of the abstraction of forms but is not a simple abstraction. It is rather construction after decomposition of forms. Avoiding the formation of limiting form, it can approach an objective expression of reality.

For a quarter of a century, Abstract Art and New Architecture have been defined as "space expression" from which aesthetic is excluded. However, a work of art is not exclusively produced by perception or construction. Aesthetic emotion is a factor in art. Both the plastic expression and the way a work is executed constitutes that "something" which evokes our emotion and makes it "art." It must be emphasized, however, that art is expressed through universal emotion and is not an expression of individual emotion. It is an aesthetic expression of reality and of men realized by universal perception.

In practical architecture aesthetic has to be largely excluded. But architecture as art, like all other plastic arts, has to reveal the new aesthetic conceptions of our time.

The term "space expression" is right in so far as it annihilates traditional aesthetics arising from subjective conceptions and brings art to pure plastic problems. But at the same time, the use of this term shows that natural expression of space is transposed in abstract form. In architecture and sculpture three dimensional construction is inevitable, but in painting three-dimensional space has to be reduced to two-dimensional appearance. This is necessary not only to conform with the canvas but to destroy the natural expression of form and space. Only then is the equivalent space determination which abstract art requires possible in painting.

Plastic art cannot be the simple expres-

sion of space. Empty space has no other function than to make life possible. Plastically it does not represent life. It leaves us isolated with our thoughts and feelings. Reciprocal action between us and the environment is not possible and without this action, human development (culture) cannot exist. For our feelings empty space is unbearable. Think of the solitude one feels in the desert and on the ocean. It evokes all kinds of subjective sensations and fantastic images. Contact with the plastic expression of reality is lacking. Even limited spaces and forms of great size displease us. Churches, factories, etc., can depress us; objects and creatures can awe and frighten us when the space determination is incomplete.

It must be noted that empty space can evoke universal conceptions, create mental and moral activity. But this activity is in the abstract domain and always requires the remembrance of the world of oppositions.

The action of plastic art is not space-expression but complete space-determination. Through equivalent oppositions of form and space, it manifests reality as pure vitality. Space-determination is here understood as dividing empty space into unequal but equivalent parts by means of forms or lines. It is not understood as space limitation. The limitation determines empty space to particular forms. Through this action the empty space obtains a more or less definite expression, but the limited space of these forms remains vague. In order to make concrete the dynamic movement of reality and to annihilate the particular expression of the limited space, division of these forms is necessary.

The metropolis reveals itself as imperfect but concrete space-determination. It is the expression of modern life. It produced Abstract Art: the establishment of the splendor of dynamic movement.

Landscape painting expresses this movement as it is manifested in the natural aspect of realilty; it can be seen as a product of the revolt against the wrong side of town life. In its landscape painting, Impressionism affirms this strongly.

The expression of pure vitality which reality reveals through the manifestation of dynamic movement is the real content of art. The expression of life in the surrounding reality makes us feel living and from this feeling art arises. But a work of art is only "art" insofar as it establishes life in its unchangeble aspect: as pure vitality. After centuries of culture, this fact produced Abstract Art in modern times. Plastic art developed a more concrete manifestation of its content. Greater consciousness of the plastic expression of natural forms produced purer means of expression.

Since the unchangeable expression of life is established by means of forms with their colors, the proper character of these forms determines largely the expression of the composition and of the whole work of art. In plastic art, an objective representation of varied forms can produce a clearer expression of the natural aspect of reality, but cannot establish a clear expression of pure vitality. For this expression is then obscured by the proper character of the forms. The objective expression of forms limits their appearance to particularities as men, animals, plants, objects, etc. In order to establish a clear expression of pure vitality, the objective expression of the limiting forms has to be destroyed as well as the subjective expression.

Subjective vision can transform the objective expression of things but cannot destroy this expression. All plastic art annihilates to a certain degree the objective expression of forms. But when this is realized through subjective transformation, other limiting forms appear. The pure plastic way is thus the transformation of the limiting forms into a more or less neutral form.

Destruction of limiting form is necessary for a clear expression of life as pure vitality.

All plastic art and particularly Abstract Art shows the importance of the fact already emphasized that forms with their colors have a proper expression which is independent of our vision. The same fact is to be observed concerning the elements of these forms. It is not superfluous to realize that a square is not a circle, a straight line is not a curved line. The more neutral the plastic means are, the more the unchangeable expression of reality can be established. We can consider all forms relatively neutral that do not show any relationship with the natural aspect of things or with any "idea." Abstract forms or dislocated parts of forms can be relatively neutral. Appearing as volumes, planes or lines, they have to become completely neutral in the composition.

In all plastic art we observe a reduction of the natural form and color to a more or less neutral state, a relative annihilation of their particular expression, even when the intention is to express a certain particular form. For art always is intuitively an establishment of beauty, that is of intrinsic reality, and not a simple representation of men or things.

In order to express universal reality, traditional conception starts from individual, limiting forms; modern conception starts from the perception of universal reality. The forms become really "means."

Limiting forms are the plastic expression of the particular aspect of reality, but their individual character obscures the universal expression which reality reveals through them.

Abstract Art emphasizes the fact that in plastic art the expression of reality cannot be similar to that of palpable reality. The dynamic movement established by the opposition of forms and their colors constitutes the expression of universal reality. In single forms, dynamic movement reveals itself through the continuous opposition of their composing elements: volumes, planes, determined by lines and colors. For this reason, the work appears "living." But in relation to the environment, simple forms show a static balance. They appear as entities separated from the whole. In order to establish universal unity, their proper unity has to be destroyed: their particular expression has to be annihilated. In plastic art, the static balance has to be transformed into the dynamic equilibrium which the universe reveals.

It must be emphasized that it is important to discern two sorts of equilibrium: (1) a static balance and (2) a dynamic equilibrium. The first maintains the individual unity of particular forms, single or in plurality. The second is the unification of forms or elements of forms through continuous opposition. The first is limitation, the second is extension. Inevitably dynamic equilibrium destroys static balance. Opposition requires separation of forms, planes or lines. Confusion produces a false unity.

In art as in reality, the plurality of varied and similar forms annihilates the existence of forms as entities. Similar forms do not show contrast but are in equivalent opposition. Therefore they annihilate themselves more completely in their plurality.

Not only in abstract art but in all plastic art, the expression of form is subordinate to the expression of dynamic movement. Form appears only as means of expression. Throughout its development, the culture of plastic art has progressively revealed that the more determined the expression of dynamic movement becomes, the more the particular expression of form disappears. It is logical that the most neutral form is the most adequate to express dynamic movement in a clear way.

Intrinsic reality—dynamic movement—is

established in abstract art by the exact determination of the structure of forms and space, in other terms, through the composition. In painting, structure is established through the division of the canvas by means of forms (planes) or lines. Thus structure produces the plastic means and these in turn produce structure. All art shows that through undetermined structure a work of art is less clear. The clarity of the function of the structure is in proportion to the degree of abstraction. The more structure manifests itself, the more natural expression disappears. Structure has the function of determining the equivalent expression of form and space.

In abstract art, space determination, and not space expression, is the pure plastic way to express universal reality. In this way, art develops from the domain of fantasy and accident to the solution of technical problems. Intuition discerns the plastic laws veiled in nature's aspect. Technical problems cannot be solved *a priori* by theory: action and experience produce the consciousness of the laws which reality imposes upon us. Abstract art is in opposition to the natural vision of nature. But it is in accordance with the plastic laws which are more or less veiled in the natural aspect. These laws determine the establishment of equilibrium, opposition, proportionate to the development of plastic art.

Every tendency in art manifests space determination in accordance with the same laws but in different ways of execution. In the course of culture, space determination is not only established by structure and forms, but even by the mechanics of painting (brushwork, color-squares or points—Impressionism, Divisionism, Pointillism). It has to be emphasized that these techniques deal with space-determination and not with texture. The expression of texture is the establishment of the natural aspect of things. Space-determination destroys this aspect.

Painting can be a purely abstract expression. In painting reality is established within the limited space of the canvas which can be completely determined by planes. In sculpture and in architecture, the work is a composition of volumes. Volumes have a naturalistic expression. Seen, however, as a multitude of planes, sculpture and architecture can be an abstract manifestation. Moving around or within a rectangular building or object, it can be seen as two dimensional, for our time abandons the static vision of the past. By moving around, the impression of a two-dimensional aspect is directly followed by that of another two-dimensional aspect. The expression of the structure, form and color of the planes can have a continuous mutual relationship which produces a true image of the whole. This fact shows the intrinsic unity of painting, sculpture and architecture.

The conception of a mobile viewpoint appeared first in early Cubism. Already in that tendency, the need for a truer and more concrete expression was felt. But this Cubism intended to express volume. Intrinsically it remained naturalistic. Abstract Art attempts to destroy the corporeal expression of volume: to be a reflection of the universal aspect of reality.

Two Sketches for Essays
(1942–44)

Among Mondrian's papers and notes was an English draft, ca. 1942, entitled "Plastic Art: Reflex of Reality," and another of 1942–44, to which the editors have given the title "Space-Determination in Painting, Sculpture, and Architecture." Apart from minor grammatical changes, both drafts are printed here as Mondrian left them.

Plastic Art: Reflex of Reality

For the proper understanding of plastic art, it is necessary to see that reality manifests itself by substantial, palpable forms, accumulated or dispersed in empty space—and that these *exist independently of our perception.*

Empty space is undetermined: for us it means nothing and therefore leaves us [isolated] with our thoughts and feelings. No reciprocal action between us and the surrounding reality is [then] possible. Without this action, no development, no human culture, no life exists.

Forms determine the empty space. Their particular character and the way in which they are accumulated or dispersed in space determines the expression of reality.

The objective existence of determined space and forms is the plastic expression of reality.

The forms themselves, however, are determined space. Thus the intrinsic unity of forms and empty space prove the intrinsic unity of reality. All plastic art manifests this truth, and the culture of plastic art in its course shows continually increasing consciousness of the necessity to accentuate the equivalence of form and empty space. In modern time the "fond" [ground] of a picture, representing three-dimensional space, has become equivalent with the form. Like the forms, it is two-dimensionally established.

The unity of reality appears more or less clearly proportionate to the more or less exact determination of space. In all plastic art, the importance of space-determination is revealed. Composition is the foundation of all works of art. The perfect space-determination of the universe appears in nature, but because of nature's changing aspect, it often appears as confused, even incomplete. Being imperfect ourselves, we can never conceive the perfect plastic expression of nature. But it is intuitively expressed in art. Plastic art searches to clarify the confusion: to express the true manifestation of reality.

Science has proved that the true manifestation of reality is neither the expression of particular forms nor of empty space. The fact that reality is *in constant movement* is the most important factor for us. It makes us aware of "life." Plastic art reveals that, through *continuous opposition of forms,* reality establishes the dynamic movement that evokes the sensation of life.

In single forms dynamic movement reveals itself through the continuous opposition of their composing elements: volumes and planes. Volumes and planes produce lines and color: means for the more exact

determination of reality. But in relation to the whole, single forms show a static balance. Appearing as entities in empty space, they show false unity, because they are separated from the whole. To establish true unity, their static balance has to be destroyed: their particular expression has to be annihilated. The static balance has to be transformed into the dynamic equilibrium that the universe reveals.

In plastic art we see the expression of form subordinated through the expression of dynamic movement. Forms appear as necessary but only as *means of expression*.

Plastic art reveals in the course of its culture that the more determined the expression of dynamic movement becomes, the more particular form has to disappear and the more its constructive elements free themselves from the limitation of particular expression. It is of the greatest importance to see that the particular expressions of the elements of form also exist independently of us and have a *definite character*. Using the elements of form as means of expression, their choice is important. A curved line can never express what a straight line expresses, and vice versa. The same is true for color. Nothing is accidental.

It is logical that the most neutral elements of form are the most adequate to express dynamic movement in the way *it appears in reality*: this is, as universal, thus manifesting everything without limiting it.[a]

Our subjective perception, however, is always limited to a certain degree. It *transforms* the true expression of reality or makes it vague. As long as culture has not brought men to more or less objective (this word used in its original meaning as opposition to subjective) perception, the expression of reality, life, remains obscured. Man has to become an instrument, reflecting reality. Then there is no question of "creation," there is only perception: feeling and understanding.

The predominance of subjective feelings degenerates plastic art. Inner properties and influences of the past, memories, etc., oppress our perception so as to change "perception" into "conception"—Romanticism, Symbolism, Classicism appear.

Viewed plastically, reality reveals constant, unchangeable laws.

Because of the intrinsic unity of men, reaction to reality is intrinsically universal. Thus the expression of plastic art is also intrinsically universal. It could be collective, but plastic expression, intuitively seen, is more or less subjugated by subjective factors. The mutual temporal differences of men produce different perceptions and conceptions.

The greater or lesser homogeneity of groups makes for styles, tendencies, personal individual expressions. In the course of time, due to the growing homogeneity of mankind, the truer expression of reality can be approached.

[a] Neutral means of expression have no relation with any particular form or idea (Symbolism). They are pure colors, dislocated parts of form, and especially the constructive elements of form: in painting, lines; in sculpture, planes or volumes.

It has to be remarked that, although the circle and the square are particular forms, they do not appear as such in abstract art. The circle, due to its perfectly balanced manifestation, can, through composition, become a more or less neutral expression. Although the circle is a particular form (like an apple), it can constitute a more or less neutral manifestation because of its perfectly equilibrated expression. In abstract art, it is possible ultimately to annihilate the square more completely, for its limiting lines can be continued indefinitely. However, multiplicity of the square is needed.

Space-Determination in Painting, Sculpture, and Architecture

For a quarter of a century, space-expression has been discussed in plastic art as well as in architecture. In a literal sense, space-expression is not the problem to be solved, either in classic art or in architecture. (Space-"expression," taken literally, would announce a naturalistic conception.)

Space has no other function than to make life possible, but it is not life. If life is to exist, undetermined space must become determined.

Space-determination has been and remains the problem for mankind to resolve. It is the eternal problem in economics, politics, technics, science, plastic art.

The right solution could end all suffering and make war unnecessary.

For our feelings, empty space is unbearable, it makes us feel uncomfortable. The desert is not an easy place for us, and even if it is partly determined, we still feel isolated in it.

Necessity and utility always create a certain determination which gives us relief: in churches, the pillars, pews, etc.; in the circus, the trapezes, sets, people.

Masses of trees, animals, or people, which form an undeterminable block of space, are also somewhat terrifying to see. In any case, not space but life is important for us.

Plastic art is not the expression of space but of life in space. Life establishes itself in plastic art by means of continuous opposition of forms and colors that determine space. But plastic art shows us that these means as well as space have a secondary function. The dynamic movement created by these means creates life.

Reality shows space-determination plastically. But because of the extensiveness of the world this is not always perceptible to us. In spite of this, even in its pastoral appearance, reality reveals that its space-determination is not arbitrary but has its unchangeable laws. These laws contain the secret of the constant equilibrium of reality.

Reality as life also reveals space-determination. There are countries, provinces, towns, etc. But in life the laws of reality are not realized. The personal interests of men corrupt just mutual relationships.

In plastic art the laws of reality are established by the force of intuition.

Therefore art is the true mirror of reality.

Every artist knows that plastic art is not merely a playing with forms and colors. This kind of play would only produce a fantastic expression, false toward reality.

Reality shows a logical universal structure which is the manifestation of growth.

This structure can be called construction, but where reality reveals destruction also, the word construction can cause us to interpret reality in a false way.

Just as reality shows the double action of construction and destruction, art has to take the same way: the technical researches of all artists.

Nothing must be positive or negative: the force created by these polarities must be established.

As in life, space-determination is a technical problem in plastic art.

In life, where intuition is confused, technical problems have to be resolved by reasoning and science. In art, intuition

produces the right technique. Therefore there is very little to establish technically in plastic art. But the long culture of art has made evident some constant truths which all artists establish, each in his own way. Action and experience discern the theories which reality manifests.

It has become more and more clear that the composition of a work of art is not accidental: forms, planes, lines, colors have their proper function. In abstract art this becomes clearer in proportion to the degree of abstraction. Painting has the privilege to become purely abstract. In this way we transfer plastic art from the domain of fantasy and accident to a technical problem: that of space-determination. The first action is through sensibility as well as through intellect, and, in accordance with the laws of dynamic movement, the dividing of limited space which represents the universe.

Planes, forms, and colors, as well as empty space, appear in true mutual relationship as well as with the limited space; their oppositions produce the dynamic action.

Generally architecture and sculpture are seen as a construction of volumes. Volumes have a three-dimensional aspect. Their corporeality makes abstraction relative. But seen as a construction of planes, sculpture and architecture can take a new path and become abstract art. The modern vision has left the static vision of the past. The eye moves. We can move around a building or any prismatic creation. The impression from one side remains when seeing another side, which produces a richness that a picture cannot have.

In sculpture and architecture the undetermined space is reduced to an undetermined space limited by its extension. The technical problem is to find the right division of this space. This can be executed by the erection of lines or by the application of planes. As in reality, form must be expressed in equivalent relationship with the determined space. In reality they do not always have that appearance. However, the great technical problem is that neither lines nor planes speak for themselves but become resolved within the whole. Neither the lines nor the planes are the purpose, but the dynamic rhythm which establishes life.

A volume or plane absorbs a part of space. As limited spaces they are determined as entities apart in empty space. They can be dissolved as entities through division. In this way, opposition can produce the dynamic movement that destroys them as entities. But volume and plane must then be seen as micro spaces in the macro space. So statues and pictures are worlds in themselves that reality as a whole reflects. Because of its corporeality, a volume can have the same degree of abstract expression as a picture only when it is nonperspectively seen. This is only possible with prismatic forms.

Whereas in painting reality can be established on a space determined by the extent of the canvas, in sculpture and architecture this is impossible. The works appear in undetermined space, and are thus as objects in it. The space of the environment must be excluded in the vision of the work, which has to show all in itself. Interior architecture, however, approaches the possibilities of painting because every room is a determined space. (In sculpture: within; in interior architecture: relationship, all-over volume.) In this way the painting literally annihilates the three-dimensional volume.

Moving the picture into our surroundings, by giving it real existence, has been my ideal since I came to abstract painting. I think that abstract painting in its logical conclusion—using pure color and straight lines in rectangular position—can become much more real, much less subjective, much more objective, when its possibilities are realized in architecture in such a way that

the painter's capacities join the constructive. But then the constructions would be very expensive for they would require much time for execution.

I have studied the problem in several [of my] studies with removable color and non-color planes; I have made plans for interiors and for theater. [See illustrations 175, 176, and 177.]

Of course art then will become less "Art"; but is not "Art" a heritage of the past for us?

[An Interview with Mondrian] (1943)

In 1942 and 1943 Mondrian was interviewed by James Johnson Sweeney, who was planning the retrospective exhibition at the Museum of Modern Art, New York, that was realized in 1945, the year after the artist's death on 1 February 1944.

The following text consists of two letters and a postcard to Sweeney of spring and fall 1943, as edited by Sweeney in the *Bulletin of the Museum of Modern Art* (13, nos. 4–5 [1946]).[1] The Museum had acquired *Broadway Boogie-Woogie* from Mondrian's second Valentine Gallery exhibition (March–April 1943). At the time of the interview Mondrian was working on *Victory Boogie-Woogie*, still uncompleted when he died.

Mondrian followed his 24 May 1943 letter with a postcard to Sweeney:

> Only now ('43), I become conscious that my work in black, white and little color planes has been merely "drawing" in oil color.
>
> In drawing, the lines are the principal means of expression; in painting, the color planes.
>
> In painting, however, the lines are absorbed by the color planes; but the limitation of the planes show themselves as lines and conserve their great value.

The first aim in a painting should be universal expression. What is needed in a picture to realize this is an equivalent of vertical and horizontal expressions. This I feel today I did not accomplish in such early works as my 1911 "Tree" paintings. In those the vertical emphasis predominated. A "gothic" expression was the result.

The second aim should be concrete, universal expression. In my work of 1919 and 1920 (where the surface of the canvas was covered by adjoining rectangles) there was an equivalence of horizontal and vertical expression. Thus the whole was more universal than those in which verticals predominated. But this expression was vague. The verticals and horizontals cancelled each other; the result was confused, the structure was lost.

In my paintings after 1922 I feel that I approached the concrete structure I regard as necessary. And in my latest pictures such as *Broadway Boogie-Woogie* and *Victory Boogie-Woogie* the structure and means of expression are both concrete and in mutual equivalence. . . .

In my "cubist" paintings such as *Tree*, the color was vague. Some of my 1919 rectangular compositions and even many of my earlier works were painted in black and white. This was too far from reality. But in my canvases after 1922 the colors have been primary—concrete.

It is important to discern two sorts of equilibrium in art: 1. static balance; 2. dynamic equilibrium. And it is understandable that some advocate equilibrium, others oppose it.

The great struggle for artists is the annihilation of static equilibrium in their paintings through continuous oppositions (contrasts) among the means of expression. It is always natural for human beings to seek static balance. This balance of course is necessary to existence in time. But vitality in the continual succession of time always destroys this balance. Abstract art is a concrete expression of such a vitality.

Many appreciate in my former work just what I did not want to express, but which was produced by an incapacity to express what I wanted to express—dynamic movement in equilibrium. But a continuous struggle for this statement brought me nearer. This is what I am attempting in *Victory Boogie-Woogie*.

Doesburg, in his late work, tried to destroy static expression by a diagonal arrangement of the lines of his compositions. But through such an emphasis the feeling of physical equilibrium which is necessary for the enjoyment of a work of art is lost. The relationship with architecture and its vertical and horizontal dominants is broken.

If a square picture, however, is hung diagonally, as I have frequently planned my pictures to be hung, this effect does not result. Only the borders of the canvas are on 45° angles, not the picture. The advantage of such a procedure is that longer horizontal and vertical lines may be employed in the composition.

So far as I know, I was the first to bring the painting forward from the frame, rather than set it within the frame. I had noted that a picture without a frame works better than a framed one and that the framing causes sensations of three dimensions. It gives an illusion of depth, so I took a frame of plain wood and mounted my picture on it. In this way I brought it to a more real existence.

To move the picture into our surroundings and give it real existence has been my ideal since I came to abstract painting. I think that the logical outgrowth of painting is the use of pure color and straight lines in rectangular opposition; and I feel that painting can become much more real, much less subjective, much more objective, when its possibilities are realized in architecture in such a way that the painter's capabilities are joined with constructive ones. But then the constructions would become very expensive; they would require a pretty long time for execution. I have studied the problem and practiced the approach with removable color and non-color planes in several of my studios in Europe, just as I have done here in New York.[2]

The intention of Cubism, in any case in the beginning, was to express volume. Three-dimensional space—natural space—thus remained. Cubism therefore remained basically a naturalistic expression and was only *an abstraction*, not true abstract art.

This attitude of the Cubists to the representations of volume in space was contrary to my conception of abstraction, which is based on the belief that this very space *has to be destroyed*. As a consequence I came to the destruction of volume by the use of the plane. This I accomplished by means of lines cutting the planes. But still the plane remained too intact. So I came to making only lines and brought the color within the lines. Now the only problem was to destroy these lines also through mutual oppositions.

Perhaps I do not express myself clearly in this, but it may give you some idea why I left the Cubist influence. True Boogie-Woogie I conceive as homogeneous in intention with mine in painting: destruction of melody, which is the equivalent of destruction of natural appearance, and construction through the continuous opposition of pure means— dynamic rhythm.

I think the destructive element is too much neglected in art.

[A Folder of Notes]
(ca. 1938–44)

Among Mondrian's papers was a folder of miscellaneous notes ranging from quick jottings on odd pieces of paper, the backs of envelopes or exhibition announcements, to sequences a page or two in length. Except for passages used by Mondrian in his completed essays, all these notes are transcribed or translated here, organized according to theme by the editors. The editors have dated the notes where possible on the basis of subject matter and style, and of external evidence, such as postmarks, dates on letters, etc.

After his move to London in 1938 Mondrian began writing almost exclusively in English, in which he rapidly gained facility. The notes published here have been transcribed from Mondrian's original English unless otherwise indicated. Except for very minor editing, Mondrian's wording has been retained, including his spellings. Editorial material appears in square brackets; passages deleted by Mondrian appear in double square brackets.

[Religion, Life, Beauty]

Time is progress and progress is time.

Without time is darkness: we feel no progress, no evolution, but *perfectness*.
 [To] grow in time to perfectness is progress.

Difference between man and animal (nature): we see in men progress; *in nature not*.
 Is the difference only in brain and nerves?
 Anyhow, in time is Difference.
 Beyond time is in dark(ness).
 We are in time.

Art has to Show the difference between Men and Nature.
 This is the good right [privilege] of Abstract Art.
 The Separation of Men and Nature.
 In the Past they were *one*.
 True Religion Separated [them].
 But Man falsed [falsified] Religion.

Mod[ern] time followed the Past.
 Art followed in [an]other (Realistic) way True Religion.

———

. . . It can be a new religion. A religion without dogmas. Because art is plastique, that is it shows or does hear.

In a culture of year hundreds [centuries] Art has purified itself from natural domination. Antique Art, [regardless] how beautiful it is, veiled what is essential.

———

Confidence in life is not sur-human [superhuman]. For we are Life.
 Otherwise it is very difficult to see our life vanish and keep confiance [confidence] in Life.

Our individuality try to maintain itself. We are "men." Our individuality is our force [strength] and our weakness.

Force [strength] toward daily life, weakness towards Life.

———

Confidence in a (church) God create[s] selfishness for it expect[s] something for one['s] own life. Confidence in Life ([the] universal) exclude[s] selfishness, because this life is not personal.

———

As long as men make life miserable as it often is, Art and Religion are the great supports for spiritual life. But beauty and Truth then are outside life.

Growing humanity must bring them into life: *Realize Truth and Beauty*. Then life becomes itself Beauty and Truth. Then life itself is Art and Religion. Then Art and Religion are superfluous. But destruction of Art and Religion is not the way: Humanity's *Progress* is the way.

———

[[Nothing can tell us what we have to do. Philosophy, Religion, Science, Art and Show the General Way of Human Progress. It can be helpful or hindering. But it cannot dogmatize our Individual way. What we have to do depends [on] our Individual Being—as far as we are Free, inner and outside [inwardly and outwardly].

In Art Intuition is Strong. But in Human Life it has not the same Power.]]

———

[The Meaning of Beauty]

What is the essential beauty [value] of all art? Is it the simple narrative representation of men, nature, objects, actions, or events? Plastic art shows that it is the harmony, the unity, the equilibrium of dynamic action, the tension of forms and colors, the equivalence of mutual and proper relations that creates beauty *in every representation of reality*. Plastic art reveals that this plastic expression is art's real value. Independent of subject, it depends only on its true plastic expressive means: form, color, and relations. Thus plastic art creates beauty with every narrative representation, just as nature does, but in a way that evokes the emotion of men.

In nature's aspect beauty is often unintelligible to men; in life motion or action covers or disturbs it. In nature and our whole reality the aesthetical emotion depends upon the kind of narrative representation, the subject. Thus by narrative means, in general, beauty is impossible. In spite of all, it exists. Plastic art reveals thus that there is *a constant beauty* that is established in different ways. It is the same in life. In life there is a beauty independent of actions, events, and human situations. Just as in art and nature, human life has to express that beauty: man needs to enjoy it. Can he accomplish his vocation? Oppression makes it very difficult.

In life, situations, actions, events determine the possibility of enjoying beauty. *Thus these factors become the most important in life*, a fact that is in perfect contradiction with human nature.

In our days, through the selfish actions of men, human situations and relations are not in mutual balance. Thus a real struggle for life and higher life is created that prevents for a great many the possibility to live a "complete" life, that is, material and moral life in balance. This fact is so real that generally even the notion of such a life is lacking. Our life is bound to material action in such a way that it excludes moral action: spiritual life is viewed as merely an entertainment. More and more life is losing its real value, its general beauty. But it is not only this fact that degrades life. Material action generally has lost its purity. In this way it loses even its particular beauty. Everything

has become commerce [trade]. Material and moral terrains are so mixed up that there is no distinction of values. Even high qualities such as goodness and love are no longer pure—even art. Plastic art shows that all forms *must have their own value* to become equivalent. In life all expressions must have their own value. Trade can be beautiful in itself, but it has to be pure.

It may be objected that our life depends on economic factors. But are not economic situations the result of human actions, and is politics not a product of men? Economic situations are forms inevitably growing out of the needs of men, but, just as in Art, forms are transformable and to be brought to a mutual equivalence. Whereas Plastic art shows that it is possible by the transformation of forms, colors, and relations to establish general beauty, why would it not be possible to a certain extent to realize this beauty in life?

In our days it seems neglected that life is a universal vitality that appears in each of us differently and is more or less strong in each individual. We have the need to express that life. Because of its identity all human manifestations have in different ways a similar expression. Thus art and life, labor and entertainment are intrinsically identical. All is created by the necessity to express life, to exteriorize our vitality. It will be objected that illness and death make the constant enjoyment of beauty and life impossible. But enjoyment of beauty can be in the abstract and is then even stronger. The need to enjoy beauty is greater when there is suffering from separation by death. And is dying in a beautiful world not preferable to dying in misery?

The fact that the mutual inequality of men makes incomprehensible to the one what is comprehensible to another does not involve the separation of human manifestations. The principal thing is to see that they are all only *necessities* to express the experience of life, vitality, and never the *purpose* in our existence. The expressions are created by actions: but neither actions nor expressions are our real life. However, the feeling, the consciousness of life in us and around us would only be sufficient for men in a state of perfection. To be able to respire, to enjoy the experience of life, would then be our whole need. Our imperfectness creates other needs. Action and its consequence creates a complicated life in which the beauty of life is nearly lost. However, human culture proves that both art and life are progressing. Human progress is the establishment of a life in which we can live our real life, enjoy its beauty. Human progress is the agelong struggle to annihilate the obstacles that oppress life and its beauty.

[Life, Time, Evolution]

When we exclude time,
then all in One—Unity.
But we live in time.
Time, for us, is Real.
Thus for us all is One—Unity.
All is different in form and
Moving; Different in Progress.

The deepest Content of Art is the
 expression
of vitality
free from Time.
It does not change, is always
the same
But the Expression of Art
is in Time, thus changeable,
always different and
Moving with the Time

———

Real Contents of Art remains: form changes!

Tradition recreates the unchangeable truth in new forms.

> Unchangeable remains: old forms disappear.
>
> If they do not disappear, unchangeable is not valid.
>
> Then convention appears.
>
> The unchangeable is loose [free] from time:
>
> Forms are bound by time.
>
> Forms are Changing: the Unchangeable is Constant.
>
> Human Culture contains Past and Present by forms created.
>
> Forms changing, Human Culture Shows a changing.
>
> By reality and history, H. [Human] culture is fixée [defined].
>
> So we see Progressive Growing.

We have to see H. [Human] culture as a whole: time as a Mean[s] to see Changing—Progress. On a scale of time is our life-time: We measure time, see reality with our existence (life).

> We have to see [as] whole our really whole human culture: Past and Present.
>
> We have to create conformable to our time, to reject creating forms of the Past.
>
> We have [not merely] to Reject the forms of the Past *but to know them*:
>
> We must Compare.
>
> We must see the Growth of Life.
>
> We must have the Experience of the Past and not its forms.
>
> Without knowledge or experience we cannot reject.
>
> Without rejecting we cannot create New (things).
>
> In time there is Progress: beyond time all is as in One Plan.
>
> We are living in time. We have to reckon with its Changing.

Time is Real for us.

Beyond time is the True Reality, but not Our Reality

By means of our reality we have to come to the true Reality.

Hidden more or less by our Reality, the true Reality is always present.

Progress is unveiling of the true reality.

———

Like [just as] there is a static equilibrium which cannot be durable because it is the expression of a limited form, there is a logic which is untrue because it is based on subjective considerations. Science is abolishing this logic, but Plastic Art is unveiling *another logic* which is *the objective logic of the reality*. Modern time sees Plastic Art unveiling the *Laws of Nature*, [that] in the Plastic art of the past [was] already established but covered [obscured] by the natural appearance of things. These laws manifest an undeniable logic. In modern art *nothing accidental* is allowed: a work of art has to be *a logic[al] construction*.

[If] the recognition of evolution [is] subjective, it is *not subjective logic*. Subjective logic *arranges* forms, choses [things], events, while recognition of evolution is *observation* [of] what *manifests itself* in our reality.

Einstein exclude[s] the subjectivity of the observer. This is in perfect accord with modern plastic art which is abolishing representation of subjective feelings and conceptions and sees relations and measures as principal, limited forms as expressive means.

Science and art proclaim the loose of [freedom from] passing events: their relativity.

Whereas this fact is of great importance to life, Science has created the danger that human evolution will be denied by excluding

of time. Einstein proclaims the abolition and the disparition [disappearance] of it. But human evolution performed itself in time.

Modern plastic art is abolishing time by excluding natural vision of reality. Its neutral expressive means are without any time indication, being valid in every period. But art's culture performs itself in time. It shows a constant *growth to more objective vision.*

Whereas Plastic Art reveals that in *all periods* there is in *all Art* a "something" that is identic[al,] it shows that it is "time" that causes the changes, progress, evolution. Science says there is no time, no evolution, in reality. So shows Art. Really there is no time, no evolution in Pl. Art. There is *perfect movement, dynamics*, thus in rest. There is space: nothing. Pl. Art is an expression of that space: and the truer it does this, the greater Art will be. But for our subjective being, there is time, there is change, there is evolution. Pl. Art shows that to get rid of this subj[ective] seeing, is Pl. Art's evolution.

Our subj[ective] seeing has to express dynamic movement: this is Art's real content. All subjectivity is superfluous. We have to find the most unchangeable forms and the purest relations of them to establish [the] *unchangeable*, space, movement.

———

Mod[ern] Art is also abolishing time by its non-representative expression of neutral forms which are without time indication: these forms are in every period valid.

But because Modern Art is not only grown out of the Art of the Past but also is Constantly Growing now to less subjective representation, it shows not only Progress but Evolution.

Art is Real for us in our daily reality-conception where[as] Mathematics, Science go beyond it.

Thus seen out[side] of Art there is

difference in [the] conception of reality.

As Science denies evolution, Art recognizes it.

Art is [the] reflex[ion] of human life, thus human life has to agree with art.

———

Like [just as] there is an equilibrium (static) that must be abolished and another [a dynamic equilibrium] that must be established, so there is a logic to abolish and another to recognize.

[Just as] science is abolishing our subjective logic, art is unveiling the objective logic of the reality.

Subjective logic has to be abolished, objective logic has to be recognized.

[If] seeing of evolution [is] subjective seeing (for it is in time), it is not subjective logic.

Subjective logic arranges the events, while seeing of evolution is seeing what is [has] Happened and is Happening in the real order of life, reality's expressions.

———

[Life, Art]

A "style" requires a more or less collective expression in art.

What (tegenwerkt) [opposes] collectivity (tegenwerkt) [opposes] the appearance of a Style.

What (tegenwerkt) [opposes] collectivity? What makes it impossible? Individual feelings and conception. Egoism. material difficultys struggle for life and for [a] high[er] life.

———

. . . life itself in the splendour of its vital force. Daily life shows the factors construc-

tion-destruction good and evil,—in non-equivalent opposition.

Life is the unity of oppositions. Art reflects this unity. This is its highest value.

————

There is only one true moral[ity]: that of Life.

Life impose men laws inébranlable [imposes unshakeable laws on men].

First Law for men is not to go against Life. [This] includes not to kill.

2. Not to destroy the Unity of Life's Expression: those of Daily (Human) life.

3. Not to Destroy the dynamic equilibrium of Life.

4. To accept Destruction of [the] Static Equilibrium that creates False Unity.

5. To Construct Real Unity.

6. To make Daily life [the] True Expression of Life.

It is the question to live *following* Life and not to *make* his life.
We cannot know what is good, but we can distinguish what is Right.

Z. The moral[ity] of love is replaced by that of Right.

————

For us in D. [daily] life is no logic, the events happen inexpectly (unexpectedly) and échappe [escape] our control. But art shows that behind it is hidden the Undeniable Logic of Life.

The Moving of Eternal Growth.

————

All these are progressions of life thus needs of life. But when they are oppressing us, no place for *living* is left.

Separation [of] work and leisure time is a substitute [for] *living* . . .

————

Art is a substitute to real life, that is, life that is not mismaakt [deformed] by men. Man not as ideal man, but as he is.

————

Simplicity.
Just as art did not achieve simplicity until it became satiated with frivolous forms, so humanity will not achieve simplicity until it knows excess.

Translated from the French (ca. 1937–38)

————

Daily life created all kind of conceptions of Art, all kind of Styles but at the base of all in all this is true life.

So the only definition of art [that] is constant: the (evolution) (development) of Art is the abolishment of the temporal visions and the unveiling of true reality (life) and Art.

This is the good right of Abstract Art. (follows definitions of Naturalistic and Abstract Art.)

————

The acceptance of the necessity of change annihile [annihilates] the tragic of life.
Superrealisme

Men are mostly instruments of their own (propre) individual feelings. During creation artists are instruments of universal feelings.

(ca. October 1942)

————

We must reject nothing of the past but must purify everything. For in the beginning everything was good and became debased only during the culture of particular form in which everything became particular. Universality was lost: it must be re-created.

Life purifies: life, science, and art are becoming purified. By truly following this purification of life, we belong to our epoch.

Translated from the French (ca. 1938)

In nature, just as in man, rhythm is more or less concealed. In the confusion of nature, man must recover, distinguish and determine pure rhythm in himself and around him.

Man therefore must transform nature and himself. It is clear that in this culture, a certain point must come where rhythm, stripped of what conceals it, is clearly revealed. This point is obviously relative. It therefore divides human culture, creating a new life.

The rhythm of life is realized in all beings, in all forms and lines, in all that really exists in the world, in everything palpable, audible and visible. And thought? Thought therefore must rely exclusively on that. That is the *truth*. Thus we see the importance of (plastic) creation. All fantasy is false.

Translated from the French (ca. 1938)

Introduction

In our days the classical definition of Art—expression of the beauty of life—may look foolish but is all the same right.

To feel this, one has to see *what* is life.
One has to see life as that understandable thing that is matière,
energie, spirit, intellect, feeling, *all in one.*
One has to see it as *complete.*
Our daily life is not complete. Our individuality neither.

We see and feel parts of life, appearances of life,
then we live in time. Periodes show parts of life.

But time shows all.
For us time is moving. So *we move towards completeness.*

Introduction

Subjectively, the definition of Art depends on our individual conception, our personal vision of life.

Objectively, there is only one definition: Art is one of the expressions of life. This is a pretty large definition, but when we add, for instance, esthetical to expression, then we do wrong to Art. For Art is not an esthetical expression apart from life, but expression of the whole of life.

Really, esthetical does not exist. There is only "life." Plastic expression is equally not right when plastic is understood as making form. For true life is not only making forms, but also *the reciprocal action of forms*, the creation and abolishing of forms.

Never it can be expressed in limited forms. The mutual relationship of forms express the dynamic action of life.

So all conventional laws of esthetic vanish. We have to see Art independent from what is called Art.

First we have to be conscious of life. Then we become conscious of Art at the same time.

True, pure life is beautiful in itself. In all its manifestations. It is the relationship of reality around us and ourselves that creates daily life with all its wederwaardigheden [vicissitudes].

Life, Reality, is all in all—Unity.
We see parts of reality. This by the oppression of time and our individuality.
Notwithstanding, *Reality shows all.*
Forms are really life.
Forms are expressions of complete life.
But we cannot see this complete through the particular form.

We see the particularity.

We must do abstraction of the particularitys. Then we see complete life.

Art is an expression of complete life.

Art is an expression of the palpable reality.

This expression is beauty for (true) reality is beautiful.

————

We could say art is the *plastic* expression of reality. But if plastic means form, then this is wrong. For form, being particular, shows a *part* of reality. *Particularity must be abolished*, then we can see complete Reality.

Art is the objective expression of reality, life, which is beauty in itself.

Man can only by intuitive power represent it. For then he is free from particularity: the individual.

Life is only form in limited time.
In illimited [unlimited] time it is movement.
Movement of two principal opposite forces.
Art shows these growing to equivalence.

————

[Self-Destruction as Construction]

Plastic art affirms that destruction of others is a primitive, animal action, while self-destruction is human. We can freely state that while destruction proceeds from the desire to better construct one's particular existence and is evidently detrimental to others, self-destruction destroys one's self in so far as one is limited by particular form. It is logical that self-destruction requires a certain degree of human development, and self-destruction is the liberation of one's real personality. Human progress is proportionate with consciousness of the need for self-destruction. It is real human construction.

Plastic art reveals that modern time distinguishes itself by this consciousness. Modern art, already before Cubism, shows

this consciousness of the necessity to free ourselves from the limiting factors in us and around us. Cubism shows a certain consciousness of this need. In abstract art at present this consciousness is developing, and we can observe progressive liberation of the factors that prevent the unfolding of our intrinsic personality.

This liberation from limitation to one's self creates human beings adequate to form a unity. Abstract art establishes unity through its expressive means liberated from limitations.

While the culture of art advances that of mankind, it foretells a world of individual freedom and common unity.

In human nature the opposition construction and destruction is struggling to reach equilibrium. But external opposition makes periods of construction and destruction necessary. It causes the lack of personal equilibrium because one of our inner forces is oppressed.

We have to feel equilibrium on the abstract domain: science, art, philosophy, religion. When we have the aesthetic capacity, we can recognize in its aspect the true expression of reality: equilibrium. But its changing of aspect makes this difficult to do.

Through its concrete appearance, plastic art can make us feel equilibrium strongly. It manifests reality—our external opposition—as it is intrinsically: equilibrium.

(ca. 1942.)

[Art, Nature, Reality]

The expressions of manifestation of reality are always plastical. Objective vision [being] for us impossible, the common-subjective perception is the most true vision of things. Because the palpable reality around us does not describe but only shows images, our interpretations of these images are relative.

The appearances of reality evoke sensations, does us [causes us to] make conclusions and create conceptions, but these are only true [insofar as they are] based on the appearance. Physionomie thus has a true foundation. Based on our subjective individual impression, they [appearances] are uncertain.

Science has revealed that plastic expression is not limited to the surface of things. Behind the plastic expressions of common vision is another plastic expression perceivable by means of instruments. By this means there is more to see in nature than the common vision sees. (Sky with stars, etc.) The plastic expression of reality is materie [material]. But there also is a deeper apparition perceivable through science and technic.

However, there are other means to see the plastic expression of reality. These are the oppositions and relations of things. As always is recognized, we become [gain] knowledge of the things by their oppositions. Esthetically, we become aware of the dynamic movement of life by means of a rhythm of oppositions created by the different things in reality. These oppositions are manifested through the things as well as in the things themselves. These are the oppositions of form and color. This expression of rhythm is plastic as well, for it is manifested as well as the things are manifested. When Abstr. Art represents this rhythm and excludes form, it thus remains plastic.

In art all modelling of things through form and color is called plastic expression for it represents the plastic expression of reality. When painting on a plane represents the same plastic expression of reality, evidently it is also plastic expression. But as soon as it adds to this expression subjective (psychological) expressions, then it is no more plastic but litteraire [literary] in plastic form. As long as art expresses itself in form and colors it remains plastic.

(ca. 1940–43)

Everybody knows that in Art the natural aspect is more or less transformed. This transforming is an abstraction. The final conclusion of this abstraction created "Abstract Art."

To well understand abstract art, the reason why abstraction has been and is necessary in all art. Abstraction reduces the domination of the subjective vision, which is necessary to create Art. It reduces the subjective to universal.

———

Individuals (men) being mutual[ly] different, the plastic means must be different. While in the past the naturalistic was commonly used as plastic means (with exceptions (Byzantine)), and in modern time the natural appears more or less transformed in abstract forms, we can see this as detachment from natural (animal-like) collectivity, a development of the individual. In this way the individual can create a more human collectivity.

In the art of the past the artist came above animal collectivity, every one creating a different transformation of the naturalistic means.

———

Subjective and Objective art. Abstract painters can be more subjective than naturalistic painters—in spite of lack of subject.

movement (action) in space
movement esthetical action on
space (plane of canvas)

(ca. 1941)

———

Abstract art reveals that it not is a simple abstraction of the natural aspect. It is a real transformation of it. In this Abstract Art follows the way of the art of the past. In the

course of its culture Plastic Art showed an increasing transformation of reality.

(October 1942)

———

Plastic Art reflection of Reality—so we (could) can entitle Abstract Art with the name New Realisme.

Art always is in direct relation to reality. Reality changes in time. Art has to change its expression. The essential content of Art remains, is unchangeable, as is the essential content of reality.

(ca. 1942–43)

———

But in plastic art the only intention is to express not this reality but life.
New realism.
Abstr. Art is the determination of the structure veiled in naturalistic art.

———

Conceiving art as a reflection in us of our surrounding reality, our subjective vision becomes subordinated to this reality. Then there is no question of personal conceptions or feelings: for artists there is only the need to make an image of reality. Automatically he establishes not his feelings or conceptions, but reality.

Reality then is conceived as substantial, palpable; not metaphysically, not a product of imagination, of phantasie. It is seen plastically, i.e., as an accumulation of forms, volumes and planes composed conformable to reality. Then Forms, static in themselves, are dynamic movement as unity.

Reality manifests itself as constant and objective—independent of us, but as changeable in space and time. Consequently, its reflection in us contains both properties. Mixed up in our mind, these *properties are confused* and we do not have a proper image of reality.

This fact explains the multiple conceptions and, in art, the so different expressions.

The purer the artist's "mirror" is, the more true reality reflects in it. Overseeing the historical culture of art, we must conclude that the mirror only slowly is purified. Time producing this purifying, shows a gradually more constant and objective image of reality.

———

Although on the kind of mirror, personality, all art depends, there is no question of personal conception, there is personal *perception* of one *sole reality*. Consequently art is universal with personal representation. Never it is individual, for this *translates* the personality and *not reality*.

———

Plastic art is a *perception* dependent on our personal vision—which vision becomes more or less collective according to [the] more or less collective homogeneity of men.

Consequently it is homogene [homogeneous] with our surrounding reality and never can be fantasie or imagination.

Plastical laws rule art as well as that reality.

———

In order to understand the true meaning of Abstract Art, we have to conceive us [ourselves] as an reflex [reflection] of reality. This means we have to see us as a mirror in which reality reflects itself.

Then we see objectively: there is no place for fantasie, romantic, literary conceptions which are subjective.

Now it depends on our personality, the mirror, how reality is reflected.

There is no question of creation, for *all is created*.

If our personality is deep enough to see reality is its essence, then Abstract Art is created. Then we see pure dynamic movement.

[Modern Art, Tradition]

So many are proud of Tradition. But mostly Tradition is confused with Convention. Long-age principes in Art accepted [ancient principles accepted in Art] cannot be continued at present. It is insufficient to change forms and colors without changing [the] *construction*. [For] then the conception of the Past continues in new dressing [disguise].

The real value of Modern Art is only the result of the culture of the Past and not its manner of expression. This result is International because Art's Content is everywhere the same. This content is the only true Tradition.

In social life the individual cannot échap. [escape] a certain oppression resulting of [from] the inequality of men.

———

When we understand (conceive) tradition as the overlevering [transmission] of the great general principes of Life, which [do] not change, then tradition is valid for the whole world. It is international. It stands opposite [to] Convention, principes [principles] found out by man during human culture which of course is changeable and not internationally bound to people and country.

Memory of one's own life good or bad, always memory spoils present life. One regrets the good or is bothered by the evil.

The dynamic movement of the earth is for us like "rest." In the vague [in a vague way] Nature creates movement that inspires rest by forms and colors.
A moving wheel, spokes are not seen.
But in [within] this vague[ness] we must express Movement that inspires rest.

Perhaps they are going too fast, but the whole world is going fast now. It is only important whether one is on the right or the wrong way.

Tradition, Convention—Culture.
Tradition is confused with Convention.
Tradition Basic Truths (enduring).
Convention composed of transitory truths.
Culture = work (development) of the Basic Truths. Culture and Tradition International. (America as well.)

Translated from the Dutch

———

Conventional national[ism] *impeding*.
Convention is the way one knows.
Convention decides the way.

American fresh without convention.
But with culture and tradition.

Convention, a sort of memory, greatest obstacle to enjoyment of life and art.

Have they not burned in the street so many important books, then chased out [purged] museums also . . .

It is by Convention that one does not advance culture [in] the way of progress.

———

There is no such thing as National Tradition. And if it exists, than it is a [residue] of the Past not valid now. Human Culture is International, over the Whole World. Only it appears in different forms.

Because all these forms are Passing and continually changing, Tradition of Forms is impossible. True tradition has No Form. It only can be what is behind the forms.

Fortunately, it is remarkable that this Culture, Human Progress, Absorb them in its

Cours[e] More and More Quickly.
They have to choose Past and Present.

All *kind* of Mod[ern] Art but not all M[od-
ern] Art is progressing.

Modern Art so far as it is Really Art shows
Human Progress, is in search for freedom.
But the majority of what is called Art is no
Art at All. It keeps to the past because
progress is not Living in them. When it is
the Majority, this fact Retains [restrains]
progress. It is the same in life. The abolition
of the past-mentality takes time.

————

When there was no Convention, no material
nor Moral oppression—when there was more
Freedom, Modern Art in general would be
more "Modern" Art.

All what is *not of our time* (in thought as
well as in reality) is oppressing it and will be
banned by it in course of progress.

(ca. 1941)

————

In accordance with science and pure reason,
plastic art reveals the confusion that time
causes. For not than [only] after long periods
of darkness consciousness of its real content
is obtained. The suppression of time, for us
not possible, would show true reality. It
would show vitality in its constant aspect.
We see the events and plastical manifesta-
tions obscured, and only the comparisons of
the successive periods can enlighten us about
what is concealed by time.

Plastic art reveals only one sole culture,
valable [valid] for all. Differences of place
and race may produce different representa-
tions, but the content of Art is always
identical. The increasing mixture of the races
and progressively developing communication

and technics has been fertile for human
culture. The metropolis with its internation-
alism, on the top [at the apogee] of human
culture, proves the truth of this.

Through the establishment of its real
content, comprehensible for all, plastic art
has always revealed that in order to reach
freedom, nationalism[—]necessary to consti-
tute oppositions[—]has to grow to an inter-
nationalism that unifies humanity.

The struggle for freedom shows that the
intrinsic human qualities, innate in human
nature, but obscured by the struggle for life,
are not lost but only oppressed. The present
struggle for freedom shows the truth of this;
plastic art assures us the possibility to obtain
freedom from oppression. For it has mani-
fested this.

(ca. 1940)

————

Where Art shows the way of progress as
leaving nature, Human progress cannot be
towards it. Already Voltaire said: ("Man
perfects himself as he departs from nature")

Life, going [evolving] from country life to
metropolitan life reveals what art shows.

Nothing is to [be] regret[ted], nobody is to
blame or [to be] criticize[d].

Progress in Science and Technic is admitted:
why should human progress be disputed?

Destin [Fate] and Freewill growing to equiva-
lence.

Modern Art product of the Metropolitan.

New Art, new life . . . actually it is hard to
think of it. However, Art and life [have]
shown that it already exists. It only is Op-
pressed.

New Art and new life will develop itself in lines already begun by many and ended by a few.

What [restrains] human progress is that the majority of the mentality is oppressed by the Past.

(ca. 1941)

————

Art always had the great privilege to show the beauty of "Life."

Indirectly it brought beauty in[to] human life, it always was [the] expression of the beauty of "Life" *through* human life. It must become pure expression of Life. Then it can help human life to become [the] true expression of Life.

Human taste (in Art and life) is generally primitive. Progresses by up and downs: by continual creation and destruction of his products.

Art has to follow not nature's Appearance but its Laws, and to express these laws conformable to men.

Better than arguments, Dance and Mode [fashion] for instance show the difference between past and modern time.

(ca. 1941)

————

If there is Progress, Continual Development, then there is Only One Direction to take. Then there is only a march Forward. But men like to Dwell Around [stray], Nevertheless, they come at last out on Progress way.

Progress has made the Metropolis.
Evil has chased man out of some of them.

This fact proves sufficiently its value.
It shows the Oppressors.

But generally men do still like [the] tragic. "Thrill" films are wanted.
There is a Fear for Equilibrium. It is not seen as Dynamic movement because equilibrium now appears static [to them].
In Human Life and in Art it is too much still veiled.

It was necessary and will remain necessary until there is more balance in Human Life.

Art shows that to establish a Dyn. Equi. [dynamic equilibrium] this opposition must remain. Therefore Nazis are wrong willing [in wanting to] unify Europe to an static unity. Art shows that only equivalent oppositions can create true Unity.

(ca. 1941)

————

Art and life show that real unity is fancy by natural domination [conceived through the natural], how[ever] concealed this may be. Nature itself, [no matter] how beautiful it is, is a "veiled" unity. Therefore it is ununderstandable to man. Human Evolution [serves] to bring nature nearer to him. Man has to create a human surrounding and to develop to real human being. But often nature is stronger than man. So all unity remains very relative.

[[Formerly subject was a help. Now it becomes more and more an obstacle to see Art[']s Real Contents. Whole Modern Art shows it.]]

A portret [portrait] has to tell something particular and has thus the right to be natural.

As Surrealism has something particular to tell, it has the right.
But it must not be seen as more real art.
(ca. 1941)

———

Arising from the perfectness of Life the acceptance of Daily life just as it is, with all its Tragic, follows. This also is the beauty of Daily-Life: the full enjoy[ment] of it being necessity, rejection of it would be a sin toward life.

Progress = Experience

Likewise in Art—Modern Art mostly abused in expressing passing beauty.

When war is over, one thinks to begin a new life. But if there is no change, Past will return. The right way must be chosen.

[[All that Life's beautiful contents could realise is Created. But when misused it remains hidden in long-past manifestations of human culture.]]

———

Accept the present; must see the good of this life.

Accept the present moment and rejette [reject] it directly as Past.
All that can unveil it more is useful.

Human Progress has still to inter-balance the oppositions Fate and Free-Will.

Progress continues on one sole way [road]. The Content of Life as Art (shows) the Only Moral [morality] for Daily Life.

Art is a continuous progress (Artists).

———

[Abstract Art]

Many abstract artists protest against the name "Abstract Art." They prefer to call it "Concrete Art." Certainly Abstract Art is concrete, but Naturalistic Art is also concrete. Why make confusion? While Abstract Art is concrete not in the way of the natural aspect of things, the name Concrete Art does not accentuate the right meaning of Abstract Art. Abstract Art is not the expression of man's predominantly subjective vision. It is the expression of man's objective vision realized by intuition.

In all ages intuition has pushed plastic art to [the] relative abstraction of subjective vision.

Modern time shows the logical conclusion of this fact. In this way plastic art has gradually transformed the natural appearance of things and came to definitive abstraction of it.

Abstraction is reducing particularities to their general aspect. With this determination we do not near the content of Abstract Art. Abstraction is a means to reach beyond the particular expression of things only by a sufficient degree of abstraction. If not, it reveal[s] the characteristics of things more concretely.

However, we must not see Abstract as something vague, but through its fundamental expressive means it remains concrete.

Abstract Art is in opposition with the natural appearance of reality but creates like nature creates; this means according to the same laws.

These laws are veiled in the natural aspect of things. Abstract Art brings them clearly to perception.

Abstract Art creates a reality hidden in the palpable reality around us. Hence it abolishes this palpable reality, it shows only its way.

Simple abstraction makes the things more concrete but does not create abstract art. It destroys natural forms in [their] natural aspect. These forms appear as volumes, planes or lines. It is clear that abstract art did represent them only in abstraction, but through this fact Abstract Art is *not* created. When volumes, planes, lines, remain intact, particularities are not abolished, the general expression of reality is not established. In order to do this, these means of expression must be aneantisé [annihilated through] further abstraction until they become neutral forms or, by greater consequence, reduced to the elements of form. Then the great problem is to annihile [annihilate] these new means of expression through continuous mutual opposition. [By] creating the equilibrium of these oppositions, it is possible to express in a clear way what is universal and beyond the particular appearance of forms, whether natural or abstract.

————

Where Art shows, through its culture, first the Growth toward culmination of limiting form and then—after its fulfillment—a dissolution of this form and a determination of its elements—planes, lines, colors—we freely can state that human life in its culture equally reveals this process.

The question of [whether] this process in life and art is a progress or decay [is] dissolved when we consider it as a Freeing from the Obstacles that life and art meet on the way to express their Real Content.

Seen from outside, this freeing is an Abstraction.

Seen from inside, it is a Realization.

In abstract art we see elements of form no longer as details of form-expression, but as expression itself. Undeniable progress. For all art reveals that it is established only by means of these elements—planes, lines, colors—and that every particular object-form is an interpretation, a subjective limiting of those means.

However the loss of object-form—seen from the viewpoint of form—is a decay.

In human lifetime the diminution of the physical aspect is equally revealing decay.

But everyone knows that in spite of this and through this man developed.

Humanity as a whole, retiring itself [departing] from natural primitive life, also includes decay. But nobody should desire that life again.

Plastic Art shows through its culture first a growth toward culmination of limiting form and then—after fulfillment—a dissolution of this form and a Determination of its Constructive elements—planes and lines. We freely can state that human culture equally reveals this process.

————

We can conclude that a Double Action manifests itself: Decay and Progress. A progress in the way to intensification of the inner aspect, a decay in the way of reducing the external aspect of forms.

Art in human life show[s] that this reciprocal action does not destroy form but manifest[s] it in its Highest value and is the way to near equilibrium between the opposites.

————

What is the particular value of Abstract Art by which it is distinguished from the Art of the past and naturalistic Modern Art?

That it is a more direct, stronger, purer expression of life.

What do we understand by life?

Not the repeating and alternating (changeable) événements [events] of life, but *life itself*, that is the force vital in all of us.

Thus universal force is the essential of life in its daily appearance and is worth to be expressed first and directly. Until Abstract Art, it was expressed by intuition in Art, by means of the appearance of nature and daily life, through a rhythm of nat[ural] forms and their relations. Abstract Art expresses it by a rhythm in pure forms and pure relations.

What are pure forms and relations?

(ca. 1939)

Reality.

The Neo-Plastician sees reality as substantial.

For him it is neither metaphysic nor existing as "idea."

It is not a product of imagination [an imaginary product], but tangible, observable, perceptible.

It is not subjective but objective, constant, beyond definite place and time.

The artist sees it intuitively and trys to vainc. [vanquish] the obstacles which obscure its true appearance.

The obstacles are the undeveloped state of men, [their] subjective vision and the limitations [in] and around them, which keep bound their true human being.

In the "old" is the new but veiled: the classic balance predominates.

In the "new" is the old, but the dynamic action annihilates the classic balance.

So the universal expression predomine [predominates], whereas in the past it is veiled.

True reality is here understood not as another reality. It is understood as reality just as it is, but not oppressed by anything.

New Realism excludes lyricism. Lyricism can appear in naturalistic as well as in abstract art. It reveals an individual perception, not the pure reflection of reality.

So realism is the [best] name for pure plastic art. Abstract art can be called New Realism.

(ca. December 1942)

[The Tragic, the Future]

Theatre, Opera, Classic Ballet, all restes [residues] of the past; modern time [has] long [been] changing or replacing them. The Cinema, creation of our time, has more possibilities to change conventional conceptions, to create new realities. The Screen has the advantage that Painting has: to be a plane, and can be treated like that.

Natural (perspective) vision can more eas[il]y be transformed. The Cartoon-Screen shows that even figuration can become transformed. It is astonishing what strength of expression in this way can be established. But at the same time it [can be stated] that what is really progress is altered in [a] different way. Where Life is the only true Moral[ity] for Daily-life, archaic moral[ity] gekleed [cloaked] in old stories [is still] represented [in] a mixture of conventional and most advanced productions. Unfortunately the Cinema has its binding conditions. Enormous expenses require [capacity audiences].

So the representation becomes a mixture-of-all-kind. And Daily life domine [dominates] mostly.

However, there are already Films that wonderfully solve the problem, destroying the tragic of it.

Tragic's Oppression

Where oppression is [the] tragic created by
the unequivalence of oppositions, Daily life is
tragic. "Life" [is] Equilibrium. Growing
towards Life, humanity is freeing itself from
[the] tragic. Even Art-expression has to free
itself from [the] tragic. By [the] artist[']s
individuality, despite Art's equilibrium, Plastic
Art still shows [the] more or less tragic.

One of the most difficult problems for
the Artist [is] to create equivalence, even
with the most pure expressive means. How
much more Daily life must show it.

It is an encouraging sign of human
progress that it shows more and more disgust
[for the] tragic.

*It is a joy to see that Science is progressing, that human conditions verbeteren [are
alleviating] physical suffering, one of the
most real tragic [tragedies].*

However, the want [desire] for [the]
tragic is still too much to [be] see[n] in Art
as well as in Daily life.

———

Tragic Still Wanted

Seeing around us, it seems that [the] tragic is
still wanted. People still like to see shootings,
murders and other tragic in Cinema, and
even casualtys [accidents] or executions in
reality. And this search for unhuman [inhuman] excitement is exploited even in literature.

———

But [if] we see all this, we see also progress
continue its course—on every domain.
On every domain, unseeingly [but not perceived as] new.

We see—in spite of all—Diminution of
Tragic in reality and in conceptions. There

are films that show it [in] conception and
[in] uitvoering [execution]. Jazz, Dance
collaborate in conceptions. We see the
conceptions Fate and Freewill more interbalanced.

It is not that Progress is en retard—where
men are slow, Progress is abused—for a
time.

———

[The] true observer can freely state that most
people like to be excited by [the] tragic. It is
a fact that the most filled up Cinemas show
tragic films. In life, one has only to observe
the [many] people who like to see [street
accidents], [attend] excutions, etc. etc. But
men are such an un-understandable complex
that at the same time they like comedies,
feasts [festivals], beautiful things, etc.

Art shows that *opposite human* tendencies have to come to mutual equivalence;
[when this is] created man can be harmonized, peoples can form a true unity.

Life is going to do this. Plastic Art
shows that this is its evolution.
Psychologists may find it out. Here is [only]
stated what is to be seen.

People by Individual freedom a unity.
In old Art all forms and relations melted
together in vague apparent unity.
New Art establishes its forms [as] mutual[ly]
independent, joined together by clear equivalent relations forming a real unity. Art also
shows the way that man and peoples will be
free and unified at the same time when
evolution has clarified forms and relations.

———

The Future

By studying the Progress of Art and Life, by
seeing its affirmation in Daily life, we can

freely foresee a better Daily-life. Seeing the continuous growth of art in Life towards unity, equilibrium, we may state that Daily-life will contain a relative unity. Then it is clear that the oppressive forms of the present will be destroyed. It is not [foreseeable] either when nor how. Of course, these questions are of great individual or general importance. But the *real importance* for us [is] to know that it is progressing. *Life does not reckon with time*: Life is progress—endless.

But we have to reckon with time. It is our duty. We have to build that better Daily-life that surely is coming. We have to observe its growth: not its passing événements [events]. Then we see what to do, and how to do. Then these passing événements [events] will improve more and more.

Art, always less representation of Daily-life, always more direct expression of Life, grows to unification with Daily-life.

———

Daily life is to get rid of all oppression.

Religion is a *good* oppression. The essence of its goodness, fidelity, waarheid [truth], schoonheid [beauty], all are relative. Only the deepest content of all this is true and is necessary to new life.

Art of the past not perfect.

Acceptance of the necessity of change annihilates the tragic of life.

———

The Time to Come

[Even though] the future of Daily-life seems veiled in darkness for us, it is really only the événements [events] of (Daily-) life that we cannot foresee. Its content is in great line to see [broadly discernible] by studying [its] progress [as well as] that of Plastic Art.

Seeing that progress, we freely can state the coming of a better life. Both Daily-life and Art are showing a purification of forms and of their mutual Relations. Seeing Daily-life and Art growing in this way towards Equilibrium by [constituting] mutual equivalence, we [can] foresee that the idea of a World-Federation is not fancy [fanciful].

If we are living at present [in] perhaps the most terrible time we can image, we must see this as the destroying of oppressive forms and false mutual relations in the world, and as a struggle to construct a better life. But Art shows also that we must not expect [this] all at once. Life does not reckon with time the same way as we [do]. But we must bring all our power in action to constitute [build] for the Present. The Present has the greatest value for us.

———

Many detest talk about the future. They think [the] future is not to know [unknowable], present is it [present is knowable]. This is wrong: [the] present is not to know [unknowable], and [the] future is to know [knowable] by the present.

Future is present. Not to see the future is making the present the past.

As consequence, we now live a great deal in the past. Real-present—future and present in one. Time for us is moving subjective existence. (The relativity theory (objectively true) has all the same done much wrong.)

Because we live in a world of particular and complicated forms and events, it is clear that the question should be, how abstract art can be a stronger expression of life.

This question is not otherwise than more or less technical to answer [can only be answered technically]. For it must be known that forms [do] not really express life, but *the rhythm established by them*. Abstract art shows this rhythm clearer and stronger.

The different conceptions of Art, however, must noodwendig [necessarily] show this progress of Art, in different ways. Some of the figurative tendencies, Naturalistic or Abstract, will remain in Painting or Sculpture, [which] will continue joining Architecture as decoration or space-filling where Architecture would be too empty or poor. But as soon as Architecture can be complete, able to express Life in its abundance, then it does not need paintings or sculptures: it needs the capacities acquired in these arts. Without these capacities, [architecture] never [can] be complete. Artists will be in collaboration with the architect; the engineer also has the capacities Architecture requires.

In this way Art shows that progress is continuous: Art expressions, Daily-life appearances change—but Art and Life never die.

Morality and Religion have essayed to be disinterested, but have created hypocrisy.

[But] because they are disinterested, it is the beauty of Human Progress that life discovers itself by it.

Pure reason being intuitive as art, disinterested, and advancing Daily-life, can show Life more clearly.

[The] Beauty [of] Life shows itself veiled in Nature and Daily-life—in Man.

Art is discovering Life.

Daily-life and Science are discovering Life intellectually and experimentally.

———

[[. . . Beauty is the plastic expression of Life. Thus we can state that plastic art is aesthetic expression of Universal Life.

All art reveals "something" that is always identical: Harmony. In beautiful moments it reveals itself also in reality: stronger but more confused, because all our senses are then intact and the light has more force. But we see reality and time and space: [as] changeable. Art is constant. Reality is opressing [oppressed] by all kinds of things. In art oppressions are annihilated. Art is free. It shows only harmony—beauty: beauty in Life. In Daily-life it is oppressed by ourselves or in spite of ourselves. How can we free it? This is the task humanity is going to do just as Art has done it.

Then it is clear that Art cannot be [only] an expression of a part of complete life. And yet it is mostly seen as an expression of Daily-life.

Life can be shown through nature's aspect or through Daily-life, but never be its expression of its passing moments or events.]]

A definition of Life is equally impossible to make as a definition of its aesthetic expression, Art. But seen [from] a plastical viewpoint, we can say that Life and thus plastic art manifest an equilibrium of continual dynamic movement. In opposition with Daily-life, [the] universal does not change. Its equilibrium of dynamic movement [being] unchangeable, manifests itself, of course, [as] unchangeable in art also.

Study of plastic art reveals that it establishes this equilibrium by means of a rhythm of forms, lines and colors, in a way that evokes aesthetical emotion. It depends on individual feeling and conception "how" it will be established and how it will be seen.

To this rhythm—essential in art—forms, lines and colors and the empty space between them are important, but equally important are their mutual relations. Obviously, we observe the same in social life.

Art's culture, since its origin, shows a progressive determination of mutual relations until today they even appear only by means of the elements of form. In this way we see the rhythm clearly manifest.

———

[[Art does not start only from our surroundings or come only out of ourselves. It arises from the reciprocal action [between] us and our surrounding. The purer and deeper [the] artist['s] sensibility is, the higher art will be.

It is stated that art is intuitively made. But then it seems [as] if art was only [an] inner product. And the question "What is intuition?" arises: as difficult to answer as the question "What is life?"

However, we can state about life that it is dynamic movement, as plastic art is its expression—aesthetic expression of dynamic movement: that is, equilibrium. Art, as its expression, is less definite but therefore more true.]]

Observing plastic art, we freely can state that it is expression of universal Life.

———

Plastic art in general, but particularly abstract art through the expression of intrinsic equilibrium, shows that reality is equilibrium.

But in time, through its complicated manifestation, it [reality] is tragical.

Plastic Art is the establishment of constant reality which is above the complicated natural manifestations and thus above the tragic of life.

———

In this [these] days many will lose confidence in the equilibrium of life that exists in spite of the fact that its composing oppositions are unequilibrated. In Plastic Art we see harmonie established with very opposite forms: in naturalistic art we see apples opposed by [boxes, books] etc. In abstract art spheres by rectangles.

———

Pure art only a technical term (expression). There is no pure art because our mind is loaded with forms and events.

(ca. 1941–42)

[Oppression]

The Liberation from Oppression in Plastic Art and in Life

For a layman it may be strange to hear the statement that Plastic art shows us in its culture of centuries a progressive liberation from oppression. In fact this statement is based on technical facts. Only in a technical way is the understanding of plastic art to be obtained. Whereas the technical aspect of plastic art resides in the expressive means, volumes, planes, lines, colors, and in their application [use], the development of these expressive means towards their pure state justifies the above statement. It has nothing to do with philosophy. It is not the product of reasoning but simply "shows" truth that reality manifests.

Exploring art is as a technical action. What this action produces can be a science. It can replace both philosophy and religion.

As long as a work (expression) satisfies our moral exigences it remains art.

When the vitality expressed in reality finds correspondence in our ego, we consequently feel unified with reality. All accidental forms and events disappear: we feel only the constant expression of the dynamic movement that reality expresses—we feel its equilibrium. We experience the real content of art. That is exactly what we lack in architecture. Out physical needs are satisfied, but morally we find our refuge in pictures, sculpture, applied art.

Life and Art towards Liberation of Oppression

And now we feel best what oppression is.

And now, under the threat of Oppression, we feel the best what Freedom is.

It is an undeniable fact that nature is oppressing [oppressive] toward man in spite of its constructive force. The natural constructive force, destructive at the same time, drives man to maintain his existence.

Taking all means to this purpose, he oppresses other men. This is his animal nature. But there is a human force in man. This force in man fights against oppression not only of himself *but of others.*

(ca. 1940)

———

At present, true reality—equilibrium of opposite forces—is veiled by oppressive powers. The world is in disequilibrium through the unequivalence of oppositions which appear as Democracy and Nazism.

Nazism seeks particular unity through oppression: Democracy wants universal unity through individual freedom.

Nazism is going *against* the logical progress we see disclosed in Pl[astic] Art. Democracy is homogeneous with this progress, which is human progress.

(ca. 1940)

———

Cutting off [growth] is Killing.

Question is: Is Modern Art growing Art? Or is it decadent?

Certainly not all the doomed work has been great Art. But insofar as it was Modern Art, it was growing Art. Evidently the transformation of Nature's aspect, the lack of subject, must have astonished. But the purpose of transform[ation] was not seen.

Even [if] it was an error it must be free. Life needs errors as well as truths. *Errors die by themselves.*

Truth is always winning.

[If the] Soviets really intended to create a culture for everyone, they would have been right.

In Art, work is to create beauty: unity and all that this contains. In Life it ought to be the same. But in Daily-life work has become [the] means to create an existence. The difficulty to obtain this has created a struggle. Out of this struggle grew conscious mutual exploitation and oppression.

———

We can freely state: Progress is created but particular interest destroys it.

Art and Life are Sacrificed by particular interest.

Return to natural life is equally dangerous as tragic-expression.

World as a whole can't be pure—unequivalence [of] man.
Groups can be more pure.

Unity of groups by opposition and by pure relations unity.

If [in] one group (egoisme) oppresses, all is broken.

Egoism-Power.
Equivalent Power.

When all is based on the mass, progress never can be made. For the mass is always retardataire [retardatory].

Oppression of nature = storm.
 " of natural aspect.

———

Objective and subjective oppression—by [the] reality around us and by our personal vision. Our subjective vision is determined by our

personality and the surrounding reality. In fact, we are not free. To vainc. [vanquish] the first, the character of forms [has] to [be] chosen or to be transformed; to vainc. [vanquish] the second, [the] mentality [has] to [be] transformed. For both human development is needed. In both efforts we are not free but bound by internal and external forces.

Pl[astic] Art shows Life as continuity, i.e., only culture can make us free (this by freedom).

(ca. December 1941)

———

Our imperfectness creates the need for self-satisfying [self-satisfaction] in different ways, material and moral: life, work, science, law, philosophy, sport, religion, all are *seeking*, *trying*. But we are, from outside, *forced* to do this—or die. Innerly and outerly *we are not free*. And this is the cause we cannot enjoy the *feeling of vitality* which is in us. This enjoyment needs freedom. By [because of] our imperfectness *we have no real freedom*, thus cannot really live. The search for inner freedom will create freedom more and more. It is a joy to see evolved in art that freedom is a creation itself.

What is impossible today may be possible tomorrow.

Wrong to reckon with time in the fulfilling of a purpose.

———

Understanding of the content of plastic art is important for life. For if we see the difference between objective and subjective expression, if we see that objective expression shows true reality while subjective expression [is] our own representation of it, then we see that if we follow the latter we follow an untrue reality made by ourselves or by others, thus untrue life of actions and events; while following the first we follow true life, pure vitality.

Palpable reality reveals itself by plastic forms. Thus modeling of forms is plastic action in life and art. While the intention is no other than reproduction or representation of things in reality—this can not [be] otherwise than by means of values, planes and lines—plastic expression is based on the plastic expression of reality and not on our thoughts and feelings.

When we represent this through the things in reality, our product is not plastic *expression of things themselves* but description of things by plastic means.

Palpable reality, [the] three-dimensional, cannot be represented three-dimensionally on a plane (canvas) without being false. [As] three-dimensional, it would [be] the vision of reality and not reality, and thus no more represent true reality; two-dimensional, the representation remains plastic, for it establishes the plastic expression of reality.

———

Art is also an oppression as long as it represents objective or subjective limitations. It retaint [keeps] us from reality, life as it intrinsic[ally] is. It then represents daily life in an untrue aspect, for daily life lacks the equilibrium of art. In social movements this is more or less recognized, but plastic art is used as propaganda and education. Its true content [i.e., equilibrium] which is exactly what social life aims [at] was not seen.

This is proved by the fact also that abstract art which tends to the expression of true reality was not recognized. However, it must be remarked that abstract art in most of its expressions is confused and contains limiting remains of the art of the past.

———

Oppression through Art itself.
Art of the past more oppressive than modern art. But even abstract "Art" is still not without oppression.

This oppression is relative (subjective).

Art must free [itself] and is freeing itself from itself—just as man, in progress, is freeing himself from his subjectiviteit (individu) [subjectivity (individual)], losing himself in unity.

This progress is the highest men can reach: reached, he is Sur-men [becomes superman]. But [then he] falls out[side] of society, [Then the] "individual" is force and necessity.

Art is freer and can lose Art [Art can lose itself] in our environment. Then it becomes *Real* Unity: Reality.

Sculpture and Painting lose themselves in Architecture.

———

In spite of all misery at present, it can be our great joy to see art and life detaching themselves from oppression.

If this fact in life [is] not clearly [seen] through its confusing elements, in Art it is incontestably manifested.

Following the culture of art during the centuries, we see an increasing freeing from the subjective representation of particular forms and colors which, through their predomination, obscure the full expression of arts real contents.

In life it must be the same.

(ca. December 1941)

———

[Destruction]

We can observe that destruction is evil only when it destroys entirely. Then there is no power to reconstruct. When destruction destroys limitations, it becomes good in human culture. Destroying of inner and external limitations is the only way to progress. It is a liberation. Limitation binds us, and all that binds prevents construction, growth.

Observing this, we see in art the great importance of the destruction of the limitations which particular form contends [contains]. When we observe the fact that Cubism has accomplished not only the mutual separation des [of] forms, [previously] mixed up together and confused in an apparent unity, but also the separation of their constituent elements, we see the great importance of that art tendency. For this separation leads to the independent establishment of volumes, planes, lignes [lines] and couleurs [colors]. Freed from subject-matter, these expressive means can be composed in such a relationship that they dissolve themselves and establish only the dynamic rhythm which is the true expression of plastic art.

(ca. 1940)

———

[Just as] modern art liberated its proper means of expression through the abolition of subject and object matter, and the destruction of the peculiar [particular] expression of forms, life is freeing itself from all sorte of limitations in the same way. Lacking the freedom of plastic art, it only advances slowly. In all domains of life, we can observe an increasing liberation of limiting forms. In spite of the actual confusion, life emancipates itself more and more from physical and moral oppression. Plastic art affirms that separation of forms, abolition of confusion, clarifying, is necessary to this.

Plastic art shows that the way to constant construction is destruction and separation. These actions, however, are opposed (against) human nature. Our instinct always is to construct, to unifie [unify]. Life shows

us that we almost [mostly] do this in a wrong way and [so] destroy.

———

Already many limiting forms of the past are dissolving. In consequence, life shows the same confusion as in general art shows. Conventional forms are dissolving, but new forms mostly lack [the] good qualities concealed in old forms. In modern art new expressions mostly lack the intrinsic value of art.

———

Color can vivify a great plain plane but not entirely annihilate its appearance as entity. It has to be divided.

(ca. 1943)

———

We have to destroy the entity through complexity. Multiplicity of forms, volumes, planes is needed to produce a relationship of constantly opposing elements.

Confusion of the elements produces a confused rhythm and so a confused expression of reality.

Color relationship is not enough to express a clear perception of reality. Color has to be determined and this cannot [be] otherwise than in the way of establishing lines. The character of these lines determines the rhythme.

All is subjugated by *laws*, always the same in every art-expression.

———

1. The plurality of the forms in reality annihile [annihilates] their existence as entity.
2. In the forms, the plurality of other forms by which they are composed annihilates their existence as entity.

———

The existence as entity is in reality annihilated by [the] variety or similar plurality of forms. Similar forms annihile [annihilate] more than varied [forms]. They do not show constrast but are in equivalent opposition.

(ca. 1942)

———

[Instinct, Intuition, Culture]

When we can discern in men two opposite forces, an animal and a human force, then [we can see that] art risque [risks being] subjugated by one of these forces. The animal force viewed as instinct, the human force as intuition, we can say that art risque [risks] to be obscured by the expression of instinct. For all works of art reveal that it appears by intuition. It is clear that only an equivalence in man of these forces can produce art.

Instinct we can consider to be a self-edifying force, intuition self-denying.

There is a great danger that in art the instinctive expression predomine [predominates], especially in [the] primitive uncultivated state of man, and [when] the animal force is strong.

Culture has to create an equivalent state of the opposite forces. It has to cultivate the human force in man.

However, it can also weaken this force.

Much depends on education, surrounding, etc.

But most depends on men themselves: on the quality of the two forces in them.

———

[[Who is against culture, is preferring a primitive state. Animals, trees and plants can grow without culture, a human being not.]] Plastic Art reveals that time and experience

constitutes human culture. *It can culture help or destroy. Education is not culture.*

———————

. . . A work of art is not exclusively produced by perception. Esthetical emotion is a factor in art. However it has to be emphasized that art is expressed through emotion but art is not expression of emotion. New art requires a new esthetic.

Several kinds of perception are possible.

It has to be [kept in mind] that intuition is not similar with instinct. Instinct is an animal, intuition an human property.

Instinct is self-concentration, self-edification, limitation.

Intuition is self-denying, self-destructive, expansion.

Culture can develop both. If it develops intuition, human action is the result. If it develops instinct, the animal-nature in men appears.

Art shows human culture in esthetical aspect.

This culture is universal and has the privilege to guide humanity.

As culture is an action of centuries, primitive expression is lacking culture of [the] content of culture (instinct [or] intuition).

With this it is lacking the consciousness which culture produces. But when primitive intuition is strong, great works of art manifest themselves.

More consciousness in plastic art is the cause of the difference between art in abstract form of the past and the abstract art of modern time.

(ca. 1943)

———————

In this time primitive instinct causes misery, and uncontrolled intuitive action is doing much harm.

Only consciousness of reality can produce a better life.

Consciousness results from culture.

Culture needs age. Who is young is unconscious. He belongs still to the past. He is Old.

Who is aged can have culture, can be conscious of this time. He can be young.

Who is against culture is against growth. He is dead. He is going back to the animal-state of life.

(ca. 1943)

———————

Some remain always young, expressing themselves in an old way. Others grow aged and express themselves young.

(ca. 1943)

———————

As science increasingly affirms, in nutrition just as in art, debasement began by depending on taste. To say that we lost our natural taste may suggest the primitive, but the uncultivated never have it. Only the more advanced, the most cultivated, can recreate it with the help of science and pure intuition. Natural taste perhaps existed only among early men of the past who were still pure. But man very quickly became savage, primitive in the bad sense of the word.

It is always said about food, as well as love, beauty, art, "*do you like that?*" But this reckons only with the senses and deception follows. That belongs to the past. Instead of the basis of taste, we need the basis of knowledge: science and reason. We must ask ourselves is it good, is it right? And then, is it good or right for me and for others?

Translated from the French (ca. 1938)

———————

The human species still has too much hair (an animal trait): but cutting and shaping give it more and more style.

———

[Structure, Dynamic Movement]

The art of our time has created neutral forms free lines and colors, exact relationships. By the interiorization of forms (abstraction), [their] mutual and inherent relationships really are established as relationships; that is, they exactly express the positions and dimensions of the forms, lines and colors, and therefore the composition. By this fact *they establish equilibrium in an exact and clear way.*

We can thus justifiably speak of a new art, created gradually at first, then very rapidly by abstracting from natural appearances. That is why we speak of an abstract art: which nevertheless is more concrete than naturalistic art.

That is why we can say that the new art begins when the means of expression and relationships are established determinately.

In the whole history of art, we see no real change in the representation of the means of expression and of their relationships until our epoch, which freed forms and relationships from their subjugation and determined them in a new way by stripping forms of their particular character and relationships of their static expression.

Translated from the French (ca. 1938)

———

The equilibrium of a single form requires equilibrium of its constructive elements. [The equilibrium] of several forms necessitates their mutual equilibrium and equilibrium between the forms and space.

[[Obviously every form is in relative equilibrium otherwise it could not exist. This equilibrium can have a limiting static character, creating a "thing-in-itself." Since such a thing cannot exist in life, its equilibrium must necessarily be broken. But particular form, by its constructive elements, can also establish a dynamic equilibrium.]]

Every form becomes alive through the dynamic equilibrium of its constructive elements. We see this clearly in the new art. Dynamic equilibrium is created by continuous opposition of lines, colors and relationships. But for form not to appear in a static equilibrium that limits it to a thing-in-itself, a plurality of forms is required. Form cannot be alone in space, but must be resolved, united in space so that the whole shows what particular form establishes: dynamic equilibrium.

Translated from the French (ca. 1938–39)

———

When we observe the increasing abstraction of form and color during the historical culture of plastic Art, we see that this culture is a process of clarifying. We see plastic art more and more moving toward the constant expression of reality, become more and more objective. We see form and color more and more as the temporary means through which constant dynamic movement is established.

We recognize that the dynamic movement of reality is the expression of plastic art and the pure establishment of this movement is its real content.

———

Pure abstract vision *contains* the perception of reality in its universal aspect. This aspect is not an accumulation of forms, but of the dynamic movement which makes the forms living. Plastically this movement is established by relationships of shapes or lines. Consequently, lines and shapes are only means of

expression. The character of these means determines this expression.

Opposition of two forces creates dynamic movement.

(ca. 1942)

———

The individual expression of the planes as well as their mutual static balance must be destroyed.

Abstract Art shows clearly that the expression of intrinsic life is not Confusion but Opposition.

Opposition requires Separation.

True unity is by separation and not by Confusion.

Confusion creates a false unity that evidently destroys itself.

In love, physical and emotional life have not to be joined with the life of the mind but have to be in opposition with it.

(ca. 1943)

———

Opposition

Man and Man cannot produce children. The opposition of the sexes achieves it.

Men do not advance and produce through equality but through the differences of their being.

Translated from the French (ca. 1938)

———

In all plastic art, structure manifests itself through the limtations of the colors, forms, planes. These limitations represent themselves as lines. In this way the planes manifest themselves through their circumference and lose their individual aspect. We can thus consider line as expression of structure. In nature, where the structure of reality [ap-

pears] more or less confused, colors, forms, planes, become most evident. They express the natural aspect. In abstract art, the more the structure is revealed, the more the natural expression disappears. Structure established only in lines would separate art too much from nature and in this way have no relation with our human existence. Expression only in colors, forms, planes, would make it naturalistic.

In abstract art, the accent can be on the expression of oppositions by planes, or on the expression of opposition by lines through oppositions of the surface of the planes, through oppositions of their limitation.

In the way to express dynamic movement, [a] difference in conception is possible. The accent can be put on the establishment of planes in their color-aspect, or on the lines which limit the planes.

Determined space, [as] surfaces of naturalistic objects, etc., is naturalistic. They [naturalistic objects] reveal themselves by color, Color naturalistic [naturalistic color]: as primary color [it is] purified, [and] remains the individual factor in abstract art in the duality [of] structure and form.

———

Movement (action) in space.
Movement esthetical action on space (plane of canvas).

(ca. 1941)

———

Important is to discern two sorts of equilibrium appearing as:

1. static balance,
2. dynamic equilibrium.

So it is understandable that some oppose against equilibrium, [by] some others it [is] defended.

———

The reality around us as well as life is plastically manifested as dynamic movement. Art creates the equilibrium of the factors of this movement and chooses them. The factors being straight lines of primary colors in rectangular opposition, all [that is] accidental is eliminated. Pure rhythm is established.

————

In nature things are so expressive, so real, so living, that we do not notice rhythm at all.

So it is in Art, but otherwise. The rhythm is accentuated more than in nature but in a way that it dissolves itself as a Unity.

In opposition [with] Daily-life, Universal life does not change. To express it in art, there must be in art something that [does] not change.

Plastic art shows that this unchangeable [factor] just is Life's equilibrium of movement.

————

[Space Determination]

Tired by the conflicts of this world, people like to be in thought transferred in another world. This éxplique [explains] the research for distractions and for Art. Art can (is able) to create a more equilibrated, a purer world. But this other world has to be a world *we can live in*, thus directly related with the palpable reality around us. Purity beyond our capacities is untrue.

[For] more than a quarter of a century Art theories have emphasized the importance of space-expression in Abstract Art. There is spoken [one speaks] of space-time. [It] is believed even that the accentuation of space, thus time, would make us enter a new dimension. But seeing time as another expression of space, and space being a naturalistic

reality of three dimensions, we can conclude that there is no question of this [a new dimension]. Space-expression is naturalistic and thus has to be *destroyed* in order to create an abstract expression. Abstract [is here] understood as expression of movement which is the content of form.

In painting, the empty canvas is an expression of naturalistic space, determined by [its] circumference. In sculpture, the statue as a whole is a filled-up naturalistic space-expression. Both *expressions have to be destroyed* in order to reach abstract expression. Naturalistic space is filled-up with imaginary (subjective) naturalistic or geometrical forms. *All these forms have to be destroyed*, because they all are expressions of naturalistic space. Consequently, not the construction of space (form), but the destruction of it is what abstract art requires.

————

Expression of Life and not expression of Space is important.

Space is empty, life is full.

Space-expression is or creates subjective feelings.

Expression of life, vitality, dynamic movement, is universal.

Form is space as well as empty space. Thus form, volume, plane and line must be destroyed and not expressed. This is required for the work as a whole and for its composing elements. Only then the constructive elements can create a continual opposition that forms the dynamic rhythm of life.

(ca. 1942)

————

In pure abstract painting, the plane is the (abstract) expression of space. Painting, if it is to be abstract, has no reason to abandon the plane in order to be concerned with

space. To the contrary: to be truly abstract, it must remain within the plane. But it is necessary that the plane shows the equivalence between what is "space" and what is image so that the one annihilates the other. Thus the expression—abstraction of the space-impression—is created in a determined way. [[. . . The space of the plane must be equivalent with whatever is on it. This equivalence thus will destroy the natural vision of space: will create true abstract painting.]]

It is for sculpture to occupy space.

Rhythm

Life and art, beyond time and space being always the same (constant, identical), are revealed in time and space as more or less veiled, diffuse, confused, clouded, following the rhythm of life which can be realized in a pure way.

Art affirms plastically the ancient truth that life is equilibrated rhythm. Art always realizes this equilibrium in life.

As in nature, the life we live is equally part of this equilibrium, but as in nature, there are nevertheless storms, disasters, temporary disequilibrium.

Translated from the French

———

In nature things are so expressive, so real, so living, that we do not notice rhythm at all. So it is in Art—but otherwise; the rhythm is accentuated more than in nature but in a way that it dissolves itself as a Unity.

(ca. 1940)

[The Plastic]

All the qualities of naturalistic art are in the new art, and all the values of the new art are in the art of the past. The question is the

degree of clarity concerning the essential in art. Do we really have clarity? As long as feeling or intellect dominates, there is no clarity. To establish equilibrium, light is necessary. Art shows that slowly light is dawning. The equilibrium of life clearly must be established (realized).

The essential is to know how. Because life is manifested through man, man should know what he has to do.

All of life shows it, science demonstrates it, *art makes it plastically visible*, i.e., as *pure image*.

The clear manifestation of equilibrium is the content of the new.

Translated from the French (ca. 1938–39)]

———

For "plastic"—all that establishes itself as palpable appearance (all that creates a palpable *image*). (And what about music?)

Plastic is all that establishes itself in space. Music is not really [pure] plastic for it also establishes itself in time. But it can follow plastic's abolishing time—(shortness of tone, etc.).

Plastic is understood not as "modeling form" but as "composing an image by means of lines, planes, or volumes."

Establishing the structure of reality is making abstract art.

Abstract art establish[es] the structure of reality.

The establishment in [a] concrete way of the structure of reality, [which] in natural appearance [is] confused, is the content of abstract art.

Space-expression sounds primitive and naturalistic, space-determination is the content of human-culture.

(1942)

All plastic art shows that space-determination is the pure technical way to express reality.

Every tendency shows a particular way of space-determination, (Impressionism, Divisionism), visible in [the] placing of line or color, even [if] only in the brush touch.

In Abstract Art structure and means [are] concrete, in naturalistic art [they are] confounded so as to be separated.

[The] problem: unified, equilibrium.

———————

[[Space.

A limited space, determined only by the character of its circumference, leaves the space undetermined: empty.

Forms determinent [determine] empty space. They are limited spaces but, without division, are undetermined space. Then only their character is determined by their circumference.]]

———————

With the problem of division arises that of proportion, opposition, relationships.

. . . from the old classic esthetics to pure realistic plastical problems.

———————

[The Meaning of Plastic Expression]

In order to understand what plastic expression in art means, it is important to observe that the particular forms that reality manifests have an expression proper to them and independent of us.

This expression can either have an oppressive effect on us or it can be neutral. This fact prevents our objective vision of things. Their particular expression is created by the particular character of their elementary forms and colors. These forms are composed of volumes and planes. Volumes are determined by planes, planes by lines. Or we can say that planes are the intersections of volumes, lines the intersection of planes. Color also determines the particular aspect of things. It is essential to observe that elementary forms and colors in their proper and mutual relationship and not our particular vision of them create the appearance of the different manifestations, the plastic manifestation of palpable reality.

Plastic art aims at establishment of the universal, objective expression of reality. In order to accomplish this, the plastic art of the past neutralized the particular character of form and color through mutual opposition and more or less [greater or lesser] transformation of natural forms and colors. Through this fact, plastic expression in art is distinguished from plastic expression in palpable reality. It no longer consists in "modeling" forms or representation of natural colors, but establishes reality by means of forms and colors. But despite oppositions and modifications, things [objects] continue to have a particular expression. This expression binds us to the manifestations and events of everyday life, whereas Art deals with the expression of pure life, vitality, *free* from time and current events. The culture of plastic art has gradually created consciousness in us of the need to deliver art from its oppressive factors.

The vitality of living organisms as well as their physical characteristics is manifested not only through their appearance but through their movement. Vitality is more difficult to discern in inorganic things. Nevertheless we feel the vitality of reality in everything that exists. In plastic art this feeling of vitality is created through the dynamic rhythm of forms and colors. This rhythm is the pure plastic expression of art.

Two human tendencies have always appeared in plastic art: one endeavoring to

express inner feelings and conceptions, events, actions, and another that aims to reach universal expression. These two tendencies have a reciprocal action that produces progressively purer expressions in art. Plastic art reveals that the opposition of subjective tendencies, predominant in human nature, can be vanquished in the establishment of an objective expression of reality. The annihilation of limitations creates progress.

[Plastic Expression: Painting, Sculpture, Architecture]

In order to understand the meaning of the term plastic expression it is essential to observe the fact that the different forms that reality manifests have an expression proper to themselves and independent of us. Evidently this expression evokes sensations in us originating in the forms themselves as well as produced from our subjective feelings [and have] an oppressing or animating effect on us. First we must observe that this sensation results from the particular character of the forms and colors by which things are manifested, and from their dimensions. However, we should not forget that this sensation evoked by the things around us is also a product of our own personal feelings.

Nevertheless, despite personal, subjective vision, common collective vision of reality exists. This vision excludes personal feelings and recognizes the expression of things in their realistic appearance. It can be defined as the plastic expression of things. It must be emphasized, however, that in this vision the accent is on the appearance of things in their individual or collective significance and not on reality as unity in which things are as dissolved. Plastic art reveals that the relationship of forms and colors creates the expression of the vitality of life as complete reality, and that forms and colors are the means to express it.

When we observe that plastic art requires the expression of reality as unity, then we see that plastic expression in art cannot be identical with the common vision of things. Nevertheless plastic art is based on this vision. It tends towards an objective representation of reality. It has to eliminate more and more the predominance of subjective feelings. The common vision of things can be imitated by modeling [of] forms and application of colors. But art requires a living image of reality—of complete reality.

The general appearance, the plastic expression of things created by their form and color, is determined by the constructive elements of form: volumes, planes, lines. Volumes are determined by planes, planes by lines. Planes are the intersections of volumes, lines the intersections of planes.

If we observe that *our conceptions of reality and our feelings concerning it* are dependent on the appearance of things and on our subjective attitudes towards them, then we realize that both these factors have to be in mutual accordance in order for us to feel harmony.

In plastic art the expression of harmony always has been created through the selection of forms, planes, lines, colors. But plastic art has always remained indifferent to subject matter in so far as it has been not oppressed by external influences—daily life, religion, politics, history, etc. But modern art has excluded the latter and thereby demonstrated clearly that the constructive elements of form are the only true means of expression and that vitality can be expressed by their proper and mutual relationships.

If we realize that the means of expression are only "means" and that the expression of dynamic movement is the true content of art, then it becomes clear that art

remains "art" as long as it establishes this content. The question "whether abstract art is still art" is due to the misunderstanding of the function of plastic art as well as to the dominance of our subjective vision. Traditional vision also blinds us and prevents us from feeling the essential nature of plastic art established through pure means.

When a work expresses reality through volumes, planes, lines, colors in a way that makes it a world in itself, a complete unity in itself, then it is "art." But it is clear that this definition separates art from our environment. A work of art can never be a constructive part of that environment, for it is complete in itself. It may compensate for the lack of unity, beauty, in our interiors or buildings, but it can never contribute by means of its representation to the complete creation of our environment. It is only through its form, proportions, color, dimension, that a work of art can help establish architectural relationship. In this respect a picture functions just as well or even better with its face to the wall, for then it appears as a "plane" and as part of the architectural construction.

Architecture has to be complete in itself. In order to satisfy our physical and moral exigencies, it is logical that the most advanced modern architecture excludes works of art. But because of this such buildings often seem empty and barren. The reason for this is that color is lacking as well as equivalent relationships. These two factors, so essential in art, have been studied in painting and sculpture. The capacities to be used in an *Architecture, which aims not only at* utility and function but also at complete expression, have to reveal the capacities of painting and sculpture.

Evidently the expression of architecture has to be more objective than painting and sculpture until now. What is lacking in them is color and equivalent relationships, elements essential in art, which have been profoundly investigated in painting and sculpture.

[Volumes and Planes]

Volumes as well as planes are a limited part of universal space. In plurality, they are entities in themselves if they are not dissolved by equivalent parts of that space.

As separated objects in space [micro- in macrocosmos], they can be dissolved through division into parts that produce oppositions that annihilate their entity.

However, volumes in themselves can express an equivalence of form and space only when some parts are taken out. This is established in modern sculpture as well as in architecture.

Every work of plastic art is a world in itself reflecting reality as a whole. If a sculpture appears separated from empty space, in a painting, the extent of the canvas, the planarity of the canvas, permits expression in an abstract way.

In sculpture and architecture this is only possible when their volume is seen as a construction of planes.

Modern vision has abandoned the static vision of the past: the fixed viewpoint has become constantly moving. Perspective vision is excluded. Round or curved objects, having two-dimensional aspects, appear three dimensional. But a building and any prismatic object can be seen in [its] two-dimensional aspect. Here we remark that *while a round or curved form [viewed] by section can appear abstract, prismatic objects in two dimensional appearance can be directly* abstract in themselves.

The moving viewpoint enables us to see

an object in its true proportions and relations. Moving around buildings and objects, and moving within interiors, the impression of one two-dimensional aspect is directly followed by that of an other aspect. If color is used, unification of sculpture and architecture with painting is possible. The expression of the planes and colors of the whole work is at once absorbed by the eye in direct continuity and in their true value. The relationships are exactly perceived. The work becomes more real.

This is also felt in Cubism. But it is not seen that mobility of view[point] enables [us] to dissolve volume. To the contrary, Cubism tried to express volume and [thus] remained naturalistic. Pure abstract art dissolves the volume and its corporeal expression. Therefore it is abstract.

[Architecture]

It is clear that architecture has to satisfy our physical needs and is related in the first place to this. But it is not necessary that our human needs be sacrificed by this. It has to be related and conditioned to the organical existence of our selves as well as to that of everyday life; but this does not involve that it is complete expression of this existence, [as] it is not expression of what in human nature [is] beyond everyday life and is universal—thus beyond timely existence [existence in time].

This is not to [be] create[d] by estetic [aesthetic], always subjective. Only the universal expression of reality can guide us. [If] in new architecture objective expression [is to be] neared, one has to feel and recognize the universal expression of reality.

In order to obtain an objective expression, new architecture could make use of mathematics, if [that] were really conceivable

[[for instance, the golden section doctrine]]. [When] true mathematical laws are subjectively applied, a *static expression is the result.*

One must not rely upon mathematics nor upon [the] natural aspect of reality. One has to reduce this aspect to its fundamental expression which manifests itself through the utmost abstraction of natural aspect. This abstraction reveals [to] us [the] multiple complex of the constant opposition of form in the rectangular [inter]section of vertical and horizontal volumes, planes, lines. We have to establish a dynamic movement of this multiplicity in the way it reveals itself in palpable reality. If we follow *this expression in architecture*, an objective expression must result. Following nature's aspect and organism, evidently curved forms, planes, and lines are created, and with this a more obscured appearance of reality.

The oppression of animal nature in man is revealed in Modern Architecture as a whole, [in] buildings, furniture, shows [exhibitions]. We can observe the tendency to be organical, to satisfy our physical exigencies. [Thus] it becomes related to our animal existence—primitive. It nears more animal than human comfort. A dog makes himself a comfortable arrangement to lie on.

Man has moral [spiritual] exigencies which imply a reduction of physical comfort or rather transform it.

———

The predominance of the straight line in architecture is a tradition based on human nature. When the curved line technically is needed, it is clear that only in its most tensed manifestation can [it] be used, and [it] has to be predomined [dominated] by the straight line.

———

The predominance of the curved line brings

the accent on our natural, organical line.

Organical Architecture expresses the predominance of men's primitive nature.

Organic life of course contains our whole life. But our whole life must be expressed, our whole being satisfied.

(ca. 1942)

Architecture only [accounted for] our physical needs, [but] our moral [spiritual]—our mentality—[is] seeking for "art."

Vitality, however, is continually manifesting itself in pas [step] with human development. The most modern art is in research to obtain the grade [degree] of objectivity necessary to realize art in our environment.

———

The capacities created by Painting and Sculpture join the new architecture.

So Painting and Sculpture continue on another way—enter in Daily life. So Daily life grows more and more to Life: [Life] that is complete.

———

But how in art to *express*, [to] establish the complete expression of reality?

Modern art already shows efforts to express, [to] realize the essential qualities of painting and sculpture in architectural appearance. (Holtzman)

In actual three-dimensional works of H. H. [Harry Holtzman] the "picture" still more from the wall moves into our surrounding space. In this way the painting annihilates more literally the three-dimensional volume."

Must make use of the capacities obtained in painters and sculptors. Will have to *join*, collaborate with the ingenieur [engineer] to create complete architecture because it is difficult for one person to obtain all capacities necessary.

———

[Metropolis]

Painting has no direct (living) value when it is not in direct relationship with the actual surrounding reality. For Men of the City the city must be sublimated in the painting—the whole [of] city life must reflect in it. Metaphysic[al] painting has not this direct relationship. Being too far off from our surrounding, leads to misinterpretation or misunderstanding.

(1942)

———

Reality changes with time.
Primitive nature.
City-culture is Freeing from the grasp of nature.

(ca. 1942)

———

The Metropolitan with all its opposition, with all its strain and struggle, necessary to exhaust men's capacities.

International—Representative of human highest culture

———

[Teaching]

Is it necessary to start from nature? To pass through naturalistic painting? It is not necessary, to do over again what others have already done. Now it is no longer a question of eliminating nature. Today the laws of nature have been clearly demonstrated. We need to work in a new way. We need no longer search: we need to follow the laws.

Translated from the French (ca. 1938–39)

———

The method of abstracting the natural aspects of things is no longer necessary or to be recommended. Now we can compose a

work directly with the abstract elements (forms, lines, colors). In this way there is no danger of relapsing into naturalistic composition.

Translated from the French (ca. 1938)

———

In order to establish, we need something to establish. In order to create, we need lines, forms, colors. These can be taken from our surroundings: from nature or from whatever has been created for use, utility, necessity. Or from imagination; but the latter can go beyond visible forms only by distorting them. Nothing really comes directly from us, nothing is truly new.

But by working this way we remain within the *naturalistic domain*. In this way any transformation or composition of the things we see around us remains *natural*, we risk remaining naturalistic. In this way we would oppose our human environment and the needs of cultivated man. This is the old way followed by the most modern academies.

There is another way, but it appears too impoverished to those who want to make "pictures." Only this way can be acceptable to those who would construct a human environment and things useful for man.

This way directly takes lines and forms, whether geometric or not, studies them and composes them esthetically according to *esthetic laws*.

These esthetic laws have always been the same: each period reveals them differently through its own means. These laws are all we need retain from the past, from tradition. Education and environment have nurtured an esthetic tradition that is now false.

We need a new esthetic. To achieve it, we must lay bare the essential of the work of the past. We need the abstraction of forms. We need the laws and nothing else. These, together with the forms and nothing else, can produce the purely plastic.

Today, the time of clarity, light and utility, needs pure plastic.

What can be taught is the composition of forms, lines and colors, their relationships and their plastic significance.

The laws of equilibrium.

The character of equilibrium.

The subsidiary laws involved.

We can do one of two things: make a work of art, or make an esthetic object. Both are subject to the same laws. But the outcome is altogether different. Let us leave aside the question whether "art" is still necessary. Our goal is the creation of a useful and esthetic environment.

All that is necessary to life is good. And what is good is beautiful.

Translated from the French (ca. 1938–39)

Notes

Piet Mondrian: The Man and His Work

1. New York, S. R. Guggenheim Museum, *Piet Mondrian Centennial Exhibition*, 1971, 35–49.
2. Sigfried Giedion, *Architecture, You and Me: The Diary of a Development* (Cambridge: Harvard University Press, 1958), 44.
3. I have named the wall compositions *Wall Works, 1943–44* in order to distinguish them from the paintings. Most of Mondrian's paintings were labeled "compositions."
4. *Mondrian Centennial*, 22.
5. Le Corbusier, *The New World of Space, 1948* (New York: Reynal & Hitchcock, 1948), 21.
6. Herbert Read, *Icon and Idea* (Cambridge: Harvard University Press, 1955), 133.
7. *Toward the True Vision of Reality*.
8. Karl Mannheim, *Ideology and Utopia* (New York: Harcourt Brace, 1936), 192.

Mondrian: Art and Theory to 1917

1. "Cubism and Neo-Plastic" (1930), par. 17.
2. On Mondrian's art to 1908, see Robert P. Welsh, *Piet Mondrian's Early Career: The "Naturalistic Periods"* (New York: Garland, 1977). On Mondrian and his uncle, see Herbert Henkels, *Mondriaan in Winterswijk, Een essay over de jeugd van Mondriaan, z'n vader en z'n oom* (The Hague: Gemeentemuseum, 1979); Henkels, "Mondrian in his Studio," in Stuttgart, Staatsgalerie Stuttgart, *Mondrian: Drawings, Watercolors, New York Paintings* [1980]). On the Hague School in relation to Mondrian, see Regina, Saskatchewan, Norman Mackenzie Gallery, *Piet Mondrian and the Hague School of Landscape Painting* (exh. cat.), 1969; texts by Nancy E. Dillow and Robert Welsh; *Mondrian and The Hague School: Watercolors and Drawings from the Gemeentemuseum in The Hague* (Manchester: University of Manchester, Whitworth Art Gallery, 1980). Texts by J. Sillevis and H. Henkels.
3. Henkels, "Mondrian in his Studio," 228.
4. Henkels, "Mondrian in his Studio," 239; Henkels, *Mondriaan in Winterswijk*, 29.
5. Orthodox Calvinism, moreover, looked with suspicion on symbolism and theosophy, Abraham Kuyper (1837–1920), the statesman and leader of the Free Reformed Church party, who was a contemporary of Mondrian's father and befriended him, expressed his views on this subject in *The Antithesis between Symbolism and Revelation, Lecture delivered before the Historical Presbyterian Society in Philadelphia, Pennsylvania* (Amsterdam, 1899). See Bettina Polak *Het fin-de-siècle in de Nederlandse schilderkunst:. De symbolistische beweging 1890–*

1900 (The Hague: Martinus Nijhoff, 1955), 4; H. R. Rookmaaker, *Synthetist Art Theories* (Amsterdam: Swet and Zeitlinger, 1959), 196–200 and notes, 63.
6. On Mondrian's early figural work, see R. P. Welsh, *Piet Mondrian's Early Career*, 34 ff.; Welsh, "The Portrait Art of Mondrian," in *Album Amicorum J. G. van Gelder* (The Hague: Martinus Nijhoff, 1973); H. L. C. Jaffé, "Een gedateerde plafondschildering door Piet Mondriaan," *Oud Holland* 83, nos. 3–4, (1968): 229–38.
7. On Symbolism and the "Stylizers," see Carel Blotkamp et al., *Kunstenaren der idee: Symbolistiche tendenzen in Nederland, c. 1880-1930* (The Hague: Haags Gemeentemuseum, 1978); B. Polak, *Het fin-de-siècle*.
8. See Caroline Boot and Marijke van der Heijden, "Gemeenschapskunst," in *Kunstenaren der idee*, 36 ff.
9. Edouard Schuré, *Les Grands Initiés* (Paris: Perrin, 1889). A Dutch translation appeared in 1907, after a partial translation in 1901. Cf. Michel Seuphor, *Piet Mondrian: Life and Work* (New York: Harry N. Abrams, 1956), 53.
 The chief originator of modern theosophy was Madame H. P. Blavatsky (1831–91), author of *Isis Unveiled*, 2 vols. (New York: J. W. Bouton, 1877) and *The Secret Doctrine*, 2 vols. (London: Theosophical Publishing Co., 1888). For a full discussion of Mondrian in relation to theosophical thought, see R. P. Welsh, "Mondrian and Theosophy," in New York, Solomon R. Guggenheim Museum, *Piet Mondrian 1872–1944: Centennial Exhibition* (1971), 35–52.
10. "Trialogue," scenes 1, 2, and 4. Cf. "Toward the True Vision of Reality," par. 1.
11. H. L. C. Jaffé, *Piet Mondrian* (New York: Harry N. Abrams, 1970), 22.
12. A. B. Loosjes-Terpstra, *Moderne Kunst in Nederland 1900–1914* (Utrecht: Haentjens Dekker & Gumbert, 1959), ch. 3 and 4. "Luminism" derives from "chromo-luminarisme," an alternative term for Neo-Impressionism used in the circle of Seurat (ibid., 70, 253). Mondrian speaks of Luminism in the "Trialogue," scene 6.
13. Mondrian singles out Van Dongen's use of color in the "Trialogue," scene 7. He later wrote: "I admired Matisse, van Dongen, and the other Fauves" ("Toward the True Vision of Reality," 1941). No other Dutch "Modernist" is mentioned in his essays.
14. On the iconography of *Devotion* and its connection with Rudolf Steiner's anthroposophy, see Welsh, "Mondrian and Theosophy," 35–52.
15. *De Controleur* 20, no. 1004 (23 October 1909), reprinted in "Documentatie: Kunstenaarsbrieven aan Kees Spoor (2)," ed. L. van Genneken and J. M. Joosten, *Museumjournaal* 10, no. 5 (1970–71):262–63; the entire letter is translated in *Two Mon-*

drian Sketchbooks 1912–14, ed. R. P. Welsh and J. M. Joosten (Amsterdam: Meulenhoff, 1969), 10.

16. "The New Art—The New Life," 263, below. In "The New Plastic in Painting (46 below), Mondrian writes: "the symbol constitutes a new limitation on the one hand, and it is *too* absolute on the other;" see also 52 in the same essay. Other references to the use of symbols occur in the "Trialogue," scene 4, and in "No Axiom but the Plastic Principle" (178 below).

Welsh ("Mondrian and Theosophy," 40) remarks that "Theosophists in general disparage the word 'symbol.'"

On the problem of expressing the spiritual and invisible in terms of visual art, see Sixten Ringbom, *The Sounding Cosmos: A Study in the Spiritualism of Kandinsky and the Genesis of Abstract Painting* (Abo: Akademi, 1970). In scene 7 of the "Trialogue," Mondrian discourages the idea of expressing the suprasensory in painting.

17. "The Necessity for a New Teaching in Art, Architecture, and Industry," 312 below. See also *Two Mondrian Sketchbooks*, 1:49–50; "Neo-Plasticism: Its Realization in Music and Future Theatre," par. 7.

18. Guillaume Apollinaire, "A travers le Salon des Indépendants," *Montjoie* 1, no. 3 (18 March 1913).

19. To H. P. Bremmer, 29 January 1914, in "Documentatie over Mondriaan (1)," ed. J. Joosten, *Museumjournaal* 12, no. 4 (1968):211–12.

Bremmer edited the portfolio series *Beeldende kunst*, where he reproduced and discussed certain of Mondrian's compositions. Besides purchasing work by Mondrian on his own behalf, Bremmer guided the acquisitions of Mrs. H. Kröller-Müller whose collection became the nucleus of the present Kröller-Müller State Museum, Otterlo. From 1916 to 1920, on Bremmer's recommendation, the Kröller's provided Mondrian with a stipend in return for a specified number of works.

20. To Bremmer, 8 April 1914, in "Documentatie (1)," 212.

21. To Lodewijk Schelfhout, 12 June 1914, ibid., 215. Mondrian often saw adverse criticism as a challenge and vindication: "I am glad criticism is . . . completely against us. Otherwise we would have nothing left to do" (Mondrian to Van Doesburg, 17 May 1920, in Amsterdam Stedelijk Museum, *De Stijl*, 1951, 72. Mondrian once compared his youthful obstinacy to that of Van Gogh when he held his hand in the flame of a candle (Carl Holty, "Mondrian in New York, a Memoir," *Arts* 31 (September 1959):17–21).

22. "The New Plastic in Painting," 44.

23. On the evolution of Mondrian's art between 1912 and 1917, see Joop Joosten, "Between Cubism and Abstraction," Mondrian Centennial, 53–66.

24. Quoted by A.-O. (Augusta de Meester-Obreen), "Piet Mondriaan" (a propos the Rotterdamsche Kunst Kring's Alma-Le Fauconnier-Mondriaan exhibition of February 1915), *Elsevier's Maandschrift* 25, no. 50 (1915):396–99; reprinted in "Documentatie (2)," *Museumjournaal* 13, no. 5 (1968):267.

25. Reproduced in facsimile with English translation and an introduction by R. P. Welsh: R. P. Welsh and J. M. Joosten, *Two Mondrian Sketchbooks 1912–1914* (Amsterdam, Meulenhoff, 1969).

26. M. van Domselaer-Middlekoop, "Herinneringen aan Piet Mondrian," *Maatstaf* 7 (1959–60):275–78. On Van Domselaer, see 148 below.

27. The following excerpts are adapted with minor changes from *Two Mondrian Sketchbooks*. The texts are difficult to date precisely: Welsh (ibid., 14) inclines to 1913–14; Joosten suggests summer 1914 for the texts of sketchbook I ("Mondrian's Lost Sketchbooks from the Years 1911–14," in Stuttgart, Staatsgalerie, *Mondrian*, 69).

28. Mondrian, "Homage to Van Doesburg," 1931.

29. The editors are indebted to Mr. A. L. van Gendt, Amsterdam, for the text of Mondrian's letter. The date of 31 January 1910 (based on a postmark?) is in another hand. Joop Joosten questions this date (communication of November 1984).

Saalborn recognized the spiritual qualities of Mondrian's work at the 1911 Moderne Kunstkring exhibition in his article "Piet Mondriaan en de anderen," *De Kunst* 4, no. 197 (November 1911):74–77.

30. "It is the HIGHER-SELF, the real EGO who alone is divine and GOD" (H. P. Blavatsky, *The Secret Doctrine*, 1:445). Blavatsky quotes Hegel's *Philosophy of History*: "the essence of man is spirit. . . . Only by stripping himself of his finiteness and surrendering himself to pure self-consciousness does he attain truth. Christ-man, as man in whom the unity of God-man (identity of the individual with the Universal consciousness . . .) appeared, has in his death and history generally, himself presented the eternal history of Spirit—a history which every man has to accomplish in himself, in order to exist as spirit" (ibid., 52).

PART I: DE STIJL PERIOD: 1917–24

1. Translated from the Dutch text of the Manifesto in *De Stijl* 2, no. 1 (November 1918):2–3.

The New Plastic in Painting

1. Letter to H. van Assendelft, 5 September 1917.

2. As revised by Mondrian on his tearsheets. In *De Stijl*, the passage ran: "can be placed free of one another, which is impossible in architecture."

3. The sentences in brackets were deleted by Mondrian on his tearsheets.

4. Schoenmaekers, *Het nieuwe wereldbeeld*.

5. "*Vormbeelding*, the plastic of form." The equivalent term *morphoplastique* first occurs in *Le Néo-Plasticisme* (1920).

6. G. J. P. J. Bolland (1854–1922), professor at Leiden and perhaps the most celebrated Dutch philosopher of his day, treated a wide range of subjects along the lines of the Hegelian system. His collected writings, *Zuivere rede en hare werkelijkheid* (The reality of pure reason) was several times reprinted and augmented (chief editions 1904, 1909, and 1912). The passages quoted by Mondrian in chapter 5 below (51) first appeared in Bolland's *Aesthetische geestelijkheid* (The aesthetics of spirit), published in 1907.

7. Dr. Schoenmaekers held that the vertical "ray" (from the sun) was more taut, active, and inward than the horizontal "line." Mondrian abandoned this conception in his subsequent writings.

8. This paragraph reflects statements in a lecture given by Rudolf Steiner in The Hague on 8 March 1908, of which Mondrian

owned the printed resumé. See Welsh, "Mondrian and Theosophy," 38.

9. On Matthijs Maris, brother of the Hague Impressionists Willem and Jacob, see above, 12. Upon Maris's death, not long before this passage was published, Van Doesburg wrote a respectful tribute.

10. Mondrian depicted farmhouses and woods in this manner as early as 1889–1900. The bare tree, subject of a memorable series ca. 1908–9, reappears in his Cubist work of 1912–13. The sea provided the motif for several late Cubist works in 1914–15.

Natural Reality and Abstract Reality: A Trialogue

1. Carel Blotkamp, "Mondriaan—Architectuur," *WONEN/TABK* 4–5 (1982):12–51; also Nancy J. Troy, "Piet Mondrian's Atelier," *Arts Magazine*, December 1978, 82–88; Troy, *The De Stijl Environment* (Cambridge: MIT Press, 1983), 135–141.

2. *Het vaderland*, 9 July 1920. See Herbert Henkels, "Mondrian in his Studio," in Stuttgart, Staatsgalerie Stuttgart, *Mondrian*, 260, 89.

3. According to the *Manifesto of Futurist Architecture* (11 July 1914), "the fundamental characteristic of [Futurist] architecture will be expendability and transience. Our houses will last less time than we do, and every generation will have to make its own" (translated by Reyner Banham, *Theory and Design in the First Machine Age* (New York: Praeger, 1967), 135. The passage was quoted in Robert van 't Hoff's discussion of a project by Antonio Sant'Elia in *De Stijl* 2, no. 10 (August 1919):116.

[Two Paris Sketches]

1. The present account is indebted to Carel Blotkamp, "Mondrian als literator," *Maatstaf* 26, no. 4 (April 1978):1–30 (followed by the Dutch text of the two sketches).

2. "The De Stijl Manifesto II: On Literature" was completed by Van Doesburg on his return to Holland; it appeared in the journal's April 1920 number over the signatures of Van Doesburg, Mondrian, and the poet Antony Kok, an early contributor.

3. *De nieuwe gids* 25 (May 1920):703–23; reprinted in L. van Deyssel, *Werk der laatste jaaren* (Amsterdam: Meulenhoff, 1923), 104–34.

4. Presumably, Margaret in Goethe's *Faust*. Mondrian, like Goethe, calls her Gretchen.

5. The celebrated conductor J. W. Mengelberg (1871–1951) led the orchestra of the Amsterdam Concertgebouw from 1895 to 1945.

6. Isadora Duncan's brother Raymond (1874–1966) lectured widely on the arts (and practiced several of them), advocating self-sufficiency through the handicrafts. He was often seen in Paris and New York, dressed in a Grecian manner.

7. Emile Jaques-Dalcroze (1865–1950), Swiss composer and educator, created Eurythmics, in which a sense of rhythm was developed by translating music into bodily movement.

8. Mondrian had written to Van Doesburg on 4 December 1919: "I went [to the Louvre] to see Courbet's famous *Atelier*. Of course it is good, but not good in the way a Rembrandt is *good*."

Neo-Plasticism: The General Principle of Plastic Equivalence

1. "Les Grands Boulevards" and "Little Restaurant—Palm Sunday" both completed by mid-April 1920.

2. Blotkamp, "Mondriaan als literator," 15.

3. Blotkamp, "Mondriaan als literator," 19.

4. Els Hoek, "Mondriaan," in Carel Blotkamp et al., *De Beginjaren van De Stijl* (Utrecht: Reflex, 1982), 72–73, from which are also drawn the passages from Mondrian's letters to Van Doesburg. See also Nicolette Gast, "Georges Vantongerloo," ibid., 254–55.

Mondrian discusses the naturalistic character of the traditional scales or proportional systems in "The Manifestation of Neo-Plasticism in Music and the Italian Futurist Bruiteurs" (see below, 151). See also: "Neo-Plasticism: Its Realization in Music and Future Theatre" (below, 160). Mondrian to Van Doesburg, 7 February 1922 (below, 157) and Summer 1922 (below, 157); "Down with Traditional Harmony" (below, 191); "Realist and Superrealist Art" (below, 231); "A Folder of Notes" (below, 390).

5. See Mondrian to Van Doesburg, 30 June 1920 (above, 132 see also below, 142).

6. According to Marinetti in the "Technical Manifesto of Futurist Literature" (1912), the substantive directly followed by "its double . . . to which it is bound by analogy" expresses "the immense love that joins distant and seemingly different and hostile things." Mondrian could have found this text in his copy of *Les Mots en liberté futuristes* (1919), presented to him by Marinetti.

7. From Dominique Braga, "Le Futurisme," *Le Crapouillot* (Paris), 14 April 1920, 2–3. Braga here draws upon Marinetti's "Technical Manifesto of Futurist Literature."

8. Mondrian is citing the article in which Gide repudiated Dada, which had finally achieved only "meaningless sound, total nonsignificance" ("Dada," *Nouvelle Revue française* [Paris], no. 79 [1 April 1920]:477–81).

9. The "normal," in geometry is the perpendicular relationship.

10. See below, 148.

11. On his copy of the pamphlet, Mondrian substituted "painted and described" for "sang or plastically expressed."

The Manifestation of Neo-Plasticism in Music and the Italian Futurists' Bruiteurs

1. Here and below, Mondrian is quoting the French translation of Russolo's "The Art of Noises," first published in Italian, in 1913.

2. This and the preceding paragraph were included only in the Dutch version printed in *De Stijl*.

Neo-Plasticism: Its Realization in Music and Future Theatre

1. The painter Gino Severini (1883–1966) joined the Futurists in 1910. From 1916 on, he worked more figuratively. "Drawn into the circle of Lhôte, Lipchitz, Ozenfant, Cocteau, and

others," he "turned toward a calmer, more rational art" Marianne Martin, *Futurist Art and Theory, 1909–1915* (Oxford: Clarendon Press, 1968). Severini was the first non-Dutch artist to contribute to *De Stijl* (1, no. 2 [1917]), where his writings appeared until January 1919. Mondrian probably first met him in Paris in 1912–13.

The Realization of Neo-Plasticism in the Distant Future and in Architecture Today

1. *Bouwkundig weekblad*, 11 June 1921. Oud's article was first given as a lecture in February to the Rotterdam Opbouw group; it has been called "the first major theoretical pronouncement by any of the leading architects of the mainstream of development in the Twenties" (Reyner Banham, *Theory and Design in the First Machine Age* [New York: Praeger, 1967], 157).
2. Note by Mondrian in his Bauhaus book (1925): "I was unaware when I wrote this essay (1922) that the Staatliches Bauhaus at Weimar, transferred to Dessau in 1925, was already working in this direction."

Is Painting Inferior to Architecture?

1. See Carel Blotkamp, "Mondrian—architectuur," 38–40; Nancy J. Troy, *The De Stijl Environment* (Cambridge: MIT Press, 1983), 16, 180.

Neo-Plasticism

1. *Futurist Aristocracy*, ed. N. L. Castelli (first number April 1923) advertised itself in *Noi* as "American Review of the Transatlantic Futurism."

No Axiom but the Plastic Principle

1. "Dadaïsme," *De Stijl* 6, no. 2 (April):28–30; no. 3 (May-June 1923):38–41.

Blown by the Wind

1. *De huif*, as printed in *De Stijl*, is probably an error for *De huik*.
2. Footnote by Van Doesburg in *De Stijl*: "The editors assume no responsibility for this statement."

PART II: AFTER DE STIJL

1. Mondrian's relationship to *i 10* is recalled in A. Lehning and J. Schrofer, *Een Keuze uit de internationale revue i 10* (The Hague: Bakker, 1963).

Down with Traditional Harmony

1. For Mondrian's letter and the text of this article the editors are indebted to Prampolini's brother, Alessandro Prampolini.

The Evolution of Humanity Is the Evolution of Art

1. "The Stages of Humanity," by Dr. Hélan Jaworski. Jaworski also contributed to *L'Esprit nouveau* in 1920. Mondrian mentions him again in "The New Art—The New Life" (below, 256).

The Neo-Plastic Architecture of the Future

1. Mondrian adapted the bracketed passages in this and the next paragraph from "The Realization of Neo-Plasticism in the Distant Future and in Architecture Today" (1922).

Purely Abstract Art

1. Yve-Alain Bois, "Mondrian en France, sa collaboration à 'Vouloir,' sa correspondance avec Del Marle," *Bulletin de la Societé de l'Histoire de l'art français*, 1981, 281–98, thoroughly documents Mondrian's relationship to Del Marle and his three contributions to *Vouloir*. The following extracts are from seventeen communications from Mondrian to Del Marle between January 1926 and August 1927, appended to Bois's article.
2. Bois, "Mondrian en France," 284 and n. 17, regards Del Marle's improvements as excessive and, in places, erroneous.
3. For a copy of this manuscript the editors are indebted to its owner Mr. Guido Molinari, Montreal, as well as to Mr. Arthur A. Cohen, New York, and Mr. Gilles Gheerbrant, Montreal.
4. The terms "counterconstruction" and "counter-composition" were introduced by Van Doesburg in 1924 in connection with his program for a plastic based on active opposition, or contrast ("Toward a Plastic Architecture," *De Stijl* 6, nos. 6–7 [1924]:78–82). See headnote to "Home—Street—City," below.

The New Plastic Expression in Painting

1. Besides Zervos's reference to Dutch architecture, Mondrian possibly had in mind the opinion held by Léger, among others, that abstraction was a "Nordic" tendency.

Home—Street—City

1. Bois, "Mondrian en France," documents 6 and 13.
2. Ibid., document 9.
3. "Painting: From Composition to Counter-composition," *De Stijl* 7, nos. 73–74 (1926):17–28. Translation adapted from Joost Baljeu, *Theo van Doesburg* (New York: Macmillan, 1974), 151 ff.
4. Letter of 26 June 1933 in Alfred Roth, *Begegnung mit Pionieren* (Basel: Birkhaüser Verlag, 1973), 174. This volume contains many letters from Mondrian to the distinguished Swiss architect (b. 1903) who became his friend in April 1928 when he worked as an assistant to Le Corbusier and Pierre Jeanneret in Paris. Mondrian replied at considerable length to queries by Roth in connection with a study of color in architecture, writing him on 28 June 1933: "I have not concerned myself with matters of architecture for ten years, but I am glad you compelled me to: for architecture is the future" (ibid., 176).

General Principles of Neo-Plasticism

1. The present translation is based on Mondrian's manuscript as reproduced in facsimile, *Art d'aujourd'hui*, December 1949.
2. Yve-Alain Bois, "Mondrian in Paris," document 11, 293. The events surrounding the questionnaire were reconstructed by Bois.

Jazz and Neo-Plastic

1. Bois, "Mondrian en France," document 17, 294.
2. *De Telegraaf*, 12 September 1926.
3. The eminent French physiologist Charles Richet (1850–1935) also wrote on topics of humanitarian interest. He is mentioned by Kandinsky in *On the Spiritual in Art*.

Pure Abstract Art

1. On the Zurich circle, see Roth, *Begegnung mit Pionieren*, 160 ff.

Realist and Superrealist Art

1. *Retour à l'univers des anciens: étude astrologique et philosophique* (Paris: Chacornac, 1929). Hoyack (b. 1893) wrote on a wide range of subjects. The Hoyacks were among Mondrian's Dutch friends in Paris in the 1920s.

Cubism and Neo-Plastic

1. E. Tériade, "Documentaire sur la jeune peinture: III. Conséquences du cubisme," *Cahiers d'art*, January 1930, 22.

The New Art—The New Life

1. On 16 June 1932 Mondrian wrote Roth that Michel Seuphor had found a way to publish "The New Art—The New Life" in connection with "Les Tendances Nouvelles," but an author's subsidy of 1,000 francs would be needed, something impossible for Mondrian at the time (Roth, *Begegnung mit Pionieren*, 167). According to Seuphor (written communication to the editors, 30 October 1975), " 'Les Tendances Nouvelles' was the title of a series of books printed in a small Franco-Polish printshop ('Ognisko'), where I was employed in 1930 and 1931. There was a project to publish P. M.'s manuscript, but the latter never achieved a final form. P. M. was still improving it in 1933 [See Mondrian's "Introduction to 'The New Art—The New Life,' " below]. 'Les Tendances Nouvelles' ceased all activity in spring 1932."
2. The Swedish sociologist Sven Backlund, a friend of Alfred Roth's, visited Mondrian in Paris in the fall of 1931. The following year, Backlund agreed to write a preface for "The New Art—The New Life." In his article, "Piet Mondrian," *Hyregästen* 9, no. 20 (15 October 1931), he reported that

Mondrian, while most interested in developments in Russia, felt that these were not radical enough. "It is a mistake [Mondrian said] to limit everything to the workers. In this way attention is diverted from what is fundamentally human . . . I have many friends among anarchists and communists. But it will not go as they imagine" (Roth, *Begegnung mit Pionieren*, 163 ff.).
3. Hélan Jaworski, "L'Intériorisation de l'eau de mer," *L'Esprit nouveau*, nos. 11–12 (1920):1267–72. According to Jaworski the circulation of blood in man is analogous to the circulation of seawater in ancestral primitive organisms. See headnote and note 1 to "The Evolution of Humanity Is the Evolution of Art" (above, 193).
4. These lines were written before political repression in the Soviet Union became a widely recognized fact. Until the Stalinist purges of 1936–38, post-Revolutionary Russia appeared to most liberals as an experiment pointing the way to a more equitable society.

Introduction to "The New Art—The New Life"

1. Amsterdam, Stedelijk Museum, *Piet Mondriaan* (exhibition catalogue) (1946), 35.

Plastic Art and Pure Plastic Art

1. Letters from Mondrian to Jean Gorin in *Macula* 2 (1977): 128–34.

PART III: ENGLAND AND THE UNITED STATES: 1938–44
The Necessity for a New Teaching in Art, Architecture, and Industry

1. In *Moholy-Nagy*, ed. Richard Kostelanetz, Documentary Monographs in Modern Art (New York: Praeger, 1970), 176–77.
2. This paragraph was crossed out by Mondrian.
3. Refer to Appendix, pages 403–4, for facsimiles of Mondrian's notes.
4. Refer to Appendix, pages 405, for facsimile of Mondrian's notes.
5. Refer to Appendix, pages 403–10, for facsimiles of Mondrian's notes.

An Interview with Mondrian

1. The two letters appear in facsimile in *Piet Mondrian: The Early Years* (Solomon R. Guggenheim Museum exhibition catalogue, 1957). Sweeney described the correspondence in *Art News* 50, no. 4 (Summer 1951).
2. Mondrian's preparatory notes for this interview included the paragraph beginning "In actual three-dimensional works of H. H. . . . (391 below).

Sources

In the present volume, texts published during Mondrian's lifetime have been supplied with additions or corrections taken from his original manuscripts or tearsheets. Such departures, as well as the use of texts unpublished in Mondrian's lifetime, are indicated in editorial notes. Unless otherwise stated in the headnotes, manuscripts and tearsheets mentioned were in Mondrian's estate; they are housed, together with a number of other documents pertaining to Mondrian, in the Beinecke Rare Book and Manuscript Library, Yale University.

"The New Plastic in Painting" (De Nieuwe Beelding in de schilderkunst). *De Stijl* (Leiden) 1, no. 1 (October 1917):2–6; no. 2 (December 1917):13–18; no. 3 (January 1918):29–31; no. 4 (February 1918):41–45; no. 5 (March 1918):49–54; no. 7 (May 1918):73–77; no. 8 (June 1918):88–91; no. 9 (July 1918):102–8; no. 10 (August 1918):121–24; no. 11 (September 1918):125–34; no. 12 (October 1918):140–47; 2, no. 2 (December 1918):14–19.

"Dialogue on the New Plastic" (Dialoog over de Nieuwe Beelding [zanger en schilder]). *De Stijl* 2, no. 4 (February 1919):37–39; no. 5 (March 1919):49–53.

"Natural Reality and Abstract Reality: A Trialogue" (Natuurlijke en abstracte realiteit). *De Stijl* 2, no. 8 (June 1919):85–89; no. 9 (July 1919):97–99; no. 10 (August 1919):109–13; no. 11 (September 1919):121–25; no. 12 (October 1919):133–37; 3, no. 2 (December 1919):15–19; no. 3 (January 1920):27–31; no. 5 (March 1920):41–44; no. 6 (April 1920):54–56; no. 7 (May 1920):58–60; no. 8 (June 1920):65–69; no. 9 (July 1920):73–76; no. 10 (August 1920):81–84.

"Les Grands Boulevards" (De groote boulevards). *De nieuwe Amsterdammer* (Amsterdam), 27 March 1920, 4–5; 3 April 1920, 5.

"Little Restaurant—Palm Sunday" (Klein restaurant—Palmzondag). Written 1920; published posthumously.

Neo-Plasticism: The General Principle of Plastic Equivalence (Le Néo-Plasticisme: Principe général de l'équivalence plastique). Paris: Editions de l'Effort Moderne, 1920.

"The Manifestation of Neo-Plasticism in Music and the Italian Futurists' *Bruiteurs*" (De "bruiteurs futuristes italiens" en "het nieuwe" in de muziek). *De Stijl* 4, no. 8 (August 1921):114–18; no. 9 (September 1921):130–36. In French as "La manifestation du Néo-plasticisme dans la musique et les bruiteurs futuristes italiens," *La vie des lettres et des arts* (Paris), August 1922, 132–43.

"Neo-Plasticism and Its Realization in Music" (Het Neo-plasticisme [de Nieuwe Beelding] en zijn [hare] realiseering in de muziek). *De Stijl* 5, no. 1 (January 1922):1–7; no. 2 (February 1922):17–23. In French as "Le Néo-plasticisme, sa réalisation dans la musique et au théâtre futur," *La vie des lettres et des arts* (Paris), August 1922, 304–14.

"The Realization of Neo-Plasticism in the Distant Future and in Architecture Today" (De realiseering van het Neo-plasticisme in verre toekomst en in de huidige architectuur). *De Stijl* 5, no. 3 (March 1922):41–47; no. 5 (May 1922):65–71.

"Is Painting Inferior to Architecture?" (Moet de schilderkunst minderwaardig zijn aan de bouwkunst?). *De Stijl* 6, no. 5 (1923):62–64.

"Neo-plasticism" (Het Neo-plasticisme). *Merz* (Hanover), no. 6 (October 1923).

"No Axiom but the Plastic Principle" (Geen axioma maar beeldend principe). *De Stijl* 6, nos. 6–7 (1924):83–85.

"Blown by the Wind" (De huik naar den wind). *De Stijl* 6, nos. 6–7 (1924):86–88. "Homage to Van Doesburg" (Notities bij het overlijden van Theo van Doesburg). *De Stijl*, last number (1932): 48–49.

"Down with Traditional Harmony!" (A bas l'harmonie traditionelle!). Written 1924; unpublished.

"The Arts and the Beauty of Our Tangible Surroundings" (Les Arts et la beauté de notre ambiance tangible). *Manomètre* (Lyons), no. 6 (August 1924).

"The Evolution of Humanity Is the Evolution of Art" (L'Evolution de l'humanité est l'évolution de l'art). *Bulletin de l'Effort Moderne*, November 1924.

"The Neo-Plastic Architecture of the Future" (L'Architecture future néoplasticienne). *L'Architecture vivante* (Paris) 3, no. 9 (Autumn 1925):11–13.

"Purely Abstract Art" (L'Art purement abstrait). *Vouloir* (Lille), no. 19 (March 1926).

"The New Plastic Expression in Painting" (L'Expression plastique nouvelle dans la peinture). *Cahiers d'art* (Paris) 1, no. 7 (July 1926):181–83.

"Home—Street—City" (Neo-plasticisme: De woning—de straat—de stad). *i 10* (Amsterdam) 1, no. 1 (January 1927):12–18.

"General Principles of Neo-Plasticism" (Principes généraux du Néo-plasticisme). From facsimile of manuscript in *Art d'aujourdhui*, no. 5 (1949):1–2.

"Painting and Photography" (Diskussion über Ernst Kallais Artikel "Malerei und Fotographie"). *i 10* 1, no. 6 (June 1927):235.

"Jazz and Neo-Plasticism" (De jazz en de Neo-plastiek). *i 10* 1, no. 12 (December 1927):421–27.

"Pure Abstract Art" (Die rein abstrakte Kunst; L'Art abstrait pur). *Neue Zürcher Zeitung* (Zurich), no. 2060 (26 October 1929).

[A Note on Fashion.] Source unidentified.

"Realist and Superrealist Art: Morphoplastic and Neo-Plastic" (L'Art réaliste et l'art superréaliste: la Morphoplastique et la Néoplastique). *Cercle et Carré* (Paris), no. 2 (15 April 1930).

"Cubism and Neo-Plastic" (Le Cubisme et la néo-plastique: réponse à M. Tériade). *Cahiers d'art* (Paris) 6, no. 1 (January 1931):41–43.

"An International Museum of Contemporary Art" (Un Musée contemporain international). Written 1931; unpublished.

"The New Art—The New Life: The Culture of Pure Relationships" (L'Art nouveau—La Vie nouvelle: La Culture des rapports purs). Completed 1931; published posthumously.

"Introduction to 'The New Art—The New Life.'" Written June 1932; unpublished. "Neo-Plastic" (La Néo-plastique). *Abstraction-Création* (Paris), no. 1 (1932):25.

[Untitled.] *Abstraction-Création*, no. 2 (1933):31.

[Untitled.] *Abstraction-Création*, no. 3 (1934):32.

"The True Value of Oppositions in Life and Art" (La Vraie Valeur des oppositions dans la vie et dans l'art; De werkelijke waarde der tegenstelligen). *Kroniek van hedendaagsche kunst en kultuur* (Amsterdam) 5, no. 3 (15 December 1939):34–36.

"Reply to an Inquiry" (Réponse à une enquête). *Cahiers d'art* 10, nos. 1–4 (1935):31.

"Art without Subject" (Kunst zonder onderwerp). In *Abstract Art*. Amsterdam Stedelijk Museum, April 1938, 6–8. Exhibition catalog.

"Three Notes." *Transition* (Paris), no. 26 (1937):118–19.

"Neo-Plastic" (Neo-Plastiek). *Werk* (Zurich) 25, no. 8 (August 1938):25. "Plastic Art and Pure Plastic Art." In *Circle: An International Survey* of *Constructive Art*. London: Faber & Faber, 1937.

"The Necessity of a New Art Teaching." Written ca. 1938–40; unpublished.

"A New Religion?" Written ca. 1938; unpublished.

"Art Shows the Evil of Nazi and Soviet Oppressive Tendencies." Written May 1940; unpublished.

"Liberation from Oppression in Art and Life." In *Plastic Art and Pure Plastic Art*. New York: Wittenborn & Schultz, 1945.

"Abstract Art." In New York. Art of This Century Gallery. *Art of This Century*, edited by Peggy Guggenheim, October 1942. Exhibition catalogue.

"Notes for an Interview." Written early 1941; unpublished.

Toward the True Vision of Reality. New York: Valentine Gallery, January 1942.

Bibliography

A. LIFE AND WORK

1. General

Blok, Cor. *Piet Mondrian: Een catalogus van zijn werk in Nederlands openbaarbezit.* Amsterdam: Meulenhoff, 1974.

Bois, Yve-Alain. "Mondrian, Draftsman." *Art in America* 69, no. 8 (October 1981): 94–113.

Henkels, Herbert. "Mondrian in his Studio." In Stuttgart, Staatsgalerie Stuttgart, *Mondrian: Drawings, Watercolors, New York Paintings.* 1980, 219–69. Exhibition catalogue.

Jaffé, H. L. C. *Piet Mondrian.* New York: Harry N. Abrams, 1970. Recommended introductory reading.

Ottolenghi, Maria Grazia. *Tout l'oeuvre peint de Mondrian.* Paris: Flammarion, 1976.

Seuphor, Michel. *Piet Mondrian: Life and Work.* New York: Harry N. Abrams, 1956. Recommended introductory reading.

Welsh, Robert. "Mondrian as Draftsman." In Stuttgart, Staatsgalerie Stuttgart, *Mondrian: Drawings, Watercolors, New York Paintings*, 1980, 35–63.

Wijsenbeek, L. J. F. *Piet Mondrian.* New York: New York Graphic Society, 1968.

2. The Naturalistic Period

Henkels, Herbert. *Mondriaan in Winterswijk: een essay over de jeugd van Mondriaan, z'n vader en z'n oom.* The Hague: Haags Gemeentemuseum, 1979.

Welsh, Robert P. *Piet Mondrian's Early Career: The "Naturalistic" Periods*, New York: Garland, 1977.

———. "The Portrait Art of Mondrian." In *Album Amicorum J. G. van Gelder.* The Hague: Martinus Nijhoff, 1973.

3. The Modernist Period

Van Ginneken, Lily, and Joosten, J. M. "Documentatie: Kunstenaarsbrieven aan Kees Spoor." *Museumjournaal* 15, no. 4 (1970–71):206–8; no. 5 (1970–71): 261–67.

Welsh, Robert P. "Mondrian and Theosophy." In New York, S. R. Guggenheim Museum, *Piet Mondrian Centennial Exhibition*, 1971, 35–52.

———. "Mondrian and Theosophy." In New York, S. R. Guggenheim Museum, *Piet Mondrian Centennial Exhibition*, 1971, 35–52.

4. The Cubist Period

Joosten, J. M. "Between Cubism and Abstraction." In New York, S. R. Guggenheim Museum, *Piet Mondrian Centennial Exhibition*, 1971, 53–56.

———. "Abstraction and Compositional Innovation." *Artforum* 11, no. 8 (April 1973):55–59

———. "Mondrian's Lost Sketchbooks from the Years 1911–16. In Stuttgart, Slaatsgalerie Stuttgart, *Mondrian: Drawings, Watercolors, New York Paintings*, 1980, 63–73.

Joosten, J. M., and Welsh, Robert P., eds. *Two Mondrian Sketchbooks, 1912–14.* Amsterdam: Meulenhoff, 1969. Facsimile with English translation.

Van Domselaer-Middelkoop, M. "Herinneringen aan Piet Mondriaan." *Maatstaf* 7 (1959–60):269–93.

Welsh, Robert. "Piet Mondrian: The Subject Matter of Abstraction." *Artforum* 11, no. 8 (April 1973):50–53.

5. The Early Neo-Plastic Period

Blotkamp, Carel. "Mondrian's First Diamond Compositions." *Artforum* 18, no. 4 (December 1979):33–39.

Hoek, Els. "Piet Mondriaan." In Carel Blotkamp et al, *De beginjaren van De Stijl, 1917–1922.* Utrecht: Reflex, 1982, 47–82.

Joosten, J. M. "Documentatie over Mondriaan: 26 brieven van Piet Mondriain aan Lod. Schelfhout en H. P. Bremmer 1910–1918." *Museumjournaal* 13, no. 4 (1968):208–15; no. 5 (1968):267–70; no. 6 (1968):321–26.

———. "Documentatie over Mondriaan: 17 brieven van Piet Mondriaan aan Ds. H. van Assendelft 1914–19." *Museumjournaal* 18, no. 4 (1973):172–79; no. 5 (1973):218–23.

Seuphor, Michel. "Mondrian et la pensée de Schoenmaekers." *Werk* 53, no. 9 (September 1966):362–363.

6. The Twenties and Thirties

Bois, Yve-Alain. "Mondrian en France, sa collaboration à 'Vouloir,' sa correspondance avec Del Marle." *Bulletin de la Société de l'Histoire de l'Art français,* 1981, 281–94.

Champa, Kermit. "Piet Mondrian's Painting Number II: Composition with Grey and Black." *Arts* 52, no 5 (January 1978):86–88.

Doesburg, Nelly van. "Some Memories of Mondrian." In New York, S. R. Guggenheim Museum, *Mondrian Centennial Exhibition*, 1971, 71–73.

"Lettres à Jean Gorin." *Macula* 2 (1977):128–34. Fourteen letters from Mondrian to the sculptor between 1931 and 1939.

Roth, Alfred. *Begegnung mit Pionieren.* Basel: Birkhäuser, 1973. With a memoir on and letters from Mondrian.

Welsh, Robert. "The Place of 'Composition with Small Blue Square' in the Art of Piet Mondrian." *Bulletin of the National Gallery of Art of Canada* (Ottawa), no. 29 (1977):3–32.

7. London and New York

Holty, Carl. "Mondrian in New York, a Memoir." *Arts* 31 (September 1957):17–21.

Holtzman, Harry. "Some Notes on Mondrian's Method: The Late Drawings" and "Piet Mondrian's Environment." In New York, Pace Gallery, *Mondrian: The Process Works*, April 1970. Exhibition catalogue.

Masheck, J. "Mondrian the New Yorker." *Artforum* 13, no. 2 (October 1974):58–65.

New York. Carpenter & Hochman Gallery. *Piet Mondrian: The Wall Works: 1943–44*, 1984. Exhibition catalogue. Introduction by Harry Holtzman.

Nicholson, W. and others. "Mondrian in London, Reminiscences." *Studio International* 172 (December 1966):285–92.

Rose, Barbara. "Mondrian in New York." *Artforum* 10, no. 4 (December 1971):54–63.

Sweeney, James Johnson. "Mondrian, the Dutch and De Stijl." *Art News* 50, no. 4 (December 1971):25–27, 62–64. Includes correspondence from Mondrian also contained in the present volume.

Welsh, Robert. "Landscape into Music: Mondrian's New York Period." *Arts* 40, no. 4 (February 1966):33–39.

Wiegand, Charmion von. "Piet Mondrian: A Memoir of his New York Period." *Arts Yearbook* 4 (1961):57–66.

B. SELECTED EXHIBITION CATALOGUES

New York. S. R. Guggenheim Museum. *Piet Mondrian Centennial Exhibition*, 1971. Texts by H. L. C. Jaffé, Robert Welsh, Joop Joosten, and others.

Paris. Orangerie des Tuileries. *Mondrian*, January–March 1969. Introduction by Michel Seuphor.

Stuttgart. Staatsgalerie Stuttgart. *Mondrian: Drawings, Watercolors, New York Paintings*, 1980. Includes texts by Holtzman, Joosten, Welsh, Henkels, and Von Maur.

Toronto. Art Gallery of Toronto. *Piet Mondrian, 1872–1944*, February–March 1966. Text by Robert Welsh.

C. CONTEXT AND AFFINITIES

1. Romanticism and Impressionism

Manchester. University of Manchester, Whitworth Art Gallery. *Mondrian and the Hague School*, 1980. Exhibition catalogue. Text by J. Sillevis and Herbert Henkels.

Regina, Saskatchewan. Norman Mackenzie Art Gallery. *Piet Mondrian and the Hague School of Landscape Painting*, 1969. Exhibition catalogue. Texts by Nancy E. Dillow and Robert Welsh. Exhibition Catalogue.

Rosenblum, Robert. *Modern Painting and the Northern Romantic Tradition: Friedrich to Rothko.* New York: Harper & Row, 1974.

2. Symbolism

Blotkamp, Carel, et al. *Kunstenaren der idee: Symbolistische tendenzen in Nederland, ca. 1880–1930.* The Hague: Haags Gemeentemuseum, 1978.

Polak, Bettina. *Het fin-de-siècle in de Nederlandse schilderkunst.* The Hague: Martinus Nijhoff, 1955.

3. Modernism and Cubism

Cooper, Douglas. *The Cubist Epoch.* New York: Phaidon, 1970. Catalogue of exhibition at New York Metropolitan Museum of Art and Los Angeles County Museum.

Loosjes-Terpstra, A. B. *Moderne Kunst in Nederland 1900–14.* Utrecht: Haentjens Dekker & Gumbert, 1959.

Museumjournaal 17, no. 6 (December 1972). *Het Nieuwe Wereldbeeld.* Abstract tendencies in Holland, ca. 1914.

4. De Stijl

Baljeu, Joost. *Theo van Doesburg.* New York: Macmillan, 1974.

Blotkamp, Carel, et al. *De beginjaren van De Stijl, 1917–1922.* Utrecht: Reflex, 1982.

De Stijl. Amsterdam: Athenaeum, 1968. Complete facsimile.

Jaffé, H. L. C. *De Stijl 1917–1931: The Dutch Contribution to Modern Art.* London: Alec Tiranti, 1956.

Jaffé, H. L. C., ed. *De Stijl.* New York: Harry N. Abrams, [1971]. Illustrated anthology with introductory text by Jaffé.

Minneapolis. Walker Art Center. *De Stijl 1917–1931: Visions of Utopia.* Edited by Mildred Friedman, 1982.

Oxenaar, Rudolf W. "Bart van der Leck." *Artforum* 11, no. 10 (June 1973):36–43.

———. *Bart van der Leck 1876–1958.* Otterloo: Rijksmuseum Kröller-Müller, 1976.

5. The Twenties and Thirties

Dallas. Museum of Fine Art. *The Paris-New York Axis: Geometric Abstract Painting in the Thirties*, October–November 1972. Exhibition catalogue. Text by John Elderfield.

Elderfield, John. "Geometric Abstract Painting in Paris in the Thirties." *Artforum* 8, no. 9 (May 1970):54–58; no. 10 (June 1970):70–75.

6. New York and After

New Haven. Yale University Art Gallery. *Mondrian and Neo-Plasticism in America*, 1979. Text by Nancy J. Troy.

Seitz, William. "Mondrian and the Issue of Relationships." *Artforum* 10, no. 6 (February 1972):70–75.

D. Theory and Specific Aspects

1. General

Baljeu, Joost. "The Problem of Reality with Suprematism, Construc-

tivism, Proun, Neoplasticism, and Elementarism." *Lugano Review* 1 (1965):105–24.

Champa, Kermit. *Mondrian Studies*. Chicago: University of Chicago Press, 1985. ?

Hill, Anthony. "Art and Mathesis: Mondrian's Structures." *Leonardo* 1, no. 3 (July 1968):233–42.

Schapiro, Meyer. "Mondrian, Order and Randomness in Abstract Painting." In *Selected Papers: Modern Art 19th and 20th Centuries*. New York: Braziller, 1978.

2. *The Diamond Format and the Oblique*

Baljeu, Joost. "The Fourth Dimension in Neoplasticism." *Form* 9 (1969).

Carmean, E. A., Jr. *Mondrian: The Diamond Compositions*. Washington: National Gallery of Art, 1979. Exhibition catalogue.

Jaffé, H. L. C. "The Diagonal Principle in the Works of van Doesburg and Mondrian." *Structurist* 9 (1969):15ff.

3. *Architecture*

Banham, Reyner. "Mondrian and the Philosophy of Modern Design." *Architectural Review*, October 1957, 227–29. Reprinted in *Arts Yearbook* 4 (1961).

———. *Theory and Design in the First Machine Age*. London: Architectural Press, 1967; New York: Praeger, 1967.

Blotkamp, Carel. "Mondrian—architectuur." *Wonen-TABK* 4–5 (1982):12–51.

Bois, Yve-Alain. "Mondrian et la théorie de l'architecture." *Revue de l'art* 53 (1981):39–52.

Troy, Nancy J. "Piet Mondrian's Atelier." *Arts*, December 1978, 82–88.

———. "Mondrian's Designs for the Salon de Mme B . . . à Dresden." *Art Bulletin* 62, no. 4 (December 1980):640–47.

———. *The De Stijl Environment*. Cambridge: MIT Press, 1983.

4. *Literature and Music*

Blotkamp, Carel. "Mondriaan als literator." *Maatstaf* 26, no. 4 (April 1978):1–24.

von Maur, Karin. "Mondrian and Music." In Stuttgart, Staatsgalerie Stuttgart, Mondrian: Drawings, Watercolors, New York Paintings, 1980, 287–311.

Appendix

Practical Instruction—Planes

3 Praktische onderwijs — Planes —

Verkrijgen door vrij [...] door de [...]

I vorm en kleur

1° beelding — lijnen en vormen van fantasie en [...]

[...] kleine idem

2° b. van een zelfde soort, van meerdere soort.

3° b. lijnen geom. vormen en lijnen —

kleine idem

4 Idem van eenzelfde soort, van meerdere soort

5 geom. lijnen —

kleine idem

6 Idem van een soort, van meerdere

apart
snijdend
(los)

(constructie)

V.V.

II verhouding (fantastisch)

II

7? beelding. verhoudingen van vorm en kleur

/ | — van stand /// zelfde stand

/ \ | 8° idem van kleur. /\ verschill. stand —

9 idem van afmetingen

— /

| | +9 idem van kleur

11 idem ~~toevallig~~ verhoudingen — toevallig

zelfde stand

/ \ / \ / \ V repetitie. verschil ~~afmet.~~

12 idem van kleur —

13 van ~~geometrische~~ verhoudingen — zelfde stand, verschil stand.

| — | — " afmet.! } afmeting oppositie — } evenwichtig van zelfde van verschil } evenwichtig. (evenwaardigheid)

14 Strikte evenwaardigheid ✗
15 Betrekkelijke evenwaardigheid — } van vorm en kleur —

✗ Komt duidelijk uit in de architectuur —

Planes and Space

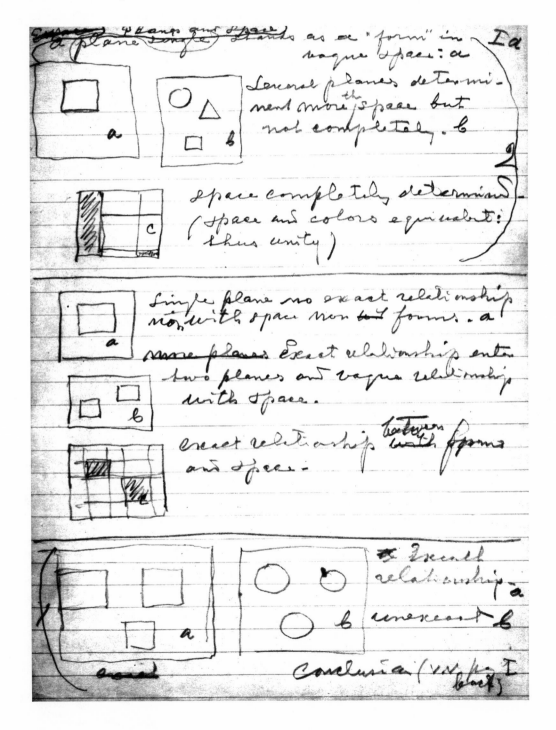

Conclusion by Teacher

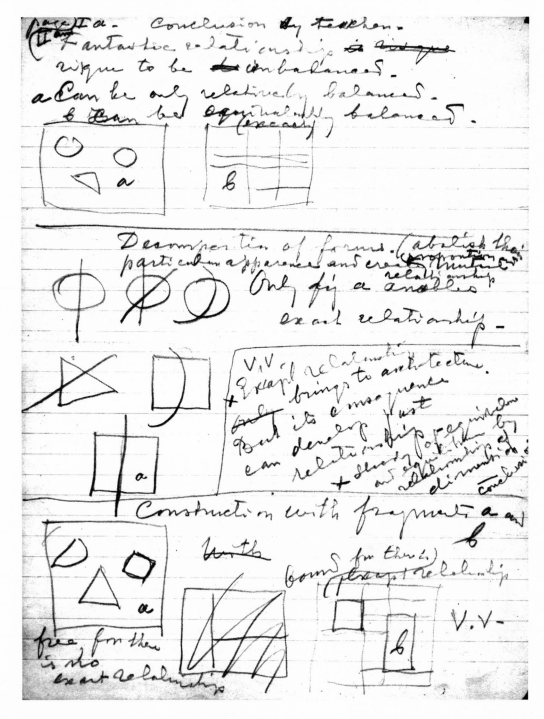

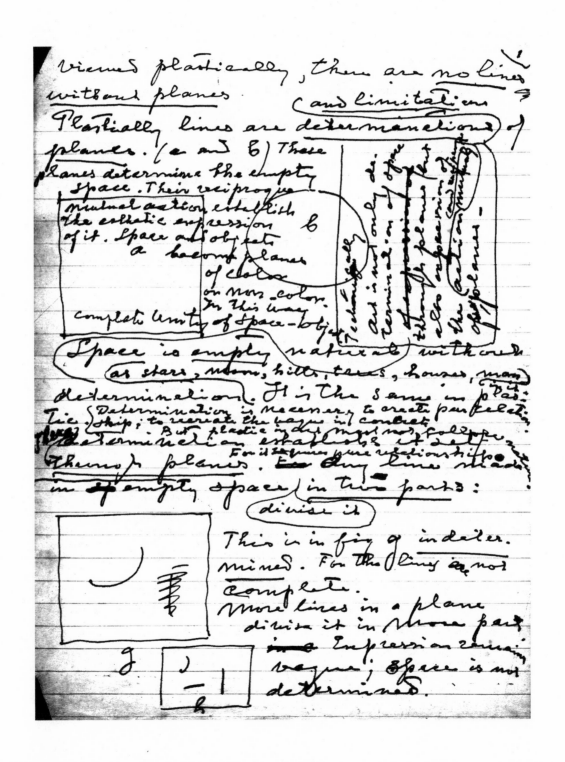

Viewed plastically, there are no lines
without planes. (and limitations)
Plastically lines are determinations of
planes. (a and b) These
planes determine the empty
space. Their reciprocal
mutual action establish
the esthetic expression b
of it. Space and objects
a become planes
of color
or non-color.
In this way
complete unity of space-object

Space is empty (natural) without
(as stars, moons, hills, trees, houses, man)
determination. It is the same in plas-
tic. Determination is necessary to create perfect
ship; to recreate the vague in contrast.
But plastic in dividual must not follow
determination establish it self
the most planes. For it assumes pure relationship
in empty space in two parts:
divide it

This is in fig g indeter-
mined. For the lines are not
complete.
More lines in a plane
divide it in those part
in a expression even
vague; space is not
determined.

g

Viewed in the way of art-plastic, ~~the~~
~~no~~ lines ~~it~~ are part of planes, establish
or not.

a = established
b not

In art-plastic
lines are determi-
nations or limi-
tations of planes. ~~This can be in harmonion~~

b determination of
empty plane

c limitations of
plane.

~~In Plastic (art)~~
Planes and ~~not~~ lines determine the emp-
ty space.
In nature and in naturalistic art ~~these planes are~~
~~fine of~~ — in relief.
In nature and in naturalistic art no
pure relationship is possible.
Will plastic art establish pure relation-
ship, it must not follow nature.
In painting it must keep to the planeness
of the canvas, in sculpture and architec-
ture it must create planes through moving
around the work in the way that no perspec-
tive vision establish it self.
Plastic art must create planes & In conse-
quence ultime (in pure relationship to
the canvas — (it must do this)

Natural space is empty without
determination of that space in it. ×

a : empty
b : determined

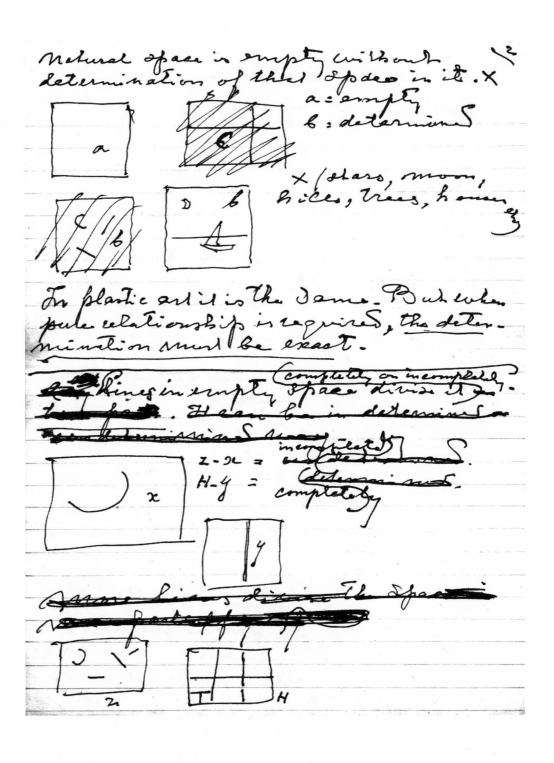

× (stars, moon,
hills, trees, houses)

In plastic art it is the same. But when
pure relationship is required, the deter-
mination must be exact.

$z - x =$ incomplete
$H - y =$ completely

any line ~~a line~~ drawn in a plane
changes its expression: fig a.

It abolishes the plane.

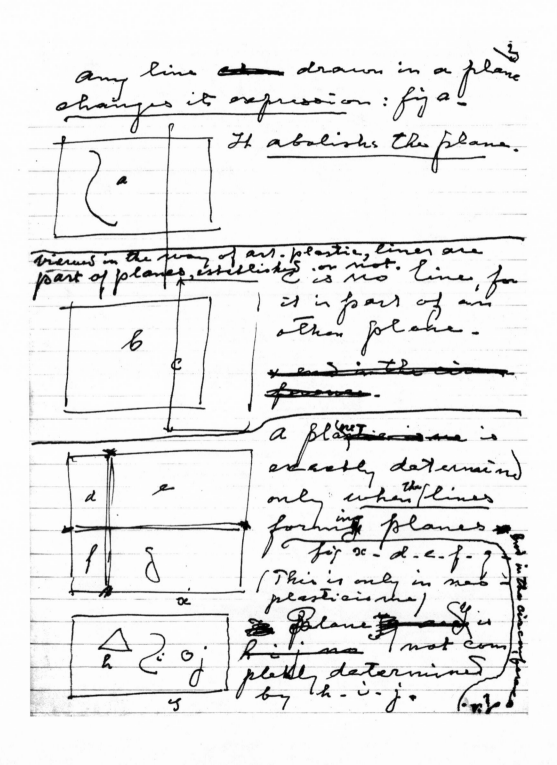

viewed in the way of art. plastic, lines are
part of planes, istillishs or not. c is no line, for
it is part of an
other plane.

~~x end in their~~
~~plane.~~

a ~~planicisme~~ line is
exactly determined
only when the lines
forming planes
fig x - d - e - f - g
(This is only in neo
plasticisme)

~~Plane~~ y is
k i j no not com
pletely determined
by k - i - j.

but in the airost planes

(·x·)

Index